W9-CPQ-040

THE
VATICAN

THE VA

PUBLICATION AUTHORIZED BY THE VATICAN
and published in connection with the exhibition
The Vatican Collections: The Papacy and Art

TICAN

Spirit and Art of Christian Rome

The Metropolitan Museum of Art, *New York*
Harry N. Abrams, Inc., Publishers, *New York*

The text of this volume is based in part on *The Vatican and Christian Rome*, published in 1975 by Libreria Editrice Vaticana.

This volume is issued in connection with the exhibition *The Vatican Collections: The Papacy and Art*, organized by The Metropolitan Museum of Art, New York, The Art Institute of Chicago, and The Fine Arts Museums of San Francisco.

The Metropolitan Museum of Art, New York
Bradford D. Kelleher, Publisher
John P. O'Neill, Editor in Chief
John Daley, Editor
Joan Holt, Project Manager
Gerald Pryor, Designer
Composition by U.S. Lithograph Inc., New York
Printing and binding by Arti Grafiche Amilcare Pizzi S.P.A.—Milan

Library of Congress Cataloging in Publication Data

Main entry under title:

The Vatican.

 Bibliography: p. 395
 1. Art—Vatican City. 2. Christian art and symbolism—Vatican City. 3. Vatican.
I. Metropolitan Museum of Art (New York, N.Y.)
N6920.V3 1982 708.5'634 82-14271
ISBN 0-87099-348-8
ISBN 0-8109-1711-4 (Abrams)

CONTENTS

POPE JOHN PAUL II

His Holiness Pope John Paul II announced the exhibition The Vatican Collections: The Papacy and Art *on April 29, 1982, in the Aula del Sinodo in the Vatican to an assembled group of Vatican officials, American prelates, museum directors, and representatives of the press:*

Through your efforts to promote the patrimony of art that is preserved in the Vatican, you are giving an eloquent testimony to your esteem for art and for its role in helping to uplift the human spirit to the uncreated source of all beauty.

In its constant concern not to neglect the spiritual dimension of man's nature, and to urge the world to direct its gaze upwards to God—the Designer and Creator of the universe—the Holy See welcomes your devoted collaboration with the Vatican Museums as they strive to communicate to as many people as possible all the cultural benefits of that artistic heritage of which they are the custodian.

In particular, I am happy that our meeting today coincides with the official announcement of the Vatican Exhibition in the United States entitled *The Vatican Collections: The Papacy and Art*. This unprecedented event, which was fostered by Cardinal Cooke as a result of my own visit to the United States, immediately found the ready and generous cooperation of so many distinguished persons. . . . This important initiative, jointly organized by the Vatican Museums and The Metropolitan Museum of Art of New York, in collaboration with The Art Institute of Chicago and The Fine Arts Museums of San Francisco, likewise received the enthusiastic welcome of the Archdioceses of New York, Chicago, and San Francisco. . . . My special gratitude goes to all the representatives of the museums involved and especially to the directors thereof.

In accordance with the purpose of the exhibition itself, the works of art will begin to relate the long and interesting relationship between the Papacy and art throughout the centuries. Above all, these works of art will have a contribution to make to the men and women of our day. They will speak of history, of the human condition in its universal challenge, and of the endeavors of the human spirit to attain the beauty to which it is attracted. And, yes! These works of art will speak of God, because they speak of man created in the image and likeness of God; and in so many ways they will turn our attention to God himself.

And thus the history of the Church repeats itself: her esteem for art and culture is renewed at this moment and in this generation as in the past. . . .

The Vatican

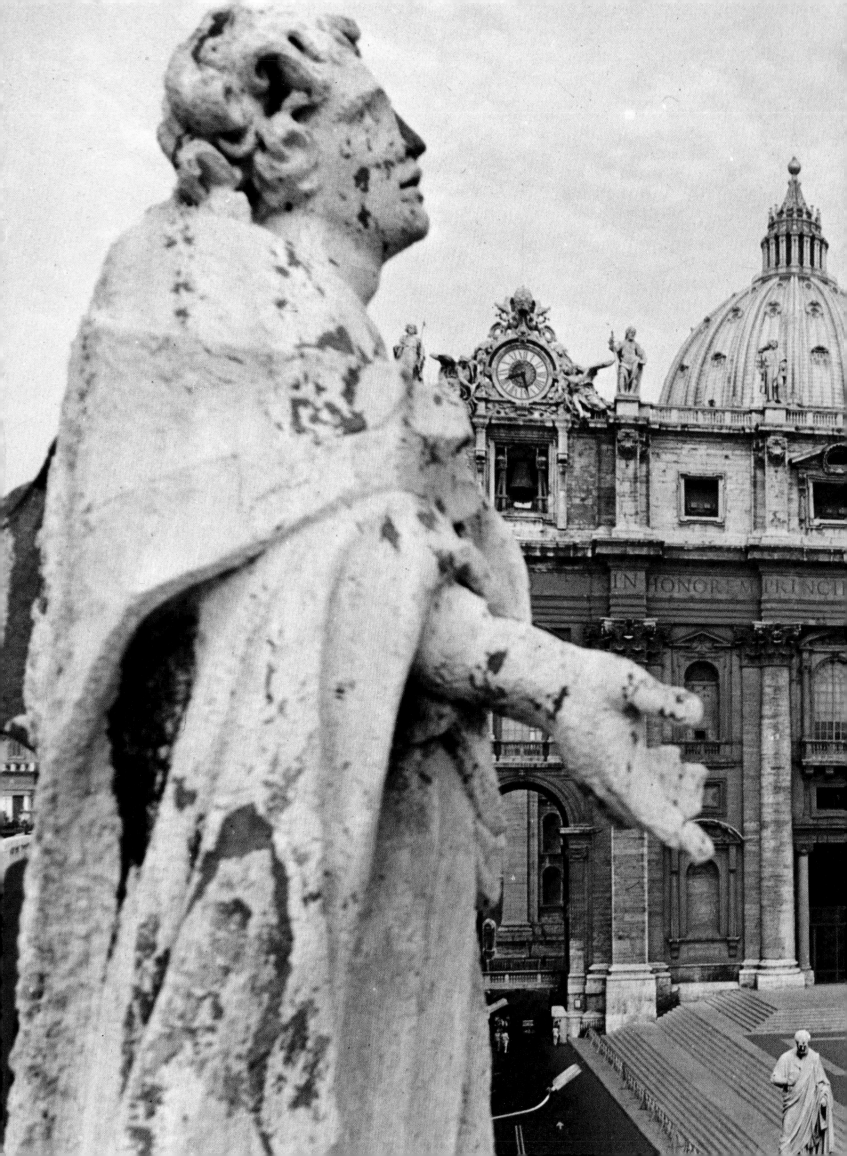

HISTORICAL NOTE

The ancient Romans gave the name Vaticanum to a large, apparently rather sketchily defined area that stretched along the right bank of the Tiber from the Janiculum to the Milvian Bridge. The meaning of the word is obscure; it is probably of Etruscan origin. The terrain consisted both of hills, the Montes Vaticani, and of level ground, the Campus Vaticanus. It was sparsely populated, chiefly by small farmers and—since the soil was rich in clay—by manufacturers of pottery, bricks, and tiles. Until the middle of the first century A.D., the ferries that plied the Tiber provided the only direct link with the center of town. Nevertheless, by the time of Augustus the Vaticanum was already considered an integral part of Rome; it was included within Trans Tiberim, the fourteenth of the administrative districts into which that emperor divided the city.

The Vaticanum enjoyed a poor reputation—Tacitus, in fact, describes it as "infamous"—because its low-lying portions were marshy and gave rise to malaria. According to Pliny its snakes were large enough to swallow babies whole. Even its wine was despised: "Vaticana bibis, bibis venenum," wrote the satirist Martial—"Drink Vatican and you drink poison."

These drawbacks did not, however, prevent wealthy Romans of the early Empire from acquiring land in the Vaticanum and constructing luxurious villas with vast gardens. The most important of these belonged to the elder Agrippina, who left it to her son Caligula; another was inherited by Nero after he arranged to have his aunt Domitia Lepida assassinated. The development of the area, in fact, dates from the reigns of Caligula and Nero. A bridge (known in medieval times, at least, as the Pons Neronianus) was built across the Tiber. Ancient sources mention an enclosure called the Gaianum where Caligula practiced horsemanship and chariot racing, and a great basin of water, the Naumachia, used for mock sea battles.

But the most significant by far of these imperial projects was the Vatican Circus, begun by Caligula and completed by Nero. According to tradition, which archaeological excavations seem to corroborate, it was adjacent to the present site of Saint Peter's basilica. The obelisk which Caligula had brought from Egypt to adorn the circus, and which is now in the middle of Saint Peter's Square, stood, until 1586, a few meters to the south of the side wall of the basilica; it had presumably marked the center of the *spina*, the long ridge that ran down the middle of every Roman circus. It was in the Vatican Circus that Nero, blaming the Christians of Rome for the fire that ravaged the city in A.D. 64, threw many of them to the wild beasts or had them crucified. And it was during this first persecution, according to a very ancient tradition, that the apostle Peter, the first bishop of Rome, was martyred *juxta obeliscum*, "beside the obelisk."

Three important roads, the Via Cornelia, the Via Triumphalis, and the Via Aurelia Nova, crossed the Vaticanum and converged near the Pons Neronianus. As in other parts of suburban Rome, these roads were lined with sepulchral monuments of various sorts. It was in this area that the emperor Hadrian, in A.D. 135, built his great mausoleum (which in the Middle Ages was transformed into a papal fortress, Castel Sant' Angelo); he also built a new bridge, the Pons Aelius (now Ponte Sant'Angelo) to connect the mausoleum with the center of the city. Other ancient mausoleums in the vicinity remained standing until comparatively recent times, and numerous tombs and funerary altars have been discovered in the course of excavations. Adjoining Nero's circus was a cemetery, consisting mainly of the tombs of pagan families. But a small, poor plot within it was maintained by Christians. And it was believed, at least from the middle of the second century, that here Saint Peter was buried.

On October 28, 312, the emperor Constantine won a decisive victory over his rival Maxentius at the Milvian Bridge, on the outskirts of Rome. He attributed his success to the intervention of the God of the

A statue of a saint atop the colonnade designed for Saint Peter's by Gianlorenzo Bernini between 1656 and 1660.

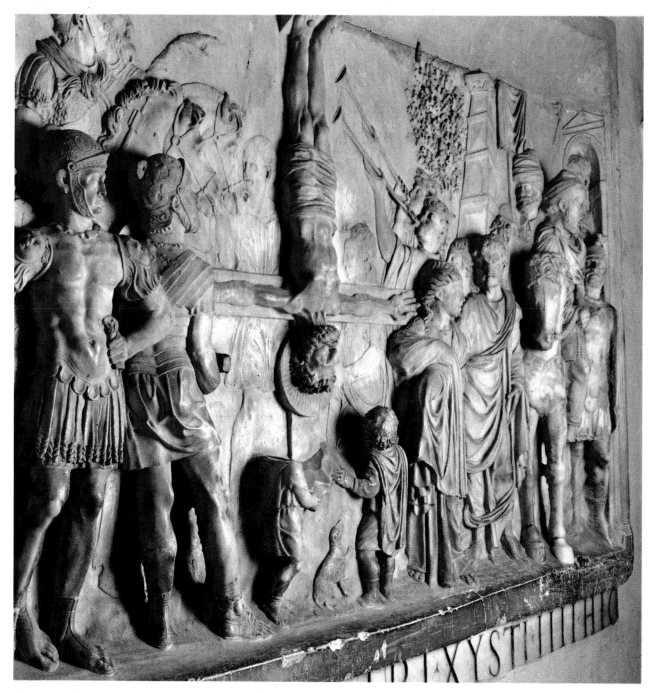

The *Crucifixion of Saint Peter*, one of the four reliefs that adorned the marble ciborium constructed by Sixtus IV in 1479 over the high altar of Old Saint Peter's.

Christians, and, though for reasons of state he remained unbaptized until he was on his deathbed in 337, he immediately reversed the religious policy of most of his predecessors: not only did he grant the Christian community freedom of worship, but he proceeded to do everything in his power to further its interests. One of his first acts was to build a great basilica for the bishop of Rome, Pope Melchiades, on imperial property at a place on the eastern edge of the city known as the Lateranum after its original owners, a family called the Laterani. The basilica was originally dedi- cated to the Savior; later its name was changed to San Giovanni in Laterano. From the beginning it was the cathedral church of Rome, and it remains so to this day. Existing buildings at the same site were placed at the disposal of the church; the popes established their residence there; a vast palace, called the Patriarchium, grew up piecemeal as an ecclesiastical bureaucracy gradually evolved. For a thousand years the Lateran was the administrative center of the Roman church.

A few years later Constantine built another basil- ica, larger than the Lateran and equally splendid, in

the Vatican—directly over the cemetery where Christians had long venerated the remains of Peter. Its form was, on the whole, similar to that of the Lateran basilica, but its purpose was completely different. It was, like other Early Christian places of worship, a *martyrium*: commemorative banquets were held there in honor of Saint Peter, and it served as a kind of covered cemetery; many of the faithful were buried within its precincts. The vast dimensions of Old Saint Peter's testify to the fact that, already in Constantine's time, multitudes of pilgrims converged upon Rome to honor the Prince of the Apostles.

In the centuries that followed the Constantinian foundation, numerous buildings sprang up in the Vatican, around Saint Peter's. First of all, there were lodgings for pilgrims. From the time of Pope Symmachus (498–514), there were two *episcopia* along the north side of the basilica, where the popes and their retinues could be quartered temporarily when they came from the Lateran to officiate at liturgical functions. Residences were also constructed for the numerous monks and secular clergy who were permanently attached to the basilica. There were hostels and bathhouses for the poor. In the eighth century *scholae* were established, where pilgrims from the North—Saxons, Longobards, Franks, and Frisians—were looked after by priests of their own nation. The constant influx of pilgrims was, naturally, an important source of income for the lay population, and a thriving commercial quarter, the Borgo, grew up between Saint Peter's and the Tiber.

Medieval Rome was frequently beset by wars and civil strife, and from time to time the popes found it expedient to leave the Lateran and take up temporary residence in the Vatican. But until the ninth century, Saint Peter's and the buildings around it were defenseless—they lay outside the fortified circle of city walls that the emperors Aurelian and Probus had erected in the third century. In 846 Saracen pirates landed at Ostia

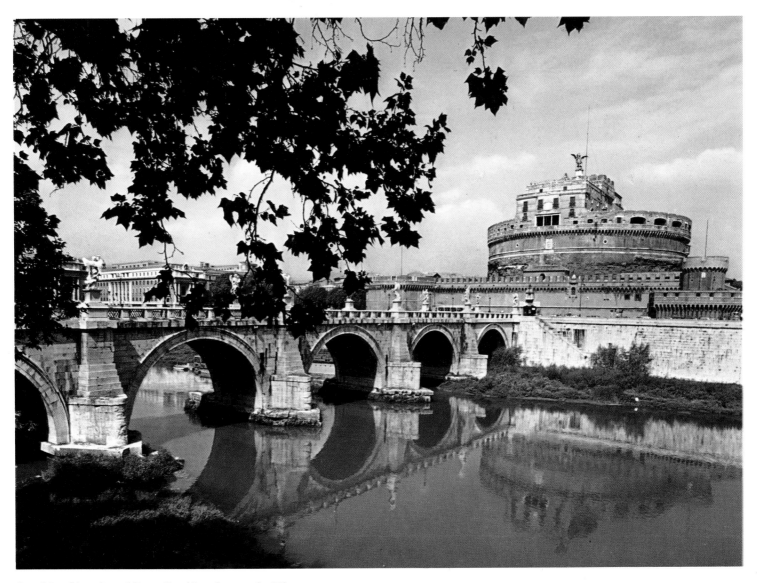

Castel Sant'Angelo and Ponte Sant'Angelo over the Tiber.
Originally constructed as the mausoleum of Hadrian in A.D. 135,
Castel Sant'Angelo became a papal fortress during the Middle Ages.

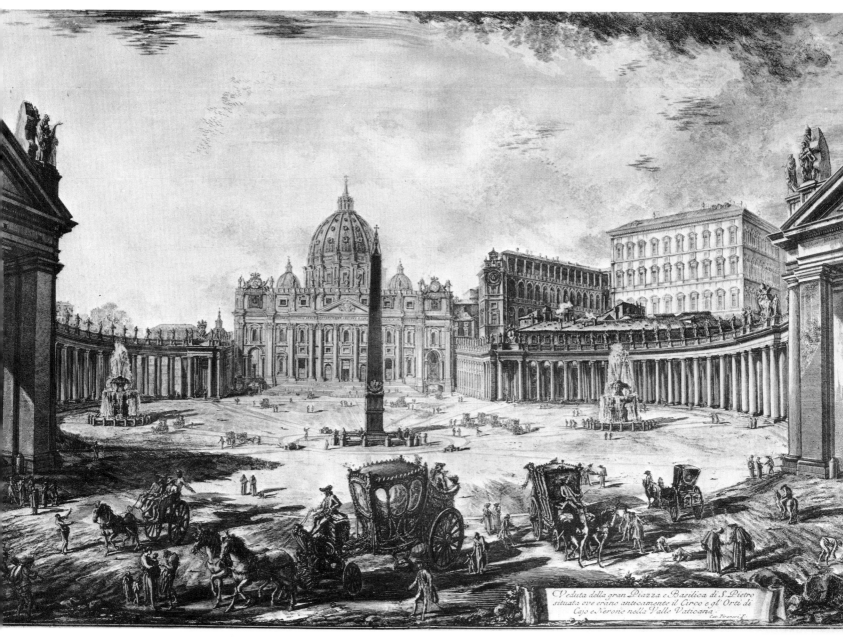

View of Saint Peter's, engraving by Giovanni Battista
Piranesi (1720–78), from *Vedute di Roma*.
The Metropolitan Museum of Art, Rogers Fund, 1941 (41.71)

and attacked Rome. The city resisted the siege, but Saint Peter's was sacked, its rich treasury was looted, and—what was worse—the shrine of the Apostle was defiled. The reigning pope, Sergius II, died a few months later; his successor, Leo IV, began in 847 to encircle the basilica, the other ecclesiastical foundations, and the Borgo with a wall. It stood twelve meters high and had four main gates and forty-six fortified towers. On June 27, 853, the Leonine City, as the enclosed area was now called, was inaugurated with a solemn procession. The Vatican became an urban entity in itself, physically and even juridically distinct from the city of Rome. Certain branches of the papal government were transferred here from the Lateran. Later popes, over a period of many centuries, enlarged the walls and extended the territory of the Leonine City.

Saint Peter's, in the Middle Ages, was not just a pilgrimage church. As the power of the papacy grew, the shrine of the first pope acquired even greater symbolic importance. From the time of Leo I (440–61), numerous popes were buried in various parts of the basilica; some were buried at the Lateran. Papal elections normally took place at the Lateran. But, apparently beginning with Leo III (795–816), new popes were crowned at Saint Peter's; they then rode in procession to the Lateran to "take possession" of their cathedral, San Giovanni. And it was in Saint Peter's that, on Christmas day in the year 800, Leo III crowned the Frankish king, Charlemagne, Roman emperor. For centuries thereafter, Western emperors of various dynasties traveled to Rome to be crowned by the pope in Saint Peter's. So important was this ceremony that it

sometimes took place in dramatic circumstances. When the German king and emperor-designate Henry IV was excommunicated and deposed by Pope Gregory VII, Henry, in 1084, marched on Rome, occupied the Leonine City, and had himself crowned in Saint Peter's by an antipope of his own choosing, Clement III. Henry's successor, Henry V, also invaded Rome; in 1111 he abducted Gregory's successor, Paschal II, and forced him to go through with the coronation—in secret, but in Saint Peter's.

Between 1305 and 1376 the popes resided with their entire court at Avignon in southern France. During their absence conditions in Rome deteriorated drastically. The population was reduced to 17,000; whole quarters of the city were abandoned; streets became impassable; churches, houses, and palaces—including the papal residence at the Lateran, the Patriarchium—fell into ruin. When Gregory XI returned from Avignon to Rome in 1377, he moved into the Vatican. In the following year, however, there began the Great Schism, during which there were two, and for a time three, rival claimants to the papal throne; it was a period of incessant disorder, and further damages were inflicted upon the city. When in 1417 the schism was ended, and peace restored, the new pope, Martin V, decided not to rebuild the crumbling Patriarchium. He and his successors would remain at the Vatican, near the tomb of Saint Peter, symbol of the origin and of the continuity of their office. From that time until the present day, the Vatican has been the established and official residence of the popes, and the seat of the central government of the Catholic church.

For many centuries the popes were temporal sovereigns as well as spiritual leaders. From the time of Constantine, in fact, the church had possessed vast estates throughout Italy and even beyond its borders. After the collapse of the Roman Empire in the West, Rome and other parts of Italy remained theoretically subject to the emperor at Constantinople. But Italy was overrun by Germanic invaders and despoiled by local barons in interminable conflict with each other.

In the midst of the chaos, the bishop of Rome came to exercise considerable political authority. Under Gregory the Great (590–604) the church's lands in central Italy, known as the Patrimony of Peter, were organized as a de facto state, ruled by the pope and his administrators in the Lateran and defended by an armed militia. In 754 the Frankish king Pippin bestowed upon the Holy See extensive territories in central and northern Italy, and the settlement was confirmed by Charlemagne in 774; thus the popes became sovereigns of a recognizable political entity, the Papal State.

Despite constant struggles with feudal families and republican communes, with German emperors and French kings, the Papal State endured for more than a thousand years. Papal government was briefly overthrown three times: in 1798, when, in the wake of the French Revolution, a Roman Republic was proclaimed; in 1808, when the Papal State was annexed by Napoleon's empire; and in the revolution of 1848–49, when a second Roman Republic was established. The state ultimately succumbed to the process of Italian unification. In 1860 the northern provinces were annexed by the kingdom of Italy, and in September 1870 Rome fell and was declared the capital of the new nation.

In 1871 the Italian government unilaterally passed the so-called Law of Guarantees. Church and state were declared separate; the pope was to retain control over the Leonine City, the Lateran Palace, and the papal villa at Castelgandolfo; he was to be accorded the honors due to a sovereign. But Pius IX (1846–78) indignantly repudiated this arrangement. He and his three immediate successors lived as voluntary prisoners within the Vatican Palace, while many nations continued to recognize the pope as a sovereign. Only gradually, during the early years of the present century, did the hostility between the Holy See and the Italian state begin to abate. Finally, in 1929, the Roman Question was definitively settled by the Lateran Treaty, which recognized the Vatican City as a free, independent state with the pope as its ruler.

JOHN DALEY

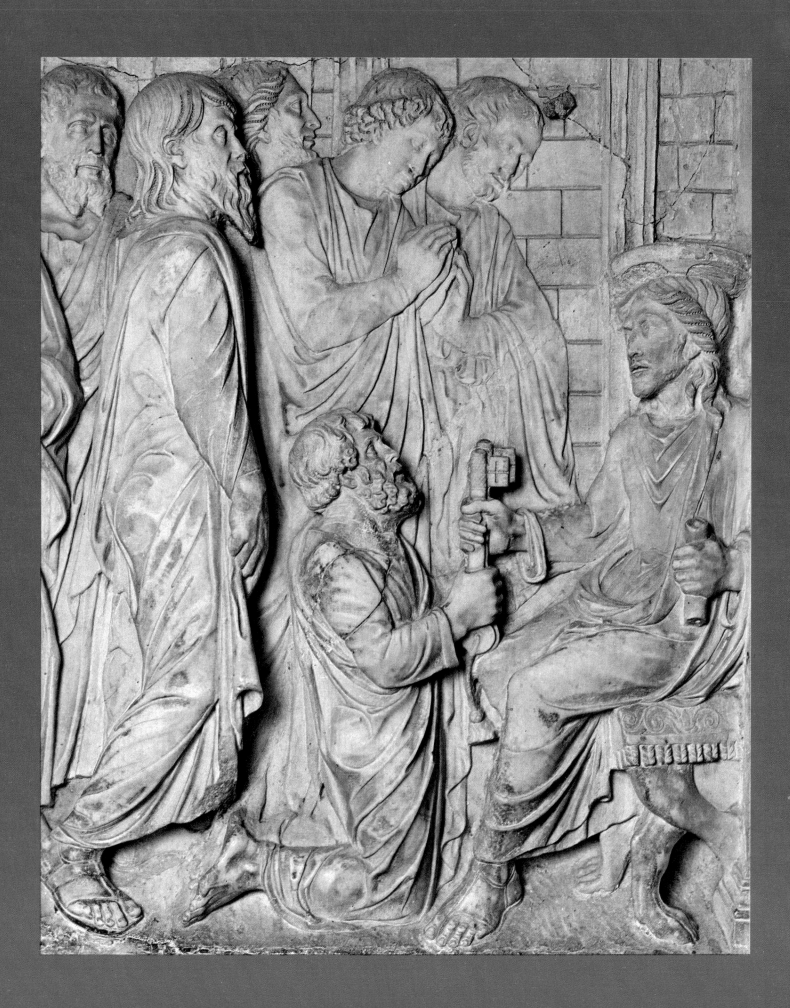

THE GOVERNMENT OF THE CHURCH

The Pope, the Bishops, and the Cardinals

The pope's mission is based, according to the Catholic faith, on the prerogative of the primacy of jurisdiction given by Jesus Christ to Saint Peter and transmitted to his successors in the see of Rome. This is not only a primacy of honor; it entails the power to govern. It stems from Jesus' words to his apostle Simon, the son of Jonah, "Thou art Peter [*Petrus*; in Aramaic, *kêpā,* 'rock'], and upon this rock I will build my church: and the gates of Hell shall not prevail against it. I will give you the keys to the kingdom of heaven: and whatsoever thou shalt bind on earth shall be bound in heaven: and whatsoever thou shalt loose on earth shall be loosed in heaven [Matt. 16:18–19]," and from his solemn charge to Peter after the Resurrection, "Feed my sheep [John 21:15–17]."

The Acts of the Apostles attest to Peter's exercise of this primacy from the very beginning of the church, and history records the activity of his successors, the bishops of Rome, in clarifying matters of faith, as, for example, during the christological disputes of the early centuries. This activity resulted in the recognition of a binding papal *magisterium*—supreme authority in deciding controversies and doubts, and in making laws for all the faithful.

United with the pope are the bishops, successors of the apostles, who rule over individual churches. These churches are usually defined territorially as dioceses, though they may also consist of particular groups of persons, such as members of a certain rite, immigrant communities, or the armed forces.

The appointment of bishops has been carried out in various ways over the centuries, according to prevailing political, social, economic, and cultural circumstances in particular places at particular times. For a long time the principal method was election by certain groups or categories of persons; the election was then approved by a competent higher authority. As communications became easier, and as the need to pro-tect bishops from undue interference became increasingly clear, these elections were generally replaced by direct nomination by the Roman pontiff.

To these two elements—the local church presided over by the bishop and the universal church ruled by the pope, who guarantees the unity of the entire structure—have been added a number of administrative institutions. Some of them are of very ancient origin, such as the ecclesiastical province (governed by a metropolitan or archbishop), the primatial district, the exarchate, and the patriarchate. Later, local churches united with each other territorially, along national, ethnic, or political lines. As the known world gradually enlarged, new forms of ecclesiastical collaboration grew up and took shape, such as national episcopal conferences (which since the Second Vatican Council have an official status) and their various regional and continental confederations.

Practical cooperation has assumed diverse institutionalized forms at various times. The earliest was the synod or council. For this there assembled, even in ancient times, the pastors of a province, of a primatial territory, of a patriarchate, of a nation, of a continent, or of the whole church. When the subjects under discussion were of universal interest, the presence and approval of the guarantor of the unity of the whole church, the Roman pontiff, was necessary.

The college of bishops assembles for ecumenical councils. Together, and under the guidance of their leader, the pope, they discuss problems of faith and morals and those pastoral questions which concern the whole church. The last two ecumenical councils, in 1869–70 and in 1962–65, took place in Saint Peter's, the Vatican basilica, and are therefore known as the First and Second Vatican Councils.

A special form of consultative collaboration with the pope is the synod of bishops. This institution was established by Paul VI with the *motu proprio* "Apostolica Sollicitudo" on September 15, 1965. Bishops from all over the world take part in the synod. Some are

Christ Giving the Keys to Saint Peter, detail of one of the marble reliefs from the ciborium of Sixtus IV.

elected by the various episcopates; others are appointed by the pope. The synod is one expression of the doctrine of episcopal collegiality that was developed during the Second Vatican Council. According to this doctrine, however, it is also possible for the bishops to act collegially with the pope, at his initiative and under his guidance, without assembling physically in one place.

Another ecclesiastical institution of ancient origin is the cardinalate, which participates in the papal government of the Catholic church. In charge of the principal parish churches of Rome, known as titular churches, were priests with special powers and with responsibility for all the clergy belonging to those churches. There were twenty-five of them at the time of Pope Marcellus I (308–09); later their number was raised to twenty-eight. Besides serving their own parishes, they also took turns in presiding over the ceremonies in the four major basilicas of Rome. From the eighth century on, they were often called cardinals; the origin of the word is uncertain.

In addition to these prominent priests there were also, in Rome, certain deacons who presided over regions of the city, nineteen at the time of Gregory the Great (590–604), and later twelve. Their functions were primarily administrative. There were also six palatine deacons, who were employed in the service of the pope in his Lateran cathedral. Because of their important positions, these regional and palatine deacons came to be called cardinal deacons.

Finally, there were the bishops of the seven suburbicarian dioceses, on the outskirts of Rome. These bishops were often summoned by the pope to assist at the sacred ceremonies in the Lateran basilica. They were therefore considered members of the Roman clergy, and were called cardinal bishops. In all, then, there were eighteen cardinal deacons, twenty-eight cardinal priests, and seven cardinal bishops. In 1586, the total number of cardinals was raised to, and fixed at, seventy by Sixtus V. Six of them, bishops of particular dioceses in the vicinity of Rome, were designated as cardinal bishops; fifty, mainly leading bishops from various parts of the world, as cardinal priests; and fourteen, usually priests with administrative assignments in the Vatican, as cardinal deacons. Recently, the popes from John XXIII on have further increased their number.

As the highest-ranking members and representatives of the Roman clergy, the cardinals took on a particularly important duty when, beginning in 1059, the right to elect the pope was reserved to them. But they also gained increasing importance as collaborators of the pope's in governing the entire church, above all as papal legates. From the eleventh century onward, they were called to Rome from other churches on a

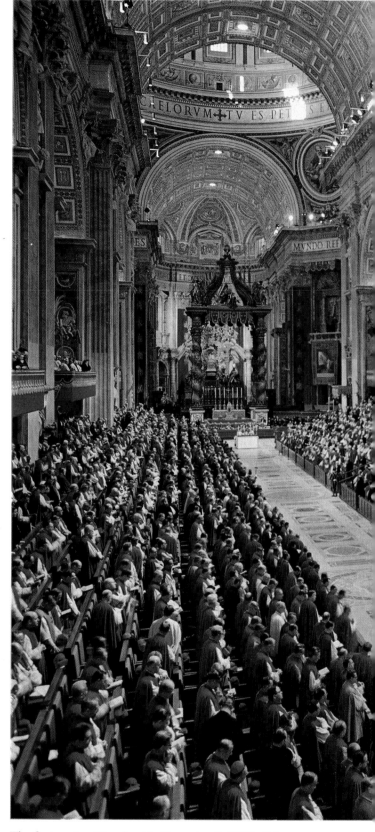

The first session (October 11–December 8, 1962) of the Second Vatican Council, in Saint Peter's Basilica.

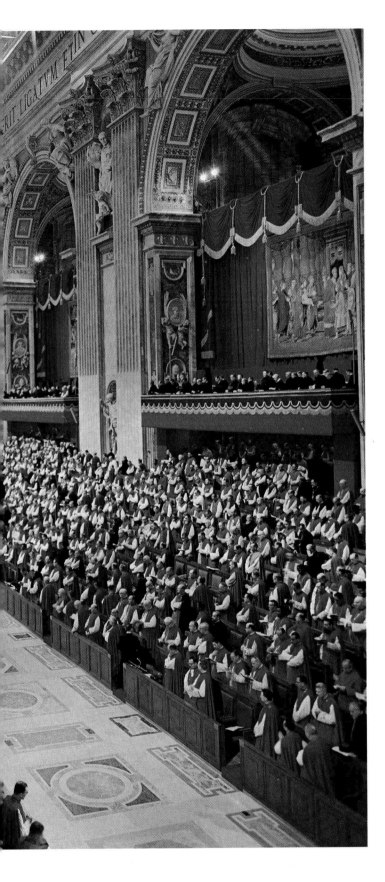

permanent basis, and thereby became incorporated into the Roman clergy. Even today, each cardinal, though he may have a diocese in a distant land, has his own "titular" church in Rome.

Besides electing the pope, the college of cardinals also assumes the ordinary government of the church during a vacancy in the Apostolic See.

The Evolution of the Roman Curia

In the exercise of government, the popes always needed assistants of a lower grade for the dispatch of ordinary affairs. These subordinates gradually formed a considerable complex of administrative departments, and this became known as the Roman Curia. Through the centuries, the institution as a whole has undergone a continual development. A brief description of its history will help to explain its present structure and functions.

In the first centuries, the pope was permanently assisted in matters of faith, morals, and discipline by the *presbyterium*, which was constituted by the Roman clergy and which acted as a council. Later, only certain categories of the clergy were actively represented; among these the cardinals (deacons, priests, and bishops) were the most important.

The various functions of the government of the Roman church came to be administered by special categories of papal assistants. The first to appear was that of the notaries, headed by a high-ranking official, the *primicerius*, and his deputy, the *secundicerius*. The notaries constituted a college; they dealt with chancery matters, and also acted as legates, apostolic visitors, and judges. They had custody of the *scrinium*, or archive, and of the library of the Holy See. Everyday work was supervised by the chief scribe, the *protoscrinarius*. Another college, that of the *defensores*, protected the poor and also watched over the rights of the church, administering its estates and performing various judicial duties. Other papal officials included the *arcarius*, or general treasurer of the church; the *sacellarius*, who handled the ordinary expenses of the papal household; the *vestiarius*, who was responsible for precious objects such as vestments, altar furnishings, and liturgical books; and the *nomenclator*, a kind of master of ceremonies who also received and answered petitions.

Another advisory group was the synod, which met at least once a year, during Lent, and which discussed important problems of faith and discipline. Members of the non-Roman clergy, coming from the provinces or traveling through Rome, also participated in this synod.

The three orders of the cardinalate—cardinal deacons, cardinal priests, and cardinal bishops—gradually

emerged among the members of the *presbyterium* and of the synod. From the time of the Gregorian reform in the eleventh century, the cardinals began to form collegially the ordinary council of the pope. There began the so-called era of consistories, in which the pope deliberated on the ordinary and extraordinary affairs of the church in Rome and throughout the world in the presence of the cardinals. The consultative functions of the *presbyterium* and of the synod thus passed to the consistory—that is, to the cardinals who assembled with the pope, sometimes several times a week. The great importance of the cardinals and of their college derives, therefore, not only from their voice in papal elections, but also from their share in the government of the entire church. This function, which in principle was only consultative, was often in effect a determining factor in the pope's decisions.

For the preparation, and later also for the deciding, of judicial cases the popes made use of men particularly versed in the law, whom they called their chaplains. The chaplains' decisions, especially after the middle of the twelfth century, virtually came to constitute the general law of the church, through the precedents established by the solution of particular cases.

These skilled chaplains, competent in the field of law, attained ever greater importance as they worked together with, and under, the college of cardinals. But they were not alone. Other officials began to form ever more permanent organizations with specific competence in a steadily increasing range of affairs, which they dealt with at the direction of the popes. Thus there arose the Chancery with its various sections, whose task was to draw up papal documents and keep the archives, and the Apostolic Camera, in charge of the economic and financial administration of all the property of the Holy See. In time, the chaplains' organization for dealing with contentious cases became a permanent tribunal, later called the Sacred Roman Rota (the name Rota seems originally to have designated the round table at which the members sat). Finally, there was established the Sacred Apostolic Penitentiary, a tribunal for exercising papal power in matters of conscience.

Thanks to the continuous development and subdivision of the already existing departments there were eventually added the Apostolic Datary, which granted favors requested of the Holy See, and the Signatura, which acted as the supreme tribunal in disputes and criminal cases and which also granted favors that went against the provisions of common law.

The spirit of the Counter Reformation in the sixteenth century led Sixtus V (1585–90) to give the Roman Curia its first complete and systematic revision. The reform, promulgated in the apostolic constitution "Immensa Aeterni" of January 22, 1588, left substantially untouched the administrative and judicial bodies that then existed. However, it distributed the various functions of the consistory among permanent departments with clearly defined areas of competence. With the help of expert assistants, the groups of cardinals who composed the departments could now deal with the numerous affairs of papal government in a swifter and less costly manner. Final decisions were of course reserved for the pope, in whose name and by whose authority the cardinals acted.

The new departments were called congregations of cardinals. According to the needs of the time—which encompassed temporal as well as spiritual matters, for the pope was also sovereign of the Papal State—Sixtus organized fifteen such congregations: for the Holy Inquisition; for the granting of favors; for the erection of churches and for consistorial provisions; for the well-being of the ecclesiastical state; for sacred rites and ceremonies; for the defense of the ecclesiastical state; for an index of forbidden books; for the execution and interpretation of the Council of Trent; for relieving the burdens of the ecclesiastical state; for the university of Rome; for consultation with the religious orders; for consultation with the bishops and other prelates; for the upkeep of roads, bridges, and waterways; for the Vatican printing press; and for consultation on affairs concerning the ecclesiastical state.

One of the reasons for the reform of the Curia was a great increase in matters to be dealt with by the papal government, caused by the expansion of the Catholic church through missionary activity outside Europe, especially in the recently colonized continents of North and South America. It soon became apparent that a new body was needed, to provide the missions with uniform papal direction and to attend to the needs of newly converted Christians. On January 22, 1622, Gregory XV created a new curial department, called the Congregation de Propaganda Fide. This congregation has for centuries exerted great influence over the whole church, particularly in the pastoral and judicial fields.

The papal Secretariat of State took form from the fifteenth century onward, and gradually grew in importance. At first it consisted of a body of secretaries who sorted the diplomatic correspondence of the Holy See; later they were entrusted with the actual drawing up of letters and with other assignments. In time their head, the "domestic secretary," also became the pope's chief assistant in various matters of importance, especially those of a political nature. Leo X (1513–21) created a parallel office, that of the "confidential secretary" or "major secretary"; this function was later entrusted exclusively to a close relative of

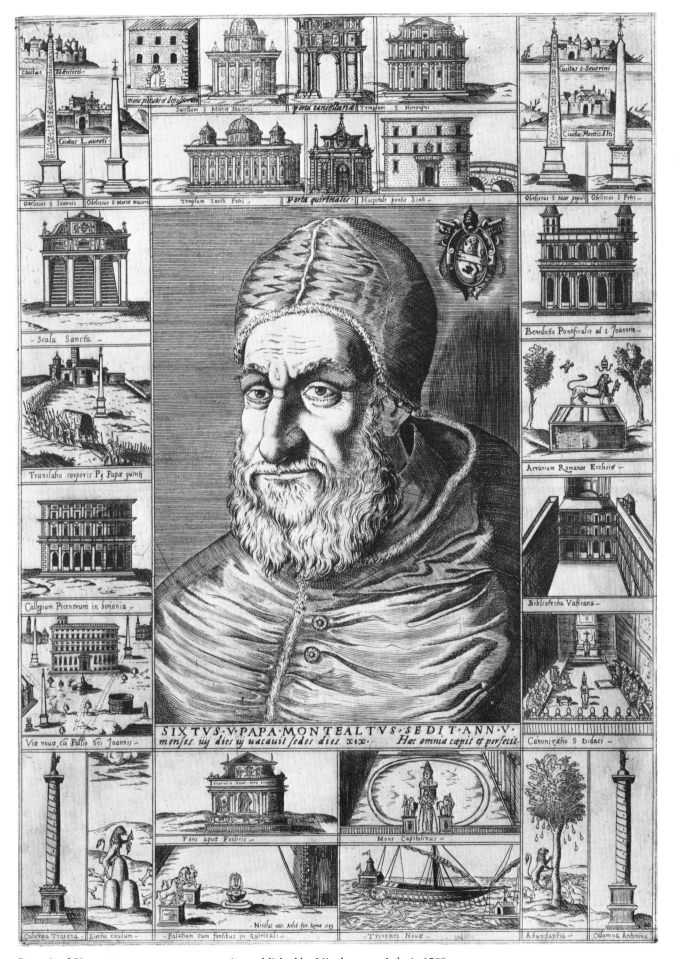

Portrait of Sixtus V, an anonymous engraving published by Nicolaus van Aelst in 1589.
Surrounding the portrait are a number of the buildings and monuments constructed
or restored during Sixtus's brief pontificate. The Metropolitan Museum of Art,
Elisha Whittelsey Collection, Elisha B. Whittelsey Fund, 1949 (49.95.146).

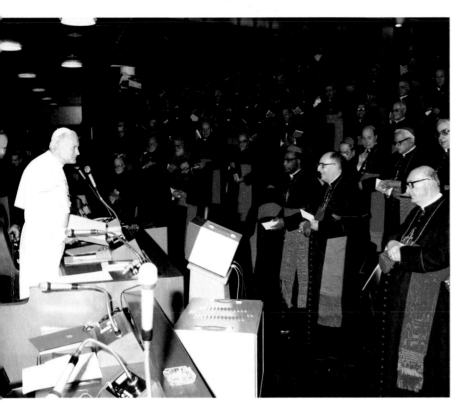

Pope John Paul II at the 1980 Synod of Bishops, held in the new Audience Hall.

the reigning pope, known as the "cardinal nephew." Paul V (1605–21) gave this official the title of secretary of state; Innocent X (1644–55) left the internal administration of the Papal State to his cardinal nephew, but appointed another prelate, called the cardinal secretary of state, to manage its foreign affairs. The cardinal-nephew system, which was open to obvious abuses, was abolished by Innocent XII in 1692. From then on, all the political business of the church was conducted by the cardinal secretary of state.

Changed circumstances in the church, as well as inconsistencies, overlappings, and conflicting claims to competence among the congregations, necessitated another reform of the Curia three centuries later: it was carried out by Pius X with the apostolic constitution "Sapienti Consilio" of June 29, 1908. The reformed regulations were included in the new code of canon law which was then being drawn up and which was published in 1917. Outdated organizations were suppressed and new ones, including congregations for the sacraments, for religious, and for the Eastern church, were instituted; clearer distinctions were drawn between various types of jurisdiction. The functions of the Sacred Roman Rota and the Signatura, which had been all but taken over by the congregations and other departments, were restored.

Nevertheless, after a relatively short period, rapid changes in the conditions of life required another *aggiornamento* in the Roman Curia, and this was carried out by Pope Paul VI in accordance with the explicit wish of the Second Vatican Council, expressed in the conciliar decree "Christus Dominus." This decree, published on October 28, 1965, recognizes and confirms the necessity of the Curia as an instrument for the pope's activity, but it also deems a reform appropriate and specifies its principal motives and aims: revision of the number of departments, their titles, their competences, their procedure, and their coordination. It expresses the desire that the members, officials, and consultors of the departments, since they are at the service of the entire church, should be chosen from various parts of the church in order to give an international character to the central bodies. It suggests that among the members of the departments, there should be diocesan bishops as well as cardinals, and also that lay persons distinguished for virtue, knowledge, and experience should be heard.

In his allocution to the personnel of the Roman Curia on September 23, 1963, Paul VI had already indicated the reasons and aim of the *aggiornamento*: the inadequacy of the curial departments and of their practices with regard to the needs and usages of modern times, and the need both to simplify and decentralize them and to enlarge them for new functions.

The project was immediately put in the hands of a commission of three cardinals. This commission set out to determine what should be kept, what should be suppressed, and what should be modified and adapted. It studied material of a historical nature, as well as proposals made by bishops and various departments consulted in the preparatory phases of the Second Vatican Council, the speeches of the council fathers on the reform of the Curia, the advice and responses of the departments, the suggestions made by archbishops and bishops from every part of the Catholic world, and the opinions of experts on the subject and of specially qualified representatives of the Curia itself.

This material was then amply discussed within the commission for reform, and successive drafts were made of a document which took into account both the commission's findings and the directives of the pope, who personally and constantly followed the entire proceedings. Once it had defined the general lines of the reform, the commission collaborated with the various departments in working out a definitive plan that covered all of them. It then drew up a complete document. The text was compiled, discussed, and examined under the personal direction of the pope, who wished to take into consideration all the observations that had been received. The reform of the Roman Curia was then promulgated on August 15, 1967, with the apostolic constitution "Regimini Ecclesiae Universae," a decree animated by fidelity to tradition as well as by commitment to progress.

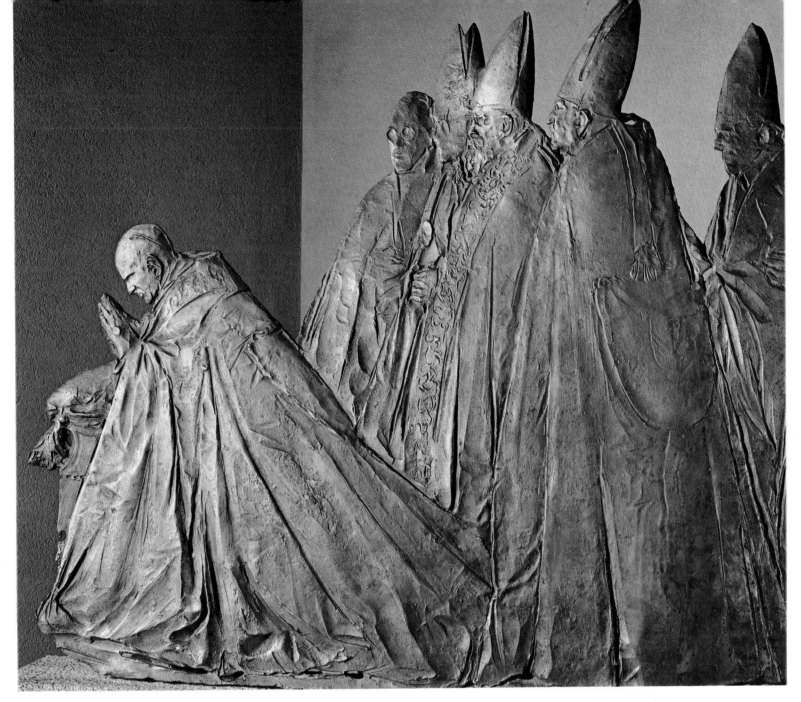

Detail of one of the panels of a large bronze relief, executed in 1967 by Lello Scorzelli, representing the Second Vatican Council, 1962–65. Collezione d'Arte Religiosa Moderna.

Structure and Activities of Today's Curia

The reformed Roman Curia is characterized, in general, by the presence of representatives of the worldwide episcopate in addition to the cardinals, who were formerly the only members at meetings of curial departments; by a greater internationalization in all its sectors; by the limited duration (fixed at five years) in office of member cardinals and bishops and of its highest officials—cardinal prefects, cardinal presidents, and senior prelates—in order to ensure constant injections of fresh vigor into the positions of greater responsibility; by a closer and more direct collaboration be-

tween the curial departments and diocesan bishops; by a more thorough coordination of the work of individual departments, through regular meetings of all the heads of the departments under the presidency of the cardinal secretary of state; and by the institution within the Apostolic Signatura of a body to settle disputes over competence among the various departments.

The Secretariat of State

Under the new arrangement, the Secretariat of State has been given seniority over all the other departments

of the Curia. It is also called the Papal Secretariat, and is directed by the cardinal secretary of state, assisted by a "substitute." It is the direct instrument of the pope in the government of the church, particularly in his relations with other curial departments and with cardinals, bishops, and papal representatives throughout the world. The Secretariat of State performs special tasks that the pope entrusts to it, besides taking care of ordinary affairs such as the drafting of papal briefs, the maintenance of the papal diplomatic service, protocol, and the bestowal of honors. It is also in charge of the cipher—that is, of the various code systems used in secret correspondence with papal legates.

As a result of the *motu proprio* "Quo Aptius" of February 27, 1973, the Secretariat of State absorbed the Apostolic Chancery, which historically was the first form of papal secretariat and which has now ceased to exist as an autonomous office. The tasks previously carried out by the offices of Briefs to Princes and of Latin Letters are now also discharged by the Secretariat of State.

Parallel with the Secretariat of State is the Council for the Public Affairs of the Church, which deals with national governments and with questions regarding civil legislation and diplomatic relations. The prefect of this council is the cardinal secretary of state, who thus guarantees, in his own person, the unity of action of the two departments.

The Holy See enjoys the prerogative of sovereignty in international law—a sovereignty distinct from the territorial sovereignty of the Vatican City State. The Holy See in fact represents in the entire world the Catholic church, which is a society in its own right, independent of any other power. As a sovereign entity, the Holy See sends representatives from Rome, and receives representatives of national states. These diplomatic relations are highly developed today.

At present there are ninety-five representatives of the Holy See with diplomatic status (thirty-four apostolic nuncios and sixty-one pro-nuncios) and twenty-one apostolic delegates, who are representatives without diplomatic status. (The diplomatic personnel receive their training in an ancient institution founded for this purpose, the Pontifical Ecclesiastical Academy.) The diplomatic corps accredited to the Holy See consists of ninety-three missions, headed by ninety ambassadors and three special envoys or ministers. Foreign representatives cannot reside in the Vatican City, because of its limited territory; they normally live in the city of Rome, with the customary diplomatic immunities.

The duties of papal legates (who are usually archbishops) were defined in a *motu proprio* of Paul VI, "Sollicitudo Omnium Ecclesiarum," of June 24, 1969.

Their primary mission is to serve the local churches and to strengthen the bonds between those churches and the pope. In addition, they are accredited to states and governments as representatives of the Holy See, with the aim of promoting the cause of peace and the progress of peoples.

The Holy See is also sensitive to the problems of disarmament, international security, and development, as well as to the social, cultural, and scientific problems of the modern world. It therefore has permanent representatives to international governmental organizations— the United Nations Organization and some of its specialized agencies such as UNESCO, FAO, UNIDO, WHO, and ILO—and to nongovernmental organizations such as the International Committee for Historical Sciences, the International Committee for Paleography, and the International Committee for Neutrality in Medicine.

The Sacred Congregations

In accordance with time-honored tradition, the next most important category among the departments of the Curia is constituted by the sacred congregations.

The first is the Sacred Congregation for the Doctrine of the Faith, which continues the work of the department formerly called the Holy Office, but in a more positive spirit. Its functions are to watch over and to promote the teaching of faith and morals. It also functions as a tribunal in matters that concern the spread of ideas considered to be contrary to Catholic doctrine. This congregation has norms of procedure that have been brought up to date with special care so as to give the greatest possible protection to the rights of accused persons. Associated with it are the Theological Commission and the Pontifical Biblical Commission.

The second department has also changed its name, from Sacred Consistorial Congregation to Sacred Congregation for Bishops. Its tasks are to prepare the nominations of bishops and to supervise the development of the territorial and personal organizations that make up the individual churches. It also supervises the activity of the hierarchy and the condition of the dioceses. Its competence is, however, restricted to the territories not subject to other congregations. The Pontifical Commission for the Pastoral Care of Migrants and Tourists and the Pontifical Commission for Latin America are subordinate to this department.

The Sacred Congregation for the Eastern Churches deals with practically all matters concerning the territories and persons of the Eastern rites.

The Sacred Congregations for the Discipline of the Sacraments and for Divine Worship were unified by Paul VI, on July 11, 1975, as the Sacred Congregation

for the Sacraments and Divine Worship. It is divided into two sections: the first deals with the administration of the sacraments and the celebration of Mass, and also examines cases concerning nonconsummated marriages and the validity of ordinations; the second deals with the regulation of worship, both liturgical and extraliturgical, for the church of the Latin rite.

The Sacred Congregation for the Clergy is the former Congregation of the Council, and is concerned with the secular clergy and its apostolic activity. It is divided into three sections. One is concerned with the spiritual training of ministers and their various diocesan organizations, as well as their preparation and intellectual and pastoral renewal; another with the different ministerial activities; and the third with the material needs of the ministers themselves and of their ministry—that is, with church property and its preservation and administration.

The former Sacred Congregation for Religious is now called the Sacred Congregation for Religious and for Secular Institutes. The new name indicates attention now given to secular institutes, which are associations of men and women who live their personal consecration through the practice of the evangelical counsels, without taking public vows and while remaining in the world. But the principal task of this congregation is still the direction and care of the various forms of religious life—that is, of those communities of men and women who profess public vows of poverty, chastity, and obedience, within the different religious orders and congregations. The competence of the congregation extends to all the aspects of that life. Also dependent upon it are the third orders—associations whose members, aspiring to Christian perfection in the world, imitate the spirit of a particular religious order and accept direction from it.

The Sacred Congregation for the Propagation of the Faith has also been given a new name, the Sacred Congregation for the Evangelization of Peoples. It is competent in matters concerning missionary activity, the government and discipline of Christian life in territories where the Catholic church has not yet spread or is only minimally represented. Its jurisdiction extends to some parts of Europe and the Americas, to nearly all of Africa, to the Far East (except for most of the territory of the Philippine Islands), and to Australia, New Zealand, and Oceania.

The Sacred Congregation for the Causes of the Saints is concerned with the procedural aspect of the preparation of beatifications and canonizations, with the ascertainment of the heroic virtue, or of an antecedent cult, of candidates for sainthood, and with the miracles required for the proclamation of a *beatus* or saint.

The Sacred Congregation of Seminaries and Universities has assumed the new name of Sacred Congregation for Catholic Education, and has enlarged its field to all Catholic instruction and education of every order and degree. Its concern, therefore, is the training not only of future sacred ministers, but also of all young people, in Catholic schools—from the elementary schools to the universities—as well as the instruction of adults through various kinds of permanent education. The three offices making up this congregation correspond to its threefold competence: seminaries and institutes of intellectual and professional training for religious and for secular institutes, universities dependent on ecclesiastical organizations, and pre-university schools for young laity that are dependent on ecclesiastical authority. In addition, it is concerned with theoretical and practical aspects of education in general.

The Tribunals

Besides the sacred congregations, Pope Paul's reform of the Roman Curia has preserved, with necessary and appropriate modifications, the ancient departments concerned with the administration of justice, which for this reason are called tribunals.

The Sacred Apostolic Penitentiary is the tribunal for matters of conscience; it is also the office for favors, absolutions, and dispensations. Furthermore, whatever concerns the granting and use of indulgences is now its exclusive competence.

Next is the Supreme Tribunal of the Apostolic Signatura. In one section it maintains the functions that it previously exercised, acting, that is, as the supreme jurisdictional body for deciding judicial controversies arising within the ecclesiastical order. In other words, it acts as a high court of appeals, especially for the other pontifical tribunal, the Sacred Roman Rota; in general it insures the correct administration of justice in the ecclesiastical tribunals of the world. For this purpose it also sets up and supervises regional and interregional tribunals. The most important innovation in the Apostolic Signatura is the introduction of a section to safeguard the laws regarding decisions in administrative procedure, including those made by the departments of the Roman Curia. Whenever the possibility arises that such a decision may have violated ecclesiastical law, recourse may be had to the Apostolic Signatura, which judges the legitimacy both of the recourse and of the disputed act. In addition, this second section normally judges conflicts of competence among the departments of the Roman Curia, and administrative cases referred to it by the sacred congregations.

The Sacred Roman Rota, while preserving its former prerogatives, has extended the sphere of its

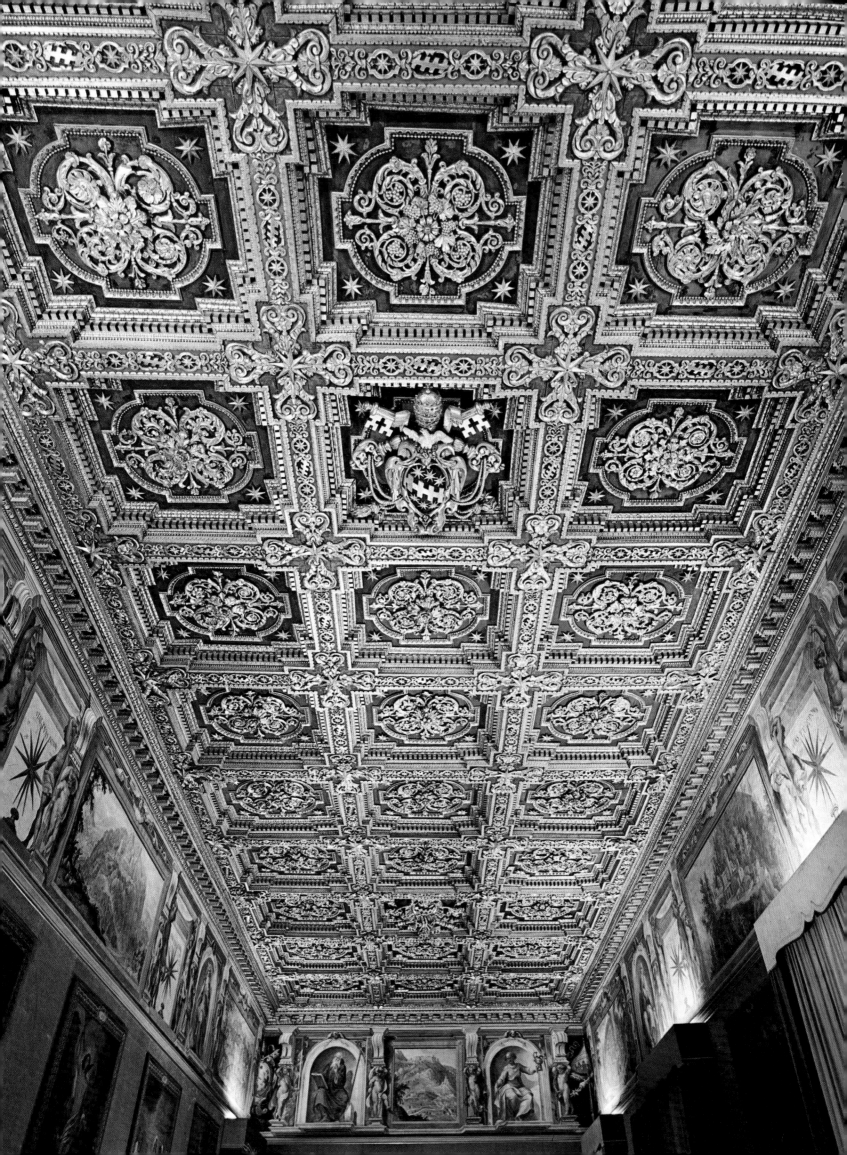

competence, since the judgment of all marriage cases brought before the Apostolic See is now exclusively its concern; even the cases previously reserved to the Holy Office and to the Sacred Congregation for the Eastern Churches are now in its care. The Sacred Roman Rota also runs a course for the training of Rota advocates and of future judges and other officials of ecclesiastical tribunals.

The Secretariats

The secretariats are new departments of the Roman Curia that had already been established before the recent reform; they have been incorporated into the framework of the other departments.

The Secretariat for Promoting Christian Unity was created by John XXIII in 1960. Today it consists of two sections: one for Eastern and Orthodox Christians, and one for the various confessions of Western Christendom. Its task is the pursuit of union through dialogue and the promotion of ecumenical initiatives. It is also concerned with religious questions regarding Judaism.

The Secretariat for Non-Christians, established by Paul VI in 1964, has the task of fostering relations with non-Christian religions, with regard both to theory and to practical matters affecting mutual understanding. It is concerned in a particular way with relations with Muslims.

The Commission for Judaism and the Commission for Islam, established by Paul VI in October 1974, depend respectively on these two secretariats.

The Secretariat for Nonbelievers was created by Paul VI in 1965 to study atheism and to promote dialogue with those who profess it.

The Offices

The offices constitute a fourth category of curial department. The first of these is the Apostolic Camera, which was established centuries ago; today its functions are limited mainly to the administration of the property and temporal affairs of the Holy See during a vacancy. The other offices are of recent institution.

The Prefecture for the Economic Affairs of the Holy See supervises the activities of those bodies, including autonomous ones, that administer the property of the Holy See. It is also empowered to tax the administrative bodies. It reports directly to the pope on all matters.

The Administration of the Patrimony of the Apostolic See has two sections, the ordinary and the extraordinary: the former administers the property of the Holy See, while the latter deals with matters entrusted to it from time to time by the pope.

The Prefecture of the Papal Household was created by the reform of Paul VI and combines three former departments: the Sacred Congregation for Ceremonial, the Office of the Majordomo, and the Office of the Maestro di Camera. The prefecture is in charge of all papal audiences and other extraliturgical ceremonies, it runs the papal household, and it arranges visits and journeys by the pope outside the Vatican. In addition, it regulates the precedence of all departments and individuals in their relations with the pope.

The reform of Paul VI also established the Central Statistics Office of the Church. This office has the task of collecting and tabulating data on various aspects of the life of the church, and of publishing this information annually in two volumes, the *Annuario pontificio* and the *Raccolta di tavole statistiche*.

The Pontifical Cappella Musicale, the Swiss Guard, the Office for Relations with the Employees of the Holy See, and the Archives of the Second Vatican Council are also included among the offices.

Other Departments

Paul VI also created curial departments that do not belong to the above categories.

The Council for the Laity was set up on January 6, 1967, to promote all the activities of the apostolate of the laity as recommended by the Second Vatican Council in the decree "Apostolicam Actuositatem." The Pontifical Commission for Justice and Peace was established on the same date to carry out the suggestions of the conciliar constitution "Gaudium et Spes."

The Pontifical Commission for Social Communication grew out of the Pontifical Commission for Didactic and Religious Films—later the Pontifical Commission for the Cinema—which had been instituted by Pius XII in 1948. It received its present name in 1964, when its field of activity was considerably enlarged as a result of the conciliar decree "Inter Mirifica." It now deals with all aspects of the modern means of social communication: films, television, radio, and the press. The commission is also in charge of the press office of the Holy See, and it directs and administers the Vatican Film Institute.

The Pontifical Council "Cor Unum" was established on July 15, 1971, to coordinate the activities and the distribution of the funds of Catholic organizations operating in the field of charity and aid. These organizations, both international and national, belong to the council as members. Similar aims are pursued in a more restricted manner by the Holy Father's Relief Service, which is directed by the Almoner of His Holiness. This office devotes itself to good works and to aiding the needy who have recourse to the charity of the pope.

The Sala del Concistoro is in the residential wing added to the Apostolic Palace by Sixtus V. The room was decorated under Clement VIII, whose coat of arms appears on the richly carved and gilded ceiling.

The Committee for the Family created by Paul VI was replaced by John Paul II in May 1981 by the Pontifical Council for the Family. This is a department for pastoral study and research, at the service of the church and in particular of the Holy See and of the various departments of the Roman Curia. Its sphere of competence includes the spiritual, moral, and social problems connected with marriage and the family.

Although their scope is scholarly, the Pontifical Commission for Sacred Archaeology (established in 1952) and the Pontifical Committee for Historical Sciences (established in 1954) exist to serve pastoral needs.

A number of departments of a temporary nature must also be mentioned: the Pontifical Commissions for the Revision of the Code of Canon Law of the Latin Church, and of the Code of Canon Law of the Eastern Churches; two departments working on a critical edition of the Bible, the working group for the revision and correction of the Vulgate and the Pontifical Commission for the New Vulgate; and the Pontifical Commission for the Interpretation of the Decrees of the Second Vatican Council.

General Considerations

Detailed norms regarding the competence, structure, and working methods of the curial departments are given in the *Regolamento generale della Curia Romana*, which came into effect on March 1, 1968, as well as in the apostolic constitution "Regimini Ecclesiae Universae." In general, the various categories of departments correspond to the different powers of the Roman pontiff. The sacred congregations and the secretariats exercise administrative functions: the interpretation and application of ecclesiastical laws, the maintenance of discipline, and the granting of dispensations and favors. The tribunals have juridical functions in questions of conscience and, where the Apostolic Penitentiary is concerned, in sacramental matters as well. The offices and the commissions have auxiliary functions in specific fields.

Since, however, division of powers does not exist, as a principle, in the church, the areas of competence of the various departments are not always clearly delimited. For example, the Sacred Congregation for the Doctrine of Faith exercises judicial as well as administrative functions, and the Apostolic Penitentiary is concerned with administrative as well as judicial affairs.

The curial departments have only vicarious power —they act, that is, in the name and through the authority of the pope. The pope must therefore confer specially delegated powers in extraordinary cases, especially for decisions that constitute an exception to the legislation in force. For the same reason, though the powers of the departments do not expire at the death of a pope, their exercise must be suspended, except for urgent cases that require an immediate decision. In such cases the consensus of the college of cardinals, which is responsible for the government of the church during vacancies of the Holy See, must be obtained.

The structure of all the departments (with a few exceptions) is similar. Each one is presided over by a cardinal prefect, or president. He is assisted by a secretary, the senior prelate, who is assisted in turn by an undersecretary. The work is divided among major officials, of two distinct classes; minor officials, divided into three grades; and lay personnel, also divided into three grades. The pope himself appoints the senior personnel, down to the major officials. The rest are appointed by the cardinal prefect with the approval of the pope. Those with the highest responsibility—that is, the cardinal prefect and the senior prelate—are appointed for five-year terms, which are renewable. At the death of the pope the terms of office of the cardinal prefects and the secretaries of the departments expire, and the incumbents must be confirmed in office by the new pope. On reaching the age limit of seventy-five, the heads of the departments must submit their resignations.

The most important deliberations of the departments are undertaken by the cardinals and bishops who are members. For sacred congregations the number of member bishops is generally seven. Each department is also assisted by consultors, whose number is not fixed, and who form a college charged with studying individual cases; they give their opinions orally or in writing. Special experts are also at the disposition of some of the departments.

The procedures of the administrative departments provide for various stages and levels of consultation. First of all, there is the congress, which is composed of the cardinal prefect, who presides, the secretary and the undersecretary, and the personnel assigned to deal with the matters being considered; others may be called in if necessary. The congress discusses and decides ordinary affairs; it also considers what must be presented for the approbation of the pope, submitted to a more detailed examination, or sent back for examination by the ordinary or the plenary congregation.

The ordinary congregation is composed of the cardinals and member bishops who may be present in Rome; it is held, when the need and the opportunity arise, in accordance with the special norms of each congregation.

Plenary congregations, on the other hand, are held once a year with all the members, cardinals and bishops, present. At this time questions of major im-

portance involving general principles or normative programs are examined.

The work of the congregations is carefully prepared in advance; information is assembled and studied, and dossiers on the specific problems to be discussed are sent to all the members, under the seal of secrecy, a month before the meetings begin. The congregations are devoted to discussion and deliberation. The pope is informed of all the proceedings at audiences with the cardinal prefect or the senior prelate, and he takes the measures that he considers opportune. If, however, there is a possibility that someone will have recourse to the Apostolic Signatura against decisions of the congregation, these decisions may not be submitted to the pope until thirty days after the interested parties have been notified of them.

The college of consultors of a department, known as the Consulta, is convoked by the senior prelate a few days before the plenary congregation, in order that it may give its own advice about the questions to be discussed. The consultors may also be asked to draw up the documents of their own departments. Special commissions may also be set up within the individual departments to deal with matters of particular importance.

The *Regolamento generale della Curia Romana* also includes rules covering all aspects of the employment of the personnel of the departments: nomination and appointment, promotion, transfer, termination of service, work schedule and absences, leave, holidays, salary, disciplinary sanctions, and special provisions. One of the most important obligations of the personnel, given the delicate nature of the mission which they fulfill in the service of the central government of the church, concerns discretion and secrecy about official matters. Secrecy is regulated both by general principles contained in the *Regolamento* and by particular instructions from the pope. The secret of office, also called the ordinary secret, is imposed on all the employees of the Roman Curia. In addition, there is the pontifical secret, an obligation of special gravity imposed in order not to compromise the spiritual and public welfare of the church and of the faithful, or the inviolable rights of individuals and communities.

Though the church is a community of men, and therefore a visible society, the ends it pursues are spiritual. The pope, as successor of Peter, is its supreme pastor, and the activity of the Roman Curia, the instrument of the pope's government of the entire church, is essentially a participation in his pastoral activity. All the work of the Curia serves a pastoral purpose; this is the basis and the premise of its very existence, the constant and vital reason for the historical development that we have described in outline, and the inspiration of every reform.

ALFONS M. STICKLER

Overleaf: The basilica and Saint Peter's Square, seen from the southeast.

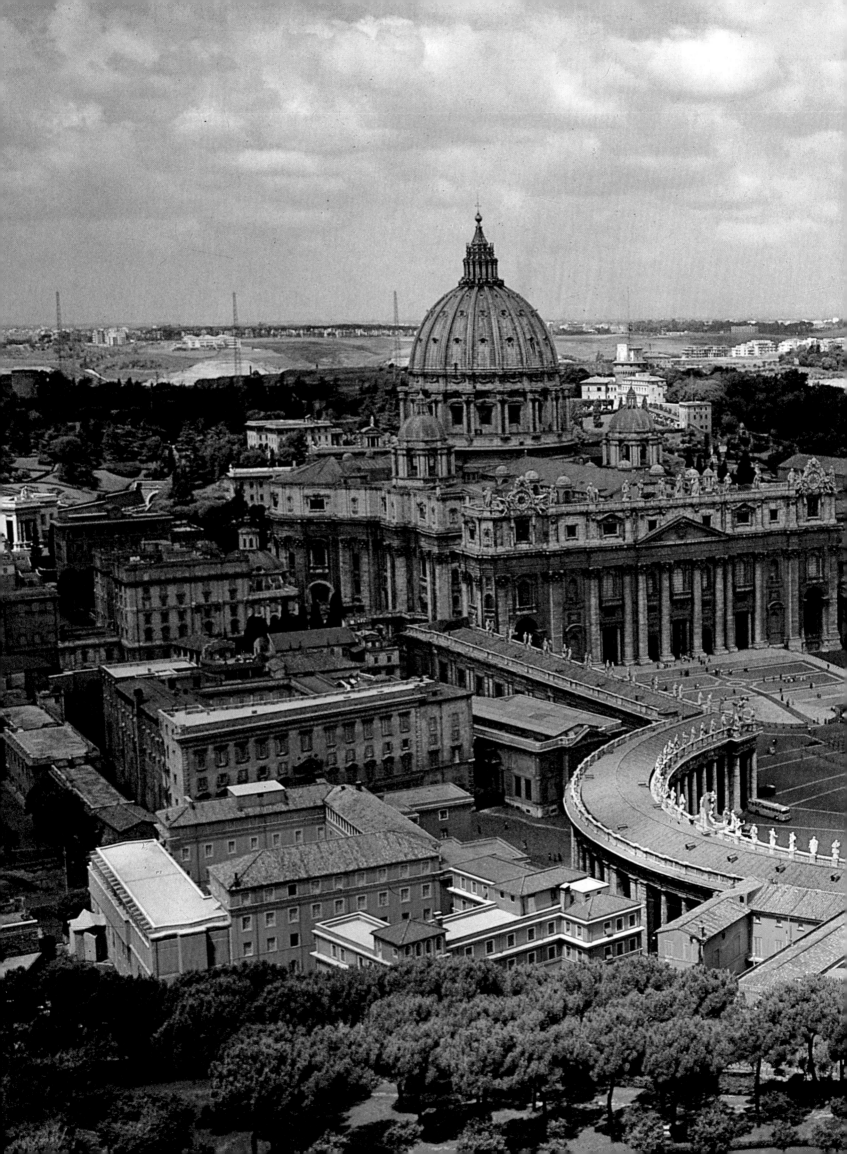

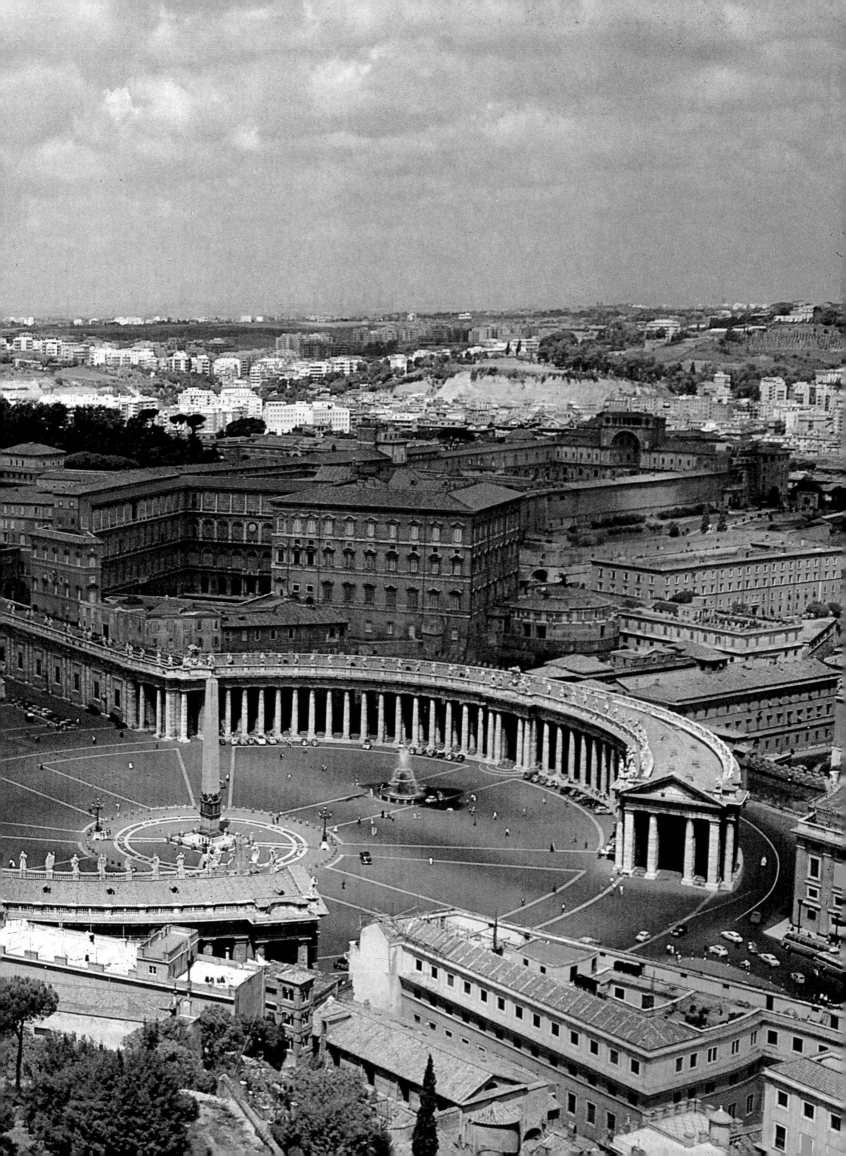

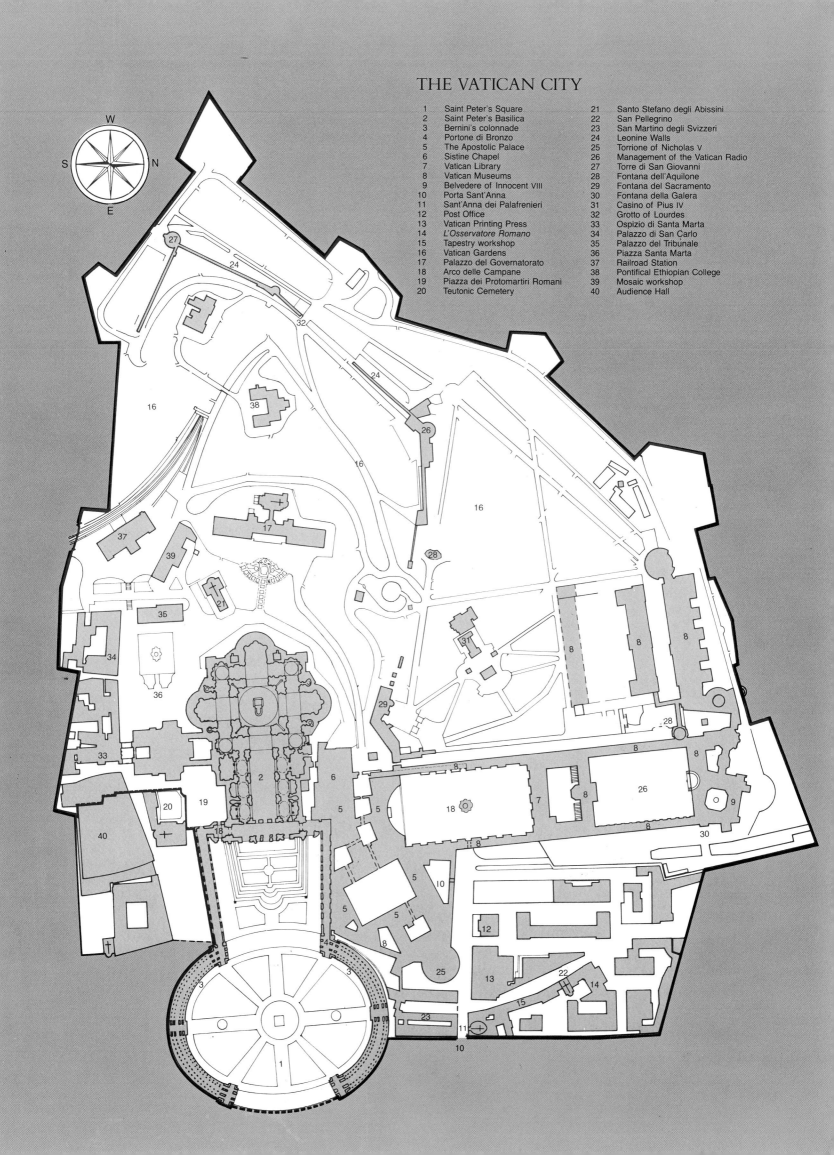

THE VATICAN CITY

1 Saint Peter's Square
2 Saint Peter's Basilica
3 Bernini's colonnade
4 Portone di Bronzo
5 The Apostolic Palace
6 Sistine Chapel
7 Vatican Library
8 Vatican Museums
9 Belvedere of Innocent VIII
10 Porta Sant'Anna
11 Sant'Anna dei Palafrenieri
12 Post Office
13 Vatican Printing Press
14 *L'Osservatore Romano*
15 Tapestry workshop
16 Vatican Gardens
17 Palazzo del Governatorato
18 Arco delle Campane
19 Piazza dei Protomartiri Romani
20 Teutonic Cemetery

21 Santo Stefano degli Abissini
22 San Pellegrino
23 San Martino degli Svizzeri
24 Leonine Walls
25 Torrione of Nicholas V
26 Management of the Vatican Radio
27 Torre di San Giovanni
28 Fontana dell'Aquilone
29 Fontana del Sacramento
30 Fontana della Galera
31 Casino of Pius IV
32 Grotto of Lourdes
33 Ospizio di Santa Marta
34 Palazzo di San Carlo
35 Palazzo del Tribunale
36 Piazza Santa Marta
37 Railroad Station
38 Pontifical Ethiopian College
39 Mosaic workshop
40 Audience Hall

THE VATICAN CITY STATE

The Territory

The Vatican City, established in 1929 by the Lateran Treaty between the Holy See and the kingdom of Italy, is the world's smallest sovereign state. Its territory, an enclave within the city of Rome, covers only 44 hectares; the principality of Monaco is approximately 3.5 times larger, the republic of San Marino 138 times, the principality of Liechtenstein 360 times, and the principality of Andorra 1000 times. As a glance at the map will show, the Vatican City is roughly trapezoidal in shape. Its boundaries coincide, for the most part, with the walls built by Popes Paul III, Pius IV, Pius V, and Urban VIII between 1540 and 1640. This enclosure is broken by the vast expanse of Saint Peter's Square, which provides access to the basilica for pilgrims, worshipers, and visitors; here the frontier is marked by a simple line across the pavement of the square.

Saint Peter's Square is 19 meters above sea level; to the north and west, the Vatican Hill rises to a height of 77.5 meters. About one-third of the territory is occupied by buildings of various sorts, one-third by streets, squares, and courtyards, and one-third by gardens.

Five principal zones may be distinguished. Facing the center of Rome, on an east-west axis, is the monumental complex consisting of Saint Peter's basilica —the foremost shrine of Catholic Christianity—and the square in front of it, enclosed by its majestic colonnade. Saint Peter's Square was designed to accommodate the huge crowds that frequently gather there. The pope traditionally imparts his benediction to the people in the square from a window in the palace on Sunday mornings; shortly after his election in 1978, John Paul II began the practice of holding weekly public audiences there when the weather permits. To the northeast of the square, towering over it, is the equally monumental, but asymmetrical and heterogeneous, Apostolic Palace; here the pope lives, here some of the most important organs of his government (including the Secretariat of State) have their offices, and here

(in the Sistine Chapel) the cardinals convene, after the death of a pope, to elect a new one. North of the palace proper is a vast extension that contains the Vatican Museums and the Vatican Library. It is made up of what was originally a separate building, the Villa Belvedere, at the northernmost extremity of the Vatican Hill; of two long parallel wings built in the sixteenth century to connect the palace with the villa and later joined to each other by two shorter wings; and of two modern buildings, adjacent to the north end, which house four of the museums. To the east of this extension is a small urban quarter, entered through a gate called the Porta Sant'Anna. It includes the parish church of the Vatican City, Sant'Anna dei Palafrenieri, living quarters for the Swiss Guards and for certain Vatican officials, the offices of various administrative departments, the main post office, the printing press, the headquarters of the newspaper *L'Osservatore Romano*, and a workshop where tapestries are restored. To the west of the basilica and the palace are the beautiful, tranquil Vatican Gardens.

Citizenship

Vatican citizenship, unlike that of other states, is not normally acquired by right of birth. It is granted to church dignitaries and others who, by reason of their office, because they are employed there, or by a special concession from the pope, reside in the Vatican City. The cardinals of the Curia enjoy the privilege of Vatican citizenship whether or not they live within the Vatican precincts. There are also a number of residents—employees and their wives and children —who are not citizens. In 1932, three years after the Lateran Treaty, the population of the Vatican City was 1,025. It has declined since then: today there are about 1,408 citizens and about 500 residents.

Juridical and Administrative Structure

According to the Lateran Treaty, the Vatican City is a sovereign political entity, distinct from the Holy See.

Map of the Vatican City.

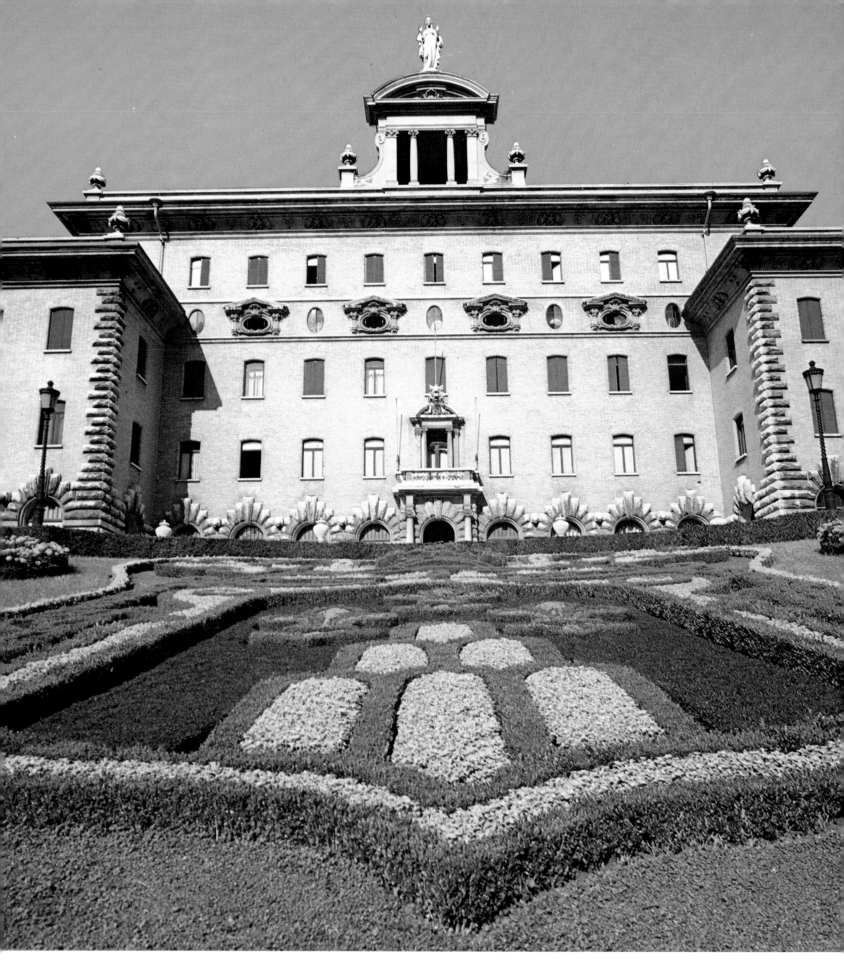

The Palazzo del Governatorato, built by Luca Beltrami between 1928 and 1931.
Located behind the apse of Saint Peter's, it houses the offices of the Pontifical
Commission for the Vatican City State.

The Palazzo del Governatorato contains a sumptuous apartment originally reserved for distinguished guests. It is now used for the meetings of the Pontifical Commission.

Its raison d'être, however, is to provide a physical basis for the independent carrying out of the Holy See's spiritual mission. Therefore, though it has all the functions and attributes of a state, its political and social order is unique. It is the world's only elective absolute monarchy; legislative, judicial, and executive power are vested entirely in its ruler, the pope. When the Holy See is vacant, these powers are exercised by the college of cardinals.

The laws and regulations of the Vatican City are issued by the pontiff and, through his delegated authority, by the Pontifical Commission for the Vatican City State, which is composed of seven cardinals and one special delegate, and by the governor of the state (whose office is at present vacant). Additional sources of law are the code of canon law and the apostolic constitutions. Foreign legislation, including that of Italy, has no force unless it is specifically adopted by Vatican legislation.

The judiciary consists of a single judge, a tribunal of first instance, a tribunal of appeal, and a court of cassation, which, under a *motu proprio* of Pius XII

dated May 1, 1946, exercise their powers in the name of the sovereign.

Executive power is exercised by the Pontifical Commission and by a special delegate whom it appoints. Paul VI, with the *motu proprio* "Una Struttura Particolare" of March 28, 1968, instituted a Council of State, which collaborates with the Pontifical Commission in examining particular questions and gives its own opinions and advice.

In its everyday operations the Pontifical Commission makes use of the administrative departments and services of the Governatorato, which has its headquarters in the Palazzo del Governatorato, behind the apse of Saint Peter's. These departments consist of the General Secretariat, the General Department of Pontifical Monuments, Museums, and Galleries, the General

Department of the Vatican Radio, the General Department of Technical Services, the Department of Economic Services, the Department of the Vatican Observatory, the Department of Archaeological Studies and Research, and the Department for the Papal Villas.

Other services depend on the General Secretariat or on one of the three general departments. The General Secretariat is responsible for the Personnel Office, which deals with staff relations and registers citizens and residents; for the Post and Telegraph Office; for the Security Office, which enforces the laws and ordinances of the state; and for the Information Office for Pilgrims and Tourists in Saint Peter's Square, which looks after both categories of visitors and organizes guided tours of the basilica, the palace, and the gardens. The Supply Office is also subordinate to the

The entrance to the Vatican railway station.
The arms are those of Pius XI.

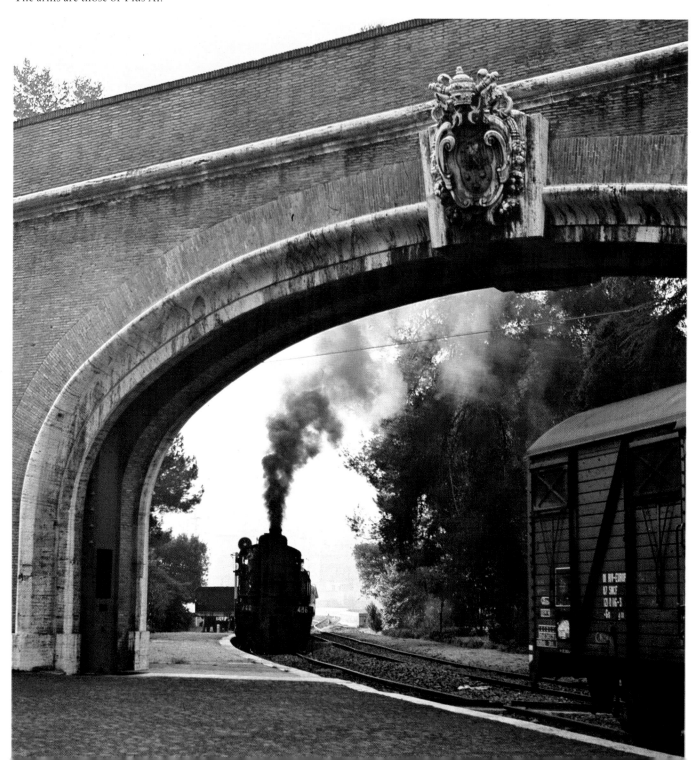

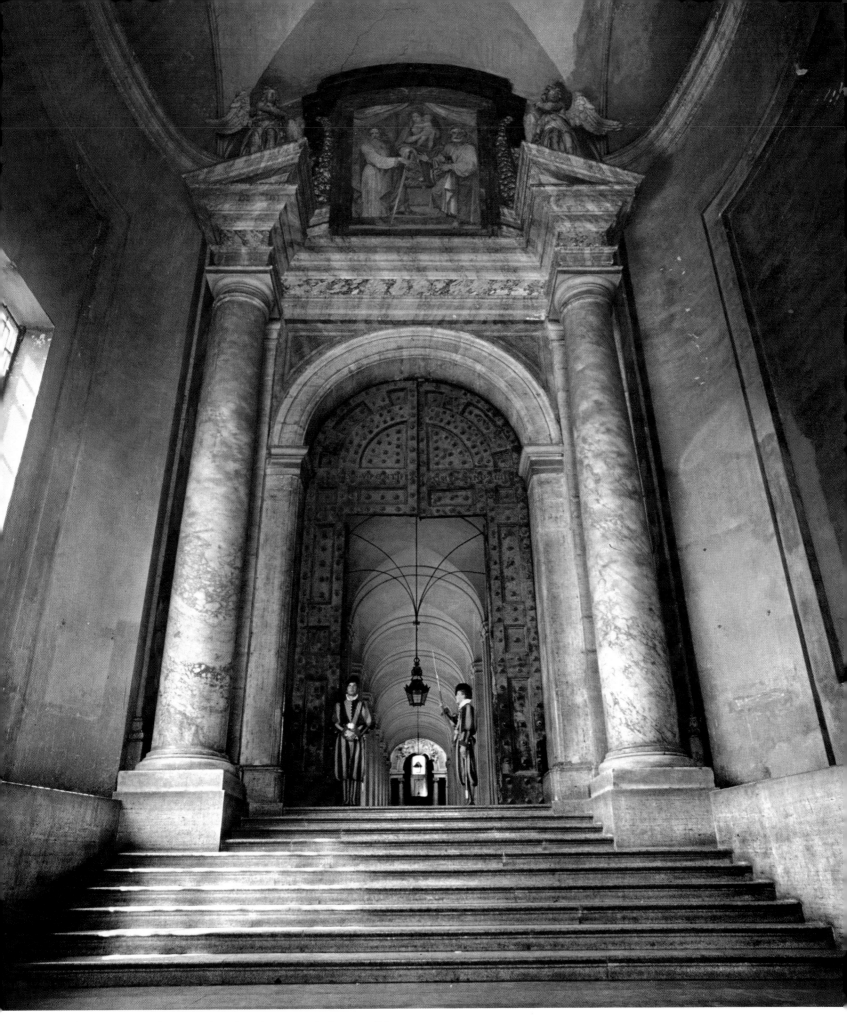

The official entrance to the Apostolic Palace, known as the Portone di Bronzo.
The bronze doors, cast by Orazio Censori and Francesco Beltramelli,
were installed in 1667.

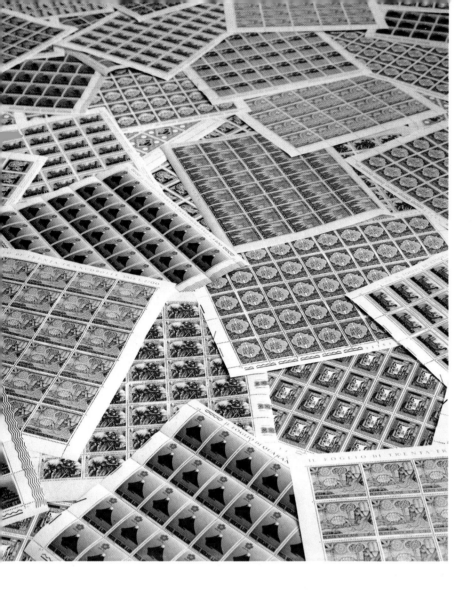

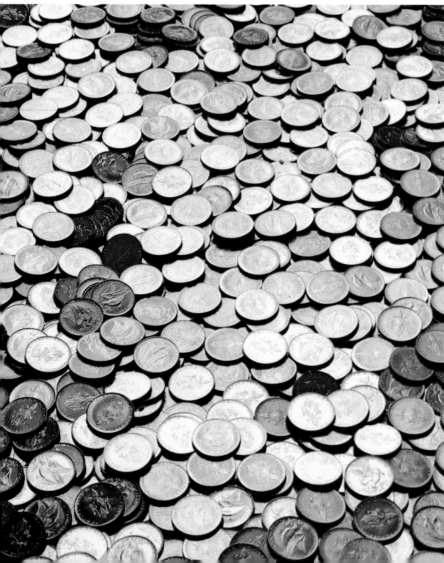

General Secretariat; it is in charge, among other things, of the handling of merchandise at the Vatican railway station, which is linked by a spur to the Italian railway system. Other dependencies of the General Secretariat include the Legal Office, the Philatelic and Numismatic Office, and the Central Accounting Office.

The General Department of Pontifical Monuments, Museums, and Galleries is responsible for the conservation, exhibition, and study of the monuments and works of art in its care. Its research bureau and its restoration studio are internationally renowned.

Like every other state, the Vatican City has its own flag, which consists of two fields, a yellow one next to the staff and a white one with the papal tiara and keys. The official coat of arms has two crossed keys, surmounted by the tiara, on a red field.

The Vatican is a state without an army. The last symbolic vestiges of the armed forces of the old Papal State, except for the Swiss Guards, were suppressed by Paul VI in 1970. The Swiss Guards, who number fewer than a hundred men, watch over the pope's person and stand sentinel at the three main entrances to the Vatican: the Portone di Bronzo, which leads from Saint Peter's Square into the papal palace; the Arco delle Campane, to the left of the basilica, which gives access to the Governatorato and the other buildings in the gardens; and the Porta Sant'Anna, which leads to the administrative quarter.

The Vatican issues its own coins and postage stamps. The coins are struck by the Italian mint, in the same denominations as Italian coins and with the same size, weight, and metallic composition as their Italian equivalents; they are legal tender in Italy and, thanks to an agreement ratified in 1932, in the republic of San Marino. Vatican stamps are produced by the Italian state printing office.

Under the Barcelona Convention, the Vatican City, like other landlocked states, is entitled to maintain a fleet of ships flying its own flag. Navigation is governed by special rules issued by the Pontifical Commission in 1951.

International Relations

In the Lateran Treaty the Holy See expressly states its intention and desire to remain outside temporal disputes between other states unless the contending parties themselves agree to call upon its peacemaking mission. At the same time it reserves the right to exert at all times its spiritual and moral influence. Consequently, the treaty stipulates that the Vatican City shall, at all times and in all cases, be regarded as neutral and inviolable.

The sovereignty of the Vatican City is universally recognized. International relations are conducted by

Traditional signs of political sovereignty, Vatican stamps and coins also reflect the agreement between Italy and the Holy See: the stamps are printed by the Italian state printing office, and since 1929 the coins have been produced by the Italian mint.

the pope through the Secretariat of State. The Vatican belongs to a number of international organizations, including the Universal Postal Union, the International Telecommunication Union, the International Institute of Administrative Sciences, the World Medical Association, the International Study Center for the Conservation and Restoration of Cultural Property, and the International Astronomical Union. It is also a member of four international organizations for space communications. It has adhered to numerous international conventions, such as the Convention on Road Traffic, the Convention on Maritime Law, and the European Cultural Convention. The entire territory of the Vatican City is under the protection of the Hague Convention of May 14, 1954, which safeguards property of cultural interest in the event of armed conflict; its moral, artistic, and cultural patrimony is recognized by international law as a treasure belonging to all mankind, and therefore entitled to be respected and defended.

JOSÉ M. SÁNCHEZ DE MUNIÁIN

The architecture of the third gallery of the Logge is by Raphael;
the wall decoration, with maps of Europe, Asia, and Africa,
was executed under Pius IV by the French cartographer
Étienne Dupérac and the painter Giovanni Antonio Vanosino.

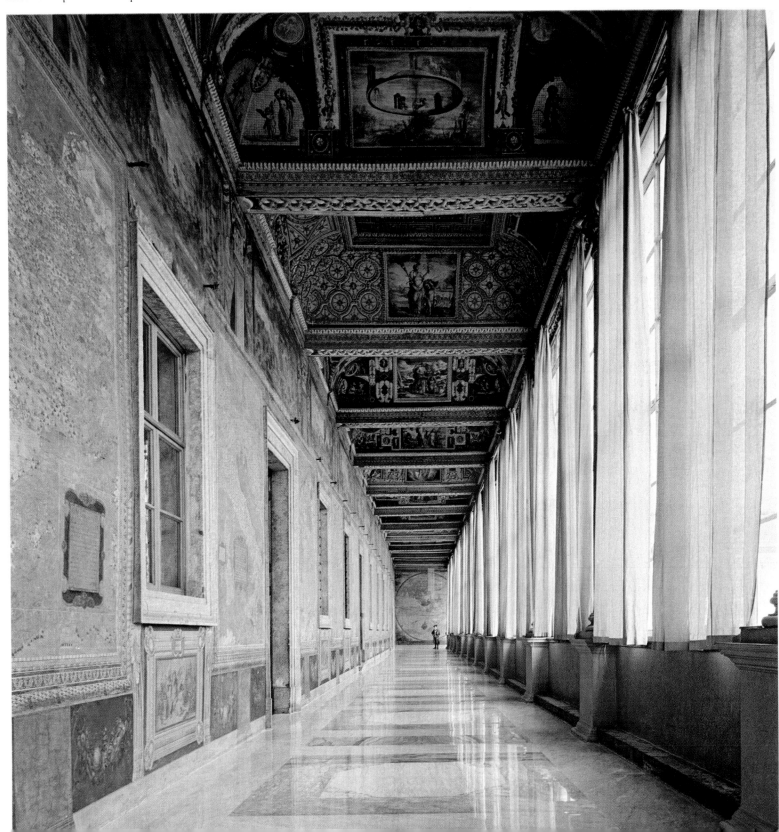

The Instruments of Social Communication

L'Osservatore Romano

The *Osservatore Romano* is known throughout the world as the Vatican newspaper. But there are, in fact, seven different publications that bear the name. The most important is the daily newspaper, which appears in Rome every working day at 3 P.M. Since 1947 there has also been a weekly edition in Italian, and today weekly editions are also published in English, French, Spanish, Portuguese, and German.

These seven publications deal with the life of the church in its central government and in its local manifestations. They have a common characteristic and a common purpose: faithful adherence to the ideas of the pope, and the dissemination of those ideas throughout the world. The daily edition, naturally, provides fuller coverage, not only of religious, but also of political, social, and cultural matters; the weeklies cover the same subjects, in a more succinct but equally incisive manner.

The *Osservatore Romano* is 121 years old. It was founded in 1861—nine years before the Italian conquest of the Papal State—by two political exiles from Emilia, Nicola Zanchini and Giuseppe Bastia, with the consent of Pius IX's civil government. It was originally conceived as an independent complement to the official state newspaper, the *Giornale di Roma*, but from the start it has had semiofficial status. The church was, and has always remained, its proprietor. Publication was suspended only once in its history—from September 15 to October 16, 1870, during the stormy days of the occupation of Rome by the Italian troops. After 1870 it was the only newspaper of the Holy See, whose claims it defended vigorously until the Roman Question was resolved by the Lateran Treaty in 1929.

The church's point of view on the major events and issues of the nineteenth and twentieth centuries has been scrupulously presented by the *Osservatore Romano*. All encyclicals and other important papal statements have been published in its pages. It provided a detailed chronicle of the First Vatican Council of 1869–70. It was a protagonist in the doctrinal debate over liberalism and socialism during the last quarter of the nineteenth century, and later it echoed the thoughts of the pope in the modernist controversy. During the First World War it maintained a balanced position. It had an active role in preparing public opinion for the Lateran Treaty; it defended the pope's condemnation of the ideologies of fascism, national socialism, and communism; it promoted his efforts to prevent the Second World War; during the postwar crisis it gave ample coverage to papal guidelines for the construction of a just society founded on peace and harmony and respect for the rights of all men. In more recent times it has reported and interpreted the deliberations of the Second Vatican Council and of the synods of bishops.

For a time, during the period of fascist dictatorships, the *Osservatore Romano* was the only free journalistic voice to be heard throughout a very large part of Europe. In 1939–40 its circulation rose to nearly 100,000, and it might easily have exceeded this figure had the paper's printing plant been adequate to the growing demand. The *Osservatore* was severely criticized on the many occasions when it dared, in the name of truth and justice, to oppose those in power. But its prestige over the years has always rested precisely upon the detachment, balance, and calm with which it has viewed world events in the light of the faith.

In administrative matters, the paper depends upon the Administration of the Patrimony of the Apostolic See; in everything else it depends upon the Office of Information and Documentation of the Secretariat of State, which also supervises the Vatican Radio and the Press Office of the Holy See. Its administration is entrusted to a religious order, the Salesian Congregation of Saint John Bosco. In 1937 the Salesians were assigned the management of the Vatican Polyglot Press, of which the *Osservatore* then formed one section. Later the newspaper became autonomous, but continued to be administered by the Salesians.

The *Osservatore Romano* has no foreign correspondents, since it can depend for its information on institutional sources such as the episcopal conferences. It can also call upon friends and admirers throughout the world for news and occasional articles.

Though the Vatican newspaper can hardly be said to be in the forefront with regard to the technological methods of modern journalism, it is animated by a total devotion to the ideas for which it is the spokesman. A historian of journalism, Professor John C. Merrill of the University of Missouri, has placed it among the ten most important dailies in the world. In his book *The Elite Press* (New York, 1968), Professor Merrill writes:

ANNO I.

NUM. 1.

L'OSSERVATORE ROMANO

PATTI DELL'ASSOCIAZIONE

Il prezzo d'associazione da pagarsi anticipatamente è fissato:
Per Roma — Un'anno Sc. 6. — Un semestre Sc. 3. 10.
— Un trimestre Sc. 1. 60. — Fuori di Roma con l'aumento relativo all'ammontare delle tasse postali stabilite pei diversi Stati.
Un foglio separato costa baj. 5. — Chi vorrà in Roma il Giornale a domicilio pagherà baj. 15 mensili.
Il Giornale si pubblicherà tutti i giorni meno le Feste di Precetto alle ore 5 pomeridiane.

GIORNALE POLITICO-MORALE

Lunedì 1 Luglio 1861

LE ASSOCIAZIONI SI RICEVONO

Piazza de' SS. XII Apostoli Num. 56 alla Tipografia Salviucci. — La distribuzione si farà all'ora indicata, nella Piazza stessa al Num. 56.
Le lettere e i gruppi debbono essere diretti franchi alla Direzione e Amministrazione dell'OSSERVATORE ROMANO Piazza de' SS. XII Apostoli Num. 62.
Ogni gruppo porterà il nome e cognome del trasmittente.
Per le inserzioni si pagherà in ragione di baj. 3 per linea; i manoscritti non si renderanno.

AVVISO

Quei Signori a cui si spedisce il presente numero, s'intenderanno come associati per un trimestre, qualora non lo restituiscano indicando il rispettivo loro nome.

L'OSSERVATORE ROMANO
A' SUOI LETTORI

In quale momento l'*Osservatore Romano* viene anch'esso a prender posto fra l'immenso numero dei giornali italiani?

È questa una dimanda che nascerà senza dubbio all'annunzio del nostro *Osservatore*, dimanda che noi medesimi abbiamo sentita in tutta la sua forza, e alla quale ci è stato mestieri rispondere, prima di determinarci all'impresa in cui ci mettiamo.

L'Italia è omai divisa in due campi contrari, ognuno de' quali avendo francamente inalzata la propria bandiera, tutti coloro che parteggiano per uno de'combattenti, sono di necessità in un'opposizione irreconciliabile rispetto all'altro. Ogni dubbio, ogni illusione tornano impossibili, e conviene saper grado alla Provvidenza d'aver condotte le cose a tal punto, che ogni uomo ragionevole non possa esitare un istante solo sotto quale stendardo egli debba schierarsi.

Noi ascoltammo iteratamente l'Augusto Capo della Chiesa Cattolica dichiarare, che gli attuali rivolgimenti d'Italia iniziati cogli auspici d'una falsa indipendenza e d'una menzognera libertà, non hanno altro scopo che di abbattere, se fosse possibile, la Religione, e con essa tutti i principj, che da questa Chiesa unicamente derivano, e senza de' quali si dissolve ogni comunanza sociale. Lo abbiamo sentito, nella sua Allocuzione del 18 Marzo passato, ripudiare ogni partecipazione » a quel» la falsa e indegna civiltà, che calpesta il di» ritto e la giustizia, che eccita e fomenta » la licenza, che cammina al suo fine colla » frode e colla violenza, e tenta di distrug» gere la Chiesa di Cristo ». E quale consorzio (ha detto il Pontefice) può esistere fra la giu-

stizia e l'iniquità? Quale società fra la luce e le tenebre? Quale accordo fra Cristo e Belial?

Ebbene, tosto dopo l'Allocuzione del Vicario di Gesù Cristo, anche i rivoluzionari manifestarono apertamente i loro propositi, le loro ferme intenzioni. Sotto il pretesto di far guerra al potere temporale della Chiesa, come onorando alla chimerica unità dell'Italia, e cooneestando la brama di rapir Roma al Pontefice per farne la Capitale del nuovo regno, essi hanno decretata la ruina della religione Cattolica, per surrogarle la servitù delle coscienze, e il trionfo dell'arbitrio, e della forza materiale.

Lasciamo parlare il Conte di Cavour al Parlamento italiano nella seduta del 25 Marzo. —
» È impossibile di concepire un'Italia costi» tuita, senza Roma per Capitale. Il potere tem» porale del Papa non può più esistere. *Estra*» *neo al movimento dei secoli, il Papa è ob*» *bligato per dovere religioso di opporsi alle ri*» *forme socialmente necessarie*; bisogna dun» que rispettare i suoi *scrupoli* e spogliarlo.
» Il Potere temporale non è una garanzia per
» la sua indipendenza spirituale, è piuttosto
» un ostacolo. L'unione del potere temporale
» collo spirituale è un flagello in Roma come
» a Costantinopoli: toglierne il peso al Papa
» è renderlo libero ; e per renderlo libero noi
» dobbiamo andare a Roma, ove giunti, pro-
» clameremo la *separazione della Chiesa dallo*
» *Stato, la libertà della Chiesa*, e ne scri-
» veremo i principj nello statuto fondamentale
» del regno ».

I cattolici, del pari che i rivoluzionari italiani conoscono troppo bene qual senso convenga attribuire a quel detto — *Separazione della Chiesa dallo Stato, e libertà della Chiesa*: ma dove la quistione si fa nitida e chiara, dove l'intento degli avversari si palesa in tutta la sua evidenza, egli è là in quelle altre memorande parole. *Estraneo al movimento dei secoli, il Papa è obbligato per dovere religioso di opporsi alle riforme socialmente necessarie.* Noi non desideriamo di più. Vi è dunque un movimento del secolo in opposizione al movimento della Chiesa di Cristo; vi è un dovere religioso contrario ai doveri della setta rivoluzionaria; vi sono riforme socialmente necessarie, ma religiosamente vietate.

Noi credevamo, e abbiamo la sorte di credere ancora che non vi abbia se non una sola verità, e per conseguenza una sola necessità morale e sociale, la necessità della giustizia, la necessità del rispetto dovuto al diritto. Una dunque delle due assertive dev'essere assolu-

tamente falsa ne' suoi principj, funesta nelle sue applicazioni e ne' suoi effetti, come l'altra per ragion dei contrari dev'esser santa e infallibile nelle sue massime, utile e benefica nelle sue pratiche effettuazioni.

Che il Pontefice parli in nome di Dio, la fede ce lo insegna, e la civiltà evangelica diffusa pel mondo ce ne offre da diciannove secoli la riconferma. Chi sono pertanto questi uomini che si ribellano alla voce del Vicario di Gesù Cristo, che spargono dottrine avverse alle sue, e che contristano di tanti mali la nostra povera patria ? Sono uomini trasportati da immensa ambizione di dominio e di prepotenza, uomini che rinnegano ogni idea la più elementare di religione, e di buon senso : e voi li udite diffatti pareggiare la potestà Spirituale del Romano Pontefice a quella del successore di Maometto ; dar nome di *scrupolo* alla sublime fermezza onde Pio IX resiste alle violenze rivoluzionarie ; osteggiare il dominio temporale della S. Sede come *ostacolo* alla sua spirituale indipendenza, nell'atto stesso che la voce del Supremo Gerarca, e la storia di dodici secoli attestano che la Provvidenza ha voluto appunto di quel dominio temporale costituire una forte guarentigia all'indipendenza della cattolica religione e dell'Augusto suo Capo : e sono giunti per fino a proclamare che il Dio di Pio IX non è il Dio di Vittorio Emanuele.

Compiangiamo la loro cecità, o per dir meglio, la loro scelleraggine, ma rallegriamoci della loro franchezza. Se da principio, i semplici e gl'inesperti potevano cadere in inganno, perchè la rivoluzione non aveva ancora smascherati i suoi progetti, concecchè la Chiesa li avesse già presentiti e denunziati al mondo cattolico; oggi che la luce è manifesta e l'inganno non può essere volontario. In una lotta in cui si cimentano interessi di tanto momento, quali sono gl'interessi della fede, della civiltà della stessa esistenza sociale, nessuno può restarsi spettatore inerte, ma dee combattere con una delle due parti.

Noi seguimmo finora colla massima ansietà cotesta pugna, ed affrettammo coi nostri voti il trionfo di quella parte, verso la quale ci sospingevano le convinzioni dell'animo, le voci della coscienza, e gli stessi affetti del cuore. Ed oggi in cui tutto sembra indicare l'appressarsi di quell'istante supremo, dal quale dovrà dipendere la vittoria della fede o dello spirito irreligioso, quella della giustizia o della iniquità: oggi che, umanamente parlando, tutte le speranze di un fortunato successo sembrano

The first number of *L'Osservatore Romano*, dated July 1, 1861.

41

A recent number of the newspaper. The daily edition provides full coverage not only of religious matters but also of political, social, and cultural issues.

L'Osservatore Romano has seen persecutors and dictators come and go. In war as in peace it has presented news and opinion with a serenity and sense of history one would expect from an organ published in the shadow of St. Peter's. . . . The paper's influence far outstrips its modest circulation. . . . Leading churchmen around the world take the paper; also many other opinion and political leaders read it. . . . Even the Kremlin has a subscription. The paper is widely quoted throughout the world—from the pulpit, from the press, and from radio and television.

Even if *L'Osservatore* were printed only in Italian, or even Latin, it would have considerable influence and impact throughout the world. It would be quoted often and widely (as it is); it would serve as a source of ideas for articles in many languages; it would filter into dozens of languages of the world. It is possible that the paper could have greater impact if it were more like other newspapers or if it were published in many other languages, but it is doubtful. As it is, *L'Osservatore Romano* gains prestige from the very fact that its circulation is restricted and its character is extremely stolid and serious. It is highly probable that the paper would lose something very important if it were to pattern itself after the "newspapers of the world," even those of high quality.

VIRGILIO LEVI

The Vatican Radio

The Lateran Treaty included provisions for the Vatican Radio, which was created by Pius XI as an expression of the sovereignty and independence of the Holy See and as an extraordinary medium for the church's apostolate. It was the pope's desire to set up an installation that would be in the vanguard of the world's radio stations. With this purpose in mind, he called upon the experience of the inventor of the radio, Guglielmo Marconi. And on September 21, 1930, he appointed the Jesuit father Giuseppe Gianfranceschi of the Pontifical Academy of Sciences (who had been the companion of Umberto Nobile on the polar expedition of 1929) first director of the new broadcasting station.

The first transmitter was installed by the Marconi Company of London. The antennas, soaring high behind Michelangelo's dome of Saint Peter's, were considered a technological marvel at the time.

The inauguration took place at 3:30 P.M. on February 12, 1931, in the presence of Pius XI, of Marconi and his wife, of Father Gianfranceschi, and of cardinals, church dignitaries, and other distinguished guests. Among the cardinals was the Secretary of State, Eugenio Pacelli, who later, as Pius XII, was to have so active a role in the development of the Vatican Radio. The pope first unveiled a commemorative plaque with a Latin inscription that summed up the primary purpose of the radio, "that the voice of the Supreme Pastor may be heard over the airwaves to the ends of the earth, for the glory of Christ the King and for the good of mankind." There followed a radio message, the first ever sent by a pope. The voice of Pius XI was heard simultaneously in every part of the world: "Being able, from this place, to avail ourselves for the first time of Marconi's wonderful invention, we address ourselves to all things and to all men, speaking to them, now and in time to come, with the very words of Holy Scripture: 'Listen, heavens, while I speak; let the earth hear the words of my mouth. Hear, all you peoples.'"

The years from 1931 to 1939 were an experimental period for the Vatican Radio. News of the pope's activities and of the life of the church in the world was regularly broadcast, as were reports of a scientific nature on the program "Bulletin of the Pontifical Academy of Sciences." By September 21, 1933, at a general audience for the radio's personnel, Pius XI could say:

> The Vatican Radio is of worldwide importance, and it is furnished with first-class equipment. But machines, however excellent, are still machines; they need constant care, supervision, and expert handling if they are to serve their purpose effectively. We know, and you know, that the Vatican Radio is going well, and that it is highly appreciated throughout the world. And not only is it going well; it is also rendering a high service to the church and to the pope.

The director of the radio from 1934 to 1953 was Father Filippo Soccorsi, S.J. In 1937 a twenty-five-kilowatt Telefunken transmitter for shortwave broadcasting and new directional antennas were installed, and in 1939 regular international broadcasts were initiated. In the same year the first studios of the Vatican Radio were opened in the Palazzina of Leo XIII, which had been built as a summer residence for the pope at the top of the Vatican Hill; from 1919 to 1933 this building had been the site of the Vatican observatory. From January 1940 on, programs were broadcast daily in Italian, French, English, Spanish, and German, and two or three times a week in Portuguese, Polish, Ukrainian, Lithuanian, and Russian.

The development of these initiatives was abruptly cut short by the Second World War. For its duration, the Vatican Radio was almost entirely concerned with the transmission of inquiries about civilians, missing soldiers, and prisoners. A total of 1,240,728 messages were sent, involving 12,105 hours of broadcast time, equal to about eight hours a day.

After the war, the radio began to build up an international editorial staff to handle its news services. By 1948 nineteen different languages were used in occasional programs. Today there are regularly scheduled daily news broadcasts in Italian, Spanish, Portuguese, French, English, German, and Polish.

In 1948 the Central Committee for the Holy Year launched a worldwide appeal to offer to Pius XII, on the occasion of the jubilee of his priesthood, the funds necessary to amplify the power of the Vatican Radio. The most substantial gift, a hundred-kilowatt shortwave transmitter, was contributed by the Catholics of the Netherlands.

A commission for the new installations was constituted on October 8, 1951, and an arrangement was reached between Italy and the Holy See, conferring extraterritorial status on the site of the projected transmitting center at Santa Maria di Galeria, about eleven miles north of Rome. Father Antonio Stefanizzi, who became director of the radio in 1953, dedicated himself to the project. The transmitting center was inaugurated on October 27, 1957, in the presence of Pius

XII, who undertook for the occasion the longest journey of his pontificate, from the papal villa at Castelgandolfo to Santa Maria di Galeria.

On the thirtieth anniversary of the Vatican Radio in 1961, Pope John XXIII declared: "The voice that comes forth from the center of Catholicism, passing over the boundaries of nations, has rendered more perceptible the brotherhood of peoples united in the profession of a common faith and in a life of exemplary charity; it has kindled a light in the hearts of the oppressed." In the same year, the pope inaugurated a hundred-watt Telefunken shortwave transmitter donated by the archbishop of Cologne, Cardinal Frings; in 1962 a similar transmitter, a gift of the Catholics of Australia and New Zealand, was installed.

During the years of the Second Vatican Council, from 1962 to 1965, the Vatican Radio was in a state of constant mobilization. Its technical division planned and installed the sound apparatus in Saint Peter's, and took charge of recording and broadcasting the important events of the council. On June 30, 1966, Paul VI inaugurated three new RCA transmitters, donated by the Catholics of the United States—two of 100 kilowatts and one of 250 kilowatts. He announced, on this occasion, a plan for the modernization of the program division of the radio. In the following year, its administration was reorganized in accordance with the increased complexity of its operations. Father Giacomo Martegani became its head, with the title of delegate director general; Father Roberto Tucci succeeded him in this post in 1973.

Today about three hundred people, coming from thirty-five countries and speaking thirty-two languages, work for the Vatican Radio. They include religious (both men and women), secular priests, and laymen; their backgrounds are in the apostolate, in technology, and in the arts and sciences. Besides the permanent staff, there are about 150 outside collaborators. The nucleus of the management is composed of about 30 Jesuit priests who work exclusively for the radio. Certain programs, however, are directed by members of other religious orders or of the secular clergy.

The radio broadcasts twenty hours a day, and produces about five hundred programs a week. Since it is heard in nearly every part of the world, exact statistics as to the size of its audience cannot be obtained. To judge from surveys carried out in certain countries, and from the correspondence it receives, the number of listeners can be estimated at several million.

The fundamental goal of the Vatican Radio is to serve the universal church, and this is reflected in its structure. Those responsible for its programs do not produce a single set of texts to be translated into thirty languages; rather, its various linguistic divisions pro-

A view from the Vatican Palace. The tower in the background, built upon the medieval foundations of the Leonine walls, houses the management of the Vatican Radio.

duce a wide range of programs designed to satisfy the religious and cultural needs of many different parts of the world. To the nations of Eastern Europe, for example, where religious information is scarce, it broadcasts news, liturgical services of several rites, and the voices of bishops who may not have access to the radios of their own countries. In broadcasts to non-Christian countries it stresses themes of human interest, such as peace, justice, and worldwide cooperation, while in collaboration with international organizations it contributes to vast campaigns against the scourges that afflict humanity, such as hunger, illiteracy, disease, racism, drug addiction, and pollution.

No aspect of human life is considered extraneous; much time is devoted to music, art, and science. But prayer remains an essential feature of the radio's programming: live broadcasts of the Mass, the rosary, and the Angelus do not make news, but they unite large numbers of listeners in a common expression of their faith.

The Vatican Radio operates, so to speak, in three concentric circles, corresponding to the three kinds of wavelengths it uses. The largest circle is that of the shortwave radio. From Africa to Latin America, from Australia to Canada, the shortwave reaches listeners of the most widely differing languages and cultures; from Japan alone, some five hundred letters reach the Vatican Radio every month. The second circle, that of medium-wave broadcasts, includes the whole of Europe and the Mediterranean basin. Reception is excellent in the evening and at night, but it is drastically reduced during the day; the area must therefore rely on the shortwave for daytime broadcasts. The third circle, the most restricted, is that of frequency modulation (FM), which in practice includes only Rome and the surrounding district.

To these three types of wavelength there correspond, at least in theory, three different types of program. Shortwave broadcasts are inevitably broken up into short programs that take into account the diversity of languages and cultures throughout the vast regions that they reach. By their very nature these are "broadcasts by appointment," intended for listeners who are mainly interested in news and facts.

The medium wave is characterized by a more leisurely pace. Its purpose is to offer the listener longer and more varied programs: music, drama, interviews, talks, and so on. During the daylight hours the medium wave would need booster stations in the regions it is intended to serve, but the Vatican Radio cannot count on such stations. For this reason, and because of the larger number of languages spoken in the European range, the medium wave cannot be used as much as would be desirable.

The FM radio is entirely different. Given its local

range, its programs do not have to be divided among many languages. It has ample time at its disposal; it therefore enjoys great flexibility and can offer its listeners a wide variety of programs. The fact that it can broadcast stereophonically adds to the high quality of the FM programs.

Obviously, the advantages of FM are available to a relatively small circle of potential listeners; this is why, in the apportioning of the limited resources at its disposal, the Vatican Radio has given preference to improving shortwave and medium-wave services, which are directed to far wider sectors of the church and of the world.

ROBERTO TUCCI

The Press Office of the Holy See

During the Second Vatican Council, and especially when the decree "Inter Mirifica" on the means of social communication was discussed and approved in 1963, many of the council fathers echoed the desire felt by numerous Catholics for religious information that would be complete, readily available, and above all reliable and in harmony with the times. Paragraph 19 of the decree states: "For the fulfillment of his supreme pastoral responsibility regarding the instruments of social communication, the Sovereign Pontiff has at his disposal a special office of the Holy See." A footnote to paragraph 19 goes on to say: "The council fathers, however, willingly acceding to the wish of the Secretariat for the Supervision of Publications and Entertainment, respectfully ask the Supreme Pontiff that the duties and competence of this office be extended to all the media of social communication, including the press, and that experts, including laymen, from various nations be named to it."

These are the premises of the Pontifical Commission for Social Communications, which had already been in existence since 1940, though its functions were limited to the cinema and radio. Its competence was later extended by Pius XII, in 1952, and by John XXIII, in 1959. It received its present form, in fulfillment of the council decree, with Paul VI's *motu proprio* "In Fructibus Multis" of April 2, 1964. The Press Office was set up a few years later, within the framework of the pontifical commission, for the purpose of giving to journalists and, through them, to newspapers, agencies, radio, and television, the official statements and the religious and moral teachings of the pope and of the central government of the church. The news service began on October 6, 1966, and functions according to norms laid down in special regulations.

From 1938–39 there had existed an information service linked with the *Osservatore Romano*. The service was entrusted to an editor of the newspaper. For thirty years it published daily bulletins containing items that were about to be published in the Vatican daily. It also dealt with journalists' inquiries on various subjects, but its activity was always somewhat limited, indirect, and inadequate for the growing demand for information.

In founding the Press Office, the Holy See wished to respond to real and keenly felt needs. The office is an official source by reason of its nature and constitution, as may be seen from the pastoral instruction "Communio et Progressio," published on June 3, 1971, by the Pontifical Commission for Social Communications to complement the conciliar decree "Inter Mirifica." It is responsible for publishing the discourses of the pope, the official daily news bulletin, the acts of the sacred congregations, and documents of the papal *magisterium*. The publication of the documents of the Holy See is coordinated with the offices of social communications set up by the episcopal conferences of the local churches, so that texts of particular importance are published simultaneously in Rome and in the rest of the church. Annual meetings of those in charge of the Press Office and of the local offices aim at perfecting this cordial cooperation and at gradually eliminating breakdowns in coordination.

The Press Office is of course in constant contact with the Secretariat of State's Information and Documentation Office, upon which also depend the other means of social communications directly controlled by the Apostolic See, the *Osservatore Romano* and the Vatican Radio.

The activity of the Press Office of the Holy See consists principally in maintaining permanent contact with accredited journalists. There are more than three hundred journalists, and they represent newspapers, agencies, and radio and television services of all the countries of the world. Meetings are held every Thursday, at which the director of the Press Office comments on points of current interest and answers as fully as possible the questions asked by the journalists present. Daily news bulletins are also published and made available to the journalists.

On special occasions, as for example when documents of particular importance are published or when events of worldwide interest occur, press conferences are held at which experts deal with the texts or events in question and provide any clarifications requested.

In certain circumstances the office is called upon to provide extra services—for example during sessions of the synod of bishops, when it has the task of providing the permanently accredited journalists and several hundred special correspondents with detailed communiqués published shortly after each meeting. Members of the staff belonging to the various language groups—Italian, English, French, German, and Spanish—comment on the day's work in daily interviews. They also provide explanations and clarifications upon request.

The Press Office is on the ground floor of one of the extraterritorial buildings that house the sacred congregations, outside the Vatican, near Saint Peter's Square. Large glass doors lead into a spacious lobby, from which one passes to the press-conference room, which seats 240 persons and is furnished with equipment for simultaneous translation and for film projection. On the left is a room with tables, telephones, and telephone booths, for the use of accredited journalists. On the right are the offices of the management and secretariat. On the upper floor are the archives and a reference library.

In order to be able to use the Press Office and its facilities, correspondents from the daily papers, periodicals, agencies, and radio and television stations are required by the regulations to present a declaration from their employers guaranteeing their professional good standing. In the case of countries in which journalism is regulated by law or union rules, it is also required that applicants should provide proof of their membership in the appropriate professional associations, or that they should join the Foreign Press Association in Italy.

The office operates on the principle that while freedom of interpretation is recognized, absolute objectivity is essential. Incorrect conduct in this or other matters—for example, failure to observe the obligation not to publish a document before a specified day and hour—is punishable by temporary or permanent sanctions.

Requests for permission to make television or cinema films or to take photographs are dealt with by the Pontifical Commission for Social Communications, which from time to time grants such authorizations in conformity with a regulation for audiovisual recordings of ceremonies in places directly dependent upon the Holy See, which was approved by the pope on August 13, 1964.

FEDERICO ALESSANDRINI

Overleaf: The façade of Saint Peter's was completed in 1612 by Carlo Maderno. Above the central portal is the Benediction Loggia, from which the pope imparts his blessing to the crowds below.

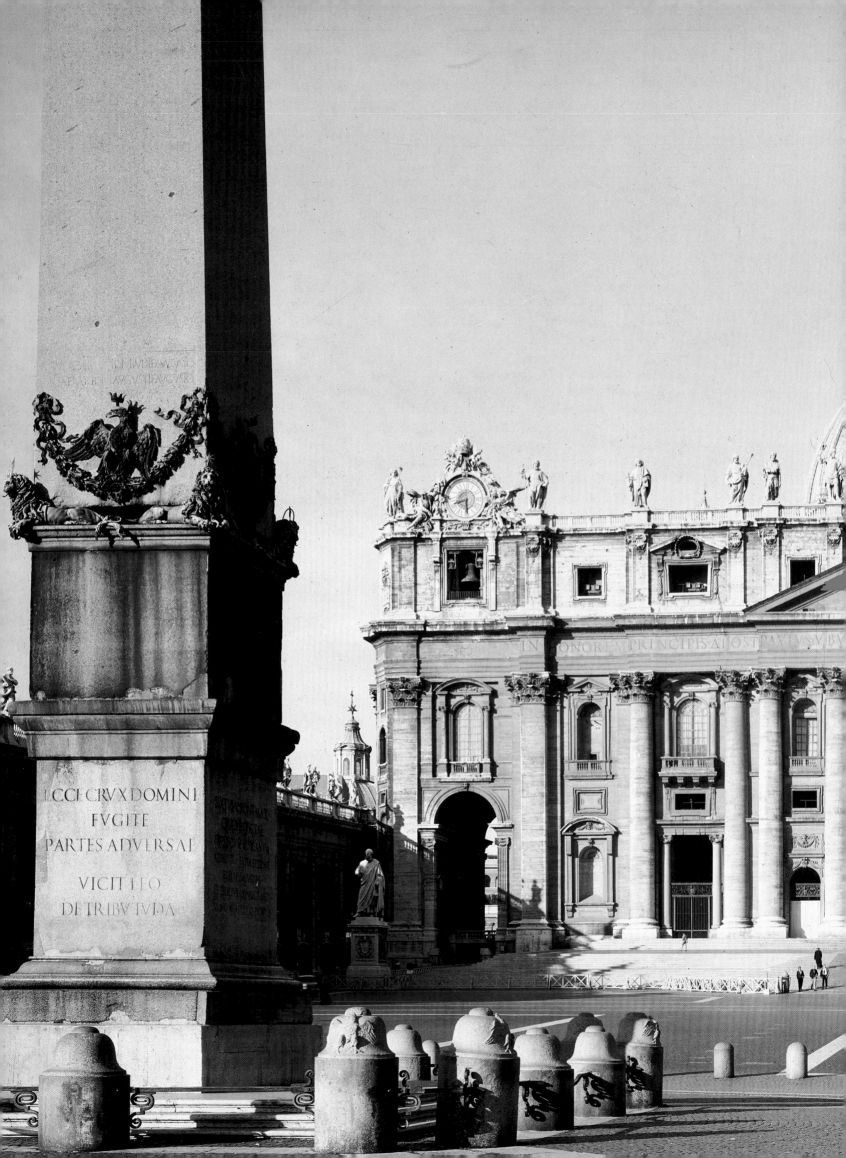

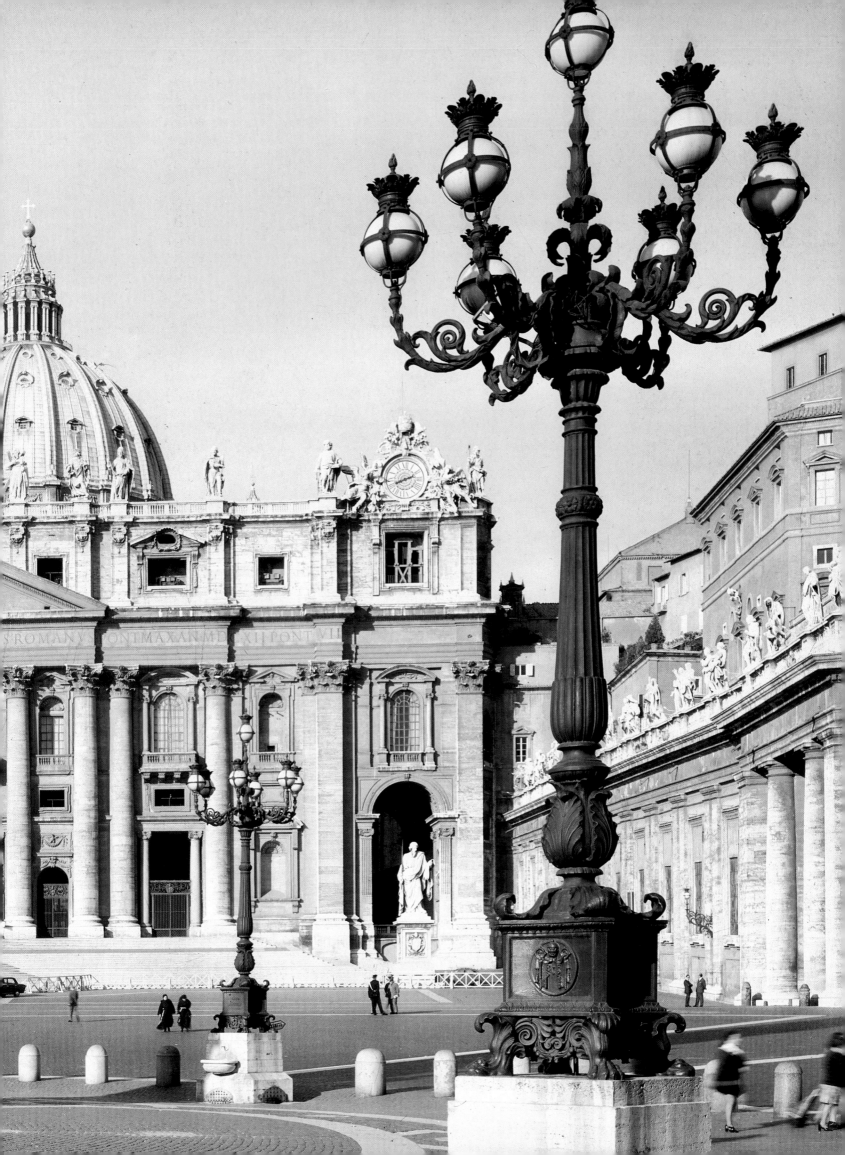

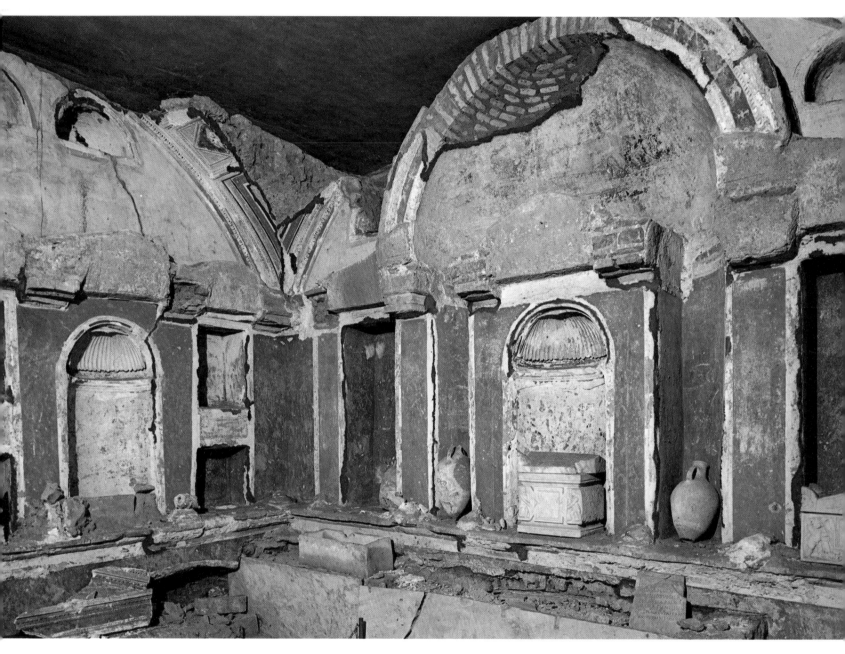

The mausoleum of the Caetenni, dating from the second century, in the Roman
necropolis discovered during excavations that took place during the decade
1939–49 below the level of the Constantinian basilica.

SAINT PETER'S

The Tomb of Peter and the Constantinian Basilica

The history of the tomb of the apostle Peter at the Vatican has been enormously enriched during the forty-three years since Pius XII, at the very beginning of his pontificate, decided to extend to the entire area below the crypts of Saint Peter's (including the area below the papal altar) archaeological investigations that had been initiated by chance discoveries at the site chosen for the burial of his predecessor, Pius XI. Little by little, as incrustations of legend were stripped away and erroneous scholarly hypotheses disproved by the material evidence, the *memoria* of Peter began to appear in a more exact perspective. It became possible to confront the monument with descriptions of the site in ancient texts and to proceed backward through the centuries from the present basilica to the Constantinian one; to the necropolis of the second century, where a small funerary monument marked the site of Peter's tomb; and finally to the archaeological context of the first century, which sheds light on the beginnings of the whole historical development.

We have said that the funerary monument marked the site of Peter's tomb; one cannot maintain, strictly speaking, that the tomb itself has been discovered, for the excavations did not bring to light the body of the apostle as it was buried after his martyrdom, nor was anything found in the small cavity just beneath the monument that could have belonged to a first-century tomb, even a modest one. It would be wrong to conclude, however, that the excavations have added nothing to our knowledge of the first decades of the tomb's history.

The second-century necropolis had grown up along a secondary road that flanked the north side of the circus of Caligula and Nero. The excavations have established that the family tombs of which the necropolis was made up were built on ground that had been used as a burial place at an even earlier date. Piles of bones, taken from earlier tombs, were found in the neighborhood of the Petrine monument; the bones had been gathered together by the second-century masons, who thus showed their piety toward the dead, though they did not respect the material integrity of the earlier tombs. This practice provides a clue to what became of the tomb of Peter at the time when the second-century monument was set up: the remains of the apostle must have been gathered together and placed under the monument. One pile of bones, in fact, was found in a small, boxlike opening, lined with marble slabs, that had been hollowed out, in the Constantinian period, in a wall that had been added to the monument in the third century. The bones had been moved to this spot, it seems, from the cavity under the monument; this, at least, has been the conclusion of a number of archaeological and historical analyses. We may say, then, that at the time of the construction of the Constantinian basilica, these bones were considered the remains of Peter, though we must admit the possibility that the identification was erroneous.

The Petrine monument was discovered, substantially intact, embedded in the masonry of a small chamber under the papal altar, known as the Niche of the Pallia. The monument consists of two superimposed niches, in the middle of a wall seven meters long; they were constructed, together with the wall, around A.D. 150. Originally they were separated by a horizontal travertine slab, the outer corners of which were supported by a pair of colonnettes. In front of the monument there was an open enclosure measuring seven by four meters, bordered in part by family tombs belonging to the necropolis; the remains of this enclosure have been excavated directly beneath the Confessio of Saint Peter's, the balustraded opening in the

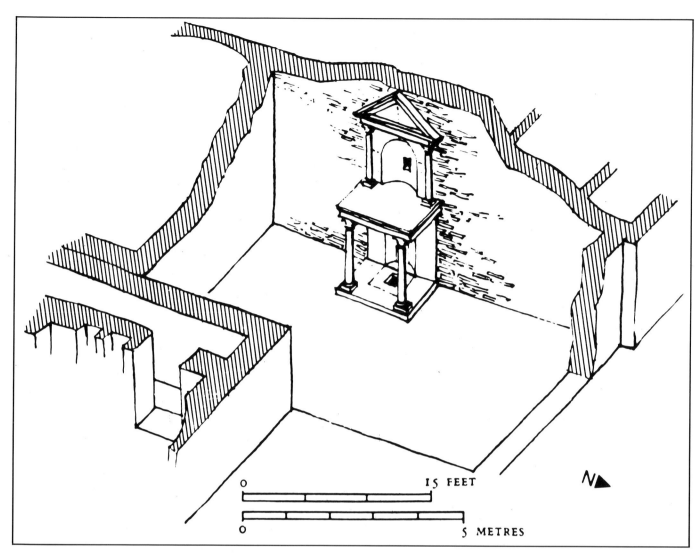

Reconstruction of the second-century funerary monument of Saint Peter.
From R. Krautheimer, *Rome: Profile of a City, 312–1308*. (Princeton, 1980).

pavement in front of the papal altar that gives access to the Niche of the Pallia. The monument has thus remained in its original place from the second century until the present day, though the ground level around it was raised both for the construction of the first basilica (during the reign of Constantine and the pontificate of Sylvester I, no doubt between 320 and 333) and for that of the new basilica (under eighteen popes, from Julius II to Paul V, between 1506 and 1615).

The position of the monument in the context of the second-century necropolis was rather unusual. Not only was it a small, individual shrine standing in the midst of a large number of tall, houselike burial chambers; it also interrupted the general arrangement of the necropolis. Most of the tombs were constructed along a rectilinear axis, but those nearest the monument are displaced so as not to encroach upon the enclosure of which it is the center. The enclosure was apparently built up in part by filling in the space between the tombs surrounding the monument; the level

of the enclosure is determined by that of the monument. And two stairways, contemporary with the tombs, seem to have been built specially to provide access to the enclosure.

One may conclude, then, that the position of the monument and its enclosure reflects a conscious effort to preserve and integrate within the developing necropolis a tomb that already existed. Alterations dating from the second half of the third century show that the monument remained the focal point of the necropolis. It was embellished at this time with marble decorations, and two small walls, flanking it on either side, were added; the enclosure—where in the mean time a number of persons had been buried in the earth—was now covered with a mosaic pavement. The entrances to the two stairways were provided with gates. Thus there is an archaeological continuity from the middle of the second century, when the monument was erected, to the first quarter of the fourth, when construction of the basilica was begun. And this in

The Niche of the Pallia, on the site of the funerary monument of Saint Peter. The mosaic figure of the Savior dates from the ninth century.

turn enables us to trace back to the middle of the second century the Petrine significance that the monument certainly had in Constantinian times.

The tomb's original architectural setting may be seen today by the visitor who descends from the basilica into the crypt and thence into the excavated areas beneath it. Transported from the twentieth century into the second, the visitor walks along narrow paths, hemmed in by the façades of ancient Roman tombs,

on what was once the slope of a hill. A short climb toward the north leads to a path that gradually rises westward, in the direction of the papal altar. Moving along, the visitor notices that the walls have been demolished to an increasingly greater extent, so that at the end of the path, at a point almost directly below the papal altar, all that remains of the last of the tombs is a pavement and the lower parts of a wall.

The state of preservation of these tombs is a good

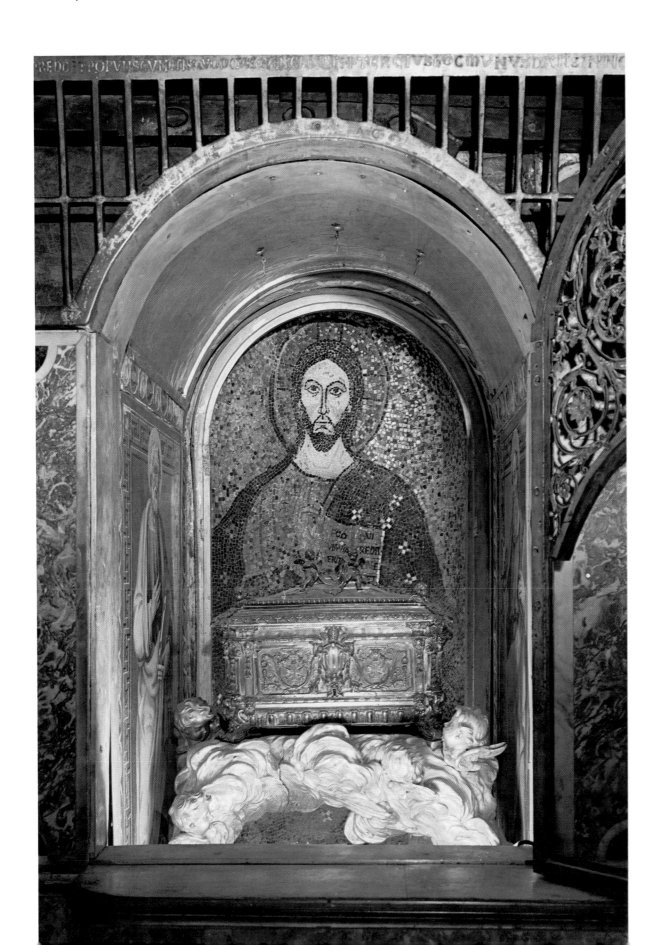

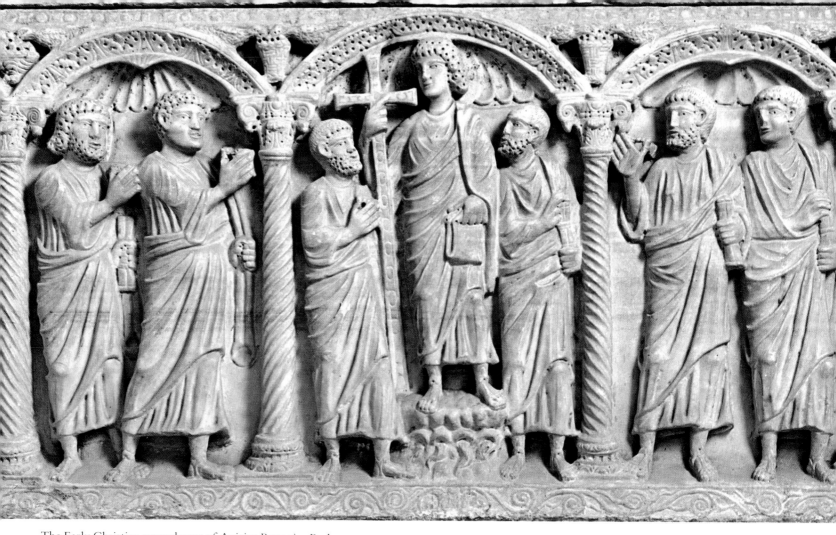

The Early Christian sarcophagus of Anicius Petronius Probus,
dating from the fourth century, was used during
the Renaissance as a baptismal font.

indication of the problems that faced Constantine's architects when they set out to construct the first Vatican basilica. The site was occupied by an important necropolis, which was still in use and had to be closed by imperial authority. The necropolis was situated, moreover, on the side of a hill. To provide a foundation for the basilica a level, artificial terrace had to be created by cutting into the Vatican Hill on the northern (uphill) side and by constructing gigantic supporting walls on the southern (downhill) side. The tombs in between were partly demolished so that the height of their walls corresponded to the level of the new terrace; the empty spaces were filled in with earth. (These foundations were the weak point of the Constantinian construction; it was when the wall over the southern substructions threatened to collapse, during the Renaissance, that it was decided to demolish the whole basilica and erect a new one.) The level of the terrace was carefully calculated so that the small niched monument rose above it, intact and isolated, directly in front of the apse of the basilica, of which the monument thus became the focal point.

A modest funerary monument in the midst of a necropolis was therefore the reason for the construc-

tion of a vast basilica in what had previously been open country. This can only be explained in the context of contemporary *martyrium* basilicas; the Christian community considered the niched monument to be Peter's tomb. The most important result of the Vatican excavations is unquestionably this: they have furnished archaeological and historical proof for a belief that the Catholic community has never doubted. If ever there was an Early Christian basilica *ad corpus*— one built, that is, to serve as a martyr's tomb—the basilica constructed by Constantine at the Vatican is the foremost example of the type.

The Vatican excavations have not only allowed us to reconstruct the tomb as it appeared—marked by the niched monument—before the construction of the basilica; they have also given us a better idea of the appearance of the shrine of the Apostle within the basilica, for they confirm and clarify descriptions of the shrine in ancient texts as well as a representation of it on a fifth-century ivory reliquary found at Samagher, a village near Pula in Yugoslavia. The aedicula stood, as we have seen, in the middle of the transept, in front of the apse. Under Constantine the flanking walls of the third century were enlarged, and their irregulari-

ties corrected. The monument, with its two-part façade, was given a marble revetment similar to that which covered the wall of the apse. A golden cross bearing the names of Constantine and of Saint Helena, his mother, was placed in the upper niche; the lower niche was closed by a double door. At some time—at least before the end of the sixth century—an opening was made in the pavement of the lower niche so that objects could be let down to touch the bottom of the tiny underground chamber beneath it. This opening still exists, in the floor of the Niche of the Pallia. Such an arrangement was typical of shrines where the remains of martyrs were venerated. Its introduction at Saint Peter's is further evidence that the niched monument was believed to stand over the actual tomb of Saint Peter. Gregory of Tours describes pilgrims lowering pieces of cloth through the opening, so that these might touch the tomb and thus become relics. In the medieval liturgy a censer was placed there on June 29, the feast of Saints Peter and Paul, and left there throughout the year. To this day, the pallia—white woolen bands that the pope bestows upon archbishops as tokens of their office—are temporarily deposited in the niche before being sent to their destinations.

The shrine of Peter was surrounded by a marble balustrade. Four twisted columns of carved marble supported a baldacchino crowned by a square architrave and two intersecting arcs; two other twisted columns, at the corners of the apse, were connected to the baldacchino by architraves. It is not only the baldacchino, however, but also its very position—in front of the apse, and at the center of the transept—that testifies to the significance of the shrine. Today, churches with transepts—cross-shaped churches—are familiar everywhere. But Saint Peter's was unique among the Constantinian *martyrium* basilicas of Rome and the Near East in having this plan; only later, during the Carolingian renaissance of the ninth century, did churches with transepts become commonplace. In the Vatican basilica, the transept was in fact the *martyrium*, the edifice centered around the tomb of the martyr and reserved for rites in his honor; the rest of the church, with its nave and four aisles, was used for assemblies of the faithful. The *martyrium*-transept was an immense rectangle, 87 meters long and 18 meters wide, separated from the nave by a great triumphal arch (above which, in a mosaic, Constantine was shown offering the basilica to the Savior) and from the aisles by four smaller arches. The nave and aisles were 91 meters long and, taken together, 64 meters wide. Besides the 6 columns of the baldacchino, 100 others, taken from a number of ancient buildings, separated the aisles from the nave and from each other, or screened the lateral arches that gave access to the transept and the outer ends of the transept itself. The en-

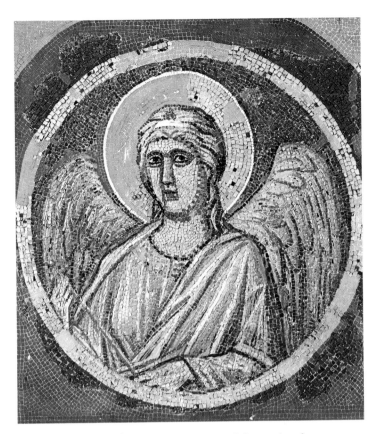

A mosaic angel attributed to Giotto is one of the works of art from Old Saint Peter's preserved in the Grotte, or crypts, of the new basilica.

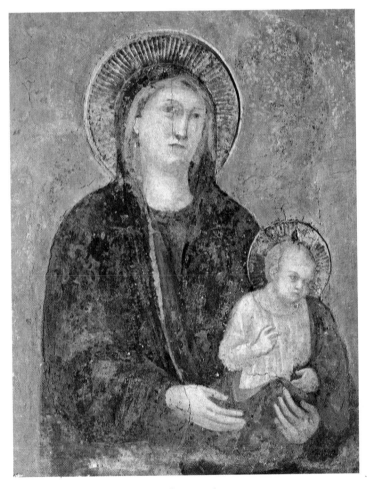

The Madonna della Bocciata, a fourteenth-century fresco from Old Saint Peter's, now in the Grotte.

trance to the basilica was a portico 12 meters deep; this was preceded by an atrium, measuring 62 by 46 meters, which one reached by a flight of 35 steps.

We have briefly described the new architectural setting that Constantine provided for the tomb of Peter. Over the centuries, the basilica was richly embellished with works of art and monumental tombs. A number of extremely impressive Early Christian sarcophagi (which were interred below the pavement), as well as statues, mosaics, and paintings of the Middle Ages and the early Renaissance, have been preserved and may be seen today in the Grotte, or crypts, of the present church. Many other treasures, though lost, are well documented; descriptions by canons of Saint Peter's and representations in works of art of various periods complement the information furnished by the recent excavations. Before the last remaining parts of the Constantinian basilica—the nave, façade, and atrium—were pulled down in 1605, the notary Giacomo Grimaldi, who was the archivist of Saint Peter's, began to compile detailed descriptions of the venerable building and the monuments within it; one of his manuscripts, preserved in the Vatican Library, is accompanied by fascinating watercolor illustrations, four of which are reproduced in this book. We cannot here describe all of the modifications that the basilica underwent during its history; two, however—the first and the last—are essential to our account.

The solution decided upon by Constantine's ar-

chitects was the best (if not the simplest) possible one for a basilica *ad corpus*, which was both a grandiose funerary monument built around a saint's tomb and a covered cemetery for those of the faithful who wished to be buried near that tomb. The funerary function of the Vatican basilica—which it shared with the catacombs—remained its primary one. But once the influx of pilgrims became so great that the liturgy had to be celebrated there frequently, the original architectural design began to pose a serious problem: the monument and its baldacchino took up too much space in the middle of the transept. It was Pope Gregory the Great (590–604) who solved this problem by reconstructing the entire tomb complex in a way that respected the integrity of the monument as ingeniously as had that of Constantine's architects.

For liturgical purposes, a permanent, easily accessible, and completely visible altar was required at the center of the transept, in front of the apse. At the same time, the Petrine monument could not be moved from this spot. The level of the area surrounding it, including the apse, was therefore raised by about one and a half meters. At the center of this new, raised presbytery, the top of the monument itself was incorporated into an altar—the first permanent altar to be erected over the tomb. Four small columns, resting on the altar, supported a baldacchino. The front of the Petrine monument remained perfectly visible from the nave, separated from it only by the six twisted col-

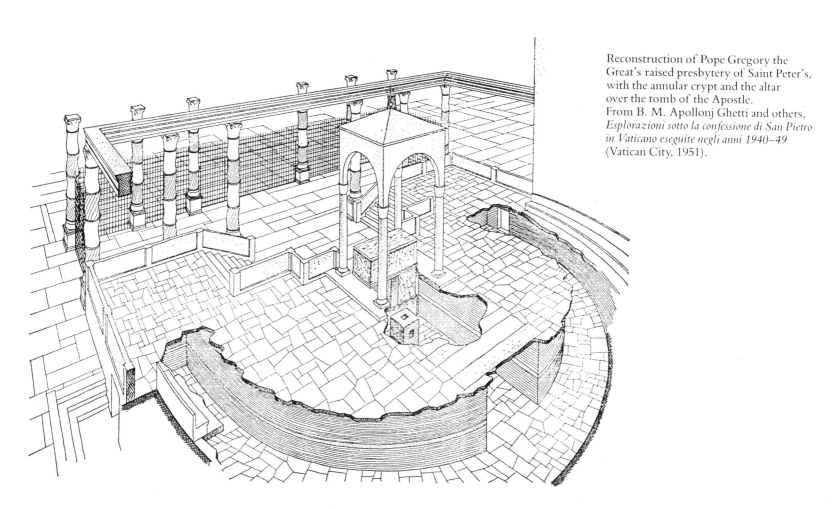

Reconstruction of Pope Gregory the Great's raised presbytery of Saint Peter's, with the annular crypt and the altar over the tomb of the Apostle.
From B. M. Apollonj Ghetti and others, *Esplorazioni sotto la confessione di San Pietro in Vaticano eseguite negli anni 1940–49* (Vatican City, 1951).

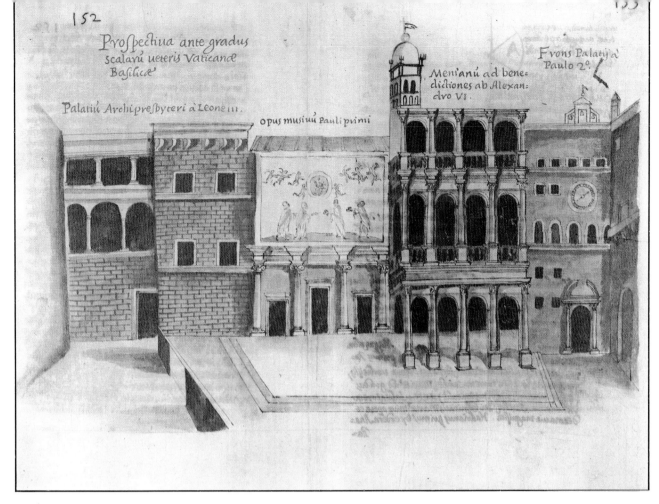

Saint Peter's Square and the entrance to the forecourt of
Old Saint Peter's at the beginning of the seventeenth century.
From a manuscript describing the old basilica, by Giacomo Grimaldi,
in the Vatican Library (Cod. Barb. Lat. 2733).

The forecourt and the façade of the Constantinian basilica at
the beginning of the seventeenth century. In the middle is the huge
bronze pinecone now preserved in the Cortile della Pigna in the
Vatican Palace. From a manuscript describing the old basilica, by
Giacomo Grimaldi, in the Vatican Library (Cod. Barb. Lat. 2733).

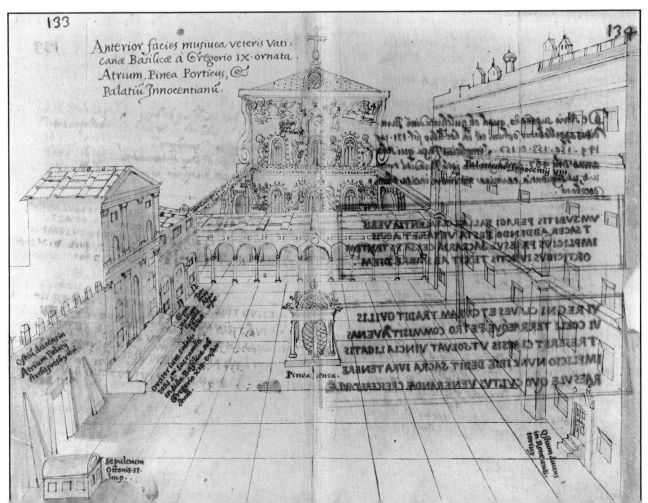

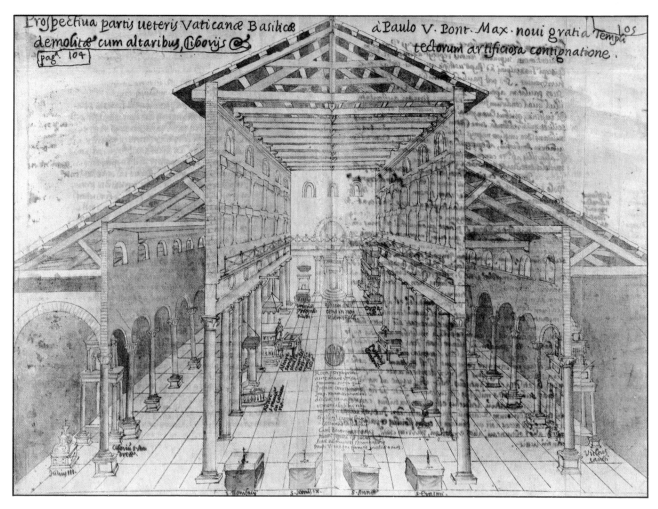

Interior of the Constantinian nave before the demolition ordered by Paul V
in 1605. At that time many of the tombs and monuments were transferred
to the Grotte. From a manuscript describing the old basilica, by
Giacomo Grimaldi, in the Vatican Library (Cod. Barb. Lat. 2733).

umns of the old baldacchino, which were now aligned
in a row and crowned by an architrave. The monu-
ment could be reached from the raised presbytery by
means of two stairways. And a new, highly original
architectural device actually increased its accessibility.
An annular crypt, or semicircular corridor, connected
with the transept by two doors, was built along the
inner wall of the apse, below the presbytery; from
this crypt another corridor, on the main axis of the
basilica, led to a chamber about two meters high—the
level of the chamber was slightly lower than that of
the Constantinian pavement—directly in back of the
Petrine monument. This chamber was known as the
Confessio because it adjoined the tomb of Peter, who
through his martyrdom became a confessor of the faith.
It is also described in medieval texts as the chapel *ad
corpus*.

The arrangement conceived by Gregory the Great
underwent only minor modifications during the fol-
lowing centuries. Under Gregory II (731–41) six more
twisted columns of marble, in the same style, were
added to the original ones in a parallel row. Callistus II

(1119–24) reconstructed the papal altar, incorporating
that of Gregory the Great.

The architectural history of the tomb of Saint
Peter was dominated, as we have seen, by the popes'
desire to preserve it intact. The same desire prevailed
during the period when the new basilica was under
construction. The first step taken by Bramante in 1507
was to erect a small enclosure to house the papal altar
and the tomb of Peter while the old basilica was being
demolished around it. This remained in place until
1592; only during the pontificate of Clement VIII (1592–
1605) was work begun on a new architectural setting
for the tomb. The pavement of the new basilica is
3.20 meters above the Constantinian level; the papal
altar, therefore, also had to be raised, and in 1594 the
present one was superimposed upon that of Callistus
II. At the same time a new, open Confessio was con-
structed in front of the papal altar; two staircases within
it lead down to the Niche of the Pallia. The decora-
tion of the open Confessio dates from the pontificate
of Paul V (1605–21).

We observed above that the plan of the Constantin-

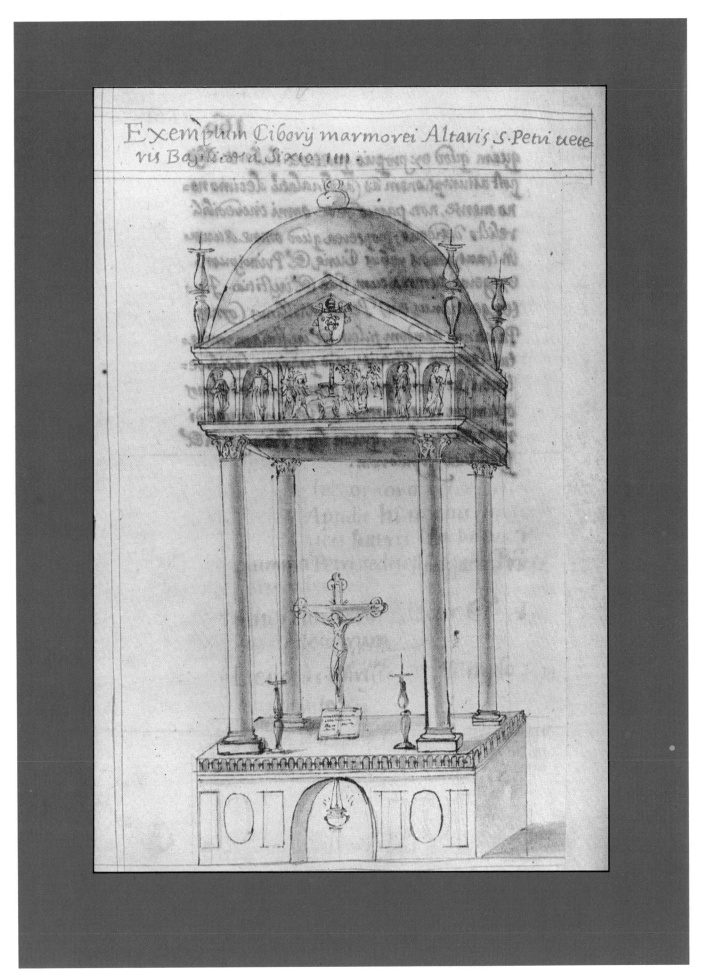

The marble ciborium erected over the high altar of Saint Peter's
by Sixtus IV in 1479. From a manuscript describing the old basilica,
by Giacomo Grimaldi, in the Vatican Library (Cod. Barb. Lat. 2733).

ian church—an apsed basilica with the addition of a transept—was later propagated in the religious architecture of the Carolingian period. The architectural scheme devised by Gregory the Great to resolve the conflict between liturgical exigencies and the inviolable presence of the Petrine monument was imitated, almost immediately, in churches where the body of a saint was venerated, even when there was not a pre-existent tomb on the site. Similarly, the open Confessio constructed under Clement VIII in the new basilica was copied—usually for no good reason—in a number of Roman churches, including San Paolo fuori le Mura when it was rebuilt in the nineteenth century.

Clement VIII also enlarged the annular crypt by adding a second corridor along the outer wall of Constantine's apse, connecting the Vatican Grotte—the subterranean passages created when the floor was raised

from the Constantinian to the present level—with the covered Confessio of Gregory the Great, which was slightly enlarged and given the name Clementine Chapel.

After the changes effected by Clement VIII, a final step still had to be taken in order to integrate the ancient *memoria* with its new and prestigious environment. The tomb remained the center of Saint Peter's, but it appeared somewhat lost in the vast space of the building. The authority of Urban VIII (1623–44) and the genius of Gianlorenzo Bernini provided the solution: Bernini designed the great bronze baldacchino over the papal altar, thus creating a majestic visual link between the tomb of Peter and Michelangelo's dome. Eight of the twisted columns that had stood close to the tomb in the old basilica (and which inspired the form of the bronze columns of the new baldacchino)

The Clementine Chapel, situated immediately behind the Niche of the Pallia.

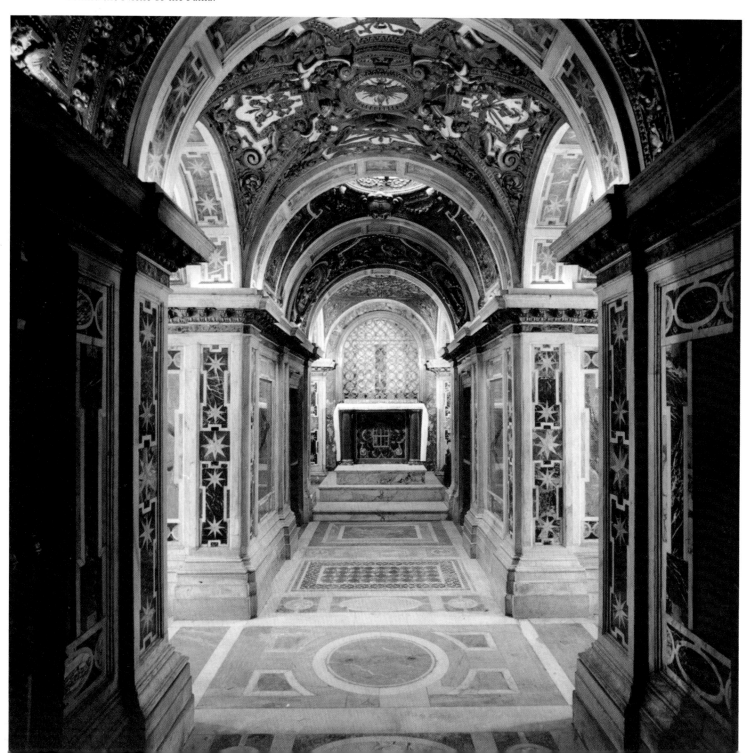

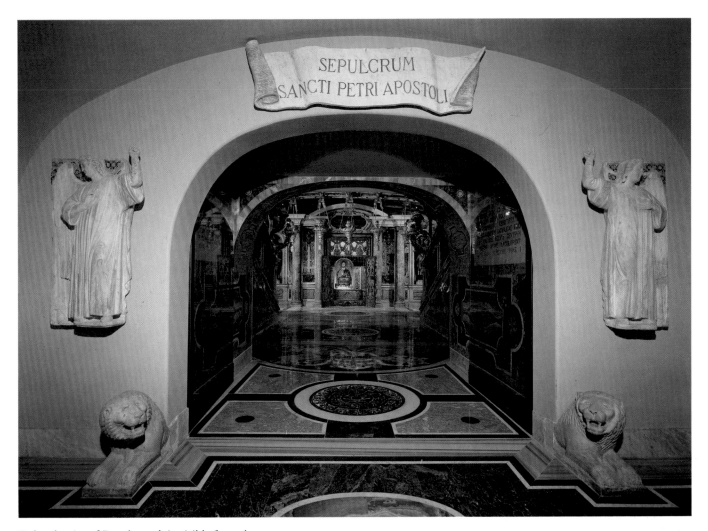

Today the site of Peter's tomb is visible from the Grotte as well as from above.

were inserted by Bernini into the four gigantic piers that support the dome. And there they remain to bear witness to the continuity, at this site, of the cult of Saint Peter's remains.

The architectural history of the Petrine monument would come to an end at this point, were it not for the fact that, very recently, the structure of the open Confessio was modified. Canova's statue of Pius VI in prayer, which had stood there since 1822, was taken away, and the east wall of the Confessio was demol-ished and replaced by plate glass, so that the site of Peter's tomb is visible from the Grotte as well as from above. The Grotte, where a number of popes are buried, correspond to the original level of the Constantinian basilica; now that the venerable site can be approached from their midst, they have become a kind of underground basilica, with the same function that the original *martyrium* basilica had in the early fourth century.

JOSÉ RUYSSCHAERT

New Saint Peter's

From Nicholas V to Paul III

By the fifteenth century, Saint Peter's was in precarious condition. The south wall leaned outward, the north wall leaned inward, and the roof was in danger of collapsing under the strain. The eleven-hundred-year-old basilica had already undergone several restorations, but Nicholas V (1447–55) now decided to rebuild it—at least in part—from the ground up. Nicholas, himself a humanist, was inspired by the ambitious projects of the great Florentine humanist and architect Leon Battista Alberti (1404–1472). Alberti dreamed of reconstructing the entire city of Rome, which had not yet wholly recovered from the ravages of the Avignon Exile and of the Great Schism; his plan is known to us through a description by his contemporary Giannozzo Manetti. Saint Peter's, with the tomb of the Apostle, was to be the center of the new city. The Constantinian nave, apparently, was to be left standing, but the apse and transept were to be replaced by three arms of equal length, with a dome over the crossing. Work was actually begun on the western arm, the choir, which was designed by Bernardo Rossellino (1409–1464), but when the pope died the project was left in abeyance. Nicholas's successors hesitated to make radical changes in the venerable basilica. Under Paul II (1464–71), work on Rossellino's choir was resumed, though it never got beyond the foundation level. Nicholas also had the roof of the nave repaired, and added a benediction loggia to the Constantinian façade.

Hesitation ceased with the accession of Julius II (1503–1513). That impetuous pontiff, inspired by a humanistic fervor for renewal and aware that the great architects of the Renaissance had already begun to transform Rome and Italy, ordered Donato Bramante (1444–1514) to proceed with the rebuilding of Saint Peter's. Bramante's project, which is known through a drawing by Antonio da Sangallo and a commemorative medal by Cristoforo Caradosso, embodied the classical ideal of architecture in its pure, lucid forms. Saint Peter's was to have a central plan, with a hemispherical dome over the intersection of the arms of a Greek cross and four minor cupolas in the corners. Sigismondo de' Conti, Julius's privy chamberlain, wrote: "The design promises to surpass every monument of antiquity in beauty and proportion. Above the basilica will rise a vault higher and more spacious than that of the Pantheon." In a solemn ceremony on April 18, 1506, Julius II, surrounded by cardinals and workmen, laid the first foundation stone of one of the four great piers that support the dome—the Pier of Veronica, as it is now called because of the statue by Francesco Mochi that adorns it. Despite all the alterations brought to the project by later architects, the nucleus of today's basilica retains the essential features of Bramante's plan.

Bramante quickly demolished most of the west end of the old basilica, and erected the four piers and the arches that were to support the dome. He died in 1514, and Julius II's successor, Leo X (1513–21), placed a triumvirate of architects—Fra Giocondo of Verona (1433–1515), Giuliano da Sangallo (ca. 1445–1516), and Raphael (1483–1520)—in charge of Saint Peter's. These men decided to alter Bramante's conception radically, by changing the plan from a Greek to a Latin cross—that is, by adding a longitudinal nave to the centrally planned area surrounding the dome. (The Greek cross was in keeping with the Renaissance love of symmetry, whereas the Latin cross was more practical for the purposes of Catholic worship; the controversy over the two types of plan was to continue until the present nave was constructed, between 1607 and 1610.) The new plan may be seen in a fresco by Raphael's pupil Giulio Romano in the Sala di Costantino in the Vatican Palace; the subject of the fresco is the approval of the project for the original basilica by Sylvester I, but the parchment that Constantine presents to the pope shows the plan for New Saint Peter's worked out under Leo X.

Baldassare Peruzzi (1481–1536) and Antonio da Sangallo the younger (1483–1546), Giuliano's nephew, succeeded Raphael as architects of Saint Peter's. Peruzzi apparently favored a Greek-cross plan similar to Bramante's. But the pontificate of Clement VII (1523–34) was marked by a series of religious, political, and military crises, and work on the basilica was virtually suspended. After Peruzzi's death, Sangallo alone remained in charge of Saint Peter's. He was occupied with other projects, however, and it required the energetic intervention of Paul III (1534–49) to persuade him to complete his wooden model for the basilica. Sangallo's project was based on a Latin cross, but it was more intricate than his predecessors', with an abundance of chapels, ambulatories, porticoes, and towers; the exterior was to be articulated by several orders of columns. A dividing wall was erected between the eleventh and twelfth columns of the nave, so that the liturgy could be celebrated in what was left of Old Saint Peter's while construction of the new basilica proceeded. Late in 1539, demolition of the western parts of the Constantinian building was completed and the foundation of the new apse was laid. Sangallo

Plan of Saint Peter's.

SAINT PETER'S BASILICA

1 Portico
2 Nave
3 High altar and Confessio
4 Left transept
5 Right transept
6 Choir
7 Cathedra Petri
8 Statue of Saint Longinus
9 Statue of Saint Veronica
10 Statue of Saint Andrew
11 Statue of Saint Helena
12 Chapel of the Blessed Sacrament
13 Bronze statue of Saint Peter
14 Mosaic of the *Navicella*
15 Filarete's door
16 Tomb of Innocent VIII
17 Michelangelo's *Pietà*
18 Tomb of Paul III
19 Tomb of Urban VIII

20 Monument to the countess Matilda
21 Monument to Constantine
22 Tomb of Alexander VII
23 Monument to Queen Christina
24 Tomb of Innocent XII
25 Tomb of Maria Clementina Sobieska
26 Tomb of Clement XIII
27 Monument to the last Stuarts
28 Manzù's door
29 Sacristy

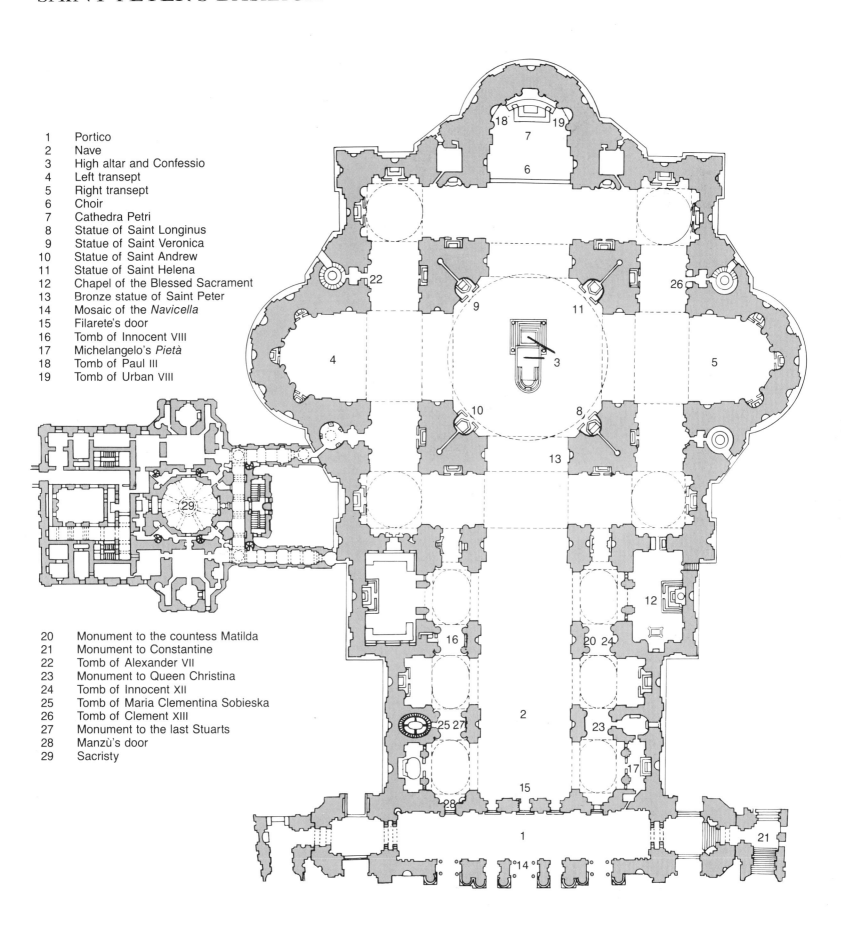

In a fresco by Giulio Romano in the Sala di Costantino in the Vatican Palace, Constantine presents a parchment with the plan of Old Saint Peter's to Pope Sylvester. The plan is actually the one devised for the new basilica by Raphael, Fra Giocondo, and Giuliano da Sangallo.

also raised the floor level of the basilica by more than three meters. The precise reason for this change is unknown; presumably it was intended to reinforce the structure. (Later, at the end of the sixteenth century and the beginning of the seventeenth, the space between Constantine's floor and Sangallo's was converted into the network of vaulted aisles known as the Grotte Vaticane.)

Michelangelo's Project

In 1546, at the insistence of Paul III, Michelangelo (1475–1564) agreed to become architect of Saint Peter's "without pay and without reward," as the papal brief that confirms his nomination informs us. Michelangelo considered Sangallo's fussy project "good for dumb oxen and silly sheep who know nothing about art"; early in 1547, he wrote in a letter that "all those who have departed from Bramante's . . . arrangement, as Sangallo did, have departed from the truth." He requested, and obtained, a free hand to make whatever changes he thought fit. Returning to Bramante's idea of a centrally planned church, he demolished most of what Sangallo had constructed. He also simplified Bramante's plan, however, and shortened the arms of the projected Greek cross; in Vasari's words: "He diminished the size of Saint Peter's but increased its grandeur in a manner which pleases all those able to judge."

Michelangelo's immediate concern was to bring the construction to a point where further modifications of the plan would be impossible—he later, in fact, obtained from Paul III's successor, Julius III (1550–55), a decree that threatened with interdiction anyone who might dare to alter his design. He concentrated on finishing one arm of the Greek cross, the southern one, and on constructing the base of the drum that was to support the dome. Once this was done, he turned his attention to the other parts. By May 1558, Michelangelo had completed, in its essentials, the first phase of his gigantic project, despite technical and financial difficulties and the bitter opposition of the admirers of Sangallo.

There remained the dome. Between November 1558 and December 1561, Michelangelo worked on a detailed wooden model for it. The construction of the drum was then begun, and the aged and ailing architect regularly had himself carried to Saint Peter's so that he might supervise the operation and observe the growth of his exasperating and beloved creation. He died on February 18, 1564, secure in the belief that no one could now spoil his Saint Peter's, the most glorious architectural monument in all Christendom. The drum was completed in May of the same year. More than twenty years were to elapse, however, before the vaulting of the dome itself would be undertaken.

Michelangelo, with his sculptor's vision, conceived of Saint Peter's as an organic whole, a single volume culminating in the great central dome. Though

the basilica has been greatly altered, the view from behind the apse still gives a good impression of this original conception, and a fresco in the Vatican Library, painted around 1590, is a fairly accurate representation of how the church would have appeared from Saint Peter's Square if it had been executed as Michelangelo planned it. The walls are made of travertine and articulated by a colossal order of paired Corinthian pilasters; the pilasters support a massive entablature that envelops and ties together the apsed arms of the Greek cross and the corner chapels. The small cupolas over the corner chapels lead the eye upward toward the drum, where sixteen pairs of projecting columns echo the pilasters of the lower walls; the windows of the drum, with their alternating triangular and segmental pediments, similarly echo the windows of the apses below. The columns of the drum serve as buttresses for the sixteen ribs of the dome. Paired columns surround the lantern, which is crowned by an orb and a cross.

After Michelangelo's death, Pius IV (1559–65) made Pirro Ligorio (ca. 1510–83) and Giacomo Barozzi (1507–1573), better known as Vignola, the architects of Saint Peter's; they completed the interior decora-

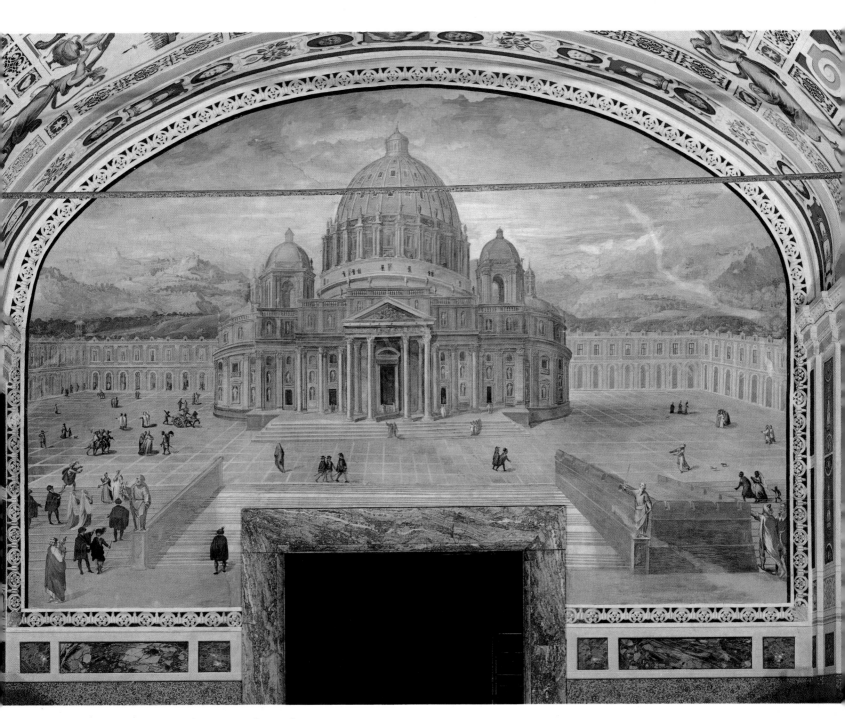

A sixteenth-century fresco in the Vatican Library shows the basilica as designed by Michelangelo without the nave added later by Carlo Maderno.

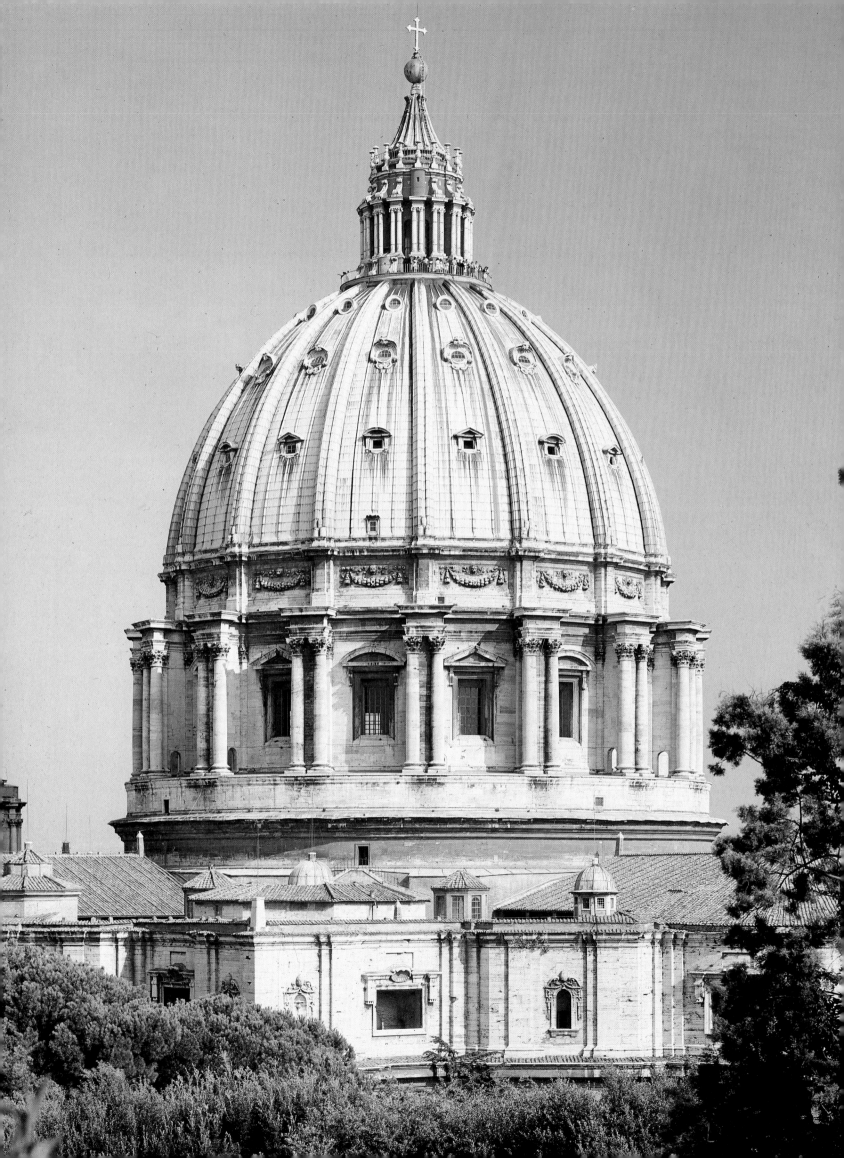

tion of the choir and transept and drew up a plan, which was subsequently abandoned, for one of the as yet unfinished minor cupolas. The next pope, Pius V (1566–72), was principally concerned with promoting the Counter Reformation and with a military campaign against the Turks; he admonished his cardinals to "delight the world less with buildings than with their virtues." Nevertheless, he set aside large sums of money for the completion of Saint Peter's. Vasari claims the credit for convincing Pius not to abandon Michelangelo's project. Pirro Ligorio was soon dismissed, perhaps because he attempted to introduce ideas of his own, and when the pope confirmed Vignola's appointment as chief architect in 1567, he imposed upon him, in conformity with the decree of Julius III, the obligation to execute Michelangelo's project without altering anything. Vignola also served under Pius's successor, Gregory XIII (1572–85), but few appreciable results, so far as we know, were accomplished under his direction.

An important step forward, on the other hand, was the appointment as chief architect, in 1574, of Giacomo Della Porta (ca. 1540–1602), on the recommendation of Michelangelo's great friend Tommaso de' Cavalieri. Della Porta completed the chapel—known as the Cappella Gregoriana, after the pope—in the northeast corner of Michelangelo's basilica; he designed a new cupola for it, and employed ancient columns from the Temple of Romulus in its decoration. The chapel was solemnly inaugurated in February 1578.

Sixtus V and the Dome

When Cardinal Felice Peretti came to the papal throne as Sixtus V in 1585, Michelangelo's design for the great dome of Saint Peter's still remained unexecuted. According to a contemporary Jesuit, the pope went about repeating that the basilica looked like a body with its head cut off. Sixtus called in his own favorite architect, Domenico Fontana (1543–1607), to work with Della Porta, and he discussed with them the enormous technical problems to be resolved. Michelangelo had planned a hemispherical dome, consisting of an inner and an outer shell; Della Porta calculated that, for reasons of statics, the dome must be given an elliptical shape. (He turned out to be wrong: the weight of the modified dome was not supported effectively by the buttressing system that Michelangelo had designed; cracks appeared in the masonry a century later and required extensive repairs.) Sixtus raised the necessary money, and on June 15, 1588, he decided that the moment had come to begin construction. Six hundred workers—or, according to one account, eight hundred—labored day and night, under Fontana's supervision, to complete "the building that would be counted," as Fontana wrote, "among the wonders of the world."

Sixtus, who felt that he had not long to live, spurred everyone on, observing that he had other important matters to attend to. (During the five years of his pontificate, in fact, this energetic autocrat not only reformed the Roman Curia and the administration of the Papal State, but also built the Lateran Palace, a new wing of the Vatican Palace, and the Vatican Library, and transformed the face of Rome by constructing new streets, aqueducts, and fountains.) The dome was finished, to the height of the lantern, in 22 months, at a cost of 200,000 gold *scudi*. This was not an extravagant sum, considering that the basilica, from the foundation to the drum, had already cost more than 500,000 *scudi* and had required 80 years of work. On May 21, 1590, four months before his death, Sixtus had the satisfaction of observing the completed dome from his summer residence, the Quirinale. The lantern and the lead facing of the dome were completed after Sixtus's death; the brass orb and the cross that surmount the entire basilica were hoisted into place in 1592.

The interior of the crossing and the dome was decorated, beginning in 1593, by a number of late Mannerist artists. The four medallions in the pendentives below the drum, each 8.5 meters in diameter, contain mosaics of the four evangelists by Giovanni De Vecchi (1536–1614) and Cesare Nebbia (ca. 1536–ca. 1614)—the pen held by Saint Matthew is 2.5 meters long. The angels and cherubim surrounding the medallions are by Cristoforo Roncalli (1552–1626), called Pomarancio, and Giuseppe Cesari (1568–1640), known as the Cavalier d'Arpino. Below the drum is a mosaic inscription, the letters of which are 1.41 meters high, with the words of Christ: "Thou art Peter, and upon this rock I will build my church. . . . I will give you the keys to the kingdom of heaven." The mosaics between the sixteen ribs of the dome, with figures of Christ, the Virgin, the apostles, angels, saints, and popes, are from cartoons by Giovanni Guerra (ca. 1540–1618), Nebbia, Pomarancio, and the Cavalier d'Arpino.

Paul V and the Lengthening of the Basilica

Saint Peter's had a long tradition of official ceremonial which, when the pope was present, required the participation of innumerable persons in picturesque and complicated processions and rites. The canons of Saint Peter's were of the opinion that the Greek-cross plan of Michelangelo's basilica was not really suitable for the carrying out of these solemnities; a nave was needed as well. Part of the old Constantinian nave was still standing, but on September 26, 1605, Paul V Borghese (1605–1621) ordered that the remaining portions be demolished. The reasons given were technical: "According to the opinion of the most expert architects,

The dome of Saint Peter's, begun by Michelangelo and completed by Giacomo Della Porta and Domenico Fontana in 1590.

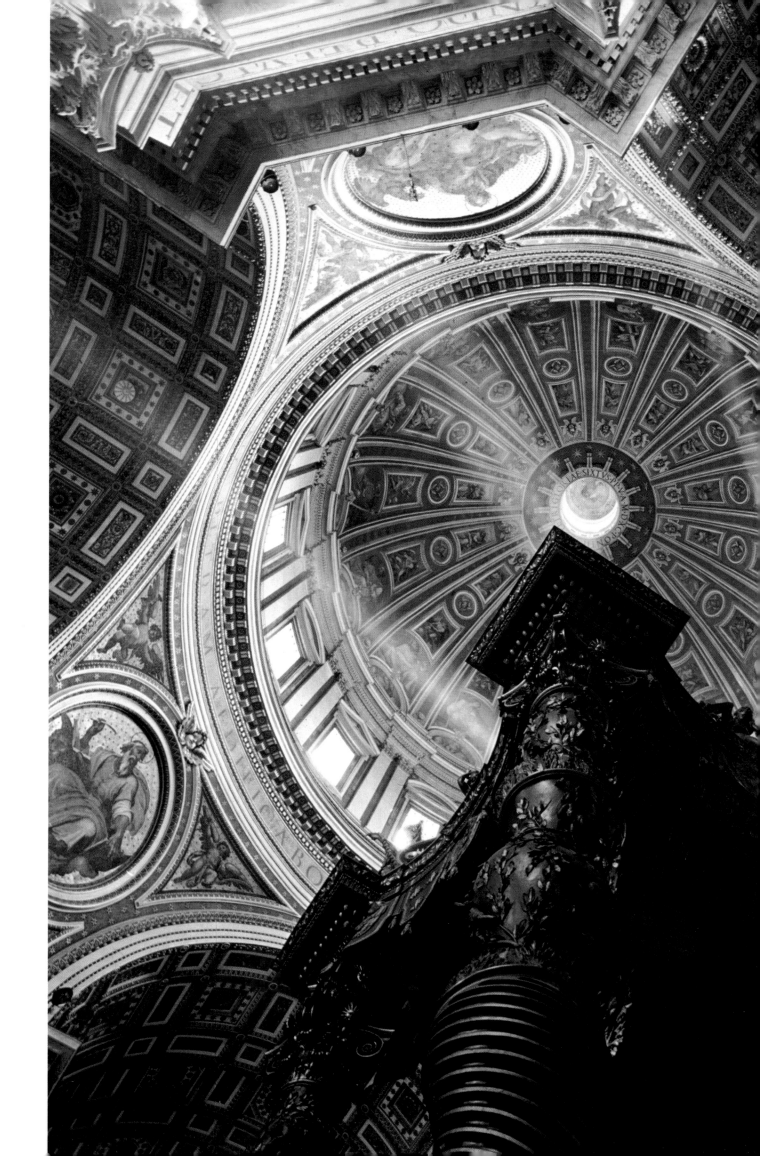

the walls of the central nave incline by five *palmi* [just over a meter] from top to bottom, and are full of cracks; the beams and the roof, rotten with age, are about to collapse."

Despite the resentment of the Romans, demolition was begun at the end of 1605 and completed by the end of 1608. Not only the old nave was pulled down, but also a number of the churches, oratories, and houses that surrounded it. Giacomo Grimaldi, the archivist of Saint Peter's, reports that during the course of this operation two ancient ruins came to light; one of them was "a brick building with a pilastered portico and vaults decorated with flowers." These ruins were immediately covered up again; not until 1940 was the necropolis beneath the Constantinian floor level systematically excavated.

At the beginning of 1607 a project for a new nave, by Carlo Maderno, was selected from among those submitted by a number of architects, including Domenico Fontana, Flaminio Ponzio, Ludovico Cigoli, and Girolamo Rainaldi. The cornerstone was laid on May 7 of the same year. The much-maligned nave—poor Maderno was judged guilty of *lèse-architecture* by the eighteenth-century architectural historian Francesco Milizia—consists of three bays added to the east side of Michelangelo's centrally planned building. It is true that the addition altered Michelangelo's design irrevocably. It must be admitted, on the other hand, that Michelangelo had neglected to include in his plan certain indispensable features: a choir for the canons, a baptistry, a sacristy, and a benediction loggia.

Maderno kept his nave as short as possible and sought to harmonize his architecture with Michelangelo's. In May 1613 he wrote to the pope that he had prepared an engraving with Michelangelo's plan superimposed upon his own, "to satisfy those who wish to see the unity of the two plans." The unity is not absolute; Maderno's nave is slightly broader than the east arm of Michelangelo's crossing, which it prolongs; its vault is slightly higher; and it is more brightly illuminated, thanks to the six large lateral windows. But the piers, the entablatures, the archivolts, and even decorative details such as the coffers of the vault are carefully designed to foster a sense of continuity. Similarly, in the altar niches of the side aisles, Maderno repeats the motifs that Michelangelo had used in the crossing.

In August 1609 the Constantinian façade was razed and the construction of the new portico and façade was begun. Work continued until May 16, 1612, when the Latin inscription on the façade—ostensibly in honor of Saint Peter, but with the pope's name, PAVLVS V BVRGHESIVS ROMANVS, placed conspicuously over the

Interior of the dome and the upper part of the baldacchino in the crossing of Saint Peter's.

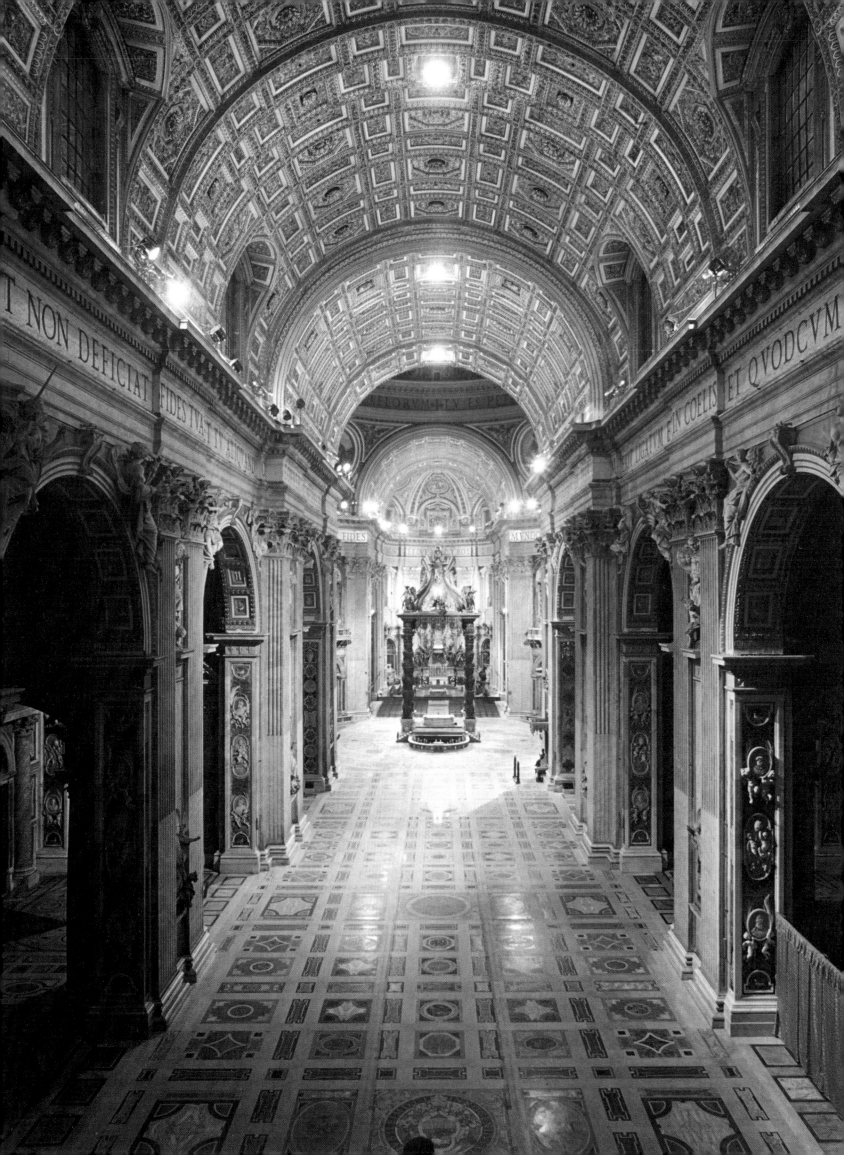

central portals—was unveiled, to the pealing of bells and the explosion of firecrackers.

Michelangelo, as we know from drawings, engravings, and medals executed soon after his death as well as from the fresco in the Vatican Library, had intended his basilica to be preceded by a freestanding portico, resembling the portico of the Pantheon, in the form of a classical temple front with six columns and a triangular pediment. Maderno's portico is an enclosed, vaulted space behind the façade, which is conceived as a continuous wall masking the entire width of the basilica and consisting of two stories and an attic, with a giant order of Corinthian pilasters and engaged columns framing the entrance portals and the windows. Maderno incorporated Michelangelo's temple front into his façade; in the center of it, at the second-story level, is the Benediction Loggia, from which the pope imparts his blessing to the crowds assembled in Saint Peter's Square. The portico is 71 meters long, 13.5 meters in depth, and 20 meters high. Its vault is richly decorated with stucco reliefs illustrating the Acts of the Apostles, executed by Giovanni Battista Ricca (1537–1627) from designs by Martino Ferabosco (active 1615–23). Five doors lead into the basilica. The last one to the right, known as the Porta Santa, is only opened during the Holy Year.

In 1612–13, the façade was extended at both ends; the added bays were to serve as foundations for bell towers. But attempts to construct the towers ended in disaster; the foundations were not strong enough to bear their weight. As a result, the façade is monotonously horizontal; it is also unrelated to the actual form of the basilica. An even more unfortunate defect is that the dome, which Bramante and Michelangelo had intended to dominate the entire basilica, is only visible from a distance; this is the inevitable consequence of Paul V's decision to add a nave to the centrally planned building.

Gianlorenzo Bernini

The portico and the façade were the last essential structural components of New Saint Peter's to be completed. But the basilica was yet to undergo an enormous transformation, from a Renaissance building into a Baroque one. This transformation was very largely the work of the great sculptural and architectural genius of seventeenth-century Rome, Gianlorenzo Bernini (1598–1680).

The high altar, which had been consecrated by Clement VIII in 1594, stood in the crossing, directly over the tomb of Saint Peter and directly under Michelangelo's dome. In order to provide it with a suitably monumental setting, Urban VIII (1623–44) commissioned from Bernini the great bronze baldacchino that now constitutes the visual focus of the entire

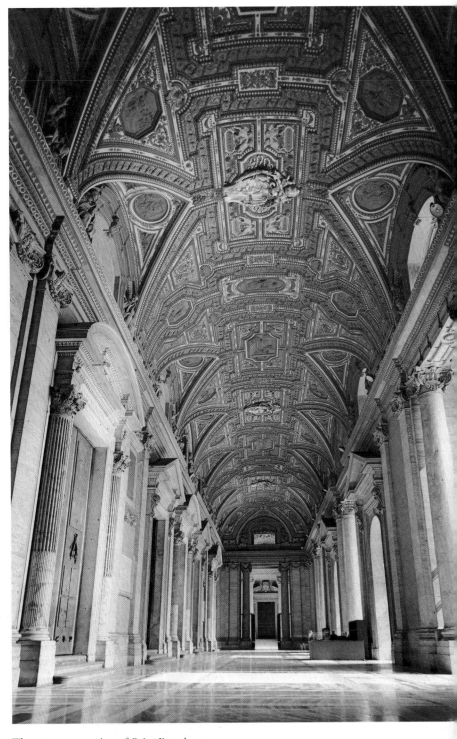

The entrance portico of Saint Peter's, constructed by Carlo Maderno.

The nave of Saint Peter's.

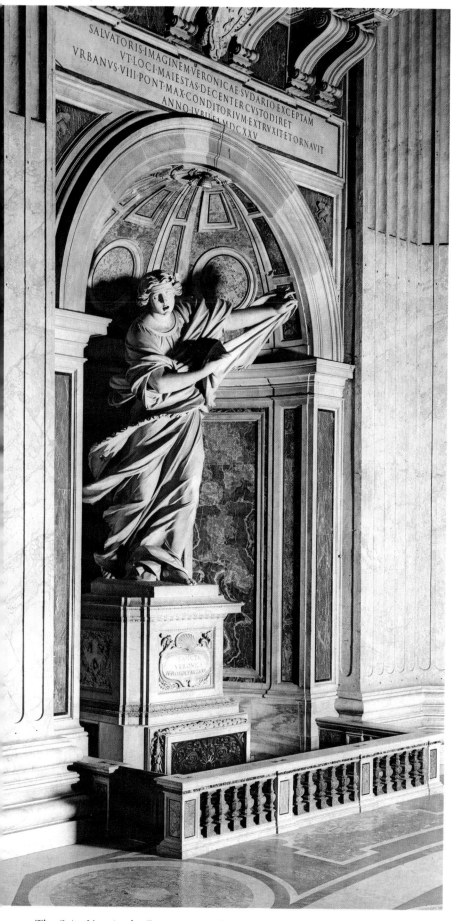

The *Saint Veronica*, by Francesco Mochi, is one of four large Baroque statues in the niches of the piers that support the dome.

basilica. Bernini began to work in 1624, and the baldacchino was inaugurated in 1633. The bronze was obtained, in part, by melting down some ancient girders in the portico of the Pantheon. This gave rise to the famous epigram about Urban VIII and his family: *Quod non fecerunt barbari fecerunt Barberini*—"What the barbarians didn't do, the Barberini did." The towering twisted columns repeat the form of the much smaller columns of the baldacchino of Old Saint Peter's, which, according to legend, had originally stood in the temple of Solomon in Jerusalem. Above, four huge volutes form a crown surmounted (like the basilica itself) by the orb and cross. Angels and putti bear the regalia of the papacy; the laurel leaves that spread over the columns, and the suns and bees in the upper zone, are heraldic emblems of the Barberini family.

In 1629 Maderno died and Bernini was appointed architect of Saint Peter's. He was still supervising the erection of the baldacchino, but Urban immediately gave him a new assignment: the conversion of the four great crossing piers into reliquary shrines. Saint Peter's had long possessed three important relics: the lance with which Longinus, the centurion, had pierced the side of Christ; Veronica's veil, with the imprint of Christ's face; and the head of Saint Andrew. In 1629, Urban transferred to Saint Peter's two fragments of the True Cross that previously had been kept in the Roman churches of Santa Croce and Sant'Anastasia. The crossing piers each had two large superimposed niches, facing the high altar. Bernini made the upper niches into elaborate tabérnacles for the relics, using eight of the twisted columns from Old Saint Peter's; in the lower niches he placed monumental statues of the saints associated with the relics. He carved the *Saint Longinus* himself, and it is one of his greatest masterpieces; the excessively agitated *Saint Veronica* is by Francesco Mochi (1580–1654), the *Saint Andrew* by François Duquesnoy (1594–1643), and the *Saint Helena*—the mother of Constantine was the discoverer of the True Cross—by Andrea Bolgi (1605–1656).

Alexander VII (1655–67) was a no less enthusiastic patron than Urban VIII had been. According to Filippo Baldinucci, who published a biography of the artist in 1682, Alexander sent for Bernini on the very day of his election to the papacy, to discuss the "great things" to be done for the embellishment of Saint Peter's.

In July 1656 the pope commissioned Bernini to design a new, monumental piazza in front of the basilica. There had been a large open space on this site since the early Middle Ages, but it was irregular and surrounded by rather nondescript buildings. In the fifteenth century, Nicholas V and Alberti planned to regularize this piazza and to connect it to the center of Rome by broad, porticoed streets, but the project came

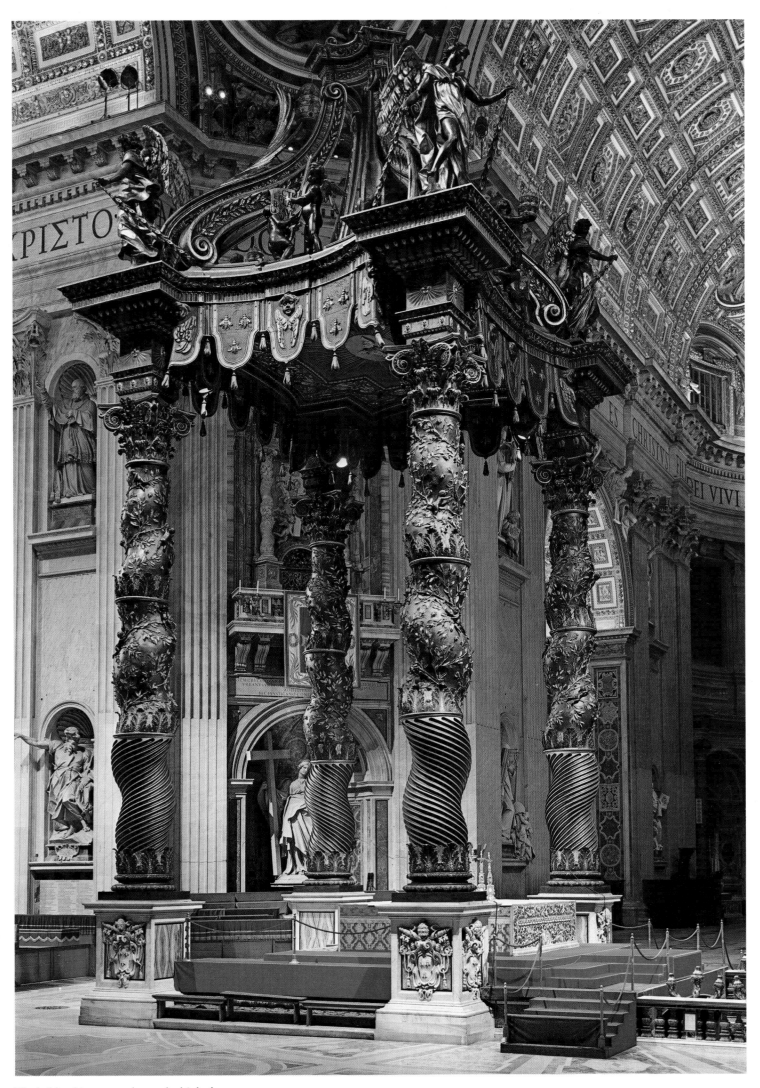

The baldacchino erected over the high altar
by Gianlorenzo Bernini between 1624 and 1633.

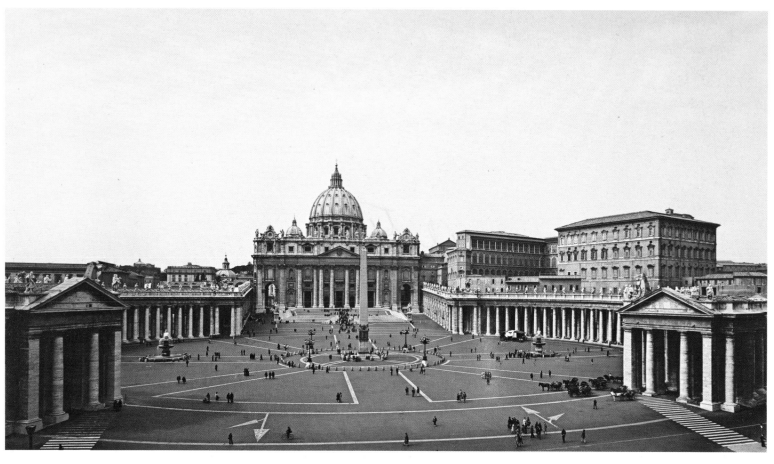

Saint Peter's Square, with Bernini's colonnades.

A medal of Alexander VII shows Bernini's design for the colonnades, including the third part, which was never built.

to nothing. Sixtus V had caused the Vatican obelisk to be transported, amid much fanfare, from its original site south of the nave to a point in front of the basilica and on its central axis. But Saint Peter's Square itself remained unworthy of the majestic basilica to which it gave access.

In accepting the commission, Bernini was faced with a number of problems. The piazza had to accommodate vast numbers of pilgrims and provide them with shelter from the sun and rain. Two places had to be visible from every part of it: the Benediction Loggia in the façade of Saint Peter's, which was used on solemn occasions, and the window in the Vatican Palace where the pope made more ordinary appearances. The terrain was irregular, moreover; it rose sharply between the obelisk and the façade. Directly in front of the basilica, Bernini laid out a trapezoidal area flanked by two low corridors that partly compensate for the excessive horizontality of Maderno's façade by making it look taller. A broad flight of steps connects the entrance portals with the lower level of the piazza, where a vast ellipse, with the obelisk at its center, is enclosed by two semicircular colonnades. There are 284 Doric columns, arranged in four rows; above, 96 travertine statues of saints look down upon the piazza. The two colonnades have a specific symbolic purpose; Bernini

Saint Ambrose: Detail of the Cathedra Petri (overleaf).

himself wrote that they represent the arms of the church, "which embrace Catholics to reinforce their belief, heretics to reunite them with the church, and infidels to enlighten them with the true faith." Bernini also intended to close the east side of the piazza with a third, shorter colonnade. It appears in a number of engravings and on a medal issued by Alexander VII, but this part of the project was never realized.

A magnificently decorated wooden throne, which had been housed in Saint Peter's for many centuries, and which is described in a separate section at the end of this chapter, was believed to be the very throne from which Saint Peter had exercised his authority as Rome's first bishop. In 1656, Alexander VII decided to move it from the baptistry to the choir, and in the following year he commissioned Bernini to provide it with an appropriate setting. Bernini's monumental Cathedra Petri, or Throne of Peter, is in fact a reliquary: the wooden throne is encased within a gigantic gilded bronze throne that appears to be suspended miraculously in the air, surrounded by angels and by the statues of two Latin and two Greek church fathers, Saints Ambrose, Augustine, Athanasius, and John Chrysostom. Above, the dove of the Holy Spirit is represented on a window of Bohemian glass, in the center of a glory of gilded angels, clouds, and rays.

As early as 1629, Urban VIII had planned the decoration of the chapel of the Blessed Sacrament off the right aisle of Maderno's nave. The altarpiece and the mosaics were assigned to the great Baroque painter

Pietro da Cortona (1596–1669), and Bernini was asked to design a monumental tabernacle. The altarpiece, representing the Trinity, was completed in 1631, and the mosaics in 1668; Bernini produced sketches and models for the tabernacle under Urban and under Alexander VII, but only in his old age, under Clement X (1670–76), did he execute the project. Work in the chapel was completed in 1674. The tabernacle, made of gilded bronze and lapis lazuli, is circular, surrounded by a colonnade and surmounted by a cupola; its form is derived from Bramante's famous Tempietto in the courtyard of the church of San Pietro in Montorio. It is flanked by two over-life-sized figures of angels kneeling in adoration.

The Cathedra Petri, designed by Bernini to encase the wooden throne believed to have been used by Saint Peter, is surrounded by statues of four great doctors of the Latin and Greek churches: Saints Augustine, Ambrose, Athanasius, and John Chrysostom.

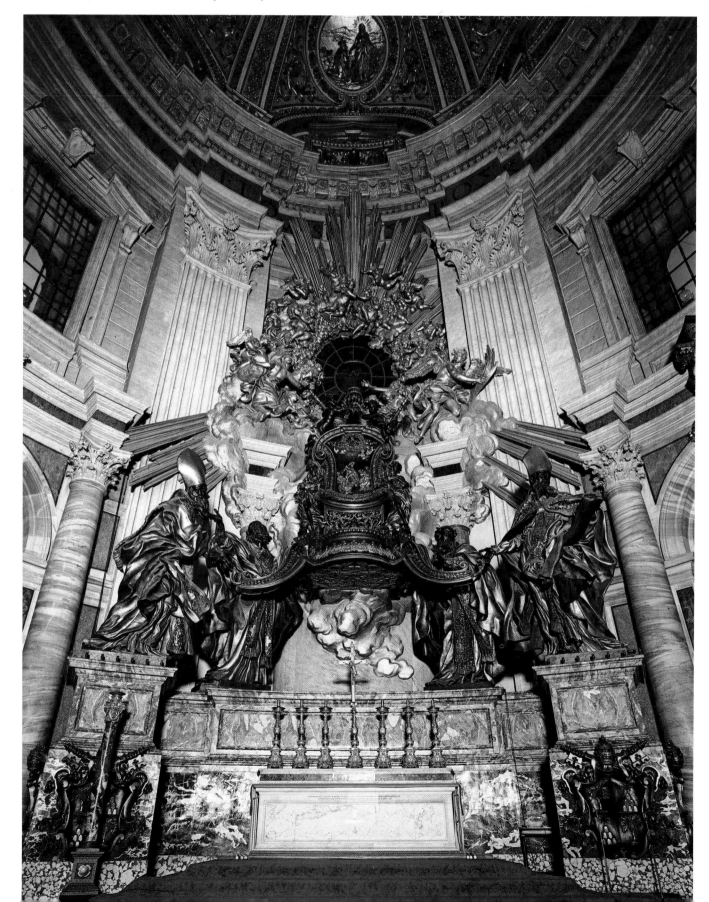

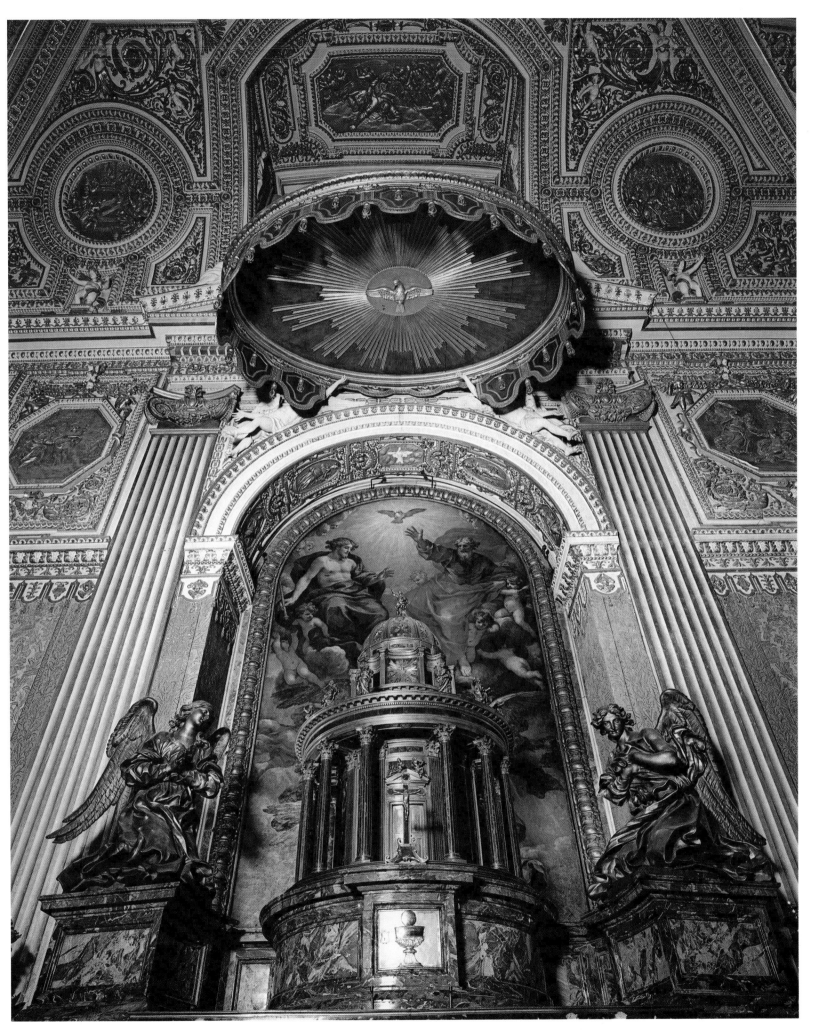

The tabernacle designed by Bernini for the altar of
the chapel of the Blessed Sacrament. The altarpiece,
representing the Trinity, is by Pietro da Cortona.

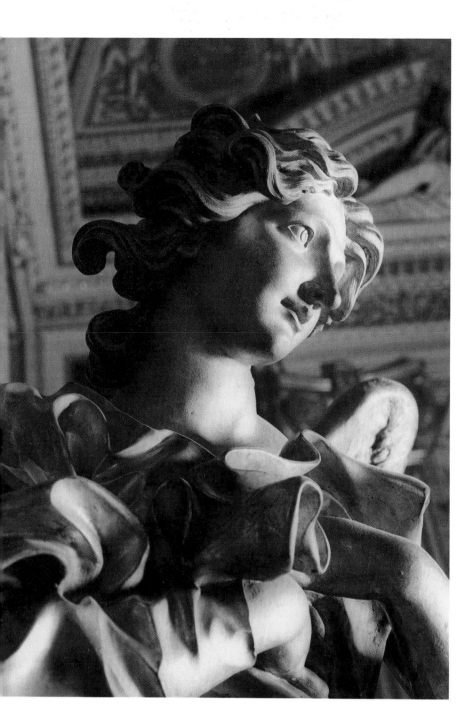

Detail of Bernini's tabernacle in the chapel of the Blessed Sacrament.

When Old Saint Peter's was demolished, most of its paintings, sculptures, and funerary monuments were destroyed as well. A few, however, survived. The bronze statue of Saint Peter that stands in the crossing, near the high altar, is usually attributed today to the Tuscan sculptor Arnolfo di Cambio (before 1245–ca. 1302). It was formerly believed, however, to be a work of the fourth or the fifth century. The statue has remained an object of popular veneration; its right foot has been worn smooth by the kisses of the faithful. On June 29, the feast of Saints Peter and Paul, it is solemnly vested with the papal robes and tiara. Another medieval work of art, a wooden crucifix attributed to Pietro Cavallini (active 1291–d. ca. 1321), is kept in a small chapel in the right aisle. A famous mosaic known as the *Navicella*, representing Christ saving the apostles from the storm, was originally made by Giotto (1267–1337) for the forecourt of the old basilica; in its present state it is almost entirely the product of later restorations. In 1674, Bernini had it installed in Maderno's portico, in the lunette over the central portal. The bronze central door to the basilica is also a relic of Old Saint Peter's; it was made by Antonio Filarete (ca. 1400–after 1469) for Eugenius IV (1431–47). Its reliefs represent Christ and the Virgin enthroned; Saint Peter (shown handing over the keys to Eugenius) and Saint Paul; the martyrdoms of the two apostles; events of the reign of Eugenius, including the Council of Florence of 1438, which had attempted to unify the Orthodox and Roman churches; and scenes from ancient mythology and history.

The oldest funerary monument in the basilica is the gilded bronze tomb of Innocent VIII (1484–92), executed in 1498 by Antonio Pollaiuolo (1431–98). Innocent is represented enthroned, raising one hand in benediction and holding in the other the point of Saint Longinus's lance—this relic had been sent to him as a gift by the sultan Bajazet II in 1492. Flanking the statue are reliefs of the four cardinal virtues, and the three theological virtues appear in the lunette. The pope is portrayed a second time, in death, on the lid of the sarcophagus.

Michelangelo's *Pietà* was commissioned in 1497 by Cardinal Jean Bilhères de Lagraulas for his tomb in the Chapel of the Kings of France in Old Saint Peter's. It is the only signed work of art by Michelangelo, who was twenty-five years old when he carved it; with this group, he ended his Florentine apprenticeship and began a new era in sculptural expression. The pure and sorrowful features of the Virgin and the peaceful face of the dead Christ mark a high point in the history of the interpretation of human emotions. The *Pietà* was installed in the first chapel of Maderno's right

aisle in 1749. In May 1972 it was damaged with a hammer by a deranged person; before the end of the year it was restored to its original perfection by the conservators of the Vatican Museums.

The first papal tomb to be set up in New Saint Peter's was that of Paul III, executed between 1551 and 1575 by Guglielmo Della Porta (ca. 1500–1577). It stands in the left-hand niche of the choir. Della Porta abandoned the traditional model for a papal tomb, and turned for inspiration to Michelangelo's tombs of the Medici dukes in San Lorenzo in Florence. The powerful figure of the pope is enthroned upon a high pedestal, stretching forth his hand in a gesture of protection. Below, reclining upon bases of African marble, are personifications of Justice and Prudence. According to an old legend, Justice has the features of the pope's sister, Giulia Farnese, who was famous for her beauty; the figure was originally nude, but in 1595

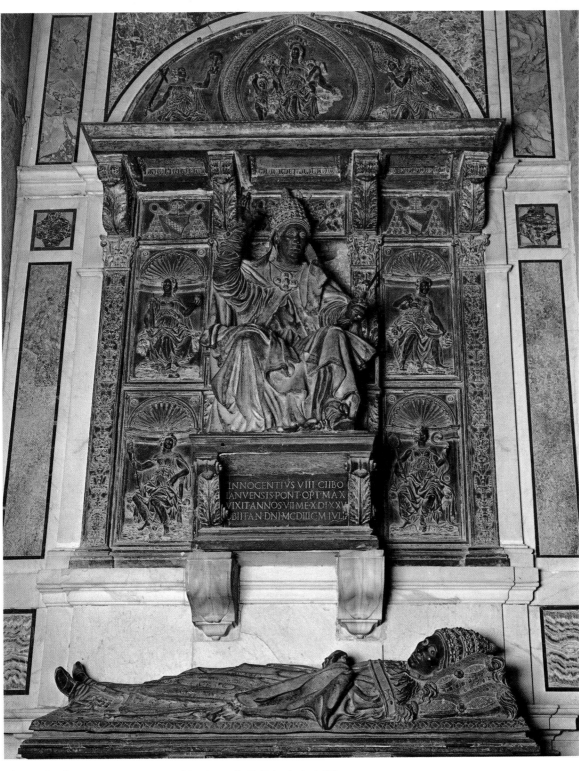

The tomb of Innocent VIII, executed by Antonio Pollaiuolo in 1498, was originally in the nave of the old basilica. Its composition was slightly altered when it was set up in the south aisle of New Saint Peter's in 1621.

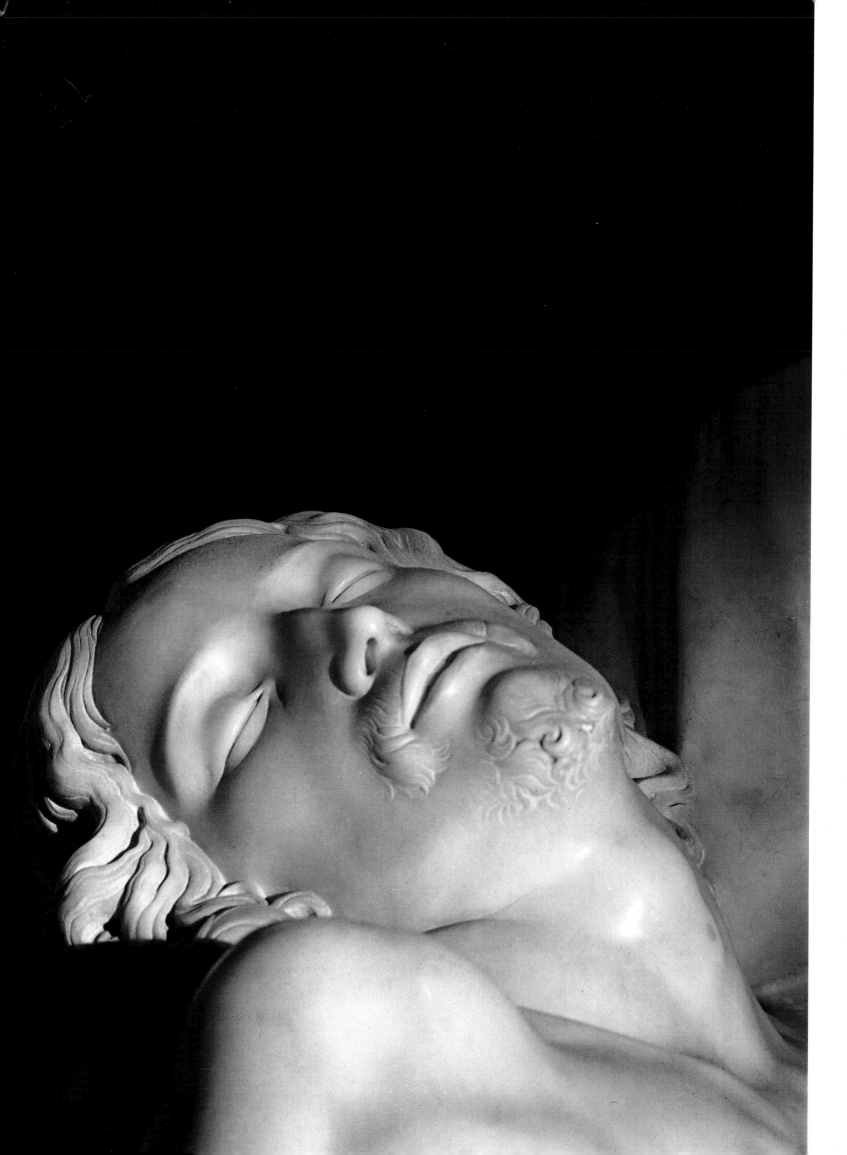

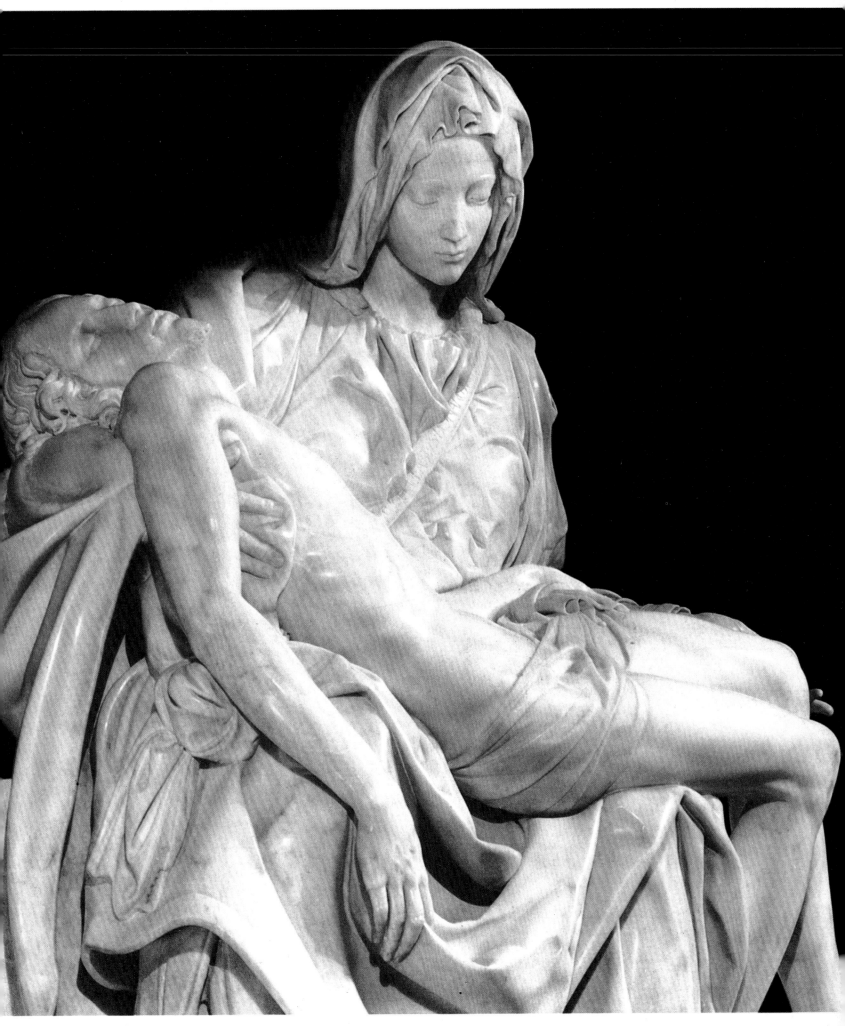

Michelangelo's *Pietà*.
Detail: Head of Christ.

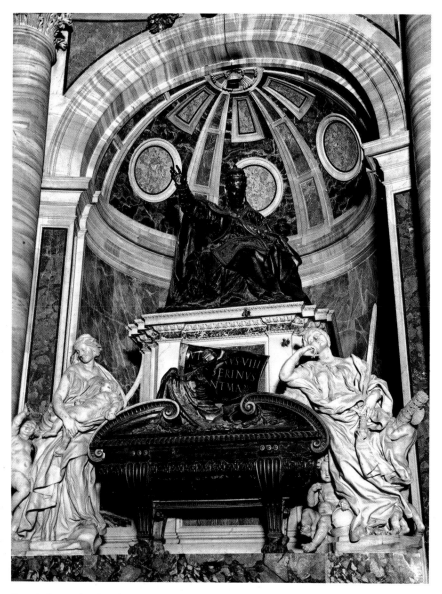

Bernini's tomb of Urban VIII,
completed in 1647.

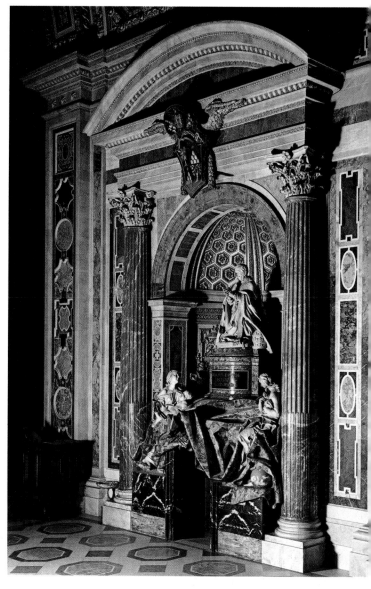

Bernini's tomb of Alexander VII,
completed in 1678.

another member of the family, Cardinal Odoardo Farnese, had it covered with a metal garment—even though he admitted that Justice should keep nothing hidden. Prudence, on the other hand, an aged, serene, and dignified figure, continues to exhibit her melancholy nudity.

Urban VIII commissioned his own tomb from Bernini in 1627; it was finished in 1647, three years after the pope's death. Urban's tomb stands in the right-hand niche of the choir, and Bernini planned it as a pendant to the tomb of Paul III. The pope's figure is wrapped in a sumptuous cope; his hand is raised in benediction. Charity and Justice are represented below, in white marble; they have the appearance less of allegorical figures than of real women, leaning with languid grace upon the black marble sarcophagus. Death, personified by a winged skeleton, also leans on the sarcophagus and writes Urban's name in a book; the

left-hand leaf curls up slightly, to reveal the name of Urban's predecessor, Gregory XV (1621–23), on the page before.

The monument to the countess Matilda (1046–1115), whose remains were brought to Saint Peter's by Urban VIII from a monastery near Mantua, was designed by Bernini, but its execution was left largely to assistants; it is hardly comparable in quality to Bernini's other work in Saint Peter's. The relief on the base, by Stefano Speranza (active ca. 1635–77), represents a triumph of the medieval papacy: the humiliating submission of the German king and future emperor Henry IV to Pope Gregory VII in 1077, in Matilda's castle at Canossa. The monument was commissioned in 1633 and unveiled in 1637.

Bernini began an equestrian monument to Constantine, the founder of Saint Peter's, for Innocent X (1644–55), and worked on it again under Alexander

The monument to Queen Christina of Sweden.
The work of Carlo Fontana and Lorenzo Ottoni, 1702.

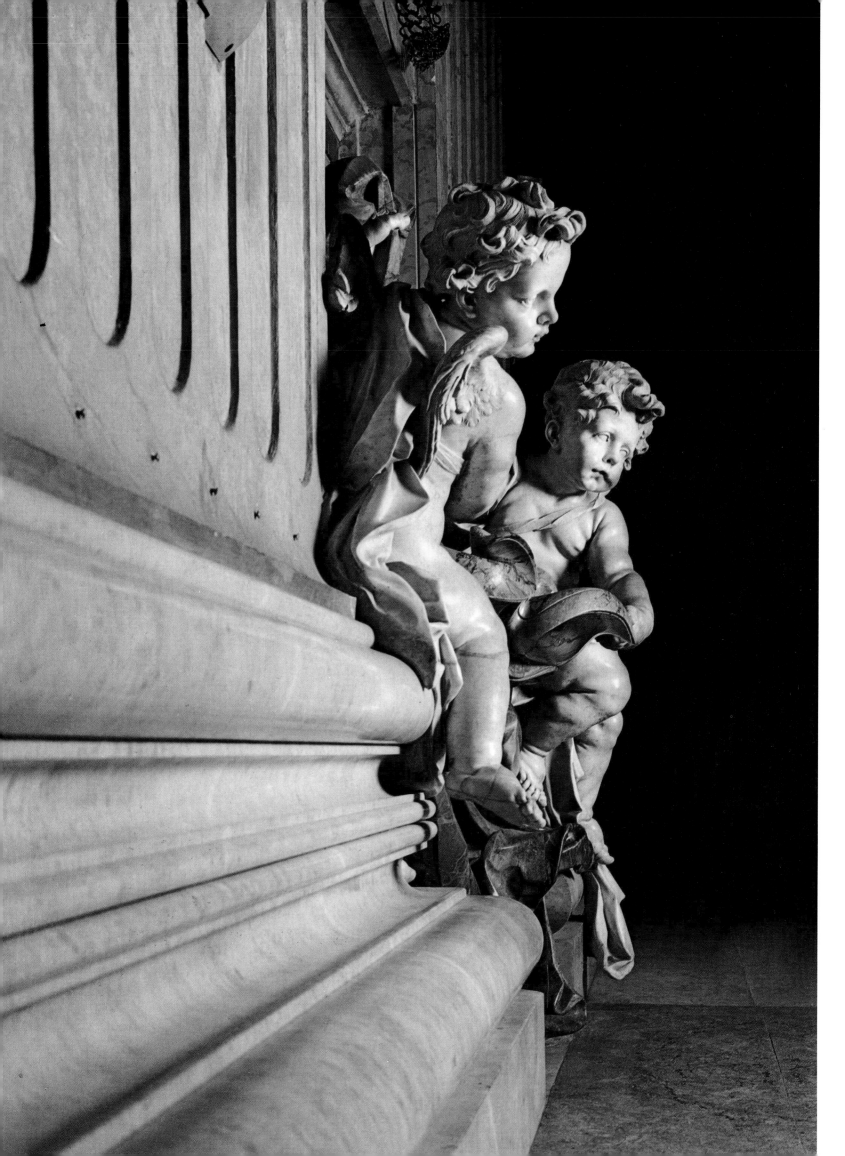

VII; it was not unveiled until 1670. The statue stands in the north end of Maderno's portico, at the entrance to the Scala Regia of the Vatican Palace. The emperor is represented at the moment of his conversion, gazing at the sign of Christ that has appeared to him in the sky. Full of drama and movement, the monument is one of Bernini's masterpieces.

The tomb of Alexander VII in the left transept was erected between 1671 and 1678, when Bernini was nearly eighty; the design is his, though assistants were largely responsible for the execution of the figures. The pope is shown kneeling in prayer on a high pedestal, which is surrounded by the figures of Justice, Prudence, Charity, and Truth. Truth was originally nude; she was covered with metallic drapery by Bernini himself, at the command of Innocent XI (1676–89). As on the tomb of Urban VIII, Death is personified by a skeleton. But the device is used even more dramatically here: the tomb is built over a real door, one of the secondary entrances of the basilica, and Bernini exploits it symbolically as the door of death; the black marble base and the upper part of the door are covered by a heavy curtain of reddish jasper, and the skeleton emerges from beneath the curtain, beckoning to Alexander with an hourglass.

The Lombard architect Carlo Fontana (ca. 1638–1714) designed the monument to Queen Christina of Sweden, who renounced her throne in order to convert to Roman Catholicism. She died in Rome in 1689, and is buried in the Grotte beneath the basilica. Christina is portrayed in a large bronze medallion; a relief by Jean-Baptiste Théodon commemorates her formal abjuration of the Protestant faith at Innsbruck in 1655.

The embellishment of Saint Peter's with tombs and other monuments continued throughout the eighteenth century. The holy-water fonts at the east end of the nave were designed by Agostino Cornacchini (1685–ca. 1740) and executed between 1722 and 1725; in keeping with the scale of the basilica, the winged putti that support the basins for the water are more than two meters high. The tomb of Innocent XII (1691–1700) was designed by Ferdinando Fuga (1699–1781); the statues of the pope and of Charity and Justice were executed by Filippo Valle (1697–1768) in 1746. The tomb is a fine work in the late Baroque style; its essential features are derived from the tombs of Bernini. Somewhat livelier in conception is the tomb of Maria Clementina Sobieska, granddaughter of the Polish king Jan Sobieski and wife of the Stuart pretender to the English throne, the self-styled James III. A statue of Charity by Pietro Bracci (1700–1773) holds in one hand a mosaic portrait of Maria Clementina and in the other a flaming heart, symbol of her devotion.

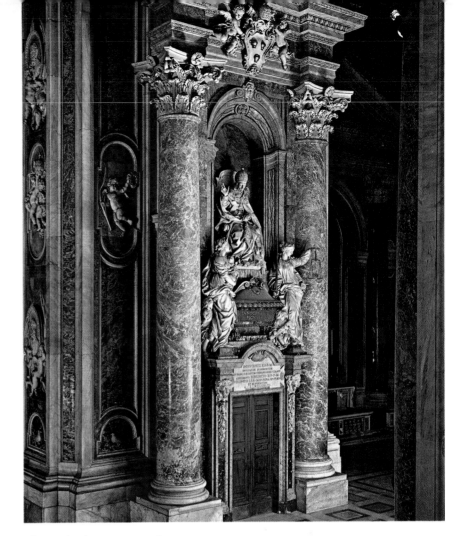

The tomb of Innocent XII, by Ferdinando Fuga and Filippo Valle.

The tomb of Maria Clementina Sobieska, by Pietro Bracci.

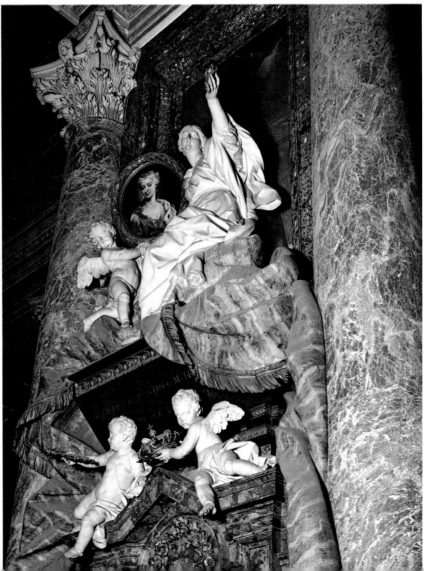

One of the holy-water fonts at the east end of the nave.

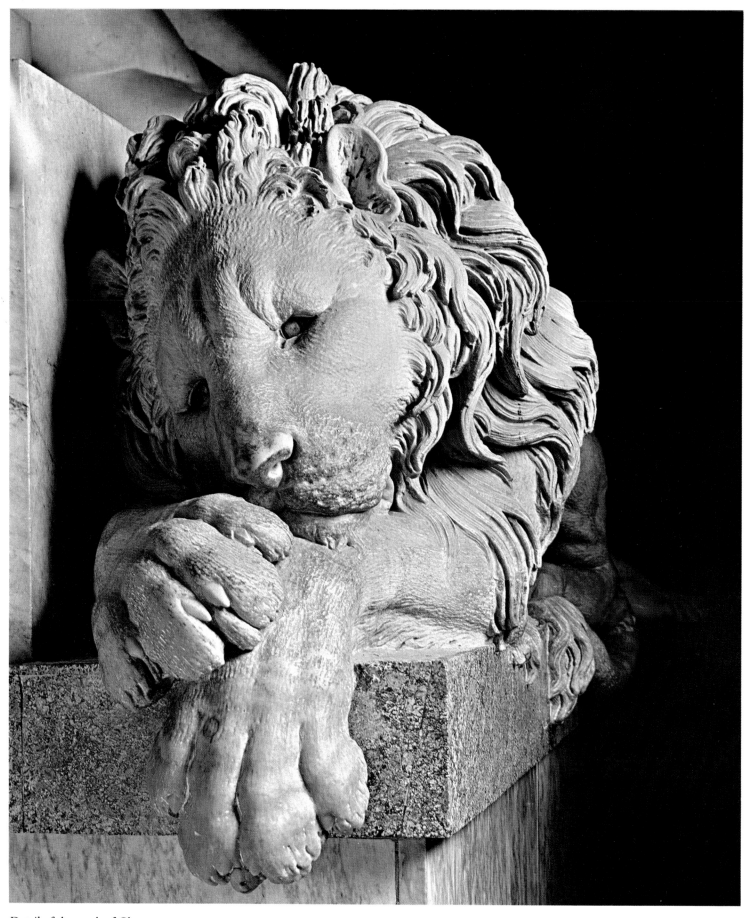

Detail of the tomb of Clement
XIII, by Antonio Canova.

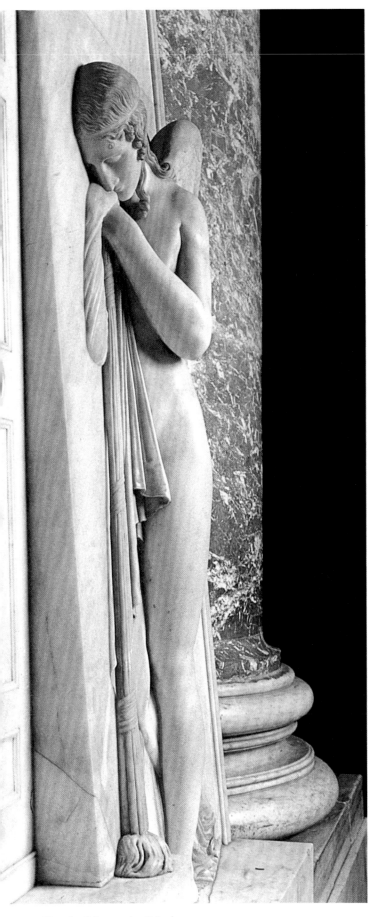

Detail of the tomb of the last
Stuarts, by Antonio Canova.

The Neoclassical style is represented in Saint Peter's by two works of Antonio Canova (1757–1822). The tomb of Clement XIII (1758–69), executed between 1788 and 1792, is one of Canova's most famous works. Two couchant lions—one sleeping, the other awake—guard the door (which, like the door in Bernini's tomb of Alexander VII, is actually one of the basilica's secondary entrances); above, Religion and the Genius of Death flank the sarcophagus; at the top of the pyramidal composition, the pope kneels in prayer, his tiara on the ground before him. Between 1817 and 1819, Canova carved the monument to the last of the Stuarts, one of whom, Henry, was a cardinal, bishop of Frascati, and archpriest of Saint Peter's. The monument has the form of a door flanked by two winged genii, their torches turned downward as a sign of mourning.

Among the few modern works in Saint Peter's is the door—the first to the left—with bronze panels by Giacomo Manzù; executed in 1963, it commemorates the convocation of the Second Vatican Council by John XXIII (1958–63). A bronze statue of Pius XII (1939–58) was cast by Francesco Messina in 1964.

ENNIO FRANCIA

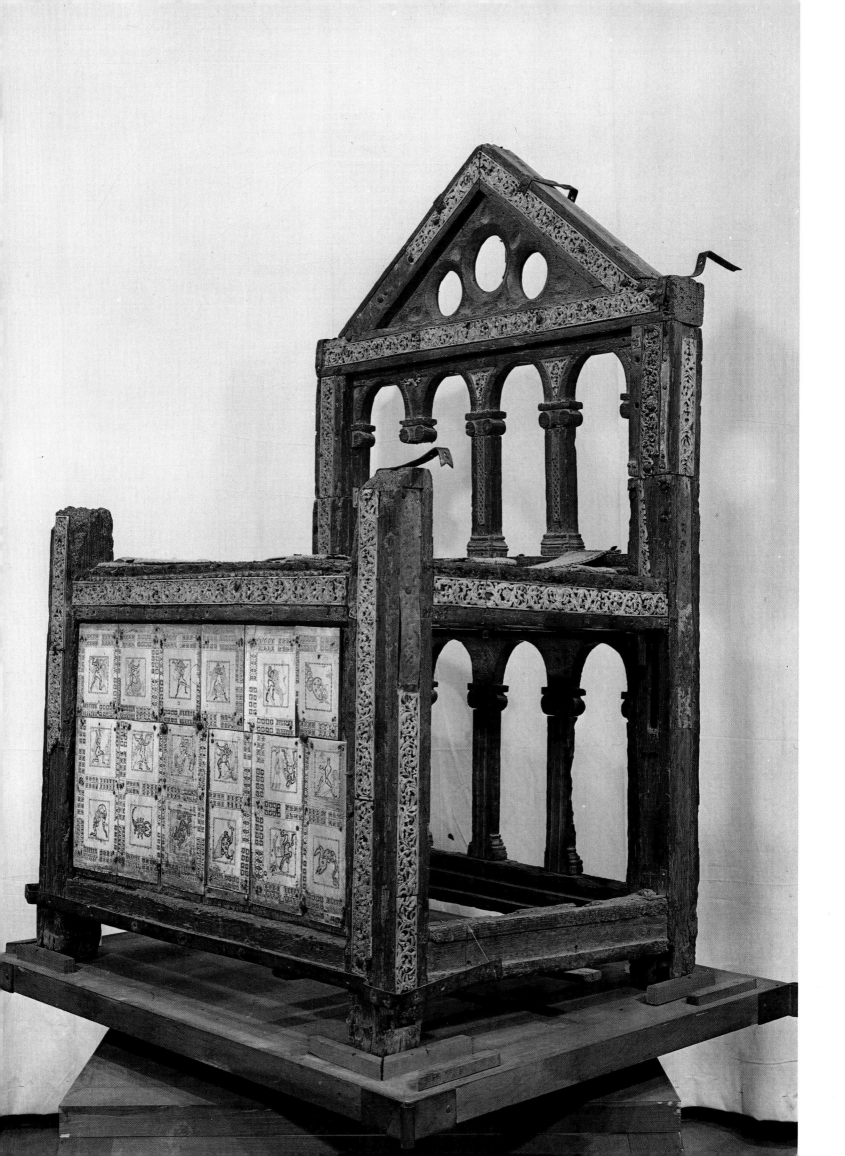

The Wooden Cathedra

Bernini's wonderful monument in the choir of the basilica is a symbolic representation of the *cathedra Petri*, or chair of Peter. This expression, as it has been used in the church since the third century, does not refer to a physical object; it signifies, rather, the authority and teaching power given by Christ to the apostle Peter and transmitted to Peter's successors, the bishops of Rome. Nevertheless, Bernini's Cathedra Petri was made to encase a wooden chair, a venerated relic which had been preserved for centuries in the basilica and which was thought to be the very chair that Peter had used. Recent studies have demonstrated that it was originally a royal throne, made for the Carolingian monarch Charles the Bald, who probably donated it to the pope on the occasion of his coronation as emperor in Saint Peter's on December 25, 875.

The chair is a product of the Court School of Carolingian art. It has a base consisting of four stout vertical supports, of equal height, joined together by eight horizontal members. The rear supports are extended at the top; laboratory tests have shown that the wood of the extensions is from the same tree as that of the base, or at least from a tree of the same date. The rectangular spaces contain colonnettes with arches; the triangular gable has three circular openings and fifteen cavities, on the front and back, which must originally have held enamels or precious stones.

This light, well proportioned wooden construction is primarily a vehicle for the ivory decoration, which was from the beginning an integral part of the throne. Narrow strips of carved ivory adorn the front, sides, and back. Stylistic differences show that they are not all by the same hand, but they were all produced in the workshop that flourished at the court of Charles the Bald. The simplest decorations, including a series of elegant openwork rhomboids on the back, are geometrical. The vegetation that covers most of the strips is inspired by the classical acanthus-scroll motif; within the spirals are tiny human figures, animals, and hybrid monsters. From an artistic and historical point of view, the most interesting strips are those of the gable. In the center of the horizontal strip is a bust of Charles the Bald with orb and scepter, flanked by two angels who offer crowns. Beyond the angels, to either side, are groups of fighting men. The composition as a whole symbolizes the beneficial power of the sovereign over the forces of evil. This symbolism is further developed on the oblique strips (only one of which is intact), where images of the sun, the moon, the earth, and the constellations signify that the king is lord of the universe.

The magnificence of the decoration corresponds to the loftiness of the iconographical theme. The human figures and the plant motifs are carved with great delicacy and precision, and the wood surrounding the ivory strips was originally sheathed in gilded or silvered metal, of which a few traces remain. The total effect was one of extreme richness and splendor.

A second and quite different group of decorations enhances the historical and artistic interest of the throne. The eighteen ivory panels arranged in three rows on the front of the seat were substituted, at an unknown date, for the original colonettes and arches. On them are represented the twelve labors of Hercules and six monsters, surrounded by decorative motifs. The figures and the ornament were incised and carved and then inlaid with gold and other precious materials. Hercules is always shown dramatically, in action; his adversaries, and the monsters in the bottom row, are represented with great stylistic refinement.

The origin and purpose of the eighteen panels have been the subject of much discussion. The throne was dismantled for study in 1968, at the instance of Paul VI, and a series of letters, which served to indicate how the parts were to be fitted together, was discovered on the wood and on the backs of the ivory panels. The style of the letters proves that the throne was assembled during the reign of Charles the Bald, probably between the years 860 and 866, somewhere in eastern France. According to one theory, the ivory panels had belonged to a throne of the time of Constantine, which had been donated to the popes and preserved in the Lateran. Other scholars believe that the panels are contemporary with the throne, or of an earlier date within the Carolingian period.

The throne given by Charles the Bald to Pope John VIII (872–82) remained in the Vatican basilica and was used as a papal throne during certain ceremonies, its use on the feast of Saint Peter's Chair is documented in the first half of the twelfth century. This liturgical custom apparently gave rise to the popular belief that the throne was in fact the chair of Peter. In the thirteenth century it was carried in processions on the feast of Saint Peter's Chair; probably at that time it was fitted with iron rings through which poles could be inserted when it was held aloft. Devotion to the supposed relic continued until the seventeenth century; by this time, however, doubts had begun to arise. Calvin questioned its authenticity, as did the Roman scholar Fioravante Martinelli, an official of the Vatican Library, who studied it at the time that Bernini's monument was constructed. The results of the recent scientific and art-historical studies have been published in a series of articles in volume 10 of the *Memorie* of the Pontificia Accademia Romana di Archeologia.

MICHELE MACCARRONE

The wooden throne preserved inside
Bernini's Cathedra Petri.

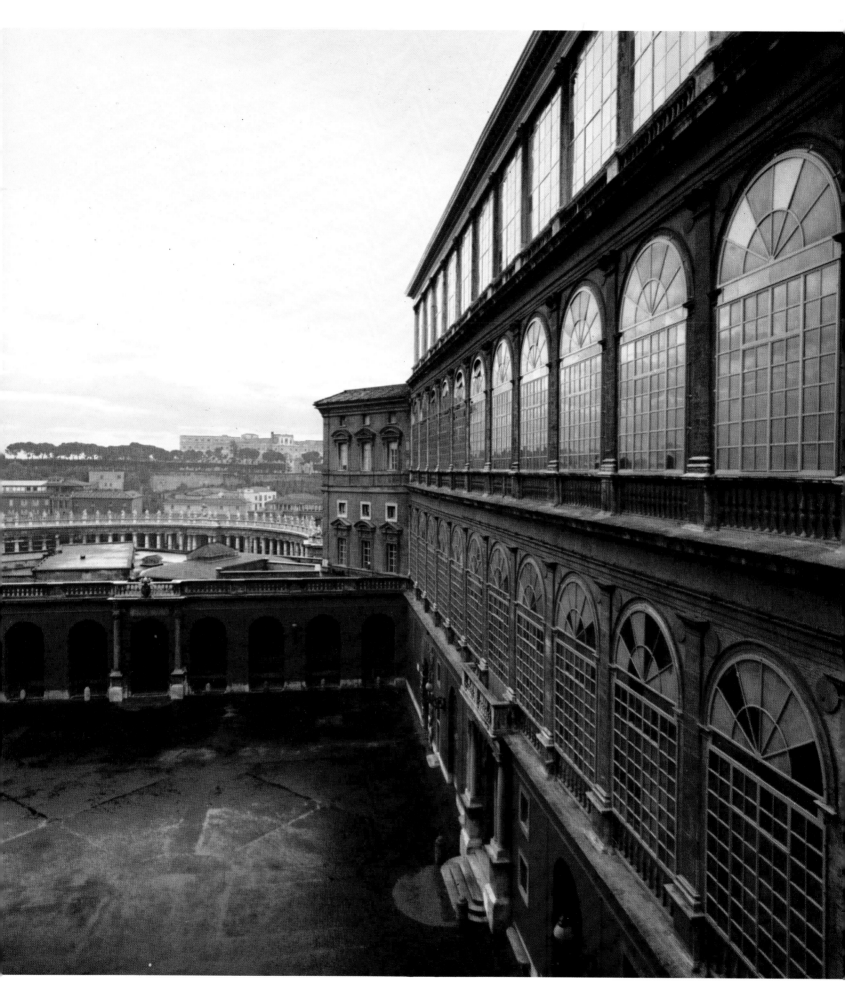

The Logge of Bramante and Raphael overlooking the Cortile di San Damaso. Bramante translated the open porticoes of the medieval palace façade into a High Renaissance structure, walling up the ground floor and building two spacious galleries. Raphael completed Bramante's façade by adding the uppermost gallery.

THE APOSTOLIC PALACE

The Medieval Vatican

The first official residence of the popes was not the Vatican but, from the fourth century on, the Lateran. For a long time the Constantinian basilica of Saint Peter remained a cemetery church in the open countryside, with only a few houses and a monastery around it to accommodate the custodians and the clergy in charge of the ceremonies at the shrine. Situated on the other side of the Tiber in what was thought to be an unhealthy district, the Vatican provided a relatively secure refuge for the popes during the frequent political disturbances of the Middle Ages. During the Laurentian schism Pope Symmachus took up residence there, from 501 to 506, and built two *episcopia* beside the basilica. In 781 Charlemagne added a residence, the Palatium Caruli, and other buildings were erected by Leo III and Gregory IV in the eighth and ninth centuries. However, it was only the turreted wall built by Leo IV (847–55) that allowed for future development, since it surrounded the whole Vatican area and made it into a secure and fortified suburb, the so-called Leonine City. Eugenius III built a new palace here between 1145 and 1153, perhaps by enlarging one of the *episcopia* of Pope Symmachus. All of these ancient buildings were demolished when the new basilica and the monumental piazza in front of it were constructed.

Innocent III (1198–1216), of the family of the counts of Segni, brought the political power of the papacy to its highest point. He ruled the Christian world of the time, but did not succeed in taming Rome, which was torn by factions and jealous of its liberties. Bloody civil strife often caused him to leave the Lateran for the more secure Leonine City. Here he enlarged the palace of Eugenius III, adding new structures to house the Curia and his retinue. Furthermore, emphasizing the Vatican's character as a place of emergency refuge, he surrounded it by a second turreted wall inside the one built by Leo IV. During restorations in the Chapel of Fra Angelico about twenty-five years ago,

part of these fortifications came to light. They were later incorporated into the palace built about 1278 by Nicholas III and almost completely preserved beneath later alterations. It is now evident that the famous chapel is situated in the space that was originally occupied by the fourth and fifth floors of a turret about twenty-seven meters high and attached to the northeast end of what is now the Sala Ducale. An examination of the tufa walls shows that both structures originally formed part of a single building of military character, perhaps a small fort. In the little room underneath the chapel, window openings were found with seats for the sentries and with arrow-slits and niches. These were decorated with frescoes when the tower was incorporated into the palace and lost its military function. This is the oldest of the buildings on the little hill to the north of Saint Peter's, then called the Mons Saccorum.

After eleven pontificates that left no physical traces in the Vatican, Nicholas III Orsini was elected in 1277. He appears to have taken up permanent residence in the Vatican, since none of the surviving documents of his pontificate were issued at the Lateran. In the three years of his brief reign he began constructing on the hill a residence that might well be called the citadel of the Leonine City. The plan was apparently for a square building with battlements and towers at the corners, surrounding the Cortile del Pappagallo, complete with water tanks and granaries, suitable for withstanding siege if the Leonine City were to be attacked. Nicholas III never saw his work completed, but he built a part of the east wing and the whole of the south wing, which connected the fortress of Innocent III and its tower with the old Palatine Chapel. This chapel, which is mentioned in a medieval inscription in the Capitoline Museum, was demolished in the fifteenth century to make way for the Sistine Chapel. The façade of the east wing overlooked a garden, called the Hortus Secretus, on the site of the present-day Cortile di San Damaso. It had two superimposed loggias, later replaced by the Logge of Bramante and Raphael. The palace of the Orsini pope

THE APOSTOLIC PALACE

Second Story

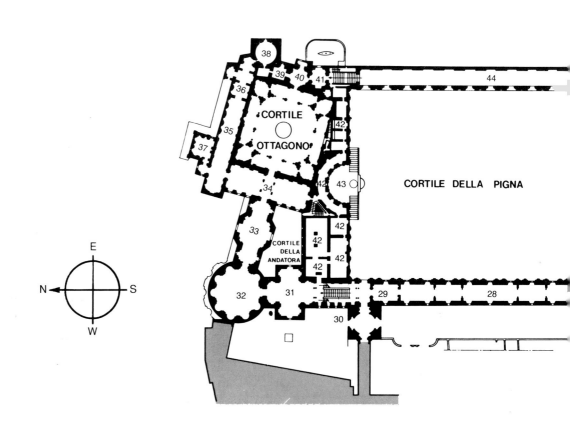

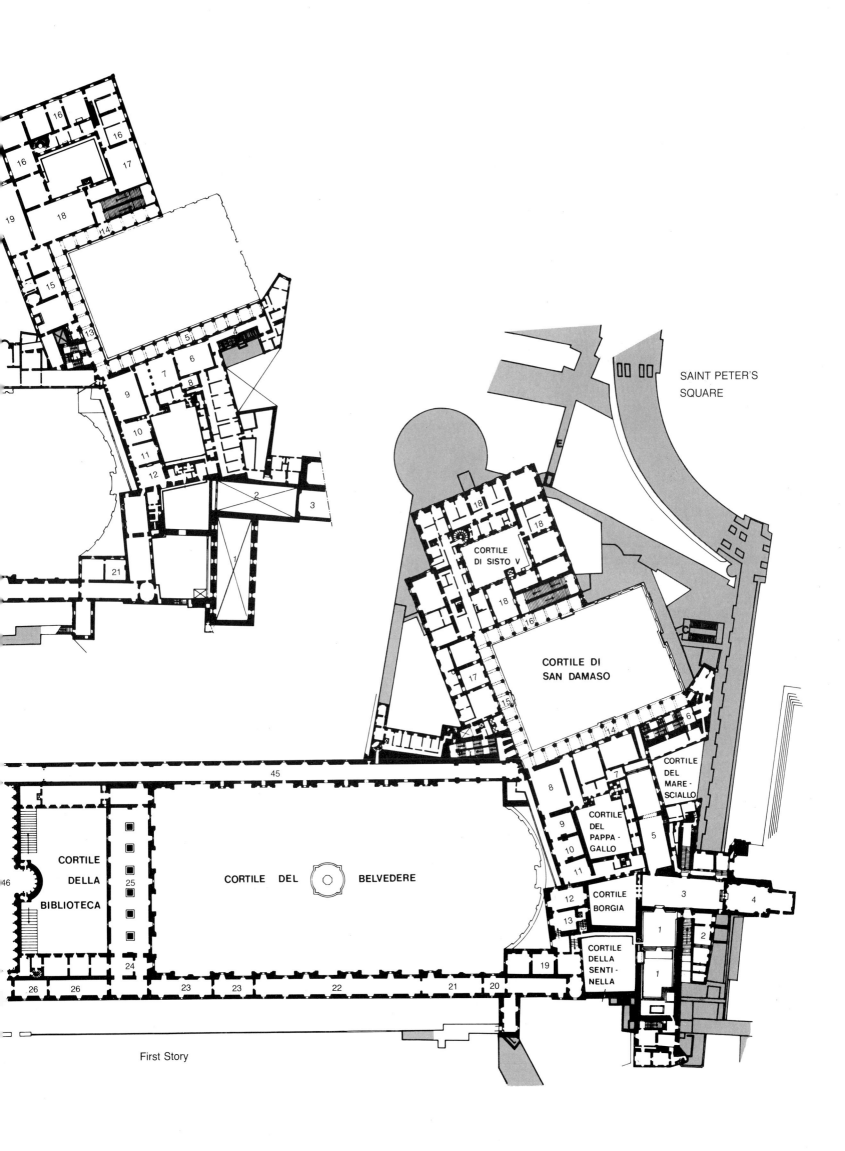

SAINT PETER'S
SQUARE

CORTILE
DI SISTO V

CORTILE DI
SAN DAMASO

CORTILE
DEL MARE-
SCIALLO

CORTILE
DEL
PAPPA-
GALLO

CORTILE
DELLA
BIBLIOTECA

CORTILE DEL ⊙ BELVEDERE

CORTILE
BORGIA

CORTILE
DELLA
SENTI-
NELLA

First Story

consisted of a ground floor and two upper stories; it reached the present level of Raphael's Logge. Almost all of the walls have been preserved beneath the sixteenth-century additions.

Investigations carried out when parts of the palace were being restored— under more or less ideal conditions for examining them—have yielded important information about their date. For instance, in most of the rooms of this part of the palace there have been discovered decorative frescoes definitely datable to the thirteenth century and very probably to the pontificate of Nicholas III. They are to be found, for example, in the Sala Vecchia degli Svizzeri, in the adjoining Sala dei Chiaroscuri, in the Chapel of Fra Angelico and the room beneath it, and on the ground floor of the Logge of the Cortile di San Damaso. At this last site some Romanesque capitals were found, which would indicate that Bramante did not destroy the medieval loggia system but used its ground floor as a foundation for his own.

Nicholas III also acquired the vineyards to the north of his palace, as far as the hill called the Mons Sancti Aegidii, where the Belvedere of Innocent VIII was later to be built. This land was transformed into a garden, or *pomerium*, and on the surrounding walls was placed the inscription, now in the Capitoline Museum, listing the works of this great papal builder. We do not know the architect, but we do know that a certain Fra Ristoro dei Campi and a lay brother, Fra Sisto, were working in the Vatican at that time; they were both Florentines who came to Rome in the last year of Nicholas's pontificate.

Three structures were built in the Vatican between 1280 and the accession of Nicholas V in 1447: a stair tower connecting the southwest corner of the Cortile del Maresciallo with the buildings at the foot of the hill; the *capella parva Sancti Nicolai*, or "little chapel of Saint Nicholas," in the south wing; an extension, constructed in two successive stages, of the east wing begun by Nicholas III. This extension included the areas corresponding to the present-day Sala dei Pontefici in the Appartamento Borgia on the first floor, and to the Sala di Constantino in Raphael's Stanze on the second. It terminated in a massive tower, which may still be seen in the well-known drawing of the Vatican by the sixteenth-century artist Martin van Heemskerck; the lower part of this tower was recently discovered. Both the stair tower and the *capella parva Sancti Nicolai* were demolished under Paul III. The chapel was destroyed merely to enlarge the adjacent Scala del Maresciallo, without regard for the frescoes by Fra Angelico that adorned it. The probable builder of the chapel and of the second section of the east wing was Boniface VIII Caetani (1295–1303), who often stayed in the Vatican, and who died there.

Nicholas V

Nothing, or almost nothing, was done to this Roman residence of the popes during the years of the Avignon exile (1309–77) and the Great Schism (1378–1417). However, with the election of Tommaso Parentucelli to the papacy as Nicholas V in 1447, a new and splendid chapter in the history of the Vatican Palace began: the Renaissance chapter. About Parentucelli, the Florentine bookseller and biographer Vespasiano da Bisticci wrote: "He used to say that if he could spend the money there were two things he would do: buy books and build." When he became pope, this holy and learned humanist did both. He was the de facto founder of the Vatican Library (officially inaugurated later in the century by Sixtus IV), and he conceived a grand building program for the Leonine City. This program, inspired by Leon Battista Alberti and described by Giannozzo Manetti, was only partly realized. Two things moved the pope to undertake it: the dignity of the Holy See and its safety, which was no longer guaranteed by the old walls of Leo IV.

Massive walls with round artillery towers were to protect the renovated Borgo, and another identical wall, inside the first one, was to defend the papal residence to the north and east against both rebellion and external enemies. Only this last part was actually built. It still exists; its imposing tower can be seen near the Porta Sant'Anna. Another of the principal ingredients of Nicholas's humanistic architectural vision was a new papal palace. This project too was only partly realized. The only new structure of Nicholas's reign was a north wing, added to the palace of Nicholas III. The "engineers of the palace" were Antonio da Firenze and, after 1451, also Bernardo di Matteo, known as Rossellino. Externally, the new wing imitated the appearance of the medieval building, even in its crenellated battlements; this is rather surprising, considering the contempt of the Renaissance for medieval architecture. Inside, however, everything was different: tufa blocks gave way to brick, beamed ceilings to vaulting, and the medieval *aula*, or hall, to the *stanza*, or room, proportioned according to the new geometric standards of Florentine humanism. All who entered the building felt transported, as though by enchantment, into the climate of the Tuscan Renaissance. The gloomy medieval castle had been transformed into a civilized dwelling for a great lord—something completely new in fifteenth-century Rome.

Nicholas had the rooms, even those of the old residence, decorated with friezes; of special importance is one found several years ago in the Sala Vecchia degli Svizzeri, which I have attributed to an unknown pupil of Pisanello's. Another recent discovery is the painted

ceiling of the pope's bedroom, where the hook that supported the canopy over the bed is still to be seen.

The Chapel of Fra Angelico

From Fra Giovanni da Fiesole (1400–55), better known as Fra Angelico, Nicholas commissioned frescoes in the small chapel and in his studio, both of which have been destroyed, and in the chapel dedicated to Saints Stephen and Lawrence, which is called today by the artist's name. The frescoes of this chapel were executed between 1448 and 1450. In the vault are the four evangelists; on the pilasters, the doctors of the church. The large wall frescoes are devoted to the lives of the two holy deacons Stephen and Lawrence. The scenes from the life of Saint Stephen, in the upper register, include his reception of the diaconate from Saint Peter; his distributing alms; his public preaching and his dispute with the Jewish elders; his arrest; and his martyrdom by stoning. In the lower register we see Pope Sixtus II—the figure is a portrait of Nicholas V—conferring the diaconate upon Saint Lawrence; the pope handing over to him the treasures of the church; Lawrence distributing alms at the door of a chapel;

Lawrence brought before the tribunal of the emperor Decius; his conversion of the prison warden; and his martyrdom. In his highly individual style, Fra Angelico combines the achievements of the Renaissance with the mystical fervor of medieval painters.

Sixtus IV

In the period between Nicholas V, who died in 1455, and Sixtus IV, elected in 1471, the wing that closes the Cortile del Pappagallo to the west was erected; thus the palace at last became the quadrilateral structure that Nicholas III had planned. Passing over some works of minor significance carried out during those years, we come to the pontificate of Sixtus IV della Rovere, under whom building activity in the Vatican resumed the grandeur and intensity that had characterized it under Nicholas V. Like his illustrious predecessor, Sixtus had two dominant passions, books and building. The fruit of the former is the noble home given by him to the Vatican Library (which is described in another part of this volume). The fruit of the latter is the Sistine Chapel.

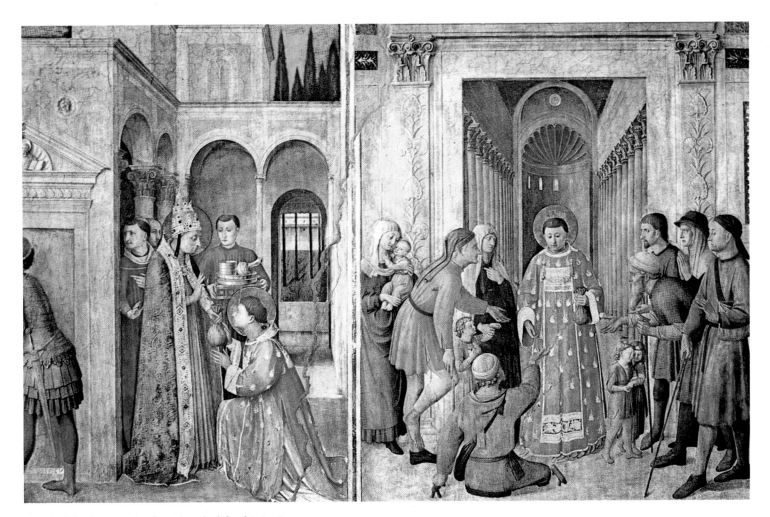

Detail of the fresco series depicting the life of Saint Lawrence, in the Chapel of Fra Angelico.

The Sistine Chapel

The fame of Sixtus IV is closely bound up with the construction of the Sistine Chapel, which remains to this day the official private chapel of the popes; among the functions held there are the conclaves for papal elections. It was built on the site of the Palatine Chapel of Nicholas III, which had fallen into serious disrepair. The work, which was probably begun in 1475, was directed by Giovanni dei Dolci, according to the plans of Baccio Pontelli, who Vasari says was the architect. The nave measures 40.23 by 13.41 meters; Eugenio Battisti has shown that these measurements correspond exactly to those given in the Bible for Solomon's temple. The height is 20.70 meters.

In building this chapel to the southwest of the Vatican Palace, Sixtus IV intended not only to add a new sanctuary to the papal residence but also to add another indispensable element toward the gradual realization of the building program of Nicholas III. This plan involved a complex of buildings around the Cortile del Pappagallo, defended by four corner towers. The tower at the southeast corner is lost, but it can be seen clearly in old prints. The northeast tower, as we have said, has been discovered in part. The Sistine Chapel is the third, though in appearance it is more like a fortress than a tower. The fourth—the Torre Borgia—was to be built opposite it by Alexander VI. Thus was completed the fortification of the little hill on its most accessible and therefore most vulnerable side; this had also, perhaps, been the strategic function of the preceding chapel of Nicholas III. Hence the striking contrast between the exterior of the Sistine Chapel, with its unadorned walls and its battlements,

The Sistine Chapel seen from the north.

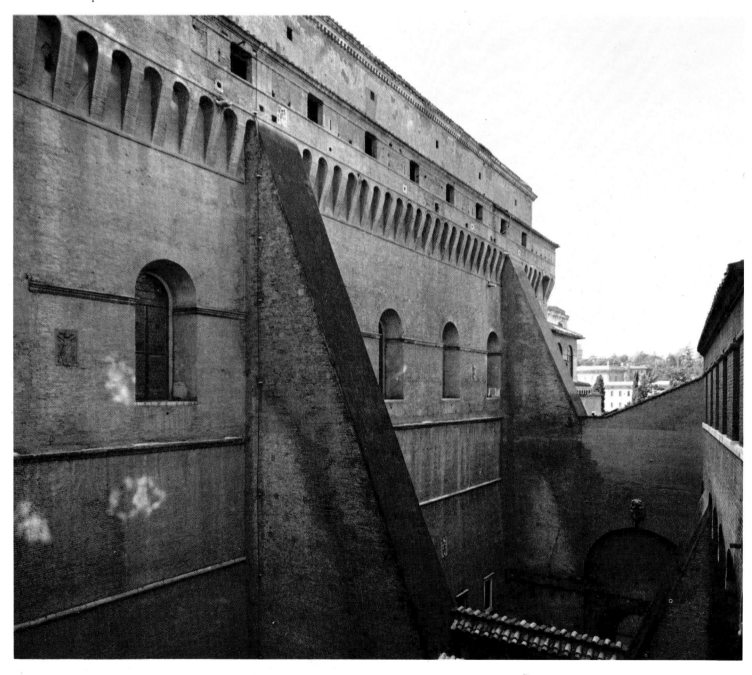

The northwest corner of the Sistine Chapel. The three stages of its decoration are represented: the side walls, by various artists (1481–83); Michelangelo's vault (1508–12); and Michelangelo's *Last Judgment* (1535–41).

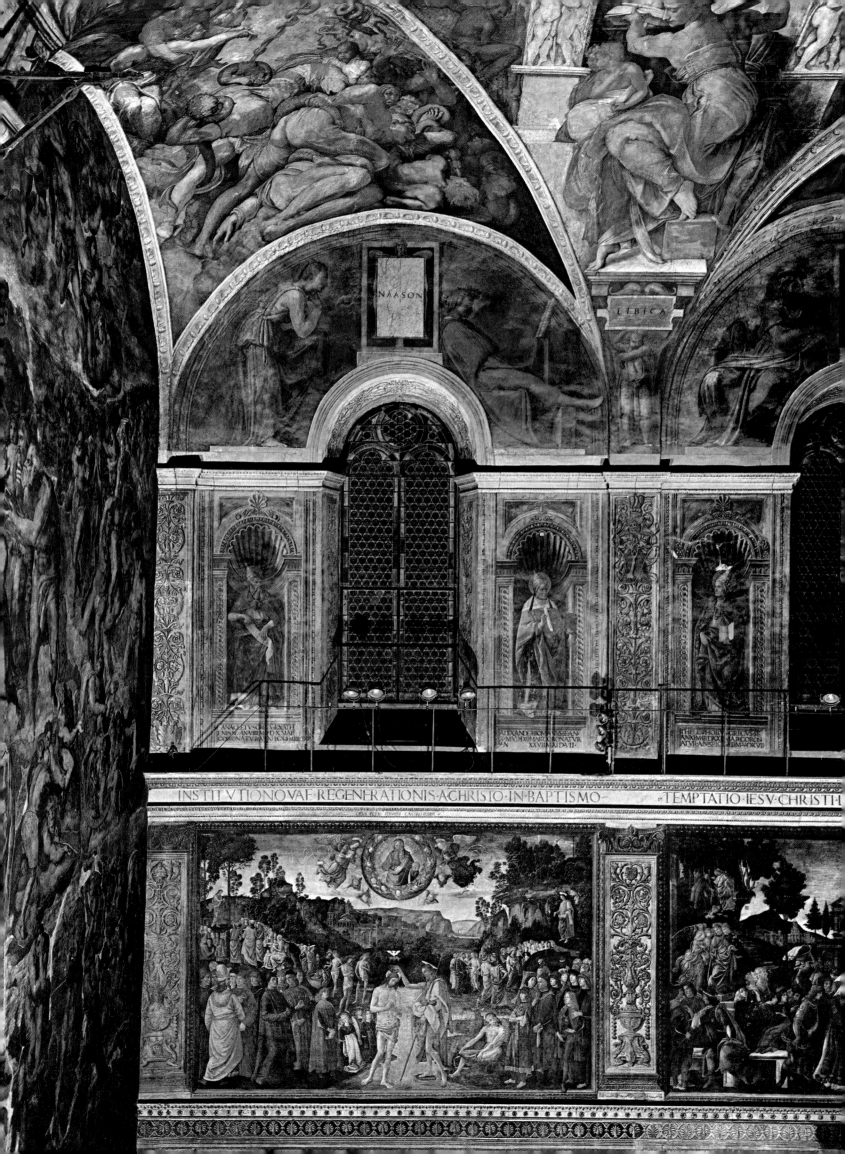

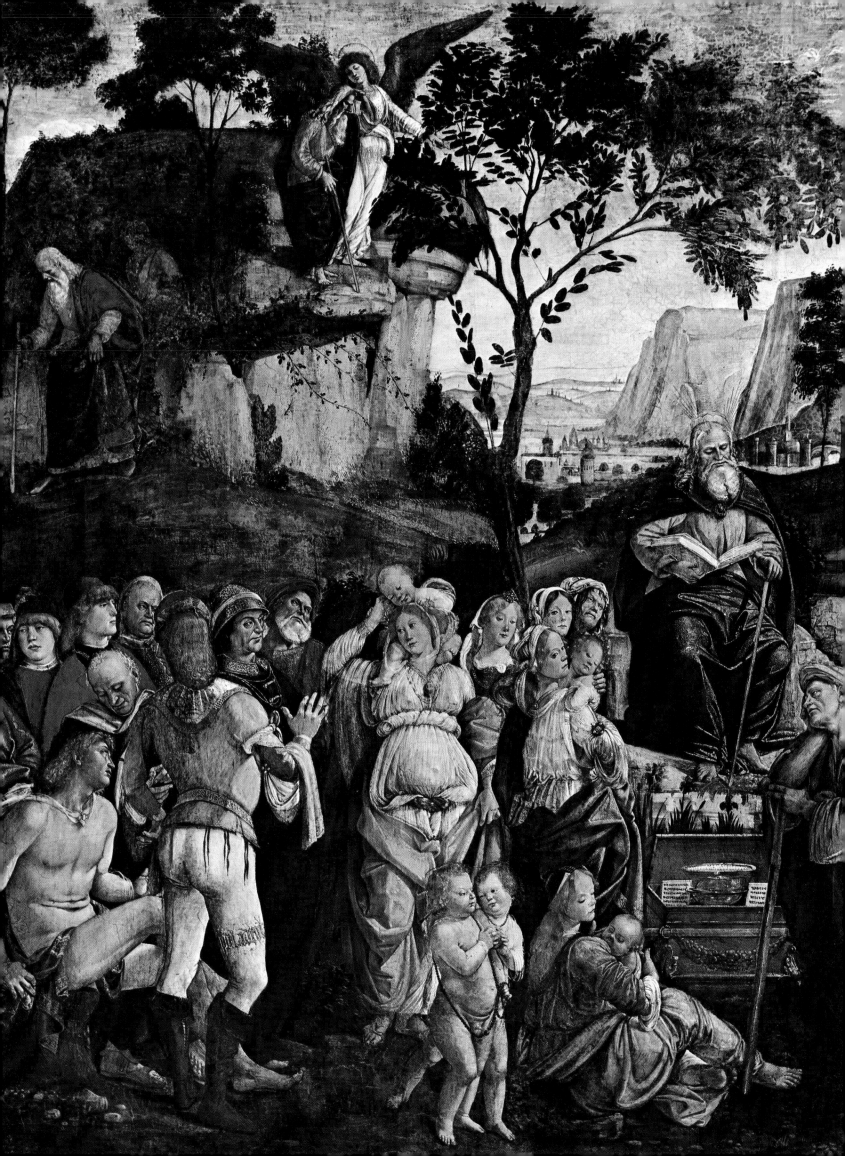

and the interior, destined from the start to be adorned with the most splendid art of the Italian Renaissance.

The *cantoria* for the famous Sistine Choir and the elegant marble screen that divides the chapel into two parts are the work of Mino da Fiesole, Giovanni Dalmata, and Andrea Bregno. The polychrome inlaid floor is a fine example of fifteenth-century Roman mosaic art.

The walls are frescoed with twelve large narrative scenes, six to each side. Those on the left as one faces the altar represent episodes from the life of Moses, who set Israel free. On the right are scenes from the life of Christ, who freed the human race. The scenes are paralleled, according to an ancient liturgical tradition that sees in Moses the prophetic forerunner of the Redeemer. The two series begin on the rear wall, to either side of the altar, with the *Finding of Moses* and the *Nativity*, both by Perugino, and end on the entrance wall with the *Dispute over the Body of Moses* and the *Resurrection of Christ*. The first two were destroyed to make room for Michelangelo's *Last Judgment*; the other two were damaged by the collapse of the architrave in 1522.

The scenes from the life of Moses include the *Journey of Moses into Egypt*, by Perugino; the *Calling of Moses*, by Sandro Botticelli, a scene of great poetic beauty; the *Crossing of the Red Sea*, by Cosimo Rosselli (whose four frescoes in the chapel are of less artistic worth than the others); *Moses Receiving the Tablets of the Law*, also by Rosselli; the *Punishment of Korah, Dathan, and Abiram*, by Botticelli, much admired for the dramatic movement of the figures, and also interesting because it includes exact representations of two ancient Roman monuments, the Arch of Constantine and the Septizonium (near the house on the left is a portrait of Alessandro Farnese—the future Paul III—as a boy, accompanied by his tutor, the humanist Pomponio Leto); the *Testament and Death of Moses*, by Luca Signorelli (it is thought that the naked youth representing the Tribe of Levi inspired Michelangelo's gigantic nude figures on the vault of the chapel).

The scenes on the opposite wall are the *Baptism of Christ*, signed by Perugino on the cornice above; the *Temptation of Christ* and the *Cleansing of the Leper*, by Botticelli (the temple in the background reproduces the façade of the Hospital of Santo Spirito, founded by Sixtus IV and built by Baccio Pontelli); the *Calling of the First Apostles*, by Michelangelo's teacher Domenico Ghirlandaio, with its beautiful landscape background and a number of fine portraits among the figures; the *Sermon on the Mount*, painted by Rosselli with the collaboration, especially for the portrait figures, of the great Piero di Cosimo; *Christ Giving the Keys to Peter*, a masterpiece by Perugino which Raphael later imitated (and improved upon) in his *Marriage of the Virgin*;

Detail of the *Calling of Moses* by Sandro Botticelli, in the Sistine Chapel.

Detail of the *Testament and the Death of Moses* by Luca Signorelli, in the Sistine Chapel.

and the *Last Supper*, by Cosimo Rosselli. In the niches between the windows are portraits of the first thirty popes, all saints and martyrs, by the same group of painters. During the course of a recent restoration, Latin inscriptions identifying each scene were discovered on the marble cornice above the frescoes. They were perhaps composed by Sixtus IV himself, and are of great importance for the exegesis of the paintings.

Innocent VIII

With the successor of Sixtus IV, the Genoese Innocent VIII Cibo (1484–92), there opened a new chapter in the architectural history of the Vatican Palace. It now began to expand northward, beyond the small original nucleus, across the garden that Nicholas III had enclosed. In the first year of his pontificate, Innocent began to construct a small building on the second hill to the north of Saint Peter's, the Mons Sancti Aegidii. It looked out over the majestic Roman campagna and was therefore called the "Belvedere" (roughly translated, "beautiful view"), a name that subsequently came into common use. Vasari attributes the design of the Belvedere to Antonio del Pollaiuolo but tells us that it was "continued by another, because [Pollaiuolo] was not very skilled in building"; documents show that the "other" was Jacopo da Pietrasanta, a famous builder of the period. The fact that the author of the project was a painter inexperienced in architecture explains certain unusual features of the Belvedere, such as the incongruity of the medieval-looking attic, with its Ghibelline crenellations, placed over a loggia in the purest Tuscan Renaissance style. Though the building makes little sense architecturally, it is highly picturesque—the sort of thing one might expect to find in the background of a painting.

The Belvedere was originally meant to be a simple ambulatory for the pope's use. Pollaiuolo's project was limited to its present north wing: a loggia of eight bays, with Doric pilasters, a cornice, and an attic, flanked by two turretlike projections. Later, Innocent decided to convert the ambulatory into a summer villa. The two easternmost bays of the loggia were therefore walled up to form two rooms, and a chapel with a sacristy was added at the other end. The chapel, with frescoes by Mantegna, was unfortunately destroyed when the Museo Pio-Clementino was built at the end of the eighteenth century. On the back wall of the loggia, Bernandino Betti, better known as Pinturicchio, painted views of the city, including one of the Belvedere itself; recent restorations have brought fragments of these to light. The east wing, which belongs to a second stage of construction, appears to be the work of Jacopo da Pietrasanta alone. In the sixteenth century, the inner garden of the Belvedere was the place where the Vatican's first collection of ancient statues was kept, and the building was used to house the artists who worked in the papal residence, including Bramante and Leonardo da Vinci.

Alexander VI

In 1492 the Spaniard Rodrigo Borgia was elected pope and took the name Alexander VI. It was he who brought to its conclusion the "ideal plan" for the papal residence, conceived by Nicholas III and gradually realized under his successors. At the death of Innocent VIII, only one element was still missing: a structure for the military defense of the northwest corner of the palace, corresponding to the fortresslike Sistine Chapel at the southwest corner; certain details in the masonry of the north wing indicate that Nicholas V had intended to build a tower on this site. Alexander completed the plan by constructing here the tower that bears his name, the Torre Borgia, which projects for about eight meters into that part of the old *pomerium* which is now the Cortile del Belvedere.

The Belvedere of Innocent VIII, built by Jacopo da Pietrasanta after a design by Antonio del Pollaiuolo.

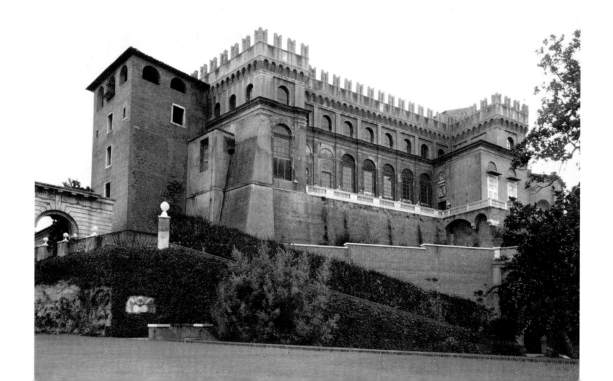

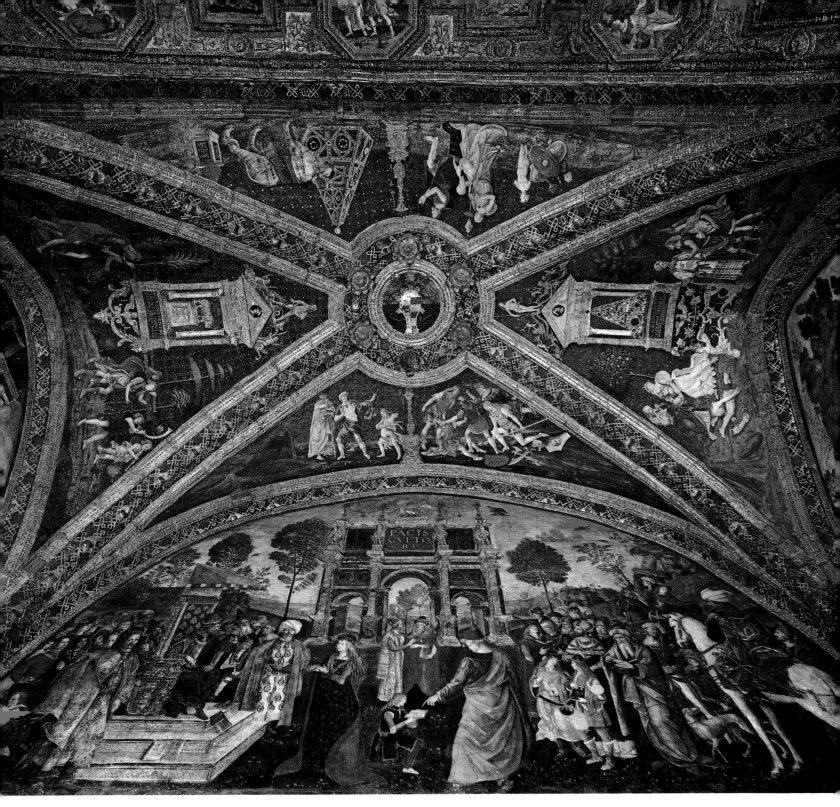

The Sala dei Santi in the Appartamento Borgia, painted by Pinturicchio.
On the vault are scenes from the myth of Isis and Osiris; the lunette illustrated here
shows the debate between Saint Catherine of Alexandria and the philosophers.

But Alexander's name is linked above all, in the Vatican, with the six rooms on the first floor of the north wing, the Appartamento Borgia, where he lived and died. The rooms themselves, of modest but harmonious dimensions, are a fine example of Tuscan architecture of the first half of the fifteenth century. They are chiefly famous, however, for the frescoes on the walls and ceilings of five of the rooms, painted by Pinturicchio, who had been a pupil of Perugino's. Pinturicchio worked from the end of 1492 until 1495, with the help, in varying degrees, of many of his own pupils, including Benedetto Bonfigli of Perugia, Piero d'Andrea of Volterra, and Antonio da Viterbo, known as Il Pastura. These frescoes are among the most ex-

pressive works of the fifteenth-century Umbrian school, and are certainly Pinturicchio's masterpiece.

Pinturicchio seems to have begun with the so-called Sala dei Misteri della Fede, where the large lunettes of the walls are frescoed with scenes from the lives of Christ and the Virgin Mary. These include an Annunciation, a Nativity, an Adoration of the Magi, a Resurrection (where the bishop kneeling at the left is a portrait of the Borgia pope, a masterpiece of psychological intuition and expressive power, of far higher artistic quality than we usually find in Pinturicchio's work), an Ascension, a Descent of the Holy Spirit, and an Assumption of the Virgin, with a praying benefactor, perhaps Francesco Borgia, portrayed at the left.

The Sala dei Santi is divided by an arch into two groin-vaulted rectangular sections. As a result, there are six lunettes: two each on the long walls, one on the window wall, and one on the wall opposite. The lunettes, the vaults, and the arch are completely covered with frescoes, and the decorative effect is reinforced by the use of gilded stucco relief, which now bears the patina of centuries. The scenes with episodes from the lives of various saints, in the lunettes, give the room its name. They are considered Pinturicchio's masterpiece. They include the story of Susanna and the elders; Saint Barbara's miraculous escape from the tower where her father, furious at her conversion, had imprisoned her; the debate between Saint Catherine

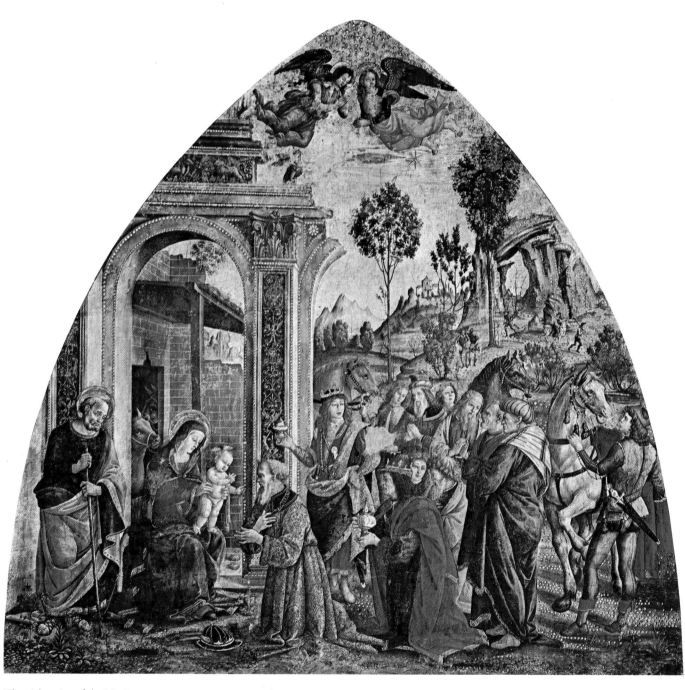

The *Adoration of the Magi*, by Pinturicchio and his pupils. Lunette in the Sala dei Misteri della Fede.

of Alexandria and the philosophers before the emperor Maximian; the meeting of Saint Anthony Abbot and Saint Paul the Hermit in the desert; the Visitation of the Blessed Virgin; and the martyrdom of Saint Sebastian. The figure of Saint Catherine is not, as is sometimes suggested, a portrait of Lucrezia Borgia or of Giulia Farnese, nor is the emperor a portrait of Cesare Borgia. Beside the throne, however, is Andrew Paleologos, the despot of Morea, with a long, fair moustache, and in the group on the left there is a portrait of the architect Antonio da Sangallo the elder, with a set square in his hand, and next to him a self-portrait of Pinturicchio. The person on horseback is thought to be Alexander VI's guest and hostage, the

Turkish prince Djem. In the background of the scene of Saint Sebastian's martyrdom are the Colosseum and the church of Santi Giovanni e Paolo, and the Saint Catherine fresco shows the Arch of Constantine decorated as a triumphal monument in honor of the Borgia pope. On the vault of the Sala dei Santi are scenes from the myth of Isis and Osiris.

The Sala delle Arti Liberali was Alexander's study; here, after his death, his body was laid out and his secret treasure was discovered. The frescoes in the lunettes, which were probably executed for the most part by Antonio da Viterbo, glorify the seven so-called liberal arts, the subjects that formed the basis of education according to the medieval system: the elemen-

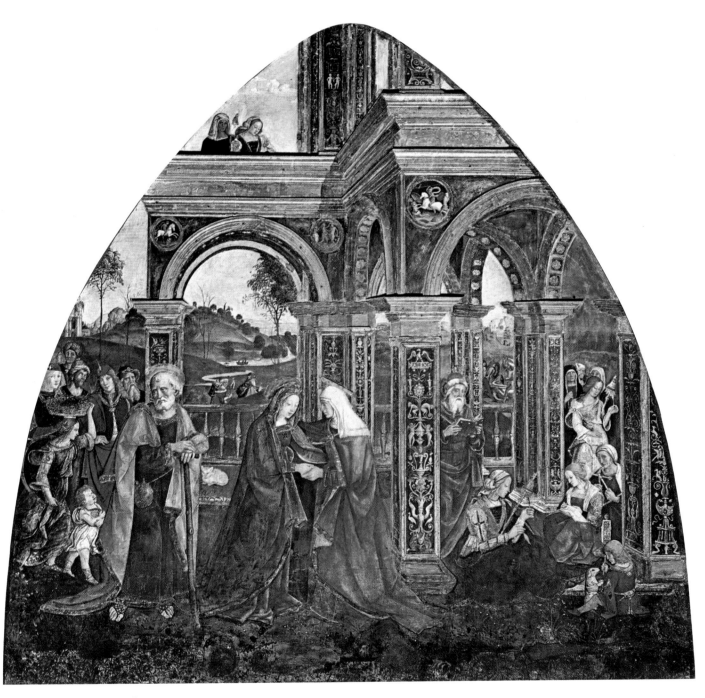

The *Visitation* by Pinturicchio.
Lunette in the Sala dei Santi.

tary *trivium*—grammar, dialectic, and rhetoric—and the more advanced *quadrivium*—arithmetic, geometry, music, and astronomy. The liberal arts are represented by allegorical female figures on gilded thrones, attended by the most famous exponents of the various disciplines. Next to Geometry, for example, is Bramante in the guise of Euclid, just as Raphael was later to portray him in the *School of Athens*. The decoration of the vault is of considerable interest; it consists of grotesques and small frescoed scenes intermingled with gilded stucco reliefs of the heraldic emblems of the Borgias, a bull and a crown surrounded by rays. The arch that separates the two sections of the vault is known as the Arch of Justice; it is decorated with five octagonal scenes illustrating the greatest of the cardinal virtues. These scenes, however, are in a sixteenth-century style and are not the work of Pinturicchio and his circle.

The next room, the Sala del Credo, is thus called because the figures of the twelve apostles in the lunettes hold scrolls, each inscribed with one article of the Creed; according to an old tradition, the Apostles' Creed was composed collegially by the apostles before their dispersal to the various parts of the world, and each one formulated one of its articles. The apostles are shown accompanied by Old Testament prophets bearing scrolls with verses of their writings that refer to the articles of faith in question. The figures were probably painted by Antonio da Viterbo after Pinturicchio's design.

The Sala delle Sibille is a square room with twelve lunettes; each one is decorated with the half-length figures of a sibyl and a prophet, representing respectively the pagan and the Hebrew worlds. This reflects an old belief that links the sibyls (prophetesses of the Greco-Roman tradition) with the Old Testament prophets in a common expectation of the Messiah. In the octagonal panels are the astrological symbols of the seven major planets, much damaged and repainted. It was in this room that Cesare Borgia, Alexander's son, was imprisoned by Julius II in 1503.

Julius II

Alexander VI died in 1503; his successor, Pius III, reigned for only twenty-six days. The new conclave elected Giuliano della Rovere, the nephew of Sixtus IV, who acceded to the throne as Julius II. Julius was an able and regal pontiff, and the years in which he ruled the church saw the full flowering of the High Renaissance. Although he was already in his sixties, the "terrible old man" (as Ludwig von Pastor, the biographer of the popes, calls him) conceived a plan for renovating Rome, Saint Peter's, and the Vatican Palace that was so grandiose that he could have no hope of

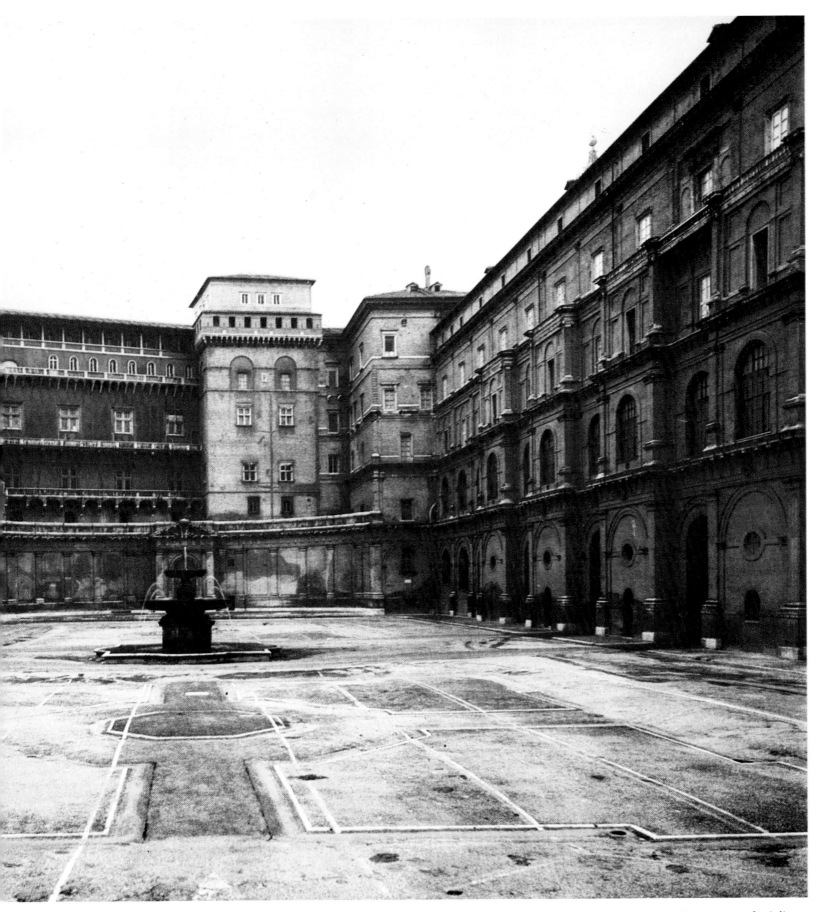

The south end of the Cortile del Belvedere, begun by Bramante for Julius II.
The long parallel wings flanking the cortile link the old Vatican Palace
(seen in the background) with the Belvedere of Innocent VIII.
Bramante's design was radically altered by later popes and architects.

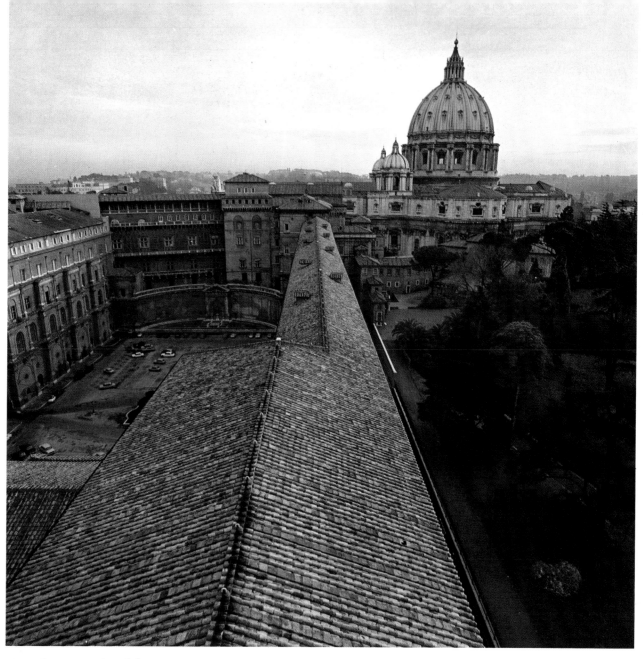

View of Saint Peter's and the Vatican from the Torre dei Venti ("Tower of the Winds") in the Apostolic Palace.

seeing it fulfilled in his lifetime. In Donato Bramante he found an architect capable of reconstructing the basilica and of transforming the Vatican into the splendid royal palace that he dreamed of. He installed Bramante in the Belvedere, and with him laid down a plan for three main undertakings: to demolish and rebuild Saint Peter's, to create the Cortile del Belvedere, and to give a new and more monumental façade to the medieval palace on the side facing the city. Any one of these undertakings would have been enough to insure the glory of his reign.

The Cortile del Belvedere

At the election of Julius II, the space between the Mons Saccorum and the Mons Sancti Aegidii—the garden laid out by Nicholas III—was still kept as an orchard and vineyard, and Innocent VIII's Belvedere was of difficult access. The pope and his ingenious architect decided to link it to the palace by two long, straight, parallel corridors, with a ground floor and two upper stories. These were to be covered by a terrace forming a kind of viaduct leading from the residence to the villa. The terrain between the two corridors rose sharply toward the villa; Bramante transformed it into the vast Cortile del Belvedere, consisting of three level expanses corresponding to the three stories of the corridors, and connected by monumental stairways. Thus the ground floor of the corridors reaches only as far as the first stairway, the middle story reaches the second, and only the upper story goes as far as the Belvedere and its famous garden of statues.

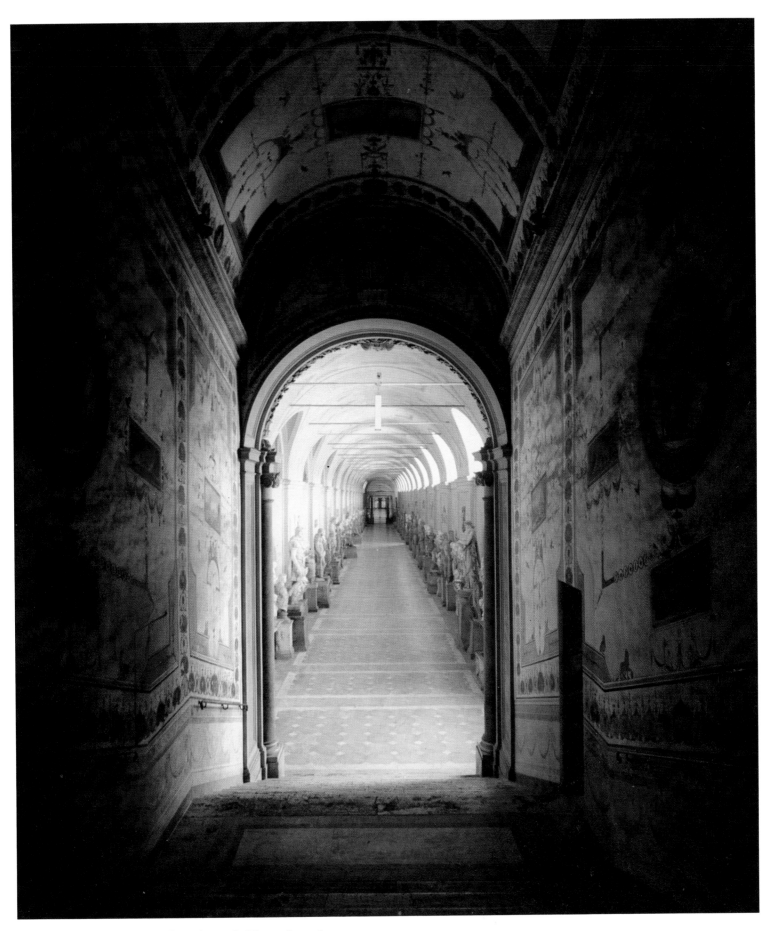

The Museo Chiaramonti seen from the north. The nucleus of
this museum is the long corridor designed by Bramante
in the east wing of the Cortile del Belvedere.

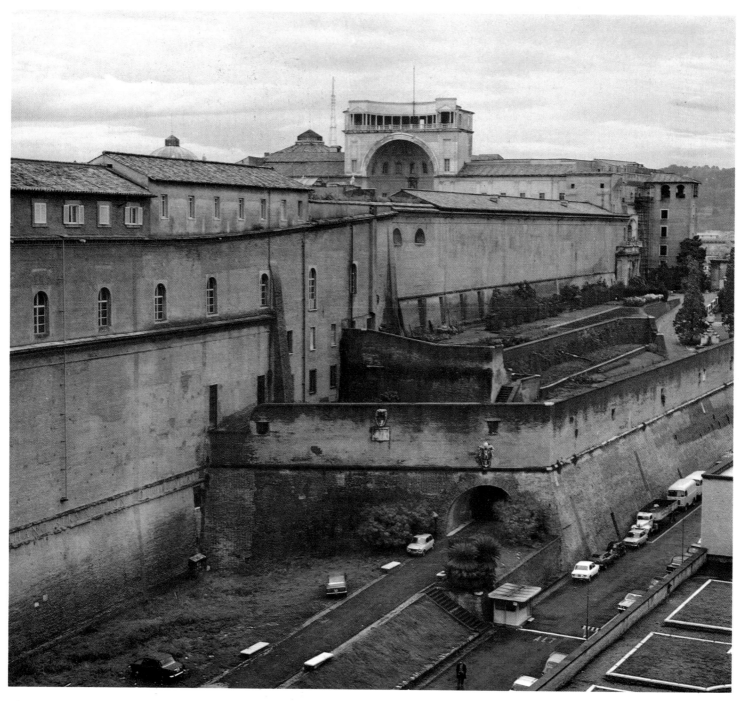

The east wing of Bramante's Cortile del Belvedere.
In the background, on the north façade of the original cortile,
is the Nicchione, or great apse, constructed by Pirro Ligorio.

The appearance of the inner façade of Bramante's corridor—today altered by additions made in the seventeenth and eighteenth centuries—can be seen in a drawing in the Soane Museum in London. Its pleasing, orderly architecture contrasts sharply with the bare, military-looking external façade. This outer wall was in fact intended for the defense of the palace, while the courtyard (which was given the curious name "Atrium of Pleasure") was used for spectacles and tournaments. The north façade of the Cortile enclosed the little garden of Innocent VIII's villa and was only one

story high. In its center was the exedra, a large niche containing a flight of semicircular steps, convex halfway up and concave the rest of the way. The south façade presented a difficult architectural problem, since it was here that the Cortile, conceived in a High Renaissance style, abutted the palace proper, with its constructions from the times of Boniface VIII, Nicholas V, and Alexander VI. A plan in the Soane Museum shows that Bramante intended to impose a certain stylistic unity by means of a wall flanked by two small projecting wings. He demolished the military battle-

ments and replaced them with a balustrade. He also had the whimsical idea of crowning the Torre Borgia with a small dome, but it was later destroyed in a fire. Bramante died in 1514, leaving the great courtyard incomplete. It was finished by Pirro Ligorio under Pius IV in 1565.

Another work of Bramante's, later imitated by many other architects, is the famous spiral staircase, inside a square tower built on to the east façade of the Belvedere of Innocent VIII to allow easier access to the garden. The circular ramp ascends in a perfect spiral, covered by a barrel vault without a cornice. The columns surrounding the central opening follow the classic Vitruvian order: sixteen are Doric, eight Ionic, and twelve Corinthian. All are of equal height, but the columns of the upper orders are slenderer than the ones below them. The staircase was begun in 1512 and finished only in 1564.

The Logge

Bramante showed no less enthusiasm in executing the second task assigned to him by Julius II, the modernization of the papal palace. Above all, the irregular thirteenth-century façade, visible to all who approached the Vatican from the center of Rome, had to be brought into conformity with Renaissance taste. Bramante took over one important feature of the medieval façade, the superimposed, open galleries of which it consisted in part; bringing out all the latent possibilities of this system, he translated it into a High Renaissance structure of far greater breadth and unity. He walled up the portico on the ground floor, and extended it for twenty-two meters southward beyond the old façade. On top of this foundation he built two open galleries —the Logge—of thirteen bays each. The arches of the first and second orders are flanked, respectively,

Bramante's spiral staircase, inside a tower on the east side of the Belvedere of Innocent VIII.

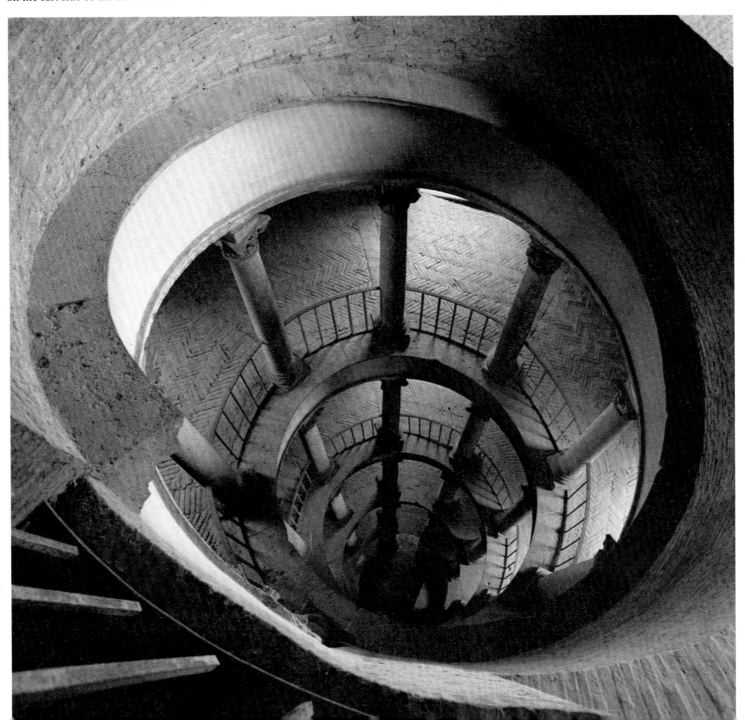

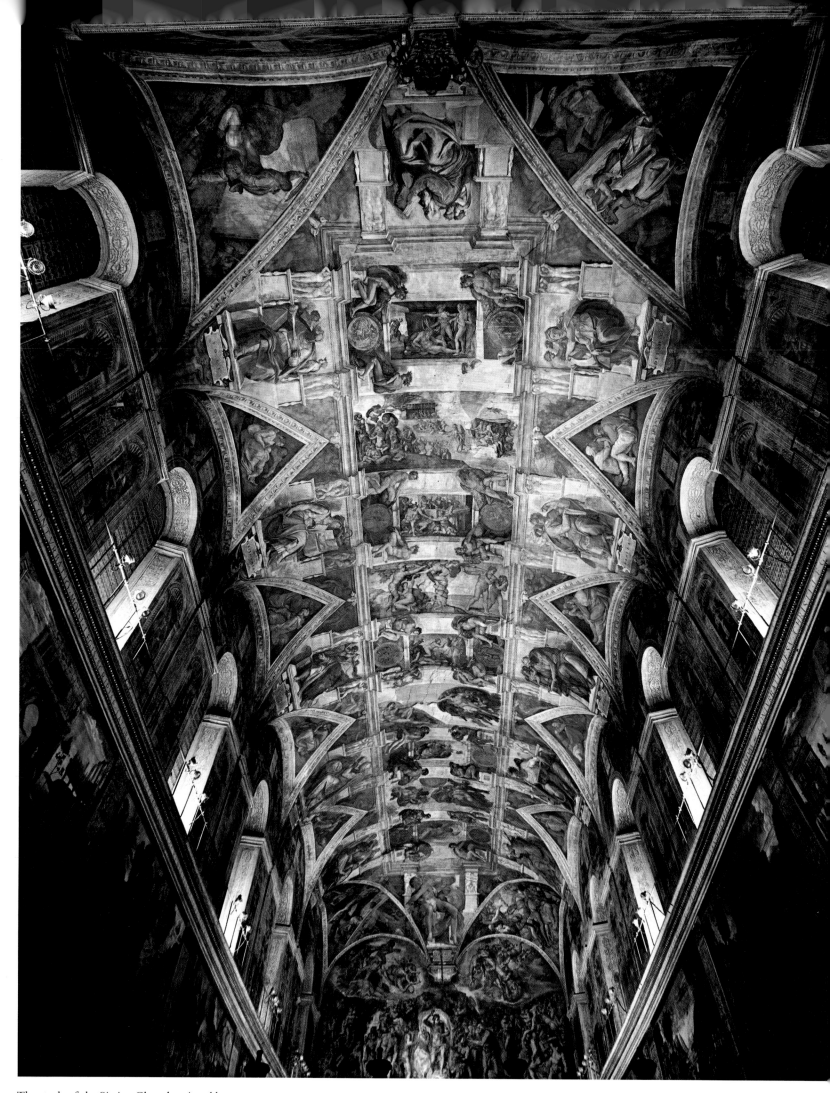

The vault of the Sistine Chapel, painted by
Michelangelo between 1508 and 1512.

by Doric and Ionic pilasters. Behind the southern extension of the façade he constructed a ramp with low steps, the so-called Scale Papali, whereby all—"even horses," as the astonished Venetian ambassador, Marcantonio Michiel, wrote in his diary—might have access to the lower gallery.

The appearance and function of the Logge were radically transformed later in the sixteenth century when, under Gregory XIII and Sixtus V, the palace was extended eastward and what had been its main façade became one side of the new Cortile di San Damaso.

The Sistine Ceiling

In 1508 Julius II ordered the reluctant Michelangelo Buonarroti—who considered himself a sculptor, not a painter—to redecorate the huge vault of the Sistine Chapel, which, since the time of Sixtus IV, had consisted simply of a blue field sprinkled with golden stars. Michelangelo soon mastered the difficult technique of painting in fresco, and the result was the greatest pictorial masterpiece of the Renaissance. Work was completed in October 1512.

The frescoes represent episodes from the Book of Genesis, from the creation of the universe to the new life on earth begun by Noah and his family. The narrative sequence begins at the west end of the chapel, where the altar is, and proceeds eastward; Michelangelo, however, worked in the opposite direction, beginning with the Noah stories and concluding with the Creation scenes. The first scene, following the biblical order, is the Separation of Light from Darkness, where the figure of the creating Spirit seems almost ethereal. In the next two frescoes, God creates the sun and moon and the vegetation of the earth (in this scene, two of the days of Creation are represented together, and the figure of God appears twice), and separates the earth from the waters, blessing his work. In the center of the vault, the story of the first parents is recounted in three frescoes. For the Creation of Man, Michelangelo chose the moment at which God, touching his creature's fingertip with his own, infuses spiritual life into the body of Adam, which is already perfectly formed. The Creation of Woman is next, with Eve, called forth by the right hand of God, rising in rapturous prayer from Adam's side. Original Sin and the Expulsion from Paradise are represented in a single dramatic three-part composition: Adam and Eve are shown in the moment before the Fall, still innocent and full of beauty; the tempter and the avenging angel seem to spring from the same tree trunk; after the Fall, the sinful couple appear woebegone and stricken in soul and body—this group is inspired by Masaccio's famous fresco in Florence, which Michelangelo had studied as a youth. Next

come the Sacrifice of Noah and the Deluge—the latter was the first of the frescoes to be painted, and in some details it reveals Michelangelo's lack of experience: the figures are too small, considering the great distance from which they must be seen, and there are other technical uncertainties; nevertheless, the scene already bears the mark of Michelangelo's famous *terribilità*, his passion for the terrible and the terrifying, which was to reach its full expression many years later in his *Last Judgment*. In the last fresco, life begins again on the devastated earth, and with it physical and moral evil, symbolized by the involuntary drunkenness of Noah and the pitiless scorn of his son. This episode provides the thematic link between the fresco cycle of the vault and the earlier cycle of the walls, where Old Testament scenes prefigure the life of Christ. The entire chapel now celebrates a single story: the creation of the universe and of man, through love; the revolt of man and his punishment; the rebirth of life amidst corrupt nature, but with the promise of redemption, preserved by Israel for centuries and fulfilled by Christ on Calvary.

The smaller scenes of the Genesis cycle appear in frames supported at the corners by nude figures of young men who seem to be commenting, with simple gestures, on the events represented. Along the entire length of the vault are painted, in alternation, figures of prophets and sibyls, seated on massive thrones. Among the most beautiful are the weeping Jeremiah, next to the scene of the first day of Creation, and the Delphic Sibyl, next to that of the Deluge. In the four corners of the vault are biblical scenes: Haman and Mordecai to the left of the altar, the Bronze Serpent to its right, Judith and Holofernes to the left of the door, David and Goliath to its right. All allude to the Redemption, prefigured in the history of Israel.

Raphael's Stanze

Only a few months after Michelangelo began work on the Sistine ceiling, toward the end of 1508, Julius II entrusted to Raphael of Urbino, who was then barely twenty-five years old, the decoration of the rooms of his private apartment, known as the Stanze, situated directly over the Appartamento Borgia, on the second floor of the wing built by Nicholas V. Several fifteenth-century painters, including Piero della Francesca, had worked in the Stanze, and others, such as Perugino, Sodoma, Baldassare Peruzzi, and Lorenzo Lotto, had been employed there by Julius himself. But their work, with a few exceptions, was destroyed by order of the pope to make room for Raphael, who was occupied with the Stanze until his untimely death in 1520.

Raphael began with the Stanza della Segnatura, so called because it later became the seat of the tribu-

Overleaf: The *Creation of Man*, by Michelangelo, the central fresco of the cycle on the vault of the Sistine Chapel. Michelangelo has chosen to represent the moment at which God infuses life into the body of Adam.

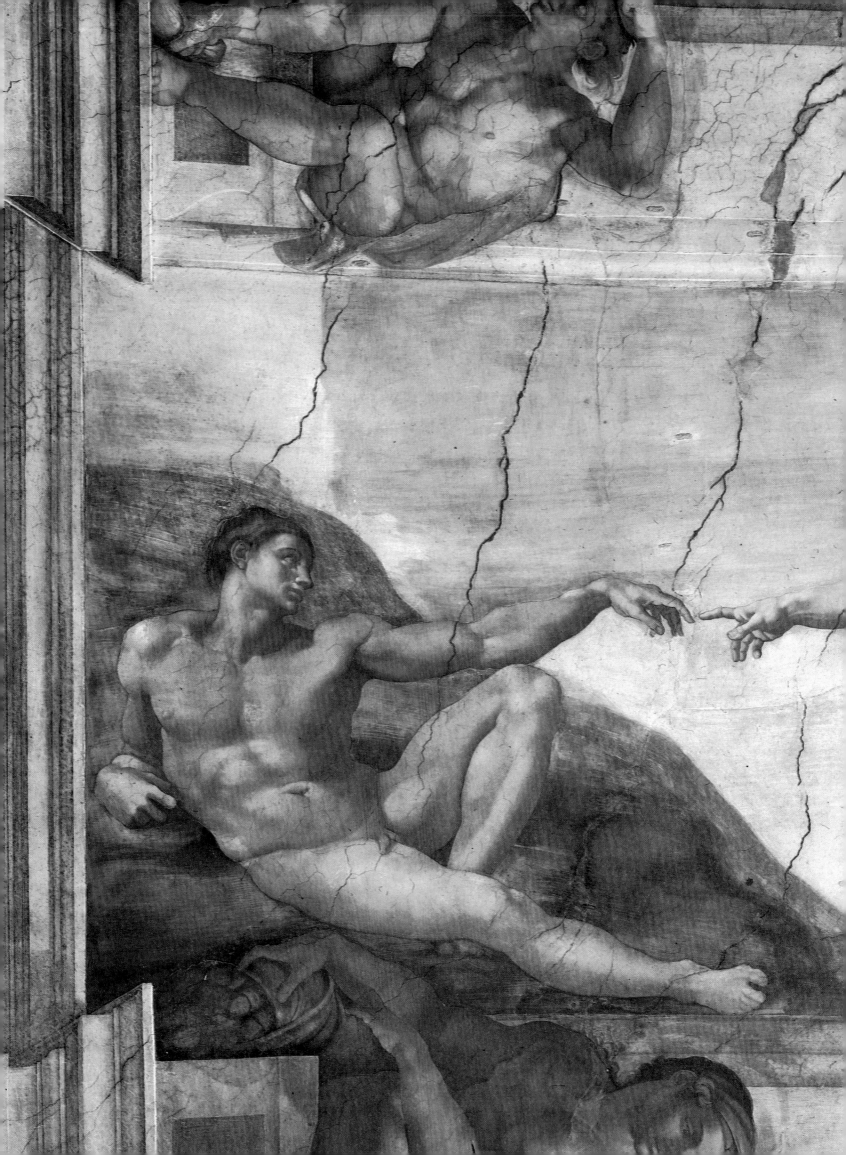

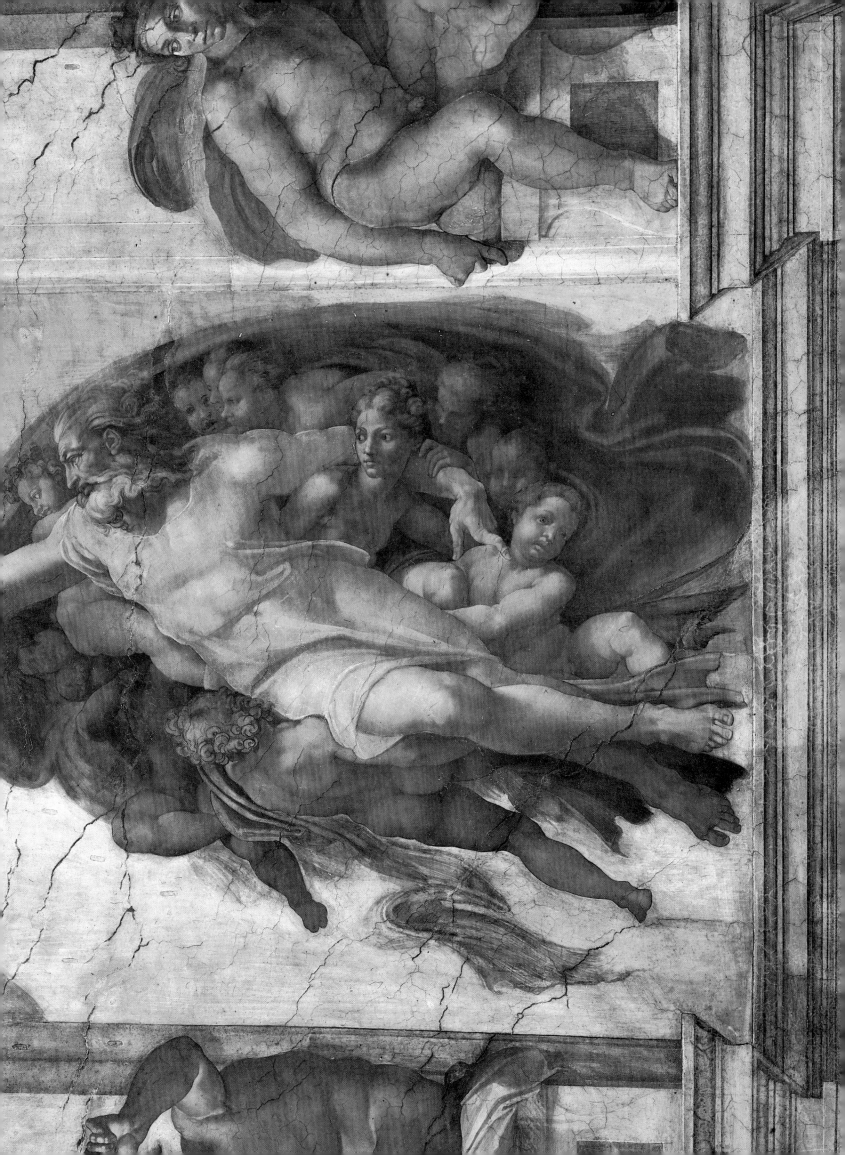

nal of the Apostolic Signatura. It was intended, however, to be the study and private library of Julius II, and its frescoes constitute the most important monument of Christian humanism that the Renaissance produced. The contemporary humanist Paolo Giovio tells us that Julius himself was chiefly responsible for the choice of subjects. The frescoes are all related to the three fundamental ideas of Christian Platonism (which was then at its apogee, thanks principally to the influence of the philosopher Marsilio Ficino), the True, the Good, and the Beautiful. These ideas are illustrated historically, in the wall paintings; allegorically, in the rectangular compartments of the vault; and symbolically, in the roundels of the vault. Thus, the so-called *Disputa* corresponds to theological or revealed truth, and the *School of Athens* to philosophical or rational truth; the frescoes of the Virtues, canon law, and civil law correspond to the Good; and the *Parnassus* to the Beautiful.

The name *Disputa*, or *Debate over the Blessed Sacrament*, was erroneously given in the seventeenth century to the fresco on the west wall, which in fact depicts the glory of the Church Triumphant, adoring the Blessed Trinity in heaven, and its communion with the Church Militant on earth, where saints, popes, and theologians adore God in the Eucharist. This was the first fresco painted by Raphael in the Vatican. In spite of the admirable balance of its composition, it is very uneven in its details, and still reflects the Umbrian manner of the painter's early days. There are many portraits, including Dante, Sixtus IV, and Savonarola on the right, and Fra Angelico and Bramante in the extreme left-hand corner.

The *School of Athens*, on the opposite wall, shows an imagined meeting of the most famous philosophers of ancient times, with Plato and Aristotle, the leaders of Greek thought, presiding, under the arches and vaults of a vast basilica designed by Bramante and prefiguring his design for Saint Peter's. In the short space of time that had elapsed between the painting of the previous fresco and the present one, Raphael had gained complete mastery of the technique. His style has lost all trace of uncertainty and is fully sixteenth-century. Here again are a number of portraits: Plato is Leonardo da Vinci; Euclid is Bramante, measuring with a pair of compasses a geometrical design drawn on a slate; beside him, in the right-hand corner, stand Raphael himself, wearing a black cap, and, it is thought, Sodoma in a white cloak. Meditating alone in the foreground is Heraclitus, the pessimist, a powerful idealized portrait of Michelangelo, inspired by the prophets of the Sistine Chapel and especially by the Isaiah. On the collar of Bramante-Euclid's tunic is the painter's signature: R.V.S.M., that is, *Raphael Urbinas Sua Manu*.

It is interesting to compare this fresco with the *Disputa*. The unfinished church in which the meeting of the theologians is taking place is complemented by the vision of Paradise, as natural theology is completed by divine revelation; in the *School of Athens* the hall is indeed finished but the sky is empty, because philosophy alone cannot lead to the understanding of revealed mysteries.

In the lunette of the south wall, personifications of three of the cardinal virtues, Fortitude, Prudence, and Temperance, symbolize the moral content of the Law; Justice appears apart from the group, in a medallion on the ceiling, in keeping with the Platonic theory that justice is not a virtue in itself but the sum, and the guide, of all the others. The Law itself is represented in two scenes to the left and right of the window below the lunette: Tribonianus is shown delivering the Pandects, the foundation of civil law, to the emperor Justinian, and Gregory IX is receiving the Decretals, a standard work of canon law, from the saintly jurist Raymond of Peñafort. The figure of Gregory is a portrait of Julius II.

The *Parnassus*, in the lunette on the opposite wall, shows Apollo on the summit of the sacred mountain, playing the lyre to a rapt audience of the nine Muses and a crowd of poets grouped according to their literary genres. Among them may be seen Sappho, at the lower left, with a scroll in her hand; Petrarch, beside the tree to the left; Ennius, higher up, writing to the dictation of the blind Homer; Dante and Virgil next to Homer; Baldassare Castiglione, on the right side, with a black beard; Boccaccio, in a Florentine robe; Ariosto, chin in hand; Antonio Tebaldeo, in profile, with a white beard; and Jacopo Sannazzaro, in a yellow tunic. Not all of these identifications are equally certain.

In the vault, corresponding to the *Disputa*, is a small rectangular fresco, the *Fall of Man*; to its right is a roundel with the personification of Theology, inspired by Beatrice in the *Divine Comedy*. A female figure setting in motion the mechanism of the cosmos, representing the *primum mobile* (or, perhaps, Astronomy), and a roundel with the personification of Philosophy (or Knowledge) clad in the colors of the four elements and seated on a throne decorated with two statuettes of the Diana of Ephesus, correspond to the *School of Athens*. A *Judgment of Solomon*, and the personification of Justice, correspond to the wall frescoes representing the cardinal virtues and the Law. To the *Parnassus* correspond an *Apollo and Marsyas* and the personification of Poetry. The rest of the vault decoration, consisting of grotesques and tiny painted scenes, is fifteenth-century in style and must antedate Raphael's work. The inlaid marble floor, on the other hand, must be slightly later, as emblems of Leo X are combined with the crossed keys of Nicholas V and the name of Julius II.

Raphael finished his work in the Stanza della

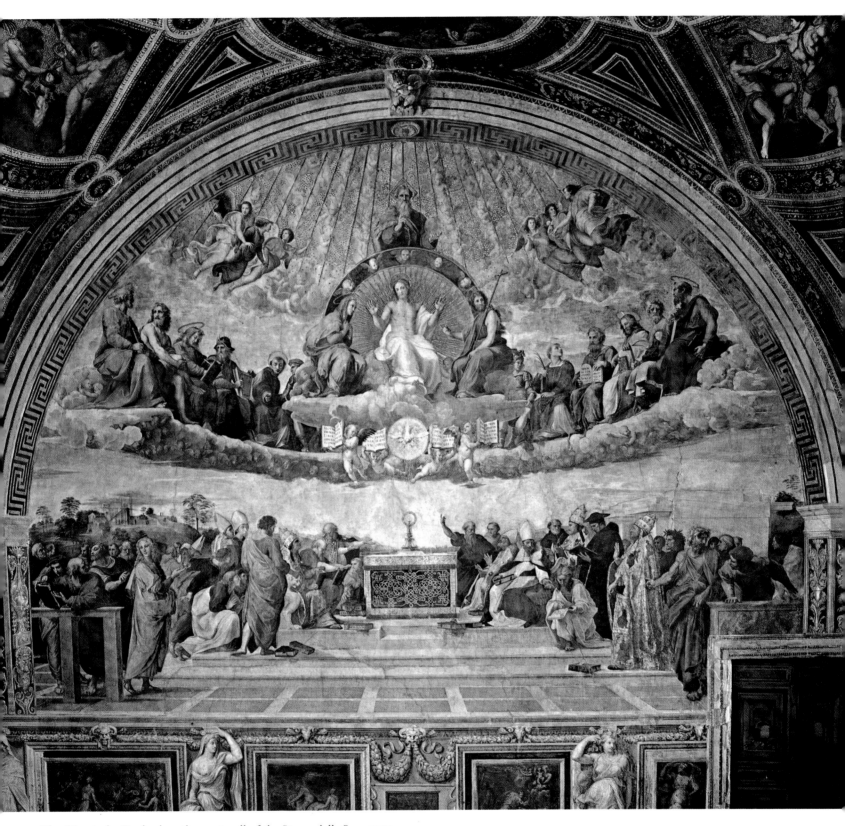

The *Disputa*, by Raphael, on the west wall of the Stanza della Segnatura, includes many portraits. Among those on the right are Dante, Sixtus IV, and Savonarola; at the extreme left-hand corner are Fra Angelico and Bramante.

Overleaf: Detail of the *Disputa*, or *Debate over the Blessed Sacrament*, in the Stanza della Segnatura.

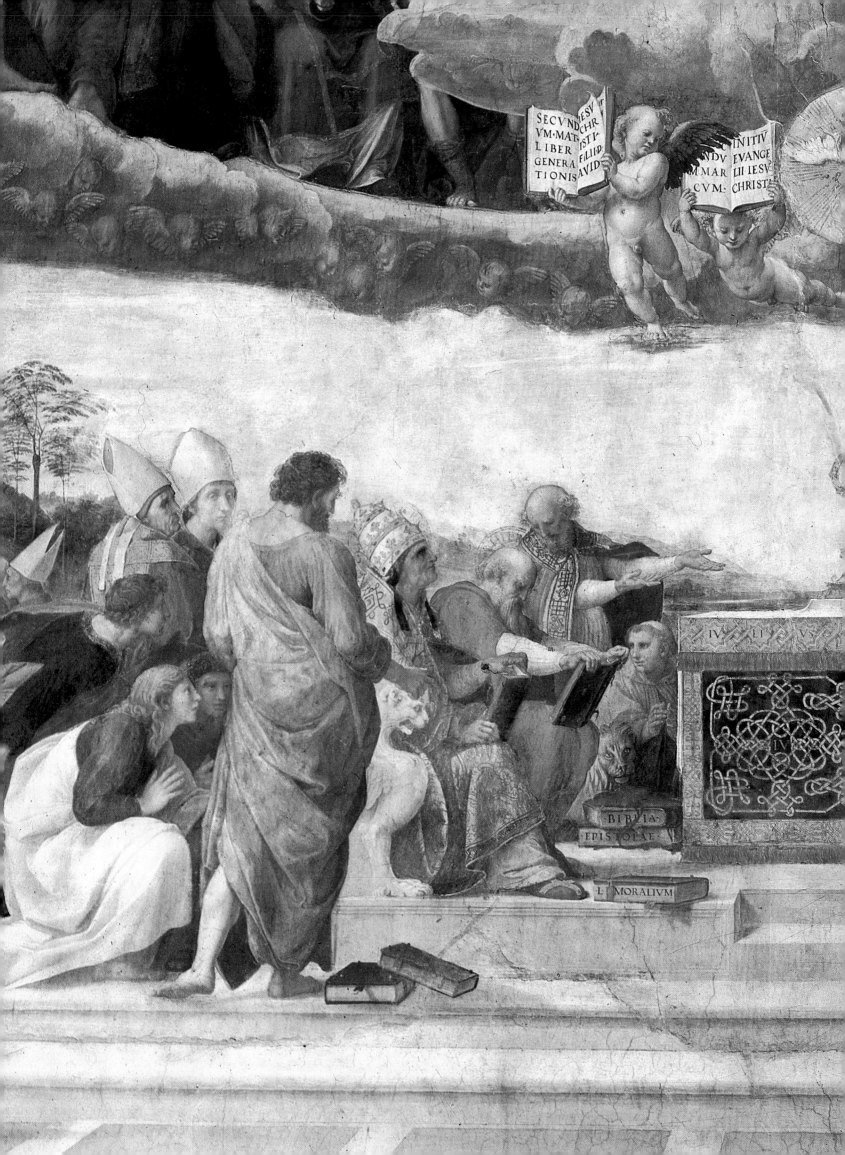

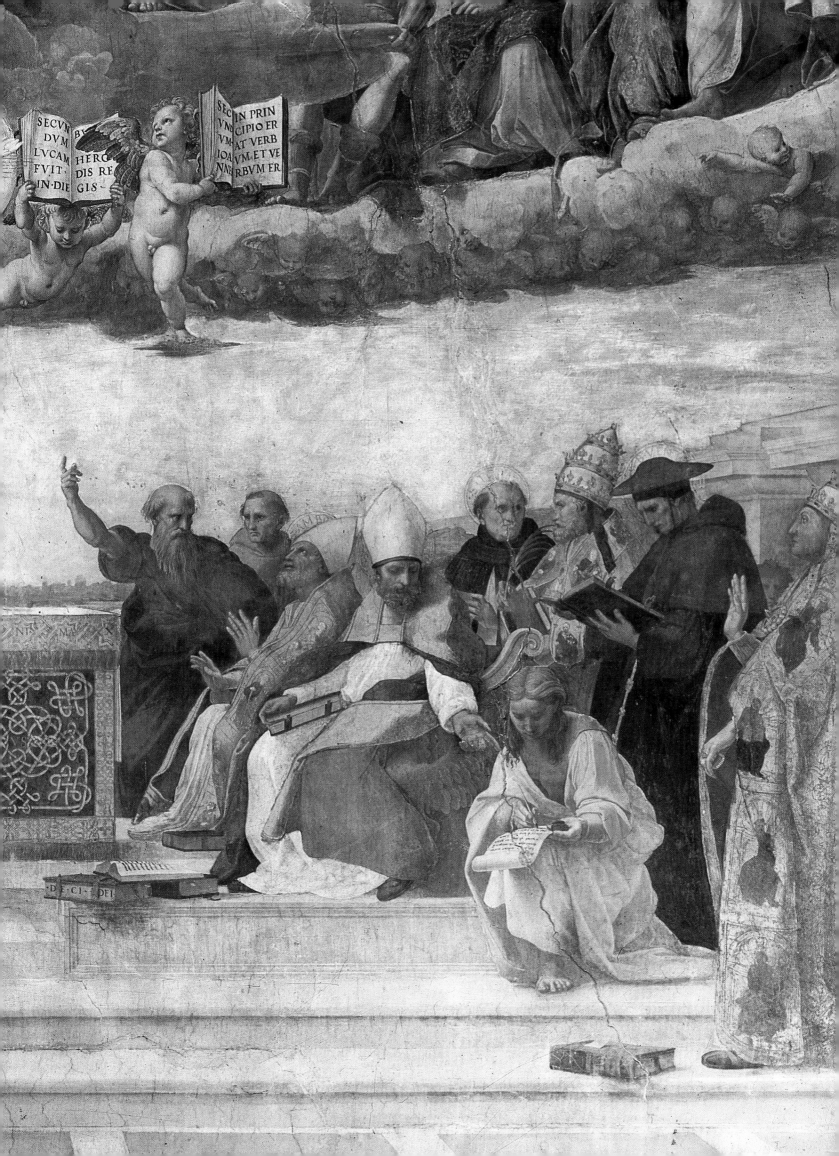

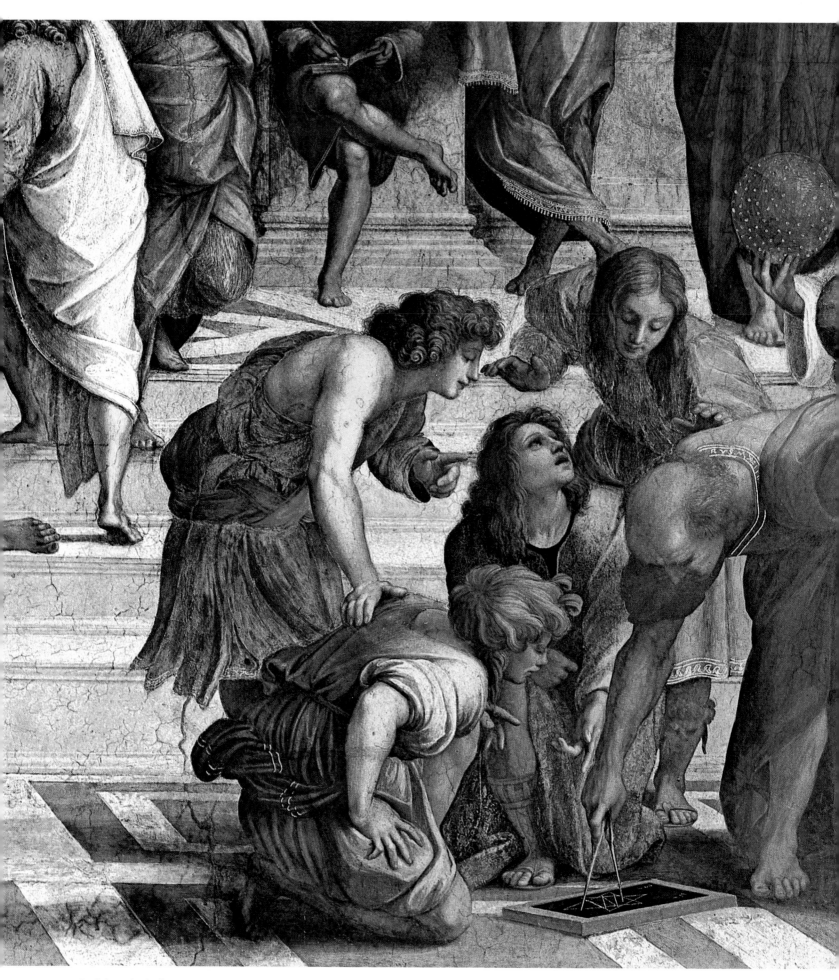

Detail of the *School of Athens*, by Raphael, on the east wall of the
Stanza della Segnatura. In the center of the group is Euclid
(a portrait of Bramante); the second figure from the right
is a self-portrait of Raphael.

Segnatura in 1511, and soon afterward began the decoration of the adjacent Stanza d'Eliodoro. In this room, emboldened by the example of Venetian masters, Raphael produced the most vivacious scenes that ever came from his brush. Here too, however, the practice of entrusting to his assistants the execution of most or all of his compositions, which was to have a crucial effect upon his later work, becomes evident for the first time, particularly in the *Encounter of Leo the Great with Attila*. The theme of this room, which was also, perhaps, devised by Julius II, is the miraculous intervention of God on behalf of his church.

The Stanza d'Eliodoro takes its name from the fresco on the east wall, the *Expulsion of Heliodorus*, a composition of tumultuous whirling and turning movement. Heliodorus, who has come to steal the treasure of the temple in Jerusalem, is driven off by angels, one of whom is mounted on a horse reminiscent of Leonardo's horses. On the left, in a symbolic anachronism, Julius II advances on the *sedia gestatoria* (the portable throne of the popes), not as a participant in the action, but as an onlooker. The figure of Julius is one of Raphael's best portraits. Among the members of the pope's suite is Marcantonio Raimondi, the famous Venetian engraver, who is carrying one of the poles of the chair. Also portrayed is Giovanni Pietro dei Foliari, the secretary for petitions, with his name written on a document. The fresco is an allusion to the wars waged by Julius against the enemies of the Papal State.

The *Mass of Bolsena*, on the wall to the right of the *Heliodorus*, is a jewel of coloring; it shows the influence of the Venetian painters on Raphael's art. The scene depicted took place at Bolsena in 1263. A priest tormented with doubts about the real presence of Christ in the Eucharist was saying Mass in the town and saw the host bleed in his hands at the moment of the consecration. The blood-stained corporal, which is still preserved in the cathedral at Orvieto, was especially venerated by Julius II, who is shown here in a posture of adoration. This miracle gave rise to the feast of Corpus Christi, which was extended to the universal church by Sixtus IV, the uncle of Julius II. Raphael's skill is particularly notable in the way he makes all the figures on the left lean toward the center and extends the architrave of the window to make it the base of the altar, thus correcting the lack of symmetry of the space he had to paint on, which was dominated by a large off-center window. Exceptionally well preserved is the group of Swiss Guards (the corps was founded by Julius II in 1505), which is extraordinarily Venetian in its coloring. This group gives some idea of what all the frescoes must have looked like when they were freshly painted.

On the west wall is the *Encounter of Leo the Great*

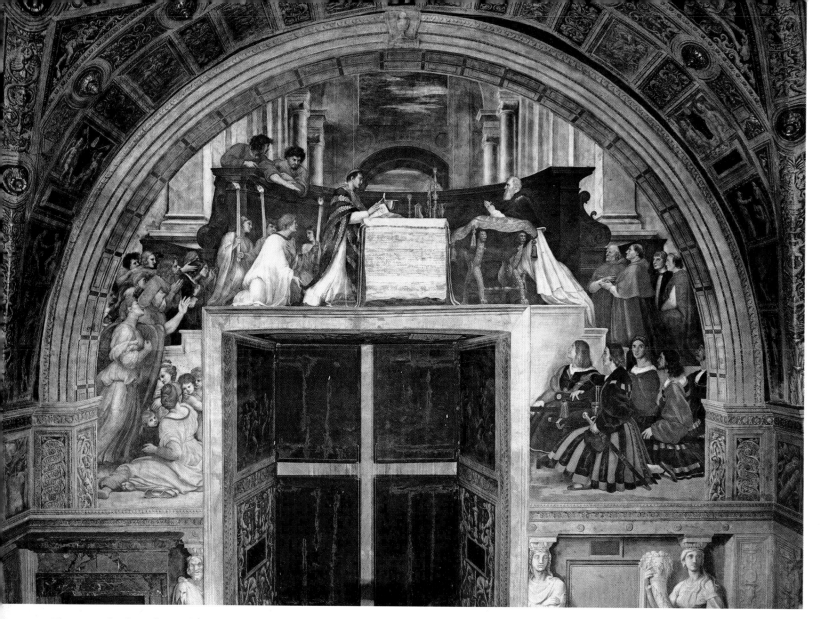

The *Mass of Bolsena*, by Raphael,
in the Stanza d'Eliodoro.

with Attila. This meeting actually took place near Mantua, but Raphael imagines it taking place at the gates of Rome, the goal of the Huns. The pope and his suite advance calmly from the left, while the apostles Peter and Paul, both armed with swords, throw confusion into the ranks of the enemy by their sudden appearance in the skies. While the fresco was being painted, Julius II died, and Leo the Great was given the features of Julius's successor, Leo X, who thus figures twice in the same composition: Raphael had already portrayed him as a cardinal mounted on a mule. We also find portraits of members of Leo X's court. Among them are the master of ceremonies, Paris De Grassi, carrying the processional cross; Serapica, the privy chamberlain of the pope, shown serving as a groom; and the Spanish mace bearer, Andrea da Toledo.

The *Liberation of Saint Peter from Prison*, on the opposite wall, is described in the Acts of the Apos-

tles: an angel appears to Peter as he sleeps and leads him to safety. Raphael has followed the sacred narrative closely, and the nocturnal scene is especially famous for the light that seems to come from five different sources: the moon, the dawn, the torches, and the angel, who appears twice. The luminous effect in the central part is emphasized by the black prison bars cutting across it, in vivid contrast to the dazzling angel, who seems really to radiate light.

The third room, called the Stanza dell'Incendio after one of its frescoes, the *Fire in the Borgo*, was decorated between 1514 and 1517. Little or none of the painting is from Raphael's own hand, for in those years he was overwhelmed by work and contented himself with furnishing designs and sketches to his pupils, Giovan Francesco Penni, Giulio Romano, and others, and supervising the execution of the frescoes. The theme of each composition is intended to honor Leo

X in the person of two great and saintly popes of the same name, Leo III (795–816) and Leo IV (847–55).

The *Fire in the Borgo*, on the wall opposite the main window, represents an episode taken from the *Liber Pontificalis*. According to this medieval source, Leo IV extinguished, by making the sign of the cross, a fierce fire that had broken out in the Borgo Santo Spirito. In the background of the fresco are the façade of Old Saint Peter's (the demolition of which had already begun, by order of Julius II), the Benediction Loggia, and part of the Vatican Palace. The scene is inspired by the Homeric account of the burning of Troy, and is the only painting in the room in which one may detect, here and there, Raphael's own hand.

Very fine, and much imitated by later artists, are the group, to the left, of a youth carrying an old man on his shoulders (evoking Virgil's account of Aeneas' escape from Troy with his father Anchises), and the figure of the woman with a jar of water to the right.

The *Battle of Ostia*, to the left of the *Fire in the Borgo*, represents another event recorded in the *Liber Pontificalis*, Leo IV's naval victory over the Saracens at the mouth of the Tiber in 849; it alludes to the energetic repression of Saracen piracy off the coast of Lazio by Leo X. The enthroned figure of Leo IV is, in fact, a portrait of Leo X; behind him stand his secretary and great friend, the learned Cardinal Bibbiena, and his cousin, Cardinal Giulio de' Medici, the future Clem-

The *Encounter of Leo the Great with Attila*, by Raphael, in the Stanza d'Eliodoro.

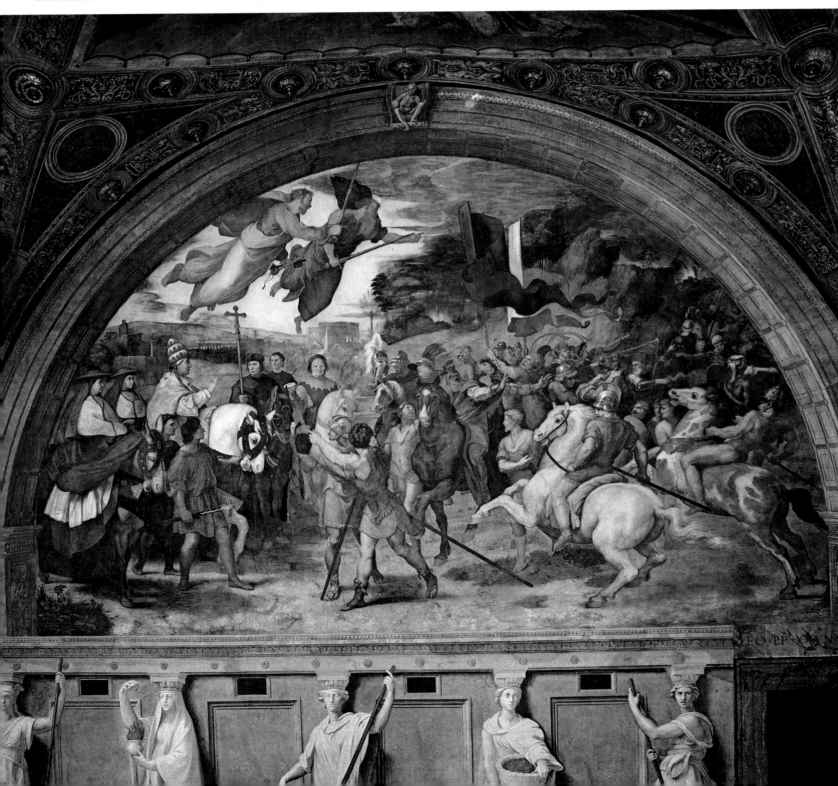

ent VII. In the background is the fortress of Ostia, which Baccio Pontelli had built for Cardinal Giuliano della Rovere, the future Julius II. The execution of this fresco may be attributed to Giulio Romano.

The *Justification of Leo III*, in the lunette over the main window of the Stanza dell'Incendio, commemorates an event that took place in Saint Peter's basilica on December 23, 800, when that pope decided to speak out in his own defense against the calumnies of his enemies. The inscription reads: "It is for God and not for men to pass judgment on bishops." The fresco is of poor workmanship, though the composition is harmonious and stately.

The fourth fresco in the room, the *Coronation of Charlemagne*, depicts a ceremony that took place in the same basilica two days later: on Christmas night of the year 800, Leo III invested the Frankish king, Charlemagne, with the title of Roman Emperor. Once again, Leo III has the features of Leo X, and the figure of Charlemagne is a portrait of Francis I; this is an allusion to the concordat between France and the Holy See, signed in 1515. The page boy carrying the crown is Leo's nephew, Ippolito de' Medici. The fresco is interesting artistically for its unusual perspective, for its sense of space, and for the play of light.

The paintings on the vault—a complicated glorification of the Blessed Trinity—are by Perugino; Vasari tells us that Raphael left them intact as an act of grateful homage to his former master.

Leo X

Cardinal Giovanni de' Medici, the second son of Lorenzo the Magnificent, became pope, as Leo X, in 1513. He was a highly cultivated man and a dedicated patron of the arts; in the Vatican, however, he restricted himself to continuing—with additions and variations—the projects conceived by his predecessor, Julius II. In artistic matters his name is linked, above all, to that of Raphael. We have seen that Raphael completed the decoration of the Stanza d'Eliodoro, and planned and supervised the decoration of the Stanza dell'Incendio, under Leo. In 1514 Bramante, on his deathbed, urged Leo to appoint Raphael his chief architect, and this was promptly done. Raphael, who had no experience as an architect, prepared himself for his new occupation by reading Vitruvius's classic treatise on architecture, which was translated into Italian for him by the humanist Marco Fabio Calvo of Ravenna.

Raphael's Logge

Raphael contributed to the carrying out of Bramante's project for the Cortile del Belvedere; the second gallery of the east corridor was erected under his supervision. More significant, however, was his completion of the Logge which Bramante had begun to construct as a new façade for the Vatican Palace. Vasari writes that Raphael "did some designing for the Papal Stairs and the Logge, which had been well begun by Bramante but which had remained unfinished because of the latter's death; they were then carried on with the new design and architecture of Raphael, who made a wooden model of them, with greater order and ornamentation." Thus Raphael did not limit himself to completing the work of his teacher; he also improved on it, though he did not choose to venture too far from Bramante's style. Just as Bramante developed the architectural possibilities of the medieval triple portico, so Raphael, following the rules of Vitruvius, logically completed Bramante's façade. In fact, when he had finished the second gallery as it had been designed, he built above it a colonnade with a straight entablature supported by fourteen Corinthian columns, thus realizing the classical sequence of the three orders. Together with this third gallery, he constructed the third story of the palace, without which the heightened façade would have been an absurdity.

In this added story are preserved two precious examples of Raphael's architecture: the little portico known today as the Loggetta, and the Stufetta, or bathroom, of Cardinal Bibbiena. They formed part of the apartment of Leo's secretary, Bibbiena, and were decorated between 1516 and 1519. The Loggetta, rediscovered in 1943, had been completely forgotten; the Stufetta was known but had fallen into ruin. The Loggetta, which overlooks the Cortile del Maresciallo, has three large arches alternating with four smaller ones, flanked by Doric pilasters that support a classical entablature. The elegant grotesques with which it is adorned are the work of Raphael's school, executed under his direction. Cardinal Bibbiena's bathroom is a small, sail-vaulted room, two and a half meters wide and just over three meters high, with a small window set into the side wall and two niches with finely carved marble bases. The room is covered with frescoes of mythological subjects, designed and partly executed by Raphael himself, on the model of the ancient paintings discovered a few decades earlier in the ruins of the *Domus Aurea* (Golden House) of Nero. This little masterpiece proves that greatness in architecture does not depend on vast dimensions, but on correct scale—"divine proportion," as the men of the Renaissance liked to say.

Raphael was also responsible for the decoration of the interior of the second story of the Logge that Bramante had begun and he had completed. He provided the designs and sketches, and the work was executed by his pupils, especially Giovan Francesco Penni, Giulio Romano, Perin del Vaga, and Giovanni da

North wall of the Stanza d'Eliodoro, with the
Liberation of Saint Peter from Prison, by Raphael.

123

Udine, between about 1517 and 1519. It was Giovanni da Udine who produced the wonderful grotesques and stuccoes, in which he closely imitated the decorations of Nero's Golden House. This style of decoration is called "grotesque," in fact, because its prototypes were found in the *grotte*, or caves—that is, in the subterranean halls—of the Golden House.

The first story of the Logge was open to the public, but the second was reserved for the private use of the pope, who kept his personal collection of antiquities there; one of the stucco reliefs shows him walking in this splendid gallery and giving his blessing to a bishop. Though the Logge have been badly damaged (more by men than by time), they still produce a festive and agreeable impression. Curious, and

typical of the Renaissance mentality, is the freedom with which the pagan mythological subjects on the walls are combined with the religious themes in the compartments of the vaults. The vault is frescoed with scenes from the Old Testament and the Gospels—fifty-two episodes in all, four to each of the thirteen bays. Hence the ensemble is sometimes known as Raphael's Bible.

Clement VII and Paul III

Raphael died, at the age of thirty-seven, on April 6, 1520; in December of the following year, Leo X died. The difficult conclave that ensued resulted in the election of a Dutch pope, Hadrian VI, who was a meteor of

The small portico known as the Loggetta, designed by Raphael. Decorated between 1516 and 1519, it formed part of Cardinal Bibbiena's apartment in the Vatican Palace.

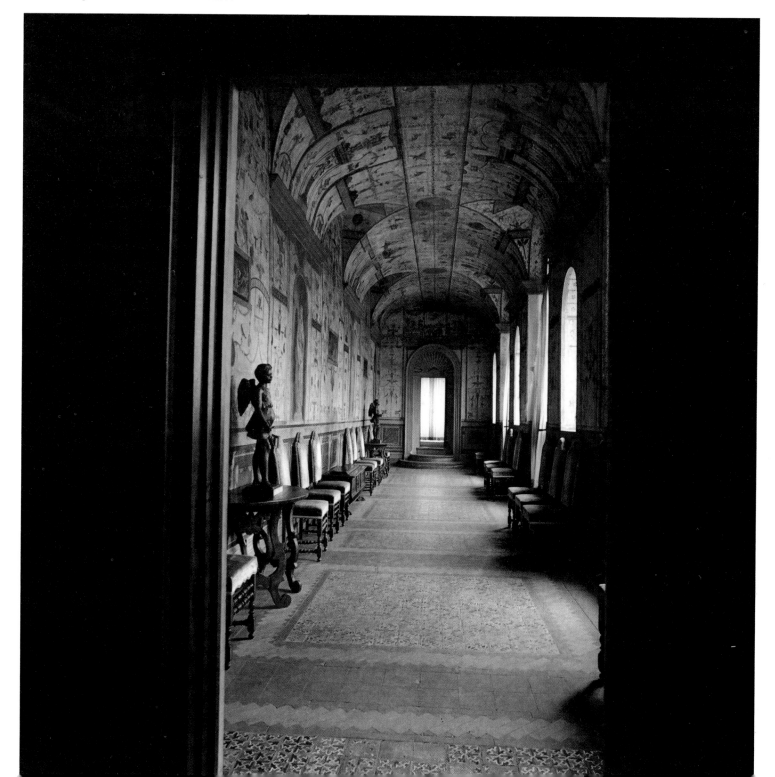

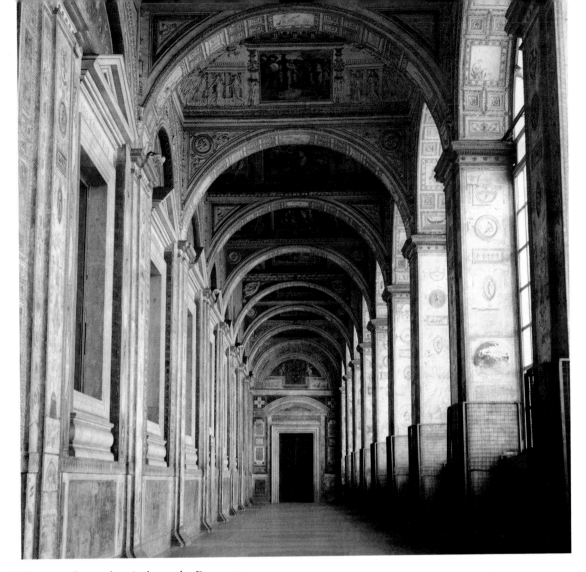

The second-story loggia, begun by Bramante and decorated by Raphael.

sanctity in the firmament of the Renaissance—which he abhorred. He reigned for only twenty months, and left no material mark on the Vatican. He was succeeded by Leo's cousin, Giulio de' Medici, who took the name Clement VII and whose pontificate was dogged by disaster. Clement proved incompetent to deal with the Lutheran reformation in Germany, which had begun during Leo's reign and which now came to a head, and he was caught in the middle of the struggle for control in Italy between the German emperor, Charles V, and the French king, Francis I. In 1527, German troops under a renegade French leader occupied Rome and, while Clement was shut up in Castel Sant'Angelo, subjected the city to the worst destruction it had endured since the barbarian invasions. Nevertheless, some work was carried out in the Vatican under the second Medici pope. He appointed as his architect Antonio da Sangallo the younger, who was responsible for the vault of the Sala Ducale and the upper stories of this wing of the palace. Also datable to Clement's pontificate is the completion of the fourth of the Stanze, the Sala di Constantino, the decoration of which had been planned under Leo X, but which was left unfinished at Raphael's death. According to contemporary accounts, Raphael himself was responsible for two allegorical figures, Justice and Meekness, which are painted in oil and not, like the other decorations, in fresco. The rest of the room is the work of Raphael's pupils, who claimed to have the master's original drawings at their disposal. Four large frescoes depict the episodes in the life of Constantine, the first Christian emperor, that led to the establishment of the Christian church in Rome and throughout the empire: his vision of the cross as a promise of victory, the Battle of the Milvian Bridge, his baptism, and his legendary donation of Rome to the papacy. Of these, the *Baptism of Constantine* was designed and painted by Giovan Francesco Penni; the other three are by Giulio Romano.

For the inspired boldness and royal grandeur of its undertakings, the reign of the last of the humanist popes, Paul III Farnese (1534–49), can well bear comparison with that of Julius II, with whom Paul shared a similarly tenacious will and a love of glory. He sum-

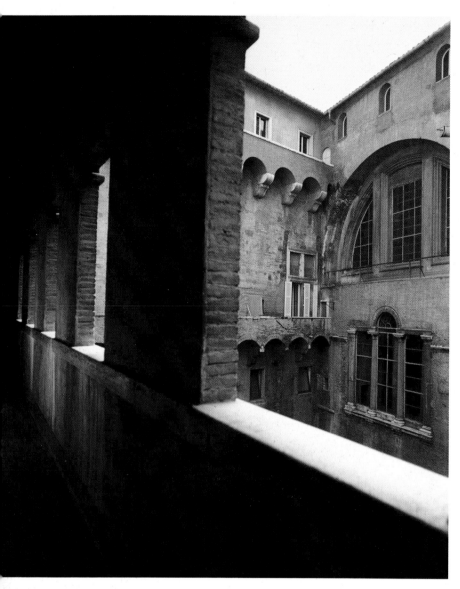

The windows at the north end of the Sala Regia,
seen from the Torre Borgia.

moned Baldassare Peruzzi from Siena and gave him
the task of repairing and consolidating Bramante's east
corridor of the Cortile del Belvedere, which had partly
collapsed in 1531. However, the principal architect of
Paul III was Antonio da Sangallo the younger, who
succeeded Peruzzi in 1536. He continued the work on
the corridor and built its upper story. He also strength-
ened the foundations of most of the old palace; this
operation, Vasari tells us, was a question "more of
danger than of honor"—that is, it was motivated by a
sense of responsibility, not by a desire for fame. The
fame of Sangallo and of the Farnese pope rests not on
these genuine but relatively obscure achievements, but
on another undertaking, in which the talent of the
architect and the taste of his client were able to ex-
press themselves freely: the renovation of the south-
west part of the papal residence, where hitherto little
had been done.

This part of the palace included the Sala Regia,
the Cortile del Maresciallo, the *capella parva Sancti
Nicolai*, and the old staircase leading to the Sala Regia.
These were used for public functions, whereas the east
and north wings were for the pope's private use. The
work was begun in the early spring of 1538 and was
carried out simultaneously according to a single, uni-
fied plan.

When Sangallo began work on the Sala Regia it
was a room with a beamed ceiling; above it were a
second story and an attic, in which the doors and win-
dows were placed haphazardly. Demolishing these,
Sangallo reinforced the walls and covered the room
with a majestic barrel vault forming a perfect half-
cylinder nearly six meters in diameter, set on a rich
cornice thirteen meters from the floor. The room was
adorned with stucco by Perin del Vaga, a former pupil
of Raphael's. Sangallo also demolished the *capella parva
Sancti Nicolai*, with its frescoes by Fra Angelico, in order
to enlarge and straighten the old stairway, the Scala
del Maresciallo. To replace the chapel, he constructed
a new one, known as the Pauline Chapel after Paul III.
It adjoins the Sala Regia to the south, and consists of a
vaulted rectangular space with a narrower rectangular
choir at the south end.

The Last Judgment *and the Pauline Chapel Frescoes*

It was under Paul III that Michelangelo returned to the
Vatican, to paint his great *Last Judgment* on the wall
above the altar of the Sistine Chapel. This fresco had
been planned by Clement VII as a "penitential memo-
rial" of the terrible Sack of Rome of 1527, which many
considered a divine punishment for the paganish ex-
cesses of the Renaissance. For Paul III, however, who
confirmed the commission to Michelangelo, the *Last
Judgment* was an allusion to the ecumenical council that
he so ardently desired—it was finally convoked at
Trent in 1545—and to the grave theological problems
discussed during the long years of its preparation, in-
cluding the primacy of Peter, justification, and the cult
of the Blessed Virgin and the saints. The immense fres-
co was painted between 1535 and 1541; it represents
the late style of Michelangelo, who was beginning to
be more deeply interested in religious problems than
in art. Content is here more important than form. In
comparison with the classical perfection of the Sistine
ceiling, the style of the *Last Judgment* seems strange,
distorted by mystical passion. On the whole, however,
it is faithful to the aesthetic norms of the Renaissance,
which had been established to a large extent by
Michelangelo himself, and to the traditional iconog-
raphy of the subject.

In the upper center, enthroned on the clouds of
heaven, Christ appears as judge, making a gesture of

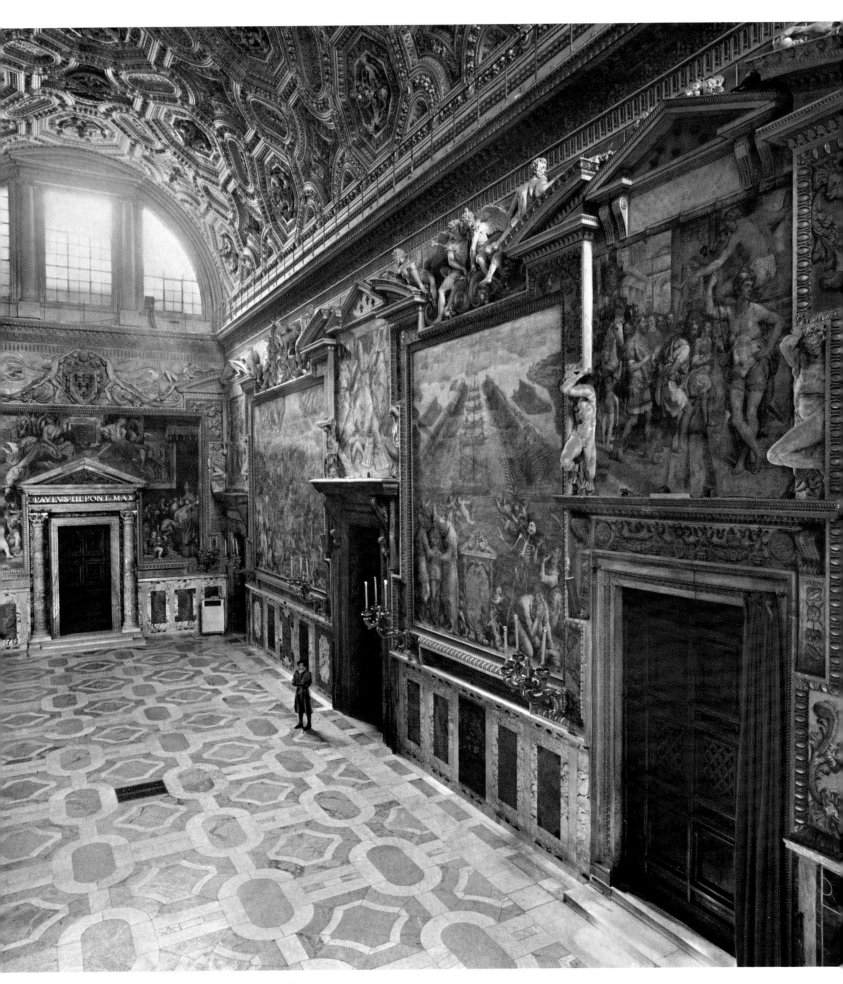

The Sala Regia. Under Paul III, Antonio da Sangallo the younger
added the majestic barrel vault to this medieval hall and Perin
del Vaga provided the stucco decoration. The frescoes were
painted for Gregory XIII by Giorgio Vasari.

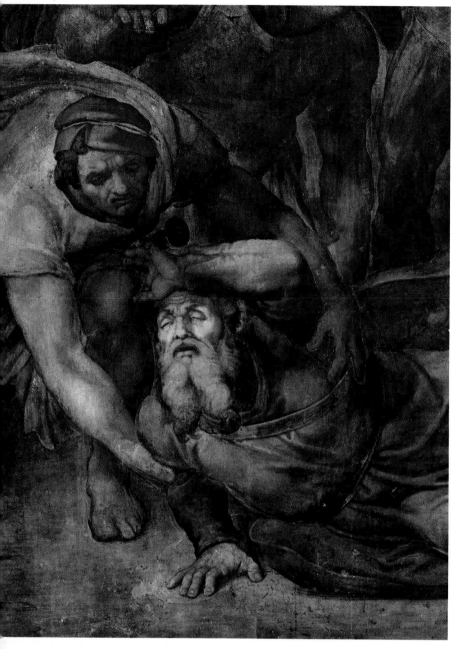

Detail of the *Conversion of Saint Paul,*
in the Pauline Chapel.

condemnation. His figure recalls ancient representations of Apollo and Hercules. Beside him stand the Blessed Virgin, who shares his halo; Saint John the Baptist; and Saint Andrew with his cross. At his right stands Saint Peter, with his enormous keys; Saint Paul is beside him. At Christ's feet are Saint Lawrence with his gridiron and Saint Bartholomew carrying his own skin, the face of which is a self-portrait of Michelangelo himself, a misshapen caricature. To the left of this central group stand the women, to the right the men. Among the latter are Simon of Cyrene, carrying the cross of the Redeemer, and Dismas, the good thief, with his own cross. In the small group of martyrs we see Saint Catherine with her wheel, Saint Blaise with his comb (these figures were later repainted by Daniele da Volterra), Saint Simon the Zealot with his saw, and Saint Sebastian with a bunch of arrows. In the middle section below are, on the left, the risen dead going up to heaven; in the center, a group of angels blowing trumpets; and on the right, the damned being thrust down to hell, struggling in vain with the angels (who are all represented without wings). One figure is unforgettable: a desperate member of the group of the damned, gazing into the abyss with one eye and covering the other with his hand. In the bottom section the resurrection of the dead is shown on the left, in the center a cave full of devils, and on the right the gate of hell with the bark of Charon, judge of the netherworld according to Dante. Michelangelo has given Charon the features of one of Paul III's masters of ceremonies, Monsignor Biagio Martinelli of Cesena, adding a long pair of ass's ears because Martinelli had taken the liberty of criticizing Michelangelo's work.

The *Last Judgment* had not yet been unveiled when Paul III requested, or rather ordered, the reluctant sculptor to paint two frescoes on the side walls of the Pauline Chapel, which Sangallo had recently constructed. One was to represent the Conversion of Saint Paul and the other, according to the first edition of Vasari's *Lives,* the Granting of the Keys to Peter; the subject of the second fresco was later changed to the Martyrdom of Saint Peter. Michelangelo began to work toward the end of 1542, and completed the first fresco in the summer of 1545; Paul III, as a token of his esteem, climbed a ladder in order to have a close look. Immediately afterward, the painter began the second fresco, which he completed early in 1550, when he was seventy-five years old.

The subject of the first fresco was no doubt dictated by the pope himself, who used to go to the basilica of Saint Paul each year on January 25 to celebrate the feast of the conversion of the apostle whose name he bore. And Michelangelo must have welcomed the opportunity to depict this event in the Acts of the Apostles, the preeminent example of the working of

The *Last Judgment,* by Michelangelo,
in the Sistine Chapel.

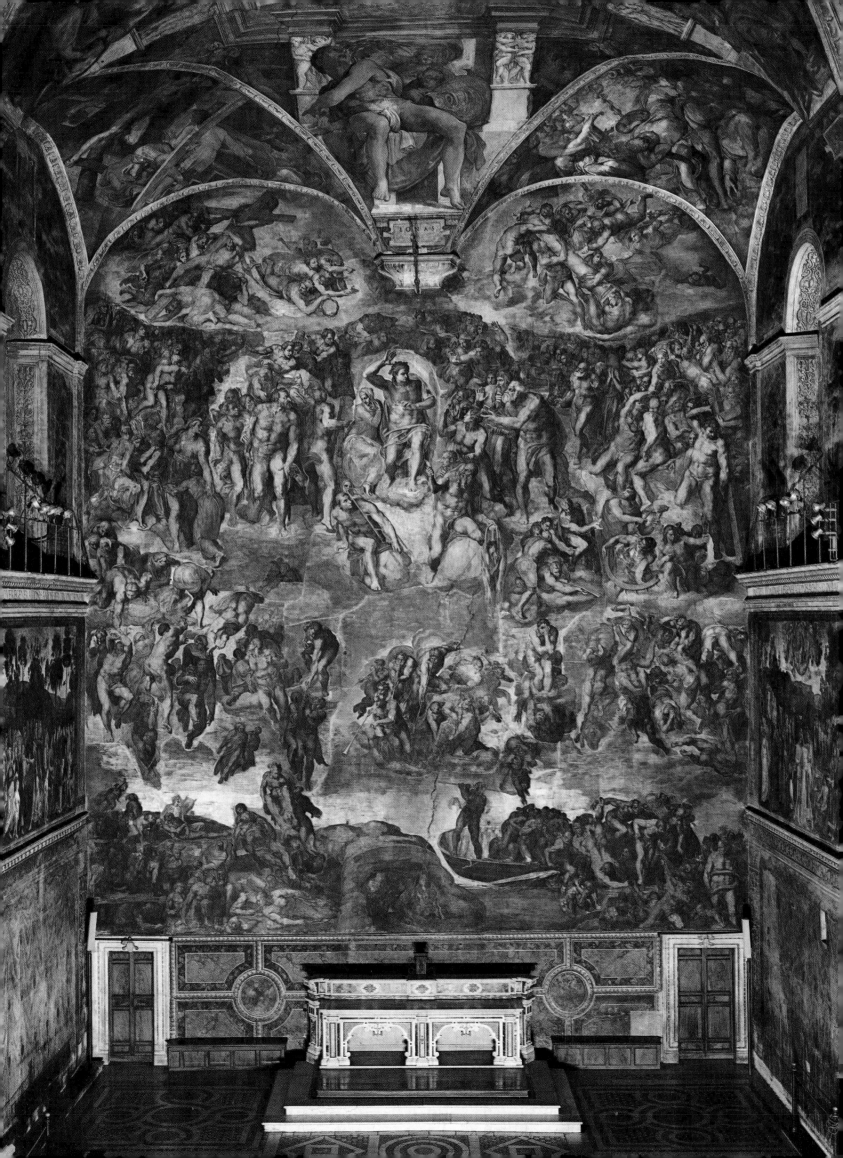

divine grace; the theme of grace was a central one in the pre-Tridentine disputes, and one in which Michelangelo was deeply interested, as we know from the religious poetry of his later years. This interest explains some of the unusual stylistic aspects of the fresco.

In the *Conversion of Saint Paul*, Michelangelo follows faithfully the text of Saint Luke: Christ appears on high, surrounded by a multitude of wingless angels, hurling a thunderbolt with his right hand, while with the other he points to the city from which the persecutor will emerge as the Apostle of the Gentiles. Saul, thrown from the saddle and blinded, hears the divine call and raises himself up on his elbow with the help of a soldier. The others meanwhile are fleeing in disorder and the horse is galloping off into the distance. On a hill, amidst the barren landscape, is Damascus, the city toward which the party is traveling in order to arrest the Christian community there. It is sketched with quick brushstrokes, almost in the Venetian manner. As in the sacred text, the essence of the episode is the dramatic dialogue between the soul and God. Christ is hidden from Saul by the light that flashes

Detail of the *Last Judgment*, showing the group of the Elect and the figures of Saint Peter, with the keys, and of Simon of Cyrene, taking Christ's cross on his shoulders.

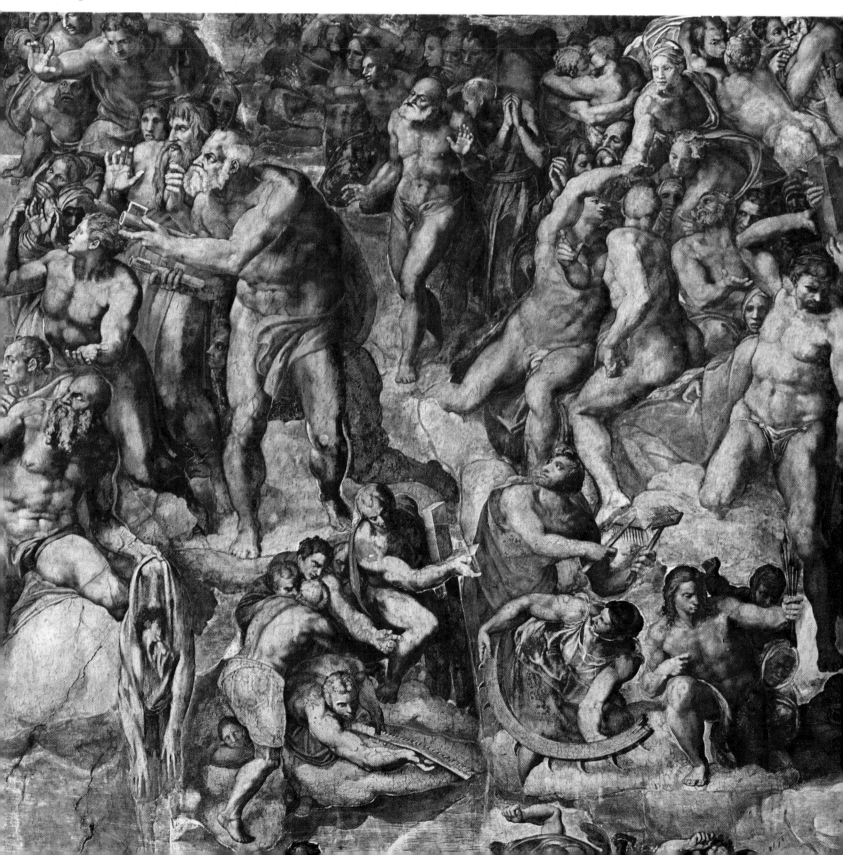

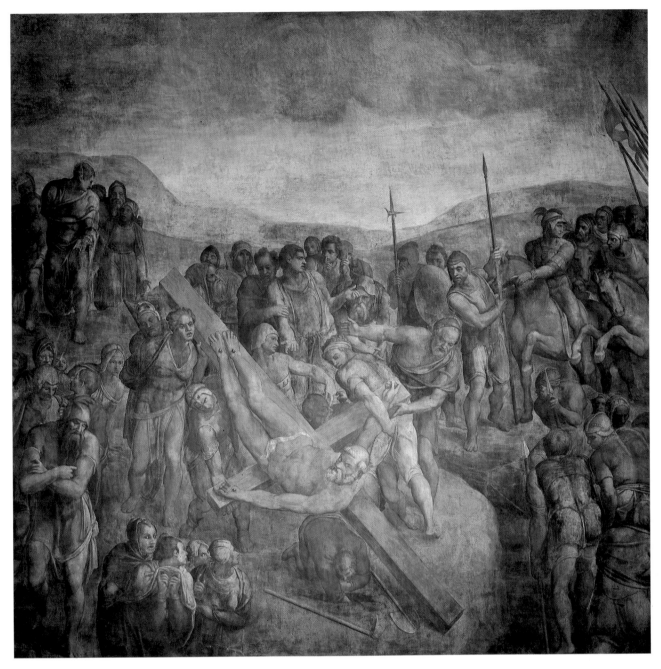

The *Martyrdom of Saint Peter*, by Michelangelo,
in the Pauline Chapel.

from his all-powerful arm; the massive body of the fallen sinner is lightened, spiritualized, drawn upward by grace.

The miraculous nature of the event is expressed through stylistic means that are quite contrary to the classical aesthetic norm of idealized realism that triumphs on the Sistine ceiling. A classical fresco harmonizes with its architectural setting and complements it; here—even more than in the *Last Judgment*—the solidity of the wall is denied, and we seem to catch a glimpse into the space beyond it. This impression is heightened by the way in which foreground figures of soldiers are cut off by the lower edges of both the

frescoes of the Pauline Chapel. The composition of the *Conversion of Paul* is rendered deliberately asymmetrical by the phosphorescent diagonal that divides it from top to bottom. The size of the Lord's arm is not in proportion to his figure, but rather to its value as the symbol of his power. The luminous face of Saul, now become Paul, is not darkened by the shadow of the man bending over him. The different treatment of the various figures is also anticlassical. Saul and the soldier are carefully delineated; they are among the most perfect figures ever created by Michelangelo. But others, in whom the ethical interest of the scene is not concentrated, are rendered so sketchily as to seem

hardly real—many, in fact, are drawn in a manner that no one in the sixteenth century could have considered worthy of the author of the famous male nudes of the Sistine ceiling. Such a comparison is not legitimate, but it was made at the time by people who did not understand that classical "design" is not the only possible one, nor that the uncertainties and oddities of the *Conversion* represent the search for a new formal language. For the language of the High Renaissance, with its clearly drawn, humanistic limits, could not offer a vehicle for the kind of mystical content that concerned Michelangelo here. It should be pointed out that the figure of Saul is a slightly idealized portrait of Michelangelo himself: this emphasizes the intimate nature of the fresco, which is indeed the reflection of a deeply personal religious experience rather than a work of art in the usual sixteenth-century sense.

The fresco on the opposite wall, the *Martyrdom of Saint Peter*, is of an entirely different nature. One might almost say it represents an attempt to recover from the mystical reverie of the *Conversion of Paul*. In that painting, violent agitation reigns; the flash of lightning is the dominant element in a heaven no less populous than the earth, where men scatter in panic. Here, on the other hand, the empty sky stretches its livid hues over desolate heights, and a slow movement binds together compact groups of figures as in a travertine bas-relief. On the left, a mysterious force draws upward a solid group of legionaries, which is cut off by the edge of the fresco; the same force passes over the central group and descends again on the other side, losing itself once more in the invisible abyss. A troop of armed cavalry on one side, and on the other a procession of people, sad and silent, led by a giant with folded arms, enter into the fatal current, like symbols of the iniquitous law and the vileness of the mob that kill the apostle. Peter undergoes his martyrdom as though it were an apotheosis. He is a titan; he could rout his tormentors, but does not wish to. A young disciple, in the group above the cross, is in the act of shouting out his indignation; a companion restrains him by grasping his arm, while another exhorts him to silence by putting a finger to his lips. The four women in the foreground weep, unable to restrain their sorrow and compassion. The young gravedigger, making the hole to hold the cross, is an isolated figure, a man apart, indifferent to what is happening around him, detached from the world, plunging his bare arm into the cold earth, almost as if attracted by the fascination of death, by its peace.

The two frescoes of the Pauline Chapel are the last representational works of art by Michelangelo. His century did not understand this final evolution and, respectful of his glory, kept silent rather than find fault. He himself perhaps suffered from self-doubt, and in his final years he sought peace for his anguished spirit, and health for his soul, in the abstract harmonies of architecture, building the cupola of Saint Peter's, as Vasari tells us, "for the love of God and without any reward."

From Julius III to Gregory XIII (1550–85)

Paul III died on November 10, 1549; Antonio da Sangallo had preceded him three years earlier. Their passing may be said to mark the end of the Renaissance, both as a cultural phenomenon and as a period in the history of the church. In the arts, the Renaissance was now giving way to a new, anticlassical style, called Mannerism, which in some ways was a forerunner of the Baroque; in religion, the humanism of the earlier sixteenth century was superseded by the spirit of the Counter Reformation, as formulated by the Council of Trent.

As far as the Vatican Palace is concerned, the reign of Julius III (1550–55) is of no great importance. His architects were Girolamo da Carpi and Jacopo Vignola, and they were supervised by the aged Michelangelo, who was much venerated by the new pope. They constructed a few rooms behind the north façade of the Cortile del Belvedere, to the left of Bramante's exedra. This façade had served only as a sustaining wall for the Cortile delle Statue adjoining the Belvedere of Innocent VIII, which was on higher ground than the upper level of the Cortile del Belvedere. A second story was added to this façade, and the upper part of the exedra was transformed into an enclosed semicircular corridor joining the old rooms to the east with the new ones to the west. Bramante's original flight of convex and concave steps within the exedra thus no longer served a purpose; it was replaced by a new one, designed by Michelangelo but much altered in later times. Julius also built an apartment for himself over the south end of the east corridor of the Cortile del Belvedere; it was frescoed by Daniele da Volterra and Taddeo Zuccari.

The twenty-two day reign of Marcellus II in 1555 left no architectural trace, though a masterpiece of sacred music, Palestrina's *Missa Papae Marcelli*, was composed in this pope's memory. Marcellus' successor, Paul IV, who reigned until 1559, was content for the most part with continuing and decorating the constructions begun by Julius III. It was Paul who appointed to the post of papal architect Pirro Ligorio, a Neapolitan, who was to play a considerable role under the next pope, Pius IV (1560–65).

A drawing of the Cortile del Belvedere by Giovanni Antonio Dosio, made at about this time, shows how much of Bramante's monumental project still remained unexecuted. The entire west corridor

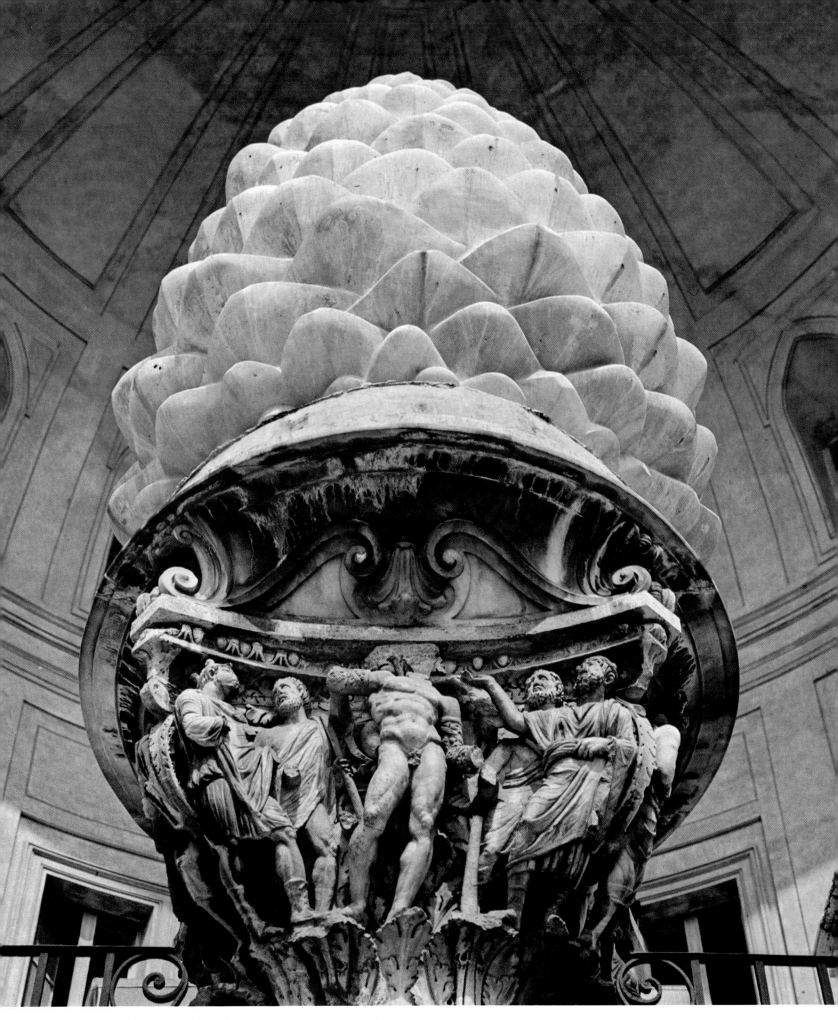

The northern subdivision of the original Cortile del Belvedere is called the
Cortile della Pigna. It takes its name from the gigantic bronze pinecone
that stands in Pirro Ligorio's Nicchione. In ancient times the
pinecone adorned a fountain in the temple of Isis; during the Middle
Ages it was moved to the forecourt of Saint Peter's, where it
remained until the beginning of the seventeenth century.

Pirro Ligorio began the construction of the west wing of the Cortile del Belvedere under Pius IV, keeping to Bramante's original project for the monumental court.

was still to be constructed; the stairways connecting the three levels had to be finished; and the thorny problem of the south end was unresolved. Pirro Ligorio, under Pius IV, turned his attention to the west corridor; a plan and an elevation, drawn by him, are preserved in the Istituto Nazionale di Archeologia e Storia dell'Arte in Rome. With the exception of a few details, Ligorio kept to Bramante's original project in constructing the west wing; the south façade—which was never completed—would, however, have hidden the windows of the Borgia Apartment behind a two-story exedra decorated with niches and statues, like the stage set of a Roman theater. Ligorio also added a new wing to the rooms built by Julius III at the north end, enclosing on its west side the Cortile delle Statue of the Belvedere of Innocent VIII.

Ligorio's principal contribution was the construction of the Nicchione, or great apse, that surmounts Bramante's exedra on the north façade of the Cortile del Belvedere. As Bramante had left it, the exedra, with its almost Mannerist flight of steps, was the focal point of the cortile; it added complexity and variety, but harmonized completely with its setting. Girolamo da Carpi, by adding a story and surrounding it by a closed corridor, had deprived it of its architectural purpose; it was now merely a semicircular niche, like an apse without a vault. Ligorio, with his Neapolitan imagination, conceived the idea of bringing the new construction to its logical conclusion by adding the missing vault. This he did, in a way consonant with his artistic taste, which was the product of his antiquarian erudition. Inspired by Roman monuments, he enclosed the exedra within a new construction, converting it into a true apse with a hemispherical vault, tall enough to stand out above the adjacent wings (the cornice is more than seventeen meters above the ground) and thus to provide the Cortile del Belvedere once again with a monumental focus. The Nicchione is so original, so audacious, so imposing in its Roman sobriety that some historians have supposed that Ligorio was following a lost design by Michelangelo. It was originally covered by a simple roof; in 1564 a terrace was added at the top, consisting of a semicircular peristyle flanked by pedimented aediculae. As critics have pointed out, this addition seems flimsy in comparison to the massive apse beneath it. It is true that the proportions are not those of real classical architecture. They reflect, however, the imaginary architecture of decorative Roman painting. And the contrast with the terrace above it has the effect of making the Nicchione look even taller than it actually is.

In the Vatican Gardens, Pirro Ligorio built the villa known as the Casino of Pius IV, which will be described in another chapter of this volume. He also began the construction of what is now the Cortile di

Pirro Ligorio and Martino Longhi the elder constructed the north wing of the Cortile di San Damaso, repeating the design of Bramante's and Raphael's Logge.

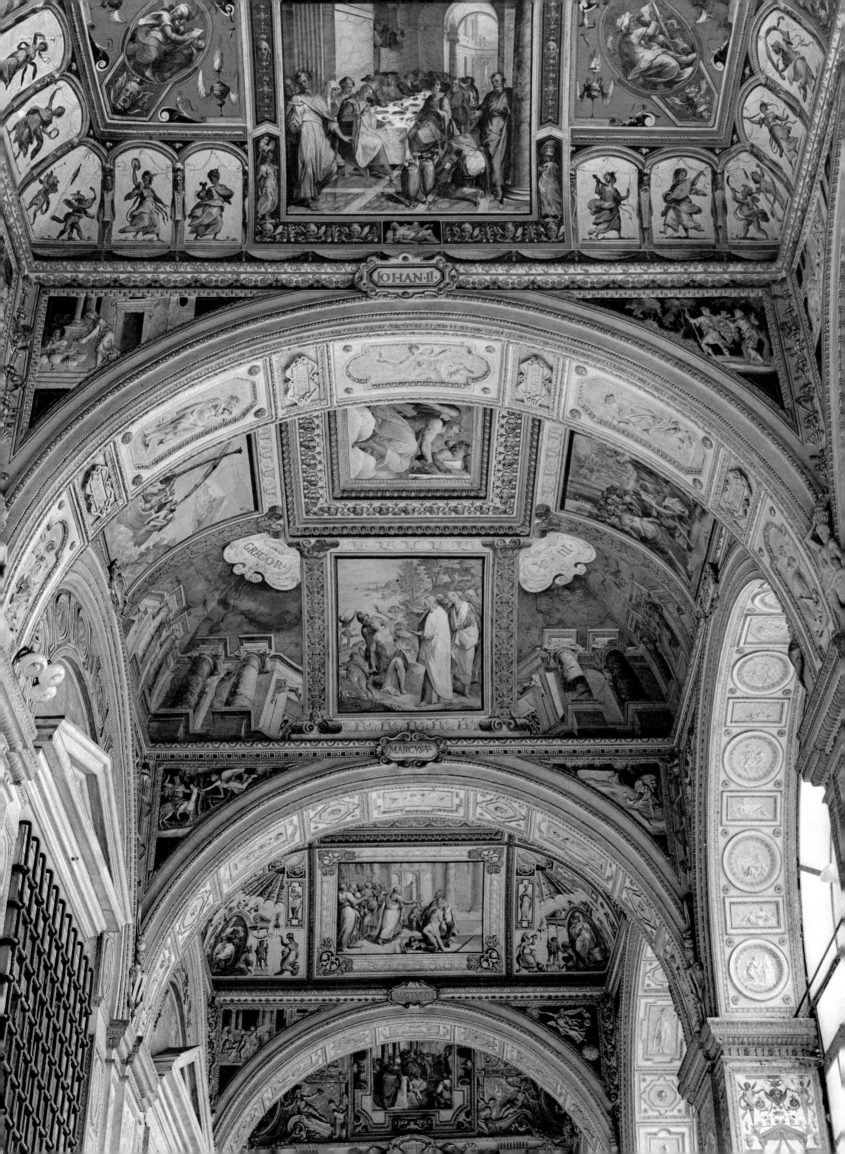

IOHAN·II

GREGOR

MARCVS·V

San Damaso. The Logge erected by Bramante and Raphael as the main façade of the palace terminated, at the north end, in a corner tower left over from the fourteenth century, beyond which was the east corridor of the Cortile del Belvedere. The heterogeneous appearance of these three adjacent structures was considered unsatisfactory. Antonio da Sangallo had proposed a solution similar to the one that Ligorio now adopted: the isolation of Bramante's and Raphael's façade by means of a new wing perpendicular to it. The garden of the old palace, the Hortus Secretus, would thus be closed on its north as well as on its west side; this marked the beginning of its transformation into a courtyard. Documents show that Ligorio worked on this project from June 1563 until the death of Pius IV in 1565, but only the first three bays of the new wing were constructed at that time.

The pope elected in 1566, the saintly and ascetic Pius V, was not, as is sometimes said, hostile to the arts. But he was rather suspicious of them; he donated many of the statues acquired by his predecessor, in fact, to the municipal collection on the Capitoline. Immediately after his election, he ordered the completion of Ligorio's west corridor of the Cortile del Belvedere, only the first floor of which had then been constructed. He also continued work on the Torre Pia, an imposing structure begun under Pius IV to connect the new corridor with the Torre Borgia. Gregory XIII (1572–85) appointed as his architect Martino Longhi the elder, who completed the second arm of the Logge di San Damaso without altering Ligorio's plan. The new Logge were richly decorated with stuccoes and frescoes; behind them, Longhi built the wing known as the Palace of Gregory XIII, which contains some of the most elegant rooms in the Vatican.

Longhi disappeared from the scene after 1577, and his place was taken by Ottaviano Mascherino, who completed the third story of Ligorio's corridor, the famous Galleria delle Carte Geografiche, which takes its name from the thirty-two maps painted in fresco on its walls. They constitute the most important cartographical undertaking of the sixteenth century; they were drawn up between 1580 and 1583 by the Dominican cosmographer Egnazio Danti of Perugia, who furnished the cartoons for the frescoes. The maps offer an extremely accurate description of all the regions of Italy, ancient and modern, together with the islands of Sicily, Sardinia, and Corsica, and the territory of Avignon, which was still the property of the Holy See. Beside the entrance, on a smaller scale, are views of the siege of Malta, the battle of Lepanto, the isle of Elba, and the Tremiti Islands; at the other end are represented the chief ports, Genoa, Ancona, Venice, and Civitavecchia. The vault of the gallery, lavishly decorated with gilded stuccoes and historical and al-legorical frescoes related to the various regions, is the work of a team of Mannerist painters headed by Girolamo Muziano and Cesare Nebbia. A contemporary of Gregory XIII's wrote: "What surpasses all wonderment is the gallery, which has been decorated throughout with stuccoes and gilding and paintings of the topography of all Italy, distinguished according to the various provinces, to a very accurate scale; it is perhaps the most beautiful thing of its kind to be seen today." At the northern end of this splendid gallery rises the imposing Torre dei Venti, the "Tower of the Winds." It was planned by Gregory—who is famous above all for his reformed calendar, the Gregorian calendar in use today—as an astronomical observatory.

Sixtus V

Sixtus V, the former Felice Peretti, elected in 1585, was the last of the great builder-popes of the sixteenth century. During the five years of his pontificate, he and his architect, Domenico Fontana, completely transformed the face of Rome. In the Vatican they constructed a new home for the Apostolic Library and a new wing of the palace, where the pope resides to this day.

The new library, which will be discussed more fully in another chapter, is a building perpendicular to the two corridors of the Cortile del Belvedere and connected to them at either end, about midway between the old palace and the Belvedere of Innocent VIII. It has the architectural dignity that is characteristic of Fontana's style, but its construction destroyed irrevocably one of the main functions of the Cortile del Belvedere as Bramante had conceived it, which was to provide an uninterrupted vista, rising gradually in three stages, from the windows of the Vatican Palace toward the exedra. For this reason a later pope, Paul V (1605–21), considered demolishing the library, but his plan was never put into effect.

The new residential wing, on the other hand, is a notable contribution to the architecture of the period. We have seen that the addition of a new arm to the Logge by Ligorio and Longhi solved an architectural problem that had been posed, but left unsolved, by Bramante. Longhi and, after him, Mascherino attempted to carry the solution to its logical conclusion by adding a third arm, perpendicular to the second and facing the original façade that Bramante had conceived. The third arm, as completed by Fontana, was to serve as the façade of a completely new papal palace, to the east of the old nucleus, rectangular in plan and built around an internal courtyard, covering an area of 2,809 square meters. Like the second, the third arm repeats the structural scheme of the Logge of Bramante

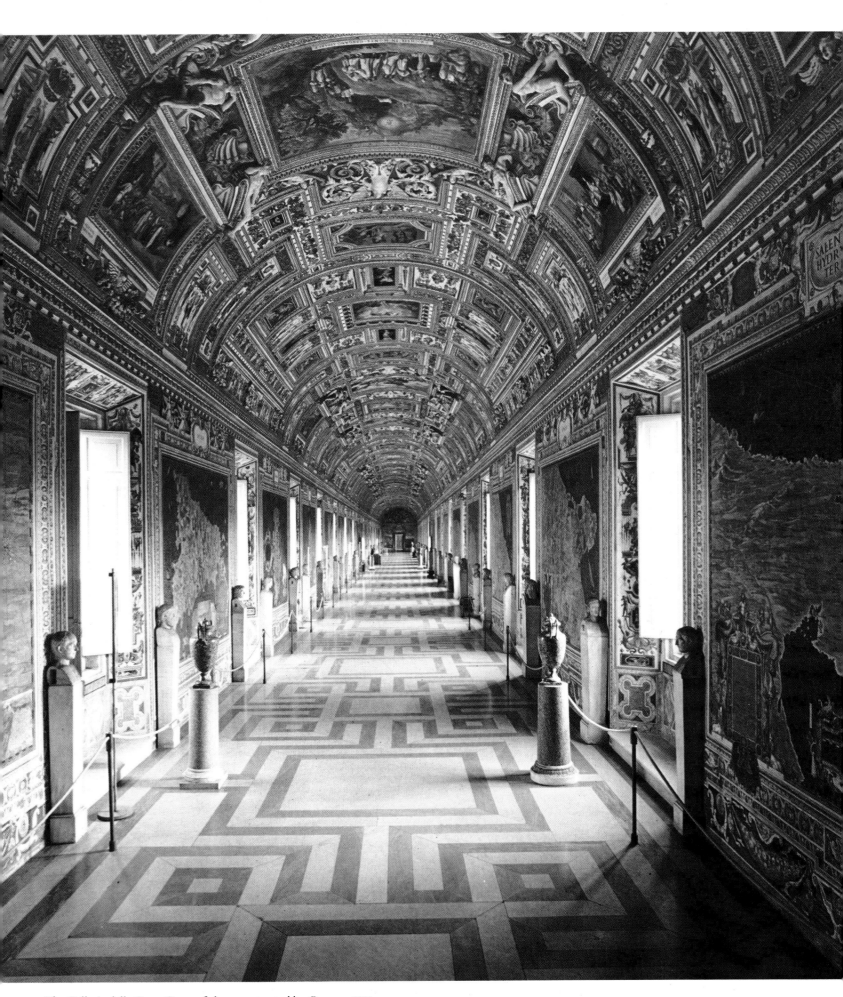

The Galleria delle Carte Geografiche, constructed by Gregory XIII
as the third story of the west wing of the Cortile del Belvedere.
The cartoons for the thirty-two frescoed maps were drawn
by the Dominican cosmographer Egnazio Danti.

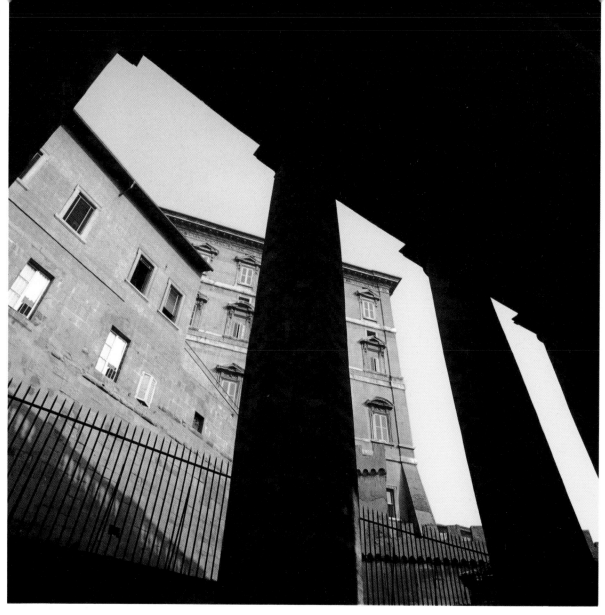

The residential wing constructed by Domenico Fontana for Sixtus V, seen from the colonnade of Saint Peter's.

and Raphael: it consists of a ground floor surmounted by three galleries, corresponding to the stories of the palace; the two lower galleries are arched and vaulted, while the third consists of a colonnade with a straight entablature and a flat ceiling. Fontana's Logge (and the new building behind them) do not, however, extend as far toward the south as Bramante's, so as not to cut off the glorious view of Rome from the earlier galleries.

Fontana's plan for the new palace called for eighty-five rooms. Work was begun in April 1589 and was almost finished by the summer of 1590, when Sixtus died. There followed three short pontificates (1590–91) that left little or no mark upon the architecture of the Vatican. The pontificate of Clement VIII (1592–1605) coincided with the transition from Mannerism to the early Baroque. Domenico Fontana left Rome; his place was taken by his brother Giovanni and the architect Taddeo Landini, who were given the task of completing the palace of Sixtus V. The cornice, in fact, is

decorated with the emblems of the new pope. It was Landini, in all probability, who audaciously tampered with Fontana's plan by removing the floor between the second and third stories in one corner of the palace and converting the original rooms into a single vast hall, the Sala Clementina, which measures 23 by 14.40 meters and serves as the majestic vestibule to the papal apartments. It is vaulted, and lit by two tiers of windows; the Mannerist decorations are by Giovanni and Cherubino Alberti. The adjoining Sala del Concistoro, with its richly carved and gilded ceiling, was frescoed by Cherubino Alberti and Paul Bril.

The Seventeenth and Eighteenth Centuries

With the completion of the palace of Sixtus V at the beginning of the seventeenth century, the complex of buildings begun by Nicholas III in 1277 acquired the form it was to conserve until the construction of the

Museo Pio-Clementino at the end of the eighteenth century. Clement VIII and most of his successors preferred to spend large parts of the year at a new palace, the Quirinale, which was constructed late in the sixteenth century as a summer residence, on a hill in Rome where the air was supposed to be healthier than in the low-lying Vatican. A few popes, such as Paul V (1605–21), made minor improvements in the Vatican, but he and his successors during the Baroque period tended to lavish their attention on the embellishment of Saint Peter's Basilica. With the completion of Carlo Maderno's façade of Saint Peter's in 1614, a new problem arose: how to link the basilica harmoniously with the picturesque but disorderly conglomeration of buildings, of different periods and styles, that rose to its right—the Vatican Palace. Various plans were submitted; Paul V chose one by Martino Ferrabosco and the Dutch architect Jan van Santen (known as Vasanzio in

The Cortile di San Damaso and
the palace of Sixtus V.

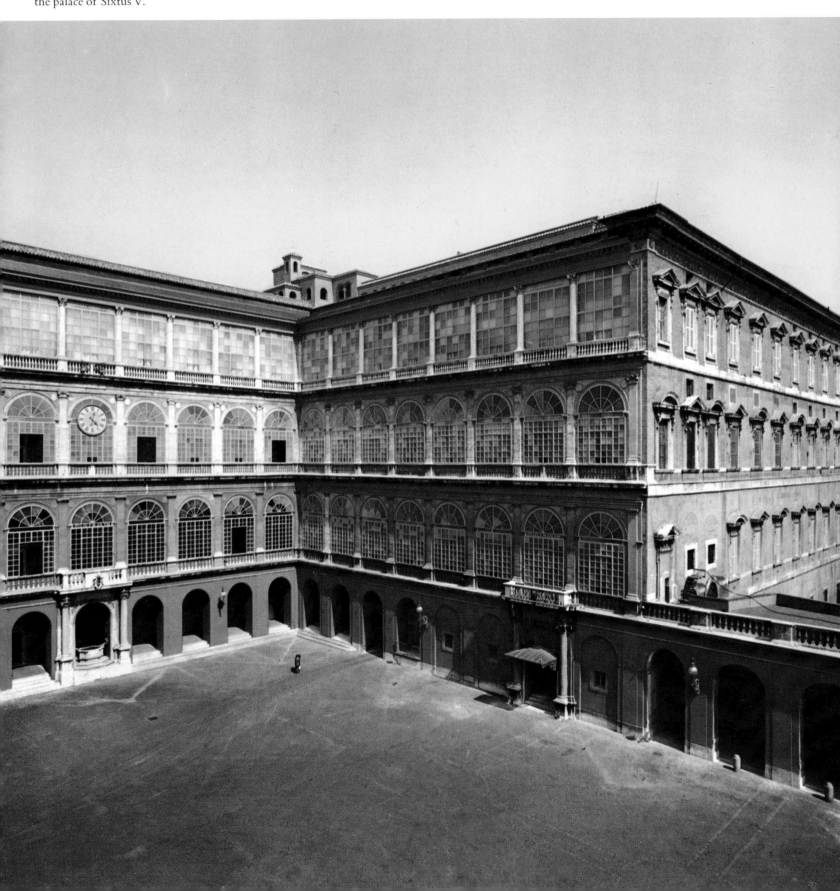

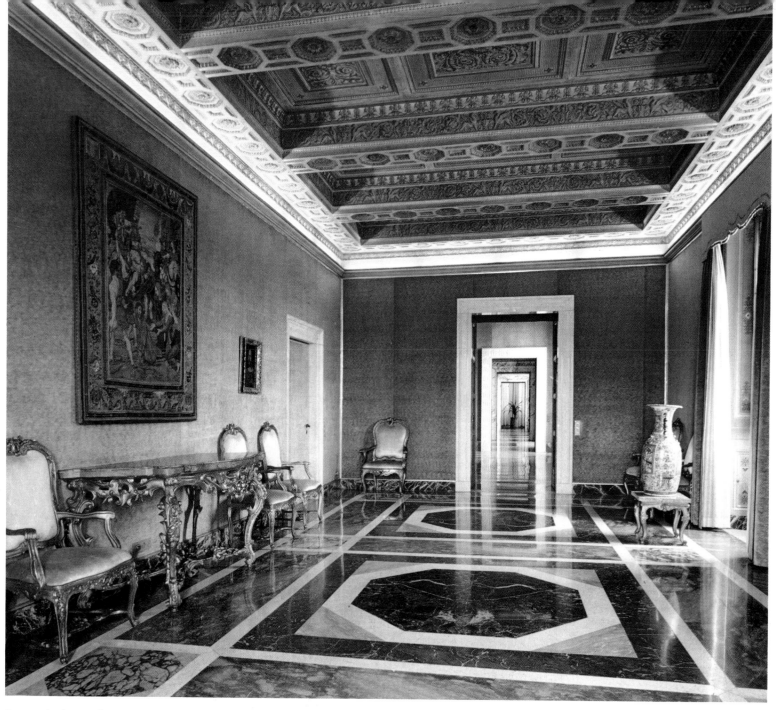

A room in the papal apartments
in the palace of Sixtus V.

Italy), both of whom were assistants of Maderno's. The project was for a new entrance to the palace, called the Porta Horaria, consisting of a gallery (which was never built) connecting the north side of Saint Peter's Square with a tower (later pulled down to make way for Bernini's colonnade) surmounted by a monumental clock and a graceful belltower. All that remains of this complex is a small addition to the palace, adjoining Bramante's Logge to the south and projecting diagonally toward the square; this was perhaps designed by Maderno.

Of much greater importance in the building history of the Vatican Palace was the reign of Alexander VII Chigi (1655–67), whose greatest claim to glory is Bernini's colonnade around Saint Peter's Square; he also had Bernini design a new, monumental entrance to the palace, the Scala Regia, which is one of the most important examples of Baroque architecture in Italy and, indeed, in the whole world.

Bernini used to say, "If you want to see what a great man can do, you must put him in difficulty." And difficulties were not lacking when he built the Scala Regia, which he himself considered the most arduous operation that he ever undertook. The task entrusted to him by the pope was to replace the old staircase leading from Saint Peter's Square to the Sala

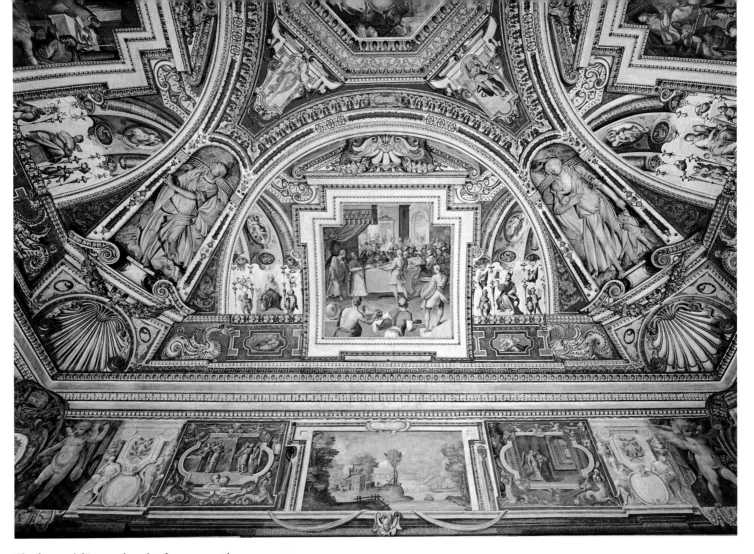

The frescoed frieze and vault of a room on the
second story of the palace of Sixtus V.

The pope's private library in
the palace of Sixtus V.

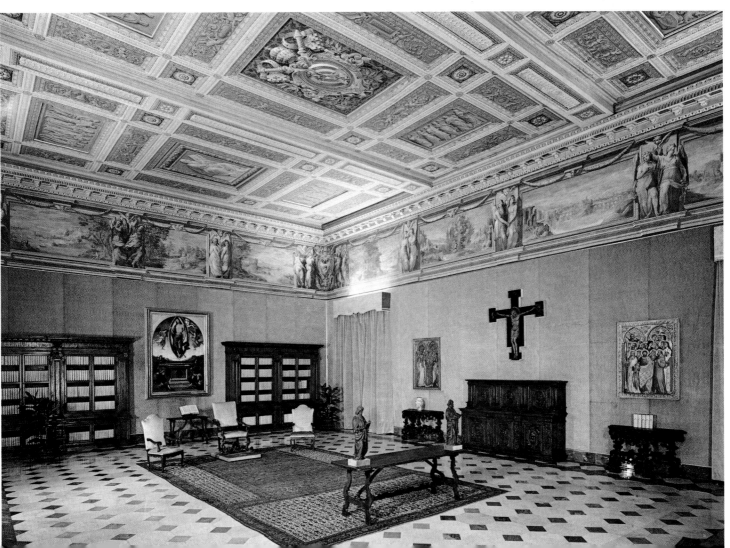

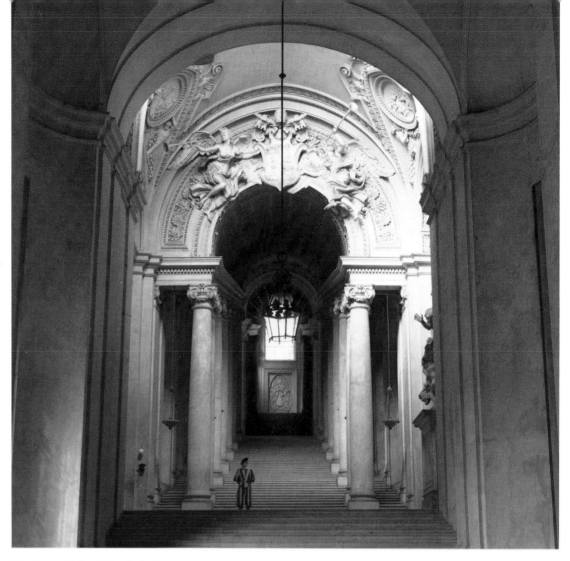

The lower flight of the Scala Regia.

The Sala Ducale, renovated by Bernini for Alexander VII.

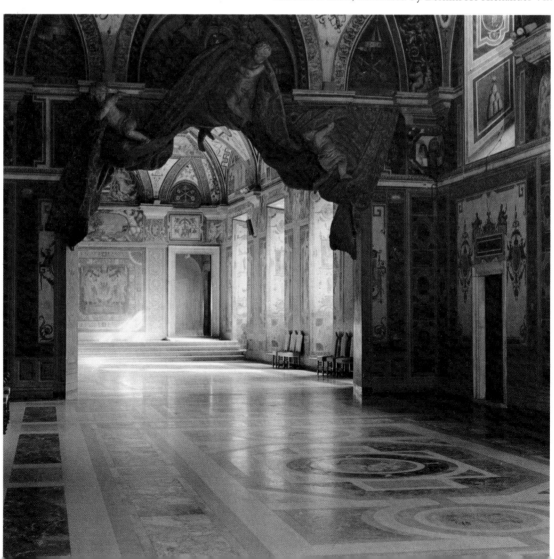

Regia in the palace, which had been built by Antonio da Sangallo, with a new one that was wider, more convenient, better illuminated, and more ornate. Bernini faced and solved the many problems involved in the most logical and practical way, with the simplicity of genius. The existing lower flight could not, in fact, be widened or rendered more convenient by interrupting the steps with landings. Bernini did, however, use elegant, economical means to provide it with a noble décor. On each wall six pairs of pilasters support a cornice from which springs a barrel vault, ornamented with stucco and illuminated by two openings. The upper flight had to conform to an oddly shaped ramp whose walls are 8.30 meters apart at the bottom and 4.80 meters apart at the top; since these walls and their vault supported the weight of the Sala Regia and the Pauline Chapel on the floor above and could not, therefore, be reconstructed, Bernini solved the problem by lining the staircase with an interior colonnade, which supports its own barrel vault on its architrave. The diameter of the vault is less than the distance between the walls at the bottom of the flight, so that the entrance to it no longer seems disproportionately large; at the same time, this arrangement strengthens the whole structure considerably. As the stairway ascends, the height of the vault and the height and diameter of the columns diminish; this creates an extraordinary effect of theatrical perspective that makes the flight look longer than it actually is. The Scala Regia was completed in the summer of 1665.

Alexander VII also assigned Bernini to renovate the old Sala Ducale, which consisted of two contiguous halls, each on a different axis. Bernini, with his genius for theatrical decor, compensated for this irregularity with a device that was itself irregular: he partially masked the opening between the two spaces with simulated drapery of marble, held aloft by flying angels.

Clement XIV, Pius VI, and Pius VII

After Alexander's death in 1667, there was no more monumental construction in the Vatican for more than a century. Clement XIV, who came to the throne in 1769, opened a new phase in the building history of the palace with the creation of what was to become one of the first and greatest museum complexes of the modern world: the Museo Pio-Clementino, as it came to be called. It will be discussed in the section on the Vatican Museums, but some of its architectural features may be mentioned here.

Since the time of Julius II, the Vatican's only collection of ancient statues had been kept in the Cortile delle Statue in the Belvedere of Innocent VIII. Other statues, found in excavations and bought by the popes,

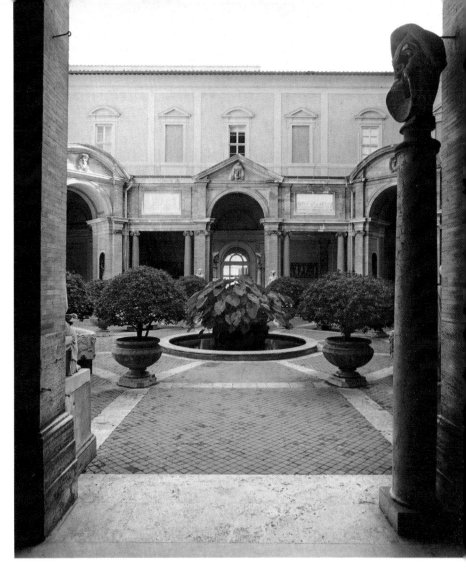

The Vatican Museums originated in the Cortile delle Statue, adjoining the Belvedere of Innocent VIII: it was here that Julius II installed his ancient marbles, including the Apollo Belvedere and the Laocoön. The cortile was given its present octagonal shape by Alessandro Dori under Clement XIV.

were placed in the Capitoline Museum—which by this time was becoming overcrowded. In 1770 the Holy See acquired the important Fusconi and Mattei collections; to house them, a new museum, called the Museo Clementino, was established. The architect Alessandro Dori transformed the loggia of the Belvedere into an exhibition gallery, called the Galleria delle Statue, and added to it the room known as the Gabinetto delle Maschere. In doing so, he altered the quattrocento character of Innocent's villa, but did not spoil it completely; Mantegna's chapel was preserved. Dori also gave to the Cortile delle Statue its present elegant octagonal form, with specially constructed niches for the Vatican's most celebrated statues, such as the Apollo Belvedere and the Laocoön.

Clement XIV died in September 1774 and was succeeded, in February of the following year, by Pius VI Braschi, of whom a contemporary wrote, "He

Sala Rotonda of the Museo Pio-Clementino.

Interior of the Sala Rotonda.

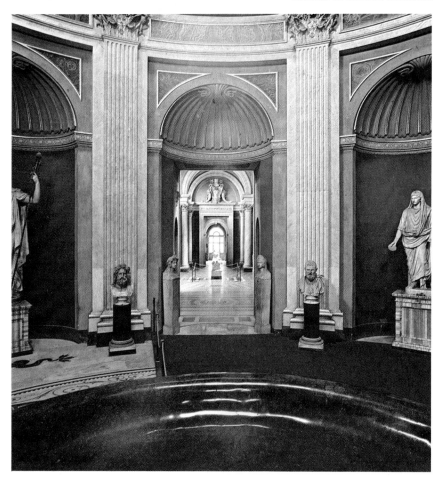

seemed born to be a sovereign." Pius was a dedicated patron of artists and scholars, and the last of the great builder-popes. The Museo Clementino, though recently founded, was already too small to house the sculpture of various sorts that was now entering the artistic patrimony of the Holy See through excavations in the Papal State and acquisitions on the art market. Pius amplified the existing museum, creating a new complex of spacious and splendid rooms, the Museo Pio-Clementino. Two architects were in charge of the operations, both Neoclassicists who were much influenced by the aesthetic ideas of Johann Joachim Winckelmann: Michelangelo Simonetti and, after his death in 1787, his former collaborator Giuseppe Camporese. The construction of the Museo Pio-Clementino began in 1776 with the ill-advised demolition of Mantegna's chapel; it was pulled down so that Gori's Galleria delle Statue might be lengthened by a mere ten meters. Other rooms dating from the fifteenth and sixteenth centuries were remodeled, and a new wing was added to the west of the Belvedere, consisting of the Sala delle Muse, with its octagonal plan, and Simonetti's masterpiece, the Sala Rotonda, an early Neoclassical re-creation of the Pantheon, with a cupola twenty-two meters high and twenty-two meters in diameter. Adjoining the Sala Rotonda, and aligning its center with the north-south axis of Pirro Ligorio's west corridor of the Cortile del Belvedere, is the Sala a Croce Greca, which, as its name implies, has the form of a cross with equal arms; here Simonetti was inspired by the grandiose simplicity of the ancient Roman baths, with their clearly defined spaces and elegant proportions. The Sala a Croce Greca is linked to Ligorio's corridor by a noble staircase that bears the architect's name, the Scala Simonetti. The adjacent entrance to the museum complex, built by Camporese in 1792–93, repeats, in miniature, the structure of the Sala a Croce Greca.

Pius VI was able to enjoy his museum only for a short time. The Papal State was invaded by Napoleon's troops in 1797, and under the harsh terms of the Treaty of Tolentino it was deprived of its greatest works of art. Pius ended his life in exile, at Valence in France, in 1799. The early years of the pontificate of his successor, Pius VII Chiaramonti (1800–1823), were also marked by political turbulence and exile; he returned to Rome after Napoleon's abdication in 1814. Pius VII acquired a large number of ancient statues for the Vatican, partly in order to make up for the losses suffered by the Museo Pio-Clementino under the French. He decided to erect a new building to house them and, on the advice of the great Neoclassical sculptor Antonio Canova, he gave the commission to the architect Raffaele Stern. Work was begun in 1817. The Braccio Nuovo, or "New Wing," was built to the north of

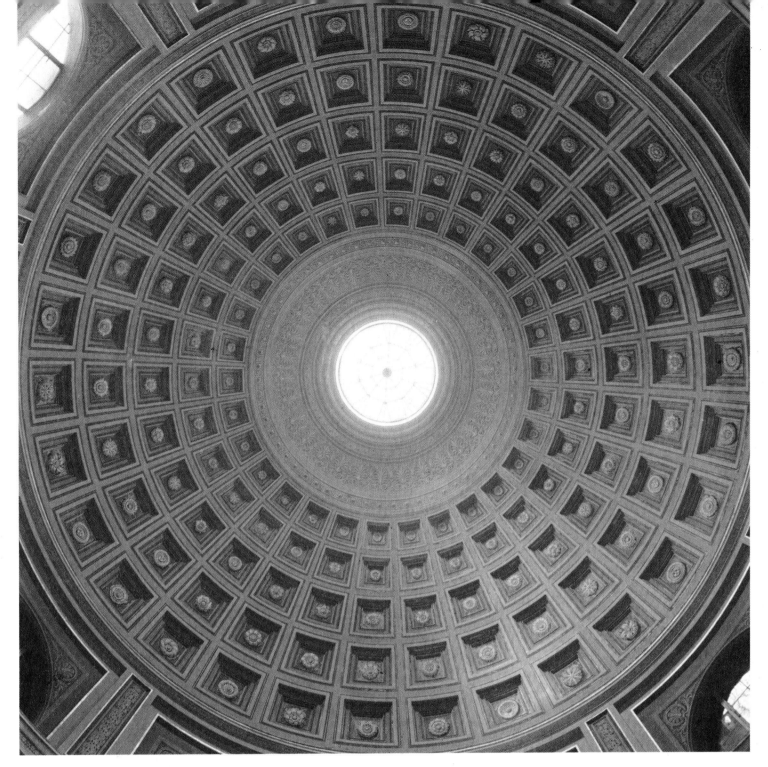

Vault of the Sala Rotonda.

Sixtus v's library and exactly parallel to it; like the library it communicates with both corridors of the Cortile del Belvedere. Stern died in 1820, and the project was completed by Pasquale Belli; the Braccio Nuovo was opened to the public in 1822. Its style is of an extreme, almost frigid sobriety. It consists of a long, barrel-vaulted corridor pierced by skylights; below the cornice is a frieze executed in bas-relief by Massimiliano Laboureur, representing classical subjects. In the windowless main walls are twenty-eight niches for statues; the larger busts stand on columnar pedestals and the smaller ones on brackets fixed to the walls. The structure of the Braccio Nuovo is determined by its function, which is to exhibit as favorably as possible the sculpture that it contains—this sort of functionalism is of course taken for granted today, but in the early nineteenth century it was an extremely advanced concept. The exterior of the building is no less severe than the interior; in the center of the façade, facing the Nicchione, is a classical temple front crowned by Roman statues.

The Braccio Nuovo was the last important addi-

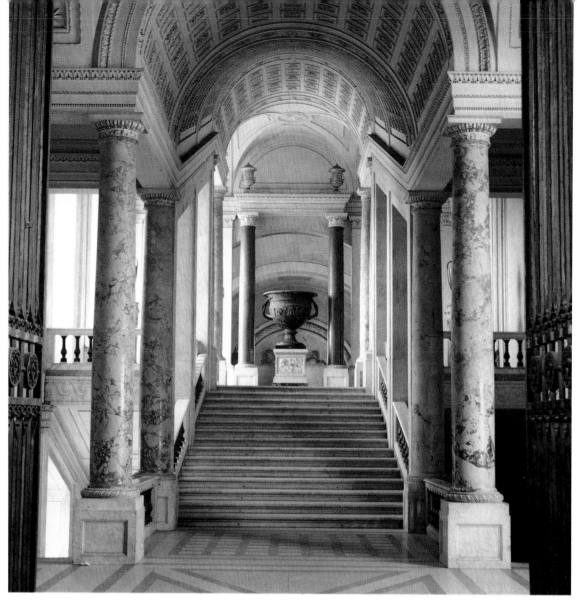

The Scala Simonetti in the
Museo Pio-Clementino.

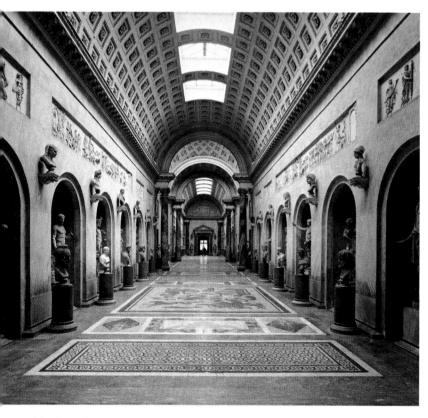

The Braccio Nuovo, or "New
Wing," in the Museo Chiaramonti.

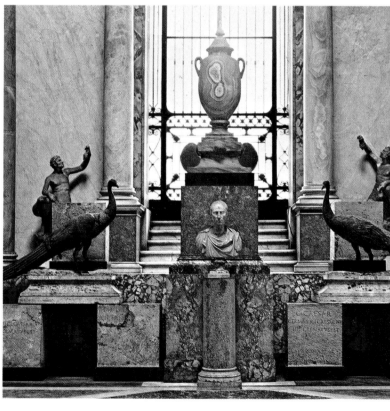

A portrait of Julius Caesar—an eighteenth-century copy of an
ancient bust—is displayed in the center of the Braccio Nuovo.

tion to the Vatican Palace. The successors of Pius VII were content with restorations, renovations, and minor improvements. Gregory XVI (1831–46), for example, transformed two floors of the wings flanking the Nicchione into the Museo Gregoriano Etrusco and the Museo Gregoriano Egizio, but this did not involve an architectural campaign comparable to the creation of the Museo Pio-Clementino. Pius IX completed the enclosure of the Cortile di San Damaso with a one-story portico that continues the ground floor of the Logge on the south and on part of the east sides of the courtyard; he also demolished the stairway that Paul V had built to connect Saint Peter's Square with the Cortile di San Damaso, replacing it with a new one designed by Filippo Martinucci. A number of rooms in the palace were redecorated during the nineteenth century, but none of them are of sufficiently great artistic interest as to warrant our attention here. After the establishment of the Vatican City State in 1929, several new buildings were constructed in Vatican territory, but these will be discussed in another chapter.

DEOCLECIO REDIG DE CAMPOS

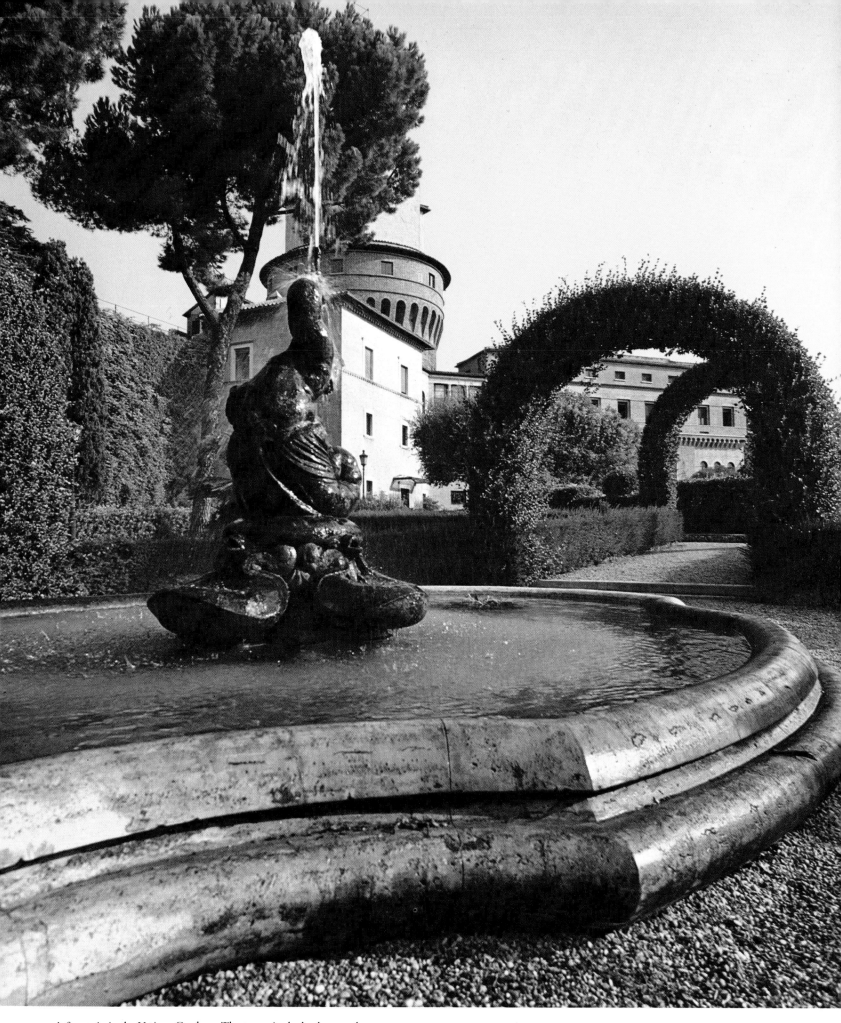

A fountain in the Vatican Gardens. The tower in the background
houses the management of the Vatican Radio.

OTHER BUILDINGS
AND THE VATICAN GARDENS

The Teutonic Cemetery

Immediately west of the gateway under the bell tower of Saint Peter's is the Piazza dei Protomartiri Romani, named for the first martyrs of Rome. This is the oldest historical site in the Vatican. Here, in the Circus of Nero, the first mass executions of Christians took place, as Tacitus tells us in the *Annals*. A memorial plaque serves as a reminder, and a stone slab in the ground states that this is the original site of the circus obelisk, which was transferred to Saint Peter's Square' in 1586 and which still serves as a silent witness and memorial to the heroic and tragic beginnings of Christian Rome.

The piazza lies between the high white walls of Saint Peter's to the north and, to the south, the Camposanto Teutonico—the "holy field," or cemetery, of the Germans. The inscription on the wrought-iron gate to the cemetery reads *Teutones in pace*, "The Germans in peace." On the outside wall is an image of Charlemagne in majolica tiles with the words *Carolus Magnus me fundavit*, "Charlemagne founded me." For indeed this cemetery dates back to Charlemagne, who established here, probably in 781, the Schola Francorum, a residence for Frankish clerics to which a hospice for pilgrims was attached. At this time pilgrims to Rome were beginning to cross the Alps on foot; they often arrived so exhausted from the hardships of the journey that they died at the hospice and were buried near the object of their pilgrimage, the tomb of Saint Peter. Thus, more or less spontaneously, the German *camposanto* came into being. It accommodated the graves not only of poor pilgrims but also of rich princes and famous artists. Today it is a beautiful, peaceful cemetery in the shade of Saint Peter's, with flowers, palms, and cypresses. On the inside wall is a large tile mosaic, no work of art to be sure, but the illustration of a lovely legend: it shows Saint Peter with his hands uplifted, in the circus, surrounded by praying Christians, gazing at a vision of Michelangelo's dome above the clouds. Though the legend is late, the fact remains that this was the site of Nero's circus, and that fifteen hundred years later Saint Peter's dome was built next to it. It is the most sacred ground in Rome for Christians, drenched with the blood of the first martyrs. The empress Helena, the mother of Constantine, is said to have brought earth from the hill of Golgotha and scattered it over this area in order to mingle symbolically the blood of Christ with that of the first Roman martyrs. Thus it is a unique privilege for the Germans that their cemetery grew up just at this spot. It is still in use today, but only for Catholics from German-speaking countries who die in Rome. Citizens of the Vatican State have no right to be buried here.

One hundred years ago the former pilgrims' hospice was turned into a college, the Collegio Teutonico in Campo Santo, for German priests who work in the Vatican or who study Christian archaeology and church history. The institute has a large specialized library and publishes its own journal, the *Römische Quartalschrift für christliche Altertumskunde und Archäologie*. There is even a small museum of Early Christian finds from tombs and catacombs. There are also the remains of two apses in Carolingian masonry; they probably belonged to the residence that Charlemagne built for himself in the vicinity of Saint Peter's. It has been suggested that the complex of the Schola Francorum also included the little Gothic chapel dedicated to the Redeemer that still stands, small and inconspicuous, between the new Audience Hall and the Palace of the Congregation of Faith.

The present cemetery church was built around 1500 by an unknown architect, probably a German, in the form of a typically German *Hallenkirche* with a nave and two aisles of equal height. It contains, among other things, a precious triptych by Macrino d'Alba,

The entrance to the Teutonic Cemetery, which dates back to the time of Charlemagne.

dated 1502, representing the Pietà. There are also some charming marble putti, executed before 1643, by the sculptor François Dusquesnoy of Brussels, who was famous for his putti: some of them also frolic on the baldacchino over the papal altar in Saint Peter's. In a separate chapel in this church are buried the members of the Swiss Guard who gave their lives during the terrible Sack of Rome in 1527; their resistance to the German invaders gave Clement VII time to flee to safety in Castel Sant'Angelo. They and their captain Kaspar Roist are represented as Roman soldiers in a Crucifixion scene, though they are wearing colorful *Landsknecht* uniforms similar to those worn by the Swiss Guards today.

Also of interest is the bronze portal, given by the late German president Theodor Heuss on his state visit to the Vatican in 1957. It was designed by a Cologne artist, Elmar Hillebrand, and incorporates many motifs: the resurrection of the dead, the dance of the blessed, and the Pietà, as well as the Hapsburg double-headed eagle (the church was built during the time of the Hapsburg monarchy), the monogram of the founder, Charlemagne, and the name of the donor, Heuss. A German confraternity meets here regularly for services. They manage the building and the cemetery, which, though located within the Vatican's walls, constitute an extraterritorial enclave under the Lateran Treaty.

The Smaller Churches of the Vatican City

The Circus of Nero as well as the early Christian burial ground extended to the foot of Vatican Hill, where today we see the small brown church of Santo Stefano

degli Abissini. This name, Saint Stephen of the Abyssinians, may sound strange for a church on Vatican soil. It is, however, the oldest surviving church in the Vatican, for it dates back to Pope Leo the Great (440–61); it was renovated by Clement XI in 1704. The portal is adorned by a Romanesque frieze. Originally a basilica with three aisles, this was one of Rome's main churches and was therefore called Santo Stefano Maggiore. Today only the nave and a few of the original columns remain; the high altar, the small Romanesque windows, and the gabled roof are modern imitations of medieval forms. The side walls are lined with tombstones and inscriptions telling of the wandering Abyssinian monks who came to Rome on pilgrimage from the late Middle Ages on, and died and were buried here. They were known as Moors or Indians, because no one knew where the faraway Christian land from which they had come was located. Sixtus IV (1471–84) assigned these pilgrims, many of whom were ill and penniless, a separate house next to Santo Stefano, where they could live at the expense of the papal treasury. This hospice was later turned into a college and seminary; it was demolished in 1930 because of damage caused by age and moisture. The church, however, is still in the care of the Ethiopians and is used occasionally for services of the Ethiopian-Alexandrine rite, especially on the feast day of its patron saint, Saint Stephen, the protomartyr.

The second oldest church in the Vatican is San Pellegrino. It is located to the north of Saint Peter's, in the modern business district, on the street called Via dei Pellegrini. This was the last stretch of the old pilgrim road that led to Saint Peter's from the north by way of Monte Mario; its end is still marked by a gate, crowned with the Borgia coat of arms, now walled up and half buried. Saint Peregrinus is a legendary saint; he is said to have been a Roman priest, sent by Pope Sixtus III in the fifth century to Gaul, where he became the first bishop of Auxerre and died a martyr's death. Probably because of his name, which means "pilgrim" in Latin, he became the patron saint of pilgrims. He is portrayed in a majolica image above the church door, holding a book inscribed with his motto: *Nulla mihi patria nisi Christus, nec nomen aliud quam Christianus*, "I have no other home but Christ and no other name but Christian."

The church dates from the time of Leo III (795–816), as does the fresco in the apse, an impressive representation in Carolingian style of the enthroned Christ, with large powerful eyes, long hair parted in the middle, and a curly beard. The church was remodeled and painted over a number of times. In the first half of the fifteenth century a new fresco with the Madonna and Child under a baldacchino carried by angels, by a Central Italian master, was painted above

The church of Santo Stefano degli Abissini.

Sant'Anna dei Palafrenieri, the parish church of the Vatican City.

the altar. In the seventeenth century San Pellegrino became the chapel of the Swiss Guard and was considered the national church of the Swiss in Rome; the Swiss cemetery is located behind the church. Under the church there is a crypt where, for centuries, members of the Pfyffer family of Altishofen were buried; even today the commandant of the Swiss Guard traditionally comes from this family. Today San Pellegrino serves as a chapel for the Vatican police force, the *corpo di vigilanza*.

In 1568 Pius V constructed a new chapel for the Swiss Guard, San Martino degli Svizzeri, immediately to the northeast of the papal palace; it was completely renovated by Paul VI in 1965. Egidio Giaroli created the beautiful bronze portal to commemorate the Second Vatican Council. It represents, among other things, a historical event that had just taken place: the meeting and embrace of Paul VI and the patriarch of Constantinople, Athenagoras; the landscape background alludes to the Roman and Greek churches. The modern stained-glass windows by Trento Longaretti depict the Stations of the Cross, the Annunciation, and the miracle of Pentecost.

In about 1568 Giacomo Barozzi, called Vignola, designed the church of Sant'Anna dei Palafrenieri; his son Giacinto Barozzi completed its construction by 1575. It is the first church in the history of architecture to have an oval floor plan and an oval dome. The Renaissance ideal had been the centrally planned building with a circular dome; the oval appeared for the first time in the work of Pirro Ligorio, in the inner courtyard of the Casino of Pius IV, only a few years before the construction of Sant'Anna. The façade of the church was later decorated by Alessandro Specchi in the Baroque style, and the entire inside décor was remodeled by Francesco Navone. In 1746 the Bavarian painter Ignaz Stern painted four frescoes with scenes from the life of Saint Anne, the patron saint of the papal *palafrenieri*. The *palafrenieri* had been grooms originally; they had later advanced to the rank of stable masters and had finally become court officials and confidants of the pope. During the Middle Ages they even had the right to bestow academic degrees in theology and jurisprudence. In 1378 they formed a confraternity; today we would call it a Christian trade union. They had enough money to build their own church. They also decided to donate a large altarpiece in honor of Saint Anne to Saint Peter's Basilica and commissioned the young Caravaggio to paint it. But when the painting was completed in 1606 the donors, and especially the canons of Saint Peter's, were appalled at the realistic representation of the elderly Anne, the homely Virgin Mary, and the naked Christ Child. They did not dare set it up in Saint Peter's, so it was placed in the church of the *palafrenieri* until the wealthy Car-

A section of the seventeenth-century walls of the Vatican. The tower belongs to the fifteenth-century fortifications of Nicholas V.

dinal Scipione Borghese bought it for his art collection in the Villa Borghese, where it is much admired to this day.

At one time Sant'Anna was but one of the many small churches that surrounded the great basilica of Saint Peter's like satellites. Today it has the distinction of being the parish church of the Vatican City, and is in the care of the Augustinian order. It is open to the public; baptisms, weddings, and funerals take place there; beneath it there is a crypt where Vatican citizens are buried. The church stands just inside the Porta Sant'Anna, the entrance to the business district of the Vatican, where the Swiss Guards, in their blue-and-white everyday uniforms, are posted.

Fortifications and Towers

During the Middle Ages the Vatican resembled a fortress, with high walls, towers, and battlements. Indeed, it had to be a fortress—on several occasions it had been besieged and plundered by Goths, Vandals, and Saracens. A few traces of its early fortifications remain. At the top of the Vatican Hill we find high, crenellated brick walls, known as the Leonine walls after Leo IV (847–55), who erected them. They encircled the hill and led down to Castel Sant'Angelo and the Tiber. When the Leonine walls deteriorated during the sixteenth and seventeenth centuries, new walls were built almost parallel to the older ones.

These walls for the defense of Saint Peter's Basilica and the papal palace became the border of the new state of the Vatican City when it was established by the Lateran Treaty in 1929. On the top of the hill where the walls form an acute angle lies the "airport" of the Vatican; it is just large enough for one helicopter. Recently the pope has used a helicopter even when going only as far as his summer residence at Castel Gandolfo. Most state visitors now also arrive by helicopter.

Nicholas V (1447–55) had the Leonine walls with their defense towers renovated; he also erected the great tower known as the Torrione to protect the papal palace. It is an impressive round structure with a diameter of forty meters. It was intended to be sixty meters high; however, it collapsed and is now less than half its planned height. The Torrione of Nicholas V has become the solid foundation of the Vatican bank. The tower at the highest point of the Vatican Hill, where the observatory used to be before it was moved to Castel Gandolfo, now houses the management of the Vatican Radio. A third tower, in the southwestern corner of the Vatican territory, was rebuilt by Pope John XXIII to serve as his hermitage. Here he intended to withdraw from the strains of the Second Vatican Council, and to enjoy peace and solitude. Unfortunately he was able to use his tower only for a few days be-

The Torre di San Giovanni in the Vatican
Gardens, rebuilt by John XXIII.

fore his illness and death. Now the tower serves as lodgings for the pope's guests of honor. At the entrance, John the Baptist and John the Evangelist are represented, and the splendid coat of arms of John XXIII is displayed overhead.

It was Innocent III (1198–1216) who had the first permanent papal palace built on Vatican soil; until then the popes had resided at the Lateran. A small tower from Innocent's time remains in the garden; to it has

been added a little brown house known as the Casa del Giardiniere. The management of the Vatican gardens is now located there. Leaning against this tower are two marble reliefs that are not related to it; they refer to two events of the pontificate of Pius IX: (1846–78) the publication in 1864 of the *Syllabus of Errors*, in which the pope condemned the heresies of his time, and the opening of the First Vatican Council in 1869. The *Syllabus* is represented symbolically, crushing evil

spirits and heretical books. It is perhaps just as well that this relief is placed here, where no one notices it.

At the far side of the gardens, among the hothouses, there is yet another tower. It bears the coat of arms of Innocent VIII (1484–92) and thus may be dated to the reign of this pope, who also had the Belvedere built nearby as his summer residence. Since the Belvedere was later incorporated into the Vatican Palace, it is described in another chapter.

The Vatican Gardens

As early as the thirteenth century Nicholas III (1277–80) had a green area planted with fruit trees and vegetables layed out to the north of his palace. Vineyards and a deciduous wood were added; the latter still exists, and is known as the Boschetto. Alexander VI was the first to start a botanical garden, in 1500. The flower garden proper was in the vast Cortile del Belvedere, between the palace and Innocent VIII's villa. This courtyard was later divided into three parts by the construction of the Vatican Library and the Braccio Nuovo of the museum. The largest of these spaces is now used as a parade ground for the Swiss Guard in the early morning and as a parking place for Vatican employees later in the day.

Paul V (1605–21) had the ancient aqueduct of the emperor Trajan rebuilt to carry water to the Vatican

The Casa del Giardiniere incorporates the remains of a tower from the time of Innocent III.

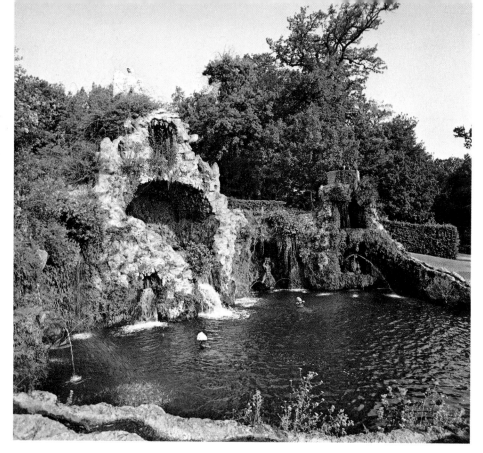

Two views of the Fontana dell' Aquilone. The eagle that surmounts
it, from which it takes its name, is an allusion to the arms
of Paul V's family, the Borghese.

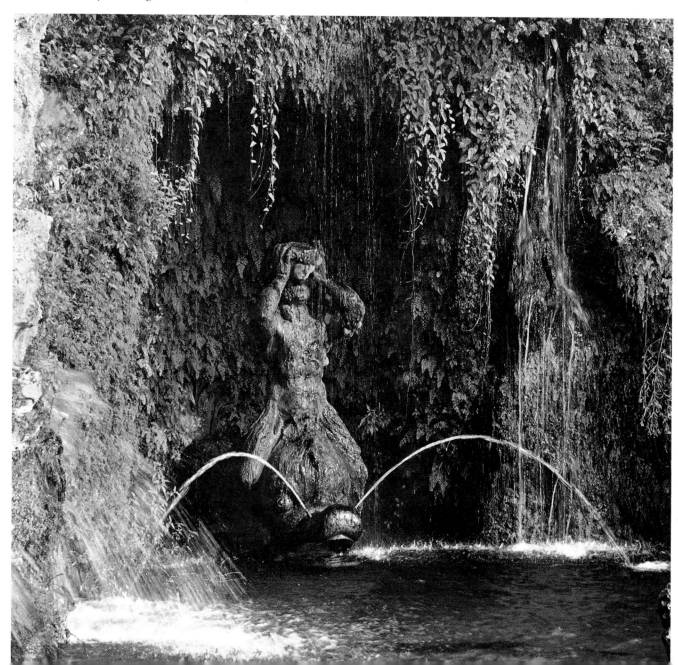

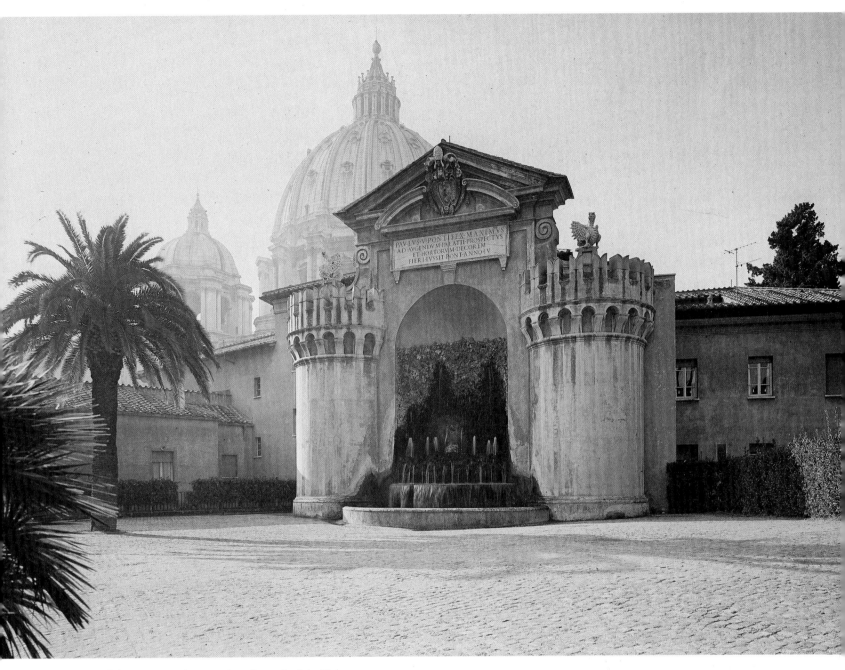

The Fontana del Sacramento is set against the wall of the Zecca, or mint, where papal coins were formerly struck.

from the Lake of Bracciano, about twenty-four miles to the north. An excellent irrigation system and countless lawn sprinklers make this garden a cool green oasis even in the heat of summer. It would be quite impossible to enumerate all the fountains of the Vatican. Three, however, should be mentioned. We owe them all to the Borghese pope, Paul V, and to his court architect, the Dutchman Jan van Santen (called Vasanzio by the Romans, who could not pronounce his name), who became famous as the builder of the Villa Borghese.

The first is the Fontana dell'Aquilone, or Eagle Fountain. It stands in the Boschetto. The eagle crouches on top of a manmade grotto, while dragons spew water into a large semicircular basin. The eagle and the dragon are the heraldic animals of the Borghese family. We see them again on the so-called Fontana del Sacramento, located slightly downhill from the Fontana dell'Aquilone. This fountain is in the form of an altar; straight jets of water rise like upright candles, and a dragon spews water in a wheel, like the golden rays of a monstrance. The Fontana del Sacramento is built against the back wall of a building, lime-washed in yellow, which was formerly the Zecca, or mint, where papal coins were struck (today they are produced for the Vatican City by the Italian state mint). The building is still known as the Zecca, but it now houses the Floreria Apostolica, a storeroom where

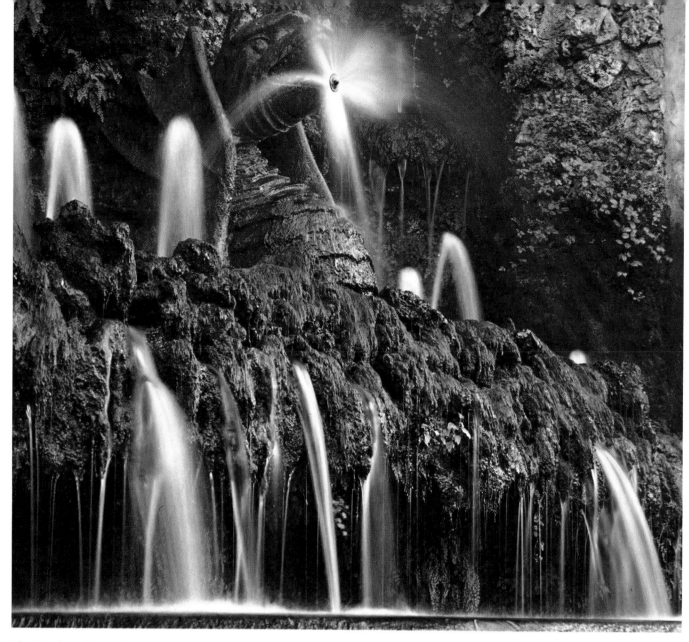

The Borghese dragon dominates the water
display created by Vasanzio for the
Fontana del Sacramento.

furniture, paintings, carpets, draperies, and other odds
and ends are kept when they are not needed to deco-
rate rooms for special occasions such as conclaves. To
the left of the fountain is the Forno, the former bakery,
which has now been turned into private living quar-
ters. The most beautiful of the fountains is located
just east of the Belvedere, beneath the windows of
the rooms where Leonardo da Vinci once stayed as
the pope's guest. A miniature ship, made of lead, seems
to float in a large oval water basin. It represents a
seventeenth-century galley, a true-to-life three-master
with oars, sails, and flags, equipped with cannons and
manned by sailors. That is why the fountain is called
the Fontana della Galera. Behind it Neptune, the god
of the seas, stands in a niche. An inscription above it
names Paul V as the builder of this fountain; it was
renovated, however, by Clement IX (1667–69) and by

The Fontana della Galera takes its name from the lead galley,
with cannons that shoot water, placed in it by Clement IX.

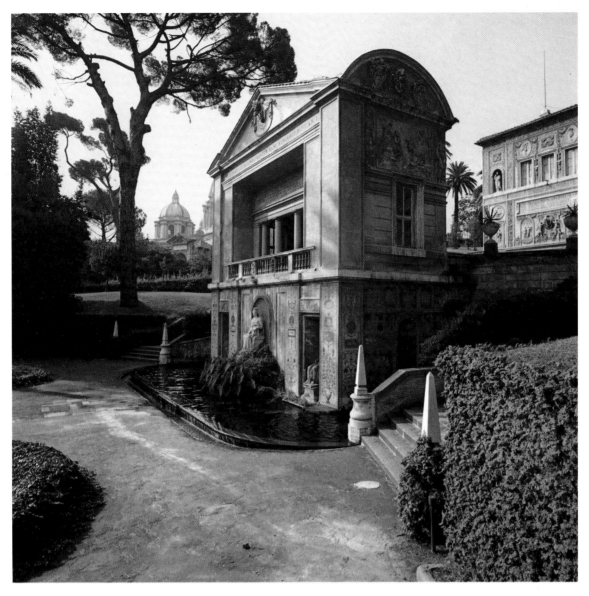

The smaller of the two pavilions of the Casino of Pius IV in the Vatican Gardens.

Pius VI (1775–99), who had his crest placed on the stern of the ship. The galley shoots water from many small cannons, to which the inscription on the upper right of the fountain refers. It is a Latin distich composed by Cardinal Maffeo Barberini before he became Pope Urban VIII in 1623: *Bellica pontificum non fundit machina flammas, sed dulcem belli qua perit ignis aquam,* "The papal fleet does not spew flames, but sweet water that quenches the fire of war," an allusion to the pope's mission of peace.

The most precious ornament of the Vatican Gardens is the Casino of Pius IV. Pius (1559–64) belonged to the Medici family of Milan; he was not related to the Florentine Medici, but he used their heraldic device —hence the "pills" in his coat of arms on the façade. This summer house no longer resembles a medieval castle with battlements, as does Innocent VIII's Belve-

dere, which was built only seventy years earlier; it is an elegant, graceful pavilion in the style of the late Renaissance. The pope had found in Pirro Ligorio an architect who was not only a builder but also a waterworks engineer and a landscape designer. The combination of these three talents resulted in this enchanting little building, beautifully embedded in the landscape on the slope of the Boschetto and surrounded by rushing water like the Villa d'Este at Tivoli, which made Pirro Ligorio world famous. The Casino consists of four separate sections, with two pavilions and two arched gateways, connected by an oval inner court like an ancient nymphaeum, where putti ride on water-spewing dolphins. Running along the outside is a stone bench for the guests whom the pope used to entertain here with garden parties and court concerts. The outer walls of the Casino are decorated with mosaics in the

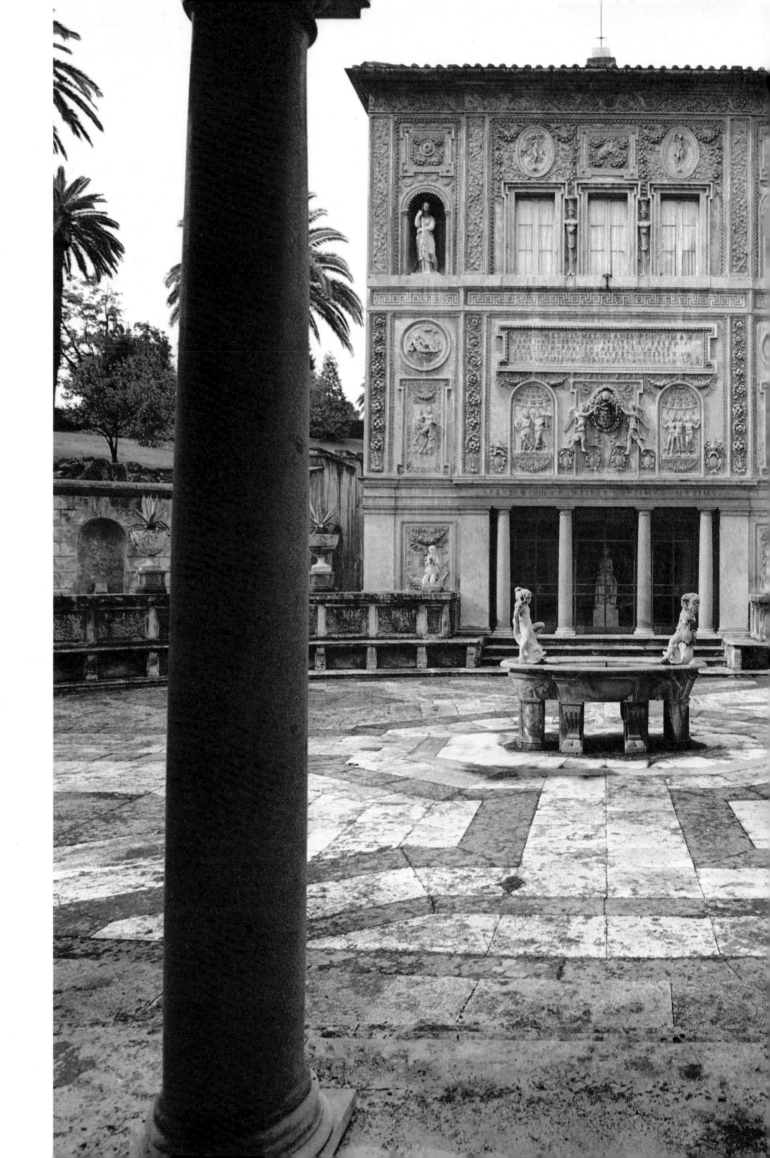

grotesque style and with stucco reliefs depicting scenes from pagan mythology. Classical statues adorn the façade and the inside rooms. The floors are inlaid with the finest multicolored majolica tiles, and the vaulted ceilings are lavishly covered with gold stucco and frescoes. Most of the frescoes were painted by Federico Zuccari and Federico Barocci. They illustrate biblical scenes according to a theological program that adheres to the awakening spirit of the Counter Reformation in its emphasis on the triumph of pure doctrine and of the true church.

Since 1926 this former pleasure-pavilion has served strictly scientific purposes. It is the seat of the Pontifical Academy of Sciences, founded by Pius XI. Himself a scholar, this pope wished to revive the old Roman Academy of the Lincei, which was founded in 1603. The new academy consists of seventy scientists from all over the world, chosen by the pope himself. A large round auditorium for their annual convention was added to the villa by the architect Giuseppe Momo. Where men once devoted themselves to the aesthetic enjoyment of art and nature, they now discuss new fertilizers, nerve cells, and cancer. Thus times change, even in the Vatican.

The gardens, as we see them today, were for the most part laid out as recently as 1900 by Leo XIII. They now cover forty-two acres, more than one-third of the area of the Vatican City. They are designed partly in the Italian style (that is, in geometric patterns), partly in the French (with flower beds), and partly in the English (with lawns and woods that simulate the open countryside). Tall cedars, stone pines, and cypresses alternate with palms and olive trees. The paths are lined with trimmed laurel and myrtle. Especially exotic trees bear labels with their botanical names. There even used to be a zoo; today, at most, one might spot a few stray cats. The pope has his own farm with fields and livestock at Castel Gandolfo. Here there is only a small vegetable garden for his private household, right within view of the dome of Saint Peter's.

The gardens have gradually been filled with statues of all kinds, fragments of classical columns, images of gods, and emperors' busts as well as modern figures of saints in marble and iron. For the most part these were gifts, like the cast-iron French saints given to Leo XIII by the French. One marble group commemorating the appearance of Our Lady of Guadalupe was given by the Mexicans; another, representing the Madonna della Guardia, was a gift of the Genoese to their compatriot Benedict XV. A figure of Saint Peter stands on a rise as a reminder of the First Vatican Council. Originally it stood on a tall column in the Cortile del Belvedere; it stuck out over the roofs of the surrounding buildings and looked so ridiculous that the

The oval court and the main pavilion of the Casino of Pius IV.

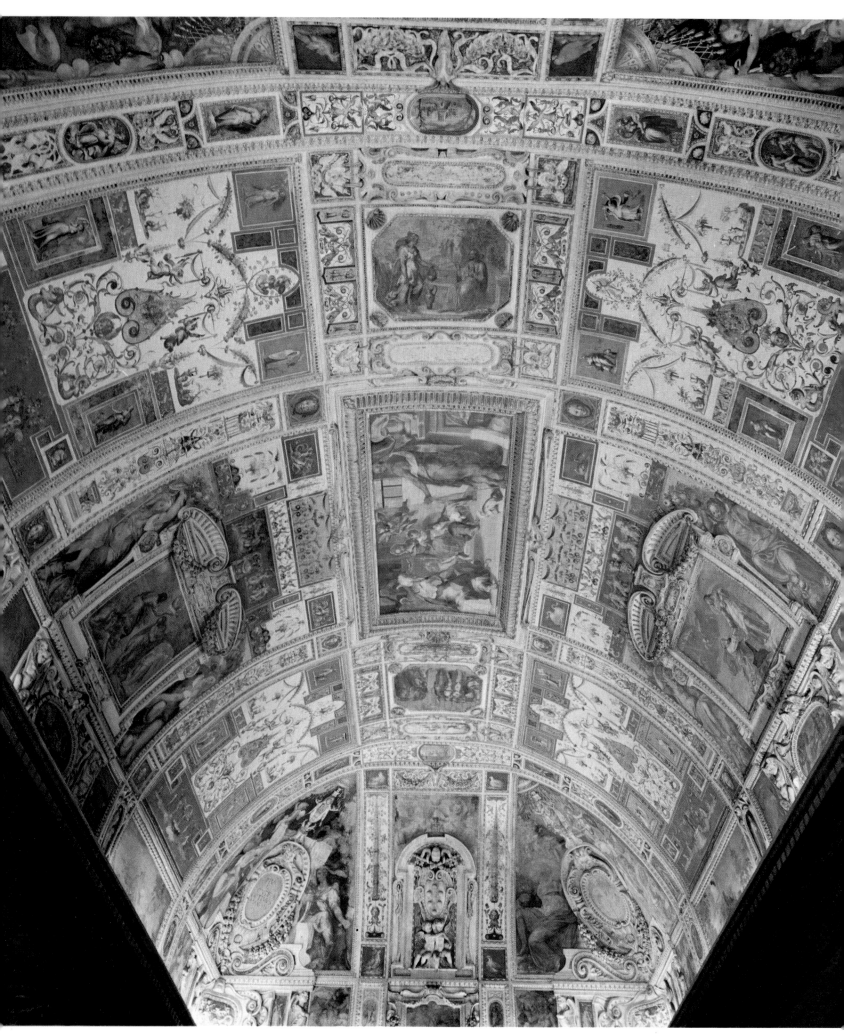

The vault of the *salone* of the Casino of Pius IV.
The frescoes are by Federico Barocci.

column was pulled out from under Saint Peter and he had to migrate to the gardens.

A bronze relief on the former garden pavilion of Leo XIII (which now houses the management of the Vatican Radio) deserves special mention. It shows two well-known personalities, Bismarck and the emperor Wilhelm I, both staunch Prussians and Protestants who in reality never visited the Vatican. What, then, are they doing here? The reason is a historic event: Bismarck, in the course of his colonial policy, had occupied the Caroline Islands in the Pacific Ocean, which actually belonged to Spain. A wave of indignation swept over Europe and war threatened to erupt. Bismarck then turned to Leo XIII, asking him to arbitrate. This skilled diplomatic gesture was intended to placate the pope after Bismarck's unsuccessful *Kulturkampf* against the Roman Catholic church in Prussia. A compromise was indeed worked out in the Vatican. That is why the relief shows the pope handing documents to both the German chancellor and the Spanish prime minister, and, in the background, Wilhelm I, with his inevitable iron helmet and moustache, indulgently slapping the Spanish king, Alfonso XII, on the shoulder. To the right, behind the pope, stands Cardinal Jacobini, his secretary of state, who had handled the negotiations. Under the agreement Spain retained control of its islands, but Germany gained the right to land cargo, conduct trade, and buy real estate there. However, the treaty did not survive for long; barely fifteen years later Spain was so poor that it sold the islands to Germany, and fifteen years after that Germany was so badly defeated in World War I that it lost them again. Now the Carolines are mandated territory of the United States.

Why was this scene depicted at just this spot? Obviously to honor the pope as peacemaker and arbiter during the time of his greatest humiliation, when the kingdom of Italy had annexed the Papal State and the pope was a voluntary prisoner in the Vatican. To comfort and honor him all the Catholic nations and organizations sent Leo XIII gifts for the fiftieth anniversary of his ordination in 1887, including the Italian archdiocese of Acerenza and Matera, which, as an inscription tells us, donated this relief. Another inscription gives the artist's name: *Il fratello della serva di Dio suor Filomena delle Minime—Felice Ferrer.* Félix Ferrer y Galcerán was a Spanish sculptor who worked in Rome, and the brother of a Franciscan nun who had died young, in the odor of sanctity. Through this otherwise unknown artist, Bismarck unintentionally got into the Vatican gardens.

On top of the hill there is a life-sized replica of the Grotto of Massabielle near Lourdes, another gift of the French to Leo XIII. This is why there are mosaic portraits of both the pope and the donor, Bishop

The entrance to the Pontifical Academy of Sciences, which since 1922 has had its headquarters in the Casino of Pius IV.

Schöpfer of Tarbes, on either side of the grotto. Originally a tall iron tower, in imitation Gothic style, surmounted the grotto; it fortunately fell victim to the change of times and tastes. The altar in the grotto comes from the Grotto of Lourdes, where it stood for a hundred years until it was given to the pope in 1958. Since then, masses have been said here and May Day vespers and candlelight processions have been celebrated; it still is a place for praying and singing.

Each pope has his own customs. Leo XIII, who was confined to the Vatican and wanted at least to enjoy some fresh air, liked to sit in front of the summer house that he built for himself on the top of the hill. Pius XI preferred to drive through the gardens in his car. Pius XII walked daily for a solid hour along the same stretch of covered wall, by himself, studying documents. John XXIII favored sitting in the Chinese pavilion in the Boschetto, accompanied by his secretary. Paul VI chose to have a roofed garden built above his living quarters in the palace. John Paul II, on the other hand, loves exercise in the open. Only in the morning, when he is occupied with audiences, are tourists allowed in the gardens, and even then only in the company of guides from the information office in Saint Peter's Square. Incidentally, there is no swimming pool in the Vatican, though there is one at Castel Gandolfo; there are tennis courts, a volleyball court, and, outside the walls, a soccer field for Vatican employees.

Modern Buildings in the Vatican

In 1900, a Holy Year was proclaimed for the first time in seventy-five years. To accommodate the pilgrims who were expected to converge upon Rome for this occasion, a rather austere hospice, the Ospizio di Santa Marta, was built near the sacristy of Saint Peter's. Today it is operated by French Vincentian sisters, and is still open to pilgrims.

Two nineteenth-century buildings, the Palazzo di San Carlo and the Palazzo del Tribunale, stand on the square adjoining the hospice, called the Piazza Santa Marta. The Palazzo di San Carlo, which has a neo-Gothic façade, was originally a hospital; today it contains offices and apartments for Vatican employees. Fifty boys between the ages of ten and fifteen live at the rear of this building; they attend school and are given free room and board in return for serving morning mass in Saint Peter's. Frequently they can be heard playing soccer on the terrace during recess. When they go home for the summer vacation they are replaced by the same number of boys from Malta—it is a special privilege of the Maltese to supply Saint Peter's with altar boys during the summer, and the boys are very proud of this duty.

Two streets next to the Palazzo di San Carlo are named for famous artists who are supposed to have lived here: the painter Perugino, Raphael's teacher, and the composer Palestrina, the greatest conductor ever to work at Saint Peter's. In front of the building there are two filling stations with long lines of cars; the price of fuel inside the Vatican is a third less than outside, since the pope does not pay duty or levy taxes. However, only citizens and employees of the Vatican City may buy their fuel here.

The Piazza Santa Marta is bounded on the north by the Palazzo del Tribunale. This was a seminary until 1929; now it houses the law court, as its name implies. As small as the Vatican is, it has its own laws, its own judges, and even its own prison—one of the few that never suffer from overcrowding.

When, in 1929, the Roman Question was settled after a sixty-year-long cold war between the Holy See and the kingdom of Italy, and the pope was recognized as sovereign of the independent Vatican City, a period of intense construction activity began under the direction of the architect Giuseppe Momo and the engineer Leone Castelli. A few buildings necessary for the functioning of the new state had to be erected. Chief among them was the Governatorato, or Administration Building, on the rise behind Saint Peter's Basilica. The lawn below it is cut in the shape of the reigning pope's coat of arms, and there is a statue of the Madonna on the roof.

To the south of the Governatorato is the Vatican railroad station. It is a rather pompous building, faced with travertine on the outside and lined with marble on the inside. It was built by Pius XI as a sign of independence. However, only a single pope has ever used this station and on only one occasion: that was in 1962, when John XXIII traveled by train to Assisi and Loreto at the beginning of the Second Vatican Council. As he did not have his own railway car, however, he had to borrow one from the Italian president. Otherwise the railroad is used only for freight. Once a day, the heavy iron gate opens and a freight train noisily clatters over the Italian railroad bridge, to supply the Vatican with all the goods it needs: food, fuel, tobacco, construction materials, and so on. At the right-hand corner of the station building we can see some peculiar holes. They date from the only bomb attack on the Vatican during the last World War, when Rome was an "open city"—that is, exempt by international agreement from battle and destruction. Suddenly, however, on the evening of November 5, 1943, four bombs fell behind Saint Peter's, missing the church by a hair's breadth. Through a miracle the dome survived; only the window panes were shattered. A few bomb fragments landed near the station and were left there as a reminder of this unexplained bombing. It has been

The Pontifical Ethiopian College, in the Vatican
Gardens, built for Pius XI by Giuseppe Momo.

surmised that the attack occurred in order to intimidate the pope, because during the war many people who were politically or racially persecuted had found shelter in the Vatican.

Between 1928 and 1930 the new Pontifical Ethiopian College was built by the same architect, Giuseppe Momo, uphill from the railroad station and the Governatorato. It is beautifully situated amid the peaceful green of the gardens and affords a splendid view from its terraces. When someone asked Pius XI why he had built a new Ethiopian college when all the others, except for the German one, were obliged to move away, he is supposed to have answered, "Because black goes well with white." The college had been founded in 1919 to replace the old hospice of Santo Stefano degli Abissini and was intended to continue the tradition of that institution as a research center and a home of African religious culture in the heart of the Vatican.

The popes wished to provide the opportunity for study in Rome to as many theology students from Ethiopia as possible; they hoped to forge stronger ties between Rome and the Ethiopian church, only a small part of which is in union with the Roman Catholic church. However, since few students are allowed to leave Ethiopia at present, the sisters of the Congregation of Maria Bambina in Milan have recently moved into a wing of this horseshoe-shaped building. They work in various capacities at the Vatican; among their other duties, they run the telephone system very efficiently.

Between the Tribunale, the Governatorato, and the railway station is the new mosaic workshop. As a building it is inconspicuous, yet it has a proud tradition going back four hundred years. It was founded for the decoration of the interior of New Saint Peter's, where all the cupolas were gradually covered with mosaics and all the altar paintings replaced with mosaic

replicas, since mosaic is more durable than painting. In this studio old mosaics are restored and new ones are produced for modern churches. The smaller the pieces used, the finer and more expensive the work; the studio is proud of having invented a process utilizing small enamel rods and of its ability to produce 28,000 different shades of color. The arts have always been encouraged by the popes; there are several other workshops in the Vatican City, including one for the restoration of wall tapestries, another for old manuscripts, and a large one for the conservation of the art treasures of the Vatican Museums.

The founding of the new state necessitated the expansion of the business and industrial quarter in the northwest of the Vatican City. New workshops for the craftsmen and construction workers were built, as well as a fire department, an electric plant, central waterworks, a central heating plant, a main post office, parking garages, barracks, and a cafeteria for the employees. A most important feature is the supermarket, called Annona, where everything needed for daily life is sold; goods are of higher quality, and cheaper, than outside the Vatican. The demand is so great, however, that there are long lines at every counter; to shop here one must have a *tessera*, an identity card issued only to residents and employees of the Vatican, church institutes, and embassies. Thanks to the Annona these people were supplied with necessities even during the shortages of the war and postwar years, and the Annona is kept open to guard against a similar emergency.

Across from the supermarket there is a pharmacy run by the Brothers of Mercy. It is open to anyone. Many pharmaceuticals sold here are not available elsewhere in Rome. In the same building there is an infirmary where doctors and first aid staff are always on call. In short, everything is provided for: the Vatican is a model state in miniature.

The New Audience Hall

In conclusion, the most recent building in the Vatican, the new Audience Hall built by Paul VI, deserves a few words. The pope engaged the greatest living Italian architect, Pier Luigi Nervi. Nervi was already over seventy years old when he received this commission, which crowns his life's work. He had the audacity to construct a completely modern building next to the greatest masterpiece of Christian architecture, the basilica of Saint Peter, and the venture turned out a success. The Audience Hall is a beautiful, harmonious building shaped like a seashell; the visitor feels like a pearl inside, and can see and hear perfectly. The wavelike roof has long ribs that converge like rays toward the podium and the papal throne. The colorful stained-glass windows, shaped like eyes, were de-

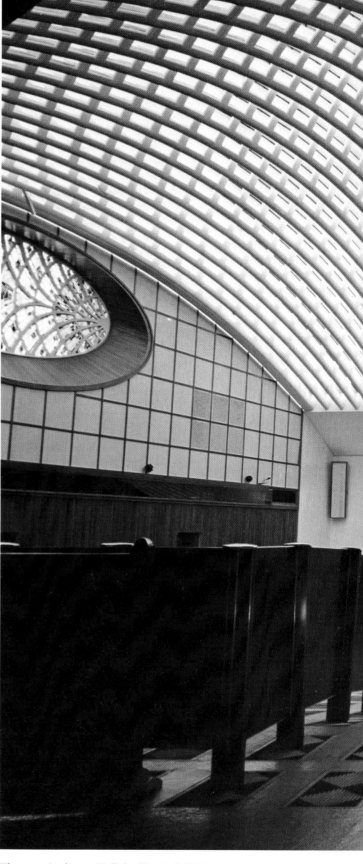

The new Audience Hall, by Pier Luigi Nervi, was completed in 1971.

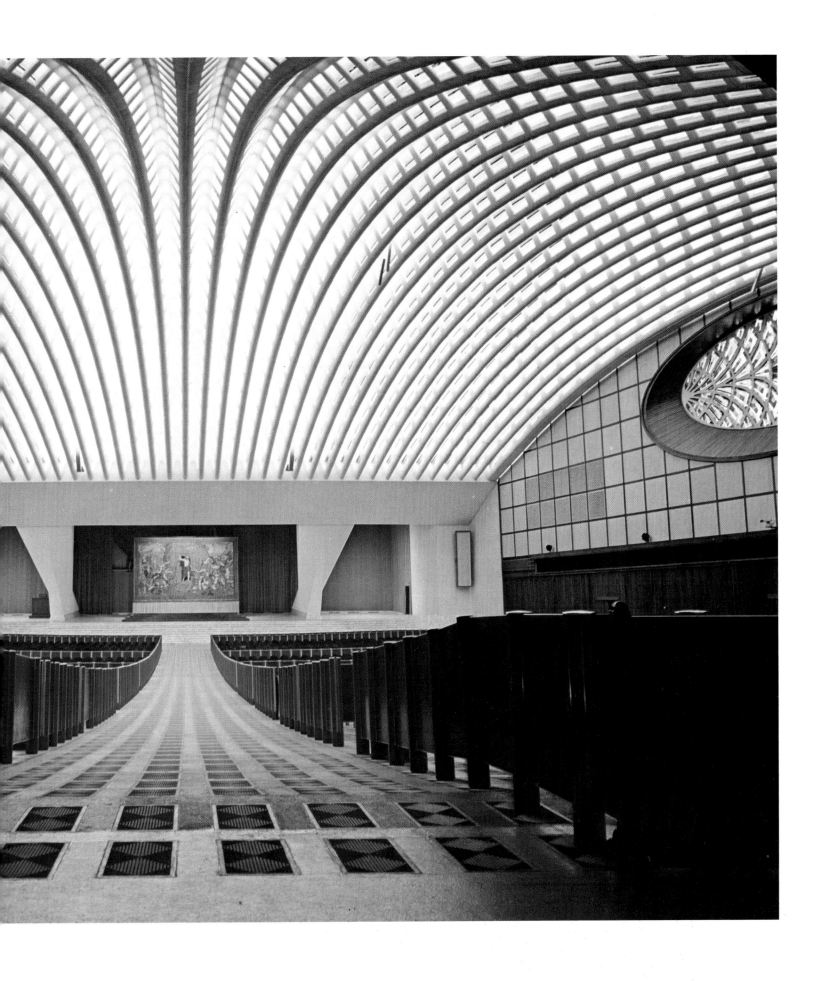

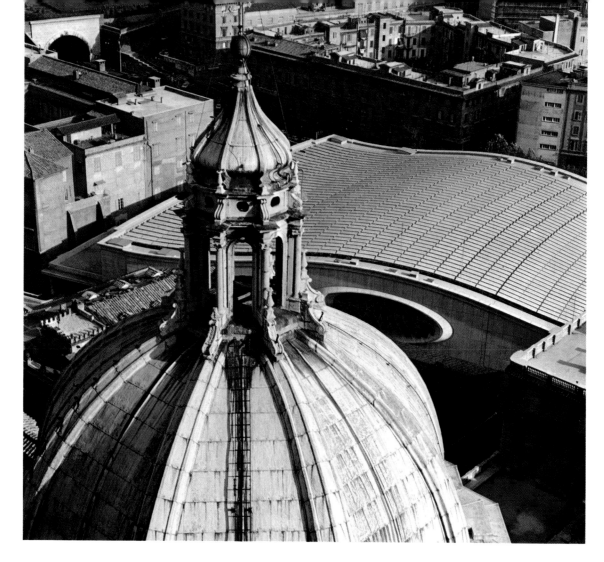

Above: The new Audience Hall seen from the dome of Saint Peter's.
Below: One of the most recent architectural works in the Vatican,
the building housing the archaeological and ethnological collections.

signed by the Hungarian artist Hans Hajnal, and an immense bronze sculpture by Pericle Fazzini, representing the Resurrection of Christ, takes up the entire front wall. The building was constructed from prefabricated cement blocks and is faced on the outside with white slabs of travertine that will gradually take on the same shimmering patina as the walls of Saint Peter's.

Unfortunately this beautiful building cannot be fully appreciated. Since the boundaries of the Vatican City were established by law in 1929, it can only expand upward, not outward. The Audience Hall therefore had to be squeezed into a corner behind the old palace of the Holy Office, and it turned out to be much smaller than had originally been planned. There are only 6,300 seats, though when a few rows of seats are removed there is standing room for as many people again. This is not enough, however, in the tourist season, so at that time general audiences are held in Saint Peter's or in Saint Peter's Square. However, Paul VI's Audience Hall was not built in vain. It is also used for conventions, concerts, and synods. This masterpiece of modern architecture, completed in 1971, marks, at least for the time being, the end of a thousand years of energetic building activity by the popes.

It is just as well, however, that the new hall does not stand out so much as to divert attention from Saint Peter's Basilica, which dominates the view from every corner of the Vatican. Above the roofs and walls, between the trees and arcades, at the end of a path or behind a hill, the blazing white dome of Saint Peter's unexpectedly appears in solitary majesty against the

The dome of Saint Peter's can be glimpsed from every corner of the Vatican Gardens.

deep blue sky. But it also benevolently encloses Saint Peter's tomb below, sheltering it like the hands of God. Around this tomb the Vatican has developed in concentric circles for nearly two thousand years; the dome seems to say that the tomb beneath is and shall remain the central point of the Vatican, its heart and the very reason for its existence.

EVA-MARIA JUNG-INGLESSIS

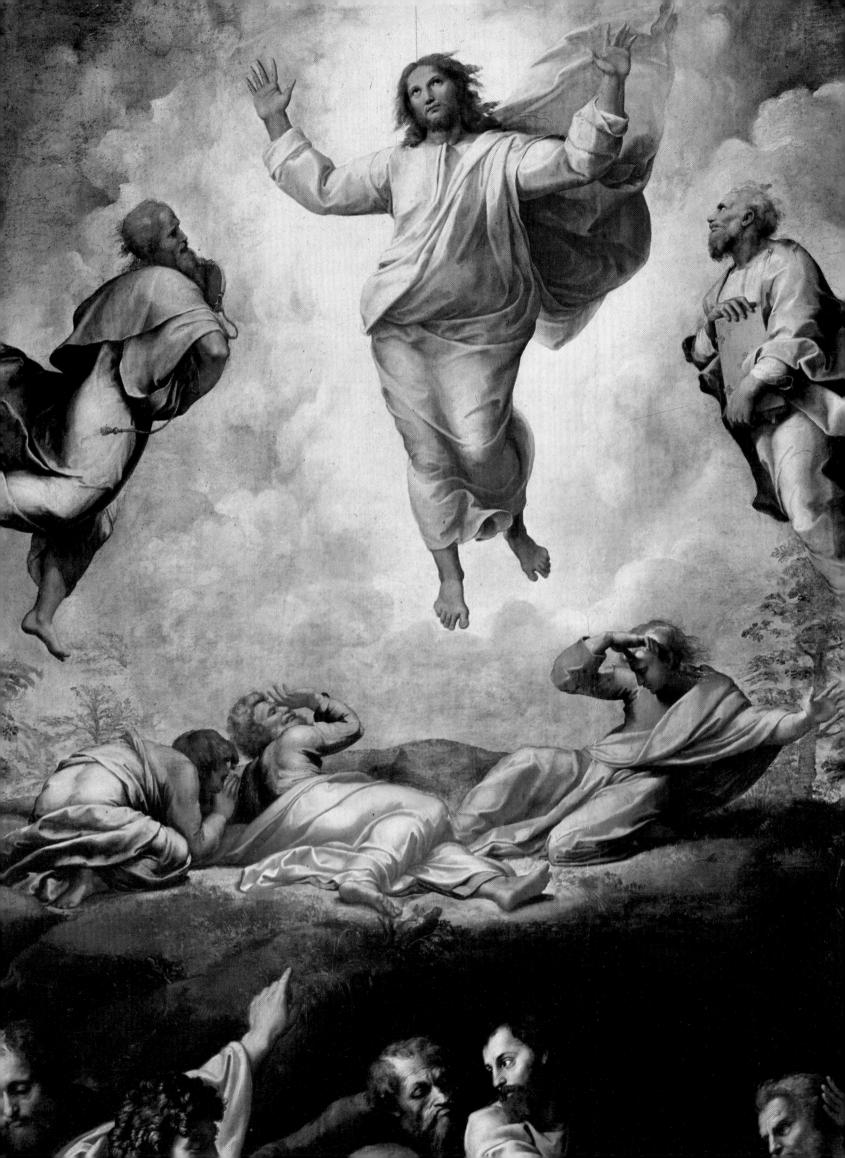

THE VATICAN MUSEUMS

Introduction

The renewed interest in Greco-Roman civilization that characterized the Renaissance brought with it the realization that in order to capture the spirit of classical antiquity libraries were not enough; museums were also necessary. The church had already incorporated into her thought the "naturally Christian" elements in the writings of the ancients, preserved by copyists in medieval monasteries. She was to do the same for the art of antiquity, which until then had been treated with either neglect or hostility. The spirit behind this new attitude was that of Christian humanism, exalted by Raphael in the frescoes of the Stanza della Segnatura, Julius II's study.

This spirit was well understood by Sixtus IV (1471–84), who in 1471 donated to the people of Rome a valuable collection of classical sculpture when he opened, in the Capitoline Palace, the world's first public museum. In 1475 the same pope, carrying out a project that went back to Nicholas V (1447–55), founded the Apostolic Vatican Library, the second public library in Europe (the first was that of San Marco in Florence).

Sixtus IV's nephew Julius II (1503–13) followed this example of generosity and made a gift to the Holy See of the ancient marbles that he owned. They were installed in the garden bounded by the north and east wings—the only ones as yet constructed—of the villa designed by Antonio del Pollaiuolo and built about 1487 by Jacopo da Pietrasanta for Innocent VIII (1484–92). It was called the Belvedere because of the beauty of the view from its splendid loggia. The sculptures placed there by Julius formed the nucleus of the future Vatican Museums; among them were the Apollo Belvedere, the Venus Felix, the Torso Belvedere, the Laocoön group, the Ariadne, and the Meleager. This collection was freely accessible, but only to connoisseurs; an inscription on the door warned the "profane" to keep away: "Procul este prophani." The garden was always full of young artists copying the ancient masterpieces, and from the beginning of the sixteenth century the villa was used to house artists in the service of the popes; one of them was Leonardo da Vinci.

The Vatican Museums remained in this embryonic state until the eighteenth century, when archaeology and the history of art came to life in the pages of Johann Joachim Winckelmann and Luigi Lanzi. The principal work of the former was his *History of Ancient Art*, published in 1764, the year after he had been appointed superintendent of the antiquities of Rome. Lanzi's *Storia pittorica d'Italia* was printed in 1795–96; it was thus contemporary with one of the largest and richest museological complexes in the world, the Museo Pio-Clementino, which was founded by Clement XIV (1769–74) and completed by Pius VI (1775–99).

The work of these two pontiffs had been prepared to some extent by their predecessors. Clement XI (1700–1721) was the first to think of collecting in one place the remarkable assortment of inscriptions, both pagan and Christian, that belonged to the Vatican. This plan was carried out by Benedict XIV (1740–58), who had the collection systematically arranged in the north section of the east corridor of the Cortile del Belvedere, where the Museo Chiaramonti is now located. The collection was transferred to the present-day Galleria Lapidaria by Pius VII (1800–1823). Another project conceived by Clement XI and carried out by Benedict XIV was the creation of the Museo Sacro of the Vatican Library, which opened in 1756 in the southern part of the west corridor of the Cortile del Belvedere. Francesco Vettori, who had donated to the new museum a large number of ancient gems, was made its director.

Clement XIII (1758–69) added the Museo Profano of the Vatican Library and housed it in the northern part of the same corridor. The Museo Profano was

intended for minor works of ancient art, but it also contained a masterpiece of classical Roman painting, the fresco known as the Aldobrandini Marriage. The same pope established a collection of medals; at first this was part of the Museo Profano, but under Pius VII it was transferred to a separate place in the Vatican Library, having been greatly impoverished by the Napoleonic sack of the Vatican collections.

In setting up the Museo Profano, Clement XIII was advised by Cardinal Alessandro Albani, a friend of Winckelmann's and the owner of the magnificent collection of ancient statuary still preserved in the Villa Albani, which was built for the cardinal by the Roman architect Carlo Marchionni, on the Via Salaria in Rome. The great German archaeologist was to have been the director of the new museum, but he died suddenly, and Giovanni Battista Visconti, whom he had designated as his successor, was appointed in 1768.

The laws of Benedict XIV restricting the export of works of art brought to the Vatican an increasing number of statues, reliefs, sarcophagi, inscriptions, and mosaics, acquired from dealers in antiquities or from the excavations that were then being carried out in Rome and elsewhere in the Papal State. It soon became clear that museums could no longer be improvised in places built for other purposes. A proper museum complex would have to be constructed, capable of housing the art treasures of the Vatican and of receiving future additions. The acquisition in 1770 of the Fusconi and Mattei collections gave the final impulse to the new enterprise. Thus the above-mentioned Museo Pio-Clementino came into being, through the munificence of Clement XIV (1769–74) and Pius VI (1775–99) and the talent of the architects Alessandro Dori, Michelangelo Simonetti, and Giuseppe Camporese.

Clement XIV did not construct a separate building; he followed his predecessors' example by making exhibition halls out of existing rooms in the Belvedere of Innocent VIII. His treasurer, Cardinal Giovanni Angelo Braschi, was responsible for the conversion of the old statuary garden into the present-day octagonal court. When Braschi became pope, as Pius VI, in 1775, he imparted fresh vigor to the project; a series of majestic halls and a monumental entrance and staircase were added to the museum. (The architectural transformations of Clement XIV and the new constructions of Pius VI are described above, in the chapter on the history of the Apostolic Palace, of which the Museo Pio-Clementino is an extension.)

The new museum was opened in 1787. But under the Treaty of Tolentino, which Napoleon Bonaparte imposed upon the Papal State ten years later, the most precious possessions of the papal collections were carried off to Paris; some of them were damaged in the process. When, after the fall of Napoleon of 1815, the booty was returned by order of the Congress of Vienna, Pius VI's successor, Pius VII (1800–1823), had to reconstitute the Museo Pio-Clementino. He also had to find a suitable place for many famous pictures that the French had carried off from various parts of the Papal State; it was decided to keep them in the Vatican. They included Raphael's *Transfiguration*, which had formerly been in the church of San Pietro in Montorio in Rome, his *Coronation of the Virgin* from San Francesco in Perugia, and his *Madonna di Foligno* from the convent of Sant'Anna in that city. These works of art were to become the nucleus of the Vatican Pinacoteca, or picture gallery.

In 1805 Pius VII had appointed Antonio Canova inspector general of fine arts in Rome and placed him in charge of the mutilated Vatican Museums. To fill the gaps left by the statues that had been carried off to France, the pope obtained large quantities of objects from dealers in antiquities and from excavations. In 1807 the smaller statues, busts, and sarcophagi were placed in the north end of Bramante's corridor, which became known as the Museo Chiaramonti, after the pope's family name; the collection of inscriptions begun by Clement XI was moved from this site to its present one, the Galleria Lapidaria, in the south end of the same corridor. As a result of the new acquisitions, when the works of art plundered by the French were finally recovered there was no longer sufficient room for them. On Canova's advice, Pius had the Roman architect Raffaele Stern construct a new wing, the Braccio Nuovo, parallel to the Sistine Library. The Braccio Nuovo is a splendid example of a Neoclassical museum; it represents the latest advances in museological theory. Unlike the rooms of the Museo Pio-Clementino, which are aesthetically self-sufficient even without the works they contain, the Braccio Nuovo was designed exclusively to display its statues to the best advantage.

Until this time, the Vatican Museums had been chiefly concerned with Greco-Roman art. Gregory XVI (1831–46) greatly increased the interest of the collections by extending them to two fields that had recently become the object of scientific study: Etruscan and Egyptian antiquities. The Museo Gregoriano Etrusco was inaugurated in 1837 in rooms on the second floor of the two wings flanking the Nicchione of the Belvedere; it contained Etruscan, Italic, and Greek objects, mainly from the recently discovered necropolis of Cerveteri, including the furnishings of the famous Regolini-Galassi tomb. Two years later the Museo Gregoriano Egizio was installed on the first floor, under the supervision of the learned Egyptologist and Barnabite priest Luigi Ungarelli. It included antiquities from the temple of Isis in the Campus Martius in

The Vestibolo Quadrato of the Museo Pio-Clementino, with the busts of the museum's founders, Clement XIV and Pius VI. In the background is a famous ancient statue, the Apoxyomenos.

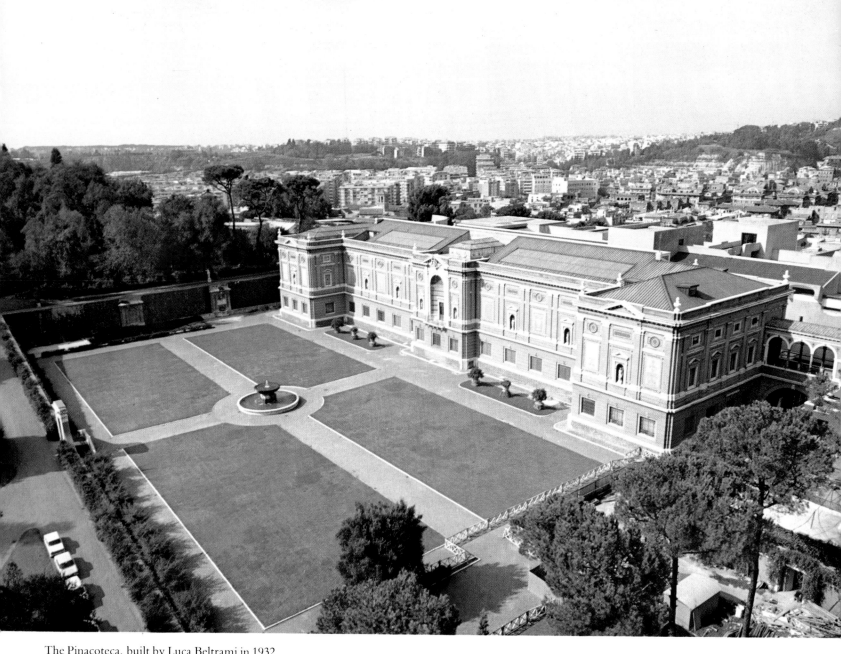

The Pinacoteca, built by Luca Beltrami in 1932.

Rome and from Hadrian's Villa at Tivoli, as well as an important papyrus manuscript of the Egyptian Book of the Dead.

Two collections established by the popes in the Lateran Palace in the mid-nineteenth century are central to our account because, more than a century later, they were incorporated into the Vatican Museums. Gregory XVI founded the Museo Profano Lateranense in 1844 to house a large number of Roman statues, sarcophagi, reliefs, and mosaics for which there was no longer room in the Museo Pio-Clementino, though many of these objects—such as the mosaics with figures of athletes from the Baths of Caracalla and

the portrait statue of Euripides—were worthy of a place in the Vatican collections. Continuing the work of his predecessor, Pius IX (1846–78) founded, in 1854, the Museo Cristiano Lateranense, devoted to Early Christian antiquities including the famous statue of the Good Shepherd and a fine collection of inscriptions and sarcophagi from the catacombs and elsewhere. These precious relics of the primitive church were installed under the supervision of the Jesuit father Giuseppe Marchi and the archaeologist Giovanni Battista De Rossi.

Leo XIII (1878–1903) transformed the corridor above the Museo Profano of the Vatican Library into

the Galleria dei Candelabri, which contains Roman statuary and the famous series of ancient candelabra to which it owes its name. The same pope restored and opened to the public the Appartamento Borgia in the Vatican Palace, under the direction of the German Jesuit Franz Ehrle.

Pius X (1903–14) enlarged the Vatican collection of paintings by adding to it the Byzantine and Italo-Greek icons that had previously been kept in the Vatican Library. This collection had been housed, since the time of Pius VII, in a number of different locations within the Vatican Palace. Finally, in 1932, Pius XI (1922–39) constructed a permanent home for it, the present-day Pinacoteca, near the entrance to the Museo Pio-Clementino. The building was designed, in a fifteenth-century Lombard style, by the architect Luca Beltrami. The same pope created the Museo Missionario Etnologico in the Lateran Palace, containing objects from all the regions of the world where the church conducts missionary activity; this important collection later became part of the Vatican Museums. Pius XI also established the Vatican's restoration laboratory, for the conservation of frescoes and panel paintings, marble, bronze, wood, and terracotta sculpture, and tapestries. Among the achievements of this organization was the restoration of Michelangelo's *Pietà* in Saint Peter's, which was disfigured in 1972 when a deranged person attacked it with a hammer; the repairs took seven months to complete. The laboratory's technicians are engaged at present in cleaning and restoring Michelangelo's frescoes in the Sistine Chapel.

John XXIII (1958–63) had a new and entirely modern building constructed, parallel to the Pinacoteca, to house the three museums that were formerly in the Lateran Palace: the Museo Profano, the Museo Cristiano, and the Museo Missionario Etnologico. All three have been reorganized to meet the critical and artistic criteria of modern museology. The building was designed by the Passarelli brothers and was inaugurated by Paul VI in 1971. It is, to paraphrase Le Corbusier, a *machine à exposer*. Its structure is conceived in the most up-to-date architectural language, in deliberate contrast to the works of ancient art exhibited in it. Its movable fixtures make it possible to install statues, busts, bas-reliefs, sarcophagi, and inscriptions so that they may be admired and studied in the best possible spatial environment and under the best possible lighting conditions.

The interior of the Pinacoteca.

The latest additions to the rich complex of the Vatican Museums are the Collezione d'Arte Religiosa Moderna and the Museo Storico, both of which were opened in 1973. The former has been installed in the Appartamento Borgia and in adjacent rooms that had formerly been used for other purposes. It contains 740 works by well-known contemporary artists, all of which were offered as gifts to Paul VI, who inaugurated the collection. The historical museum is housed in a large underground exhibition space beneath the rectangular garden to the south of the Pinacoteca. It contains coaches that once belonged to popes and cardinals, and relics, such as weapons, uniforms, and flags, of the old pontifical army and of the recently disbanded military corps.

The Vatican Museums also include those parts of the ancient papal residence that are decorated with important frescoes. These include the Chapel of Nicholas V, the Appartamento Borgia, the Sistine Chapel, Raphael's Stanze and the Logge, and many other rooms. Because of this feature, the Vatican Museums possess the greatest collection of frescoes in the world, unique in both quantity and quality.

In this brief introduction we have followed the development of the Vatican Museums from their idyllic beginnings in Julius II's garden of statues, through the palatial splendor of the eighteenth-century Museo Pio-Clementino and the cold dignity of the Neoclassical Braccio Nuovo, to the modern, functional building recently constructed to house the former Lateran museums. The phases of this evolution follow the development of aesthetic thought, and therefore of museology, through five centuries, from the sixteenth to the twentieth. They demonstrate how a purely artistic point of view gradually gave way to a critical and scientific concept of the relation between a work of art and the setting in which it is presented.

DEOCLECIO REDIG DE CAMPOS

The Museo Pio-Clementino

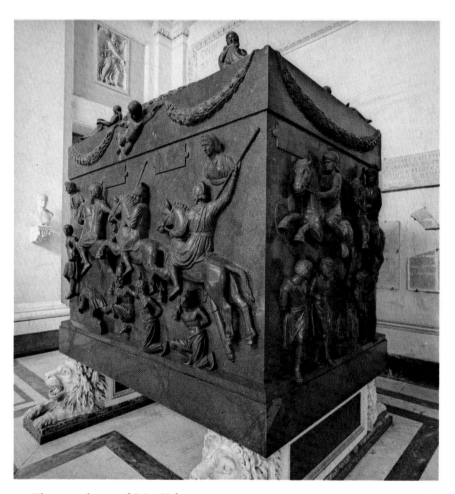

The sarcophagus of Saint Helena,
the mother of Constantine.

The rooms of this museum are grouped around the octagonal court adjoining the old Belvedere of Innocent VIII. Their architecture is described in the chapter on the Apostolic Palace. Clement XIV's and Pius VI's architects, Alessandro Dori, Michelangelo Simonetti, and Giuseppe Camporese, designed the new exhibition rooms to house specific works of art; architecture, décor, and sculpture interact to form distinct aesthetic and thematic units. The museum is a rare example of an eighteenth-century collection whose original arrangement has been preserved virtually intact. For this reason it is well to describe the sculptures room by room, in the order in which the visitor encounters them, rather than in historical sequence.

Sala a Croce Greca

The most important objects displayed in this room are two monumental sarcophagi of dark red Egyptian porphyry, which are placed so that they can be viewed from all sides.

One is the sarcophagus of Saint Helena, the mother of Constantine, who died in 329. It dates from the beginning of the fourth century and comes from her tomb at Tor Pignattara, outside Rome, the site of which is known from the life of Constantine by his contemporary Eusebius. The sarcophagus is decorated

on all four sides with reliefs depicting victorious Romans and captive barbarians. Such a subject seems more suitable for the funerary monument of a military leader proud of his success in the field than for that of a pious woman of the ruling class; probably Constantine commissioned it, before his conversion, to commemorate his own exploits. During the Middle Ages it was removed to the Lateran basilica, where it was used for the burial of Pope Anastasius IV (1153–54); Pius VI had it brought to the Vatican in 1778.

The other sarcophagus, of about 350–60, was acquired by Pius at the same time. It belonged to Constantine's daughter Constantia, and comes from her mausoleum on the Via Nomentana, which in 1254 was transformed into the church of Santa Constanza. Its relief decoration shows cupids, amidst vine scrolls, gathering and pressing grapes—a Dionysiac subject often adopted by the early Christians as a symbol of the Eucharist. The long sides have other subjects from the Dionysiac repertory: peacocks, rams, and cupids bearing garlands.

The room also contains two large couchant sphinxes in rare reddish gray Egyptian granite, of the Roman Imperial period. A half-draped statue of Augustus (31 B.C.–A.D. 14), found at Otricoli, (ancient Ocriculum) in Umbria, is an adaptation of a Greek sculptural type of the fifth century B.C., conventionally known as the Diomedes. In the center is a mosaic from Tusculum, in the Alban Hills, with the bust of Minerva; it dates from the third century A.D. Two red granite statues of the second century, from Hadrian's Villa near Tivoli, flank the door leading to the next room and function as telamones, or architectural supports; they are carved in an Egyptianizing style and are derived from figures of pharaohs or of Osiris.

Sala Rotonda

The room is paved with mosaics from Otricoli, representing battles of Greeks and centaurs, Tritons and Nereids, and marine animals. In the center is a huge basin, carved from a single block of porphyry, found in Nero's Golden House, the Domus Aurea. The eight large niches surrounding the hall contain colossal statues of divinities, heroes, and emperors; busts on pedestals stand before the pillars between the niches.

The statues include the Barberini Hera, found on the Viminal Hill in Rome and named for the princely family who originally owned it. It is a Roman adaptation of a Greek original from the end of the fifth century B.C., attributed to Phidias' pupil Agorakritos. Another Roman copy, of a statue of about 420 B.C., from the circle of Phidias, has been restored as a representation of Demeter. A statue of Juno Sospita (the Italic goddess worshiped at Lanuvium, an ancient

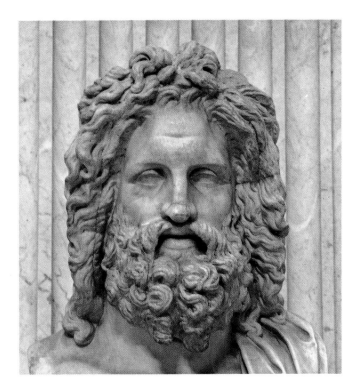

The Jupiter of Otricoli.

city in the Alban Hills, south of Rome) is probably a cult image of the second century A.D. A colossal gilded bronze Hercules, from the end of the second century A.D., is a later addition to the collection. It was found near Pompey's Theater in 1864, under slabs of stone inscribed with the initials *F.C.S.*, standing for *Fulgur conditum Summanium*: this means that the statue had been struck by nocturnal lighting and, in accordance with religious law, buried on the spot. Hercules has his usual attributes: the club, the lion's skin, and the apples of the Hesperides.

The Genius of Augustus is shown in the act of sacrifice, with his toga drawn over his head and a cornucopia in his left hand (the right arm with the *patera* —the shallow dish from which libations were poured— is a modern restoration). The Romans believed that every man had a special tutelary god, or Genius; from 7 B.C. on, the Genius of Augustus was honored in an official cult. Another imperial statue, of Claudius (A.D. 41–54), was excavated in 1855 in the theater at Lanuvium. The emperor is represented in the guise of Jupiter, half-draped, holding a scepter and a *patera*, with an eagle at his feet; his crown of oak leaves symbolizes his role as first citizen of the state. Antinous, the young favorite of Hadrian who was deified by that emperor after his death (by drowning, in the Nile) in 130, is portrayed with the attributes of Dionysus-Osiris: a crown of ivy, a *cista mystica* (the basket that held the cult objects of the Dionysiac mysteries) near his left foot, and a pinecone (which perhaps should

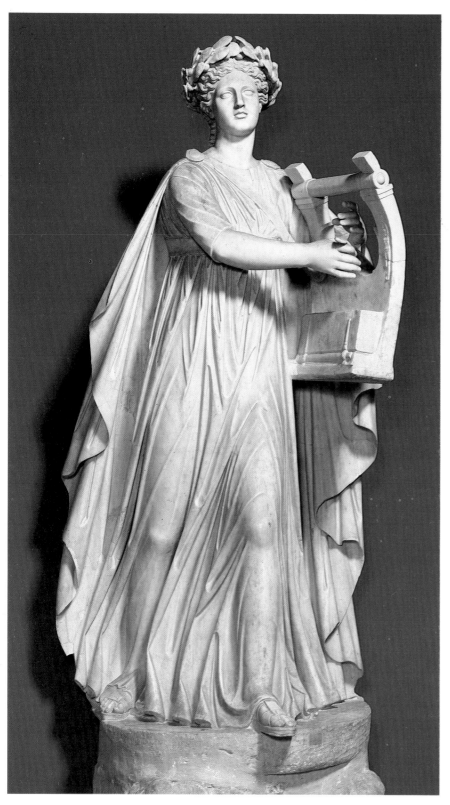

The statue of Apollo, crowned with laurel and playing the lyre, was probably executed during the second century A.D.

be restored as a uraeus, the snake symbol of Osiris and other Egyptian gods) on his head.

Among the busts in the Sala Rotonda are the magnificent head of Jupiter from Otricoli, a Roman version of a Greek Zeus of the fourth century B.C.; a fine bust, in Greek marble, of the marine god Oceanus, found near Pozzuoli; a portrait of Trajan's wife Plotina, probably made, as its proportions suggest, after her deification in 129 by her adopted son Hadrian; a colossal, somewhat idealized head of Hadrian (117–38) from his mausoleum, the present-day Castel Sant' Angelo; a bust of Antinous, found in 1790 at Hadrian's Villa; the elder Faustina, wife of Antoninus Pius (138–61); a fine cuirassed bust of Pertinax, the great commander who was made emperor against his will after the assassination of Commodus, himself assassinated by the Praetorian Guard in March 193 after a reign of only eighty-seven days, and later deified by Septimius Severus; and a lively portrait of Julia Domna, the wife of Septimius Severus (193–211).

Sala delle Muse

This magnificent hall, designed by Simonetti, takes its name from the statuary group of Apollo and the nine Muses exhibited here. As elsewhere in the Museo Pio-Clementino, the décor harmonizes with the works of art for which the room was conceived: the theme of Apollo and the Muses is developed in the ceiling frescoes, painted by Tommaso Conca between 1782 and 1787.

The Muses, daughters of Zeus and Mnemosyne, the goddess of memory, presided over the various forms of literature, music, the dance, and astronomy. Apollo was their leader, and they sang and danced to the music of his lyre. The statue of Apollo—crowned with laurel, playing the lyre, and clothed in the long, belted robe worn by the *citharoedi*, or lyre players—and those of seven of the Muses—Melpomene (tragedy), Thalia (comedy), Calliope (epic poetry), Polyhymnia (sacred song), Erato (love poetry), Clio (history), and Terpsichore (the dance)—were discovered in 1774 at the so-called Villa of Brutus near Tivoli; the other two Muses—Euterpe (lyric poetry) and Urania (astronomy)—were found later and added to the group.

The Muses were regarded as inspiring not only the arts and sciences, but all manner of other intellectual pursuits as well. Therefore, the portraits of philosophers, statesmen, and orators displayed in this room, together with those of poets, are related to its conceptual theme. All are Roman copies of Greek originals; some of them come from the same Roman villa as the statues of Apollo and the Muses. Periander, tyrant of Corinth (ca. 625–585 B.C.), a notable patron of the arts, is identifiable through an inscription with

his motto, "Exercise is everything." Another inscribed motto, "The majority of men are wicked," accompanies the portrait of the statesman Bias of Priene, who lived in the sixth century B.C. Periander and Bias were numbered among the Seven Wise Men of Greece. There is a bust of Antisthenes, the founder of the Cynic school of philosophy, who died in about 365 B.C., and one of Aeschines, the celebrated Attic orator and adversary of Demosthenes, who died in 314. The portrait of Pericles, the great Athenian statesman (ca. 495–429 B.C.), is apparently derived from the bronze statue made immediately after his death by the sculptor Cresilas. Pericles is represented as *strategos*, or commander in chief of the army, which was his official position in the Athenian state. His younger contemporary, the historian Thucydides, reports the famous Funeral Oration in which Pericles sums up his democratic creed: "As for an individual's public rank, it is not his belonging to a particular social class, but rather his personal merit, that gives him preeminence in the life of a community."

Other Roman copies of portraits of famous Greeks were gathered from various sources. The bust of Homer is of the so-called Epimenides type: the poet is shown with closed eyes, an allusion to his blindness, but the type was formerly thought to represent the Cretan poet Epimenides, who was said to have slept for fifty-seven years. The original dates from about 460 B.C. There are busts of Sophocles, Euripides, Plato, and Epicurus, derived from originals of the fourth and third centuries B.C., but the most important portrait of the group is the Socrates found at the villa of the Quintilii, outside Rome on the Appian Way. The original was probably cast in bronze, and must have been executed soon after the philosopher's death in 399 B.C., when an Athenian jury condemned

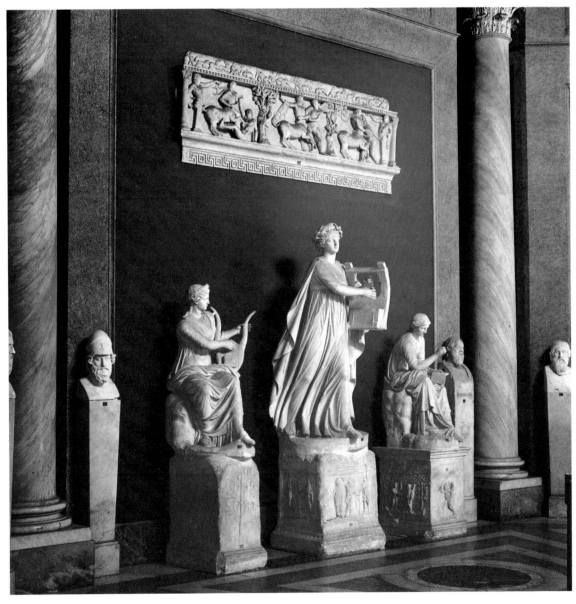

The Sala delle Muse takes its name from the statuary group of Apollo and the Muses found in 1774 at a Roman villa near Tivoli.

him to drink hemlock (the charges were failing to recognize the state gods, introducing new ones, and corrupting youth). Contemporary descriptions give us a good idea of what Socrates looked like; Alcibiades, in Plato's *Symposium*, remarks that he resembles Silenus or the satyr Marsyas—half-human beings of comical aspect. The portrait, with its singular domed forehead, small eyes, arched eyebrows, snub nose, and heavy beard, corresponds closely to the descriptions.

In the center of the room is a celebrated fragment known as the Belvedere Torso. It was placed in the Belvedere by Clement VII in about 1530. Michelangelo and Bernini are known to have admired it. The powerfully built figure sits on a rock draped with an animal skin; it has been variously interpreted as a Hercules, as one of several other heroes, or as a Marsyas. The artist's inscription, on the front of the rock, reads: "The Athenian Apollonius, the son of Nestor, is the creator [of this work]." It was probably executed around the middle of the first century B.C.

Sala degli Animali

This room houses a unique collection of animal sculpture, formed by Pius VI; it was completed in 1782. Some of the pieces are ancient; a great many, however, are fragments restored so extensively and so freely by the sculptor Francesco Antonio Franzoni (1734–1818) that they may be considered his own work.

The Sala degli Animali contains one statue of considerable importance, a Meleager carved about A.D. 150 after a Greek original of about 340–330 B.C. by the great sculptor of the late classical period, Scopas. The huntsman Meleager is represented with his dog and with a trophy, the head of the Calydonian boar.

A group representing Mithras slaying the bull in the presence of a scorpion, a serpent, and a dog—the central symbolic event of the Mithraic religion—was found in a sanctuary at Ostia and restored by Franzoni.

Galleria delle Statue

This hall was formerly the open loggia of the Belvedere of Innocent VIII. Clement XIV had it transformed into a sculpture gallery by Alessandro Dori; Michelangelo Simonetti extended it for Pius VI, destroying in the process a chapel with frescoes by Mantegna. It contains some of the best-known objects in the Vatican collections.

The Ariadne—found in the early sixteenth century and erroneously identified as Cleopatra, by which name the statue is known in the older literature—is a much admired copy of a Hellenistic piece of the second century B.C. Ariadne, the daughter of King Minos of Crete, fell in love with the hero Theseus and was aban-

The Belvedere Torso, placed in the Belvedere by Clement VII in about 1530.

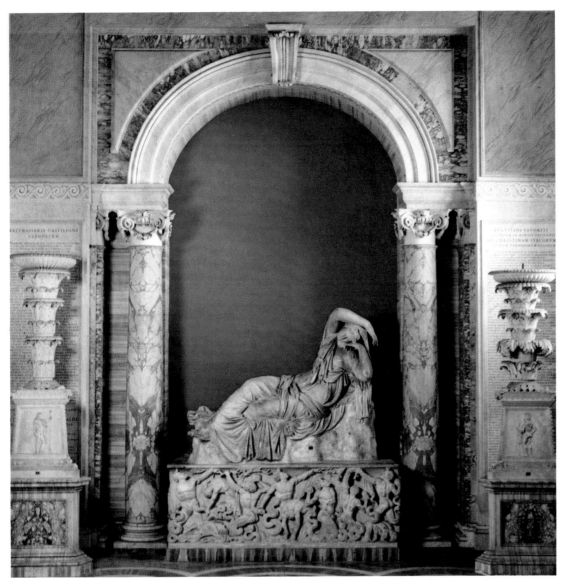

The Ariadne has been in the Vatican collection since 1512.

doned by him on the island of Naxos, only to be found, and married, by Dionysus. Here the moment before the appearance of Dionysus is represented; Ariadne is shown asleep, leaning her head upon her left hand and encircling it protectively with her right arm. A Roman sarcophagus from the end of the second century B.C., with a relief representing giants slain by the gods, is used as the statue's base. Flanking the niche that houses the Ariadne are the two Barberini candelabra, named for their former owners; they were originally part of the sumptuous furnishings of Hadrian's Villa. They are elaborately carved in white marble. On the triangular bases are relief figures of gods and goddesses: Jupiter with a scepter and a thunderbolt, Juno with a scepter, Mercury with a ram, Mars with a helmet and a lance, Venus with flowers, and Minerva with a helmet, a shield, and a serpent.

The Apollo Sauroktonos—the Greek word means "lizard slayer"—is a copy of a bronze by Praxiteles of about 350 B.C.; it was found on the Palatine Hill. The god, represented as a graceful youth, is about to spear a lizard with a dart (the dart is missing in the copy, but Pliny the elder records its presence in the original). Scholars are uncertain about the meaning of this act; it could be a playful allusion to Apollo's destruction of Python, a monstrous dragon, in his role as liberator of mankind from affliction.

Another famous marble copy is the Mattei Amazon, derived from a bronze original of about 430 B.C. Pliny the elder tells of a competition among four celebrated artists of the fifth century, each of whom provided a statue of an Amazon for the temple of Artemis at Ephesus. Several rather closely related Amazon types exist in Roman copies, and it is generally held that the Mattei figure goes back to the statue by Phidias, which according to Pliny came in second in the competition.

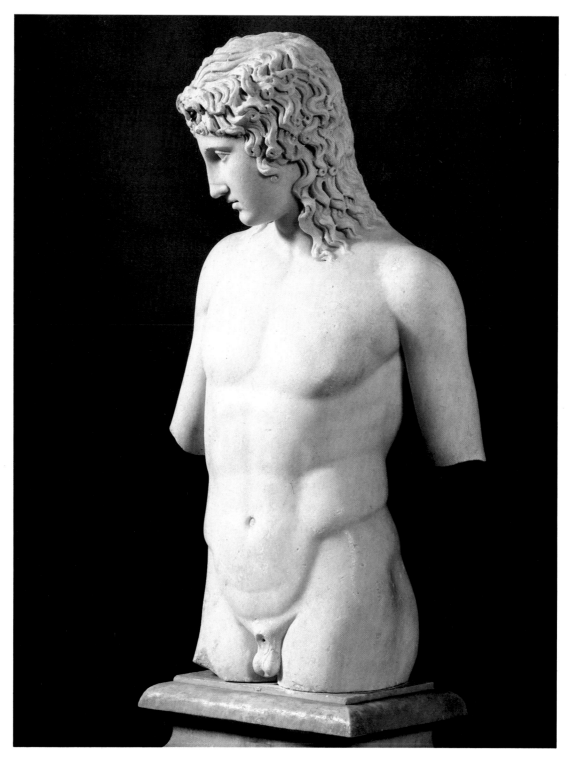

The Eros of Centocelle, found in the Roman suburb of that name, is a Roman copy of a statue of the Peloponnesian school from the beginning of the fourth century B.C.

The "Ingenui" Hermes, so called from the name —that of the artist or of a donor—carved on the base, is a Roman copy of the second century A.D. after a Greek original of the fifth century B.C. The god has a pair of wings growing from his head above the temples, and carries a herald's rod (restored) and a lyre.

The Eros of Centocelle was found in the Roman suburb of that name, on the Via Labicana. That the long-haired nude youth is to be identified as the god of love is certain from the traces of wings on his back. The statue is a Roman copy of a work of the Peloponnesian school from the beginning of the fourth century B.C.

Two seated portrait statues of Greek comic playwrights, Menander and Posidippus, were found together on the Viminal Hill. Both heads have been completely reworked.

View from the Galleria delle Statue into the Galleria dei Busti. The seated statues flanking the arch are portraits of the comic playwrights Menander and Posidippus. In the background is the Verospi Jupiter.

Galleria dei Busti

Four small rooms in Innocent VIII's villa were joined, by means of arches resting on columns of *giallo antico* marble, to form this gallery, which continues the axis of the Galleria delle Statue. It takes its name from the busts of Roman emperors and other personages that are arranged in elegant rows upon its shelves. In the niche at the far end is the statue known as the Verospi Jupiter, after the palace in Rome where it was formerly housed. It is a work of the third century A.D. based on the gold and ivory cult statue in the temple of Jupiter on the Capitoline Hill, which was executed by a Greek sculptor called Apollonius—who may perhaps have been the same man as the author of the Belvedere Torso—after the fire of 85 B.C. The enthroned, powerfully built god holds a scepter (a modern restoration) in his left hand and a thunderbolt in his right.

A basalt bust of Serapis (a syncretistic divinity, uniting in himself the characteristics of Jupiter, Osiris,

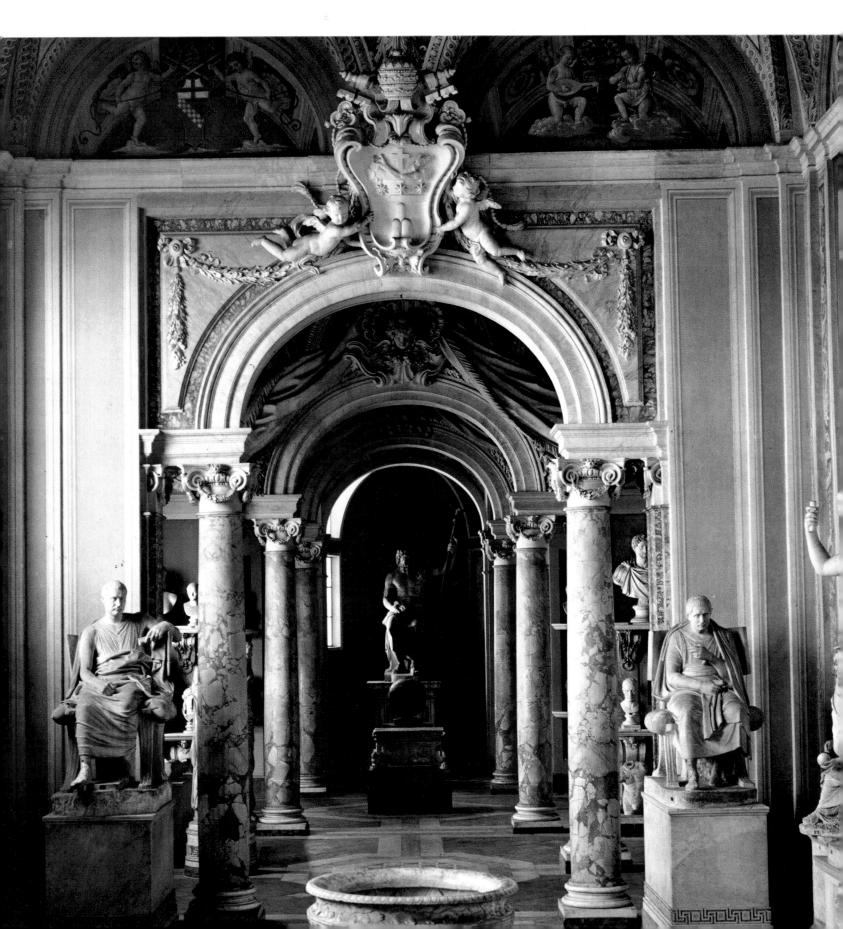

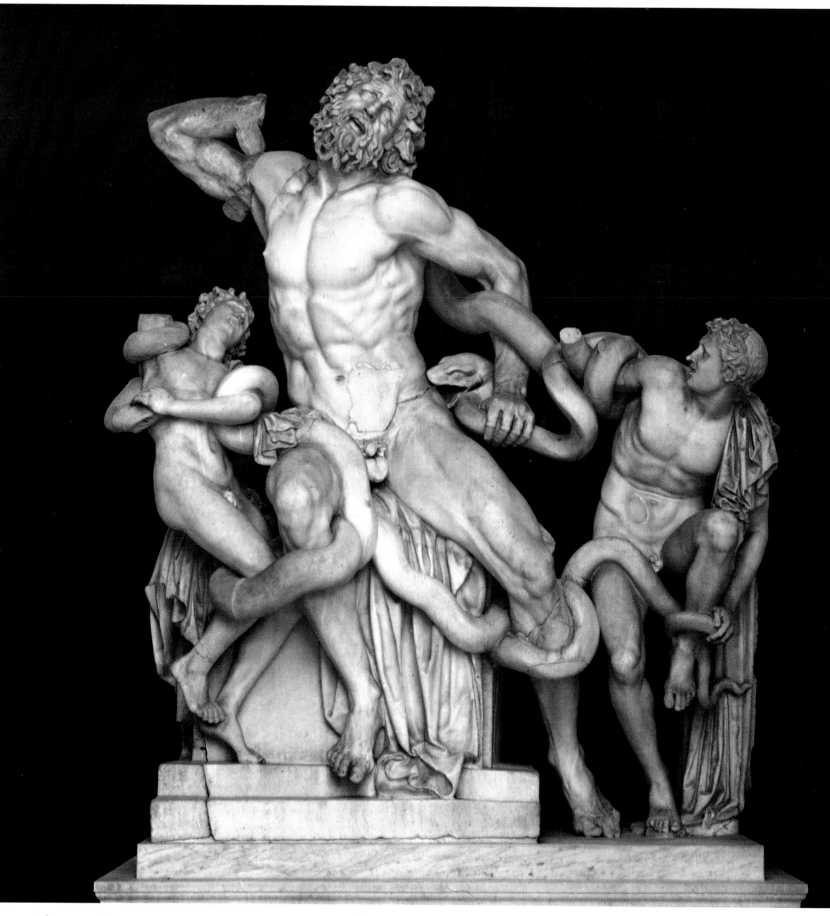

The Laocoön group, discovered in 1506 on the Esquiline Hill.

Apis, and Pluto is derived from the cult statue by Bryaxis in Alexandria. There is also a head of Menelaus in a parade helmet, of the second century A.D., found at Hadrian's Villa. It is from a copy of the famous Hellenistic group of Menelaus carrying the body of Patroclus, popularly known as the Pasquino group.

The Gabinetto delle Maschere houses another statue of Venus at her bath, a Roman copy of a famous work by Doidalsas, a Bithynian sculptor of the third century B.C. Here the goddess, intent upon her bathing, crouches in the water that gushes from an invisible source above her. This copy was found near Rome in 1760; in ancient times it graced the bath of a wealthy Roman's villa.

Other statues in the room include a red marble satyr, fondly contemplating a bunch of grapes, from Hadrian's Villa, and a group of the Three Graces, a Roman copy from the second century A.D. of a late Hellenistic original, the charm of which lies in the combination of repetition and variation in its forms.

Cortile Ottagono

The old garden of the Belvedere, once planted with orange trees, is the original nucleus of the entire museum: it was here that, after 1503, Julius II arranged his collection of statues, including the famous Apollo that takes its name from the villa. Under Clement XIV, Simonetti surrounded it with a portico and constructed the four corner recesses that give it its octagonal shape. The entrance is flanked by two Molossian hounds, Roman copies of Greek originals of the third century B.C. Under the portico are statues, granite basins, and sarcophagi.

The famous Laocoön group, by the Rhodian sculptors Hagesander, Polydorus, and Athenodorus, was discovered in 1506 on the Esquiline Hill, on the site of Nero's Domus Aurea. It probably dates from the first century B.C. or the first century A.D. The group was reconstructed in 1957–60, and the original right arm of the figure of Laocoön, which the archaeologist Ludwig Pollak had discovered in 1905, was inserted.

Laocoön, a Trojan priest of Apollo, and his two sons are shown in the formidable coils of two serpents, on the steps of an altar. One of the snakes is about to bite the hip of Laocoön, who struggles upward and tries in vain to pull its head away; the other has already sunk its fangs into the younger son, who falls writhing in pain. The elder son is still endeavoring to free himself. In Laocoön's hair there are traces of attachments for a laurel wreath, the mark of a priest of Apollo.

According to one version of the myth, the snakes were sent by Apollo to punish Laocoön for having married against the god's will and begotten children before the very altar. In the most detailed and moving version of the story, however, in Virgil's *Aeneid*, Laocoön warns the Trojans against accepting the wooden horse in which the Greek warriors are hidden, and hurls a lance at it. This arouses the hatred of Athena, who sends the snakes: thus the fate of Troy is sealed. Among the Trojans, only Aeneas listens to Laocoön's warning; he escapes the destruction of the city and sets out upon his voyage to Italy. The story had a particular significance for the Romans, since the Julio-Claudian house claimed to be descended from Aeneas.

The portraits in the gallery are of considerable interest. Augustus is shown crowned with ears of wheat as the sign of his membership in the Arval Brotherhood, the ancient priestly college that he restored prior to 21 B.C. Another bust, in white Parian marble and extremely well preserved, was formerly thought to be a portrait of the young Octavian, but it probably represents one of his grandsons, Gaius or Lucius. Other imperial portraits include those of Tiberius, Titus, Nerva, Antoninus Pius, Marcus Aurelius, Lucius Verus, Caracalla, Alexander Severus, and Macrinus. A fine double portrait from a tomb, dating from the end of the first century B.C., consists of half-figures of a man and wife with their right hands joined. This gesture, the *dextrarum iunctio*, symbolized fidelity and concord, especially in marriage. The couple are popularly called Cato and Portia, but their real names, M. Gratidius Libanus and Graditia M. L. Chrite, are known from an inscription recorded in the seventeenth century but no longer in existence.

Gabinetto delle Maschere

This room, which was added to the Belvedere of Innocent VIII by Pius VI in 1780, takes its name from four mosaics with masks embedded in its pavement; they were found at Hadrian's Villa in 1779. The ceiling is decorated with mythological scenes, painted in oil by Domenico De Angelis: the Judgment of Paris, the Finding of Ariadne, Diana and Endymion, and Venus and Adonis.

The Cnidian Venus exhibited here is one of the better copies of one of the most celebrated works of art of the ancient world: Praxiteles' cult statue in the temple of Aphrodite at Cnidus. Preparing for her bath, the goddess of love lays aside her garment, serene and imperturbable in her divinity and oblivious to any idea of an extraneous presence. In Homer's *Iliad*, Hera invokes Aphrodite: "Grant me the power of desire and love with which you enchain everyone, the immortal gods as well as mortal men." Some of that bewitching beauty must have been reflected in Praxiteles' statue,

which was carved in about the middle of the fourth century B.C.; Pliny tells us that people flocked to Cnidus from every corner of the world in order to look upon it. The artistic quality of the Roman copy is not of the highest—the much admired luminosity of Praxiteles' surface, for example, is absent. Nevertheless, the statue preserves a faint echo of the splendor of the original.

Equally famous is the Apollo Belvedere, probably a Roman version, made about A.D. 130, of a Greek bronze of about 330 B.C. It came to light before the end of the fifteenth century near San Pietro in Vincoli, the titular church of Cardinal Giuliano della Rovere, the future Julius II. The god is shown advancing rapidly and lightly. He must be imagined with a bow, the symbol of his avenging power, in his left hand, and in his right hand either a laurel branch, the symbol of his health-giving and purifying power, or, more probably, an arrow. He carries a quiver on his back. His cloak, fastened at the right shoulder like a Roman general's *paludamentum*, serves as a backdrop for the radiant apparition. The statue is thus an epiphany of the god, whose divine vitality is manifested in pure movement.

A statue of Hermes, a Roman copy from the time of Hadrian of a late classical Greek bronze of the fourth century B.C., was found not far from Castel Sant'Angelo. It was formerly thought to represent Antinous, but the relaxed, elastic posture and the traveling cloak thrown hastily over the left shoulder and arm indicate that the subject is Hermes, the messenger of the gods. This identification is verified by other versions of the figure that go back to the same original; some of them were found on tombs, where Hermes appears as Psychopompus, the escort of souls to the world beyond the grave.

One of the corner recesses contains three statues executed in 1801 by the great Neoclassical sculptor Antonio Canova. They were bought by Pius VII after the principal treasures of the museum were carried off to Paris by Napoleon. One, much influenced by the Apollo Belvedere, represents Perseus with the head of Medusa. The other two are of the boxers Kreugas and Damoxenos. At the end of an inconclusive match, according to Pausanias, Damoxenos drove his hand into Kreugas's abdomen and tore out his entrails; the judges disqualified him and gave the victory to the dead Kreugas.

Gabinetto dell'Apoxyomenos

This small room, part of Innocent VIII's Belvedere, houses a Roman copy, from the first century A.D., of the Apoxyomenos, or "Scraper," a celebrated bronze statue by Lysippus, made about 320 B.C. It is the figure of an athlete, not at the moment of his victory, but afterward, when he has left the palestra and is scraping the dust and sweat from his body with a strigil. His faraway gaze reflects his physical exhaustion. Lysippus's aim, Pliny tells us, was to represent men not as they were but as they seemed to be, in a single, fleeting moment.

Vestibolo Quadrato

The sarcophagus of Lucius Cornelius Scipio Barbatus, who was consul in the year 298 B.C., is the oldest of the sarcophagi from the tomb of the Scipios on the Appian Way. It seems to have been a tradition of the Scipio family to bury their dead (as the people of southern Etruria also did) rather than to cremate them, which was the usual practice in Rome under the Republic. The sarcophagus, Hellenistic Greek in form, is made of gray tufa; it bears an inscription in praise of the deceased.

The so-called Ara Casali—it was probably a statue base, not an altar—was donated to Pius VI by the Casali family. The inscription, in a garland of oak leaves, states that it was dedicated by a certain Tiberius Claudius Faventinus. Mars and Venus are represented on the front, below the inscription; the reliefs on the other sides illustrate the legends of the fall of Troy and the foundation of Rome. The form of the base suggests a date of about A.D. 200; the figures, if they are not completely modern, have been reworked in modern times.

Sala della Biga

This small, round, domed room was built for Pius VI by Camporese above the entrance hall of the Museo Pio-Clementino. It takes its name from the marble *biga*, or two-horse chariot, in its center.

The body of the chariot and part of the right-hand horse are ancient, though they were originally unrelated to each other; the rest of the reconstruction is a splendid tour de force by Francesco Antonio Franzoni, who, as we saw, was also responsible for most of the sculpture in the Sala degli Animali. The vehicle is Roman work of the first century A.D. Its shape is that of a triumphal car, and its beautiful relief decoration of laurel leaves and acanthus scrolls recalls that of the chariots of such divinities as Ceres and Triptolemus. During the Middle Ages it served as a papal throne in the church of San Marco in Rome.

Ancient statues are disposed in a circle about the room. A statue of Dionysus (the name "Sardanapallos" inscribed on the hem of his mantle is perhaps the cult name of an Asiatic god identified with Dionysus) is an excellent Roman copy, from the first century A.D.,

The Apollo Belvedere is probably a Roman version, made about A.D. 130, of a Greek bronze. It was discovered at the end of the fifteenth century and quickly became one of the most admired masterpieces in the papal collection.

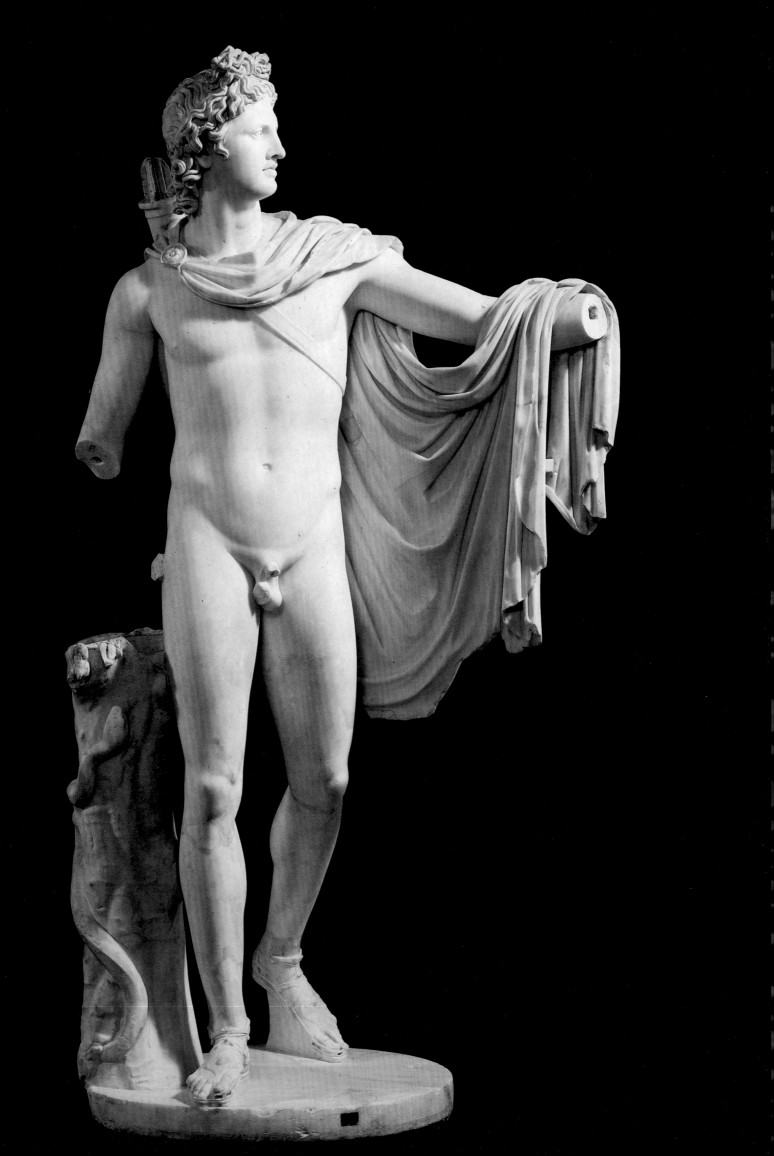

of an original by a Greek sculptor of the circle of Praxiteles. These are two statues of discus throwers. One of these athletes is preparing for a throw; his posture—the head is not original—expresses the concentration that precedes action. The vigorous form and the balanced movement suggest the school of Polyclitus, and it has been suggested, perhaps correctly, that the original was by his brother Naucydes. The copy is of the first century A.D. The other athlete is shown in the act of hurling the discus. The inclination of the head (which has been correctly restored), the torsion of the upper part of the body, the movement of the left leg, and the stretching of the arms convey a sense of physical action with unprecedented vivacity and boldness. The statue was found at Hadrian's Villa; it is a copy, from the time of that emperor (A.D. 117–38), of a bronze original executed by Myron in about 460 B.C.

Galleria dei Candelabri

The Galleria dei Candelabri, originally an open loggia over the west corridor of the Cortile del Belvedere, was transformed into a closed gallery by Simonetti and Camporese under Pius VI and subdivided into six sections by means of arches resting on pilasters and columns. The vault was painted under Leo XIII, between 1883 and 1887, by Domenico Torti and Ludwig Seitz.

The ancient marble candelabra standing under the arches give the gallery its name. Two magnificent pairs, dating from the time of Trajan (98–117), were found in the seventeenth century near Sant'Agnese on the Via Nomentana; until 1772 they were used in the nearby church of Santa Costanza. Their triangular bases are decorated with leaf ornament, sphinxes, and cupids bearing cornucopias, baskets of fruit, fillets, and other objects.

The gallery houses an interesting collection of sculpture. A statue of Artemis—the goddess is identifiable thanks to the belt from which her quiver was hung—is a Roman interpretation of a work of the early fourth century B.C., by Cephisodotus. Another Artemis, from Hadrian's Villa, is one of numerous Roman replicas of the famous cult image in the temple of Ephesus in Asia Minor, with multiple breasts and laden with attributes that symbolize the power of the goddess to further fecundity and growth. Ephesian Artemis (or Diana, as the Romans called her) was originally an Asiatic mother goddess. The Acts of the Apostles (19:23–41) testify to the popularity of her cult: "Great is Diana of the Ephesians," the people shouted when Paul attempted to convert them. And the town clerk insisted, "Who in all the world does not know that the city of Ephesus is the guardian of

The Roman *biga,* or two-horse chariot, was reconstructed in 1788 by the sculptor, Francesco Antonio Franzoni from two ancient but unrelated pieces: the body of the chariot and a fragment of one of the horses.

the temple of the great Diana and of her image that fell from heaven?"

A statue of a female runner—the palm branch on the support is a symbol of victory—belongs to the circle of Pasiteles, a Greek of southern Italy who worked in a classicizing style in the first century B.C. A nude figure of Apollo stands erect, his arms outstretched, on a base with an inscription recording a donation by a college of priests to the god of oaths, Semo Sancus. The statue and the base do not belong together; the assumption that they did formerly led scholars to identify the statue as an image of Semo Sancus. The Apollo is in the classicizing-archaizing style of the second century A.D.

A statuette of the Tyche, or Fortune, of Antioch is a small Roman copy of an important bronze by Eutychides, a pupil of Lysippus. In 300 B.C. Seleucus I, the general who, after the dismemberment of Alexander's empire, became ruler of a large part of the Near East, founded a new capital, Antioch, on the Orontes. Eutychides produced a statue of the city's tutelary divinity, Tyche, in the form of a woman seated upon a rock, with a mural crown (representing the city walls) on her head and sheaves of wheat in her right hand; at her feet the river god Orontes emerges, swimming, from beneath the rock. Another statuette also reflects a famous Hellenistic monument, known as the Donation of Attalus. Attalus I, king of Pergamon in Asia Minor, defeated the barbarous Gauls shortly before 228 B.C. To commemorate his victory he set up, on the Athenian Acropolis, a group of bronze statues representing traditional themes: battles of the Greeks with the Giants, the Amazons, and the Persians. The Vatican statuette is identifiable, from the tiara that the figure is wearing, as a copy of one of the Persian warriors. A third statuette represents Nike, or Victory (the original head is lost and has been replaced by one of Athena), leaning on a trophy and placing her right foot on the prow of a ship. The Greek original commemorated a naval victory. The Roman copy is from the second century A.D.

A number of Roman sarcophagi from the second half of the second century A.D. are decorated with reliefs illustrating myths related in one way or another to the theme of death, including those of Orestes, Niobe, Protesilaus, and Ariadne. On a later sarcophagus, of about 270–80, the deceased, a small boy, is represented on the lid as a recumbent figure. He appears again in the center of the relief on the front, this time in the guise of a philosopher: enthroned, wearing a mantle, and holding a scroll. He is surrounded by chubby little girls bearing the attributes of the Muses.

GEORG DALTROP

The Museo Chiaramonti

The Museo Chiaramonti bears the family name of its founder, Pius VII (1800–1823). Its original nucleus is a long gallery that occupies the northern half of the corridor built by Bramante to link the old Vatican Palace with the Belvedere. The objects were installed by Antonio Canova, and, except for minor rearrangements, the museum has remained as he planned it. The overall effect is somewhat overwhelming; as early as 1829 Erasmo Pistolesi wrote, in his *Vaticano descritto ed illustrato*: "Indeed the objects to be seen in this long corridor are so numerous that instead of soothing the spirit they produce a state of turmoil." The lunettes opposite the windows were painted, under Canova's supervision, by Francesco Hayez, Philipp Veit, and others with allegorical scenes celebrating Pius's contributions to archaeology and the fine arts.

Images of divinities and heroes include a colossal marble head of Athena, which was probably meant to be inserted into a body made of some other material. This Roman work, from the time of Hadrian, was modeled on the Athena Promachos of Phidias, sculpted in the fifth century B.C. A bust of Hephaestus, the divine craftsman, wearing the conical felt hat called the *pileus*, is a Roman copy of an original by Alcamenes of about 440 B.C. The model for a statue of Hercules, leaning on his club, with a lion's skin over his left forearm, would seem to have been produced in the circle of Lysippus in the fourth century B.C. A statuette of Ulysses—Roman work of the first century A.D.—must have been a part of a group representing the adventure with the Cyclops: the hero is shown offering a drink to Polyphemus.

Ulysses' wife Penelope is shown in a fragmentary relief that is probably derived from a Boeotian funerary monument of about 450 B.C.; Penelope, who was left alone for twenty years, is characterized by her sad and pensive expression. Another fragment, with the battle between the Greeks and the Amazons, is from a first-century B.C. marble copy, considerably reduced in size, of the shield of the Athena Parthenos, the huge ivory and gold cult statue in the Parthenon, made by Phidias in about 440 B.C. A relief with the Three Graces—identifiable because of the central figure, Charis, who always wears a diadem—may be an imitation of an original in the Propylaeum, the entrance to the Acropolis in Athens, where there was a cult of the Graces. The original was made about 470 B.C., the copy at the end of the first century A.D. Two relief fragments show the Aglauridae—Aglauros, Pandrosos, and Herse by name: minor goddesses, dispensers of

the nocturnal dew—moving toward the left, and one of the Horae, or Seasons, moving toward the right. The two pieces were found together on the Esquiline Hill, and must have belonged to a single composition. They are copies, from the time of Hadrian, of an original of the fourth century B.C.

The Museo Chiaramonti also contains some notable funerary monuments. One, as the inscription tells us, was that of a miller, Publius Nonius Zethus. It consists of a marble block in the shape of a sarcophagus; in the top are eight conical cavities, receptacles for cinerary urns. Two reliefs, to either side of the inscription, illustrate the dead man's trade: to the left is a donkey turning a millstone and to the right a sieve and an assortment of containers for flour. The monument may be dated to the first century A.D. The sarcophagus of Caius Junius Euhodus and his wife Metilia Acte, found at Ostia, is datable from the inscription to A.D. 161–70. It is decorated with scenes from the myth of Alcestis, who suffered death voluntarily to save her husband Admetus; the heads of Admetus and Alcestis are portraits of the deceased. A funerary monument of the late imperial period—it dates from the end of the third century—is a "speaking statue": the inscription on the base says, in the first person: "Here am I, Cornutus, grieving with my eight beloved children." Cornutus is portrayed in the guise of Saturn, the lord of the Golden Age, bearded, wrapped in a mantle, enthroned, and surrounded by children carrying fruit.

Galleria Lapidaria

In the south end of the same corridor, separated from the Museo Chiaramonti proper by an ornate iron gate, is the Galleria Lapidaria. It houses an important collection of more than five thousand ancient inscriptions, begun by Clement XI and enlarged by Pius VI and Pius VII. It was given its present arrangement, according to subject matter, by the learned epigraphist Gaetano Marini (1742–1814). Christian inscriptions are affixed to the west wall and pagan inscriptions to the east wall.

Braccio Nuovo

Pius VII decided in 1806 to add a new wing to his museum. The project was interrupted, however, by

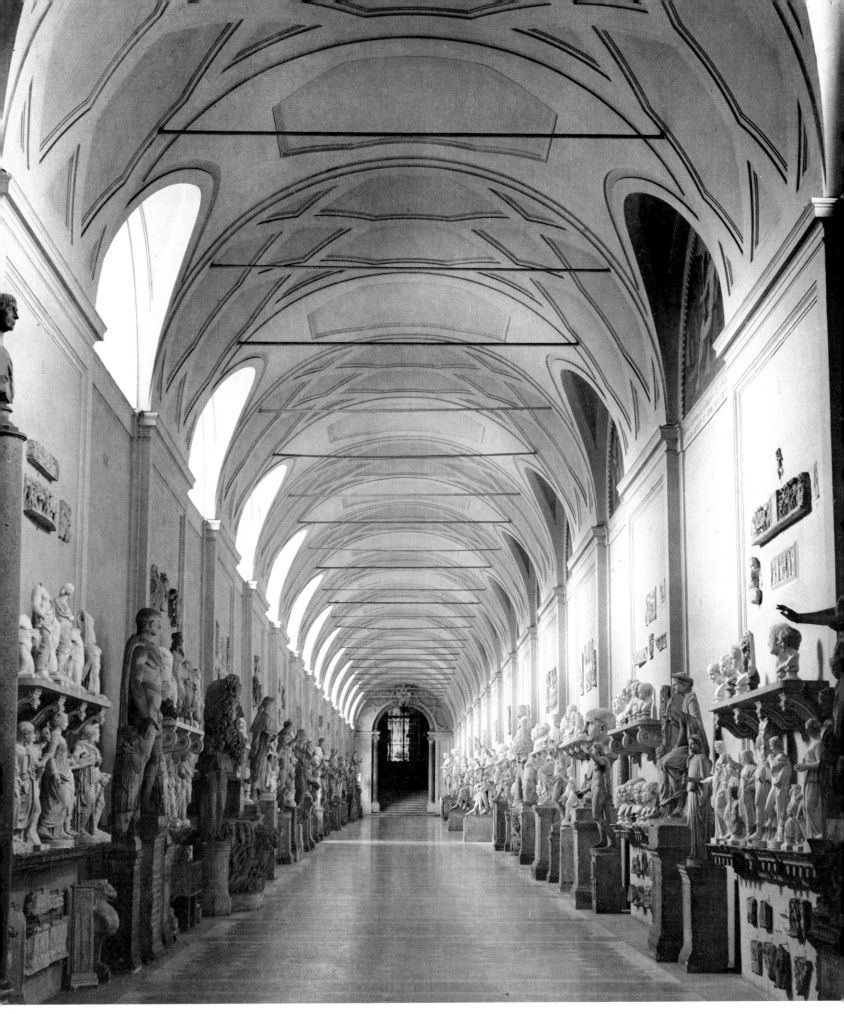

The Museo Chiaramonti bears the family name of its founder,
Pius VII. In 1807 the collection was installed by Antonio
Canova in the east wing of the Cortile del Belvedere.

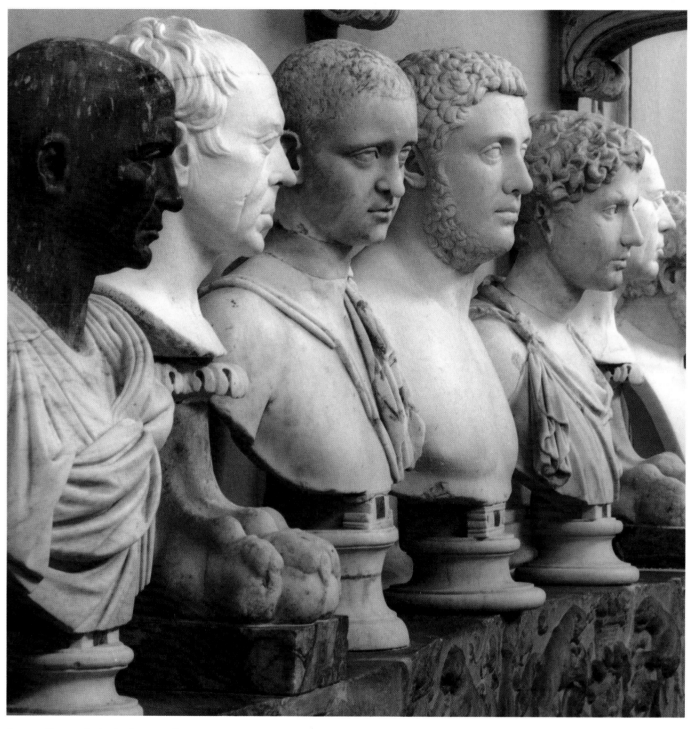

A row of portraits in the Museo Chiaramonti.

the French occupation of Rome and the abduction of the pope. Construction was begun only in 1817, to the design of Raffaele Stern, and the Braccio Nuovo was opened in 1822. Its architecture is described in the chapter on the Vatican Palace. The arrangement of the works of art is here as lucid and austere as it is bewildering and overburdened in the original Museo Chiaramonti.

The large niches in the walls are occupied by statues, the most celebrated of which is the Augustus of Prima Porta. It was discovered in 1863 at the villa of Livia, Augustus's wife, at Prima Porta on the Via Flaminia north of Rome. The emperor is portrayed in the act of addressing his troops: he is wearing a general's armor, and his right arm is raised in the gesture of *adlocutio*. The relief decoration on the breastplate celebrates an event of the year 20 B.C.: The Parthian king Phraates IV surrenders to Augustus's legate, Tiberius, Roman standards that had been lost by Crassus at the battle of Carrhae thirty-three years previously.

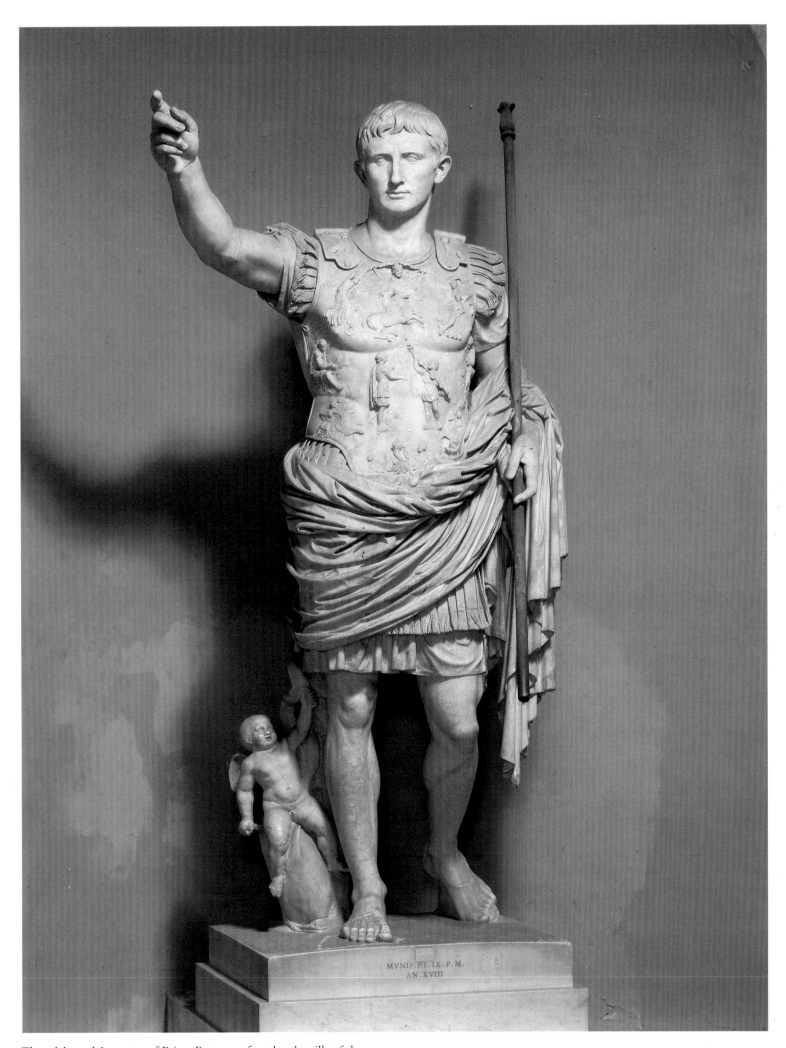

The celebrated Augustus of Prima Porta was found at the villa of the
emperor's wife, Livia. It is probably a marble version, made after
his death in A.D. 14, of a bronze statue of about 20 B.C.

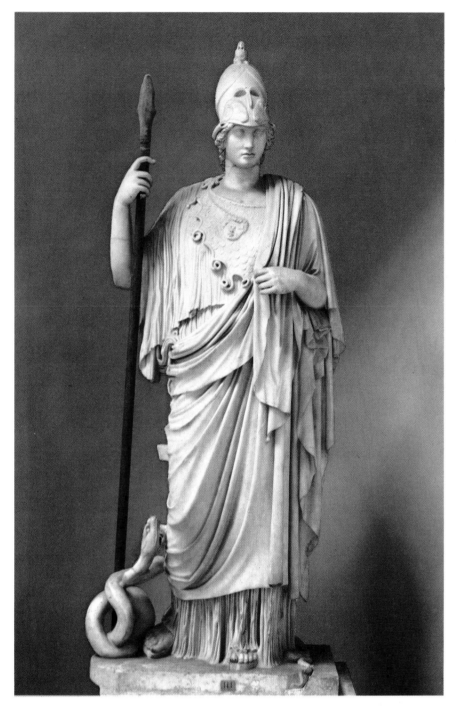

The Athena Giustiniani is a Roman copy of a Greek bronze
statue of the beginning of the fourth century B.C.

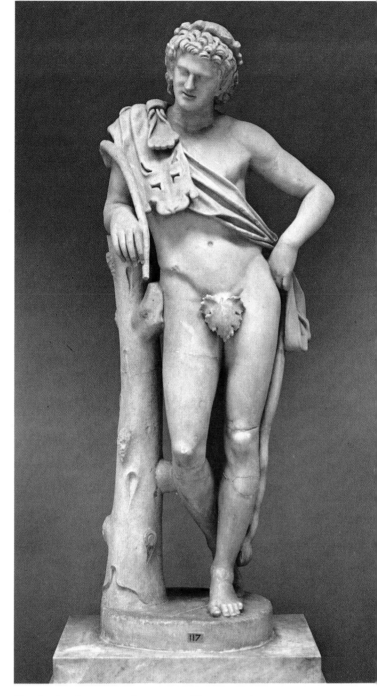

The *Resting Satyr,* one of numerous Roman copies
of a Greek statue attributed to Praxiteles.

The entire cosmos assists at this triumph of the em-
peror's policy of peaceful unification: above are Caelus,
the sky, with his billowing cloak; Sol, the sun, in his
four-horse chariot; and two other personifications,
Dawn and Dew; below is Tellus, the fertile earth; to
either side of her are Apollo, with his lyre, riding a
griffin, and Diana, with a flaming torch, riding a stag.
The central scene is flanked by two seated female fig-
ures; they are personifications of provinces, perhaps
Germany and Dacia. The emperor's right leg is sup-
ported by a cupid riding a dolphin—an allusion to
Venus, the divine ancestress of the Julian house, to

which Augustus belonged. His bare feet are a conven-
tion of heroic statuary, and the position of his legs is
deliberately borrowed from a famous statue of the clas-
sical age, the Doryphoros, or spear bearer, of Poly-
clitus. The statue is probably a marble version, executed
for Livia after the death of Augustus in A.D. 14, of a
bronze statue set up in his honor soon after 20 B.C.. In
the relief of the breastplate Tiberius, Livia's son by
her first marriage to Tiberius Claudius Nero and Au-
gustus's successor as emperor, is officially honored for
the first time.

The Braccio Nuovo contains a copy of the Dor-

yphoros of Polyclitus; the original was a bronze of about 440 B.C. According to tradition, Polyclitus worked out a theory of proportions for the representation of the human body in sculpture, and embodied this theory in a statue, which became known as Polyclitus's Canon; the Canon was almost certainly the original Doryphoros. A nude athlete is represented, carrying a spear in his left hand. His posture and gestures are simple and clear, but conceived with consummate artistry. One leg is tense, the other relaxed; one arm is in action, the other in repose. Action and inaction alternate and coalesce in counterpoise; this principle is applied, with masterly skill, down to the smallest detail.

We mentioned above, in describing the Galleria delle Statue in the Museo Pio-Clementino, the copy of an Amazon carved by Phidias, in competition with other sculptors, for the temple of Artemis at Ephesus. The Braccio Nuovo contains a copy of another of the Ephesian Amazons, this one attributed to Cresilas.

The Athena Giustiniani is a Roman copy in Parian marble of a Greek bronze from the beginning of the fourth century B.C. The goddess appears with a helmet and a spear, wearing the aegis and accompanied by a serpent. Goethe described this statue after seeing it in the Palazzo Giustiniani, the residence of its original owners; it later belonged to Lucien Bonaparte, Napoleon's brother; Pius VII acquired it in 1817.

The statue of a satyr in repose is one of numerous Roman replicas of an original generally attributed to Praxiteles and executed toward the middle of the fourth century B.C. The youthful figure, nude except for a panther skin draped over his right shoulder, leans against a tree trunk. The animal nature of the satyr is suggested by the pointed ears and by the treatment of his shaggy hair, as well as by the cunning expression of his eyes and mouth. This copy was formerly in the Ruspoli collection in Rome; it entered the Braccio Nuovo in 1822. Another half-animal figure is the marble Silenus who cradles the infant Dionysus in his arms in a Roman replica of a Greek statue of about 300 B.C.

The Athenian orator Demosthenes was a very popular figure with the ancient Romans, to judge from the number of surviving copies—more than fifty are known—of a bronze statue of him by Polyeuctus, which was set up in the Agora of Athens in 280 B.C. Demosthenes was a fearless opponent of Macedonian rule. After the Macedonians defeated the rebellious Greeks at Crannon in 322 B.C., they demanded that Demosthenes be surrendered to them; he fled to Calauria, where he took poison. On the base of the statue in the Agora was the inscription: "If you had as much power as insight, Demosthenes, the Macedonian war god would never have subjugated the Greeks."

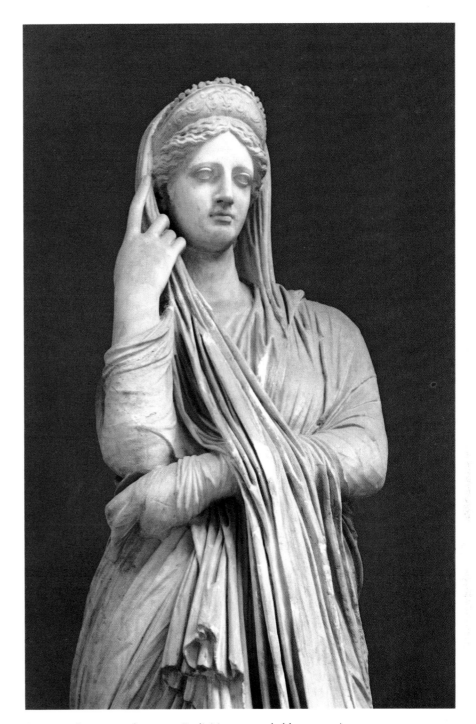

A statue of a woman, known as Pudicitia, was probably a portrait of a Roman matron of the Flavian period. The idealized face is the product of an eighteenth-century restoration.

A statue of a woman, commonly known as Pudicitia, has an idealized face, the result of an eighteenth-century restoration. Originally, it was probably the portrait of a roman matron of the Flavian period (A.D. 69–96), though the figure type seems to be of Hellenistic origin.

In the center of the south wall of the gallery is a large apsed opening. It houses the reclining statue of a river god, the Nile, found in 1513 near the church of Santa Maria sopra Minerva, in the area of the ancient temple of Isis and Serapis. Its companion piece, representing the Tiber, is now in the Louvre. The Nile is identified by the sphinxes and crocodiles that accompany him; the sixteen children swarming over and around him have been interpreted as standing for the number of cubits that the river rises when its annual flood brings fertility to the valley through which it flows. The reliefs on the base depict life along the banks of the Nile. The statue is a Roman work of the first century A.D., perhaps based on a Hellenistic original.

Besides the statues, the Braccio Nuovo also contains a large number of busts from the late Republican and the Imperial periods, standing on wall brackets and on pedestals in the form of truncated columns. They include portraits of Claudius, Hadrian, Lucius Verus (who was co-emperor with Marcus Aurelius from 161 to 169), Pupienus (who reigned for three months in the year 238), and Philip the Arab (244–49). At the west end of the gallery, in front of the entrance, is a bust of Pius VII, a replica made by Canova and his shop in 1820–22, for the Braccio Nuovo, of a portrait originally executed by Canova in 1806–1807 and donated by Pius to the Capitoline Museum in 1820.

GEORG DALTROP

The reclining statue of a river god, the Nile, was found in 1513 and immediately installed in the garden of the Belvedere, together with a similar statue representing the Tiber. The latter was carried off to France by Napoleon and is now in the Louvre.

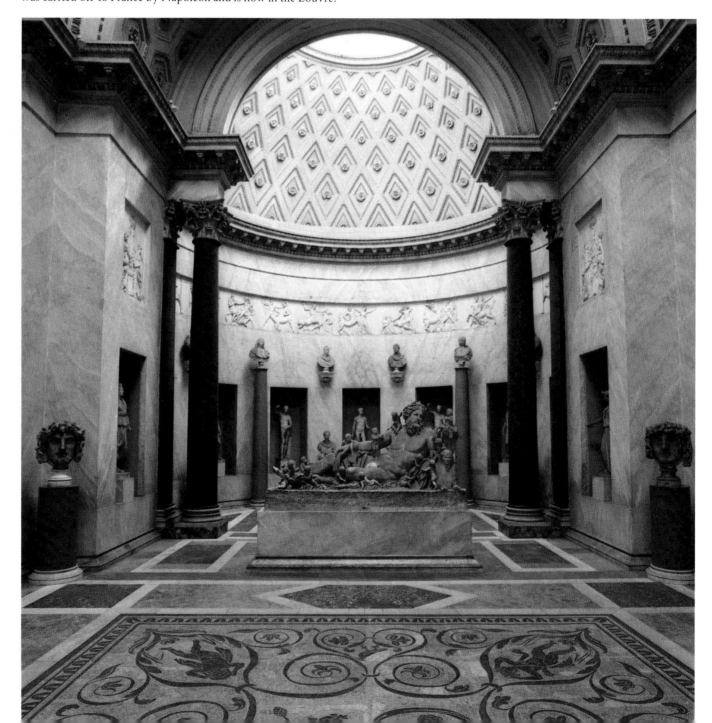

The Museo Gregoriano Etrusco

The great flourishing of Etruscan studies during the first decades of the nineteenth century and the important excavations of the period could not fail to leave their mark upon the papal collections of antiquities, since the Papal State then included the entire southern part of what had been ancient Etruria. The collection of the Museo Gregoriano Etrusco, founded by Gregory XVI and opened on February 2, 1837, consists, in fact, mainly of objects discovered in the Etruscan part of Lazio in excavations of the years 1820–40. A few objects were already preserved in the galleries of the Apostolic Library. Among them is a bronze statuette of a boy discovered at Tarquinia in 1770 and given to Clement XIV by the learned Jesuit Francesco Carrara. Another statuette, which came to light in 1587 near Lake Trasimene, is the earliest documented Etruscan find in the museum.

The decisive reason for the establishment of the museum was the discovery in 1837 of the great Regolini-Galassi tomb (named after its excavators) in the necropolis of Sorbo, south of Cerveteri. From this tomb come the most noteworthy objects in the whole Gregorian collection. After the annexation of the Papal State by Italy in 1870, the life of the Museo Gregoriano Etrusco as an active public collection of Etruscan antiquities came virtually to an end. Subsequent additions were all the result of purchases or gifts, such as the acquisition in 1900 of the Falcioni collection from Viterbo, containing minor art objects of various periods; A. B. Guglielmi's collection of pottery, bucchero ware, bronzes, and jewelry, given to Pius XI in 1935; and the collection of Greek, Etruscan, and South Italian pottery and fragments given to Paul VI in 1968 by M. Astarita.

The museum occupies the second floor of the wing constructed by Pius IV north of the Cortile del Belvedere, as well as the second floor of the Belvedere of Innocent VIII. The collection is subdivided according to material of the objects—stone, bronze, gold, terracotta, ceramic—in keeping with the taste of the period when the collection was assembled and placed on view. At that time, appreciation of individual objects far outweighed historical considerations. There was little interest in an object's archaeological context, but great interest in its permanent, intrinsic qualities —the material, more or less precious, of which it was made, its state of preservation, and its unique aesthetic quality.

The stone monuments are mostly of local tufa. This stone is easily worked, and therefore suited to the artistic sensibility of the Etruscans, who preferred modeling to carving. Two lions, dating from the end of the sixth century B.C., are from a tomb at Vulci, where they had been placed as guards on either side of the entrance. Here we have an example of direct and intuitive belief in the survival of the dead within the tomb. With the passage of time this belief declined, through the influence of Hellenic culture: the Etruscan idea of the tomb as a dwelling gave way more and more to the Greek idea of Hades, the world beyond, the world of the shades. There is evidence of this change in two figures of horses, also from a tomb at Vulci, but dating from the third or fourth century B.C. By this time the idea of the tomb as a dwelling had clearly been replaced by the idea of the journey to the world beyond.

The material from the Regolini-Galassi excavation is assembled in a single room. The richest group of objects comes from the main grave of the largest of the *tumuli*, or burial mounds, which the excavation brought to light. (Watercolors on the walls show the excavation in progress.) The tomb can be dated to the first half of the seventh century B.C. It contained the remains of at least three persons. A man and a woman of high social status were the owners of all of the gold and of the larger bronze objects; a third individual, who was perhaps of lesser rank, was the owner of the less imposing objects. The splendid belongings of the first two personages, taken as a whole, constitute one of the most complete surviving documents of the Orientalizing phase of Etruscan culture. The types of objects, the materials used (gold, silver, bronze, and ivory), and the ornamental motifs are proof of very close cultural and commercial contacts between Etruria and the principal centers of production of the Aegean and the eastern Mediterranean.

The largest bronze statue in the museum, the Mars of Todi, is one of the very few examples of large-scale Italic statuary in bronze that have come down to us. It represents a warrior armed with helmet, breastplate, and spear, in the act of pouring a libation before going into battle. The statue, which evinces a highly developed technique of bronze casting, translates into the formal language of Etruscan art a number of the iconographic and stylistic features of fifth-century Greek art. The pedantic realism of the anatomical details and of the armor is explainable in the light of the religious sensibility that saw in a statue like this—a large votive offering set up in a sanctuary, perhaps dedicated to Mars—the evocation of a living presence.

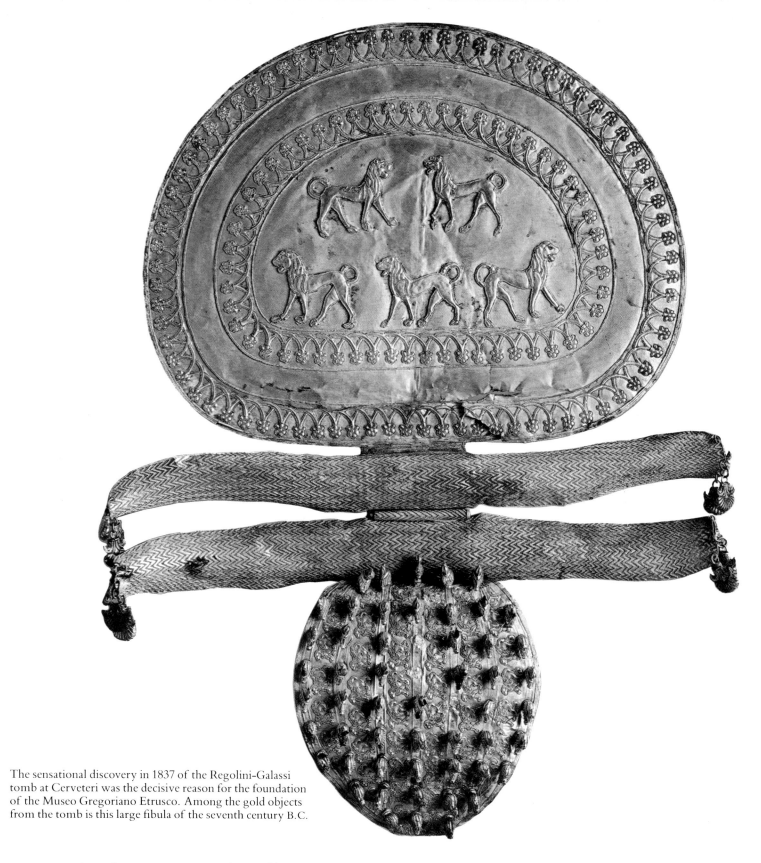

The sensational discovery in 1837 of the Regolini-Galassi tomb at Cerveteri was the decisive reason for the foundation of the Museo Gregoriano Etrusco. Among the gold objects from the tomb is this large fibula of the seventh century B.C.

Two bronze statuettes of seated boys were also votive offerings. They can be dated to the first or second century B.C. A boy playing with a bird is clearly a subject of Hellenistic origin; one comes across it in Etruria in numerous simpler versions in terracotta. The votive nature of these three statues is confirmed by their dedicatory inscriptions. The dedication to Mars is written in Umbrian—the statue probably came to Todi, a town in Umbrian territory, from an Etruscan workshop—while those on the statuettes of boys are in Etruscan.

A number of funerary urns in alabaster and limestone come from Volterra, Chiusi, Perugia, and other sites. On all their lids are reclining figures of the deceased, with prominent, realistic heads and clumsily executed bodies. The reliefs on the sides of the urns

The Mars of Todi, from the late fifth century B.C., is a rare example of Etruscan bronze sculpture on a large scale.

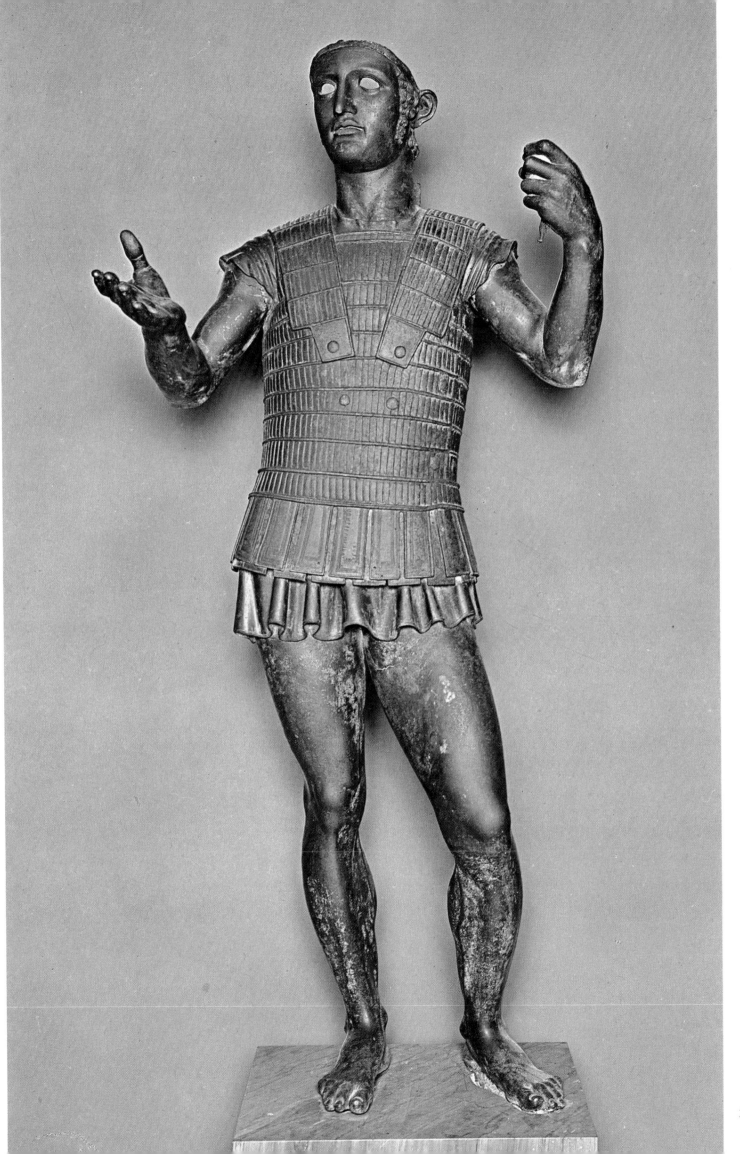

represent scenes from Greek mythology. They can all be dated to the last two centuries B.C.

The Guglielmi collection is exhibited in its entirety, and therefore the objects in it are not separated according to type as they are in the rest of the museum. The collection comes entirely from the necropolis of ancient Vulci. It includes Attic pottery and Etruscan bronzes and bucchero vases. A little pot of the finest glossy bucchero, covered with simple incised decoration, bears an inscription indicating that it was the property of a woman called Ramutha Kansinai. It can be dated to the seventh century B.C.

The museum contains a selection of the many terracotta votive offerings found during the nineteenth century at Cerveteri. These offerings were brought by the worshipers to the various temples in the town, in gratitude for a favor received, to indicate a favor requested, or simply in order to leave a souvenir of the visit. They are representations of whole figures and of parts of the human body, especially of heads. Some of these heads are of a cheap, mass-produced type; others are genuine portraits executed by hand. Among the latter are some of the most vigorous examples of Etrusco-Roman portraiture. The votive offerings date for the most part from the last three centuries B.C.

The collection of Greek, Etruscan, and South Italian pottery, thanks to nineteenth-century standards of selection, is of very high quality; it has not been altered by more recent donations. Greek pottery was imported into Etruria in great abundance, and is therefore found very frequently in Etruscan tombs. It is only possible to mention briefly the most important objects of each type.

The great Corinthian school, which ancient literary tradition credited with having taught the art of vase painting to Italy, is represented by one of its most monumental products: a large krater, known as the

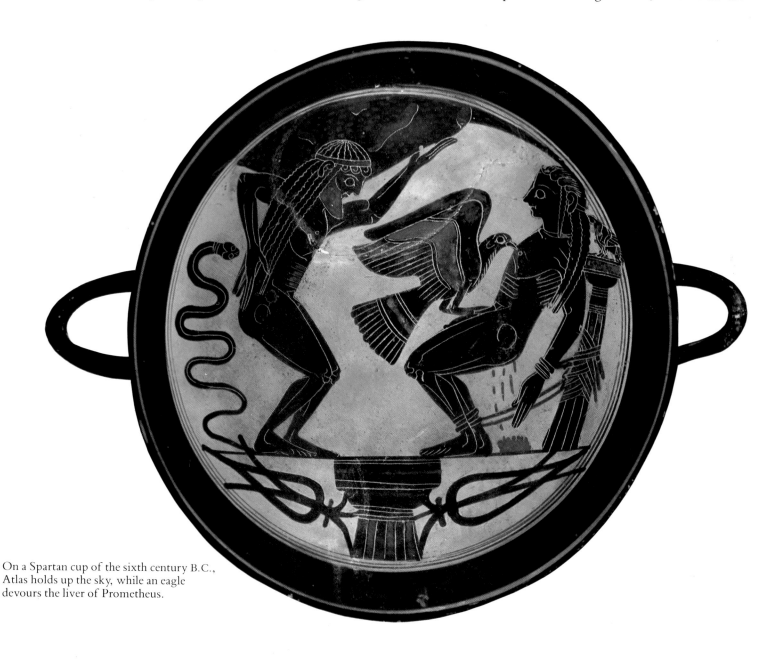

On a Spartan cup of the sixth century B.C., Atlas holds up the sky, while an eagle devours the liver of Prometheus.

Astarita krater, datable to about 560 B.C. On it is a representation of Ulysses and Menelaus setting out to rescue Helen; the vase painter has drawn upon an illustrious epic tradition that was firmly established in both poetry and art.

A cup, decorated with concentric bands on the outside and with a large figured medallion divided into two sections on the inside, comes from Sparta; Spartan products were important, though few in number. The medallion shows Prometheus, with the eagle devouring his liver, and Atlas holding up the sky. The cup can be dated to the middle of the sixth century B.C.

Two Attic amphorae exemplify the black-figured and the red-figured techniques. One dates from about 530–520 B.C., while the other was made about twenty years later. The first is signed by Exekias, potter and painter; the other can be attributed to the Kleophrades Painter. Exekias was the most important Attic black-figured craftsmen, while the Kleophrades Painter was one of the earliest and greatest exponents of the red-figured technique. The two amphorae illustrate the significance of the revolution in vase painting. In the black-figured work, the figured panel is of modest size and proportioned to the shape of the amphora, which is compact and slender; Exekias had good reason to declare himself responsible for the work, both as potter and as painter. The red-figured vase is more cumbersome in form; it served chiefly as a vehicle for the artistry of the decorator.

Toward the end of the fifth century B.C., commercial contacts between South Italy and Greece suffered the effects of strained political relations, and the Greek centers of South Italy replaced those of Attica as producers of pottery for the Etruscan market. On the whole the South Italian work was of inferior quality, depending largely on the extensive use of floral ornamentation. It did, however, reach a high level in the work of a few masters. One such master was Asteas of Paestum, a potter active in the third quarter of the fourth century B.C. A bell krater in the museum is a typical product of his workshop in its shape, subject, and ornament. It shows a performance of one of the popular farces of the time, in which the actors wore grotesque masks and gave salacious parodies of episodes from mythology. Here Zeus himself (the actor to the left) carries a ladder toward Alcmene's window while Hermes, his accomplice in the seduction, looks on.

FRANCESCO RONCALLI

Salette degli Originali Greci

In 1960 three rooms in the Museo Gregoriano Etrusco were set aside to house original Greek sculpture that

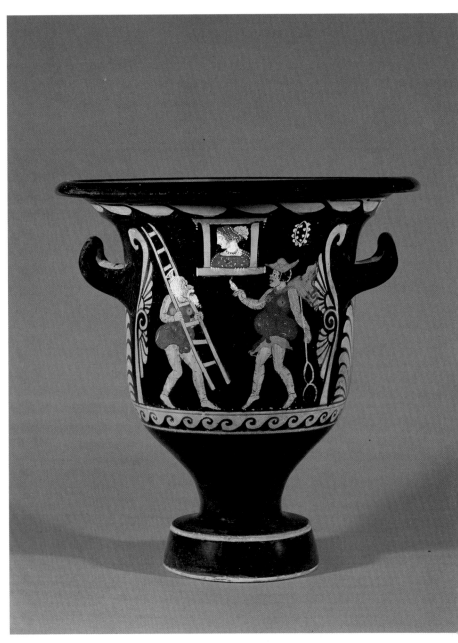

A Greek bell krater from South Italy is decorated with a scene from a popular farce, in which the actors wore grotesque masks and performed parodies of mythological episodes. It was probably made at Paestum in the third quarter of the fourth century B.C.

had previously been mixed in with sculpture of Roman origin, both in the exhibition galleries and in the storerooms.

The most important, historically, of the objects in these rooms are three fragments of the sculptural decoration of the Parthenon in Athens. One is a bearded head from metope XVI, on the south side of the temple, executed between 447 and 430 B.C. The head of a boy comes from the north frieze, which represented the Great Panathenaea, the festival held every four years in honor of Athena. The boy is a *skakephoros*: on his shoulder we can still make out the

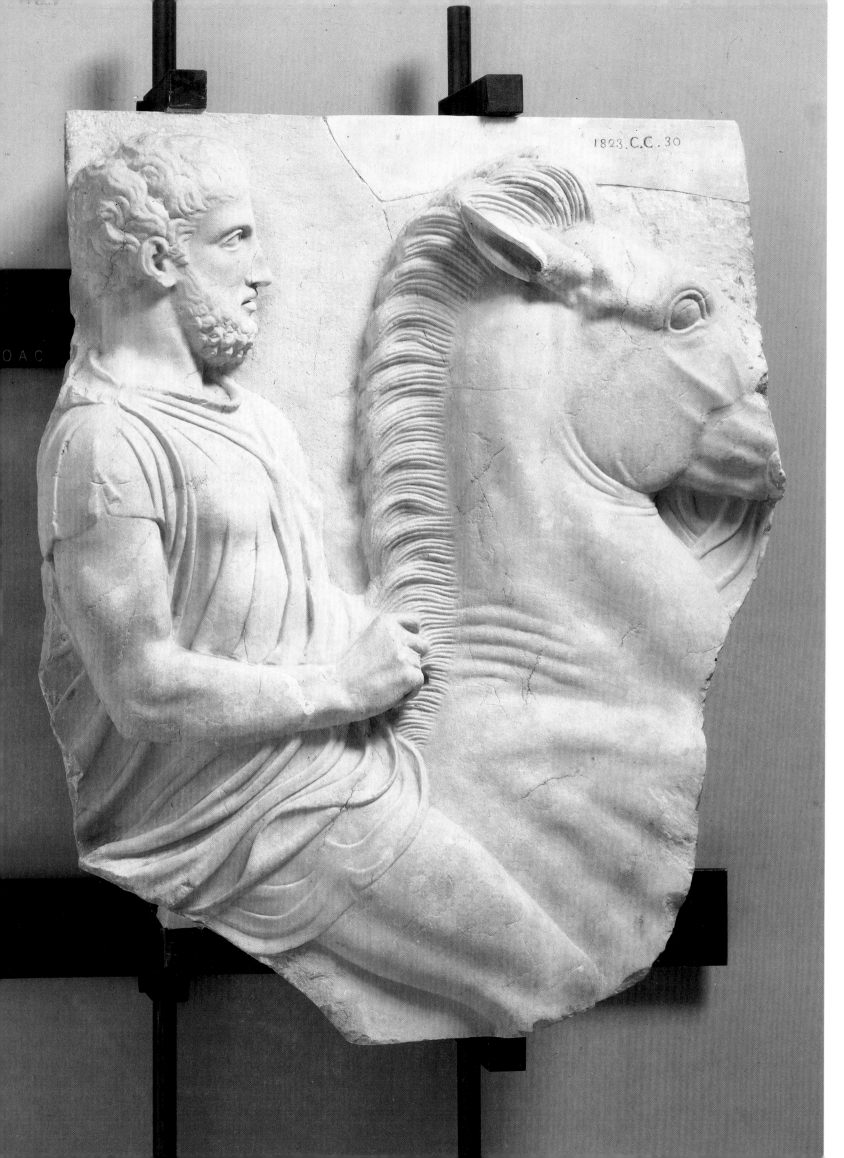

tray of votive cakes that was carried in the procession. This fragment dates from about 440 B.C. The third fragment is a recently identified horse's head from the west pediment, the subject of which was the contest between Athena and Poseidon for the dominion of Attica; the horse probably drew Athena's chariot. It exemplifies the extraordinarily high quality of the art of the circle of Phidias between 440 and 432 B.C.

A relief fragment with a horseman immediately calls to mind the grandiose Parthenon frieze. It cannot have belonged to it, however; it is carved from a different kind of marble. Because of the spirit that animates it, it is thought to be Boeotian work of about 440–430 B.C.

Two Attic votive reliefs document the cult of Asclepius, the god of healing, which was introduced into Athens only in the second half of the fifth century B.C. One of them is among the earliest examples of its type; it dates from about 410 B.C. It represents Asclepius enthroned, with his daughter Hygieia and —on a smaller scale—the donor. A somewhat later relief, from the fourth century, shows Asclepius with Hygieia, his sons, and worshipers. Another fourth-century Attic relief represents a funeral banquet. Hades, the god of the underworld, reclines on a couch, wearing a crown, with Persephone at his feet; he is being approached by a group of worshipers.

A fine funeral stele shows a youth with his arm raised in a gesture of farewell. A young boy, his servant, bears an aryballos and a strigil, the handle of which is visible in his left hand. The former contains oil for the athlete to anoint himself with; the latter is the instrument with which he scrapes dust and sweat from his body after the game—the action we have seen represented in Lysippus's famous statue, the Apoxyomenos. Only at the dawn of the classical period of Greek art, around 450 B.C., was it possible to render so convincingly the sense of a youthful presence.

GEORG DALTROP

The Museo Gregoriano Egizio

Ancient Egypt always held a particular attraction for the peoples who came into contact with its civilization, so magnificent yet so full of mystery. Not even Rome could resist this fascination; the obelisks and the many Egyptian objects that the soil of Rome has restored to us in the course of the last three centuries bear witness to the ardent admiration of the Latin conquerors for the ancient civilization of the Nile.

It was inevitable that during the excavations carried out in the eighteenth and nineteenth centuries in order to uncover classical monuments there should also come to light notable Egyptian remains. As a result of these discoveries, the popes had to find a place, in their collections of Greco-Roman sculpture, for Egyptian works or works in the Egyptian style. Under Clement XIV, Pius VI, Pius VII, and Leo XII there was thus gradually built up a collection of finds from the excavations of Domitian's villa at Paola, of the so-called Villa of Cassius, of the Gardens of Sallust, of the temple of Isis in the Campus Martius, and of the Canopus at Hadrian's Villa. Other objects were acquired by Popes Pius VI and Leo XII.

However, the first person in the West to set up a museum devoted exclusively to the Egyptian civilization from its dawn right up to its last "contamination" by Greco-Roman culture was Gregory XVI. As Luigi Ungarelli, the museum's first director, wrote in his rather labored prose: "Deeming that Egyptian archaeology was not alien to the cause of religion, but rather a new tributary and ally of the supreme truth, [Gregory] ordered that a judicious choice be made from among the Egyptian monuments in Rome's possession and good examples of them placed in the Vatican." The pope's aim was both scholarly and apologetic. Ungarelli, in fact, ends his detailed description of the new museum with the following reflections:

> This is the sum of the benefits to knowledge dispensed by the Egyptian Museum thanks to the wise care of the reigning pontiff Gregory XVI and his incomparable zeal for religion. Aside from the profit to the fine arts, here the theologian may recognize vestiges of the primitive traditions that preceded the revelation made to Moses and the prophets. The writings here collected will provide for sacred philology a better understanding of oriental biblical texts. How numerous are the points of contact between the people of God and the Egyptian people! How closely their histories are connected! What fresh light is shed upon a multitude of Hebrew forms and idioms, thanks to the consonances between the phrases of Scripture and the modes of the ancient Egyptian language preserved for us in the hieroglyphic writings!

All this, of course, may be said more properly of Egyptian studies in general than of the Egyptian museum in particular; it was nevertheless the basic idea that inspired Gregory XVI. After the reign of this pope, the only significant additions to the collection were due more to the generosity of others—such as that of the khedive of Egypt to Leo XIII—than to the

This relief fragment with a horse and rider is thought to be Boeotian work of about 440–430 B.C.

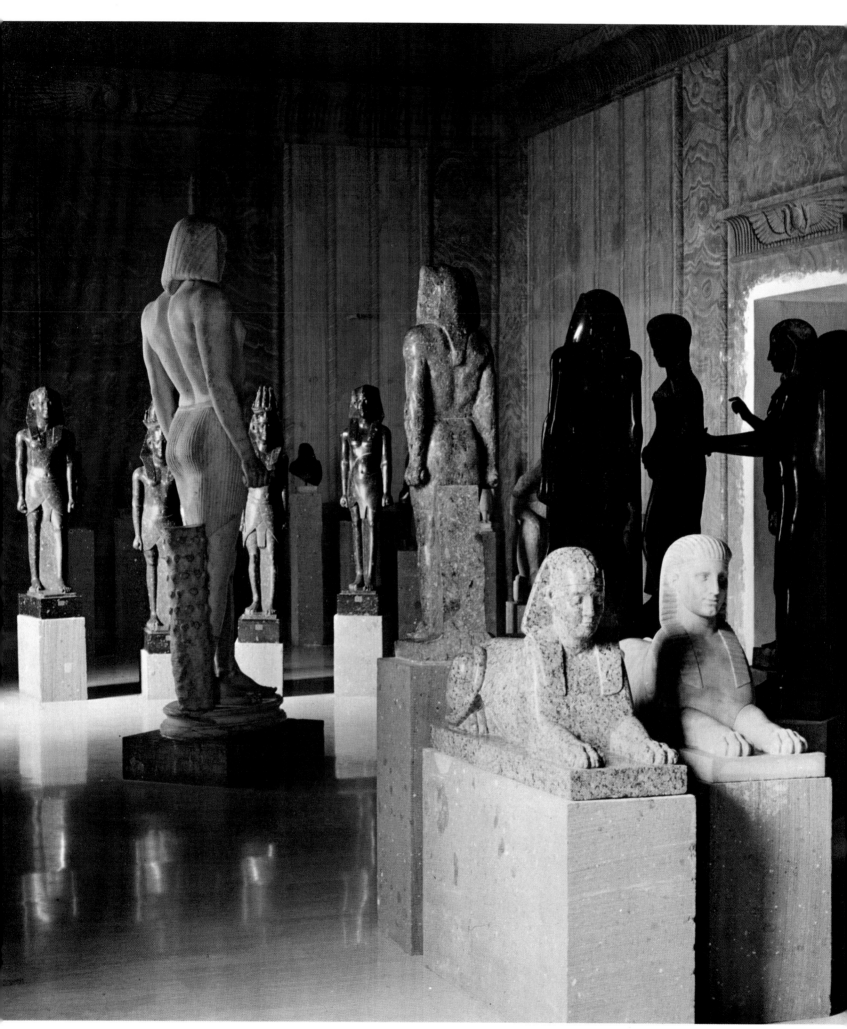

This hall in the Museo Gregoriano Egizio contains
sculpture made in Rome in the Egyptian style.

The black granite torso of the statue of Nectanebo I,
a pharaoh of the XXX dynasty (378–341 B.C.).

solicitude of the popes. The formation of the museum
thus consisted of three phases: discoveries due to ex-
cavations, and occasional acquisitions; a massive ac-
quisition of objects by order of Gregory XVI, under
whom the museum took shape; and later additions,
especially under Leo XIII and Pius XII. The museum
was inaugurated—apparently without particular pomp
—in 1839, on "the sixth day of the month of the
inundation" (February), according to the hieroglyph-
ic inscription composed by Ungarelli for the occa-
sion and painted on the walls of the first two of the
original halls.

The enthusiasm with which, in 1839, scholars
greeted the exhibition of so many objects is conveyed
by Ungarelli: "The new Museo Gregoriano Egizio
offers to the scholarly public a clear early history of
the four most noble arts of which human life avails

itself for the exercise of the intellectual faculties and
for adding pleasure to necessity: writing, painting,
sculpture, and architecture." Unfortunately, the mu-
seum hardly furnishes "a clear early history" of these
arts: it is in fact the result of random discoveries and
acquisitions, principally because it did not have from
the very beginning an Egyptologist to supervise the
structure of the collection and to acquire new mate-
rial to fill its gaps (Ungarelli was its director after its
foundation, but he was not empowered to make fur-
ther important acquisitions). The gaps are too numer-
ous for the museum to be able to provide a complete
panorama of Egyptian history. On the other hand,
many of the individual pieces or groups that it con-
tains are of considerable importance.

Among the works of sculpture are the head of
the pharaoh, Mentuhotep, of the Middle Kingdom

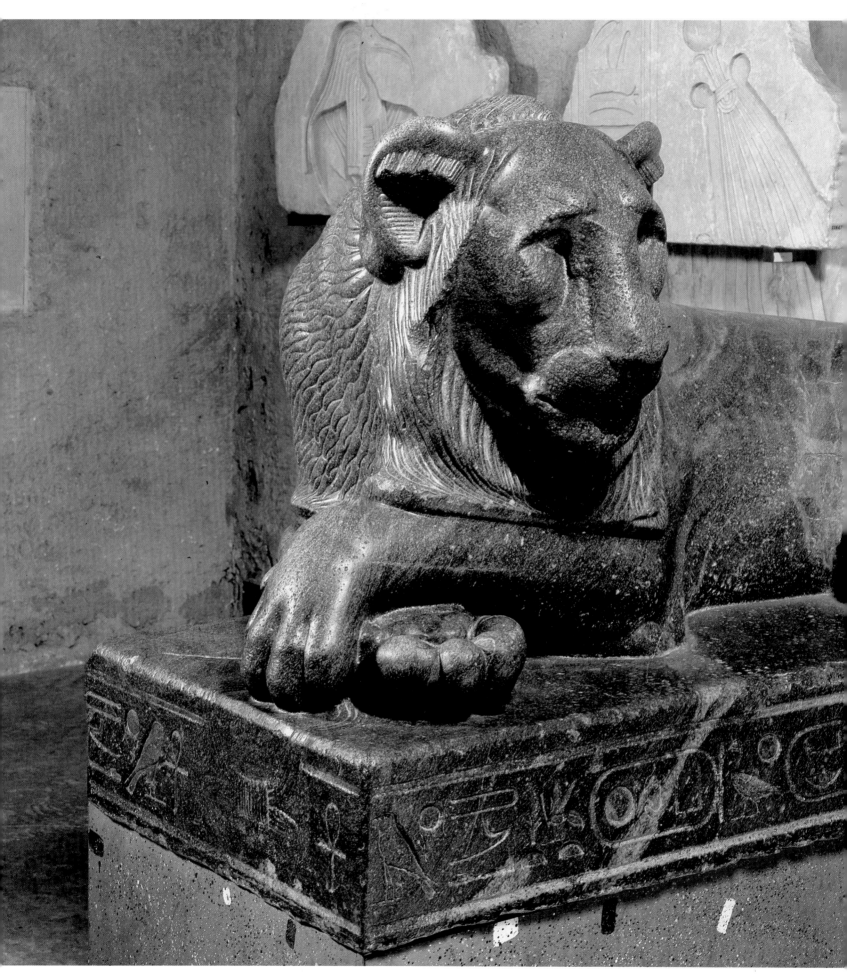

One of a pair of lions with inscriptions in honor of Nectanebo I.

(2033–1890 B.C.); a colossal statue of Queen Tiye, mother of Ramses II of the Nineteenth Dynasty (1340–1172 B.C.); the Naophoros (a statue of an official holding a small temple in his hands, with an inscription referring to the Persian invasion of 525 B.C.), which is without doubt the most important piece in the museum from the historical point of view and the one that has received the most attention from scholars; the black granite torso of Nectanebo I (378–341 B.C.), who was the last pharaoh before the second Persian conquest; and the group of the Ptolemies, a notable example of the Egyptian art of the Ptolemaic period.

But more interesting are the statues of the lion-headed goddess Sekhmet, seven of them seated and five standing. Some of the hands and arms have been mutilated, and this is clearly deliberate. The damage was probably done by Egyptian Christians who considered the statues abodes of evil spirits and sought to render them harmless. Those statues which could be easily knocked down because they stood on small plinths were overturned and broken. Those which presented too much difficulty because of their size or because they were seated on massive pedestals had their arms and hands mutilated. This was in accordance with the ancient Egyptian idea that even the gods, if they were mutilated, could cause no harm.

Another important collection consists of wooden sarcophagi. Many are painted and well preserved; others are only roughly finished. One is of particular interest and historical value. It is very ancient but was repainted during the Hellenistic period to adapt it to the taste of the time.

The six mummies in the museum are interesting because of the objects that X-rays have shown to be inside them and because of the signs of disease—among them, perhaps, tuberculosis and cancer—that can still be observed today.

The collection of plain and commemorative scarabs is particularly rich. Of special importance is one that mentions the inauguration of an artificial lake in the time of Amenophis III, of the Eighteenth Dynasty, in the eleventh year of his reign.

A large number of funerary papyri of different periods make up one of the most remarkable sections of the museum. Most of them were found in the necropolis at Thebes and sent to Rome in the nineteenth century by the Franciscan missionaries living there. The most famous is the papyrus known to the scholarly world as the "Vatican Book of the Dead." It is fifty-two feet long and in a perfect state of preservation, though it has been cut into several pieces. It contains most of the formulas which were placed in tombs so that the dead might use them to overcome monsters and other dangers beyond the grave. It is impor-

tant among the extant examples for the purity of the text and the correctness of the writing. The other papyri are considerably shorter and in some cases mere fragments. They are nevertheless of notable scientific value because of the scripts used (hieroglyphic and hieratic), the textual variants, and the light they shed on the still very uncertain history of the compilation of the Book of the Dead.

The rooms taken over by Gregory XVI to house the museum were decorated by Fabris in a rather ingenuous imitation Egyptian style; this was one of the earliest attempts in modern times at the reconstruc-

tion of an Egyptian setting. Only two of the rooms retain their nineteenth-century decoration. Two others have been transformed to reproduce the entrance way and main chamber of an Egyptian royal tomb. This reconstruction, carried out according to rigorously scientific criteria, evokes the atmosphere in which the mummies, sarcophagi, statues, and minor objects must originally have been seen. The fanciful, romantic nineteenth-century evocation of ancient Egypt and the modern reconstruction both testify to the mentalities of their own periods, like so many other parts of the Vatican Museums.

GIANFRANCO NOLLI

The Museo Gregoriano Profano

The Museo Gregoriano Profano contains the collection of antiquities of the former Museo Profano Lateranense. Much of this material was acquired by Gregory XVI (1831–46), the founder of the museum, as a consequence of excavations and discoveries in the Papal State; some of it had already entered the papal collections under Pius VII (1800–1823) and Leo XII (1823–29). At the request of John XXIII (1958–63) it was transferred to the Vatican and arranged for exhibition in the present building, which was designed to house the Museo Gregoriano Profano, the Museo Pio Cristiano, and the Museo Missionario Etnologico, and which was opened to the public in 1970. When the museum was given its new home, some of the more important pieces previously kept in the Vatican storerooms were added to it. The collection, like those of the Museo Pio-Clementino and the Museo Chiaramonti, contains a number of Roman copies and adaptations of Greek sculpture, but it also contains many important examples of original Roman work: portraits, cult reliefs, commemorative sculpture, funerary reliefs, sarcophagi, and architectural decoration, as well as a few mosaics and a rich series of inscriptions.

Roman Imitations of Greek Sculpture

Three objects are derived from the celebrated bronze group of Athena and Marsyas by Myron of Eleutherae. The group was dedicated as a votive offering on the Acropolis of Athens about the middle of the fifth century B.C. and can be reconstructed by means of ancient literary sources and representations on coins and in vase painting. Fascinated by the sound of the double flute, which Athena has invented and just thrown away, the satyr Marsyas leaps toward her and tries to seize

the instrument, but with an imperious gesture the goddess forbids him to touch it. The museum has a marble copy of the Marsyas and an incomplete torso of the same figure, as well as a fragment of the head of Athena.

A colossal statue of Poseidon is derived from a Greek bronze of the fourth century B.C., which must have been very famous, since we find it reproduced on Hellenistic silver coins. The god of the sea places his right foot on the prow of a ship; a large dolphin (added by the copyist) serves as a support. Poseidon's gaze is directed downward; the statue must therefore have stood in an elevated position. The figure is a grandiose one; the face, framed by a dense mane of hair, expresses nobility, dignity, and restrained passion.

The god of healing, Asclepius, leans upon his attribute, a staff with a snake coiled about it. His long cloak is thrown over his left shoulder, leaving his chest bare. The statue, which may be dated to the time of Trajan (98–117), probably goes back to an original, mentioned in literature, by the fourth-century sculptor Bryaxis of Athens.

The statue known as the Chiaramonti Niobid represents one of the daughters of Niobe, the wife of Amphion, king of Thebes. Niobe had seven sons and seven daughters, and boasted of the fact before Leto, who had only borne two children—Apollo and Artemis. Filled with a terrible rage at this insult to their mother, the god and goddess slew all of Niobe's children with their unerring arrows. Pliny the elder tells us of a sculptural group of the dying Niobids, attributed to either Scopas or Praxiteles, in the temple of Apollo Sosianus in Rome. The Vatican statue is identifiable as a daughter of Niobe because it corresponds in its essentials to one of a group of fourteen

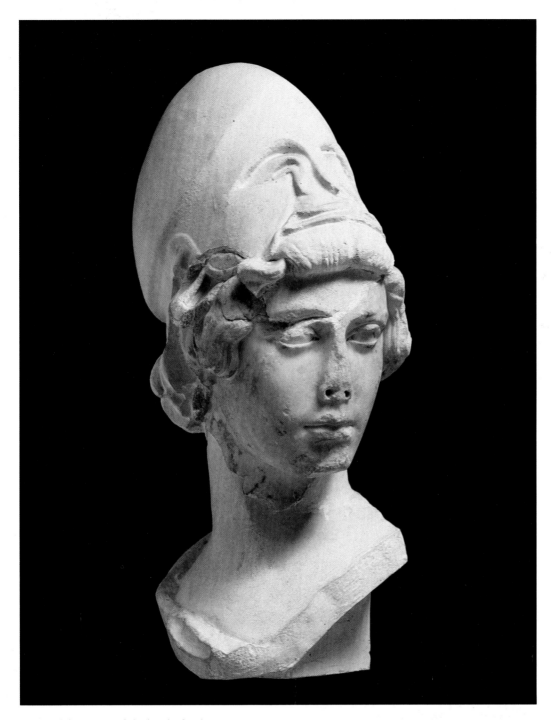

Restored fragment of the head of Athena
derived from a celebrated bronze
group by Myron of Eleutherae.

statues of the Niobids in the Uffizi in Florence. Something of the lost Greek original may still be discerned in this figure, which was probably copied as an independent work of art rather than as part of a group.

Two draped statues of women are identifiable as the Aurae, personifications of the gentle breezes. They are Neo-Attic versions, made in the early first century B.C., of Classical originals of about 400 B.C. They are believed to come from Palestrina (ancient Praeneste, twenty-three miles southeast of Rome), where they

originally crowned the corners of the pediment of a temple. Until 1956 they stood on the roof of the Sala Rotonda of the Museo Pio-Clementino.

The Museo Gregoriano Profano houses no fewer than three replicas of the famous Praxitelean satyr in repose, which we have already discussed in connection with the copy in the Braccio Nuovo. There is also an Ephesian Artemis, similar to the statue in the Galleria dei Candelabri.

Noteworthy fragments include the head of a Muse

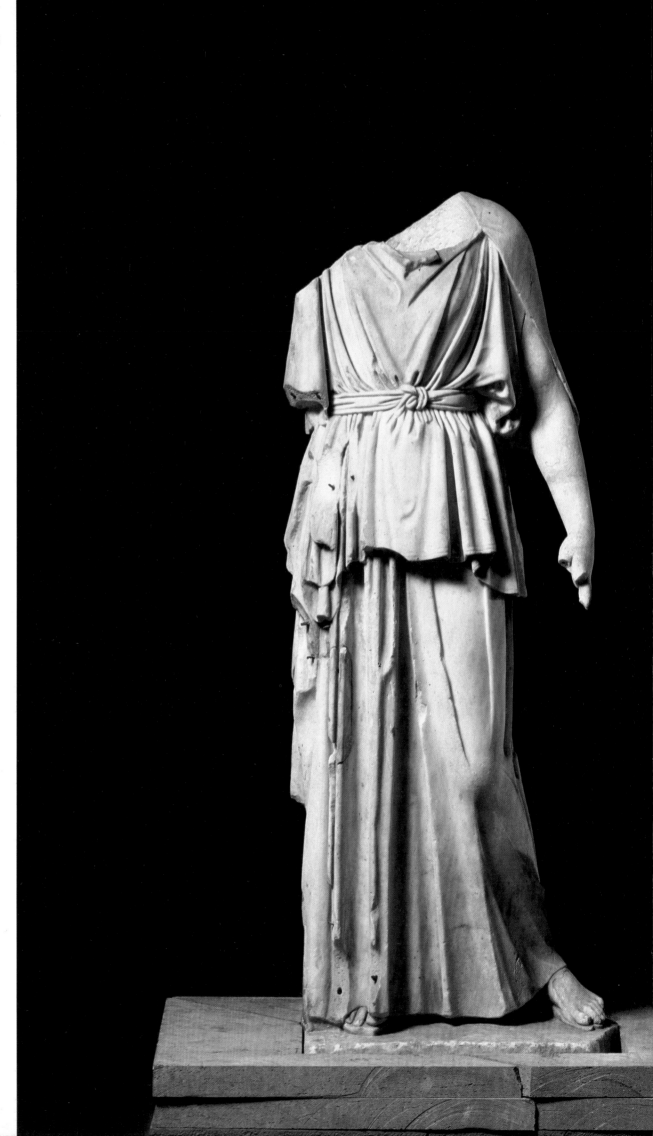

Fragmentary statues of Athena and
the satyr Marsyas, after a bronze
group by Myron of Eleutherae.
The Athena, property of the
Lancellotti family, is on loan to
the Museo Gregoriano Profano.

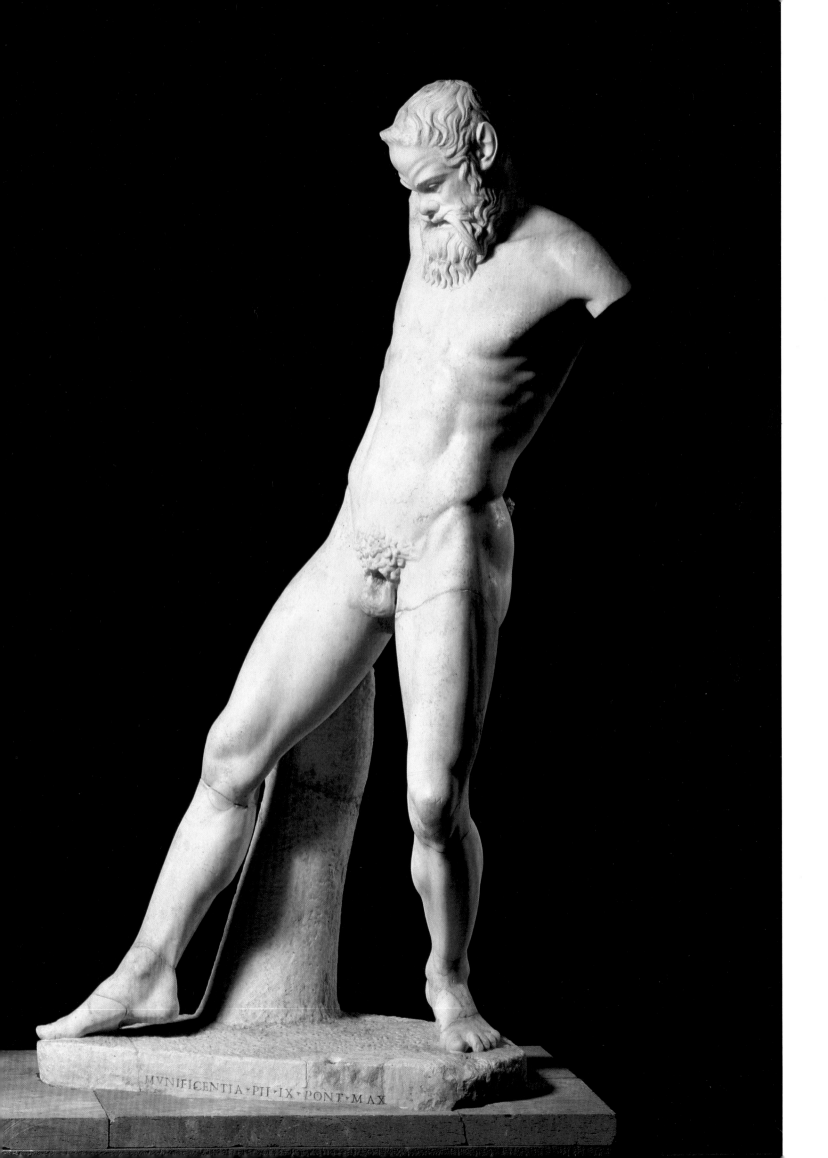

MVNIFICENTIA·PII·IX·PONT·MAX

crowned with ivy, made to be inserted into a statue, found in the immediate vicinity of the Lateran, and a torso of Artemis the huntress, whose swift forward movement is accentuated by the windswept drapery. Both are Roman copies of Greek originals of the fourth century B.C.; the Muse is in the style of the circle of Praxiteles. A basalt head is closely related to that of a famous bronze statue in Florence known as the Idolino, depicting a young athlete, a victor in the Olympic or Delphic games, in the act of pouring a libation. The Polyclitian original dates from about 440 B.C.

Two objects in the museum are related to the dramatic competitions that took place in Athens at the Dionysiac festivals. One is a triangular base, identical in form to the bases that supported the votive tripods dedicated by the winning chorus. It is a piece of exquisite workmanship, in Pentelic marble, executed in the Neo-Attic style of the first century B.C. but inspired by fourth-century prototypes. On the three sides are reliefs with dancing girls, a woman playing a lyre, and a satyr. Another Neo-Attic work, this one dating from the first century A.D. and going back to an original of the fifth century B.C., is a relief representing the sorceress Medea with the daughters of Pelias. Pelias had usurped the kingdom of his nephew Jason, Medea's husband, the hero who had won the Golden Fleece. Medea tricked Pelias's daughters into thinking that they could miraculously restore their father's youth by cutting him to pieces and boiling him in a magic potion. On the relief, Medea is shown with her box of herbs beside the cauldron that one of the daughters is preparing, while the other stands pensively, holding the knife with which she will perform the bloody deed. The composition is full of dramatic tension. Three-figure reliefs of this type—several others are known, the most famous illustrating the myth of Orpheus and Eurydice—are undoubtedly connected with the tragic trilogies performed at the Great Dionysia, the spring festival of Dionysus; they were probably votive offerings, dedicated by the winning chorus.

The triangular base of a candelabrum is decorated with reliefs on all three sides. They represent Poseidon with his mantle and trident, Hades with a cornucopia, and an unidentified goddess wearing a peplos, a scepter in her left hand. The base, of Classical inspiration, is the product of a Neo-Attic workshop of Roman imperial times.

One section of the museum is devoted to portraits of famous Greeks. The most important of them is a marble statue of the Athenian tragedian Sophocles, discovered at Terracina in 1839 and donated to Gregory XVI by the Antonelli family. Sophocles' identity is confirmed by a portrait bust of the same individual in the Sala delle Muse in the Museo Pio-Clementino, where an inscription gives the poet's name. Literary sources mention two portraits of Sophocles: one set up after his death in 406 B.C. by his son Iophon, and another in bronze commissioned during the 110th Olympiad (340–336 B.C.) by the orator Lycurgus, together with portraits of Aeschylus and Euripides. The portraits made for Lycurgus are probably the ones in the Theater of Dionysus mentioned by Pausanias. The statue from Terracina is today considered, on stylistic grounds, to be a copy of the original in the Theater of Dionysus, while the original of the Pio-Clementino head (known as the "Farnese type," after a replica once in the collection of that name) is identified with the portrait ordered by Iophon.

After his death, Sophocles was raised to the status of a hero by the Athenians. His contemporaries called him *theophiles*, "favorite of the gods," and *eudaimon*, "blessed." Yet he understood the depths of human suffering: this is evident from the seven (out of 123) of his tragedies that have come down to us. The statue shows him in the full strength of his maturity, independent and self-confident. He gazes into the distance, his mantle thrown hastily about his body. The fillet in his hair indicates his status as a priest of Asclepius; when the cult of that god was introduced into Athens in 420 B.C., Sophocles allowed his own house to be used as a shrine while the new temple was being constructed.

A Hellenistic relief, possibly from the first century B.C., has figures of a woman and a poet holding a comic mask; between them is a table with two comic masks on it. The poet has been identified as Menander, the greatest exponent of the New Comedy of the fourth century B.C. The woman is a Muse, or perhaps the personification of Comedy.

The lyric poet Anacreon (ca. 572–482 B.C.) is represented in a marble copy of the portrait statue that was probably commissioned from Phidias by Pericles in 440 B.C. There is also a fragmentary bust of Homer, of the same type as the example in the Sala delle Muse.

Roman Portraits

The museum possesses a fine collection of Roman portraits, dating from the late Republican period on. Two portraits, of the same person, have been thought to represent the poet Virgil; this identification cannot, unfortunately, be substantiated. There are a number of portraits of members of the Julio-Claudian dynasty. A colossal head of Augustus, the first emperor (27 B.C.–A.D. 14), was found at Veii, nine miles north of Rome. It was executed after his death. There are also portraits of Livia, his wife, who was born in 57 B.C. and died in A.D. 29, and of his stepson and successor Tiberius, who reigned from A.D. 14 to 37. A statue from Veii represents Drusus—either Drusus the elder, the brother of Tiberius, or Drusus the younger,

Portrait statue of Sophocles, discovered in 1839 at Terracina.

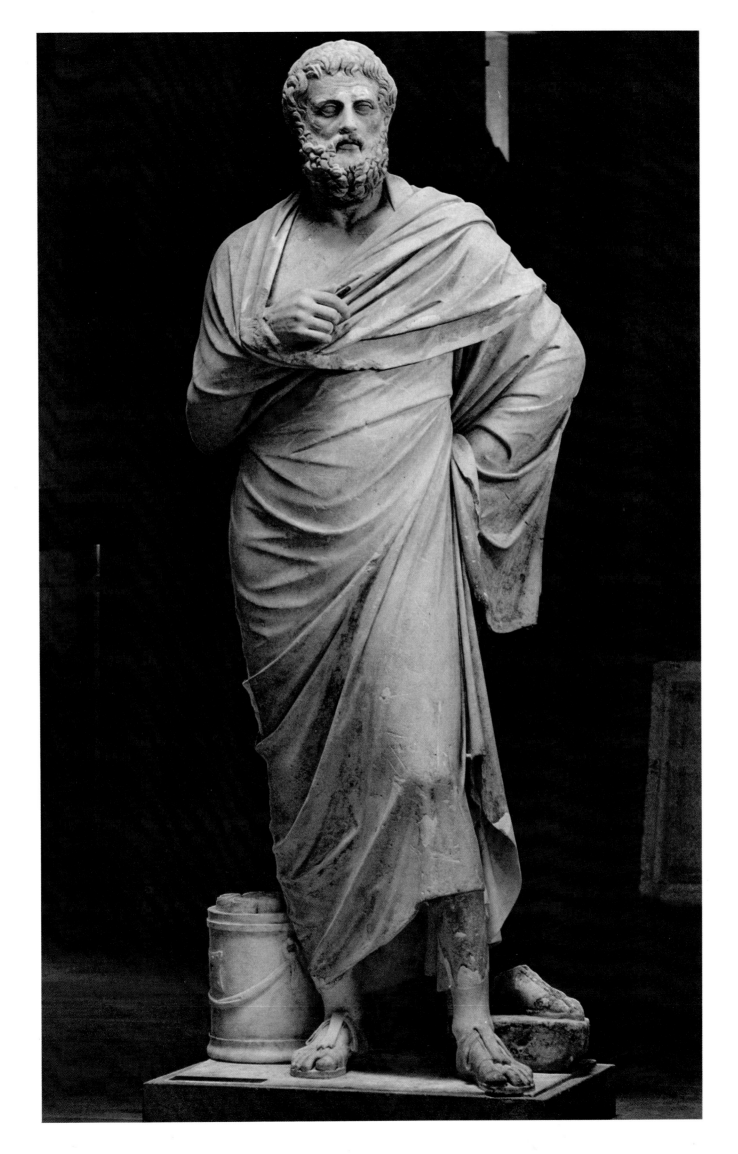

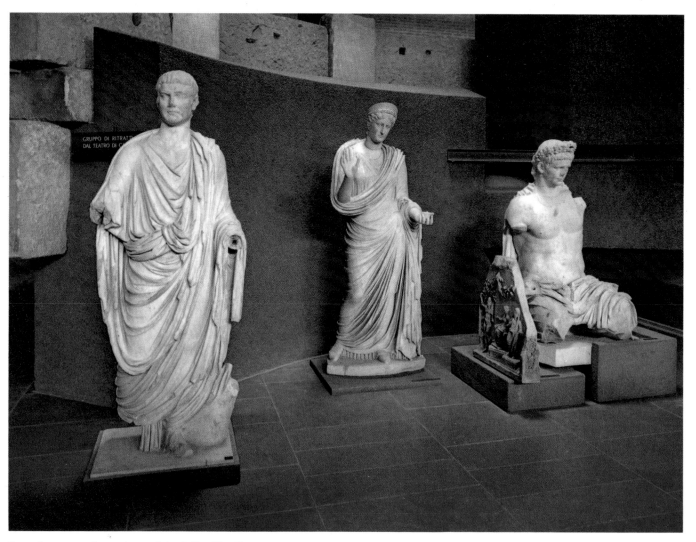

Portrait statues of members of the Julio-Claudian
dynasty from the theater at Cerveteri.

Tiberius's son (the resemblance between members of
the Julio-Claudian family is so strong that it is often
difficult to identify their portraits with precision); the
body, nude except for a cloak wrapped about the hips,
is idealized.

An interesting group of statues and reliefs of the
first century A.D. came to light during the excavations
of 1840 and 1846 in the Roman theater at Cerveteri
(the ancient Etruscan city of Caere, twenty-eight miles
northeast of Rome). Several members of the Julio-
Claudian dynasty are represented. There is a colossal
head of Augustus, and a statue of Tiberius enthroned
in the guise of Capitoline Jupiter and crowned with
oak leaves. Claudius (41–54) is similiarly represented,
and a relief found together with his statue seems
to have formed part of his throne. On it are the per-
sonifications of three Etruscan cities, identified by
inscriptions: Vetulonia, a man standing under a pine
tree with an oar over his left shoulder; Vulci, a veiled
woman enthroned with a flower in her right hand;
and Tarquinia, a man standing with his toga drawn

over his head—possibly Tarchon, the mythical founder
of the city. These figures are evidently derived from
statues; they are related to each other visually only by
means of a garland held over them by a cupid.
Personifications of other Etruscan cities no doubt dec-
orated the other sides of the throne, which may have
been an expression of Etruria's gratitude to Claudius,
who took a special interest in that region and was the
author of a book on Etruscan history. There is also a
statue of Agrippina the younger, the wife of Claudius
and the mother (by her first husband) of Nero.
Agrippina's hair style is typical of the early Imperial
period, and her face bears a striking resemblance to
other members of the Julio-Claudian family (she was
Augustus's great-granddaughter), whereas the body
of the statue—derived from a Greek prototype of the
fifth century B.C.—gives her the idealized form of a
goddess. Other portrait statues in the group cannot
be identified because the original heads have been lost.
A pair of sleeping sileni, copies of Hellenistic origi-
nals, accompany the portraits; their heads rest on a

goatskin flask that probably served as the spout of a fountain.

An altar from the same site was dedicated, as its inscription tells us, to Caius Manlius, the censor of Caere, by his clients. The sacrifice of a bull is represented on its front; on the rear a female divinity, presumably the recipient of the sacrifice, is enthroned upon a rock, surrounded by worshipers—she is perhaps Fortuna, the goddess of Caere. On each of the altar's sides is a Lar (an ancient rural deity) dancing between two olive trees.

Exhibited near the sculptural group are inscriptions from the theater of Caere in honor of Augustus, of Germanicus (the nephew and adopted son of Tiberius, and Agrippina's father), of Drusilla (another daughter of Germanicus), of Agrippina, of Claudius, and of the Senate and the People of Caere.

Portraits from later periods include a fragmentary one of the emperor Titus (79–81). Though most of the skull, the nape of the neck, the right half of the forehead, and part of the right eye have been lost, the surface of what is left is well preserved, and the quality of the carving is excellent. The subject of one portrait has been identified, thanks to another version, with an inscription, in the collection of the duke of Wellington, as Lucius Julius Ursus Servianus, who was a friend of the emperors Domitian (81–96) and Trajan (98–117); it was he who saved the empress Domitia Longina from execution. Only the torso remains of a porphyry statue of an emperor, probably Trajan or Hadrian (117–38), wearing a cuirass; the workmanship is of extremely high quality. We have already seen Hadrian's favorite, Antinous, portrayed with the attributes of Dionysus-Osiris in a statue in the Sala Rotonda; a statue in this collection—the head is missing—appears to represent him in the guise of Vertumnus, god of the changing seasons. The portrait head of an unknown, bearded man wearing a Greek helmet can be dated, on stylistic grounds, to the Hadrianic period; it probably belonged to a statue in which the subject was represented as Mars.

The same device—the identification of the human subject with a mythological personage—occurs in the portrait statue of a woman, datable from the hair style to the beginning of the third century. The pose is derived from classical representations of Aphrodite, but the otherwise nude woman is draped in a lion's skin, and she carries a club: she is thus equated with Omphale, the Lydian queen whom Hercules was forced to serve and who, in an exchange of roles, assumed the hero's attributes.

A man wearing a toga is identified in an inscription on the base—which probably belongs with the statue—as Gaius Caelius Saturninus Dogmatius; the inscription further lists the offices that he held and

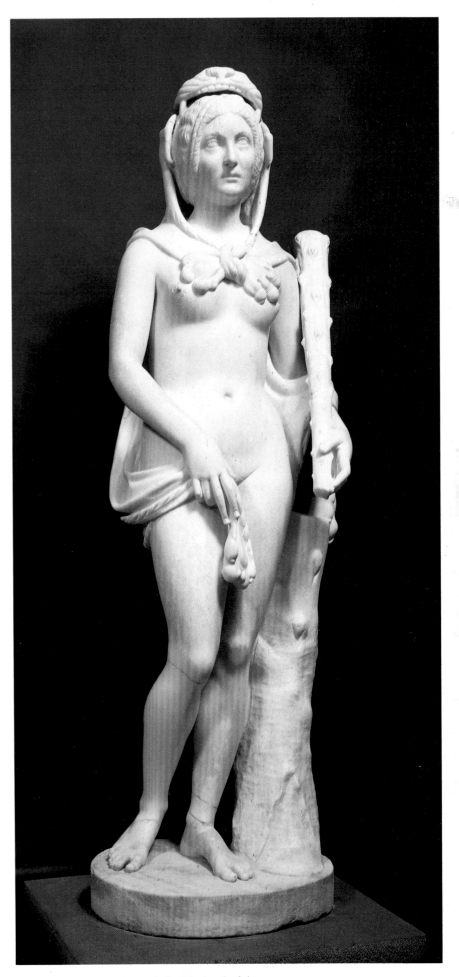

Woman in the guise of Omphale. The head of the statue is a portrait of a Roman woman of the third century.

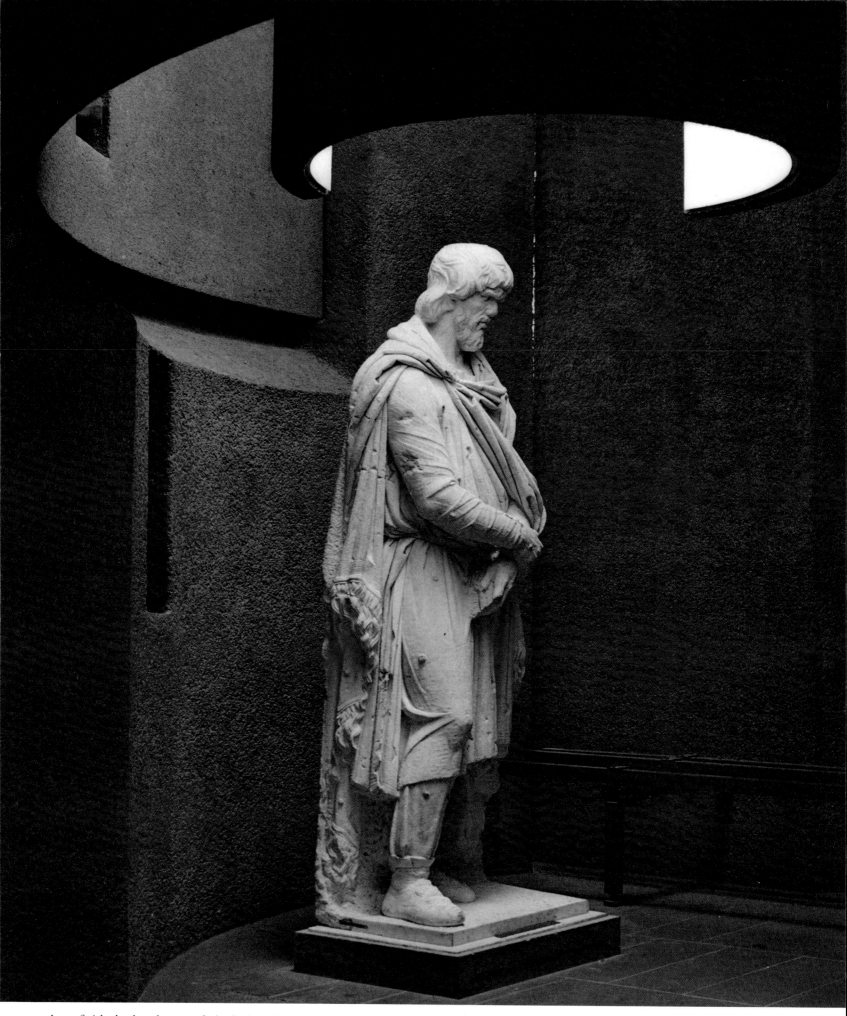

An unfinished colossal statue of a barbarian prisoner,
commemorating Trajan's campaign against the Dacians.

describes him as a trusted intimate of Constantine's. On the basis of this information, it can be deduced that the statue was set up between 323 and 337. The style of the head is compatible with a Constantinian date, whereas the cut of the toga and the marble-working technique indicate that the body was carved during the Hadrianic period, in the second century. It is probable, therefore, that an old togaed statue was put to a new use, and the head of Dogmatius inserted, in about the year 330.

Cult Reliefs

A number of original reliefs are directly connected with religious cults. A round altar of the first century A.D., from Veii, is dedicated to Pietas, the divinized personification of traditional Roman respect for religion, family, and country. It is adorned with garlands of fruit alternating with four ten-stringed lyres. Beneath the garlands are attributes of Vulcan (a Roman god equated with the Greek Hephaestus): a hammer, an anvil, tongs, and a *pileus*, the felt cap worn by craftsmen. This altar is a copy of one in the Roman Forum dedicated by Lucius Scribonius Libo and known through representations on coins. Its fine workmanship and tasteful ornament recall the Ara Pacis of Augustus.

During excavations in 1937–39 beneath the northwest corner of a Renaissance palace, the Cancelleria, three important reliefs were discovered; they had already been detached in ancient times from the monuments to which they originally belonged. Since the Cancelleria is an extraterritorial enclave belonging to the Vatican City, the reliefs became part of the Vatican collection. One of them probably belonged to the base of a monumental altar of about A.D. 30–40, known as the Altar of the Vicomagistri. The Vicomagistri were officials in charge of the local cults of the various districts of Rome, especially the cult of the *Lares compitales*, tutelary gods of the crossroads. In his reorganization of the state religion, Augustus introduced into this cult that of his own Genius (we have already described a statue of the Genius of Augustus in the Sala Rotonda). The relief depicts a sacrificial procession: the two consuls with their lictors, trumpet players, three bulls for the sacrifice with their attendants, a flutist and a lyre player, four boys with covered heads, and four togaed figures wearing laurel wreaths—the Vicomagistri. Three of the boys accompanying the Vicomagistri (the fourth figure is badly damaged) carry statuettes in their left hands: two are of dancing Lares and the third is of a figure in a toga, the Genius of Augustus.

A small altar of the first century was dedicated to Hercules, as the inscription tells us, by a certain Publius Decimus Lucrio, in fulfillment of a vow. The three lines of the inscription are interrupted in the middle by a relief of Hercules and Minerva standing beside an altar; below, the twelve labors of the hero—whom the Romans worshiped as a god—are represented in the order in which they occur in classical literature and art.

Commemorative Sculpture

By far the most important objects in this category are two reliefs found in 1937–39 together with the relief from the Altar of the Vicomagistri and known from the place of their discovery as the Cancelleria reliefs. They were carved during the reign of Domitian (81–96). The first commemorates (from Domitian's point of view) an event of the year 70: the *adventus*, or arrival in Rome, of his father Vespasian, the founder of the Flavian dynasty, who had been proclaimed emperor the previous year while with his army in Alexandria. On the relief, Domitian (who was already present in Rome, where he held the office of *praetor urbanus*) welcomes Vespasian at the entrance to the city. The retinues of the two men include both real and allegorical figures. Vespasian is accompanied by lictors, and Victory, flying behind him, is about to crown him with oak leaves; his salute is addressed not only to Domitian but also to Rome, personified as a goddess enthroned to the left, accompanied by Vestal Virgins. Domitian is flanked by the Genii of the Senate and of the People. The other relief represents the *profectio*, or departure for a military campaign, of Domitian, now himself the emperor. He wears a tunic and the *paludamentum*, the mantle worn by generals. As on the other relief, gods and allegorical figures mingle with ordinary mortals: Minerva, Mars, the lictors, and Victory (of whom only a wing is preserved) advance before the emperor; Valor supports his elbow; the Genii of the Senate and of the People stand beside him; soldiers follow with their captain. Domitian holds a scroll in one hand and raises the other in a gesture of command. His figure is easily recognizable from his hair style, though his features have been obliterated and replaced by those of his successor, Nerva (96–98). Domitian was, in fact, a tyrannical and unpopular ruler, and after his assassination the Senate subjected him to *damnatio memoriae*, official oblivion, which entailed, among other things, the effacement of his name and image from public inscriptions and monuments.

Nerva's successor, Trajan (98–117), led a successful campaign against the Dacians, a Balkan people. Trajan's Column, in the grandiose forum that he constructed, is the principal monument commemorating this victory, but evidently it was not the only one. The barbarian prisoner represented in a colossal statue

is characterized as a Dacian by his dress and physiognomy. Eight similar statues adorn the attic of the Arch of Constantine near the Colosseum, the sculptural decoration of which consists largely of spoils from earlier monuments. The statue in the Museo Gregoriano Profano, which is unfinished, was no doubt intended to stand with them at their original site, perhaps in Trajan's Forum.

Three fragments are all that remain of a large historical relief from the time of Hadrian (117–38). The togaed figure putting on *calcei patricii*, the boots worn by patricians, may well be Hadrian himself. One member of his retinue is also preserved. He is probably one of two brothers of the Caesernius family, whom we know to have accompanied Hadrian in his travels; they have been identified among the figures in the roundels on the Arch of Constantine, which originally belonged to a Hadrianic monument.

A fragment from another relief has the figure of a standard bearer, his head covered, according to tradition, with an animal skin. The standard is that of the Praetorian Guard as it appears in a number of scenes on the columns of Trajan and Marcus Aurelius. The relief, datable to the second century, was evidently a military scene; it may have adorned a triumphal arch. Another standard—that of the Twelfth Legion, called the *Fulminata*—appears on a relief fragment, also apparently from a military scene, of the second or third century.

Funerary Reliefs

The reliefs that decorated Roman tombs, cinerary urns, and funerary altars present a rich assortment of portraits, mythological and allegorical subjects, and scenes from everyday life. The earliest examples in the Museo Gregoriano Profano are three reliefs of the first century B.C., with family portraits of freedmen belonging to the Numenius, Servilius, and Furius families.

Following the rite of cremation, the ashes of the deceased were placed in round, square, or rectangular cinerary urns with lids in the form of sloping roofs, or in urns shaped like altars. Many of the examples in this collection come from the *columbarium* (literally, "dovecote"; a vaulted chamber with recesses for urns) of the Volusii on the Appian Way, which was discovered in 1825; they date from the first century A.D.

The decoration of one altar-shaped urn is unusually graceful and elegant. At the corners are two candelabra (or incense burners) and two torches. The front has a tablet for an inscription, which has been left blank, a head of Medusa in the center, a garland, and, at the bottom, a charming scene: the end of a contest between fighting cocks belonging to two cupids. The winning bird, in its master's arms, puffs out its breast and holds with one claw a wreath it has taken from a table where there are palms and other wreaths. The loser is being carried under the arm of the other cupid, who walks away weeping. On the sides of the urn are garlands, nests with baby birds being fed by their parents, and other cupids.

On the funeral altar of Tiberius Claudius Dionysius, the deceased is shown with his wife; they are standing and holding hands. On another relief, the same Tiberius Claudius Dionysius is reclining on a bed, with his wife sitting beside him. Her hair style is one that was fashionable in the time of the emperor Claudius.

Caius Julius Philetus, named in the inscription on another altar, must have been a child, to judge from the decoration. On the front is a small boy carrying a hare in his tunic and feeding it with grapes. A boy plays with a dog on the right side, and on the left another boy pulls a baby in a little carriage. Until 1925 this altar served as a holy-water font in the church of Santa Maria in Domnica.

The museum possesses thirty-nine objects and fragments, excavated in 1848, from a sepulchral monument on the Via Labicana, outside Rome, known as the Tomb of the Haterii—its proprietor seems to have been a building contractor named Quintus Haterius. It dates from the time of Trajan. In 1970 new excavations at the tomb, which is now the property of the Italian state, brought to light additional sculptural details and inscriptions.

Two *aediculae*, or shallow niches, which were presumably recessed into the wall of the tomb, contain life-sized busts of a male and a female member of the family; they are almost perfectly preserved. The man's short, curly hair is combed forward; he has prominent, bristling eyebrows and a lively, expressive face. His torso is nude, except for a cloak thrown over his shoulder. The coiled snake in front of him is an allusion to his heroic status in the afterlife. The woman has a wavy hair style typical of the end of the first century; she contemplates the world with a somewhat detached air.

On one relief from the tomb there is a scene of mourning for a dead woman. Around the funeral couch, in the atrium of a house, are lighted lamps and torches; behind the couch are wailing women and in front of it mourning servants and a flutist. Another, fragmentary relief shows a portal with the four gods of the underworld, Mercury, Proserpina, Pluto, and Ceres. A square cinerary urn is decorated with rams' heads and, between them, shells from which water gushes; in the water, ducks swim and dolphins and fish dart about. Some of the purely decorative elements of the tomb are noteworthy for their quality; among them are a fragmentary relief with lemons and quinces,

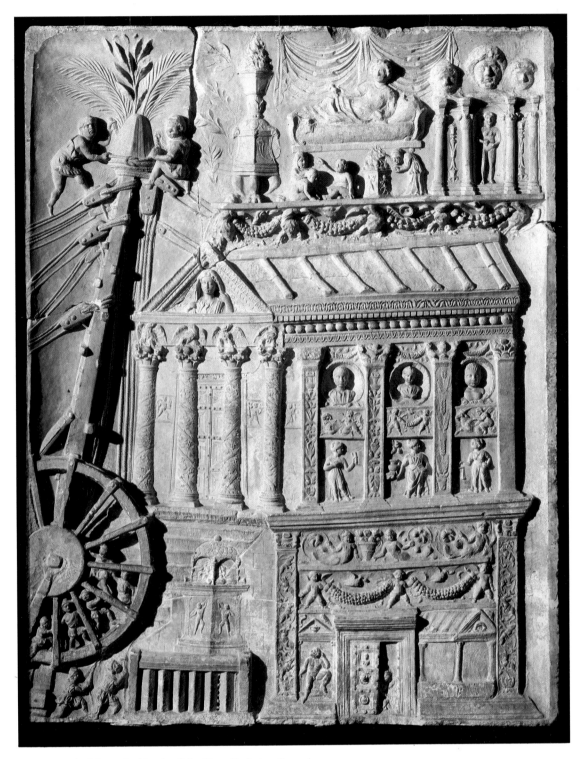

Funerary relief from the Tomb of the Haterii, dating from the time of Trajan. The mausoleum, which belonged to a building contractor, is in the form of a Roman temple; at the left is a kind of crane, operated by slaves in a treadmill.

a frieze with masks, and an exquisite pilaster on which is represented a candelabrum with roses and olive branches twined about it and four birds—perhaps parrots—perched at the top.

The two best-known reliefs from the tomb of the Haterii are representations of architecture. On one of them, five ancient buildings may be identified: an arch with the inscription *Arcus ad Isis*—the monumen-

tal entrance to the temple of Isis and Serapis in the Campus Martius, which was probably erected on the occasion of Titus's victory over Judaea in A.D. 70; the Colosseum, begun by Vespasian between 70 and 76 and dedicated by Titus in 80—the main entrance, an arch surmounted by a four-horse chariot, is shown, as well as the colossal statues that stood in the arcades; a triumphal arch, usually identified as the one erected

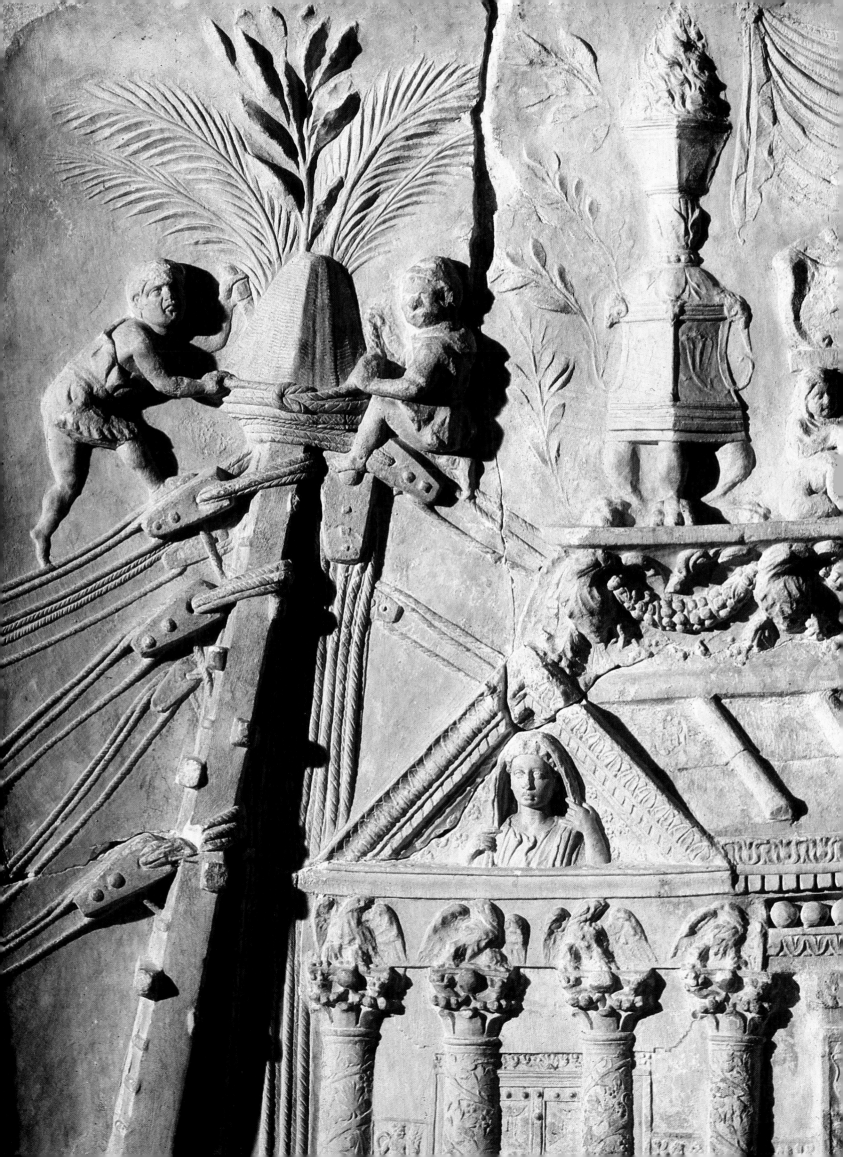

in honor of Titus in 80–91 as the eastern entrance to the Circus Maximus—through the passage we have a glimpse of the statue of Cybele, enthroned between lions, that stood in the circus; the Arch of Titus on the Sacred Way overlooking the Roman Forum, identified by the inscription *Arcus in Sacra Via summa*; the temple of Jupiter Tonans on the Capitoline, which was damaged by fire in the year 80 and restored under Domitian—the cult statue represented here, with Jupiter holding thunderbolts and a scepter, corresponds to images of the Capitoline statue on coins. The presence of such a relief in the tomb is to be explained, it seems, by professional pride: Quintus Haterius, the contractor, must have had a hand in these buildings, all of which were constructed or restored under the Flavian emperors, Vespasian, Titus, and Domitian.

The other architectural relief represents a mausoleum in the form of a Roman temple, standing on a high podium and preceded by a porch with four columns; the side is articulated by pilasters and richly ornamented with reliefs. On the pediment is the bust of a woman, presumably the deceased. The structure in front of the steps is probably the *ustrinum*, where corpses were cremated. The scene above the roof of the mausoleum is a view of its interior: the dead woman is lying on a funeral couch; in front of her an old woman is performing a sacrificial rite at an altar, and three children are playing; the rear wall, shown to the right, is in the form of a triumphal arch, with a statue of Venus and masks of ancestors. To the left of the mausoleum, towering above it, is a huge building machine, a kind of crane operated by slaves in a treadmill—another allusion to Haterius's professional activity.

Three other tomb reliefs may be dated approximately to A.D. 100. On one, the central slab with the inscription is missing. To the left is a man in a toga pouring a libation; below, a man—possibly the deceased—sleeps in a grotto with the fruit of a poppy in his hand; above is a cockfight, and cupids carrying garlands. Another represents circus games in honor of the deceased, who is shown close by, larger than life. A racer drives a four-horse chariot around the *spina*, the dividing ridge down the middle of the circus. On the *spina* are the *metae*, or finishing posts, an obelisk, two columns with statues, and a shrine crowned by four dolphins; a victor, palm in hand, leans against the left-hand *meta*. To the left the deceased is depicted again, wearing a toga and holding a scroll in his left hand; he offers his right hand to his wife in the gesture of fidelity, *dextrarum iunctio*. A relief from the tomb of Ulpia Epigone (identified by an inscription) portrays her on a couch, resting on her left side; she has a workbasket at her feet, and a lap dog peeps out from under her arm. Her hair style is typical

of the period of the Flavian emperors and of Trajan.

On a fragment from the pediment of a funerary monument on the Appian Way, cupids hold up the bust of Claudia Semne (whose name is known from an inscription). The bust stands for the soul of the departed. On another relief, which is extensively restored, a youthful warrior standing beside his horse salutes a seated woman; in the background is a slave holding his master's spear. Laurel leaves and a serpent allude to the heroic status of the deceased.

Sarcophagi

The majority of the sarcophagi in the museum are decorated with mythological scenes, though other subjects—philosophers, games, and scenes from everyday life—are also represented.

Three of them were found together in 1839 in a tomb near the Porta Viminalis, one of the ancient city gates of Rome. The tomb can be dated to A.D. 132–34 from the marks on the bricks used in its construction. One has scenes from the myth of Orestes: Orestes and his friend Pylades at the tomb of Agamemnon, who appears as a veiled shade beneath its vault; the death of Aegisthus, from whose body Orestes snatches the royal mantle usurped from Agamemnon; the murder of Clytemnestra, and two Furies with snakes and torches; and the purification of Orestes at Delphi—the setting is indicated by a tripod, a laurel tree, and the *omphalos* (the navel-shaped stone that was a cult object in the sanctuary of Apollo). On one of the short sides of the sarcophagus is a seated Fury; on the other, the veiled shades of Aegisthus and Clytemnestra in Charon's bark. The lid has a small relief of Orestes and Iphigenia in Tauris. The second of the Porta Viminalis sarcophagi represents the myth of the children of Niobe, which we have already recounted in connection with the Chiaramonti Niobid in this museum. Here, Apollo and Artemis appear as small figures on the side of the lid, mercilessly shooting their arrows at Niobe's children. The parents look on helplessly: Amphion, raising his shield, in the left-hand corner, and Niobe, her cloak billowing in the breeze, to the right. On the right side of the sarcophagus are Niobe and Amphion at the tomb of their children. The third sarcophagus has, on the front, two Gorgon masks and garlands of fruit held up by cupids and by a little satyr; on the short sides are lighted candelabra between pairs of griffins; on the lid are cupids riding various animals.

Roman sarcophagi frequently illustrate the myths of mortals who came to an untimely end. Adonis, the lover of Aphrodite, was killed by a boar. A sarcophagus of about A.D. 220 shows, on the left, the parting of the young hunter and the goddess, who is enthroned

Detail of relief from the Tomb of the Haterii; the bust in the pediment may represent the deceased.

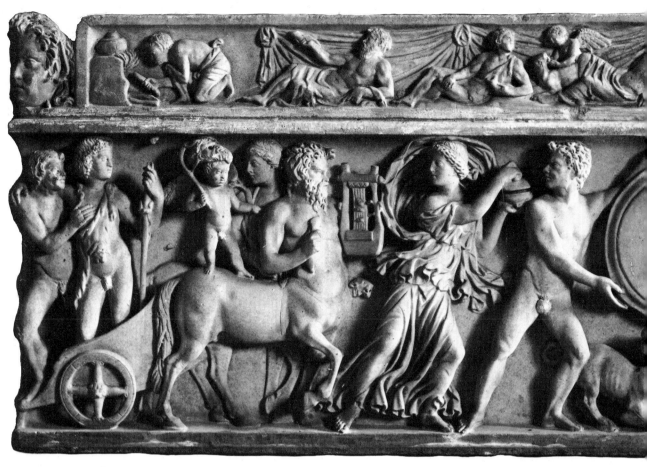

A Roman sarcophagus of the second century, with two satyrs
in the center holding a shield; to the left and right are
Dionysus and Ariadne in chariots drawn by centaurs.

and surrounded by cupids; to the right is the fatal hunt,
with the attacking boar and Adonis mortally wounded.
In the center, Adonis is enthroned beside Aphrodite,
who, inconsolable at the loss of her beloved, has im-
plored the god of the underworld to let him spend six
months of each year on earth. The myth thus alludes
to the participation of the dead in the life of the gods;
the figures of Aphrodite and Adonis have portrait
heads. The lid of this sarcophagus, which did not
originally belong to it, has scenes from the myth of
Oedipus: Laius sacrificing to Apollo at Delphi; Laius
exposing the infant Oedipus; the flight of Oedipus
from Corinth; the murder of Laius by Oedipus; and
Oedipus solving the mystery of the Sphinx.

The myth of Hippolytus (who was also killed
during a hunt—he was thrown from his chariot and
dragged to his death by his own horses, though this
scene is not shown here) is the subject of another sar-
cophagus of about 220. Hippolytus's stepmother
Phaedra, who is enamored of him, sends him a mes-
sage through her nurse, revealing her passion; Hip-
polytus, departing for the hunt, rejects her advances;
he is seen hunting a boar, accompanied by a helmeted
female figure, the personification of Valor. On the left
side of the sarcophagus is a sacrifice to Artemis; on
the right, hunters on horseback. On the fragments of

the lid—which is the original one—are scenes from
the hunt.

The participation of mortals in the life of the gods
is the theme of a sarcophagus of about 250, where it
is exemplified by parallel scenes from the myths of
Mars and Rhea Silvia and of Selene and Endymion.
In the first, a mortal maiden is found worthy of the
love of a god; in the second, a youth is found worthy
of that of a goddess. The heads of Mars and Rhea
Silvia may well be portraits; those of Selene and
Endymion, unfortunately, are restorations.

The Bacchic mysteries promised immortality to
initiates, and for this reason a great many Roman sar-
cophagi are decorated with Bacchic scenes—including
not only episodes from the myth of Dionysus (or
Bacchus; the names are interchangeable), but also play-
ful compositions with cupids, sileni, satyrs, maenads,
and other figures belonging to the entourage of the
god. One second-century example—it is exceptionally
well preserved, a fine Roman sarcophagus in all its
original freshness—has two satyrs in the center, hold-
ing a round shield that was intended to bear an in-
scription. To the left and right, Dionysus and Ariadne
(the mortal princess rescued and granted immortality
by the god) are seen advancing in centaur-drawn char-
iots, accompanied by their retinues. The lid has Bac-

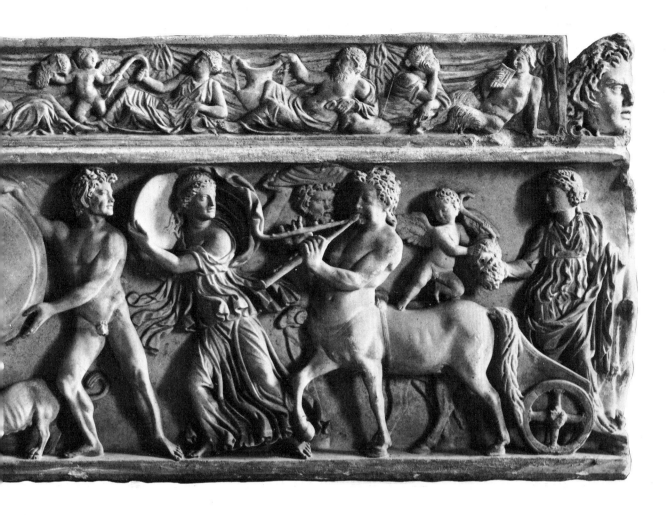

chic scenes, and satyrs' heads at the corners. A late amplification of the myth of Dionysus—it developed after the Asian expedition of Alexander the Great —describes his return to Greece after conquering India. This story is represented on a third-century sarcophagus, which is also of excellent workmanship and extremely well preserved. Dionysus rides in a triumphal chariot drawn by elephants; a winged Victory crowns him. His retinue consists of the usual sileni, centaurs, satyrs, and maenads, with the addition of exotic animals: a lion, a panther, and even a giraffe, whose head appears above the silenus in the center. The scene has an extraordinary vivacity, thanks to the variety and the agility of the figures that make it up.

Three sarcophagi have figures of cupids, making wine, playing with masks and garlands, and bearing medallions. The iconography of a fourth, from the third century, is more complicated. In the center, two cupids bear a medallion with the portrait of a woman; below this another cupid holds a mask of Silenus in front of his face to frighten his little companion. To the left and right, two pairs of cupids bear the attributes of the four Seasons. The distinguishing characteristics of the individual Seasons are muddled, however. This kind of confusion is typical of the late Empire, when the original meaning of traditional themes was gradually lost sight of; the workmanship, too, shows signs of decadence.

A large sarcophagus of about 270 has a philosopher in the center, seated on a high throne and reading from a scroll. A man and two veiled women are listening to him. The woman to the left is shown in the traditional posture of Polyhymnia, the Muse of sacred song; the other woman holds a rolled-up scroll. Two bearded personages, facing outward, flank the group. The remnants of a sundial can be seen to the right. The emphasis on the central portrait has led some to suggest that it represents Plotinus, who came to Rome from Alexandria in 244 and remained there as a teacher of philosophy for many years; he died in retirement at Minturnum, in southern Italy, in 270. The hypothesis is an attractive one, but it cannot be verified. On a fragment from another sarcophagus we see, to the right, a bearded philosopher, and the hands of another figure, holding a scroll; to the left are traces of a lion hunt. The fragmentary lid, with the representation of a cockfight, is probably the original one.

The sarcophagus of a child from about 210 has figures of athletes boxing, wrestling, and paying tribute to the victor. The bearded figures with palms are the judges; to the left a victor is being crowned, while a herald sounds the trumpet.

A third-century sarcophagus with scenes of the cultivation of grain and the production of bread was never completed; the reliefs are roughly sketched in. It is divided into two superimposed friezes. Above, a farmer guides a plow drawn by oxen; another hoes the ground; the figures to the right are reaping. Below, a wagon carries the grain to a mill; two workers turn the millstone; loaves are placed in an oven for baking. In the center is a togaed figure, a portrait of the deceased, with a scroll. His name appears on the lid, together with a Latin distich, based on a Greek epigram, in which the dead man takes leave of Hope and Fortune: he is no longer concerned with them; they may now make fools of others.

Architectural Decoration

The museum contains a few ornamental reliefs and architectural fragments of excellent quality. A group of fragments with Bacchic scenes, of exquisite workmanship, are evidently wall decorations of the first century A.D. The base of a column from the Basilica Julia in the Roman Forum is an example of the high degree of technical proficiency attained by marble workers during the early Flavian period. A number of fragments come from Trajan's Forum. Two of them are from a decorative frieze where, in all likelihood, the same motive was repeated a number of times: a Neo-Attic amphora with the figures of a satyr and two maenads in low relief is flanked by a pair of cupids, each giving water to a griffin; the legs of the cupids terminate in acanthus scrolls that surround the figures and fill the frieze with lush foliage. A relief of the second century, in Roman-Hellenistic style, is from a fountain, known as the Fountain of Amalthea: a nymph offers a large, horn-shaped drinking vessel to a young satyr, while Pan plays his pipes in a nearby grotto; the water of the fountain once gushed from a spout in the drinking horn. Two fragments of highly ornate pilaster decoration have vines growing from cups; the tendrils, leaves, and grapes occupy the entire surface; cupids and assorted animals weave in and out.

Mosaics

A large floor mosaic was reconstructed from fragments discovered in an ancient building on the Aventine Hill. The middle section has been lost, and the two concentric bands surrounding it are only partially preserved. The inner band is decorated with fauna typical of the Nile Valley, shown against a dark background. The outer band, with a white background, represents the unswept floor of a dining room—it is strewn with the remains of a sumptuous banquet; there is even a mouse gnawing upon a nut. Adjoining one side of the white band is a strip with six tragic masks and other objects. Beneath it, in Greek, is the signature of the artist: "Heraclitus made this." The mosaic is not, however, an original creation by Heraclitus; it is a copy of a famous Hellenistic mosaic by Sosus, at Pergamon, described by Pliny the elder. We know from Pliny that in the center there was a representation of doves drinking from a cup; another version is in a well-known second-century mosaic from Hadrian's Villa, now in the Capitoline Museum.

Two large mosaics from the Baths of Caracalla are installed in semicircular courts where they may be viewed in their entirety from above. Their surfaces are divided by strips with meander patterns into rectangular and square sections containing portraits of rough, brutal-looking athletes and referees. They date from the third century A.D.

GEORG DALTROP

The Museo Pio Cristiano

In 1852, Pius IX established the Commission for Sacred Archaeology for the supervision and exploration of the early Christian cemeteries. Two years later, he opened a Christian museum in the papal palace of the Lateran. He entrusted the arrangement of the sculpture to Giuseppe Marchi, S.J., and that of the inscriptions to Giovanni Battista De Rossi, whom Father Marchi himself had put in charge of Christian inscriptions in 1842. The Museo Pio Cristiano, together with the Museo Gregoriano Profano and the Museo Missionario Etnologico, was transferred by John XXIII to the Vatican and was reopened to the public in 1970.

One of the principal aims of the museum was to collect and preserve the numerous sarcophagi that over the centuries had been scattered among the palaces and villas of Rome, where all too frequently they were broken up or adapted for different purposes—some were used as fountains, for example. It is beyond any doubt the richest and most important collection of its kind in existence today, and the only one which permits both scholars and casual visitors to trace the chronological and stylistic evolution of Early Christian sculpture for a period of about 150 years. After this period, the practice of burial beneath the floors of the

cemetery basilicas became established in Rome and sarcophagi went out of use.

The sarcophagus was undoubtedly the most luxurious of the various forms of burial, and was often large enough to contain the bodies of a husband and his wife. Sarcophagi usually have the shape of an oval basin or a rectangular box, with a heavy lid like a roof or an attic with an inscription tablet in the center.

The sculptured scenes are mostly drawn from the Old and New Testaments. The Old Testament scenes most frequently represented are the Creation, the sin of Adam and Eve, their punishment, the sacrifice of Abraham, the crossing of the Red Sea, the three young men in the Babylonian fiery furnace, Daniel in the lions' den, and the story of Jonah. From the New Testament we find, above all, the miracles that proclaim the divine omnipotence of the Redeemer, such as the healing of the sick, the multiplication of the loaves and fishes, and the Resurrection. Often we find a praying figure enjoying eternal bliss among the saints. But the most frequent representation is the Good Shepherd giving his life for the flock: this is the most widely

The new gallery of the Museo Pio Cristiano.

diffused image in all Early Christian art, not only on sarcophagi but also in catacomb paintings, mosaics, epitaphs, gold glass, and lamps.

At the entrance to the museum is a fragmentary inscription from the tomb of Publius Sulpicius Quirinius, the governor of Syria under Augustus mentioned in the Gospel of Luke with reference to the census taken at the time of Jesus' birth. The inscription was discovered near Tivoli in 1764 and reconstructed by Theodor Mommsen.

The first group of sarcophagi has scenes connected with Christ's birth and the Epiphany. One lid shows Adam and Eve after the Fall, the Magi adoring the Child in the lap of the Virgin, a blank tablet held by two winged genii, Noah in the ark receiving the dove with the olive twig in its beak, the prophet Jonah cast into the sea and vomited up by the whale, and Moses striking water from the rock. It comes from the basilica of San Lorenzo and can be dated to the middle of the fourth century.

Of the same date is another sarcophagus with a large number of scenes: the adoration of the Magi; the stable with a shepherd and the ox and the ass standing near the Child in the manger; Daniel in the lions' den and Habakkuk bringing food to him; between two palm trees, the veiled figure of the deceased (whose name was Crispina, according to the inscription) with the open book of the Law bearing the monogram of Christ; the multiplication of the loaves and fishes; the arrest of Peter; the miracle of the water gushing from the rock. In the same group is the front of a small sarcophagus with the adoration of the Holy Child by the Magi and a rare representation of Ezekiel's vision of the dry bones.

Another sarcophagus shows the Jews crossing the Red Sea, an unusual subject. It dates from the end of the fourth century. On the left is the Egyptian army pursuing the fugitives, with Pharaoh himself standing in his chariot, a lance in his right hand and a shield in his left; beneath the horses of the chariot lies a figure personifying the Red Sea, while the waves are beginning to submerge the thrown horsemen. Further to the right, arches indicate the spot where the baggage-laden Jews have escaped to safety. On the far right an Israelite leads a boy by the hand, and Moses teaches his sister the canticle of thanksgiving.

Six columns with composite capitals supporting arches and triangular pediments provide an architectural framework for five niches on a sarcophagus front that can be dated, on the basis of style and iconography, to the second half of the fourth century. Within the niches, the youthful figure of Christ is shown multiplying the loaves and fishes, foretelling Peter's denial, teaching between two apostles, and working the miracles of the marriage of Cana and of the healing of the paralytic.

Also datable to the second half of the fourth century is the front of a sarcophagus that originally had six columns and five reliefs surmounted by alternating architraves and arches. Today it has only three reliefs; a fourth has recently been identified in the National Museum of Cracow. In the center stands the youthful, bearded Christ wearing a tunic and a pallium with a gem-studded triumphal cross in his right hand and, to either side, Peter and Paul. Flanking the central panel we have, on the right, Christ being led by two soldiers before Pilate, who is sitting in an attitude of indecision while a boy approaches with a jug and basin so that he may wash his hands, and, on the left, an apostle being led to martyrdom.

From the same period is a fragment of a sarcophagus front that originally had eight columns and seven niches with a symbolic image of the Resurrection in the center and the twelve apostles, wearing laurel wreaths, to either side. The central part, formerly in the church of Santa Pudenziana, is now in this museum; the right-hand part is at San Sebastiano on the Via Appia Antica. The left-hand part was identified in 1955 in a fragment which is also in the National Museum in Cracow.

The two fragments just described clearly indicate the popularity of triumphalistic themes after the middle of the fourth century. Even in the design of the sarcophagi there is a change from a continuous frieze of figures, typical of the age of Constantine, to reliefs separated by columns or pilasters or, more rarely, by trees. An important sarcophagus of the latter type comes from Tor Marancia, on the outskirts of Rome. It is divided into five fields by six spiral columns, and dates from the middle of the fourth century. Together with the preceding examples it belongs to the series commonly called passion sarcophagi, though they are really triumphal: in the center the Resurrection is symbolized by a laurel wreath surrounding the monogram of Christ above a cross with two doves on its transverse bar; beneath the cross two sleeping soldiers rest on their shields. To the right, Christ is led before Pilate while a laurel wreath descends from above. To the left, in the first panel, Simon of Cyrene, accompanied by a soldier, carries the cross; in the second panel there is an exceptionally explicit representation of a soldier placing a crown on Jesus' head: not a crown of thorns, but a royal crown of laurel.

The same central motive of the Resurrection appears on a sarcophagus divided into five fields by trees with doves in the branches. It dates from the same period. The other scenes, however, are different: God the Father receiving the offerings of Cain and Abel; two soldiers arresting Peter; Saint Paul led to his martyrdom; the suffering Job visited by his wife, who holds her nose because of the nauseating smell.

A magnificent sarcophagus, also of the middle

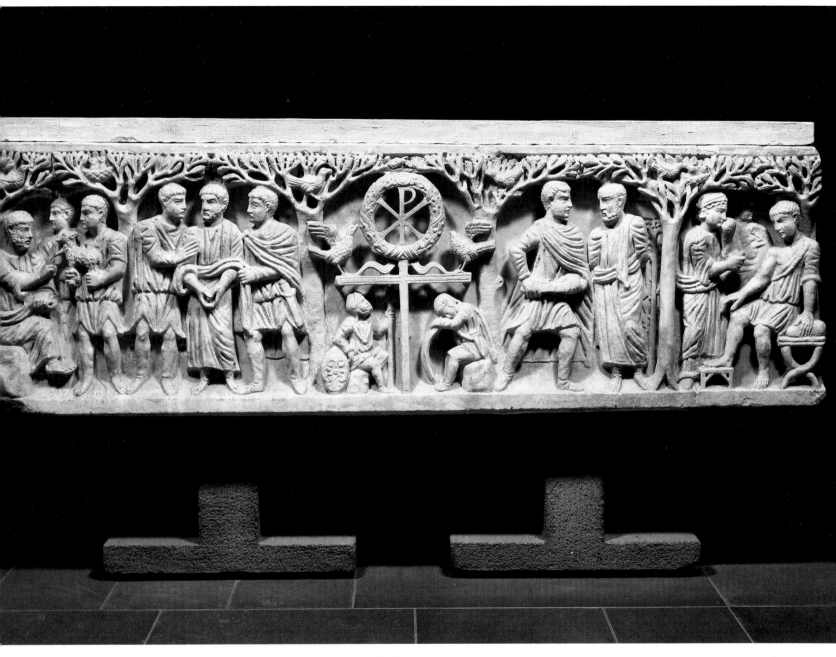

In the center of this fourth-century sarcophagus is the monogram of Christ within a laurel wreath. The scenes, from left to right, are: Cain and Abel presenting gifts to God the Father; Peter arrested by soldiers; Paul being led to his martyrdom; and Job with his wife and a friend standing in front of him.

of the fourth century, has rich decoration not only on the front of the lid but also on its sides. On the lid are the three young men in the fiery furnace assisted by the prophet; two winged cherubs bearing the tablet with the inscription of the deceased Agapene and her husband Crescentianus; Jonah being cast into the sea and, later, resting under the gourd. The front is divided by eight small columns into seven compartments with the following scenes: the sacrifice of Isaac; Moses climbing the mountains to receive the Commandments; Christ healing the man born blind, predicting that Saint Peter will deny him thrice, healing the woman with the issue of blood, and multiplying the loaves and the fishes; and Peter performing the miracle of the spring. On one side are, once again, the three youths in the fiery furnace; on the other side is the tree of knowledge with the serpent coiled around it, and Adam and Eve with the symbols of the work they must henceforth perform.

A sarcophagus from the first half of the fourth century has all the hallmarks of the Constantinian period, such as the placing of the scenes in one continuous frieze on two superimposed levels. In the center there is a shell-shaped medallion containing the busts of the deceased couple. Above, at the sides, are Christ's triumphal entry into Jerusalem; the Divine Word, represented as a young man, handing Adam and Eve an ear of corn and a lamb—the symbols of their labors; Moses receiving the Commandments from the hand of God; the sacrifice of Isaac; the raising of the son of the widow of Naim; and the multiplication of the loaves and fishes. Below are Peter's miracle of the spring; his arrest and Christ's prediction of his denial;

Daniel in the lions' den; the healing of the paralytic; the healing of man born blind and of the woman with the issue of blood; and the miracle of the marriage feast of Cana.

A comparable richness of imagery, with analogies in the iconography and the design, characterizes another sarcophagus of the middle of the fourth century. It too has likenesses of the deceased couple within a shell. This sarcophagus, however, shows the raising of Lazarus, Moses removing his sandals before climbing Sinai, and the story of Jonah.

Two sarcophagi, among the most important in the museum, come from the basilica of San Paolo. One was discovered in the time of Sixtus V (1585–90), and the other in 1838, beneath the altar of the Confessio. The first is called the Sarcophagus of the Two Brothers, since the original portraits of a married couple were latter readapted for the burial of two men. Its iconography is noteworthy for the detailed illustration of the Pilate scene (in which Christ does not in fact appear), and for the representation of Peter sitting under a tree, about to be arrested. The other, which dates from the second half of the fourth century, is called the Dogmatic Sarcophagus, from the wealth of doctrine and the profundity of theological inspiration in its decoration. On the upper level it shows the Triune God creating man and woman; the Redeemer handing the first parents their means of subsistence after the Fall—Adam must work the soil and Eve weave wool from the sheep; nearby, the tree of knowledge with the serpent and the apple; Christ, with long curly hair, wearing a tunic and a pallium, performing the miracle of Cana, multiplying the loaves and the fishes,

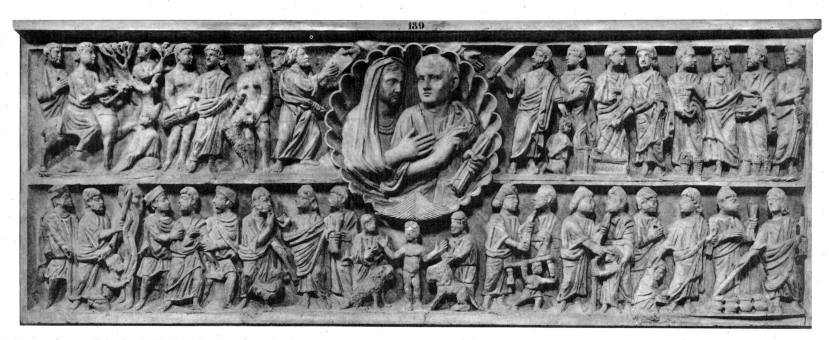

A sarcophagus of the first half of the fourth century has busts of the deceased couple in a shell-shaped medallion and biblical scenes in two continuous friezes.

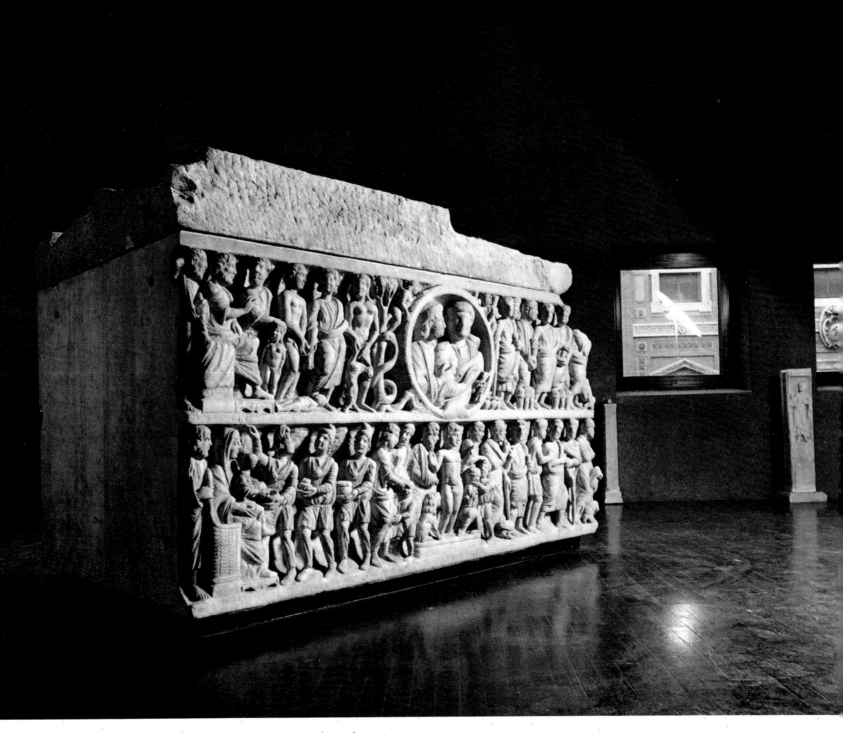

This large sarcophagus is known as the Dogmatic Sarcophagus because the tenets of Christian doctrine are copiously illustrated in its decoration. It dates from the second half of the fourth century.

and raising Lazarus, while Lazarus's sister kneels at the Lord's feet. On the lower level we see the adoration of the Magi, who are dressed in short tunics and Phrygian caps, with the first one pointing at the star above the Virgin, who is seated on a throne with the Infant in her lap; the miracle of the man born blind; Daniel in the lions' den with Habakkuk bringing him food; Christ prophesying that Peter will deny him thrice; Peter's arrest; and Peter performing the miracle of the spring. The imagery on this sarcophagus attains a coherence found nowhere else in Early Christian sculpture.

In the same style is a sarcophagus front with a continuous frieze from the church of Sant'Agnese. It deserves mention for the scene of Christ's entrance into Jerusalem and particularly for the representation of the vision of Ezekiel. The lid of a sarcophagus from the first half of the fourth century is also very interesting. It shows hunting scenes, and a bust of the deceased woman on a cloth supported by two cher-

The Good Shepherd and a woman in prayer, on the front of a
sarcophagus from the time of the emperor Gallienus (253–60).
It is probably the oldest sarcophagus in the collection.

ubs, while in the center is the tablet bearing the in-
scription. In the center of the sarcophagus itself the
deceased woman appears again, in an attitude of prayer.

The most interesting part of the so-called Christ-
mas Crib Sarcophagus is again the lid, with great
prominence given to the Nativity and the adoration
of the Magi, on the left, and to the story of Jonah to
the right of the central tablet. On the tablet and along
the upper edge of the lid is an inscription informing
us that the wife, Casta, had the tomb and the inscrip-
tion made to honor the memory of her dear husband
Crescens, against her father's wishes but with the
agreement and assistance of her stepmother.

A sarcophagus from the end of the third century
has a scene that is not often represented: the ascent of
Elijah. The bearded prophet, dressed in the tunic and
pallium, is being taken to heaven in a fiery four-horse
chariot and letting his mantle fall upon Elisha. The
same scene appears on the side of a sarcophagus from
the basilica of San Paolo, which may be dated to the
second half of the fourth century; on the front are
Cain and Abel making their offerings to God the Father.

A large sarcophagus of the middle of the fourth
century has an entirely different design. It has two
registers, and is decorated with S-shaped grooves
known as strigils, with scenes in the center and at the
ends. At the top, in the center, is a large representa-
tion of a husband and wife holding hands; behind them
is the head of Juno, the goddess of marriage, and,
below, the figure of Psyche—that of Eros has been
broken off. In the lower register is a cock fight, with
cupids to either side: one hands the palm and wreath
to the winning bird and the other weeps for the van-
quished. These scenes are part of the pagan repertory,
but the fact that the sarcophagus belonged to a Chris-
tian couple is clear from the four scenes at the ends: to

the left the creation of woman and the healing of the man born blind, and to the right the raising of Lazarus and Moses striking the rock.

Another strigilar sarcophagus, this one with only one register, has a single scene in the center: Christ predicting Peter's denial. The lid, with a blank tablet in the center, shows Adam and Eve to either side of the tree with the serpent coiled about it; two saints supporting a curtain with the bust of a veiled praying female figure; and the Jonah cycle, which is one of the most frequent subjects in Early Christian art.

Pastoral themes are dominant on another group of sarcophagi. One of them was found at Tor Sapienza on the Via Prenestina. It is important because it still bears faint traces of its original painted decoration. We should not forget that in ancient times works of sculpture were usually painted; unfortunately, time has destroyed the colors in almost every case. On the lid there is a female bust in front of a curtain held up by two putti. On the right side of the sarcophagus there is a female praying figure, and at the other end a shepherd carrying a sheep on his shoulders. A sarcophagus dating from the end of the third century has another pastoral scene. In an atmosphere of serenity and repose, two women playing the pipes flank the central portrait of an elderly woman dressed in tunic and cloak.

A woman called Juliana is represented on the right side of her sarcophagus in an attitude of prayer; corresponding to her, on the left, stands the Good Shepherd, young and beardless and with a sheep on his shoulders. The central part has the prophet Jonah, cast into the sea and being swallowed by the whale; Noah praying in the ark and the dove approaching with the olive twig in its beak; and a bucolic scene with grazing sheep.

Similar pastoral scenes are combined with representations of philosophers on the most ancient Christian sarcophagus in the collection, attributed by most scholars to the time of the emperor Gallienus (253–60). It is of Hymettian marble, with figures in high relief, and comes from the Via Salaria. There are couchant rams at two of the corners; on the front, from left to right, are three philosophers, two standing—behind the first is a sundial—and one seated with an open scroll, in the act of teaching; between two trees, a frontal figure of the Good Shepherd, bearded and wearing a short tunic, stands, with a sheep on his shoulders and two at his feet, looking toward the group on the left, composed of a veiled woman in an attitude of prayer followed by a second veiled woman, seated and with a volume in her left hand, raising her right hand in the act of speaking; behind her stands another female figure, her left hand resting on the shoulder of the seated woman.

The entire surface of another large, important sarcophagus from the end of the fourth century is covered with decoration. On the front, the figure of the Good Shepherd carrying a sheep on his shoulders is represented three times, while all the remaining space is occupied by vine branches, with winged putti harvesting and pressing the grapes; others are busy milking ewes. On the upper part of one of the sides, putti are harvesting grapes; below, others are driving oxcarts. On the other side there are more putti, representing the seasons: some are busy with the grape harvest, others are gathering wheat sheaves, others are carrying animals from the hunt. The back of the sarcophagus is decorated with geometric patterns.

Finally, there is a sarcophagus front, from the end of the fourth century, with the Good Shepherd in the center and the twelve apostles on both sides, with twelve sheep at their feet. At each end there is a young shepherd among sheep and trees.

At the end of the sarcophagus gallery are two small statues of the Good Shepherd. The first belongs to the first half of the fourth century, and shows us the Shepherd with long hair falling in curls, beardless, in a short tunic; his two hands clasp the feet of the lamb that he carries on his shoulders, and his gentle glance seems to turn toward the flock as he brings the strayed lamb back to the fold. In the other statue the Good Shepherd, in tunic and high boots, is holding a knotted stick in his left hand and hugging the sheep's feet to his breast with his right hand. The date is later and the workmanship is cruder than in the previous example.

Other objects of various kinds are also exhibited in the sarcophagus gallery. These include an interesting lead pipe from the time of Pope John I (523–26) found at the basilica of San Lorenzo. It bears the inscription SALVO PAPA IOHANNE/STEFANUS PP REPARAVIT. There are also mosaic portraits of Flavius Julianus and Maria Simplicia Rustica and another small mosaic of a cock, all found in the catacomb of Saint Cyriaca, near San Lorenzo. Finally there is the Canino Bell, so called from the site in the province of Viterbo where it was found in 1884. It had been exposed to the weather for so long and had deteriorated to such an extent that a thorough restoration was necessary. On the top are the remains of the triple ring that supported it and two triangular openings for the sound; beneath them is a cross with arms of equal length ending in spiral scrolls, typical of the eighth and ninth centuries; below, on the outside edge, an inscription tells us that the bell was dedicated to Christ and the archangel Michael by a certain Viventius.

The museum also has an incomparable collection of Christian inscriptions. The epigraphist who originally assembled it, Giovanni Battista De Rossi, had an abundance of material to choose from, so numerous

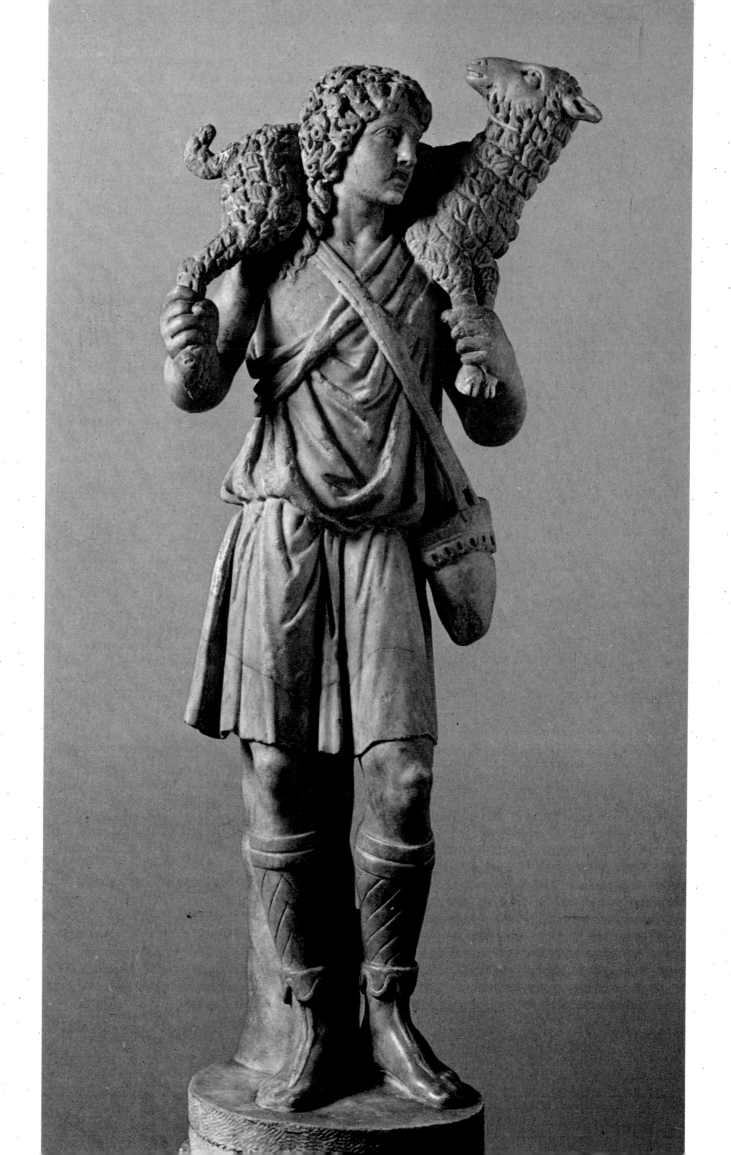

were the inscriptions scattered throughout Rome in churches, sacristies, monasteries, and private homes. In fact, from 1578, when the Christian catacombs on the Via Salaria Nova were discovered by chance, until 1841, when Gregory XVI placed Father Marchi in charge of all the catacombs, they had been systematically plundered of their precious contents. However, a large amount of material had already been accumulated in the storerooms of the Vatican Museums and of the Apostolic Library by the end of the pontificate of Pius VII. The municipality of Rome also offered Pius IX an enormous quantity of Christian inscriptions discovered near San Lorenzo and others kept in storerooms on the Capitoline. The collection occupied the triple portico and the walls of the broad principal staircases leading from the courtyard to the upper floors of the Lateran Palace.

In classifying the inscriptions, De Rossi gave first place to those dealing with public Christian worship or referring to the sacred buildings and recording their incomes and donations made to them. This material occupied the first two walls, the third being reserved for the eulogies composed by Pope Damasus (366–84) in honor of the Roman martyrs, which are a valuable source for the lives of those heroes of the faith. Another wall of these inscriptions was added later.

Second place was given to a selection of inscriptions divided into three series. The first was chronological: inscriptions whose dates can be determined, from the consuls mentioned in them, up to the year 565. The second consisted of inscriptions classified according to formulas that document belief, discipline, ecclesiastical hierarchy, civil conditions, and the family. The third series is topographical, according to the provenance of the inscriptions from the various Christian cemeteries in Rome. Other inscriptions, including an important group of Hebrew ones, were added later.

The most celebrated inscription in the museum was found in Asia Minor in 1883 and presented by the sultan Abdul Hamid to Leo XIII. It is the epitaph of Abercius, bishop of Hieropolis in Phrygia at the time of Marcus Aurelius (161–80). It was dictated by Abercius himself, and consists of a Greek ode of twenty-two hexameters. Only two fragments of the original have been preserved, but it has been possible to reconstruct the text almost in its entirety, thanks to the epigraph of a certain Alexander (who died in A.D. 216), which includes passages of the ode. Given the importance of Abercius's epitaph, defined by De Rossi as the "queen of Christian inscriptions" and the most ancient work of its kind that can be dated exactly, it is worthwhile to give a full translation:

> As a citizen of a noble city, I have had this monument made during my lifetime, in order that my body may be fittingly buried here: I, Abercius, a

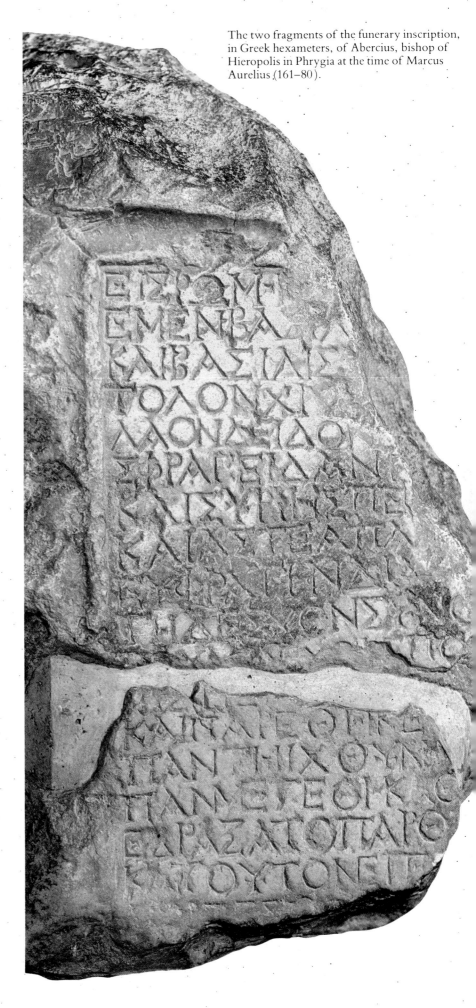

The two fragments of the funerary inscription, in Greek hexameters, of Abercius, bishop of Hieropolis in Phrygia at the time of Marcus Aurelius (161–80).

This small statue of the Good Shepherd, from the first half of the fourth century, is one of the most evocative pieces in the papal collection: the youth's gentle glance seems to turn toward the flock as he brings the lamb back to the fold.

disciple of the chaste Shepherd who pastures flocks of sheep on hills and plains, who has great eyes which look in all directions from on high. He has indeed instructed me in faithful writings... and sent me to Rome to behold the royal palace and to see the queen with golden robe and golden sandals; and I saw there a people bearing a splendid seal. I visited too the plain and all the cities of Syria, and Nisibis beyond the Euphrates; and everywhere I found companions... having Paul with me... and everywhere faith guided me and gave me for food fish from the spring, mighty and pure, which the spotless Virgin catches and gives as food every day to friends, having an excellent wine mixed for us with water, together with the bread. These things I, Abercius, have had written here in my presence; I was seventy-two years old in truth. Let him who understands and believes this pray for Abercius. But let no one place another in my tomb: he who does so will pay to the Roman treasury two thousand gold pieces and to my dear native city Hieropolis one thousand.

Other funerary inscriptions include a composition in verse by Pope Damasus, written to comfort the parents of a young woman called Projecta, who died soon after her marriage at the age of sixteen years, nine months, and twenty-five days, in the year 383, during the consulate of Flavius Merobaus and Flavius Saturninus. This and similar inscriptions illustrate the extreme simplicity of the formulas normally used in Early Christian epitaphs. One reads: "Here lies the innocent, wise, and beautiful Cyriaca, who lived three years, three months, and eight days, laid to rest in peace four days before the ides of January in the second consulate of our lord Theodosius and of Paternus," that is, in A.D. 388.

The inscriptions tell us a great deal about the faith of the early church. Numerous references to Jesus Christ as Son of God and to the Holy Spirit illustrate the doctrine of the Trinity. Not a few attest to a belief in the intercession of the saints and of the faithful departed for the living: in an inscription from the Via Salaria Nova, the parents ask their son Anatolius, who rests in God, to pray for his sister; in another, the dead person is asked to pray for his bereaved parents. Other inscriptions show the devotion of the earliest Christians of Rome to the cult of the martyrs: thus the parents of Dracontius Pelagius and Julia Aethelia Antonina acquired for their daughter a sepulcher adjoining the tomb of the martyr Saint Hippolytus.

Some of the texts are accompanied by symbols such as the monogram formed by the first two letters of Christ's name in Greek, X (*chi*) and P (*rho*); the anchor, standing for hope; or the laurel wreath, expressing the concept of eternal reward. On the funerary tablet of a certain Severa, the bust of the deceased is accompanied by the prayer that she may live in God: *in Deo vivas*. To the right is a representation of the Epiphany, the favorite scene of Christ's infancy in Early Christian art. As Saint Augustine wrote: "The Magi were the first of the Gentiles to know Christ the Lord, and being the first they deserved to represent the salvation of all peoples."

The very vocabulary of the inscriptions brings out the essential difference between the materialistic pagan conception of the afterlife and Christian belief in the survival of a principle distinct from the body. The words *anima* and *spiritus*—both signifying the soul—occur constantly, and we read that the soul has gone out from, has been separated from, has broken the chains of the body; it has flown to heaven, called by the Lord (*evocata a Domino*), borne away by the angels (*arcessita ab angelis*); it has entered into peace (*ingressa in pace*). In the middle of the third century Saint Cyprian, bishop and martyr, comforted his faithful and told them not to weep for the departed, for they are not lost to us, but only gone before us.

ENRICO JOSI

The Museo Missionario Etnologico

The Museo Missionario Etnologico was created by Pope Pius XI with his *motu proprio* "Quoniam tam Praeclara" of November 21, 1926, and was housed in the Lateran Palace. The installation was planned by the famous ethnologist William Schmidt, S.V.D., who was the museum's first director, and by his assistants Michael Schulian, S.V.D., and Pancratius Maarschalskerweerd, O.F.M. The museum was solemnly inaugurated on December 21, 1927.

The original nucleus consisted of some forty thousand objects that had been assembled for the Missionary Exhibition of the Holy Year of 1925. They had been presented to the pope by numerous bishops, priests, religious, and laymen, and they came from all the parts of the world where Catholic missions were active. The exhibition of this patrimony, which was arranged according to geographical criteria, offered a wonderful panorama of the life and activities of many non-European peoples in the economic, social, and artistic fields; it likewise gave an idea of their multifarious religious beliefs.

Other collections and single objects were added

A bronze crucifix made during the seventeenth century by the Bakongo people of Zaire.

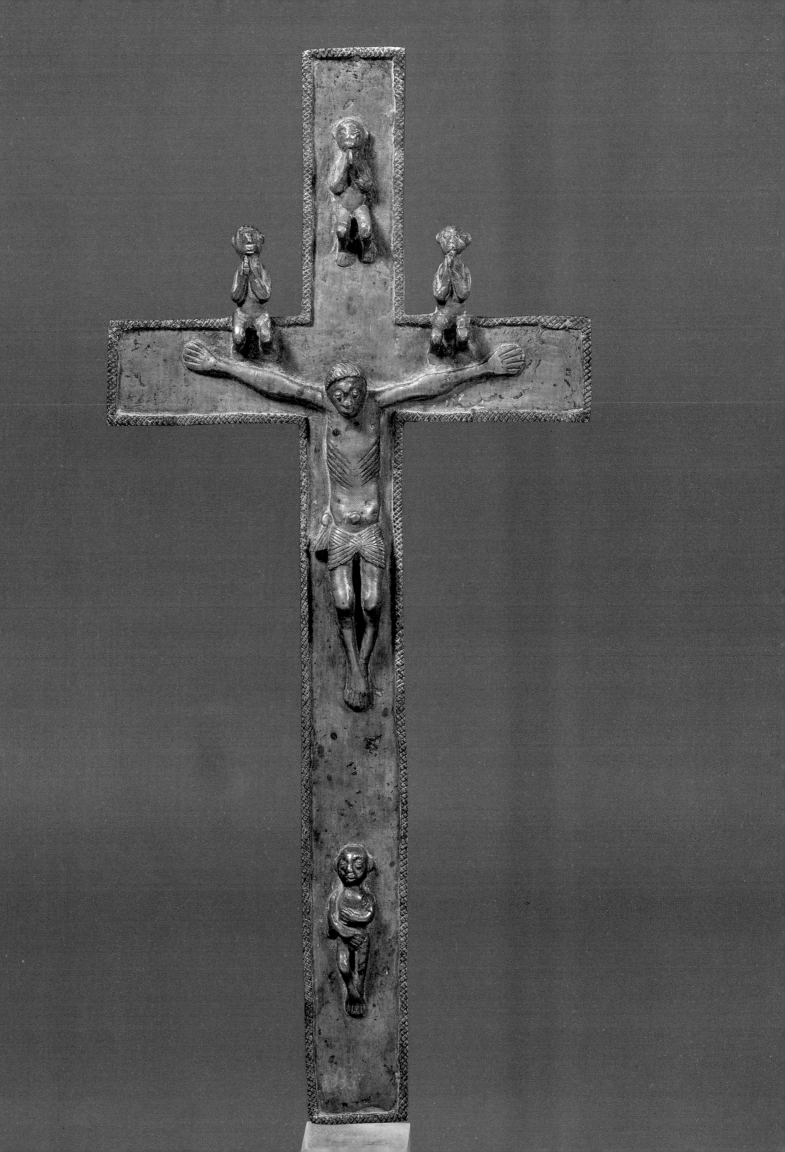

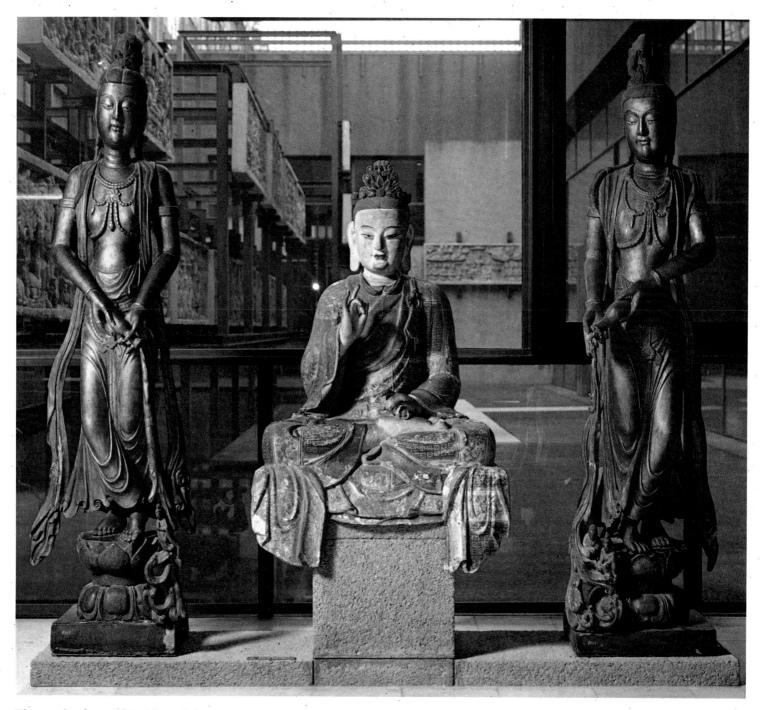

The wooden figure of Buddha and the two Bodhisattvas were probably carved in the Shansi Province of China during the Ming dynasty.

to this nucleus even before the opening of the museum. The first donation came, by an order of the pope, from the storerooms of the Vatican Museums. Another came from the Congregation de Propaganda Fide. The pope also authorized the acquisition of important examples of Indian art.

After the inauguration, gifts from all over the world continued to arrive, and the pope gave them to the museum. These donations ceased with the Second World War. Many years later, a valuable collection of carpets from Persia, Afghanistan, and the Bokhara region of Central Asia, which had been collected between the two World Wars by an Italian consul, was presented by his widow to John XXIII.

On February 1, 1963, by order of Pope John, the museum was closed to the public; the collections were dismantled and transferred to the Palazzo di San Calisto in Rome. In the following years the present building was constructed in the Vatican to house the former Lateran Museums, and in 1969–70 the Museo Missionario Etnologico was installed in its new home.

The gallery is about 700 meters long and has 25

sections. In most of them the various forms of religion of a particular non-European nation or cultural region are illustrated in historical sequence. Separate sections are devoted to the Christians of Africa and Latin America, and to an exhibit of Christian art from missionary lands.

China

At the entrance to the Chinese section are two enameled guardian lions from Peking. The male faces the exterior, the female the interior. They represent the two essential principles of Chinese philosophy and religion, Yang (male, heaven, circle, perfection) and Yin (female, earth, square, imperfection), which together make up the Tao (supreme law, order, the universe).

There is a model of the Temple of Heaven in the southern suburb of Peking. The temple was built in wood in 1420 and rebuilt in marble in 1755. At the winter solstice the emperor used to offer sacrifice to his ancestors (the sky and the deceased emperors of his dynasty) on the platform at the top of the altar; simultaneously, on the lower level, a high imperial dignitary sacrificed to the sun, the moon, the constellations, the wind, and the rain. The last sacrifice took place in 1916. At the summer solstice a similar ceremony was held in honor of the earth, in a temple in the northern suburb of Peking.

Tomb offerings of the Ch'in dynasty (221–206 B.C.), the Han (206 B.C.–A.D. 220), and the T'ang (A.D. 618–906) illustrate the cult of the dead. A collection of statues of divinized ancestors and of small domestic altars related to ancestor worship comes, with the exception of one altar, from the Aberdeen district of Hong Kong; all of these objects are from the last dynasty, the Ch'ing (1644–1912). There is a reproduction of a Ch'ing dynasty funeral procession.

Also from the Ch'ing dynasty are a Taoist picture with a delicately worked frame and an altar with Taoist emblems and sacrificial vessels.

The altar of Confucius comes from the pagoda at Ch'ü-fu, where Confucius (551–479 B.C.) was born and is buried. It is a faithful reproduction of the original, made by Chinese artists in 1935 with the permission of Confucius's descendants. The philosopher wears the imperial insignia of the Chou dynasty (1129–249 B.C.) and carries a tablet with a scepter, symbolizing dominion in the realm of thought. In front of the statue is a sacrificial table with three sacred vessels of the eleventh century. Above it is a gilded panel with the inscription "Spiritual throne of Confucius, master of most holy teachings"—that is, the place in which the soul of Confucius is enthroned.

In the section on Chinese Buddhism there is a wooden statue of the Buddha, flanked by two attendant figures. Another wooden statue represents Kwan-yin, the Bodhisattva most frequently invoked in China; an ancient goddess of fertility, Kwan-yin assumed an important position in the Buddhist pantheon, thanks to the religious syncretism of the Chinese. There are also a number of stone sculptures of the Buddha and of Kwan-yin, a stone statue of a Buddhist monk, the stone head of a monk from Lohan, and three sacred vessels from a temple in Peking.

A collection of Chinese pottery with Arabic inscriptions documents the presence of Islam in China. A large stone stele, represented here by a copy, is the earliest evidence of Christianity (in its Nestorian form) in China. Erected in 781, it was unearthed in 1625, near Sian, in Shensi province. The copy was given by Frits Holm to Benedict XV in 1916. Near a Christian altar in Chinese style is the bronze statue of Father Marcellus Sterkendries. This missionary saved the city of Kingchow from destruction in 1911–12; in gratitude, the non-Christian inhabitants melted down the most precious sacred vessels in their possession to have the statue made.

Japan

Two lions in gilded wood, guardians and protectors against evil spirits, stand at the entrance to the Japanese exhibit.

Shintoism, a religion of Japanese origin, merged during the course of the centuries with Buddhism, which was brought to Japan from China in the sixth century A.D. It is represented in this collection by a number of objects, including a model of a Shinto temple in the ancient capital of Nara; three small garden temples; vessels for wine, water, rice, and perfume used in sacrifice; a mirror, symbol of the sun goddess Amaterasu; and figures of foxes, symbols of the gods of rice and of riches. A large metal incense burner of the eighteenth century—the wooden base is a modern restoration—has scenes and statuettes of Shinto mythology; in the central medallion of the upper zone is Amaterasu, the ancestress of the Japanese imperial family, fighting against the moon and the earth.

Japanese Buddhism is documented by thirteen *kakemono*, representing the thirteen Buddhas or Bodhisattvas who are commemorated on the anniversaries of the dead, from the seventh day after death until the thirty-third year; by the mannequin of a monk, vested for an important ceremony; and by eight prayer scrolls with the text of the Hokekyo, a Buddhist prayer book.

Standing on two *butsudan* (small household altars) are sacrificial vessels, statues of Buddhist and Shinto divinities, and tablets commemorating ancestors. These *butsudan* are among the most interesting examples of

the religious syncretism of Japan. There are also Shinto-Buddhist masks, including two very fine ones representing the big lion and the little lion of the Nō theater, carved recently in the antique style out of sacred *sughi-didohi* (cedar) wood.

The collection includes paintings, by Okayama Shunkyō of Kyoto, of the Japanese Christian martyrs killed at Nagasaki in 1597, and some wooden tablets with persecution edicts.

Korea

Three models represent the main building of the Imperial Palace in Seoul, a rich house, and a poor one. There are also boxes in lacquered wood inlaid with mother-of-pearl, a wardrobe in the antique Korean style, five vases of crackled porcelain, everyday crockery, and typical Korean games and ornaments. Examples of Korean clothing include traditional men's and women's garments, and hats for everyday and ceremonial use.

Religious life in Korea is illustrated by a household altar, sacred vessels, the statue of an ancestor, and a shield used in popular festivals. Also on display are the printers' blocks used to print the first Korean catechism, and two blocks with the Ten Commandments.

Tibet and Mongolia

Tibet and Mongolia are the regions where Lamaism predominates. The original Tibetan religion, Bon-pö, is documented by representations of spirits, and by drums made from human skulls and flutes of human bones, which betray Shamanistic influence.

Mannequins of monks represent the two main branches of Lamaism, the yellow (the more orthodox of the two) and the red. Statues, Lamaist reliquaries, and cult instruments and vessels are also displayed. Two large brass statues represent Kwan-yin, or Avalokitesvara; they were made in China during the Ming dynasty (1368–1644).

A model represents the lamasery of Tch'uo-yang-Hien in eastern Mongolia. This monastery was founded in 1700 by the lama Tchuo-eul-tsi, a disciple of the Dalai Lama of Lhasa in Tibet, who had sent him to Mongolia. It includes three pagodas: the first is called the "pagoda of the four guardians of the principal parts of the world"; the second is the "pagoda of prayer," where liturgical assemblies gather on important feast days; the third is the "pagoda of beneficence," where daily rites are celebrated at dawn and sunset.

There are also Tibetan standards and religious books, and a tent of the kind used by Mongolian lamas on their journeys.

Indochina

Objects illustrating the cult of the dead in Vietnam include a wooden enclosure with statuettes of ancestors, baskets for offering rice at tombs, and two vessels for secondary burials. There is also a model of a Vietnamese Buddhist monastery.

Thailand is represented by a religious book of the seventeenth century, with its original case; chairs with tablets dedicated to ancestors; and statuettes of the Buddha made from the ashes of Buddhist monks—these betray Tibetan influence.

Statues of the Buddha and of Bodhisattvas come from various countries of the Indochinese peninsula. A white marble statuette of the Sleeping Buddha was found in the ruins of the temple of Ara in Burma; it was made in the sixteenth or seventeenth century.

A large Vietnamese litter of gilded and lacquered wood is a Christian object; made in 1846, it was carried by ten men in the procession of Our Lady of the Rosary in Tonkin.

The Indian Subcontinent

The principal religion of India today is Hinduism. The museum illustrates the two main currents of this religion: Shivaism, in which the supreme god is Shiva, and Vishnuism, in which the supreme god is Vishnu.

A votive ox, the mythical vehicle of Shiva, comes from Chamanarayngore; it was made in the eighteenth century. There is also a little votive temple in honor of Shiva, and a painting and a number of statuettes representing Shiva with his wife, Kali.

Among the objects connected with Vishnuism are two very beautiful seventeenth-century household altars, with Vishnu in the center and his various incarnations on the sides.

A large wooden urn has scenes from Hindu mythology carved on its base; inside are about a hundred statuettes of members of the crowded Hindu pantheon. Hindu cult instruments include altars, bells, knives, and vases. Ceremonial masks were used in the dances of various magic rites in South India and Sri Lanka; they reflect both Hinduism and the primitive religions of those regions. Especially noteworthy is the three-part mask of Maha Kola, the demon of the eighteen diseases. Below a large Shivaist portal from Baroda is a statue of Bhima, the protector against snakes.

The Golden Temple at Amritsar is the spiritual center of Sikhism, a Hindu sect of northern India; the museum possesses a model of it.

Islam extended its influence to vast areas of the Indian subcontinent throughout the Middle Ages and until the British conquest. It is professed today in Pakistan, Bangladesh, and some parts of northern India.

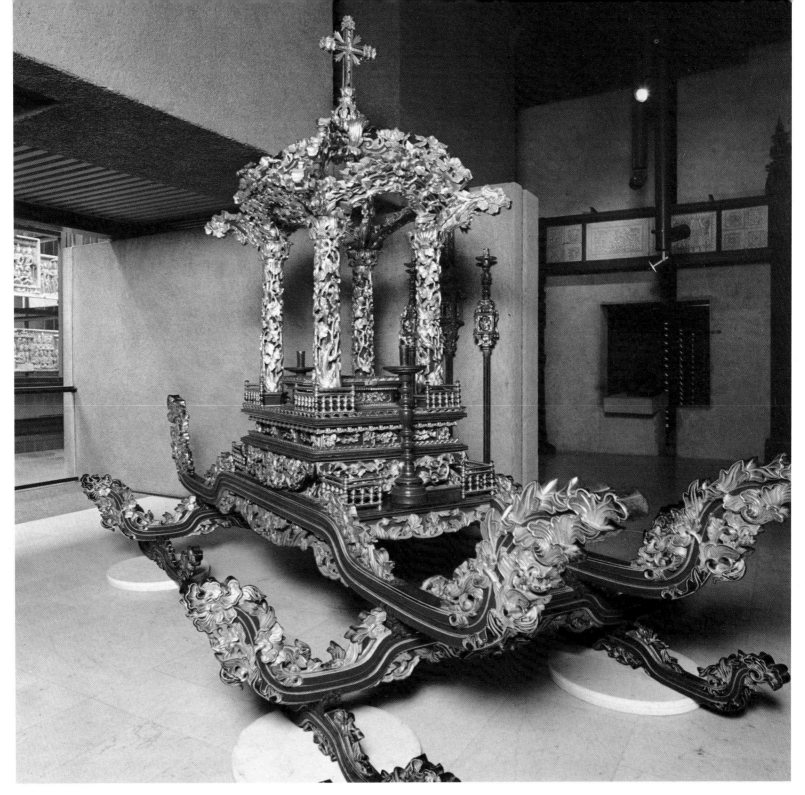

A Vietnamese litter of painted and laquered wood, made in 1846 and used in processions of Our Lady of the Rosary in Tonkin.

On display are an alabaster model of the Taj Mahal at Agra, a nineteenth-century Koran from Agra, and gems with inscriptions from the Koran.

Christian objects include seventeenth- and eighteenth-century statues of the Virgin and the saints, showing Portuguese influence, from India and Sri Lanka, and a number of votive offerings, made by Christians of the Malabar rite, from the shrine of the Virgin at Verapoly.

Indonesia and the Philippines

The primitive cults of Indonesia are represented by models of sacred birds, a basket for offering rice to the dead, and wooden statuettes of ancestors and heroes.

Until the coming of Islam, much of Indonesia was under the influence of Hinduism. From Bali, where this religion is still practiced, there are painted wooden statues of the chief Hindu divinities, includ-

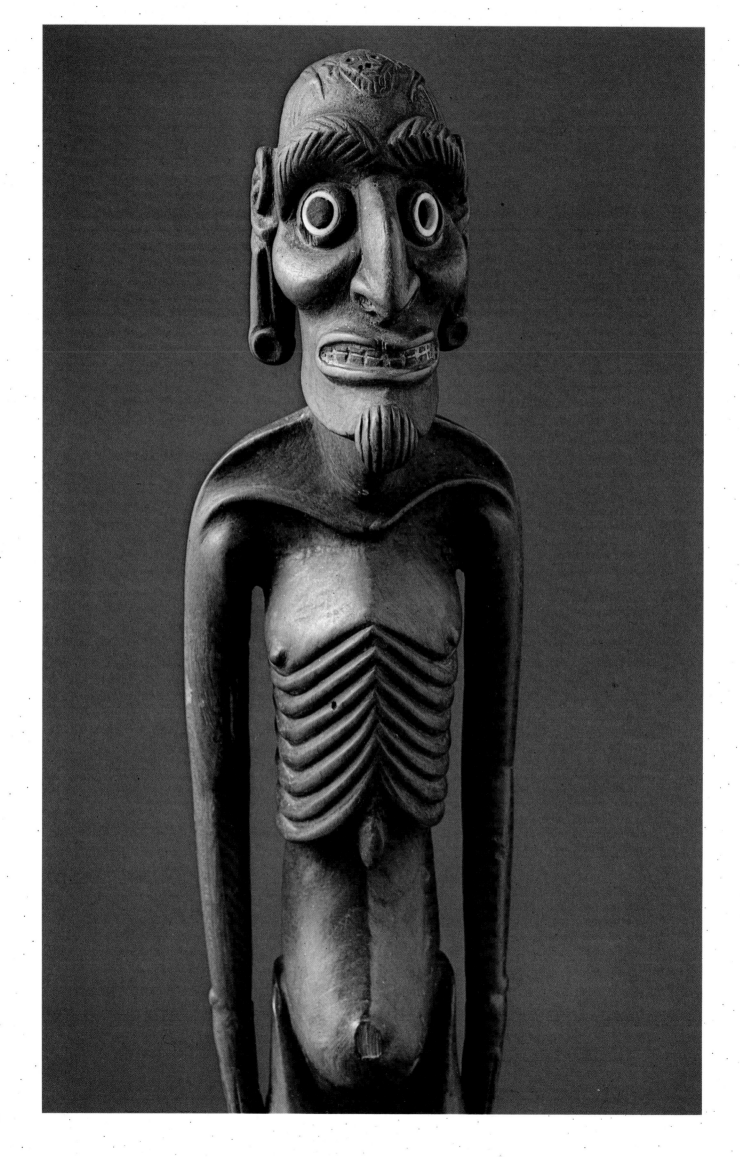

ing Shiva, Vishnu, and Kali. Buddhism also had many adherents. Twenty-four bas-reliefs illustrating the life of the Buddha from his birth to his first sermon are copies of ninth-century originals at Borobudur, the great Buddhist shrine in Java. There are also statuettes in iron and bronze of Hindu-Buddhist divinities.

Polynesia

The cult of the dead is illustrated by two boats for carrying souls to the beyond, from the Marquesas Islands; an ancestral casket from Tuamotu; and several mourning crowns. Cult instruments include urns, axes, oars, and clubs carved in wood.

Fine statues in wood and stone from Easter Island, the Marquesas, Tahiti, and elsewhere represent ancestors and the divinities of Polynesia. Two wooden statues of the god Tu—the first, with four legs, from Mangarewa, is the only example of its kind in the world—are true masterpieces of Polynesian sculpture.

The presence of Christianity in Polynesia is documented by objects belonging to two missionaries, Father Damien de Veuster (1840–89) and Father Nicoleau; both devoted themselves to the care of lepers and themselves died of leprosy.

Melanesia

Large sculptures in wood from New Caledonia represent the guardian spirits of the house. Other objects illustrate the cult of the dead and of ancestors. The little hut supported by a carved wooden pillar, from the Solomon Islands, stood on the spot where a tribal chieftain was cremated; it was used for sacrifices in his honor. Statues from the Solomon Islands and New Caledonia represent deified ancestors. There are also funeral mats from the New Hebrides.

A beautiful triple mask with carvings of an ancestor and of various mythological birds is from New Ireland.

Cult instruments include ancient stone axes from the Loyalty Islands that were used for human sacrifices, drums, and oar-shaped shields from the Solomon Islands with representations of the spirit of death.

Christianity in Melanesia is represented by three crucifixes from New Ireland, the Solomon Islands, and New Guinea. A statue of the Virgin in painted wood was the first attempt at Christian sculpture in the Solomon Islands.

New Guinea, which is famous for its wooden sculpture, is represented by a *tambaran*, or spirit hut. These huts are the spiritual and social centers of New

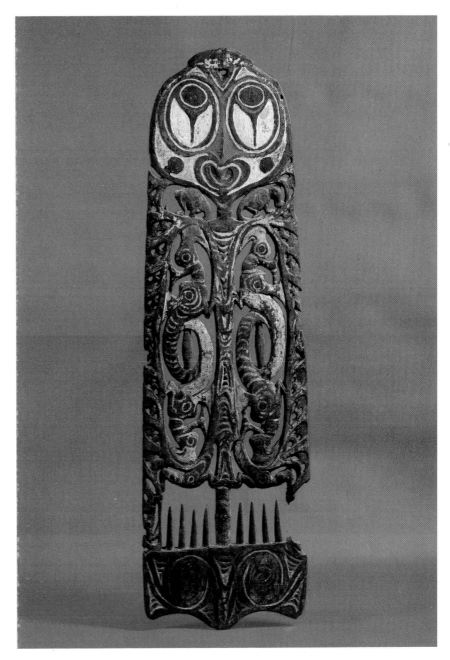

A carved board from New Guinea, representing the aquatic spirit Kamboragea.

Guinea villages. They are dedicated to the cult of ancestors and of spirits; the important ceremonies at which youths are initiated also take place in them. Women are forbidden to enter. They are constructed with great care by the men; the pillars and beams are often richly carved. Some tribes build the hut on the ground, others on piles. The *tambaran* in the museum has been reconstructed from original pieces from central New Guinea. Over the entrance are five painted human skulls. A large shield-shaped mask and a projecting figure adorn the architrave. At the apex of the roof, a clay figure represents the spirit of the house. Inside the hut, a large statue in painted wood represents the god of war. Next to it is a mythical heron decorated

A wooden carving of an ancestor, from Easter Island.

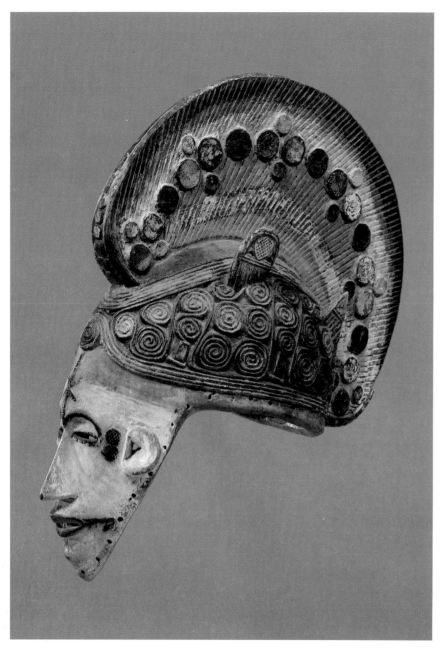

A maiden spirit mask made by the Igbo people of Nigeria.

Australia

The objects from Australia include ten carved and painted tomb poles with totem animals from the Northern Territory and from Melville Island, thirteen paintings on stone representing mythological motifs (the sun, rain, ancestors, and totem animals), and cult instruments including funeral wreaths and shields.

North Africa

A group of Egyptian statuettes illustrates the early influence of the religions of the ancient Near East in North Africa.

Islam, the principal religion, is represented by fragments of colored terracotta vases made in Egypt between the ninth century and the sixteenth; pottery for everyday use with inscriptions in Arabic, from Algeria and Morocco; and a Turkish inscription in Arabic characters, from a fortress in Algeria, invoking the protection of Allah.

Christian objects include Coptic bracelets of the second and third centuries, and terracotta molds for making altar breads, also Coptic and datable between the ninth century and the twelfth. There is also a throne presented by the king of Egypt to Pius XI.

Ethiopia

Coptic cult objects include a processional cross, an iron lectern, a cross-shaped altar stone, a censer, and four ancient Ethiopian icons. There are also ornaments made by the nomadic peoples of the southern Sudan and northern Uganda.

Madagascar

The cult of ancestors is represented by six carved wooden funerary steles from Betsileo; their white color symbolizes death. Two ancestral statuettes represent soldiers killed in Europe in the First World War; a wooden head, also representing an ancestor, was used in magic rites.

West Africa

A group of terracotta statuettes represent deities, ancestors, and priests of the Asante people of Ghana. A number of other statuettes in wood and stone represent deities of the various tribes of West Arica. Abstract wrought-iron representations of ancestors and totem animals are used in ceremonies at the tombs of the dead by the Ewe of Togo.

Ceremonial masks represent the spirits of the dead, deities, and the sacred animals of secret societies.

with feathers. The furnishings include hand drums, wooden horns for signaling, a skull mask with the muzzle of a wild boar, instruments of torture (for initiations), wooden shields, stools and headrests, plumed lances, painted human skulls, masks, and vessels for sacrifices. To the left of the main supporting pole is the hearth on which the sacrifices to the spirits are offered.

Other objects from New Guinea include sculptures of ancestors and spirits from various sites, ritual masks that also represent ancestors or spirits, and a rare and magnificent headdress of multicolored feathers.

Central Africa

Some of the small wooden statues in this collection are extremely crude, while others are most delicately stylized. They are representations of ancestors or guardian spirits, to be venerated with sacrifices and prayers; they are believed to become vindictive if sufficient honor is not paid to them. The mirrors on the bellies of some of the figures seem to be derived from glass-covered reliquaries on statues of saints brought to Africa by the Portuguese in the seventeenth century.

Three crucifixes are also on display. The two small ones are of European origin and were brought by the earliest missionaries in the sixteenth century; the large one was made in Africa and has four small nude figures attached to it. These crucifixes were found in a cave in the lower Congo, and were considered by the natives to be representations of a guardian spirit. Three wooden figures covered with metal, representing ancestors, come from Gabon. There are also ceremonial masks from various parts of Central Africa.

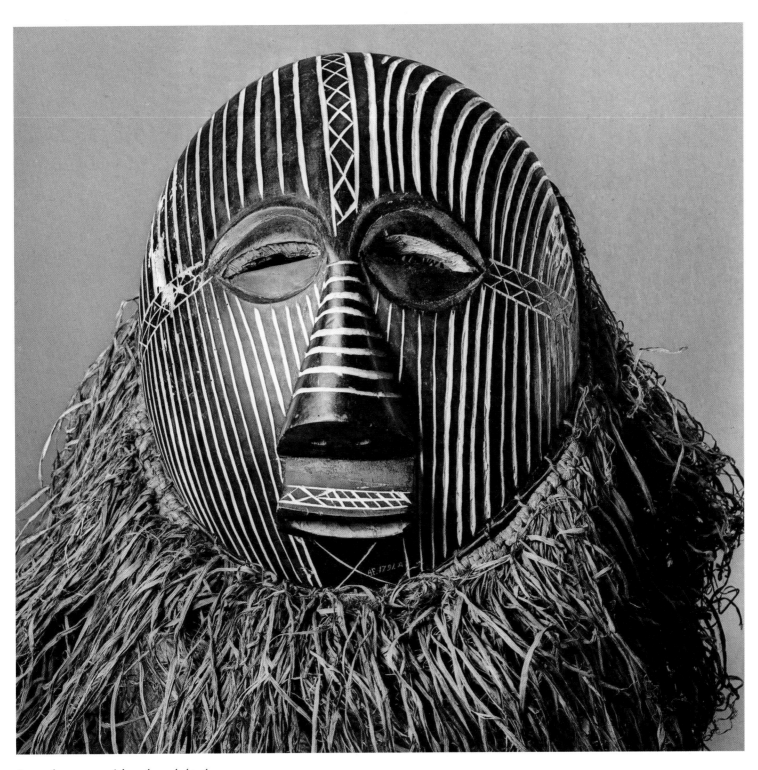

A wooden ceremonial mask made by the Baluba tribe of Zaire.

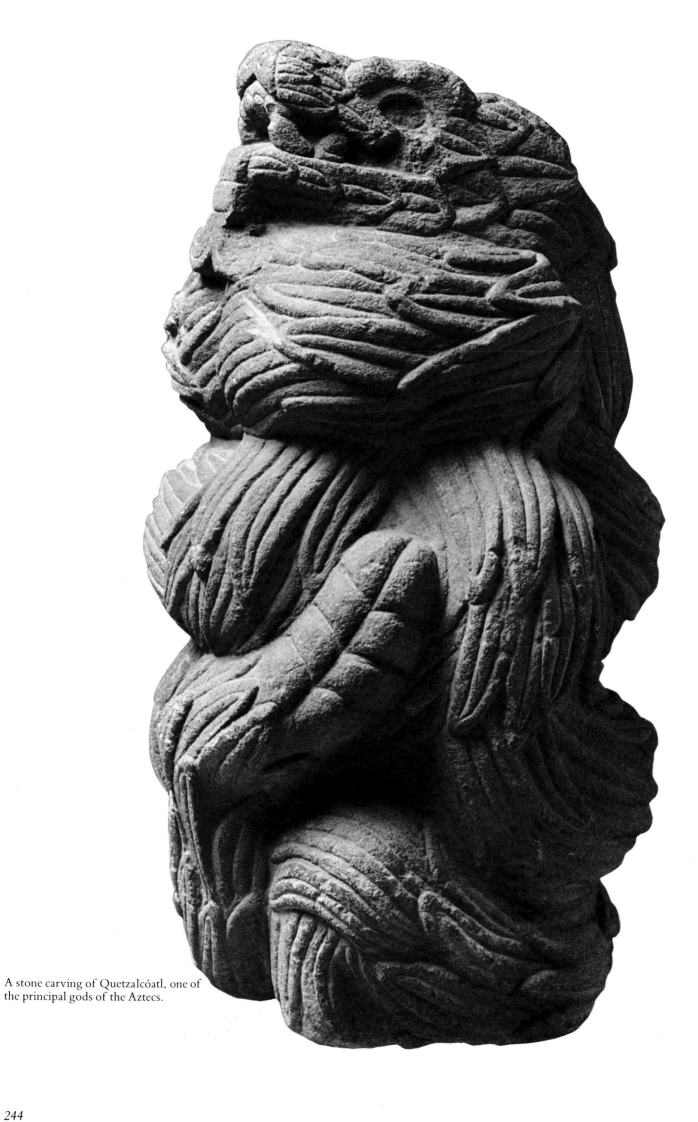

A stone carving of Quetzalcóatl, one of the principal gods of the Aztecs.

East Africa

The small straw hut displayed here was used for ancestor worship. These huts are found in the bush, and in times of calamity propitiatory sacrifices to ancestors are offered in them. There are also small wooden statues representing ancestors, various cult instruments, and a series of horn amulets. The latter are filled with special herbs and other ingredients to which the people attribute magical powers. They are kept for a person's entire lifetime as protection against lightning, enemies, illness, and possible inconveniences resulting from the return of the dead.

Southern Africa

Two reproductions of prehistoric paintings represent magic hunting rites; the originals were discovered in South Africa. Clay statuettes covered with beads represent ancestors worshiped by the women of Lesotho to insure their fertility. Ceremonial masks from Mozambique, amulets, and objects from the trousseau of a Zulu bride are also exhibited.

Christian Africa

Twenty ebony statuettes from Zaire belong to a Christmas crib; the figure of the Infant Jesus is in ivory. The carvings are strongly influenced by European art.

Four groups of brass figures from Nigeria represent a martyrdom scene, the story of the prophet Jonah, the Good Shepherd, and a man in prayer. These groups are evidently free imitations of ancient Roman models; they recall the images of Early Christian sarcophagi and frescoes. But the figures are modeled in a native style. Statuettes of the Madonna from various parts of Africa are all, with the exception of one from Madagascar, mere imitations of European art.

There are also statues of Christ and the saints, carved by the pupils of the Kirando art school in Tanzania, an ivory cross from Zaire, and a very beautiful representation of Adam and Eve from Benin.

South America

The higher pre-Columbian religions of South America are documented by plaster replicas of statues representing the goddess Bachue (from Chibcha, Colombia) and two Inca gods (from Huaraz, Peru), as well as by vases and sculptural fragments from other parts of Peru. Outstanding among the vases is a large funerary urn with painted geometric designs and a human figure, perhaps the deceased, in relief.

Five carved wood objects—two supports, two masks, and a statue—related to primitive cults were found at Santa Marta, Colombia. They were brought to Rome in 1692 and are the most ancient examples in Europe of Colombian wood sculpture. Cult instruments such as flutes, maracas, and ceremonial staffs are also exhibited.

Feather ornaments from Argentina, Brazil, Peru, and Colombia were used for religious ceremonies and dances. There are also ceremonial masks from Tierra del Fuego and Brazil.

A hut used for initiations comes from Tierra del Fuego; it belonged to a tribe that is almost extinct today.

Mexico and Central America

On one Mayan relief from Guatemala is the god of fire, represented as a destroyer, and a man dancing with a skeleton; on another is a seated tribal chieftain. A replica of a relief from Chichén Itzá in Yucatan represents the god of the wind, Quetzalcóatl. A model of the so-called Temple of the Cross in Yucatan is decorated with figures of priests offering sacrifice, mythological personages and animals, skulls, snakes, ornamental motifs, and Mayan hieroglyphs. There is also a copy of a Mayan basin for sacrificial fire, in the form of a monkey with a vase on its back.

Aztec civilization is represented by a very beautiful reddish stone statue of Quetzalcóatl in the classical Aztec style of about 1400. Five stone fragments and copies of statues show the principal Aztec gods: Quetzalcóatl; the god of rain, Tlaloc; the goddess of grain, Chicomecóatl; and the goddess of water, Chalchiuthlicue. The Aztec temple of Xochicalco is reproduced in a model.

Christian Latin America

Objects connected with Christianity in Latin America include sculpture and liturgical articles. A wooden lectern with mother-of-pearl decoration, in the form of a seashell, made by the Carib Indians of Cuba, belonged to Fray Bartolomeo de Las Heras, who was chaplain to Christopher Columbus. A metal bell was used by the first missionaries in Mexico. Two silver cruets were discovered in the ruins of a Christian church in Paraná, Brazil.

North America

Most of the objects exhibited in this section were carved by Ferdinand Pettrich (1798–1872). He was a pupil of the Danish Neoclassical sculptor Bertel Thorvaldsen, on whose advice he went to the United States in 1835. There he prepared the models for the life-sized sculptures that he later executed during his long

stay in Brazil. He eventually donated them to Pius IX.

One bas-relief represents a war dance of the Sauk-Fox and Sioux Indians of the Mississippi; another shows a battle between two hostile tribes, the Winnebagos and the Creeks. These are imaginary scenes, based on stories told by the Indians themselves; the figures, however, are taken from life. Another bas-relief represents an actual historical event: the council held at Washington in 1837, at which the United States government and the chiefs of the Sauk-Foxes and the Sioux discussed the sale of land belonging to the two tribes.

A statue represents the dying Tecumseh, the famous chief of all the Indian tribes of the West; wounded in the Battle of the Thames, in Ontario, in 1813, he propped himself up on his elbow to spur on his warriors. There are also statues of Tahtapesaah ("Raging Hurricane"), a Sioux chief, and of a young hunter, as well as busts of chiefs, counselors, and priests of the Sioux, Sauk-Foxes, Winnebagos, and Creeks.

In addition to Pettrich's work, the North American section includes Eskimo masks from Alaska and masks and sculptures of the Indians of British Columbia.

Iran

Along the walls of this section are thirteenth-century Persian majolicas from the La Farina collection in Palermo. Two star-shaped tiles have verses from the Koran around the edges. A very beautiful square tile depicts the mythological bird, the Simurgh. A picture made of glazed tiles, with scenes of travel, dates from the seventeenth or eighteenth century. On a large arch is a hunting scene in colored majolica, with fourteen human figures.

Near East

Among the objects produced by the ancient cultures of the Near East are a necklace made of seals representing Oriental deities, a clay tablet with cuneiform writing from about 2000 B.C., and stone fragments with Hittite hieroglyphics from about 1400 B.C. Later works show Greco-Roman influence: reliefs, statuettes, vases, lamps, and crystal bottles.

The religions of the Near East today are also documented. Jewish objects include a Torah scroll of about 1400 in a seventeenth-century wooden case; an early nineteenth-century Hanukkah candlestick from a synagogue; and two Megillahs (scrolls of the Book of Esther)—one of these, in a silver-gilt case, was a wedding gift for a bride.

From the Christian communities of the Near East we have small icons, silver crucifixes, and a representation in mother-of-pearl of the Last Supper and the

Resurrection, as well as a reproduction of a mosaic with a map of the Holy Land—the original map is in the ruins of a Christian church at Madaba.

Islam, the predominant religion in the Near East, is represented by vessels and objects of daily use.

Christian Art of Missionary Lands

This collection includes an extremely beautiful altar of carved and gilded wood, made in Japan, a lacquered and gilded tabernacle from Vietnam, and enameled altar furnishings from China.

Among the paintings is a very beautiful seventeenth-century Vietnamese representation of the Last Judgment. The anonymous artist, using both European and Buddhist elements, has painted a realistic vision of the end of the world, of hell-purgatory (a typically Buddhist concept of hell), and of heaven.

A painting of the Last Supper in Chinese ink on white silk is by the artist Wang Su Ta, who also painted the two panels representing the Virgin. Another picture, by Luke Hasegawa, shows the bringing of Christianity to Japan, the arrival of Saint Francis Xavier, the martyrs of Nagasaki, and the Blessed Virgin as Queen of Japan.

Models of churches illustrate Christian architecture in the Orient. Among them is the model of a pagoda erected in honor of a seventeenth-century Jesuit, Father Faber, who because of his work was accepted into the Chinese pantheon as the venerable Fang, a tutelary god.

JOZEF PENKOWSKI

The North American gallery of the Museo Missionario Etnologico. At the right is a relief by Ferdinand Pettrich, showing the meeting of the Sauk-Fox and Sioux with representatives of the United States government in Washington in 1837.

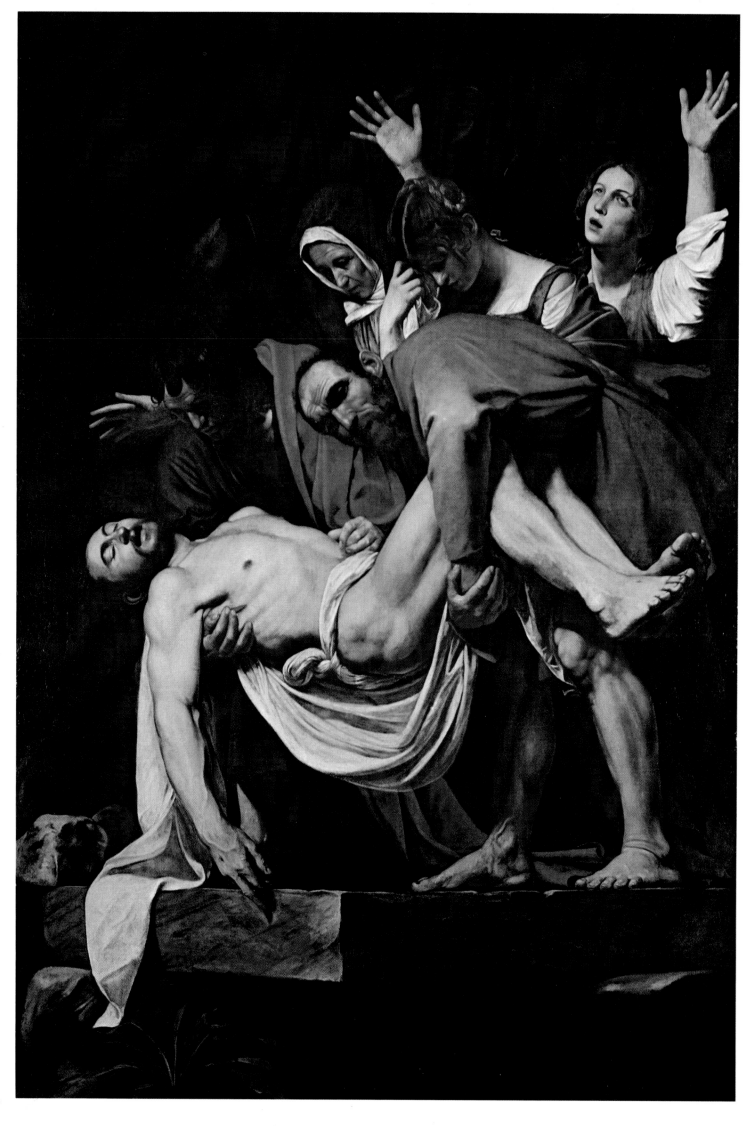

The Pinacoteca Vaticana

Pius VI was the first pope to gather in one place the paintings that his predecessors had collected over the centuries; for this purpose he transformed into a vaulted gallery an open loggia that connected the Galleria delle Carte Geografiche with the Galleria dei Candelabri. But the Pinacoteca, or Picture Gallery, had its real origin at the Congress of Vienna in 1815, when it was decided that the works of art carried off from Italy to France after the Treaty of Tolentino in 1797 should be returned. The congress urged that these works not be restored to their original owners, but rather that they be exhibited in a public place, where they might be studied and enjoyed by all.

France did not at first respect the decision of the congress. It was only through the subtle diplomacy of Cardinal Ercole Consalvi and, later, through the intervention of the pontifical commissioners Antonio Canova and Gaetano Marini that the most important works of art were eventually recovered. Pius VII, on the other hand, scrupulously carried out the congress's recommendation. He installed the paintings in the newly restored Appartamento Borgia and opened it to the public; thus the Pinacoteca came into being. Over the years the collection was housed in various parts of the Vatican Palace until finally a special building, the present-day Pinacoteca, was constructed for it in 1932. In recent years the contents of the gallery have been rearranged so as to demonstrate the historical development of the various regional schools.

The earliest work in the Pinacoteca is a relatively recent acquisition, the unique *Last Judgment* signed "Nicolaus et Johannes pictores" (Niccolò and Giovanni, painters) and commissioned, according to the inscription, by two nuns, "Domina Benedicta ancilla Dei et Constantia Abatissa" (the Lady Benedetta, handmaid of God, and the Abbess Costanza). Until the seventeenth century it was in the Benedictine monastery of Santa Maria in Campo Marzio in Rome. Judged to be of little artistic worth, it was donated to the Pinacoteca as study material; its true importance was revealed when a cleaning brought to light the inscription with the names of the artists and the donors, the original colors, and stylistic features that relate it to the frescoes —by the same painters—in the Benedictine basilica at Castel Sant'Elia and those in the church of Santi Abbondio e Abbondanzio at Rignano Flaminio. The *Last Judgment* may be attributed to the Benedictine school of the late eleventh century; though some scholars have preferred to date it to the twelfth or even to the thirteenth century, recent studies have assigned it

to the decade 1061–71. The form of the panel is unusual: it is circular, divided into horizontal zones, with an oblong predella at the bottom. Above, Christ is shown in majesty, within a nimbus; he appears again below, standing at an altar upon which are the instruments of the Passion, and flanked by angels and by the twelve apostles. In the lower zones are groups of saints, the resurrection of the dead, and, in the right half of the predella, hell. In the left half, the two donors are about to be received into the presence of the Madonna.

A *Christ Giving His Blessing* is typical of the Roman school of the twelfth century; Byzantine formulas are being superseded by a new striving toward volume and monumentality. From the same school, and from the first decades of the same century, are fragments of frescoes from San Nicola in Carcere, which were detached and mounted on canvas when the church was restored in 1855. The roundels with busts, such as the *Moses*, show Byzantine influence, but they also reveal a renewed interest in Roman art of the first centuries of the Christian era.

An important series of "primitives"—paintings of the various Italian schools that originated before the time of Giotto, all offshoots of Byzantine art but distinguishable by their regional characteristics— formerly belonged to the Museo Sacro of the Apostolic Library; some of them were transferred to the Pinacoteca in 1909, and the rest in 1932.

A *Saint Francis of Assisi* by the thirteenth-century master Margaritone d'Arezzo is of considerable interest as a document of the actual appearance of the saint, who died in 1226 and is still shown here without a halo. In this and similar panels (in the Pinacoteca of Arezzo, the Museo Civico of Montepulciano, and the churches of San Francesco at Castiglion Fiorentino and San Francesco a Ripa in Rome) the Byzantine manner, evident in the stylized drawing and lighting, is tempered by a spirit of realism peculiar to the Western world. Two painted crucifixes of the "suffering Christ" type are also of Byzantine derivation. Especially in the one attributed to the Pisan school of the fourteenth century, the combination of abstract coloring with clear indications of physical pain in the modeling of the anatomy results in a kind of expressionistic pathos. A *Madonna and Child with Saints Onuphrius, Nicholas of Bari, Bartholomew, and John the Baptist*, signed by Giovanni Bonsi and dated 1371, is close to the Sienese manner. Giovanni del Biondo's fourteenth-century *Madonna and Child with Saints* is resplendent

The *Entombment of Christ,* by
Michelangelo Merisi da Caravaggio, 1604.

The *Last Judgment*, signed by the eleventh-century
painters Niccolò and Giovanni.

Moses, twelfth-century fresco fragment from
the church of San Nicola in Carcere.

with gold, whereas Niccolò di Pietro Gerini (1368–1415) achieves a soberer kind of magnificence in his *Holy Trinity with Four Saints*. Allegretto Nuzi of Fabriano (1315–85), in his *Madonna and Child with Saints* of 1365, simplifies and translates into decorative terms the formal language of the Sienese painters, while in the *Madonna Nursing the Child* by his contemporary Francescuccio Ghissi that language is rendered subtly poetic in the graceful figure of the Virgin, wrapped in precious brocades and defined by a line that is at once flowing and firm.

The overpowering personality of Giotto (1267–1337) makes itself felt in the triptych commissioned by Cardinal Jacopo Caetani Stefaneschi, who is twice represented as a donor. The Stefaneschi Triptych was formerly in the chapter hall of Saint Peter's, and is traditionally said to have been painted for the altar in the Confessio of Old Saint Peter's, though doubt has been cast on this assertion. Scholars do not attribute the triptych to Giotto in its entirety, but it is generally agreed that he had a large part in its execution. On the front, in the central panel, is Saint Peter enthroned, while the side panels represent the apostles James and Paul and the evangelists Mark and John; the back has Christ enthroned in the center and the crucifixion of Peter and the beheading of Paul on the sides. The side panels and the predella are largely the work of assistants; there is little agreement as to their identity, though it seems certain that dominant among them was the Maestro delle Vele, who was active in the lower church at Assisi and whose personal style is recognizable in the elongation of some of the figures and in a typically Umbrian taste for decoration. The dates proposed by scholars for the triptych range from 1313 to 1330. The parts attributed to Giotto have the characteristics of his mature work: the influence of Rome has been assimilated; his pursuit of monumentality continues, but his forms have become less harsh, and chiaroscuro and color now blend with a softness that in no way detracts from the strength of the modeling and the vitality of the image.

The innovative force of Giotto's style influenced a large number of artists, especially Tuscans, of the fourteenth and fifteenth centuries. In his *Madonna of the Magnificat*, the Florentine Bernardo Daddi (ca. 1290–1348) gives to Giotto's world an interpretation of his own, in which line and color play an important part. Giotto's influence is also seen in the work of Simone Martini (1284–1344), who was a pupil of Duccio di Buoninsegna, the great founder of the Sienese school who combined the "Greek manner" with Gothic elegance. In Simone's solemn *Redeemer Blessing*, old Byzantine formulas are given new life, thanks to a greater solidity in the representation of the figure and an original sensitivity to color values.

Saint Francis of Assisi, by Margaritone d'Arezzo, about 1270–80.

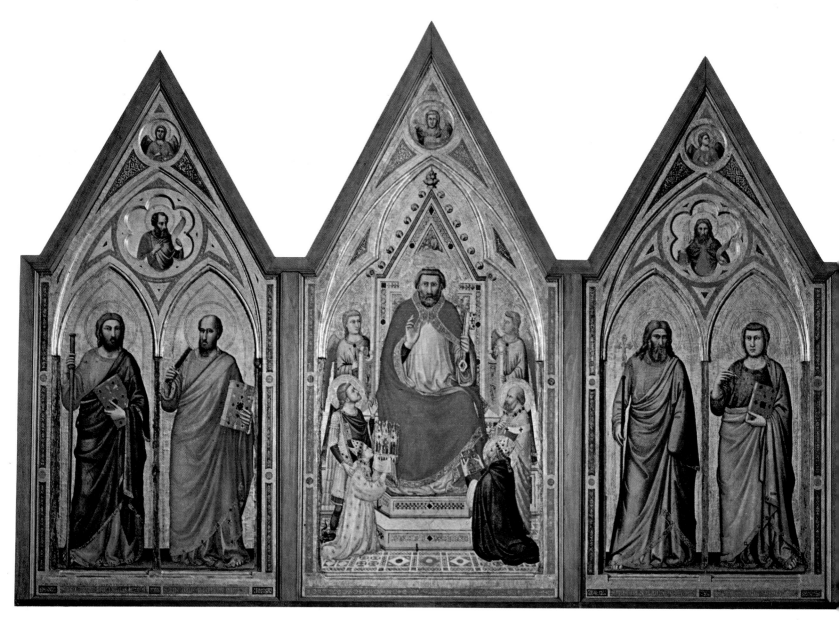

The Stefaneschi Triptych: *Saint Peter Enthroned with
Saints and Angels,* by Giotto and assistants, about 1320.

The brothers Pietro and Ambrogio Lorenzetti were also Sienese. Pietro (active 1306–1344) was trained in Duccio's style, and also assimilated Giotto's influence early in his career. His own highly personal intensity of feeling, however, led him to interpret the world more dramatically than either of those masters. Pietro is the author of two paintings in the Pinacoteca, a *Saint John the Baptist* and a *Christ Before Pilate.* A panel with scenes from the legend of Saint Stephen is attributed by some historians to Ambrogio Lorenzetti (active 1319–48) because of the way in which color is used to enhance the modeling—Ambrogio was also deeply indebted to both Duccio and Giotto. According to others, however, the panel should be ascribed to Bernardo Daddi.

The painters of fourteenth-century Emilia and Romagna evolved their own interpretation of Giotto's style, characterized by a great vivacity of form and color and represented in this collection by the *Crucifixion* attributed to Giuliano da Rimini or to an anonymous follower of Giotto, and by a series of panels from a polyptych by Giovanni Baronzio. To these works we may compare the *Madonna and Child* by Vitale degli Equi (active ca. 1330–60), otherwise known as Vitale da Bologna. Vitale's stylistic formation was both Emilian and Tuscan. In this panel, the colors have lost their Bolognese vividness and, probably under Sienese influence, have become quieter; also Sienese are the controlled modulation of the line and the soft, delicate chiaroscuro. In two small panels by Antonio Veneziano, a *Saint James* and a *Mary Magdalene,* the figures are given soft, three-dimensional form through

Christ before Pilate, by Pietro
Lorenzetti, about 1335.

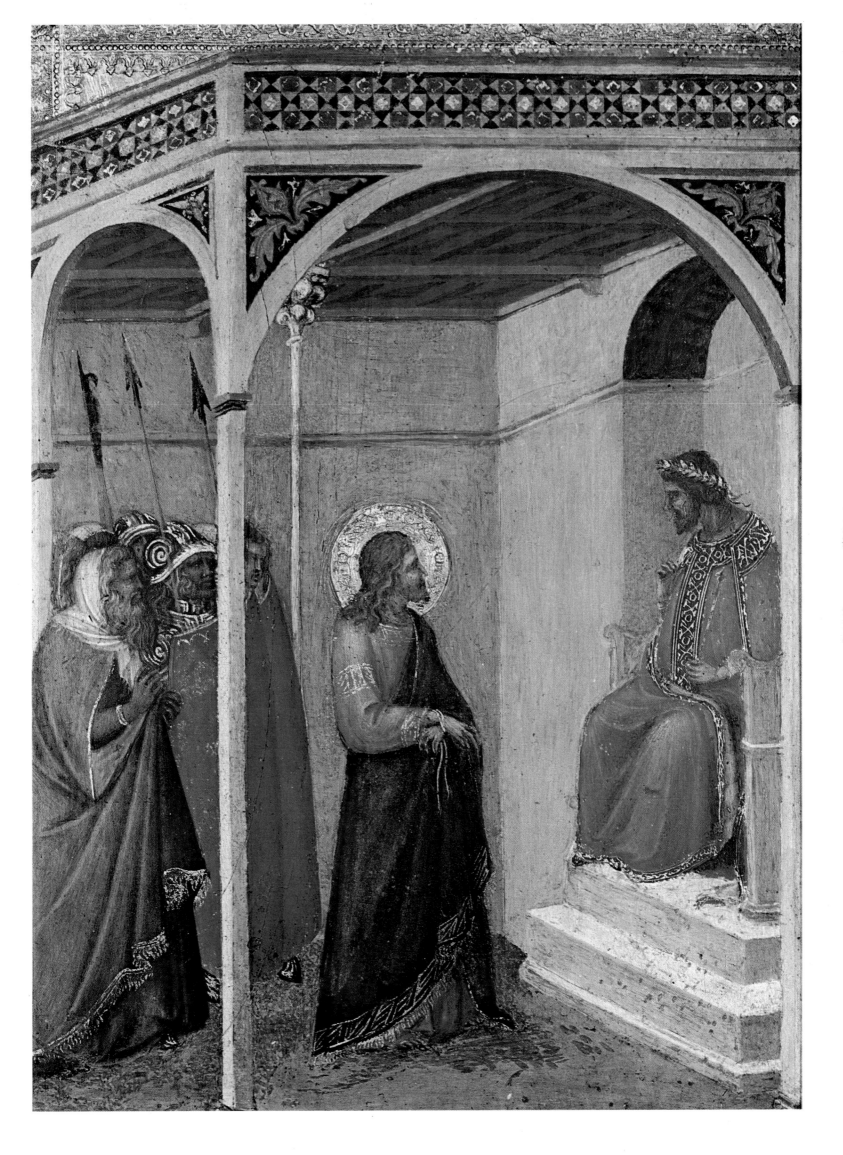

the play of light and color; thus they manifest the Venetian origin of this painter of the second half of the fourteenth century.

Sienese masters of later generations continued the line of development that began with Duccio and Simone Martini. Lorenzo Monaco (1370–1425) was a Camaldolese monk who, though he settled in Florence early on, never forgot his Sienese origins. In his paintings in the Pinacoteca, an *Ascension of Christ* and two panels representing miracles of Saint Benedict, we may observe a synthesis of sinuous line and brilliant color—Sienese qualities—on the one hand and a Florentine solidity of form on the other. The *Vision of Saint Thomas Aquinas* by Stefano di Giovanni (1392–1450), known as Sassetta, was originally part of an altarpiece painted about 1425 for the wool merchants'

guild in Florence. The panel is essential to an understanding of the development of this artist who, though he adhered to the old Sienese tradition, was also affected by the elegant International Gothic manner as well as by Florentine innovations, particularly in the study of perspective. The saint is shown within an architectural framework; as he prays before a crucifix, he hears the voice of Christ saying, "Thou hast written well of me, Thomas." But there is no attempt to present the vision naturalistically; the silence and emptiness of the rooms provide the setting for the mystical encounter of Thomas with Christ.

Sano di Pietro (1406–81) was probably a pupil, and certainly an enthusiastic collaborator, of Sassetta's; in such paintings as the *Presentation in the Temple* and the *Marriage of the Virgin*, he translated the master's

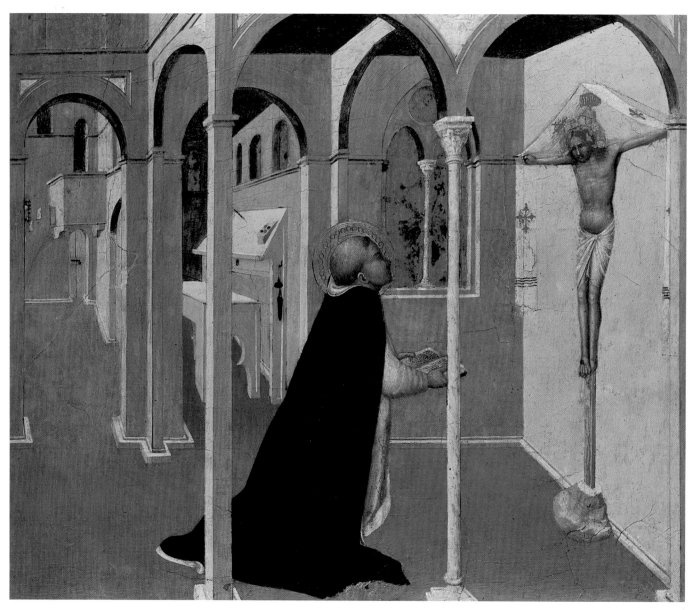

The Vision of Saint Thomas Aquinas,
by Sassetta, about 1425.

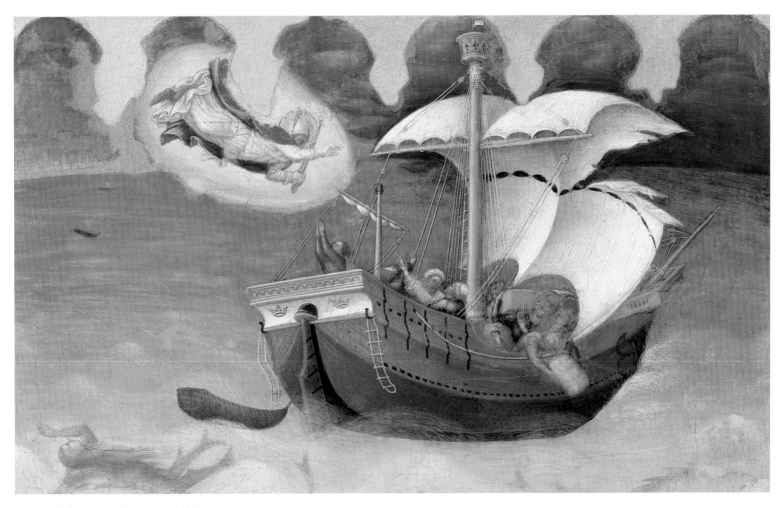

Saint Nicholas Saves a Storm-tossed Ship,
by Gentile da Fabriano, 1425.

style into less refined, more accessible terms. Giovanni di Paolo (1400–1482) created fanciful images of rare beauty, using an undulating, incisive, almost feverish line and somewhat acid colors. In his highly personal idiom, various influences blend and seem almost to cancel each other out. His *Annunciation*, dated 1444, was painted as a cover for an account book in the Ufficio di Biccherna, the public treasury of Siena. (Small panels, known as *biccherne*, were in fact painted regularly for this purpose from the thirteenth until the eighteenth century; they constitute a precious anthology of Sienese art.)

A predella by Gentile da Fabriano (1360–1427) with scenes from the legend of Saint Nicholas is from a polyptych painted in 1425 and now dispersed. Gentile's is a fairy-tale world that also includes naturalistic details. In one of the panels, a shipwreck scene, the dramatic event is transformed into a fable, thanks above all to the color. The sea seems to merge with the sky, abolishing perspective; the saint appears in a glowing nimbus; in the water, a mermaid is seen swimming away from the ship.

The *Crucifixion* by Masolino da Panicale (1393?–1447?), together with a predella panel, the *Death of the Virgin*, was part of a polyptych painted, beginning in 1425, for the basilica of Santa Maria Maggiore. Though the composition is still based on Gothic formulas, Masolino's use of broad, simple forms to achieve monumentality recalls the innovations of his younger contemporary Masaccio.

Outstanding among the artists active in the first half of the fifteenth century is Fra Angelico (1387–1455). The *Virgin and Child Between Saints Dominic and Catherine* expresses the idea of the Virgin's mystical purity through the subtle use of color and design. Yet it does not ignore contemporary developments; perspective is used with precision to create a three-dimensional composition. The painting is one of Angelico's most characteristic works. Two scenes from the legend of Saint Nicholas (parts of the predella of a polyptych painted in 1437 for the church of San Domenico in Perugia, now in the Galleria Nazionale of that city together with the third panel of the predella) belong to a more mature period. Here Angelico

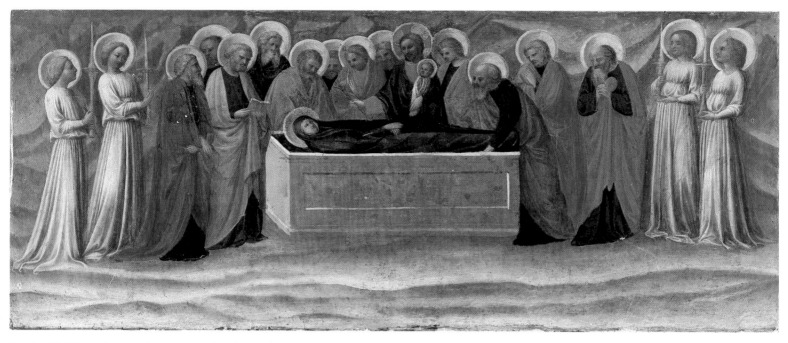

Death of the Virgin, by Masolino da Panicale, about 1425.

The Meeting of Saint Nicholas with the Emperor's Messenger
and the Miraculous Rescue of a Ship, by Fra Angelico, 1437.

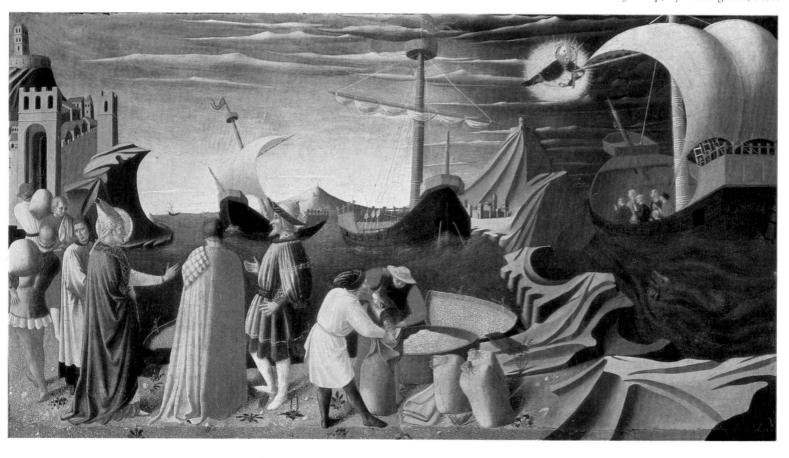

is more concerned with the three-dimensional modeling of the figures and of the bizarrely shaped rocks. The range of colors is also unusual, and the sharp contrasts are very different from the subtle, delicate harmonies of most of his works, even the later ones such as the frescoes in the Chapel of Nicholas V in the Vatican Palace.

Benozzo Gozzoli (1420–97) was one of Fra Angelico's most gifted pupils and collaborators, and a popularizer of the master's style. The fresh, spirited approach to narrative that characterizes his most famous fresco, the *Journey of the Magi* in the chapel of the Medici Palace in Florence, is evident here in his *Madonna della Cintola*; in the predella, with scenes from the life of the Virgin, elegant little figures move gracefully against a background of bright buildings and luminous landscapes. Equally pleasing in its color harmonies and in the suave vitality of its images, though it expresses no great depth of feeling, is the *Corona-*

tion of the Virgin by Fra Filippo Lippi (1406–1469). It was commissioned by Carlo Marsuppini, the chancellor of Florence, for the chapel of San Bernardo in Arezzo; the donor is portrayed kneeling, in the right-hand panel.

One room of the Pinacoteca is dedicated almost entirely to paintings by Melozzo da Forlì (1438–94). A large fresco, detached from the wall of the original Vatican Library and transferred to canvas in the early nineteenth century, represents Sixtus IV appointing the humanist Bartolomeo Platina prefect of the Vatican Library on July 15, 1475. The painting is remarkable for the profound psychological insight with which the artist portrays the two protagonists and the pope's four nephews, including Cardinal Giuliano della Rovere, the future Julius II. The crystalline light recalls the work of Piero della Francesca and the school of Urbino, where Melozzo had his early training; the intensity and depth of the colors, unusual in fresco, can be traced

The fourth room of the Pinacoteca, with paintings by Melozzo da Forlì and Marco Palmezzano.

to Flemish painters working in Italy, whose methods Melozzo adopted. The same room contains fourteen fragments of a grandiose fresco by Melozzo, the *Ascension of Christ*, which was formerly in the apse of the Roman church of Santi Apostoli. The apse was demolished in 1702, but parts of the fresco were detached and preserved. The central image of Christ in Glory is now in the Quirinal Palace; the Vatican fragments, which until 1931 were kept in the sacristy of Saint Peter's, represent apostles and music-making angels. Influenced by the experiments of Andrea Mantegna, Melozzo adopted an audacious viewpoint: Christ and the apostles were seen from below, boldly foreshortened; the angels soared above, with a joyous fullness of life. A watercolor reconstruction of the fresco, by Biagio Biagetti, has been placed in the gallery, but it is only by an effort of the imagination that we can conceive of the dynamic effect of the original composition. Marco Palmezzano (1456–1517), who assisted Melozzo in frescoes in the basilica at Loreto, is represented by a *Virgin and Saints*, in which Venetian and Ferrarese influences are apparent.

The predella panel representing the miracles of Saint Vincent Ferrer, by Francesco del Cossa (1435–77), was part of a triptych painted between 1470 and 1475 for the chapel of the Grifoni family in the cathedral of San Petronio in Bologna. The eccentric combination of architectural and natural elements in the landscape, the enamel-like colors, the flowing line, the sculptural modeling, and the convulsive, exaggerated energy of the figures are typical features of the Ferrarese school; they are given a personal interpretation, however, in which some scholars have seen the hand of Cossa's pupil Ercole de' Roberti (ca. 1456–96).

The Venetian painters of the fifteenth century are well represented by the Pinacoteca. The elegant *Madonna and Child* by Carlo Crivelli (1430–93), signed and dated 1482, is characterized by a wonderful harmony of color and design. The *Pietà* by the same painter, datable to about 1490, must have been the crowning element of a lost altarpiece. Crivelli seems to have painted it at a time when he was under the influence of the Umbrian school and especially of Niccolò Alunno. Despite its display of violent emotion, the picture lacks true pathos; it fails to convince or to move us. Archival research has established that the *Madonna and Child with Saints* formerly attributed to Carlo Crivelli was in fact painted by Vittore Crivelli (1440–1502), who may have been his brother and who imitated his style. Antonio Vivarini (1418–91) was the head of the so-called Murano school, which had its center on the island of that name in the Venetian lagoon. In 1469, in collaboration with his brother Bartolomeo (1430–90), he painted the *Saint Anthony Abbot and Eight Saints*. With its richly gilded frame,

this polyptych is an indication of Vivarini's International Gothic taste, inspired by the works of Gentile da Fabriano, Masolino, and Jacobello del Fiore. Niccolò Alunno (1430–1502), an Umbrian painter from Foligno, was also attracted to the International Gothic tradition, in which the ornamental frames of polyptychs have an aesthetic importance of their own, independent of the representational panels. His polyptych with the Coronation of the Virgin and twelve saints is an elaborate construction in which the influence of Vivarini is noticeable in the figure style.

The art of fifteenth-century Venice reached its zenith in the work of Giovanni Bellini (1430–1516). His *Pietà* in the Pinacoteca was part of a large altarpiece painted for the church of San Francesco in Pesaro and now in the Pinacoteca of that city. Generally dated to about 1473, the painting marks a major turning point in Bellini's artistic development. He was already a colorist, by temperament and training; now, exposure to the work of Piero della Francesca led him to a new understanding of the role of light and color in creating atmospheric perspective. This discovery foreshadowed the triumph of tonalism in the art of the sixteenth-century Venetians Giorgione and Titian. Bellini's feeling for color is less evident here than in the central panel of the original altarpiece, the *Coronation of the Virgin*; in the *Pietà* the modeling and the drapery have a statuelike hardness that points to the influence of his brother-in-law, Andrea Mantegna. Nevertheless, the warm browns and ambers harmonize softly in an atmospheric tonal scheme. The diagonal axis of the composition, moreover, reflects a new tendency toward the representation of a space that is not limited by the physical dimensions of the picture.

The greatest masters of the Umbrian school were Pietro Vannucci (1445–1523), known as Perugino, and Bernardino di Betto (1454–1513), known as Pinturicchio. Perugino's *Madonna and Child with Saints* is an altarpiece executed in 1495 for the Palazzo dei Priori in Perugia. The perfect balance of all the elements in the composition fills the painting with a delightful serenity. Feeling has not yet degenerated into sentimentalism; the grace of the figures is unaffected; the deep, luminous landscape is suffused with a mystical sweetness that it shares with the figures. These qualities, characteristic of Perugino's best work, also appear in his *Saint Placidus*, *Saint Flavia*, and *Saint Benedict*, predella panels from an altarpiece now in the Louvre. They also date from about 1495. Despite a certain sentimentality in the facial expressions, Perugino's fine painterly treatment saves these figures from the conventional pietism that mars much of his later work. In the *Coronation of the Virgin* by Perugino's best pupil, Pinturicchio, the rich colors and lively details recall the frescoes of the Appartamento Borgia in the Vati-

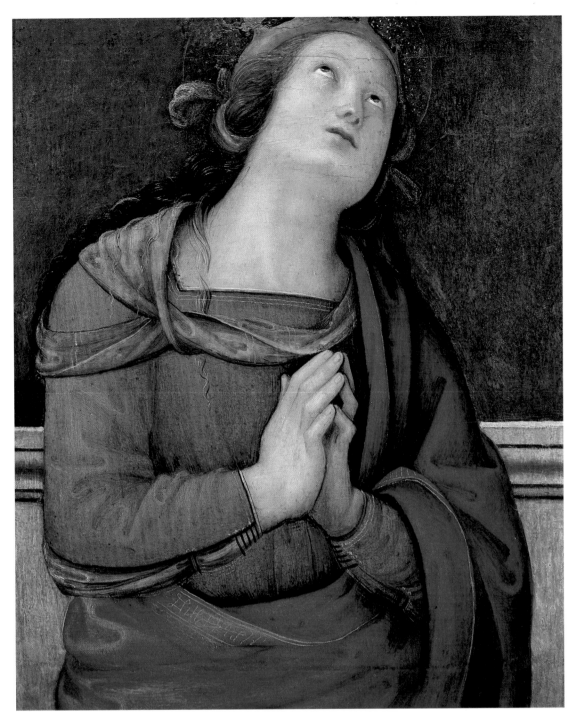

Saint Flavia, by Perugino, about 1495.

can Palace. According to some scholars the hand of an assistant, Giovan Battista Caporali, may be detected in the heads of some of the saints. Other Umbrian paintings include a *Madonna and Child* by Andrea d'Assisi, known as L'Ingegno; a *Madonna and Child* by Tiberio d'Assisi, where the influence of Pinturicchio is apparent; and a *Nativity* by Giovanni di Pietro (1450–1528), known as Lo Spagna. The works of these artists are dignified and pleasing, though superficial and lacking in true feeling. A *Saint Jerome Enthroned,* painted in tempera on canvas, is the unpretentious work of a provincial artist, Giovanni Santi (1435–94), who is best known as the father of Raphael.

One of the principal glories of the Pinacoteca is the *Saint Jerome* by Leonardo da Vinci (1452–1519). In the eighteenth century it was owned by the painter Angelica Kauffmann, and later lost sight of; at the beginning of the nineteenth century it was rediscovered by Cardinal Fesch—minus the head. The cardinal, however, had the good fortune to find the missing part in a cobbler's shop. He was then able to have the painting pieced together and restored. It entered the Vatican collection during the time of Pius IX.

Only the monochrome underpainting of the *Saint Jerome* was completed by Leonardo, who probably abandoned the panel when he moved from Florence

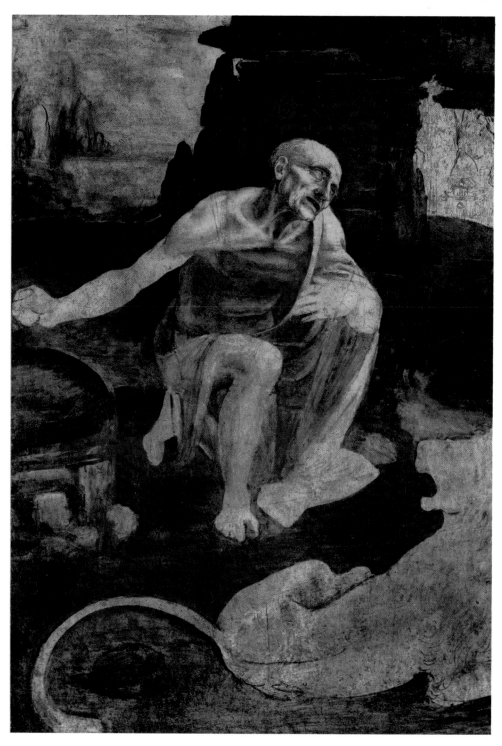

Saint Jerome, by Leonardo da Vinci, about 1482.

to Milan in 1482 at the invitation of Lodovico il Moro. It is all the more interesting for its unfinished state, which does not detract from, but rather accentuates, its aesthetic significance. The overall olive-brown tone is in perfect accord with the acrid spirituality of the hermit saint. His gaunt body and ascetic, tormented face, bathed in light, stand out against a dark rock in the center of the painting. Other jagged, realistically delineated rocks, immersed in the atmosphere, testify

no less than the representation of Jerome's anatomy to Leonardo's well-known desire to penetrate the secrets of nature.

An entire room, the largest in the Pinacoteca, is dedicated to Raphael (1483–1520); in the works exhibited here we can follow the entire course of his artistic career. The *Coronation of the Virgin* is dated 1503; it was commissioned by Maddalena degli Oddi of Perugia from the twenty-year-old artist, who was

Coronation of the Virgin, by Raphael, 1503.

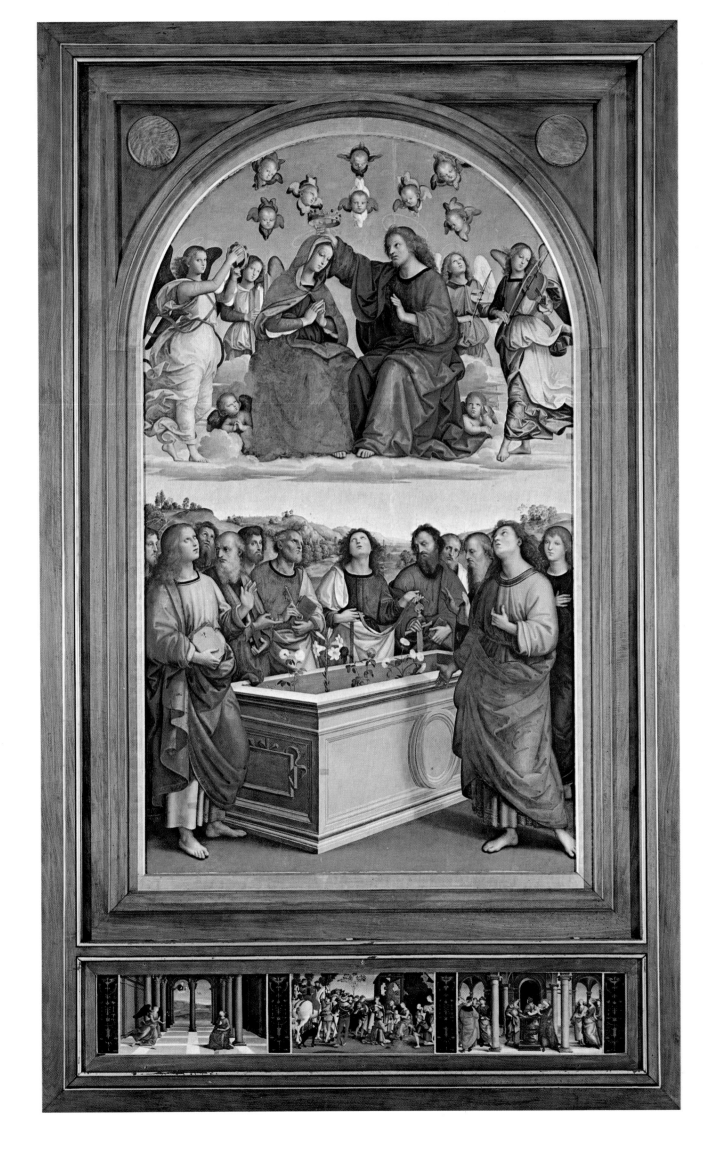

261

Faith, Charity, and *Hope,* by Raphael, 1507.

then still a pupil of Perugino's. The closeness with which Raphael followed his master's example can be seen in the composition, divided strictly into an upper and a lower zone, in the stylized and decorative drapery, and in the iridescent colors. Raphael differs from Perugino, however, in the greater liveliness and spirituality of his poetic imagination. The difference is also noticeable in the predella panels, an *Annunciation,* an *Adoration of the Magi,* and a *Presentation in the Temple.* Here Perugino's style is given new grace and intensity of feeling; the panels are dominated by rich, atmospheric color.

Three other panels with figures of Faith, Hope, and Charity, each in a roundel flanked by cherubs, originally formed the predella of the *Deposition* now in the Borghese Gallery. This altarpiece was painted for Atalanta Baglioni of Perugia in 1507, at a time when Raphael was strongly influenced by Michelangelo. The three groups, painted in monochrome, have a starkly sculptural quality.

The *Madonna of Foligno* was painted in 1511 or 1512 for the church of the Aracoeli in Rome; it was commissioned as an *ex voto* by the privy chamberlain of Julius II, Sigismondo de' Conti (who is portrayed in a red cloak, kneeling at the right), after a bomb or a thunderbolt struck his house at Foligno but caused no damage. The foreground figures—three saints, Sigismondo, and a putto bearing a tablet—are shown against a beautiful landscape in which the miraculous event is represented. The landscape is reminiscent of Giorgione in its colors and its flickering light, and some scholars have suggested that Dosso Dossi, a Ferrarese painter who imitated these aspects of Giorgione's style, may have collaborated on it with Raphael. During a recent restoration a heavy coat of varnish, which had been applied in Paris in 1797 and which had given the painting a uniform amber tone, was removed; cool, silvery colors, hitherto unsuspected, were revealed among the warmer ones. The painting is therefore in need of critical reexamination. In any case, the *Madonna of Foligno* remains one of the most representative works of that period in Raphael's career—the period of the Stanza d'Eliodoro in the Vatican Palace—when the artist freed himself a second time from the influence of Michelangelo and turned his attention to the more painterly manner of the Venetians.

Both the *Coronation* and the *Madonna of Foligno* were transferred to canvas when they were taken to Paris in 1797. The original wooden panel of Raphael's *Transfiguration,* however, has been preserved, and the necessity of repairing this panel led recently to a restoration that not only brought the colors back to their pristine splendor but also revealed that a few details of the composition had been left unfinished. This discovery, it has now been suggested, disproves the

The Transfiguration, by Raphael, commissioned in 1517.

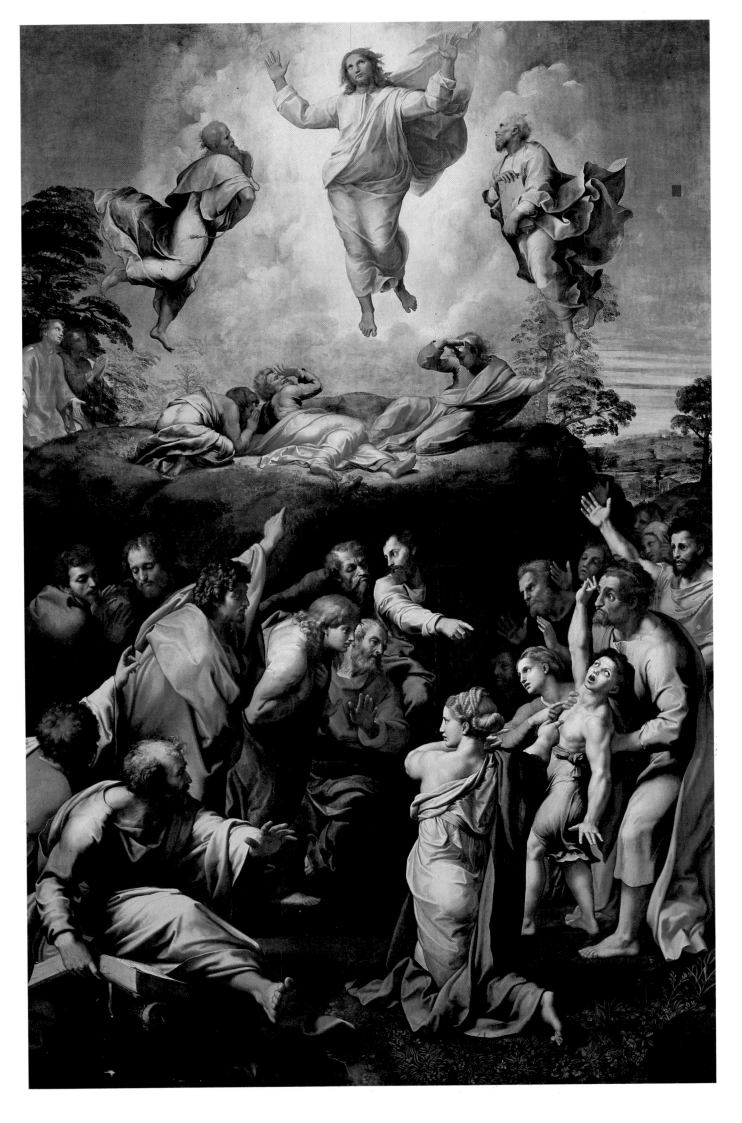

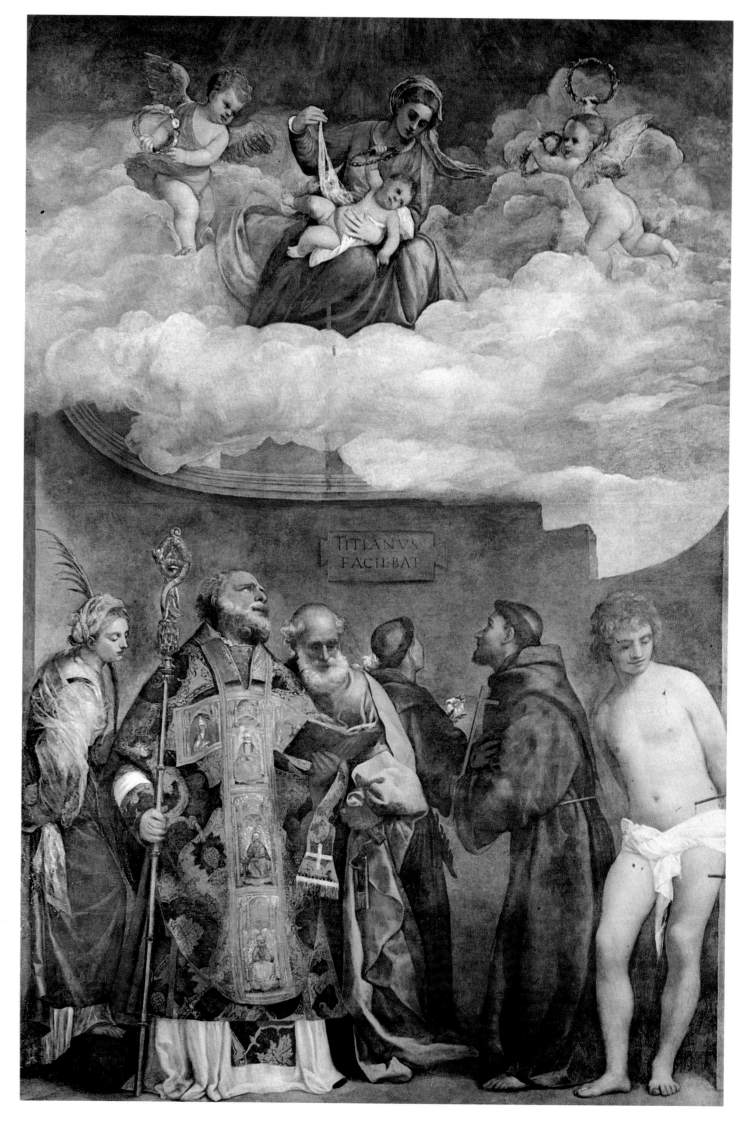

TITIANVS
FACIEBAT

264

time-honored theory according to which Raphael's pupils, Giulio Romano first among them, completed the painting after the master's sudden death in 1520. The problem remains open to discussion, but the restoration has certainly established that Raphael's share in the execution was more extensive than had previously been supposed. The *Transfiguration* was commissioned by Cardinal Giulio de' Medici in 1517 for the cathedral of Narbonne in France, but it was placed instead in the Roman church of San Pietro in Montorio; carried off to Paris in 1797, it was returned to the Vatican after the Congress of Vienna. It represents—as the restoration has confirmed—the last stage in Raphael's development toward a grandiose, fully sixteenth-century style, in which color of an almost Titianesque intensity plays an ever more important role. Here, color is gradually dissolved in the light of the landscape and the sky, reaching the acme of spirituality in the figure of Christ.

The Pinacoteca houses the ten tapestries of the so-called Scuola Vecchia, which were woven from cartoons that Raphael, with the aid of his pupils, designed and painted in 1516. Together with the second group, those of the Scuola Nuova (for which Raphael himself provided only a few sketches), the tapestries were commissioned by Leo X to decorate the lower walls of the Sistine Chapel. They were woven in Brussels, in the manufactory of Pieter van Aelst, and seven of them were ready to be hung in the chapel by Saint Stephen's Day, 1519. After the death of Leo in 1521 the tapestries were pawned for five thousand ducats, and during the Sack of Rome in 1527 they were seized and sold by German soldiers. In 1545 some of them were returned to the Vatican, but others found their way to Constantinople; these were redeemed by the duc de Montmorency, and restored to Julius III in 1554. The tapestries were again carried off in 1797, this time to France; they were returned to the Vatican in 1808. In 1932 they were installed in the Pinacoteca. The subjects of the tapestries are the Miraculous Draught of Fishes, Christ Giving the Keys to Peter, Peter Healing the Cripple, the Death of Ananias, the Stoning of Stephen, the Conversion of Saul, the Blinding of Elymas, Paul at Lystra, Paul in Prison, and Paul Preaching at Athens. Raphael's direct participation is most evident in the *Miraculous Draught of Fishes*, especially in the placid landscape reflected in the limpid waters of the Sea of Galilee. The lower border, woven after a drawing by Giovanni da Udine, shows the cortege of Cardinal Giovanni de' Medici traveling to Rome for the conclave from which he emerged as Pope Leo X.

Raphael is said to have completed the *Saint Paul* begun by the Florentine painter Fra Bartolomeo della Porta (1475–1517); it and its companion piece, the *Saint Peter* (which is wholly by Fra Bartolomeo), were in-tended for the tomb of Leo X's jester, Mariano Fetti. The *Madonna of Monteluce* was commissioned from Raphael as early as 1505 for the convent of Monteluce near Perugia, but Raphael never got beyond the preparatory stage; it was executed after his death, from his drawings, by his assistants Giulio Romano (1499–1546) and Gianfrancesco Penni (1488–1528), in an ostentatious, exaggerated version of the master's style. The painting is more interesting as a cultural document than as a work of art; its most convincing feature is the landscape background, where Flemish and Venetian influences are evident. Benvenuto Tisi (1489–1559), known as Garofalo, was strongly influenced by Raphael; in his *Apparition of the Madonna to Augustus and the Sibyl*, however, his early training in the Venetian style is apparent in the color and in the Giorgionesque landscape.

Titian (1477–1576), the greatest of the sixteenth-century Venetian masters, is represented in the Pinacoteca by his *Madonna of San Niccolò dei Frari*, which was painted for the church of that name and brought to Rome in 1700 to serve as a pendant to Raphael's *Transfiguration*. Scholars are more or less agreed that it dates from the middle of the fourth decade of the century, when Titian had reached full artistic maturity. X-ray photographs taken during a recent restoration revealed beneath the surface a sketched-in three-level composition that probably represents the master's original idea. A close examination of the painting shows that in it Titian is moving away from the influence of Giorgione, which had been dominant in his early work, and is striving toward greater volume and monumentality in his figure style. He achieves these effects, however, exclusively through his handling of color: the paint is laid on more thickly than in the past; the brushstrokes, though freer, serve to define form; matter is so drenched in light that the result is almost impressionistic. This quasi-impressionism may be seen, for example, in the three figures of Saints Catherine, Nicholas, and Peter. Traces of Titian's earlier style survive in the composition, which recalls that of his *Assumption* of 1516–18, and in the rather Giorgionesque Saint Sebastian (this figure, however, is sometimes attributed to Titian's brother, Francesco Vecellio). An *Ideal Portrait of the Doge Niccolò Marcello* is probably a free copy made by Titian, perhaps in his youth, of a portrait by Giovanni Bellini's brother Gentile. Despite the fact that it is not an original work, and despite later overpainting, Titian's distinctive personality may be discerned here, particularly in the use of color.

The Pinacoteca's two works by Paolo Veronese (1520–88) are not entirely representative of that master's art, though they are of considerable quality. His *Saint Helena* is a close relation of the ladies who popu-

Madonna of San Niccolò dei Frari, by Titian, about 1545.

late his famous banquet scenes, where sacred subject matter is perceptible only in titles such as *The Last Supper* or *Dinner at the House of Levi*, and which evoke Venetian life at the time of its greatest splendor—a time that coincided, however, with the beginning of the city's historical decline. The *Saint Helena* formerly belonged to the Sacchetti family, as did an *Allegorical Scene* that originally formed part of a ceiling (together with two other scenes now in the Pinacoteca Capitolina of Rome). In both these pictures Veronese uses a technique typical of his mature work: in order to achieve an effect of vibrant luminosity he juxtaposes strokes of pure unblended color, thus instinctively anticipating by three hundred years the method of the Impressionists.

Sebastiano del Piombo (1485–1547) learned his art from the greatest Venetian masters of his day; he later came to Rome, where he assisted Raphael in the Stanza d'Eliodoro. To him is attributed an impressive *Saint Bernard*, painted almost entirely in monochrome. Other Venetian pictures include the *Holy Family* by Bonifacio de' Pitati (1478–1553), also known as Bonifacio Veronese, a talented disciple of Palma Vecchio's and Titian's, and the *Saint George and the Princess* by Paris Bordone (1500–1577), a minor imitator of the great masters who was endowed nonetheless with a refined sense of color.

A painter ahead of his time in many respects was Federico Fiori (1528–1612), known as Barocci. The Pinacoteca has five of his paintings, a *Head of the Virgin*, an *Annunciation*, the *Rest on the Flight into Egypt* (also called the *Madonna of the Cherries*), the *Beata Michelina*, and the *Saint Francis Receiving the Stigmata*. Barocci

Saint Helena, by Paolo Veronese, about 1580.

came from Urbino, and was a pupil of the Venetian Mannerist Battista Franco; despite the apparent spontaneity and immediacy of his style, his art is problematic in its development and in its content. He takes his inspiration largely from Correggio, but his interpretation of that master is pre-Romantic in spirit and almost impressionistic in the use of color; he transforms Correggio's chiaroscuro into the kind of pastel haze that we find in the art of eighteenth-century French painters like Watteau and Boucher. The exquisite *Head of the Virgin* and the recently restored *Madonna of the Cherries*, in fact, look forward to the eighteenth century, while the *Beata Michelina*, with its turbulent, swollen storm clouds, anticipates the themes of Romanticism.

Other sixteenth-century painters represented in the Pinacoteca were less original. The eclectic Cola d'Amatrice (1489–1559) had his roots in the traditions of the fifteenth century; his *Assumption of the Virgin with Saints*, however, reveals a certain individuality despite its Umbrian sentimentalism and its references to both Signorelli and Lotto. Giorgio Vasari (1511–74), the author of a *Stoning of Saint Stephen*, was a pompous and mannered painter, though he is justly celebrated for his *Lives* of the artists. Girolamo Muziano (1528–90) managed to avoid the emptiness of academic Mannerism thanks to the Venetian and Lombard elements in his artistic background. His *Resurrection of Lazarus* made him famous virtually overnight by winning the praise of Michelangelo. In this work he successfully reconciles, in a personal if not entirely original manner, the Venetian and Roman traditions of color and of rhythmic composition. The same qualities are visible in his *Saint Jerome*. Ippolito Scarsella (1550–1620), called Scarsellino, received his artistic training in Ferrara, but during the four years he spent in Venice he was much affected by the art of that city, and especially by Paolo Veronese. His *Visitation* was painted when the influence on his work of Veronese and the other Venetians was at its peak: it is evident in the glowing colors and in the luminous landscape. Giuseppe Cesari (1560–1640), otherwise known as the Cavalier d'Arpino, is of considerable historical importance in the transition from the sixteenth to the seventeenth century. His *Annunciation*, however, with its Mannerist precision of detail, is empty and affected; its cold pietism is devoid of spiritual significance.

The Pinacoteca has few paintings by Northern European artists of the Renaissance. The *Pietà* by the German Lucas Cranach the elder (1472–1553) is not among his most important pictures; it lacks the expressive power and the graceful, stylized line that characterize his best work, though his talent as a colorist is apparent in the contrast between the leaden hue of the Virgin's tunic and the jewel-like red of her mantle.

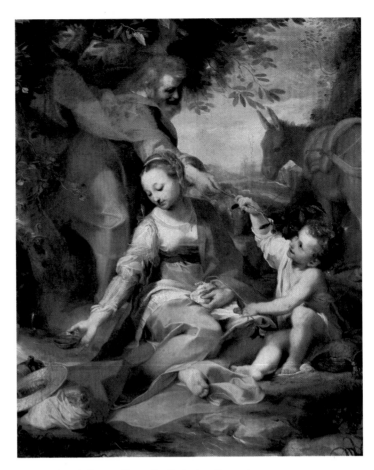

Rest on the Flight into Egypt, by Federico Barocci, about 1570–73.

Pieter de Wit (ca. 1548–1628) was born in Flanders, but his artistic education was Italian; he was active in Florence from 1570 on. He was deeply influenced by the Tuscan and Venetian painters; these influences may be observed in his *Holy Family with Saint Anne and Saint John the Baptist*, which recalls Michelangelo in its composition and in the solidity of its figures.

The most important artistic center of seventeeth-century Italy was Rome. Painters from all over Italy came to work there. In general, they followed one of two opposing tendencies: there was a classicizing school, begun by Annibale, Lodovico, and Agostino Carracci of Bologna, and the naturalistic school of Caravaggio and his followers. The Pinacoteca possesses a number of important paintings produced in Rome during this period.

The *Entombment of Christ* by Michelangelo Merisi da Caravaggio (1573–1610) was painted in 1603–1604 for the family chapel of Pietro Vittrice in the church of Santa Maria in Vallicella. It is one of the most important works of Caravaggio's so-called black manner. Caravaggio came from Lombardy, where he was trained by the Milanese painter Simone Peterzano, and where he also studied the work of the Cremonese, Brescian, and Venetian artists. In the expression of

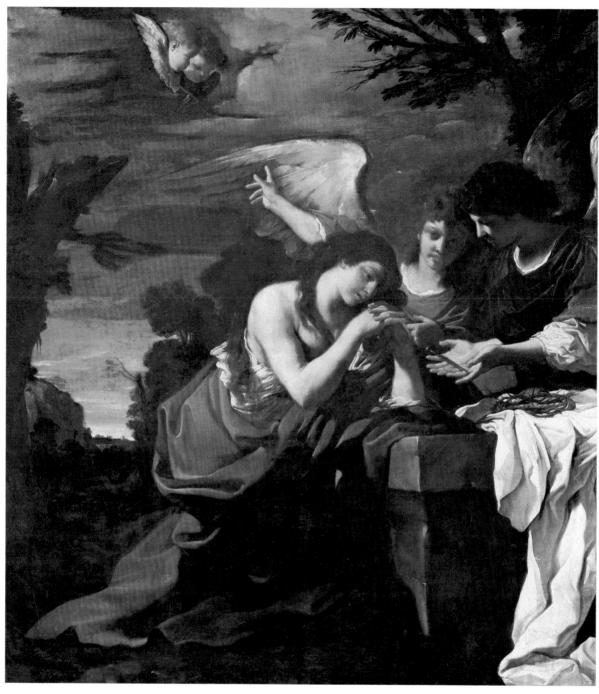

Saint Mary Magdalene, by Guercino, 1622.

his all-embracing vision of nature, light has the essential role of individuating objects, defining form, and creating color. Nature, for Caravaggio, is the world around him—the world of the disinherited, which he celebrates with a strength of spirit that redeems, in his most crudely naturalistic representations, even its most brutal aspects. The *Entombment* was painted at the period in his career when he was absorbed in exploring the use of light for dramatic purposes. Light rends the darkness and at the same time limits the scene to the compact group of firmly modeled figures on which it falls. Depth is suggested by the composition, and

especially by the relationship between the body of Christ and the marble grave slab. The figures are portraits of ordinary people (the Nicodemus is said to be a self-portrait), and this intensifies the realism of the drama. Not even the rhetorical gesture of Mary of Cleophas detracts from it.

Caravaggio's world could not fail to interest the young artists of the time, most of whom were influenced by his strong personality—especially those who came from France and Flanders. Jean Valentin (1594–1632) arrived in Rome in 1612 and was introduced into the group of Caravaggio's followers by the painter

Bartolomeo Manfredi. His *Martyrdom of Saints Processus and Martinian* is an attempt at a more complex and dramatic interpretation of Caravaggio's vision; as such, it shows a tendency toward the art of the Baroque, but the result is labored and cumbersome. A beautiful *Denial of Peter* by an anonymous French or Dutch painter shows, in its sensitive use of color and in the way in which forms are grazed by light, that the author belonged to the circle of another follower of Caravaggio, Carlo Saraceni. In his *Judith*, Orazio Gentileschi (1565–1638) has outgrown his early Mannerist training and approaches the style of Caravaggio, though dramatic lighting effects are here subordinate to clarity. To a typically Tuscan precision in delineating form, Gentileschi adds a certain preciosity in his treatment of surface and texture.

The Bolognese school is well represented by Domenico Zampieri (1581–1641), called Domenichino, by Guido Reni (1575–1642), and by Giovanni Francesco Barbieri (1591–1666), known as Guercino. Domenichino was a pupil of Agostino Carracci's. In his *Communion of Saint Jerome*, painted in 1610 for the church of the Aracoeli, he puts to advantage the stylistic traits derived from his master and adds to them Venetian touches in the landscape and in the iridescent colors. Guido Reni's background was similar to Domenichino's, but after he came to Rome he was influenced by Caravaggio—less in the *Madonna and Saints*, which is still close to the style of the Carracci, than in the *Crucifixion of Peter* with its interesting color resonances. Guercino's style includes both Bolognese and Ferrarese elements, and is also influenced by Caravaggio. His *Doubting Thomas* is in fact a synthesis of Venetian color and Caravaggesque form. His *Magdalene*, on the other hand, despite its naturalism, its strong modeling, and its vibrant color, anticipates a more superficially endearing approach, which would soon degenerate into pious sentimentalism.

An example of such sentimentalism is the *Madonna and Child* by Giovanni Battista Salvi (1609–1685), known as Sassoferrato, who was influenced by Domenichino and Reni; it has a certain stylistic distinction, but it is wholly lacking in inspiration. Another Bolognese artist who was active in Rome was Giovanni Lanfranco (1582–1647). He worked under Agostino and Annibale Carracci in the famous *galleria* in Palazzo Farnese, but was also influenced by Caravaggio, as, for example, in his *Infant Jesus Sleeping*.

Andrea Sacchi (1600–1661) was a case apart. He began as a member of the Carracci circle, but he also looked to Guercino and, especially, to the Venetians. In his work he sought to harmonize Venetian color with severe, classical form; eventually he became the leading figure of the neo-Venetian current in seventeenth-century painting. His *Vision of Saint Romuald* has been described as a "symphony of white tones": his ability as a colorist enabled him to obtain extraordinary results by applying the principles of tonal painting while working in white on white. The great French artist Nicholas Poussin (1594–1665), whose *Martyrdom of Saint Erasmus* has recently been restored, may also be numbered among the neo-Venetians because of his predilection for mythological scenes, inspired by Titian, and of his interest in Titian's and Veronese's color.

It was Pietro Berrettini (1596–1666), better known as Pietro da Cortona, who initiated the Baroque style in Roman painting with his frescoes in the church of Santa Bibiana. His *Madonna Appearing to Saint Francis* belongs to his mature period, when his native Tuscan manner had been transformed by his study of Correggio and the Venetians and by exposure to Rubens and Bernini. His atmospheric vision is Florentine and Venetian at once, and combined with a grandiose decorative sense. His *David Killing the Lion*, a sketch for a fresco in the Villa Sacchetti, is remarkable for the monumentality of its forms and the intensity of its colors. Pier Francesco Mola (1612–66) was influenced by Guercino, Sacchi, and Cortona, though he shows a certain independence in his more realistic approach. His *Vision of Saint Bruno* recalls Guercino in the steely intensity of the colors and the somewhat Caravaggesque lighting effects, and Sacchi in the landscape. No less important is Mola's *Saint Jerome*, in which, thanks to a recent restoration, his stylistic peculiarities may be more readily observed. A *Martyrdom of Saint Lawrence* is attributed to Jusepe Ribera (1588–1656), known as Spagnoletto, who reveals his Spanish origins in his dusky colors and intense chiaroscuro; influenced by Neapolitan and Tuscan followers of Caravaggio, he evolved his own superficial, Baroque interpretation of that master's naturalism.

In his splendid portrait of Pope Clement IX, Carlo Maratta (1625–1713) overcomes the tendency to academicism that sometimes weakens his work, and demonstrates his great artistic gifts. Color is used here in the manner of the greatest masters from the Venetians to Velázquez and Baciccia (who also painted a fine portrait of Clement): it is so penetrated by light that the entire painted surface seems to vibrate. The portrait is no less remarkable for its psychological insight into the character of the pope, with his delicate, sensitive hands, lean face, and acute gaze; it may be described without exaggeration as a masterpiece.

An oil sketch with music-making angels was recognized, after a cleaning restored the original brilliance of the colors, as the work of Giovan Battista Gaulli (1639–1709), known as Baciccia, executed about 1672 as a preparatory sketch for the dome fresco in Sant' Ignazio in Rome. This poetic, spontaneous little pic-

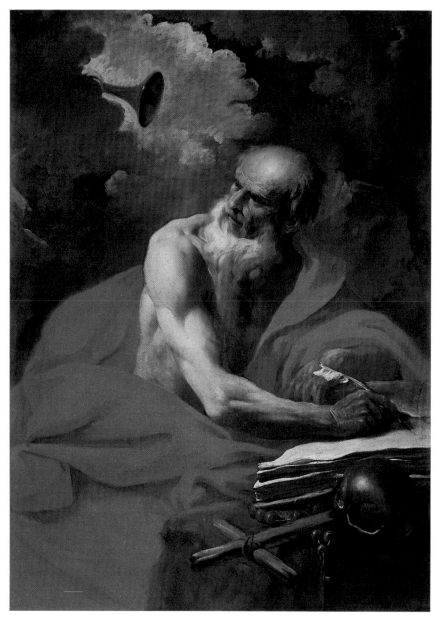

Saint Jerome, by Pier Francesco Mola, about 1660.

ture is remarkable for its light touch, delicate forms, and open, atmospheric space.

The Pinacoteca possesses a number of paintings by Flemish and Dutch artists of the seventeenth century. A *Triumph of Mars* (or *Apotheosis of Vincenzo Gonzaga*) attributed to Peter Paul Rubens (1577–1640) was in fact largely executed by assistants working from the master's sketches. Rubens's loose handling of his brush, his thickly laid-on colors, and his overblown imagery were elements of his personal style that nevertheless became permanent ingredients of the Baroque style. A *Saint Francis Xavier* that entered the Vatican collection in 1938 as the work of an anonymous artist was later recognized—on the basis of its style, especially in the beautiful, spiritual hands, and of documentary evidence—as the painting that Anthony van Dyck executed in 1622 or 1623 for the saint's altar in the church of the Gesù. It is a relatively early work, in which the influence of Rubens is still to be found in the delightful cherubs. The Dutch Jesuit Daniel Seghers (1590–1661) liked to surround—and almost to suffocate—the central figures in his paintings with wreaths of elegant, stylized flowers in bright, enamel-like colors; he is represented here by four works, a *Madonna and Child,* a *Saint Ignatius in Glory,* a *Saint Goswin,* and an *Ecce Homo.* In his *Orpheus with Pluto and Proserpina,* Matthias Stomer (ca. 1600–1650) interprets the myth in terms of the popular customs of his native Flanders. The *Herd of Horses* by Pieter van Bloemen (1657–1720) has an imaginary landscape background in which memories of Holland are apparent.

Eighteenth-century paintings in the Pinacoteca include a series of eight *Astronomical Observations* by Donato Creti of Cremona (1671–1749); they were probably painted as a result of the interest in astronomy provoked by Galileo's discoveries. The unusual subject—the sun, the moon, and the planets that were then known—is taken as a pretext for delightful genre scenes in which this elegant exponent of the Bolognese school gives expression to his poetic vein by painting tiny, graceful figures moving through vast, silent landscapes. The Arcadian mood recalls contemporary French painting.

A fine portrait of Pope Benedict XIV by Giuseppe Maria Crespi (1665–1747) was painted while the sitter was still a cardinal, and later modified: the scarlet robe was repainted in white (though the original color shows through here and there), and the rich tiara was added; other changes were discovered during the course of a recent restoration. The image of the pope is keen and lively, thanks in part to Crespi's thickly applied, almost phosphorescent colors in the Venetian tradition.

Pompeo Batoni of Lucca (1708–1787) broke away from the effete Baroque style that still dominated Roman painting in the earlier eighteenth century; he

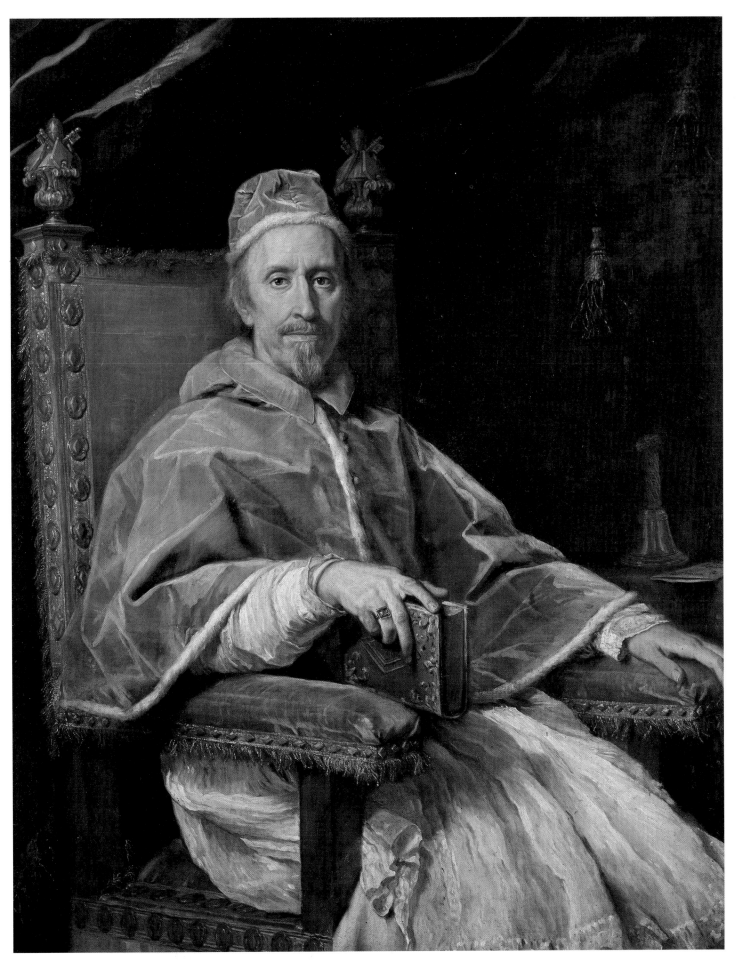

Pope Clement IX, by Carlo Maratta, 1669.

studied ancient art and Raphael, and returned to the artistic tradition of the Carracci. He is the author of a *Madonna Appearing to Saint John Nepomucene* in the Pinacoteca.

A portrait of Voltaire that had been kept for many years in the storeroom of the Pinacoteca was put on display fairly recently. Its author is the Frenchman Jean Hubert (1721–86), who was so famous for his series of portraits of the great Voltaire that he was nicknamed Hubert-Voltaire, though he also deserves credit as the inventor of a new art form—the silhouette cut from black paper and set against a white background. Here Voltaire is represented in three-quarter view, wearing an ornate fur-trimmed dressing gown and a strange nightcap that provides a bright spot in a painting otherwise based on shades of brown. What holds the spectator's attention, however, is the thin, wrinkled face with its cold but lively and penetrating eyes.

A portrait of George IV of England by Thomas Lawrence (1769–1830) is rather conventional in its composition, but it has a dignity and a realism that take in the surroundings as well as the sitter. Lawrence, a pupil of Joshua Reynolds, was one of the great masters in the tradition of English portraiture that goes back to Van Dyck.

MARIA DONATI BARCELLONA

Pope Benedict XIV, by Giuseppe Maria Crespi, 1740.

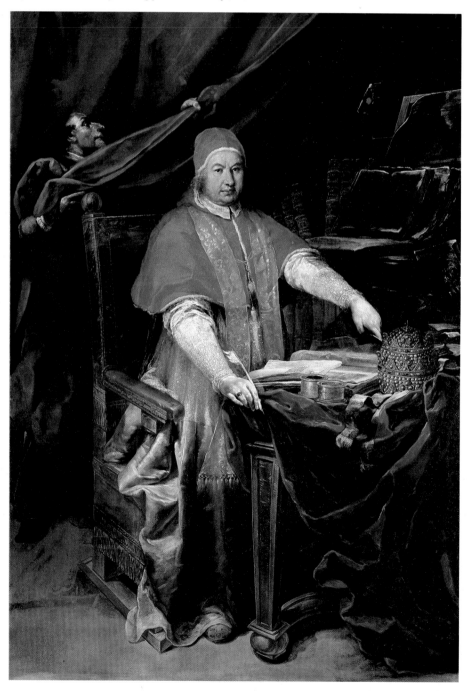

The Museo Storico

The Museo Storico, founded at the request of Paul VI, was opened to the public in 1973. It is situated in a large underground space beneath a court called the Giardino Quadrato, adjoining the Pinacoteca. The collection consists of carriages and other vehicles that belonged to popes and cardinals; uniforms, weapons, and other relics of the old papal army and the corps of papal guards that were disbanded on September 15, 1970; arms and armor previously housed in rooms of the Apostolic Palace; and a small number of works of art and photographs.

In the first section are harnesses and trappings for state occasions, including the harness used by the Standard Bearer of the Holy Roman Church, who had the rank of lieutenant general.

Three black landaus are on display: these were the popes' everyday means of transport, especially for outings in the Vatican Gardens, until the first years of the pontificate of Pius XI (1922–39), when automobiles came into use. Two heavy traveling coaches, suitable for long journeys over bad roads, are said to be the vehicles used by Pius IX when he fled Rome for Gaeta in November 1849 and for his visit to Ravenna in 1857. There is also the coach, decorated with Napoleonic symbols, of Cardinal Lucien Bonaparte, the cousin of Napoleon III.

Perhaps the most interesting object in the museum is the coach made for Leo XII (1823–29) by the celebrated Roman coach builder Gaetano Peroni. It took three years to make. It was intended for occasions of great solemnity, and was also used by Leo's successors Pius VIII, Gregory XVI, and Pius IX.

The exhibit of vehicles concludes with two sedan chairs, one given to Pius IX by the people of Naples and the other used by Leo XIII, and the automobiles used by Pius XI and Pius XII: an Italian-built Citroën, a Graham Paige, and the Mercedes Benz used by Pius XII when he went to the church of San Lorenzo in Rome to comfort the victims of the bombing of July 19, 1943.

A rack of large arquebuses divides the first section of the museum from the second, which is dedicated to the old papal army and the various corps of papal guards. Uniforms of the Noble Guard, the Pal-

The carriage collection of the Museo Storico.

atine Guard of Honor, the Papal Zouaves, the Papal Artillery, and other corps are arranged in glass cases along the walls. There are also relics of the last battles fought by the papal army, at Castelfidardo, Mentana, and Porta Pia.

An interesting selection of firearms shows the development from the old-fashioned muzzle-loaders to breechloaders. Among the older weapons are two air guns, a splendid flintlock repeater made in Rome about the end of the seventeenth century by the famous Bolognese armorer Francesco Berselli, a small Austrian flintlock with a four-chambered barrel, and fine flintlock hunting rifles used by the papal court.

The functional 1868 Remington musket made earlier types obsolete. The museum possesses a series of seventy-eight of them, with damascened barrels, gold inscriptions, and the names and coats of arms of the Belgians who donated them to Pius IX.

Larger-caliber weapons include two sixteenth-century cannons with iron staves reinforced by rings, nineteenth-century bronze cannons, and two naval carronades. The Papal Artillery is represented by a fine series of original bronze models, of various dates, some complete with gun carriages and munitions.

Other antique weapons include pikes and halberds, a magnificent sixteenth-century German sword, finely worked seventeenth-century Neapolitan rapiers, and Venetian sabers. There are two sixteenth-century suits of armor, and a fine collection of helmets, including sixteenth- and seventeenth-century morions and basinets. Some of the morions are decorated with the Aldobrandini arms and the angel of Castel Sant'Angelo.

The Papal Navy is represented by naval flags, two blunderbusses, and a model of the corvette *Immaculate Conception*. After the occupation of Civitavecchia in 1870 by the troops of the kingdom of Italy commanded by Nino Bixio, this ship was permitted by the terms of surrender to remain in the port, flying the papal flag and awaiting the possible embarkation of Pius IX.

Also on display are the standards of the Papal Dragoons, the Papal Artillery, and the Noble Guard. Whenever a new pope was elected, his coat of arms was sewn to the standard of the Noble Guard in place of his predecessor's; all of these coats of arms are now exhibited in the museum, together with portraits of the commandants of the Noble Guard. Three interesting eighteenth-century charts show the organization of the pontifical armed forces.

ANNUNZIO GANDOLFI and CARLO DE VITA

The Collezione d'Arte Religiosa Moderna

The collection of modern religious art consists of 740 paintings, sculptures, prints, and drawings by 250 artists, exhibited in 55 rooms of the Vatican Palace, including those of the Appartamento Borgia. It is intended as a testimony to man's "prodigious capacity for expressing the religious, the divine, the Christian, as well as the authentically human." With these words, Paul VI inaugurated the collection in 1973.

The story of the collection began with Pope Paul's meeting with a group of artists in the Sistine Chapel on May 7, 1964. On that occasion the pope recalled that a long tradition of friendship between the church and artists had produced an artistic and spiritual patrimony that belongs to all; the very place where the meeting was held was a moving testimony to this friendship. In the nineteenth century the collaboration had been interrupted; the themes represented in religious art were tired repetitions of the past, and artists were obliged to produce mannered imitations that left no room for free invention. But a general crisis of values had prepared the way for new forms of art that might celebrate once again the priority of the spirit.

During this ferment the religious idea was not abandoned, though it was culturally isolated and sometimes misunderstood; the situation lasted for years, and brought home the need for a clarification that would make possible a modern dialogue with God through artistic expression. Out of this necessity the collection was born, as part of the new spirit of renewal in the church.

A watercolor with the figure of an apostle by Francisco Goya, painted in about 1819, may be considered the point of departure of the entire collection; Goya's art contains the seeds of all the developments of the later nineteenth and the twentieth centuries. Ottone Rosai, Ardengo Soffici, and Primo Conti, united by their Tuscan heritage and by their participation in the avant-garde of the nineteenth century, are represented here in different moments of their painting careers. The *Moses Saved from the Waters*, by Armando Spadini, the earliest version of a subject that later became almost an obsession for the artist, reveals the essence of his painting: a harmonious balance of technique and poetry. Auguste Rodin, the French artist

The Chapel of Peace, by Giacomo Manzù, 1961.

who succeeded in uniting his love for classical art with a profundity of content that is closer to the sensibilities of modern man, is represented by the powerful *Thinker* and the symbolic *Hand of God*.

The bronze door designed by Luciano Minguzzi and Lucio Fontana for the cathedral of Milan and Emilio Greco's door for the cathedral of Orvieto are well-known works, created for buildings where art and religion have traditionally come together. The collection possesses the models that Minguzzi and Fontana, the winners of a competition held in 1950–52, produced for the Milan door, which was executed by Minguzzi in 1965. The subject is the origin and history of the cathedral. In Minguzzi's panels, images corroded by pent-up violence are seen in a context where the artist's imagination is complemented by references to tradition. Fontana eschews fixed forms; his mysterious, weightless figures mingle with the air, and his unbridled inventiveness seems almost a rediscovery of the poetics of the Baroque. The artistic activity of Emilio Greco between 1961 and 1967 is summed up in the panels for the central door of the cathedral of Orvieto. Here the sculptor approaches with profound humility the theme of the Works of Mercy, and reveals acute and penetrating psychological insight in his perfect profile of John XXIII.

The Sala dei Santi of the Appartamento Borgia, with its celebrated frescoes by Pinturicchio, houses a vast panorama of bronzes by Francesco Messina, an artist who in more than fifty years of work remained

Miserere, by Georges Rouault, 1939.

faithful to the classical tradition and to a coherent moral commitment.

The Chapel of Peace is the synthesis of the poetic creativity of Giacomo Manzù. Each of the bronzes, modeled individually by the artist, conveys unaltered the original force of his inspiration and the free, emotional response of his art to faith. The arrangement of the sculpture in the chapel is also Manzù's work. One of the pieces, a portrait of John XXIII, reflects the warm humanity of that pope and his friendly familiarity with the sculptor.

An entire room is devoted to Georges Rouault, the only great modern artist whose work can be considered essentially religious. In the *Miserere*, he expresses his participation in the drama of oppressed humanity as in a long poem, emphasizing moral values with genuine Christian feeling. In the sorrowful image of the *Ecce Homo* he gives vent to his pity for universal suffering, a sentiment that reaches its dramatic extreme in the *Crucifixion* and then seems to find solace in the denser and warmer tones of the *Nazareth*.

A different way of expressing religious feeling is found in the paintings of Marc Chagall, who draws the most imaginative elements in his work from his Russian background; to the reminiscences of legends and folklore and to his passion for animals he unites

love and compassion for his persecuted Jewish people. These elements are brought together through the ingenious use of color as form, in the style that Chagall evolved during his stay in Paris in the early part of this century.

The ferment that, during those years, opened new horizons for the figurative arts in the French capital is the force behind some of the most talented personalities of the century, personalities from whom modern art received an imprint that still remains valid and alive. Among the prestigious names represented in the collection are Paul Gauguin, with an unusual sculpted panel; Maurice Bernard, the leader of the School of Pont-Aven; Odilon Redon, whose scientifically precise drawing expresses a profound sense of mystery; Maurice Utrillo, the delightful poet of the streets of Paris; and members of the Ecole de Paris such as the Japanese painter Foujita, who brings to the themes of Western art the precious refinement of the East.

The collection also includes some of the vestments and decorations that Henri Matisse created for the Chapel of the Rosary of the Dominican sisters at Vence. The chasubles and the lithographs after designs for the wall tiles embody the main characteristics of Matisse's art, sublimated by a higher inspiration: vivid splashes of color harmoniously juxtaposed in the vestments, and a masterly handling of line in the exquisite images of the Virgin in the lithographs.

A representative group of pictures and prints by Giorgio Morandi, one of the most celebrated masters of our century, reveals an art based on meditation and rigorous introspection, modest and refined at the same time, an art that transcends objective reality by repeating the same themes in landscapes and still lifes, each time with a very different poetic accent. In contrast to Morandi is the complex personality of Filippo De Pisis, whose internal energy brings to his art extreme imaginative tension and an authentic lyrical excitement.

Some of the most famous artists of the century—Munch, Klee, Kandinsky, Moore, Nicholson, Dali, Le Corbusier, Braque, Modigliani, Casorati, and Bucci—are represented by watercolors, drawings, and engravings. In the rooms known as the Salette Borgia are works by the best-known modern Italians. Two pictures, both entitled *The Mother*, by Umberto Boccioni and Giacomo Balla, evince these painters' psychological interest in the theme before and after their experience in the Futurist movement.

During the years between the two World Wars, some of the protagonists of Italian art rediscovered Giotto and Masaccio and, in general, the tradition of the fourteenth and fifteenth centuries. This tendency is represented by the *Good Shepherd*, a wood sculpture by Arturo Martini; by the same artist's terracotta *Way of the Cross*; and by the concise images and closed

The Tree of Life, maquette for a window of the Chapel of the Rosary at Vence, by Henri Matisse, 1949.

Priest, by Emil Nolde, 1939.

forms of Carlo Carrà and Ottone Rosai. A critical rediscovery of the early Middle Ages underlies the powerful *Christ and the Apostles* by Mario Sironi.

The fascinating, polemical, and contradictory personality of Giorgio de Chirico is represented by his *Nativity* and his *Christ and the Tempest* of 1945 and 1948, the years in which he was most bitterly reproved for deserting his earlier "metaphysical" style and making an anachronistic return to the Baroque tradition.

Two small rooms are devoted to Gino Severini and Primo Conti. In the first, Severini's Cubist and Futurist past emerges in the sketches for his late frescoes and mosaics, filtered through the classicism of the Italian tradition with its natural lyricism, clear tones, and rational forms. Bronzes, oils, and watercolors testify, in the second room, to the creative felicity of Conti's last period.

In the last part of the gallery, the works of art are arranged mainly according to nationality and to artistic movements. The interesting selection from the United States is dominated by a number of paintings by Ben Shahn, almost all of them from his last years. In the penetrating vision of the tormented progress of humanity in *Man and Labyrinth*, in the emotion-filled *Farewell* dedicated to the fishermen of Bikini, and in the explosion of colors in the *Third Allegory*, the elements of this artist's personality are fused. He is acutely conscious of his social mission, open to many interests, and pervaded with a religious sense that is always faithful to the Jewish tradition. Two watercolors by Lyonel Feininger, of 1920 and 1953, illustrate the unity of style peculiar to this artist, who succeeds in giving to the alleys and buildings of old cities a reality that is not distorted, but simply dematerialized and lightened.

The German Expressionists are represented by Ernst Ludwig Kirchner, Karl Schmidt-Rottluff, Erich Heckel, and Emil Nolde (the founders of the movement known as Die Brücke), and other eminent personalities who participated in the great Expressionist renewal, including Oskar Kokoschka, Paula Modersohn-Becker, Christian Rohlfs, Gabriele Münter, Otto Dix, Max Beckmann, and Max Ernst. The brilliant Belgian precursor of the Expressionists, James Ensor, whose dreamlike universe is populated by masks, is represented by his symbolically ambiguous *Procession of the Penitents of Furnes*.

Graham Sutherland is still overwhelmed by the horrors of war in his *Study for the Northampton Crucifixion* of 1947, and immersed in the mystery of the primordial bonds between man and earth in his *Thorn Cross* of 1971. Francis Bacon's study after the *Innocent X* of Velázquez is an unnerving distortion of traditional aesthetic values.

The work of the Spanish painters in the collection illustrates the influence of religious fervor on the figurative arts in Spain today. In contrast to the chromatic vigor of Palencia is the emphatic realism of Ramón de Vargas and the crushing force of Vaquero Turcios. A sculptural *Project for an Altar* by Eduardo Chillida symbolizes the unity of the churches. There are also bronzes by Jorge de Oteiza, Pablo Serrano, Venancio Blanco, and José Luis Sanchez. José Ortega looks into history for the roots of his present, patiently relying upon print-making technique for the composition of his large "engraved fresco."

One of the most interesting rooms in the gallery contains works of great religious intensity by the creators of epic Mexican mural painting, Rivera, Orozco, and Siqueiros. Orozco's Saul, a motionless witness in the *Martyrdom of Saint Stephen*, is already half-aware of the light that will strike him down and enlighten him; the *Christ* of Siqueiros has an air of violent supplication.

Various currents in Yugoslavian painting are represented: Klajaković reveals in his *Deposition* the inspiration of Michelangelo and Rodin; Vidović portrays a desolate Gothic Christ; Dulčić is a mellow narrator of Gospel episodes. There are also pictures by the naïfs Rabuzin, Lackovič, Kovačić, and Večenaj.

MARIO FERRAZZA and PATRIZIA PIGNATTI

The story of Laocoön, in the Vatican Virgil, a manuscript from the
end of the fourth century. Cod. Vat. Lat. 3225, folio 18 verso.

THE APOSTOLIC VATICAN LIBRARY

Seventy-five years after the return of the popes from Avignon in 1377, the prevailing intellectual climate in papal Rome was that of Italian humanism. The humanists were eager to study both the classic authors and the fathers of the church; they were aware of their Greek as well as of their Latin heritage; and they considered it urgent to stock their libraries with ancient, medieval, and modern texts. Nicholas V (1447–55), the first humanist pope, caused numerous rare manuscripts to be copied, and had the Greek authors translated into Latin. He accumulated more than 5,000 volumes, which he intended to be made accessible to all scholars as well as to the officials of the Curia.

Sixtus IV (1471–84) officially founded the Apostolic Vatican Library on June 15, 1475 (the event is commemorated in a famous fresco by Melozzo da Forlì, painted for the original library and now in the Pinacoteca). In so doing, Sixtus was completing the project of Nicholas V, but he was also continuing the tradition of the Franciscan order, to which he belonged; the Franciscans had, in the past, organized public libraries in many Italian cities. The foundation of the library was also an affirmation, in keeping with the spirit of the times, of the cultural role that the church had never dissociated from her spiritual mission. The first librarian was the humanist Bartolomeo Platina (1421–81). Though it was open to all qualified scholars, the Vatican Library remained the pope's library; the librarians were officially the pope's librarians, and for the first few decades—until the early years of the sixteenth century—they were replaced with each new pontificate.

The library originally occupied four rooms on the ground floor of the Vatican Palace, in the wing built by Nicholas V on the north side of the Cortile del Pappagallo. In one of the rooms there are fresco representations of six philosophers of Greek antiquity and of six doctors of the Latin church—including two, Saint Thomas Aquinas and Saint Bonaventure, who were not officially proclaimed doctors of the church until a century after the decoration of the old library. In another room, there is a portrait of Guarino da Verona (ca. 1374–1460), accompanied by a young pupil. Guarino, who translated the *Geography* of Strabo into Latin for Nicholas V, was one of the eminent Christian humanist educators of the Renaissance.

The Library of Sixtus V

The successors of Sixtus IV continued to acquire large numbers of important books, and the central archives of the church were also brought together in the library. Since the four rooms that it occupied were located in the heart of the Vatican Palace, the library could not grow as the collection expanded. Humidity was also a problem. Gregory XIII (1572–85) thought at one point of moving the library to the corridor that he had constructed on the west side of the Cortile del Belvedere. But he changed his mind, and the corridor became the Galleria delle Carte Geografiche. Sixtus V (1585–90) considered using the new wing adjoining the Belvedere of Innocent VIII, but it was pointed out that this would make the library practically inaccessible to the cardinals of the Curia, who met in the old nucleus of the palace. Sixtus—the pope who completed the dome of Saint Peter's and who engaged in a prodigious amount of building elsewhere—therefore decided to have his architect, Domenico Fontana, construct a new home for the library, perpendicular to the east and west corridors of the Cortile del Belvedere and communicating with them at either end. The choice of this site was dictated by the pope's well-known desire for economy and for getting things done quickly; the new wing was also near the palace proper, and in a dry location. As Sixtus was no doubt well aware, by bisecting the Cortile del Belvedere he radically altered its very conception. The project was so criticized, in

Entrance to the Sistine Library.

fact, even after its completion, that Paul V later considered demolishing Sixtus's wing and transferring the library to another location.

The public part of Sixtus's library consisted of a vestibule, a large two-aisled hall (which is known as the Salone Sistino and used today for exhibitions), two small rectangular rooms, and a section of the adjacent corridor of the Belvedere, which Pirro Ligorio had built for Pius IV. Sixtus also installed his private library, which was kept locked, in two other sections of the same corridor, known as the Sale Sistine. The decoration of all these rooms was planned by the custodian of the library, Federico Rainaldi. Its complex but coherent iconographical scheme glorifies the book and Sixtus V: representations of the legendary inventors of the world's alphabets, of the great ancient libraries, and of the councils of the early church (in which manuscripts played an important role) are interspersed with episodes from Sixtus's pontificate and with views of Rome showing the transformations brought about by him. Rainaldi himself appears in the scene in which Domenico Fontana, the architect,

presents his plans to the pope. The stages in the production of printed books are illustrated in the vaults of the vestibule. The frescoes were executed by Giovanni Guerra, Cesare Nebbia, Paul Bril, Orazio Gentileschi, and other late Mannerist painters.

The bookcases, desks, and other furnishings of the old library were installed in the Salone Sistino; only the secondary rooms were provided with new furnishings. One reason for the reuse was Sixtus's impatience to see the project completed. In the fifteenth century, it had taken the energetic librarian Bartolomeo Platina six years to install the Vatican's collection of books in four rooms that already existed. Under Sixtus V and Fontana, a hundred builders and a hundred painters are said to have worked on the new library. Construction was begun in May 1587, and the rooms were decorated by the beginning of 1591. It took 157 days to move the books from the old library to the new;

the entire operation was completed by March 26, 1591.

The manuscripts were arranged as they had been in the old library, lying flat on the shelves. This certainly contributed to their conservation, but it also meant that all of the available space was soon occupied. Paul V (1605–1621) took the important step of separating the Secret Archive from the Apostolic Library, and provided new quarters for the archive. He also added two new manuscript rooms to the library, in Pius IV's west corridor of the Cortile del Belvedere. Known as the Sale Paoline, they are identical in proportion to the Sale Sistine; their decorative scheme, devised by two custodians of the library, Baldassare Ansidei and Alessandro Rainaldi, is a further development of the scheme devised thirty years earlier by Federico Rainaldi. The frescoes, by Giovanni Battista Ricci, represent ancient libraries as well as events of the pontificate of Paul V. Particularly interesting are

The vestibule of the Sistine Library, with fifteenth-century benches from the library of Sixtus IV and portraits of the cardinal librarians.

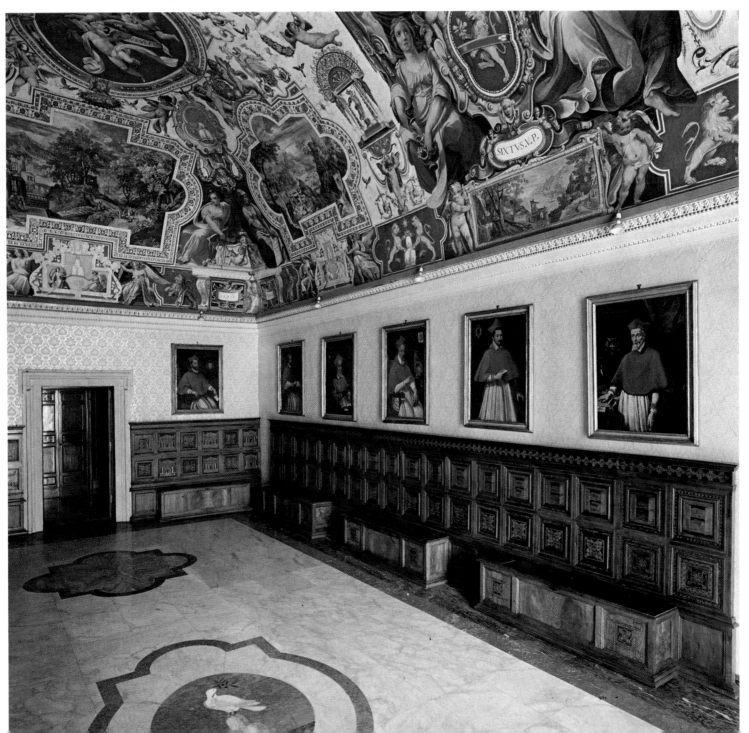

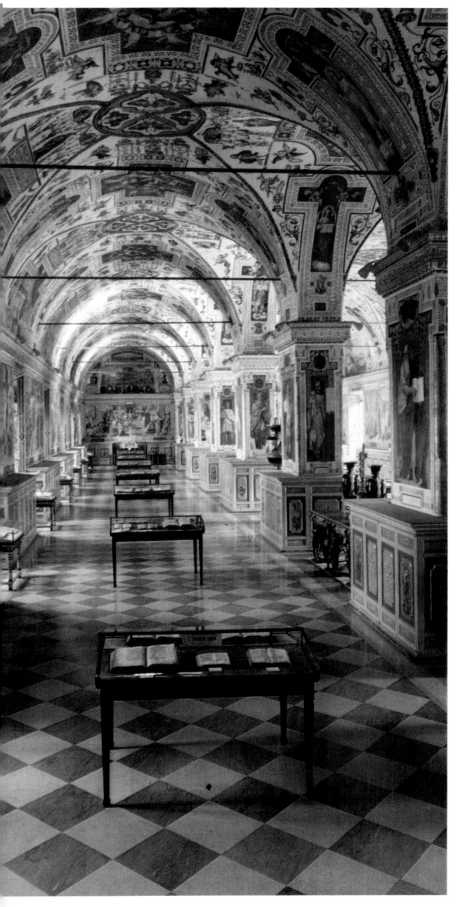

The Salone Sistino of the Vatican Library
is used today for exhibitions.

the scenes that illustrate the history of the Vatican Library: Paul is shown as following in the footsteps of Nicholas V, who first conceived it, of Sixtus IV, its actual founder, and of Pius V (1566–72), who acquired numerous documents for the archive.

Under Gregory XV (1621–23) the Vatican acquired the important collection of manuscripts of the Palatine Library in Heidelberg. This necessitated another extension, and Urban VIII (1623–44) converted eight bays of the corridor of Pius IV into an imposing room to the south of the Sale Sistine. One fresco, by Agostino Tassi, showing the arrival of the Palatine Library collection, dates from Urban's reign; the rest of the decoration was executed by Giovanni Paolo Schor under Alexander VII (1655–67), who in 1657 installed in this room the newly acquired library of the dukes of Urbino, and by Giovanni Angelini under Benedict XIV (1740–58).

In 1645, Innocent X (1644–55) had the fifteenth-century furnishings removed from the Salone Sistino and replaced by wooden cabinets of the kind that had already been installed in the rooms of the corridor of Pius IV. Nothing remains of the old furniture except for an important set of benches, with high backs and intarsia decoration, made for the library of Sixtus IV; they now line the walls of the vestibule.

The Sala Alessandrina was added to the library by Alexander VIII (1689–91) to house the manuscript collection of Queen Christina of Sweden; it comprises the four bays of the corridor of Pius IV immediately to the north of the Sale Paoline. The library was extended further to the north in 1732 under Clement XII (1730–40), when eight more bays—the arcades of which had until now been open—were walled in to form the Galleria Clementina. The decoration of both these extensions is from the reign of Pius VII (1800–1823).

The creation of the Galleria Clementina marked a turning point in the history of the Vatican Library, which now began to function as a museum as well. Clement XII embellished his gallery with a collection of "Etruscan" vases—as all ancient vases were then erroneously called—arranged above the cabinets that contained the books. In 1756, Benedict XIV (1740–58) founded the first museum in the Vatican Palace, the Museo Sacro, which he conceived as part of the library. It was dedicated to Early Christian art. He installed it in the southern end of the corridor of Pius IV, adjoining Urban VIII's gallery. For the first time, cabinets were made to house not manuscripts or printed books but objects of art, most of which came from excavations in the catacombs.

The foundation of the Museo Sacro established a tradition. Clement XIII (1758–69), who donated another collection of "Etruscan" vases to the library, decided in 1767 to complete his predecessor's work by opening

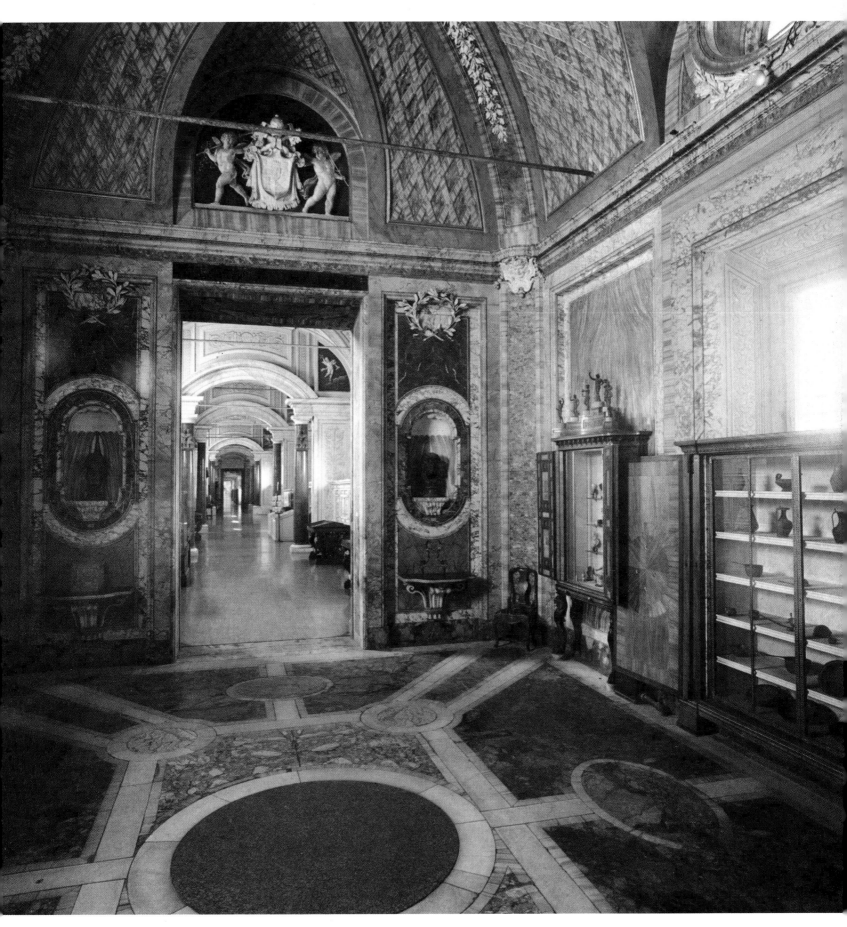

The Museo Profano of the Library.

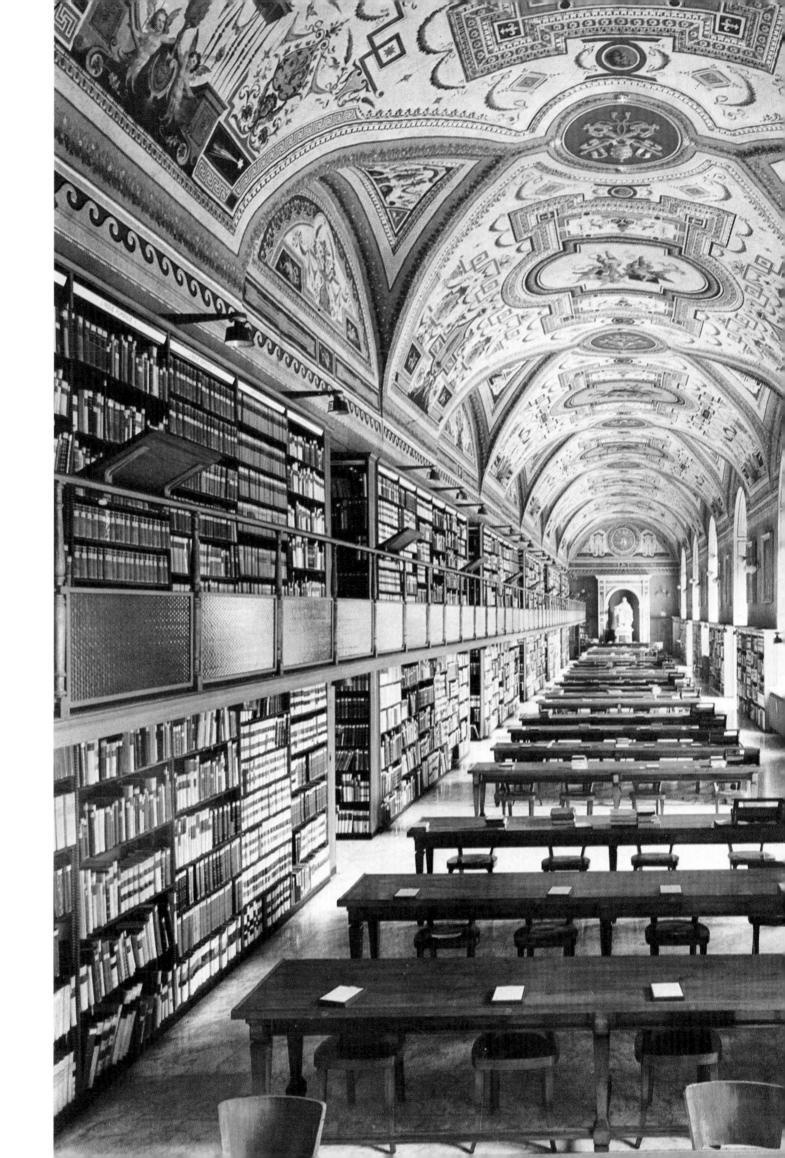

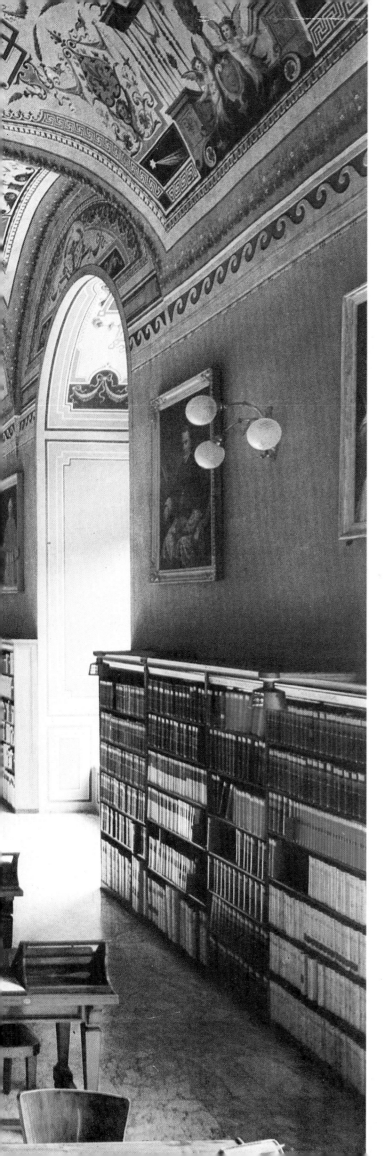

the Museo Profano in the remaining portion of the corridor of Pius IV to the north of the Galleria Clementina. This museum possessed a rich collection of ancient coins and gems. When the French occupied Rome in 1797, the most precious objects were hidden behind the books in the nearby cabinets, but in vain; most of the treasures were carried off to Paris, never to be recovered.

Clement XIV (1769–74) created a small room of the same proportions as the Museo Profano at the opposite end of the corridor of Pius IV. This was the Sala dei Papiri, where a collection of ancient papyri was exhibited in glass cases along the walls. One group had been acquired in 1732 and kept in the Sala Alessandrina; another was donated by Clement himself in 1770.

The Museo Profano and the Sala dei Papiri were decorated under Pius VI (1775–99), with frescoes by Anton Raphael Mengs and others. These rooms, which are more like salons than exhibition halls, retain their original character; they are fine examples of the artistic spirit that prevailed in Rome in the late eighteenth century. Pius VI incorporated into the library the observatory that Gregory XIII had established in Pirro Ligorio's Torre dei Venti, or Tower of the Winds; an adjacent room—which was demolished in 1817 when the Braccio Nuovo was constructed—became the Vatican's first print room. Until Pius VI's reign the corridor of Pius IV had been subdivided into separate rooms and galleries, joined end to end; Pius removed the divisions and regularized the architecture, thus creating the immensely long perspective that characterizes the corridor today.

Both Pius VI and (after the interlude of the French occupation) his successor Pius VII (1800–1823) gave collections of books, manuscripts, and "Etruscan" vases to the library; these donations are commemorated, among other events of the two pontificates, in the frescoes executed in 1818 by Domenico De Angelis in the Galleria Clementina and the Sala Alessandrina. Another fresco shows Pius's architect Raffaele Stern presenting the plan of a new addition to the library, the Biblioteca Chiaramonti. To create space for the Biblioteca Chiaramonti, Stern reorganized the rooms of the Torre Pia, which had been built in the 1560s as a link between the corridor of Pius IV and the Torre Borgia. A former chapel, dedicated by Pius V to Saint Peter Martyr and decorated by the pupils of Vasari, was given over to the library's numismatic collection; manuscripts, books, and objects of archaeological interest were housed in the adjacent rooms.

Under Gregory XVI (1831–46) and Pius IX (1846–78) several rooms of the Appartamento Borgia were annexed by the library, whose collections were expanding continually. One might have expected that after the

The south aisle of the main reference room.

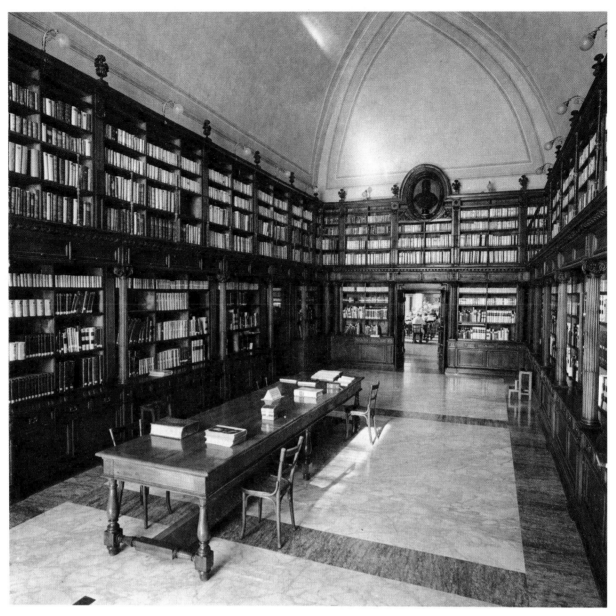

The manuscript catalogue room.

creation of the Museo Pio-Clementino and the Museo Chiaramonti the library would cease to double as a museum. Many objects, in fact—including Assyrian reliefs, Egyptian papyri, Roman sarcophagi, and Byzantine and Italian paintings—were turned over to the museums during the nineteenth century. But many others—including Etruscan mirrors, Roman wall paintings, and goldsmith work from South America—remained in the possession of the library. From the time of Pius VII, objects of art sent to the popes on solemn occasions by heads of state and by groups of the faithful were placed on permanent display in the library; under Pius IX and Leo XIII (1878–1903) there was a great influx of these precious gifts. As the various collections grew, they were shifted about from room to room. Even today, a rich assortment of objects belonging to the library is exhibited in the rooms

and galleries that were added in the seventeenth, eighteenth, and nineteenth centuries.

Pius IX restored the Salone Sistino, and during his pontificate the library's most precious manuscripts were put on display there. Pius also gave the book cabinets—which were originally of varnished walnut—their present painted decoration, which conforms to the decoration that Clement XIV and Pius VI had given the cabinets of the Sale Paoline, the Sala Alessandrina, and the Galleria Clementina.

Leo XIII's Reorganization of the Library

With Pius IX the period in the library's history that Sixtus V had initiated came to an end. Now that it had occupied the entire corridor of Pius IV and invaded the Appartamento Borgia, the library could expand no

Fifteenth-century Bible ordered from the Florentine bookseller Vespasiano da Bisticci by the duke of Urbino, Federico da Montefeltro. Represented in the medallions are the seven days of Creation and scenes from Genesis. Cod. Urb. Lat. 1, folio 7 recto.

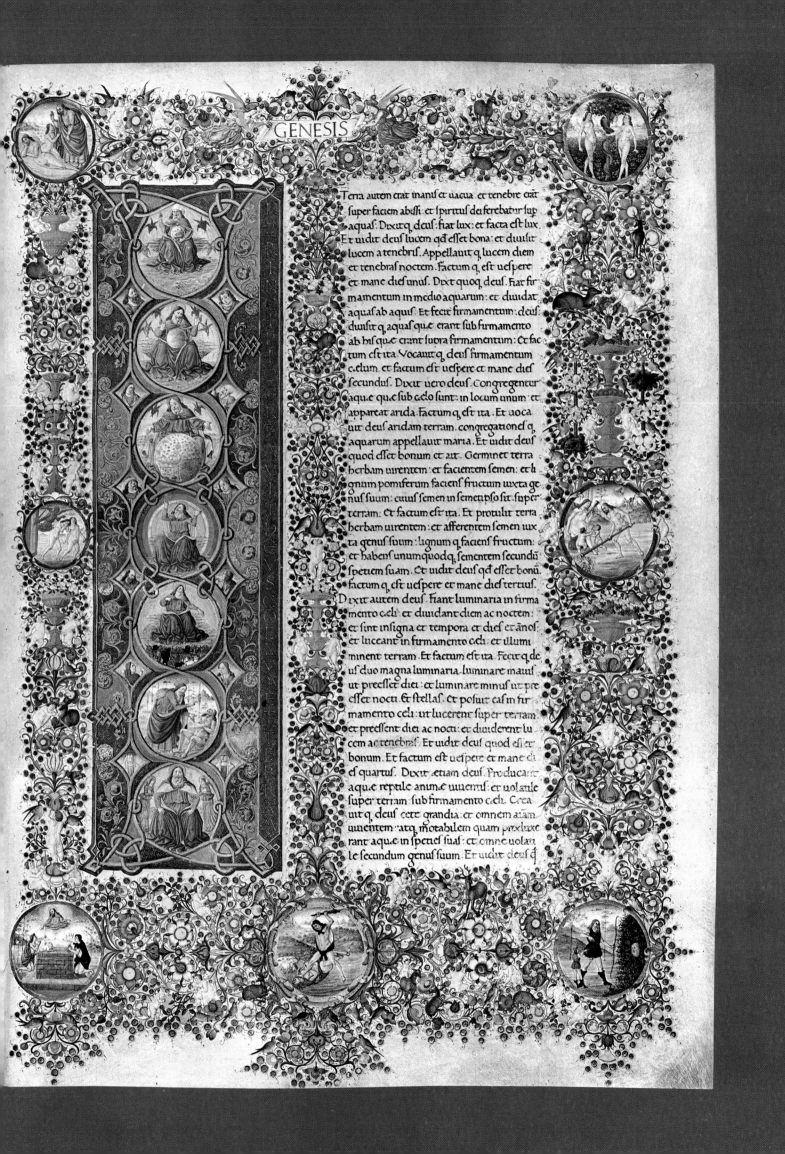

Terra autem erat inanis et uacua. et tenebre erat
super faciem abissi: et spiritus dei ferebatur sup
aquas. Dixitq deus: fiat lux: et facta est lux.
Et uidit deus lucem qd esset bona: et diuisit
lucem a tenebris. Appellauit q lucem diem
et tenebras noctem. factum q est uespere
et mane dies unus. Dixit quoq deus. Fiat fir
mamentum in medio aquarum: et diuidat
aquas ab aquis. Et fecit firmamentum: deus
diuisit q aquas que erant sub firmamento
ab his que erant supra firmamentum: Et fac
tum est ita. Vocauit q deus firmamentum
celum. et factum est uespere et mane dies
secundus. Dixit uero deus. Congregentur
aque que sub celo sunt: in locum unum: et
appareat arida. Factum q est ita. Et uoca
uit deus aridam terram. congregationes q
aquarum appellauit maria. Et uidit deus
quod esset bonum et ait. Germinet terra
herbam uirentem: et facientem semen: et li
gnum pomiferum faciens fructum iuxta ge
nus suum: cuius semen in semetipso sit super
terram: Et factum est ita. Et protulit terra
herbam uirentem: et afferentem semen iux
ta genus suum: lignum q faciens fructum:
et habens unumquodq. sementem secundu
spetiem suam. Et uidit deus qd esset bonu.
factum q est uespere et mane dies tertius.
Dixit autem deus. Fiant luminaria in firma
mento celi: et diuidant diem ac noctem:
et sint insigna et tempora et dies et annos:
et luceant in firmamento celi. et illumi
minent terram. Et factum est ita. Fecit q de
us duo magna luminaria. luminare maius
ut preesset diei: et luminare minus ut pre
esset nocti. Et stellas. et posuit eas in fir
mamento celi: ut lucerent super terram
et preessent diei ac nocti: et diuiderent lu
cem ac tenebras. Et uidit deus quod esset
bonum. Et factum est uespere et mane di
es quartus. Dixit etiam deus. Producant
aque reptile anime uiuentis: et uolatile
super terram sub firmamento celi. Crea
uit q deus cete grandia. et omnem aiam
uiuentem atq motabilem quam produxe
rant aque in speties suas: et omne uolati
le secundum genus suum. Et uidit deus q

A twelfth-century book of homilies from Constantinople. The miniatures represent the birth of John the Baptist and the Visitation of the Blessed Virgin. Cod. Vat. Graec. 1162, folio 159 verso.

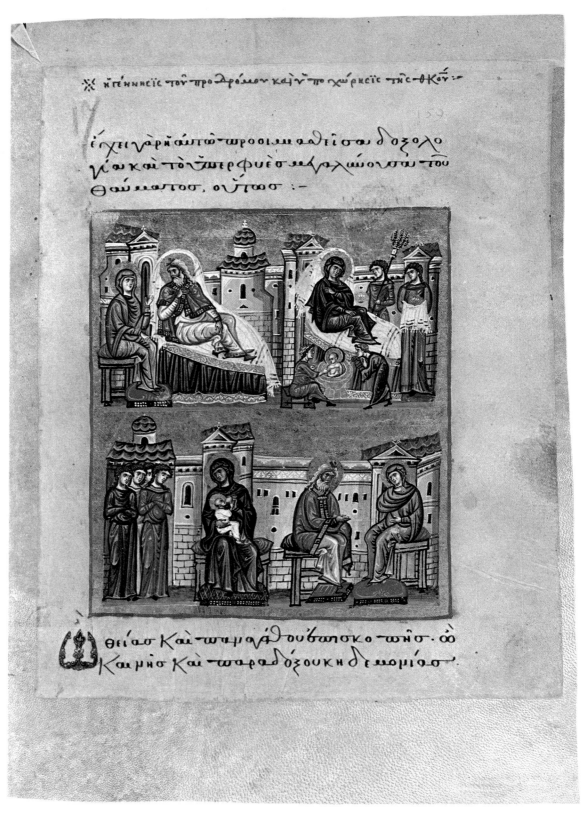

farther in that part of the palace. Radical measures had to be taken to provide more space for the storage of books and manuscripts and for their consultation by scholars. Under Pius IX the old vestibule to the east of the Salone Sistino was converted into a reading room, which soon proved inadequate. In 1885 Giovanni Battista De Rossi suggested to Leo XIII that a new wing, containing stacks and reading rooms, be constructed parallel to the corridor of Pius IV; four years later, the architect Francesco Vespignani submitted a plan for the addition of an upper story to the Salone Sistino, the Museo Chiaramonti, and the Galleria delle Carte Geografiche. Fortunately for the architectural harmony of the Vatican Palace, however, these projects were rejected. Leo XIII decided to utilize the lower levels of the palace, below the Salone Sistino and the east corridor of the Cortile del Belvedere.

The first floor of Sixtus V's wing had been as-

Epithalamium in honor of a member of the imperial family, perhaps Andronicus II Palaeologus. The miniature represents the fortifications of Constantinople. The manuscript was produced sometime between the beginning of the twelfth century and the beginning of the fourteenth century. Cod. Vat. Graec. 1851, folio 2 recto.

signed by Clement VIII (1592–1605) to the proofreaders of the Vatican printing press; under Urban VIII it was converted (together with the ground floor of Bramante's east corridor) into an armory. Like the Salone Sistino, the space beneath it was divided by piers into two aisles; there were rectangular rooms attached to the east and west ends. The south aisle was now made into a reference room; the north aisle and the two rectangular rooms became the stacks. Between April 1890 and June 1891 most of the books kept in the Gallery of Urban VIII, the Galleria Clementina, and the Biblioteca Chiaramonti were transferred to the new library. A number of governments and learned societies had made contributions for the embellishment of the reference room; a bust of Leo X, fittingly enough, was set up at one end and at the other, by Leo's request, a majestic statue of Saint Thomas Aquinas.

ТЙ ЕЦЬ, НСЪННЙЛЪ ПРЕБЫВААШЕ·
ЦРЖЕЛНХАНЛАВЪ ЗНЕНАВНДЕ ВЪ IAKO
ПНАННЦЙНВННОПННЦХ· НО ГРАННХ
РЫ ХЩАСАНПОЗОРЫДЕ ХЩА, ВЪ ЖТРОБѢ
ЕЛОУВЬ НЗ НЛЕТЬ· НВЛАСТЬ ВЬСХЫТН
ПРѢЖДЕВРѢЛЕНЕН ПРѢЖДЕ ГОДА·

iсщенне блъгаромъ·

ЦРТВОВАСНАНАДЛАКЕДЮНѢ ННАС
ЪНАБ НЕ ФОТiАНЗ ГНА Ю ЦРКВЕ· НПА
ИКЫ Ю ДАСТЬ ПРѢСТОЛѢ НГНАТНЕВН·
ВЬСХОТѢ ЖЕ ННАРОДОУ НЛАѢННЕ Ю
ДАТН· Н

НЗЫСКАВЪ ДОЛОВЫ ЗЛАТО
ХРАНАЩНХА· НЖЕ ПРѢКѢ ЕСѪ ТАЗААХѪ

† НПНСЕАЛЬ ВАСНЛІН ЦРНСРѢТНЫХ РУСН:—

Chronicle of Manasseh in a Bulgarian translation of about
1350. The manuscript represents the baptism of the
Bulgars in 864–65. Cod. Vat. Slav. 2, folio 163.

At the end of Leo's pontificate, in 1903, the ac-
quisition of the manuscripts and books of the Barberini
Library posed the problem of space once again, and a
fifty-meter section of the first floor of Bramante's cor-
ridor, which since 1825 had belonged to the Vatican
mosaic studio, was allocated to the library. The ele-
gant bookshelves of the Barberini Library were in-
stalled in the new room. Under Pius X (1903–1914)
other rooms nearby, which had previously been used
by the printing press, were adapted for the storage
and consultation of the Vatican's extremely important
collections of manuscripts. Pius XI (1922–39) con-
verted the stables on the ground floor of Bramante's
corridor into modern stacks for the printed books. At

the same time the present entrance to the library from the Cortile del Belvedere was opened to the public.

On the afternoon of December 22, 1931, the two central piers of Sixtus V's library collapsed, bringing down a whole section of the building, from the ground floor to the roof. Five people were killed. The entire staff set to work at once, and by the end of the New Year holidays most of the material in the library was again available to readers. When the damages were repaired, a plan that had already been under consideration was adopted: the two aisles of the central hall on the first floor and the rectangular room adjoining them to the west were combined to form the main reference room, which is in use today. New offices for the staff were created on the ground floor. The conversion of the premises was completed in November 1933, though further changes were made in 1936 and again in 1959. In 1971, under Paul VI (1963–78), new stacks were installed in the former carriage house on the ground floor of the west corridor of the Cortile del Belvedere.

The Function of the Library Today

The crisis of the nineteenth century, provoked by the unbridled acquisition of antiquities and works of art as well as of books and manuscripts, had the effect of restoring to the Vatican Library the essential function for which it had been conceived by Nicholas V and Sixtus IV. Today, the visitor to the Vatican Palace may admire the architecture and décor of the Salone Sistino and the corridor of Pius IV, as well as the works of art, curios, and selected manuscripts displayed in them, without necessarily being aware that these rooms are part of the Vatican Library. But the rooms created by Leo XIII and his successors on the floor below are dedicated, above all else, to the study of the Vatican's vast collection of manuscripts and early printed books.

The Vatican Library does not attempt to compete with the great national and university libraries of the world, which must keep abreast of publication in all fields, including the modern sciences. Some of these libraries also have rich manuscript collections, one or

History of Saints Barlaam and Joasaph, a manuscript of the fifteenth century. The baptism of Joasaph is illustrated. Cod. Vat. Arab. 692, folios 61 verso and 62 recto.

ל א טוב

The Four Orders of Jacob Ben Asher, written at Mantua
in 1436. The miniature represents a marriage.
Cod. Ross. 555, folio 220 recto.

A Syriac evangelary, completed on May 2, 1220, in
the monastery of Mar Mattay in Iraq. The miniature
is a representation of the Pentecost.

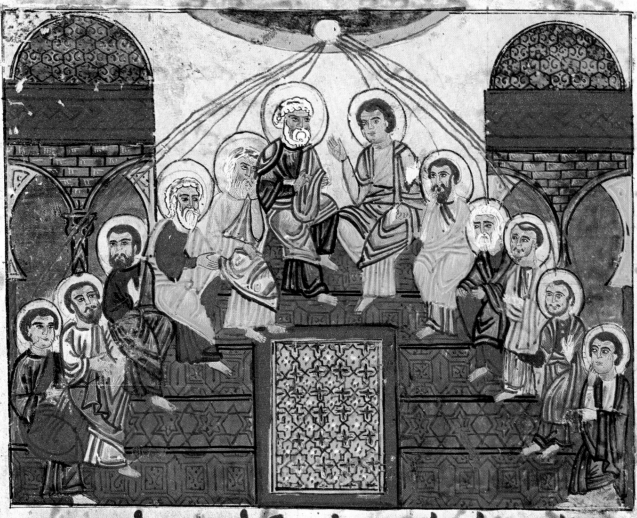

ܗܢܘ ܕܝܢ ܙܒܢܐ ܕܦܘܩܕܢܐ ܕܡܠܟܐ ܠܡܥܡܪ

ܘܠܚܡ ܝܘܠܦܢܐ ܒܗܢܐ
ܗܢܐ ܕܐܠܗܐ ܚܕܗܘ
ܕܐܠܗܐ ܕܗܘ ܐܢܘܢ ܗܘ
ܠܗܘܢ ܡܛܠ ܕܗܘ
ܡܠܟܐ ܐܠܐ ܡܛܠ ܗܕܐ
ܠܬܪ ܘܐܬܐ ܠܗ
ܟܕ ܠܐ ܢܚܘܢ ܠܗ
ܐܡܪ ܘܐܦ ܡܢܗܘܢ
ܠܝܗܘܢ ܐܡܪ ܗܘ
ܟܕ ܩܝܡ ܠܗܘܢ
ܐܬܐ ܗܘ ܟܕ ܗܘ
ܠܗ ܘܗܘ ܡܕܝܢ
ܟܘܠܗܘܢ ܘܐܡܪ
ܘܥܠܝܗܘܢ ܐܡܪ ܠܗ
ܗܘܠܡܝܢ܀ ܟܠܗܘܢ

BIBLIA SACRA
VVLGATAE EDITIONIS
AD
CONCILII TRIDENTINI
præscriptum emendata
ET
A SIXTO·V·P·M·
recognita et approbata·

Frontispiece of the Bible printed in 1590 by Aldus Manutius
the younger on the Vatican printing press set up by
Sixtus V near the Belvedere.

two of which are even larger than the Vatican's. But for the manuscript specialist working in the ecclesiastical disciplines and the humanities, the Vatican Library provides research facilities that have no equal anywhere. The main reference room, for the consultation of printed books, has all the introductory and comparative material necessary for the study of the manuscripts available in the manuscript room. Historians working in the nearby Secret Archive also have access to the main reference room. The use of the library is restricted to qualified specialists—because of limited space, and also because Rome has a number of other libraries that provide up-to-date facilities for students of the ecclesiastical and humanistic disciplines.

The Vatican Library possesses a large number of distinct collections, acquired, as we have seen, over the course of centuries. The manuscripts of the original Vatican collection (which has been constantly enlarged since the time of Nicholas V) are classified by language and number; the same collection includes printed books, which are classified by subject matter, except for the incunabula; the early books produced by the Vatican press, as well as the papyri, are classified separately. Other collections have not merged with the main collection, but have kept their original identity —either because of their importance, or in keeping with the terms of their endowment. Among the most important are the collections of the Barberini and Chigi libraries and of the old library of Saint Peter's Basilica, which contain manuscripts, printed books, and archival documents. No less important are the manuscripts and books from the Palatine, Capponi, Ferrajoli, De Rossi, Borgia (or De Propaganda Fide), Cerulli, and De Marinis collections. The collection of Queen Christina and the Ottoboni, Borghese, Boncompagni, and Sbath collections consist exclusively of manuscripts. An important collection of printed books was formed by the cardinal librarian Angelo Mai.

A few statistics may give an idea of the library's size. Some 65,000 manuscripts and more than 130,000 volumes of archival documents occupy 3,000 meters of shelves; over 700,000 printed books fill an additional 20,000 meters. Every year about 7,000 books and 7,000 periodical volumes are added to the works available to researchers.

JOSÉ RUYSSCHAERT

Gold seals (enlarged) of Frederick II, king of Sicily
and emperor, and of Ottokar I, king of Bohemia.

THE VATICAN SECRET ARCHIVE

The Vatican Secret Archive has been the Catholic church's central depository of records since the reign of Paul V (1605–1621), but a large part of its holdings is considerably older. New material from a great variety of sources has been added constantly over the years. The resulting collection is extremely complex in nature.

Although many parts of it are now open for consultation by scholars, the archive has kept its official designation as "Secret"; sovereigns' archives were formerly considered private, to be used only for the purposes of government. And the Vatican Archive still cannot be called public. It is the property of the pope, who remains in control of its administration. Nor is it a purely cultural institution like the Apostolic Library, despite the great cultural interest of many of its documents. According to Article One of the regulations laid down by Leo XIII in 1884, the first purpose of the archive is to serve the pope and the Curia in the administration of the church. Scholars are admitted only by the pope's permission.

Early History of the Church's Archives

The history of the archives of the church goes back to apostolic times. The early Christians felt a need to keep records of the church's work of evangelization and of its other activities. For this reason the bishops of Rome preserved, together with the Scriptures and doctrinal texts, the letters they received and copies of those they sent, as well as the acts of synods, the lives of martyrs, and documents concerning the government of the Christian community. Of the material accumulated in Rome before the end of the third century, very little has survived. This is largely the result of the persecution of Diocletian, who—according to the contemporary ecclesiastical historian Eusebius of Caesarea—ordered the destruction of all Christian writings in the year 303. After the peace granted by Constantine in 313, it was once again possible for the church to build up a collection of writings in an or-

derly manner. The archive, known as the *scrinium* or the *chartarium Romanae Ecclesiae*, is mentioned at the beginning of the fifth century by Saint Jerome in his letter against Rufinus of Aquileia, and in the letters of the popes from the time of Innocent I (401–417) onward. The *Liber Pontificalis*, a collection of early papal biographies, also refers to a number of documents deposited in the archives of the Roman church from the time of Celestine I (422–32) to that of Nicholas I (858–67).

It was once supposed that in the fourth century the papal archives were kept at the basilica of San Lorenzo in Damaso; this belief, based on an erroneous interpretation of an inscription of Pope Damasus (366–84), is no longer tenable. It is certain, on the other hand, that the *scrinium* was at the Lateran at least from the time of the council that met in 649 to condemn the Monothelite heresy; the *primicerius* (or chief notary) Theophylact drew up, for the council's use, extracts from the writings of Greek and Latin church fathers, and also of heretics, preserved in the Lateran archives. The presence of such writings in the *scrinium* shows that at the time there was no clear distinction between archives and libraries; this remained the case for a long time afterward.

Literary, theological, and liturgical works were kept in the archives in addition to the letters received and the copies of papal letters and other documents. New Christian communities were supplied with copies of these texts. The papal archive-library was also accessible to scholars, who used it in compiling canonical collections. A considerable number of officials were required to run the *scrinium*. They included the *notarii* and *scrinarii*, headed by the *primicerius notariorum*, who was later replaced by the *bibliothecarius* or *cancellarius*.

Important papers were also kept in other safe places, such as the Confessio of Saint Peter's, where the professions of faith of bishops were deposited, and the *chartularium*, on the slopes of the Palatine Hill, near the Arch of Titus, where at the end of the elev-

enth century Cardinal Deusdedit obtained material for his *Collectio canonum*. Until the beginning of the thirteenth century, however, the seat of the pope's archives remained at the Lateran.

Most of the archival material produced before the pontificate of Innocent III (1198–1216) has unfortunately been lost. Papyrus, the material ordinarily used by the papal Chancery for documents and registers until the eleventh century, is very fragile. Many popes were obliged to change residence during troubled times; they took their archives with them, to the inevitable detriment of the documents. Rome was constantly disturbed by struggles between rival factions of the nobility, by popular uprisings, and by war—in 1084, for example, the city was sacked by the Norman troops of Robert Guiscard. The archive possesses a diploma of the emperor Otto I, written in gold on purple parchment in 962; a volume of letters of Pope John VIII (872–82), copied in the eleventh-century script of Benevento; the original register of the letters of Gregory VII (1073–85); the Concordat of Worms (an agreement between Pope Callistus II and the emperor Henry V, signed in 1122); three letters, written in gold on purple parchment, from Byzantine emperors—two from John II Comnenus to Callistus II (1124) and Honorius II (1126), and one from Manuel I Comnenus to Eugenius III (1146); a diploma of Frederick I Barbarossa (1164), with a gold seal; and a diploma of Henry VI (1195).

A more fortunate period for the papal archives began with Innocent III. The popes of the thirteenth century stayed at the Vatican for longer periods than their predecessors had done, because it was better defended than the Lateran; Innocent began to make the Leonine City the center of curial life. He transferred two important offices, the Chancery and the Apostolic Camera, from the Lateran to the Vatican, and as a result the archives were also transferred.

The documents were better protected in the new location, though losses continued. With the pontificate of Innocent III there begins the regular series of registers of the letters of the popes, preserved in the Secret Archive under the heading Registra Vaticana. The rich collection known as the Treasury of the Pope and of the Roman Church comprises bags of gold and silver coins and precious objects of all sorts as well as documents on parchment, the registers of the Chancery, and numerous books. The archives were in fact part of the treasury, which the popes took with them when they were obliged to leave Rome.

Moves were all too frequent during the thirteenth century and the first half of the fourteenth. The archives went with Innocent IV (1243–54) to the Council of Lyons in 1245; later in the century we find them at Viterbo, under a series of popes, and later still with

Boniface VIII (1294–1303) at Anagni. In 1304 they followed Benedict XI (1303–1304) to Perugia, where after about ten years they were divided into two sections; some of the documents were sent to Carpentras (a papal town in southern France), and the rest to Assisi, where they were kept in the sacristy of the church of San Francesco. Between 1339 and 1342 this portion of the archives was sent to Avignon, where the popes had been in residence since 1309.

Following the return of the pope and the Curia to Rome in 1377, the church entered the dramatic period of the Great Schism. A few months after the election in Rome of Urban VI (1378–89), dissident cardinals elected an antipope, Clement VII (1378–94), at Fondi; in June 1379 Clement took possession of the papal palace at Avignon. The archives had remained at Avignon, and they continued to grow under Clement and his successor, the antipope Benedict XIII (1394–1423). Meanwhile, in Rome, new papal archives were formed under Urban VI and his successors Boniface IX (1389–1404), Innocent VII (1404–1406), and Gregory XII (1406–1415). Another archive originated at Pisa with the election there of the antipope Alexander V (1409–1410), who was succeeded by John XXIII (1410–15). Thus three separate archives corresponded to the three "obediences," the Roman, the Avignonese, and the Pisan.

The schism was brought to an end with the election of Martin V (1417–31) during the Council of Constance, and the archival material compiled since 1377 was gradually unifed. But all of the earlier material was still at Avignon. It was returned in several stages; the last of it did not reach Rome until 1783. After the various offices and tribunals of the Roman Curia resumed their normal functions, each built up its own archives. But the oldest registers of papal letters, because of their importance, were placed by Sixtus IV (1471–84), the founder of the Vatican Library, in a special section known as the Secret Library. The same pope deposited other documents of particular value, such as the diplomas of sovereigns and records of the privileges of the Roman church, in the fortress of Castel Sant'Angelo. The wisdom of these precautions was demonstrated during the Sack of Rome in 1527: the books and documents in the Secret Library and Castel Sant'Angelo survived unharmed, whereas many of those kept elsewhere were damaged or destroyed.

From Paul V to the Present

The popes after Sixtus IV continued to store documents in Castel Sant'Angelo. Pius IV (1560–65), Pius V (1566–72), Gregory XIII (1572–85), Sixtus V (1585–90), and Clement VIII (1592–1605) assembled archival material with great zeal. But the collection in Castel

Documents with gold seals, including two letters (dated February
1212 and September 1219) from Frederick II, king of Sicily and
emperor, to Pope Honorius III and a letter sent by King Ottokar I
of Bohemia to the same pope, written in 1217.

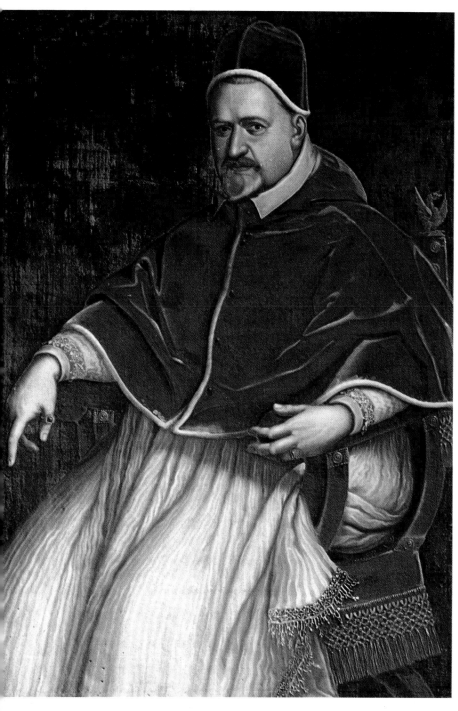

Portrait of Paul V, founder of the
Vatican Secret Archive.

Sant'Angelo could not be considered the central archive of the Holy See; it was not an archive at all, in the modern sense, but rather a treasury of precious documents. The need for a real central archive was increasingly felt. The material that was still scattered in many different places not only had to be preserved; it also had to be made easily available for the defense of the church's interests, for the conduct of ecclesiastical and political affairs and the government of the Papal State, and for the use of Catholic historians.

In 1593 Clement VIII announced his intention of bringing all of the church's documents together in Castel Sant'Angelo, but his project came to nothing. It was his successor, Paul V (1605–1621), born Camillo Borghese, who gave the church a central archive—not in Castel Sant'Angelo, but in the Vatican. Paul met with opposition from some of the departments of the Curia, which preferred to keep their documents in their own archives, but with the help of Cardinal Bartolomeo Cesi he overcame all obstacles, and within a few years of his election he was able to begin the great enterprise.

A brief of January 31, 1612, is considered the "birth certificate" of the Secret Archive; in it, Paul V made Baldassare Ansidei its archivist and mentioned the transfer of documents to the new center. But several years were required to complete the operation. Three rooms next to the Salone Sistino of the Vatican Library, which had formerly served as the residence of the cardinal librarian, were selected for the seat of the new archive; today they constitute its first floor. The wall frescoes represent donations to the church by rulers from Constantine to the German emperor Charles IV of Luxembourg. The original wooden cabinets are still in use. In them, in 1614, the documentary material that constituted the nucleus of the archive was installed. In the following year Michele Lonigo, who played an important part in the organization of the new institution, compiled the first inventory. He included a historical introduction, entitled *Erectio novi archivi Bibliothecae Vaticanae* (published in 1887 by Francesco Gasparolo), in which he informs us that the largest part of the material came from the archives of the Apostolic Camera; the rest came from the Vatican Library, the papal Guardaroba, and Castel Sant'Angelo.

The new archive became completely autonomous under Urban VIII (1623–44), when Felice Cantelori, who until 1630 was prefect of both the library and the archive, was placed in charge of the archive alone. We cannot enumerate here all the additions made by Urban and his successors; we may mention, however, the collection of the diplomatic correspondence of the Holy See, begun by Urban and continued by Alexander VII (1655–67), who had these documents installed in new rooms on the second floor. Two general inventories

are also worth mentioning. The first was drawn up by Giovanni Bissaiga in 1672 and the second by Pietro Donnino De Pretis in 1727–30. A comparison of the two shows that during the interval the entire Secret Archive had undergone a radical reorganization. The great Cardinal Giuseppe Garampi, who was prefect from 1751 to 1772, is remembered especially for the gigantic catalogue which bears his name and which is still in use.

In 1810, by order of Napoleon, the Secret Archive and the other archives of the Roman Curia were transferred to Paris and installed in the Palais Soubise. It was Napoleon's intention to bring together in Paris all of the important historical archives of the nations he had conquered. After his fall most of the documents were returned to Rome, though many volumes are still in Paris and elsewhere. The prefect Gaetano Marini, who had followed the Vatican Archive to Paris, died

The rooms assigned to the Vatican Secret Archive by Paul V.

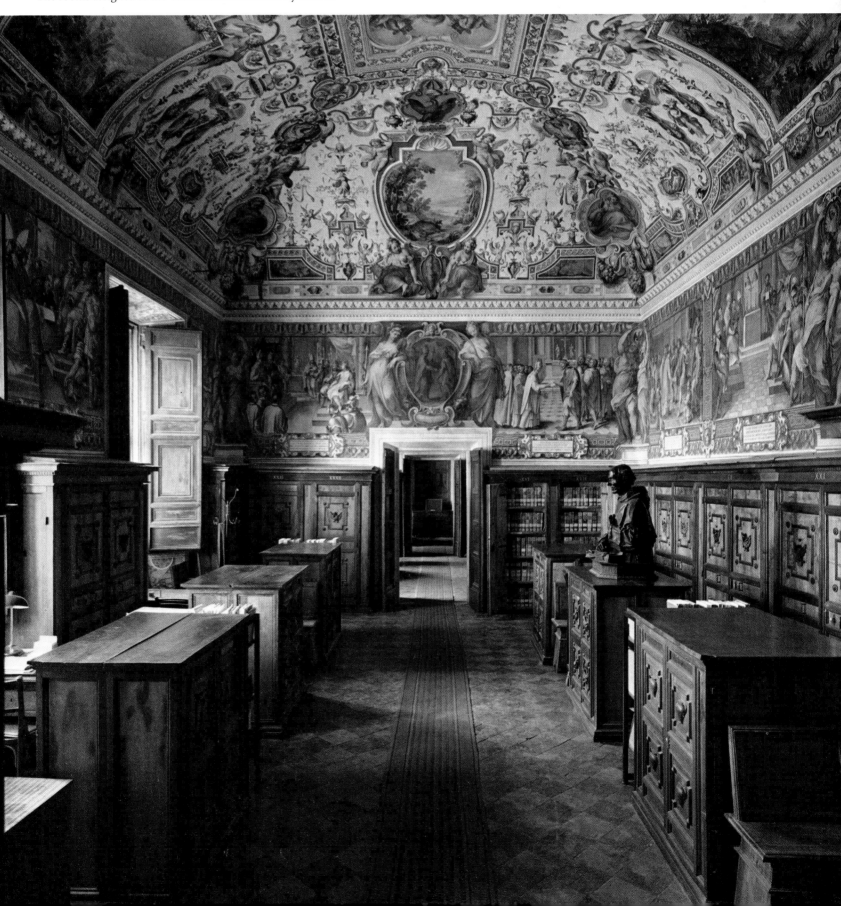

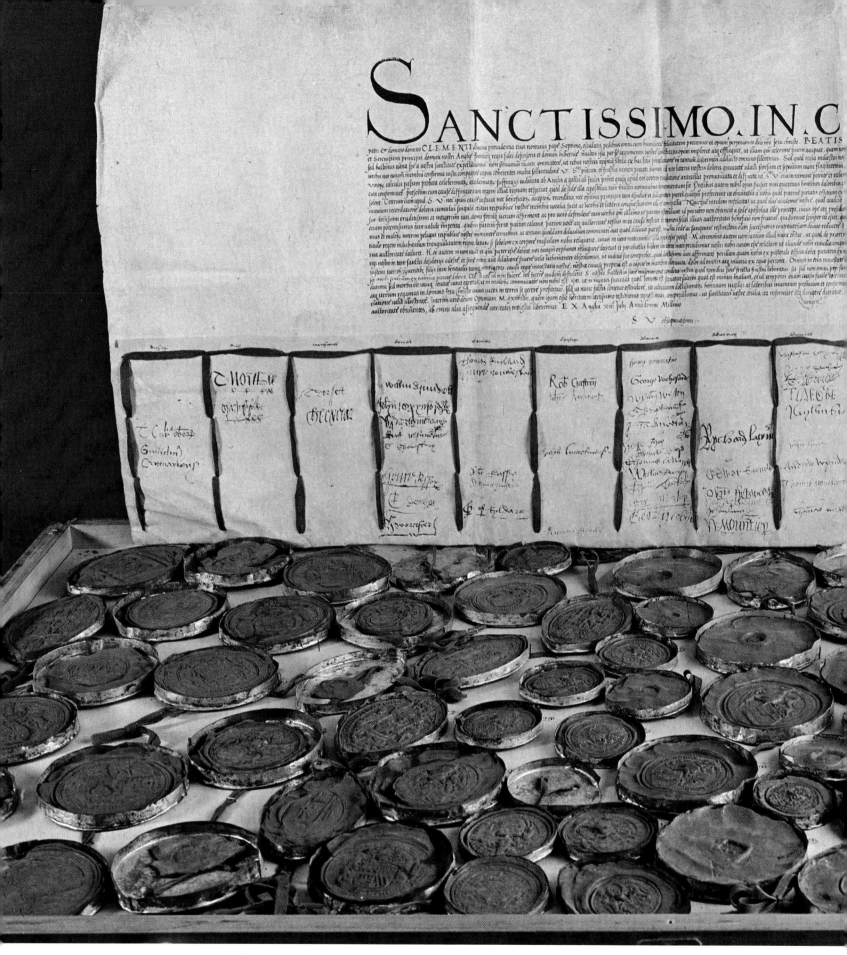

The appeal from the English peers to Pope Clement VII, urging him to annul the first marriage of Henry VIII, with the signatures of the petitioners and eighty-five red wax seals.

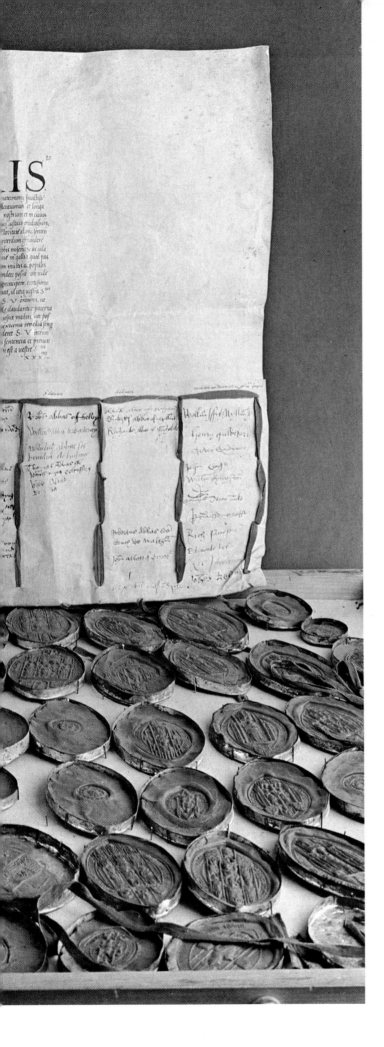

there in 1815; his nephew Marino Marini oversaw the restitution of the material between 1815 and 1817. During the prefecture of the younger Marini, between 1835 and 1836, the Secret Archive was enriched by the important collection of the papal nunciature at Venice, together with many thousands of documents from Venetian, Lombard, and Tuscan religious houses that had been suppressed by Clement IX in 1668 so that he might finance the war against the Turks with their possessions.

With Leo XIII (1878–1903) there began a new era in the history of the Vatican Archive. Aware of the great importance of the institution, Leo took a number of measures to increase its prestige. He decided, for example, that the prefect should be a cardinal, and he appointed to this office the historian Joseph Hergenroether. In 1880 he opened the doors of the archive to scholars. As a result, the Secret Archive has become the world's most important center of historical research. In 1884 Leo instituted, as a subsidiary of the archive, the School of Paleography and Diplomatics.

After the opening of the archive, an abundance of material from other places was transferred to the Vatican so as to facilitate consultation by scholars. After the First World War there was another influx of material, as a result of the increased diplomatic activity of the Holy See and the consequent multiplication of official documents. The Vatican Archive gradually acquired, in whole or in part, the archives of a number of sacred congregations, those of the diplomatic representations of the Holy See in various European countries, and those of several noble families.

In 1929 Pius XI (1922–39) provided the archive with a new consultation room for scholars, and in 1933 he had thousands of meters of metal shelving installed in the rooms formerly occupied by the Pinacoteca in the west corridor of the Cortile del Belvedere. After the Second World War, Pius XII (1939–58) converted the attics above the Galleria delle Carte Geografiche and those of the Belvedere of Innocent VIII into storerooms for the archive's documents. John XXIII (1958–63) added a photographic studio, a bindery, and a conservation laboratory; he also increased the number of consultation rooms. In 1968 Paul VI (1963–78) decided to provide the School of Paleography and Diplomatics with a new home; it opened in 1970.

It might have been supposed that the enormous increase in storage space in recent decades would suffice to meet the archive's needs for a long time to come. But this has not been the case; the premises are already filled to capacity. Vast quantities of documents have come in from the Secretariat of State and from the sacred congregations, tribunals, and offices. The entire archives of offices and military corps recently suppressed by the Holy See, including the Apostolic Chan-

Obverse of a gold bulla containing the wax seal of Charles III of Bourbon, king of the Two Sicilies, and the obverse of a silver-gilt bulla containing the wax seal of King Ferdinand IV of the Two Sicilies.

cery, the Datary, the Chancery of Papal Briefs, the Noble Guard, and the Palatine Guard, have entered the Secret Archive.

The Contents of the Secret Archive

The official letters of the popes, represented by transcriptions of the originals, are of two main varieties, bulls and briefs. These are distinguished physically—though there are other differences—by the type of seal:

bulls are equipped with metal seals, usually of lead, while briefs have seals of wax.

The oldest and most important bulls are collected in the 2,042 volumes known as the Registra Vaticana. The series begins with two isolated volumes mentioned above, containing the letters of John VIII and Gregory VII; from the time of Innocent III to Pius V the sequence is nearly unbroken; a few volumes of later, heterogeneous material is also included. The Registra Vaticana are considered the most important documentary source

Reverse of a gold bulla containing the wax seal of Charles III of Bourbon, king of the Two Sicilies, attached to the diploma of his investiture (dated April 9, 1739).

"De Sicilie Regno," by Cardinal Nicholas of Aragon,
a manuscript of the fifteenth century.

for the history of Europe in the thirteenth and fourteenth centuries. The Registra Avenionensia, consisting of 349 volumes and 4 appendices, contain the bulls of the popes and antipopes who resided at Avignon, together with documents of the Apostolic Camera. The series begins with a volume from the reign of Clement V (1305–1314), containing documents other than bulls, and continues for over a century from John XXII (1316–34) to the last years of the antipope Benedict XIII (1394–1423). The bulls contained in the Registra Lateranensia range in date from the reign of Boniface IX (1389–1404) to that of Leo XIII (1878–1901). Although their removal to Paris caused the loss of nearly half the contents, the Registra Lateranensia, with their 2,467 volumes, comprise the largest series of papal bulls.

The registers of briefs begin with the fifteenth century and are far more numerous. Many thousands of volumes contain innumerable letters.

The concessions granted in papal letters were often in response to petitions; the Registra Supplicationum, consisting of 7,400 large volumes, contain transcriptions of petitions received by the Holy See between 1342 and 1899.

The Apostolic Camera shared responsibility with the Chancery and the papal secretaries in the preparation, dispatch, and registration of papal letters, but its principal functions were administrative, financial, and judicial. The records of the Apostolic Camera, which go back to the thirteenth century and are contained in several series of registers, are therefore of particular importance. Another holding, the Fondo Concistoriale, documents the activities of the college of cardinals from the fifteenth century on; a special series within it is devoted to papal conclaves. The records of a number of other curial congregations and offices go back to the sixteenth century.

The archives of the Secretariat of State are of particular value as documentary sources for recent and contemporary history. The older sections, dating from the sixteenth century to the Napoleonic period, are classified by nunciatures and legations, and according to the rank of the persons concerned (cardinals, princes, nobles, private citizens, and soldiers). The modern sections, beginning in 1814, are classified according to subject matter. This mass of documents, covering a wide range of religious, political, diplomatic, and administrative affairs, is complemented by the archives of various nunciatures, which entered the Secret Archive in more or less recent times. The Prisoners of War and Information Office sections bear witness to the Holy See's efforts to obtain and transmit information about the fate of both soldiers and civilians during the First and Second World Wars.

Other holdings are not related specifically to curial departments. They include the archives of the Council of Trent and the First Vatican Council. A section known as the Miscellanea was compiled in the sixteenth century; its extremely varied contents, which go back to the twelfth century, include the court proceedings of the trial of Galileo Galilei in 1633. The archives of Pius IX contain numerous letters of the pope and letters from sovereigns and other illustrious correspondents. Many archives formed by well-known individuals and noble families have also entered the Secret Archive.

The so-called Diplomatic Archive does not consist of a single chronological series of documents, but rather of a number of different holdings varying in size, origin, and importance. A notable part of the Diplomatic Archive is formed by almost 8,500 documents that were formerly kept in Castel Sant'Angelo. This section covers a thousand years, and is rightly considered the most valuable of the Vatican's collections of documents. It contains records of ecclesiastical privileges, diplomas and letters from sovereigns, solemn acts of the popes, international treaties, and other papers of great historical importance. Among these documents are 69 with gold seals, ranging in date from the time of Frederick Barbarossa (1152–90) to that of Charles III of Bourbon, king of the Two Sicilies (1734–59). There are also 9 documents with silver seals, dating between 1664 and 1803. In addition to those already mentioned (the diploma of Otto I, the Concordat of Worms, and the three letters from Byzantine emperors of the Comnenus dynasty), the documents from Castel Sant'Angelo include letters written to the popes by various European rulers between the twelfth and the fourteenth centuries; the decree of the Council of Florence that proclaimed (to no avail) the union of the Greek and Latin churches in 1439; the appeal sent by the peers of England in 1430 to Clement VII, urging him to grant the annulment of Henry VIII's marriage to Catherine of Aragon; a letter of 1650 to Innocent X, written on silk, from the Chinese empress dowager Helena, who had become a Christian; and the ratification by the Swedish parliament of Queen Christina's abdication in 1654, with the signatures of the members and 306 wax seals.

MARTINO GIUSTI

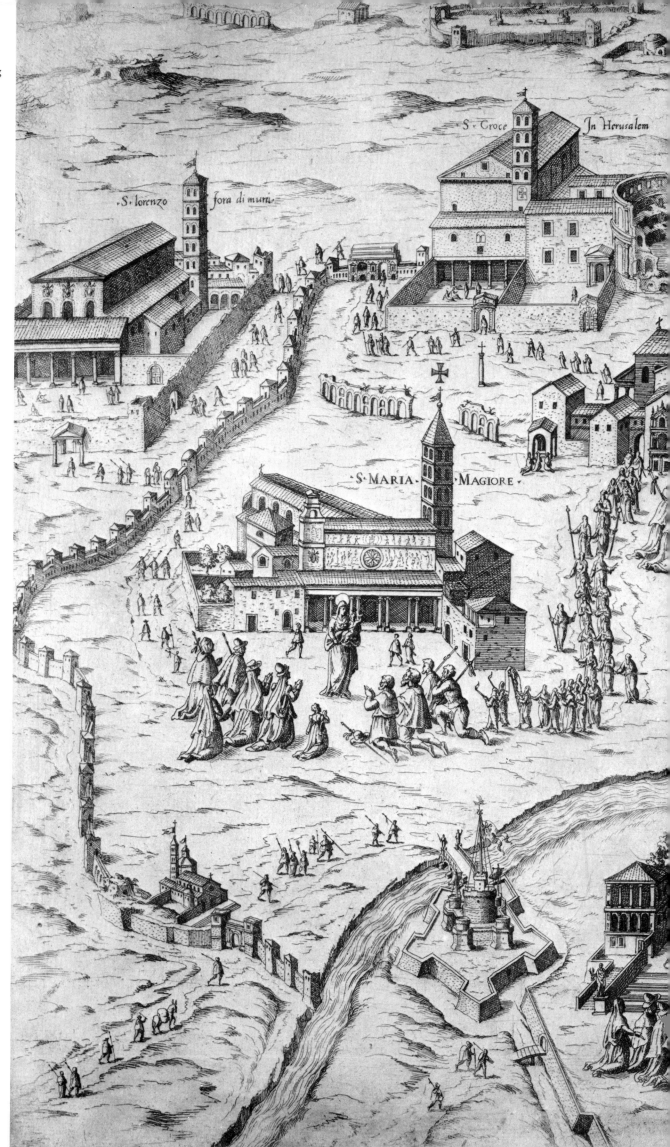

S·lorenzo fora di muri

S·Croce In Herusalem

·S·MARIA·MAGIORE·

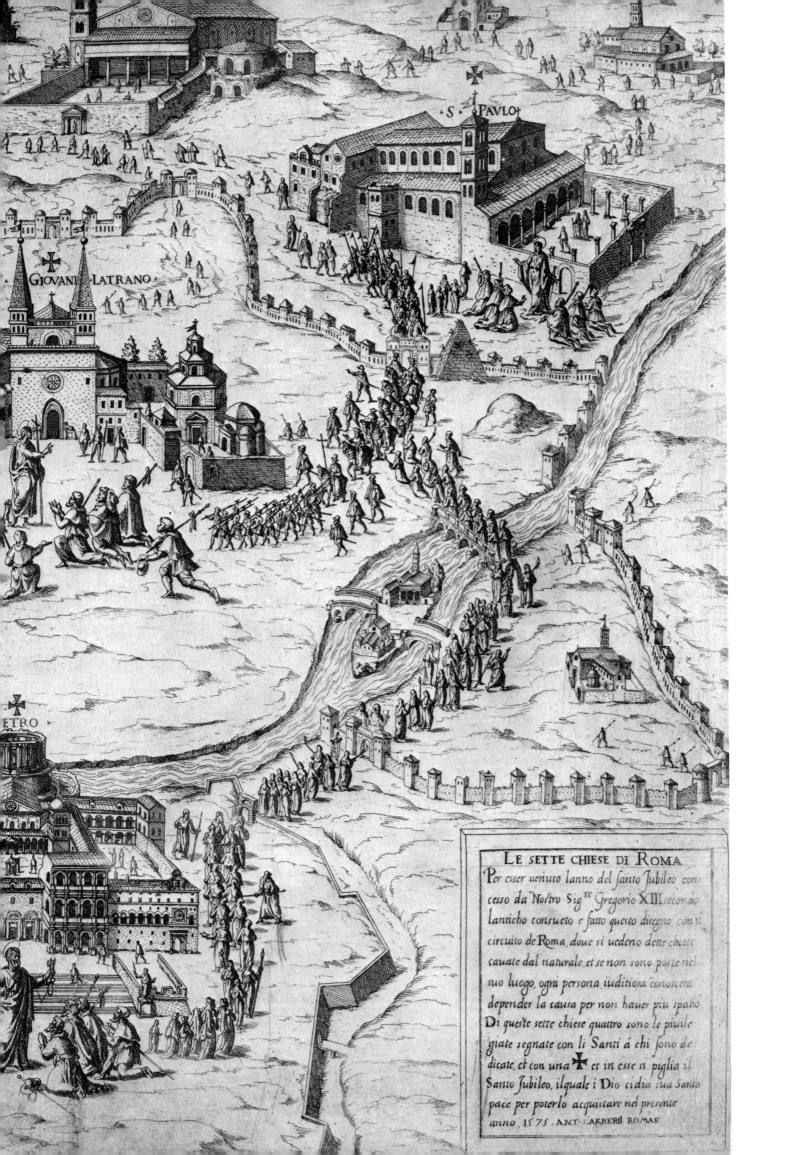

S·PAVLO

GIOVANI·LATRANO

...ETRO

LE SETTE CHIESE DI ROMA

Per esser uenuto lanno del santo Jubileo con=
cesso da Nostro Sig.re Gregorio XIII secondo
lantico consueto e fatto questo disegno con il
circuito de Roma, doue si uedeno dette chiese
cauate dal naturale, et se non sono poste nel
suo luogo, ogni persona iuditiosa conoscera
depender la causa per non hauer piu spatio
Di queste sette chiese quattro sono le piuile=
giate segnate con li Santi á chi sono de=
dicate, et con una ✠ et in esse si piglia il
Santo Jubileo, ilquale i Dio cidia sua Santa
pace per poterlo acquistare nel presente
anno, 1575. ANT· LAFRERII ROMAE

311

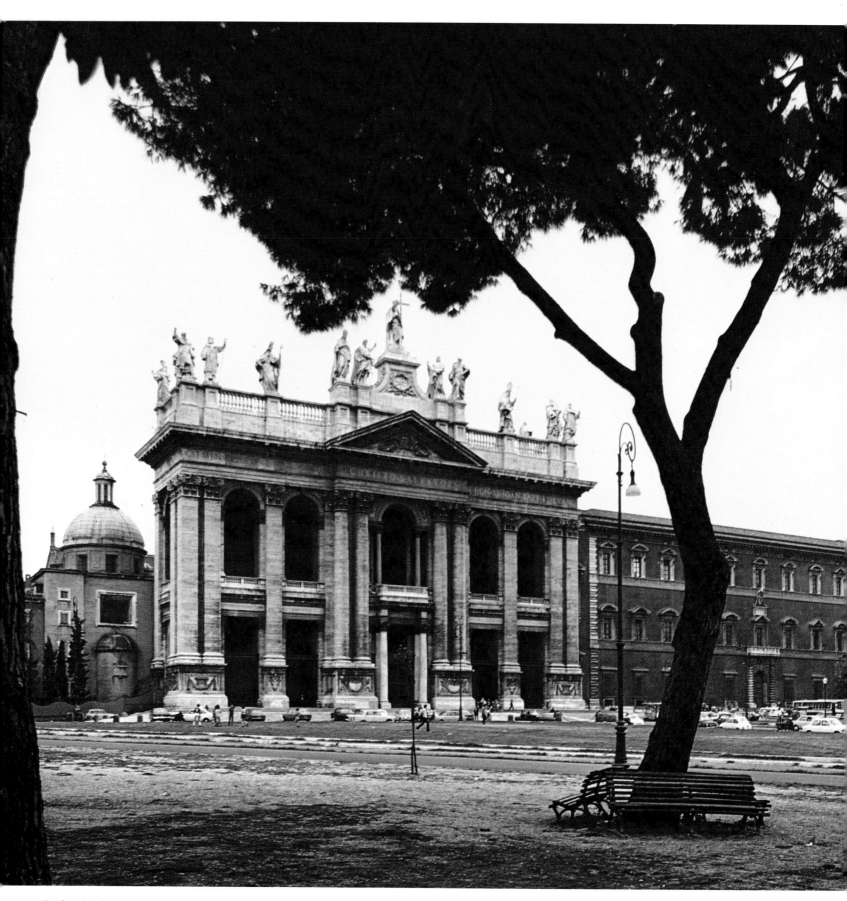

The façade of San Giovanni in Laterano, by Alessandro Galilei.
Built on land that had belonged to a family called the Laterani,
the basilica was first dedicated to the Savior and later to
Saints John the Baptist and John the Evangelist.

THE PILGRIMAGE BASILICAS

The word "basilica" has a rather complicated history. It is derived from *basilikē*, the feminine form of the Greek adjective meaning "royal"; there may be a connection with the Stoa Basilikē, the building in Athens where the *archon basileus* (a magistrate whose religious and judicial duties were inherited from the kings of early times) conducted his affairs of office. But the Stoa Basilikē was an open portico, whereas the public buildings that the Romans called basilicas were walled on all sides. Roman basilicas had various functions: the earliest ones seem to have been covered markets, but they were also used very extensively as law courts and as meeting places, and in a few instances for cult purposes. Architecturally, as we know from excavations and from literary sources, they were of several types. For the most part they were rectangular, with a high central hall lighted by windows in the upper walls and surrounded by low colonnaded aisles; some of the later examples had one or more projecting apses.

The earliest Christians celebrated the Eucharist in private houses. In Rome, as the Christian community grew, a number of houses were donated to the church or purchased by it, and set aside for religious purposes: known as *tituli*, they were the forerunners of the parish churches of more recent times. A few very simple meeting houses may even have been built by Christian congregations. But until the time of Constantine there were no buildings in Rome that resembled what we today would call churches. Once Christianity became an established religion, however, the church needed monumental buildings of its own. Pagan temple architecture could not be imitated; temples, for the Christians, had diabolical associations, and their forms were not suited for the celebration of the Christian liturgy. The church therefore turned to secular architecture for its models, and took over the general features, and the name, of the basilica for important places of worship such as San Giovanni in Laterano and Saint Peter's.

In modern architectural parlance, Early Christian churches of the standard type (and later churches that imitate them), with a longitudinal nave flanked by two or four aisles and terminating in a semicircular apse, are called basilicas to distinguish them from other types such as the centrally planned church. In Early Christian times, however, the term was used even for round structures, and soon it ceased to have a precise architectural meaning. For centuries a basilica was any venerable church at a Christian site of particular importance. Eventually, for the Catholic church, the word came to signify a church to which certain privileges were attached, and its use was circumscribed by canon law.

Canonically, a distinction is made between major and minor basilicas. The major basilicas of Rome are, in order of rank, San Giovanni in Laterano, Saint Peter's San Paolo fuori le Mura, and Santa Maria Maggiore. Major basilicas have papal altars, where only the pope may celebrate Mass, and "holy" doors, which are opened only during jubilee years. Each major basilica is in the charge of a cardinal archpriest who represents the pope (at San Paolo, which is administered by Benedictine monks, the abbot performs the archpriest's office). The clergy attached to the major basilicas enjoy various privileges of a largely ceremonial nature—for instance, they may wear in choir a violet cloak called the *cappa magna*, which is usually reserved for cardinals and bishops. Special indulgences are also granted to the faithful who visit these churches. The four churches mentioned above are also called patriarchal basilicas: San Giovanni is the official seat of the pope, who is patriarch of the West; Saint Peter's is, theoretically, the Roman seat of the patriarch of Constantinople, San Paolo of the patriarch of Alexandria, and Santa Maria Maggiore of the patriarch of Antioch. When the bishop of Jerusalem was granted patriarchal dignity, at the Council of Chalcedon in 451, the basilica of San Lorenzo fuori le Mura was assigned to that prelate. San Lorenzo counts as a patriarchal basilica, but not as a major one.

Minor basilicas, as the name implies, are of lesser status than the major basilicas, though some of them are equally ancient. The privileges enjoyed by the clergy and the spiritual benefits available to visitors correspond, in a limited fashion, to the privileges and benefits associated with the major basilicas. Numerous churches throughout the world have been designated as minor basilicas; there are eleven of them in Rome.

From very early times, pilgrims came to Rome to pray at the tombs of the apostles Peter and Paul and of numerous other martyrs. Local Christians, too, made a point of visiting the holy places; late in the fourth century Saint Jerome, in his commentary on Galatians, wrote: "Praised be the faith of the Romans! Where else do people go so zealously and frequently to the churches and the martyrs' tombs?" Under Pope Damasus I (366–84), whose secretary Jerome was, signposts in the form of metrical inscriptions were set up in the catacombs. By the seventh century guidebooks known as *itineraria*, explaining how to get from one holy place to another, were being written for the benefit of pilgrims. Medieval itineraries were long and elaborate; the twelfth-century chronicler William of Malmesbury tells us that one of them led the pilgrim out through fourteen different gates in the city walls to visit the cemeteries beyond.

In 1300 Boniface VIII (1295–1303) instituted the Holy Year, granting special indulgences to all who came to Rome, took the sacraments, and prayed at the holy places. The interval between Holy Years varied at first, but in 1470 it was fixed at twenty-five years. The influx of pilgrims on these occasions became so great that the old itineraries had to be simplified. By the late Middle Ages the existence of the catacombs had long been forgotten, and the pilgrims' interest was centered in the great basilicas and the relics they contained. At the beginning of the fifteenth century Adam of Usk wrote: "The circuits of full indulgence, to lighten the heavy toil of visiting others, are confined to seven churches: to wit, Saint John Lateran, Saint Mary the Greater, Saint Cross of Jerusalem, Saint Peter, Saint Paul, Saint Lawrence without the walls, and Saints Fabian and Sebastian"—the five patriarchal basilicas, that is, plus Santa Croce in Gerusalemme and San Sebastiano fuori le Mura. We do not know exactly why the number of churches to be visited was fixed at seven. Gregory Martin, the English Catholic scholar who spent the years 1576–78 in Rome and later wrote a book, *Roma Sancta*, about religious practices in the city, offers a commonsense explanation: "From five there grew to be seven churches, more frequented than the rest," because people traveling from San Paolo to San Giovanni "went a little out of their way" to San Sebastiano, "a church of wonderful preeminence and most glorious relics," and afterward, leaving San Giovanni, "right in the way they would needs visit the church of the Holy Cross, built by Constantine and full of precious relics, and so on their pilgrimage to Saint Lawrence and Saint Mary Major." Martin adds that although "no man thinks he has done his pilgrimage till he have devoutly visited the Seven Churches," there is no superstition involved—to say so would be blasphemy, for the number seven abounds in Scripture.

To this day it remains a pious practice to visit the seven churches. Saint Peter's has already been described in the section on the Vatican; the other six pilgrimage basilicas will be described in the following section.

JOHN DALEY

San Giovanni in Laterano

The Early Christian and Medieval Lateran

The cathedral of Rome, San Giovanni in Laterano, takes the second part of its name from the original proprietors of the land on which it stands, a family called the Laterani. This land was donated by Constantine to Pope Melchiades (311–14); the Lateran area is first mentioned in connection with the Roman church in 313, when a council of bishops was held "in domum Faustae in Laterano"—this building seems to have been a mansion belonging to Fausta, who was Constantine's second wife, the sister of his defeated rival Maxentius, and a convert to Christianity. The basilica was begun at about the same time; excavations carried out in 1934–38 revealed that it was constructed on the foundations of the barracks of Maxentius's horse guards, the *equites singulares*. It was originally dedicated to the Savior; under Gregory the Great (590–604), Saint John the Baptist and Saint John the Evangelist were also made its patrons, and it has come to be known as San Giovanni in Laterano.

The Constantinian basilica had a long, high nave with two lower aisles on either side. The columns of the nave supported straight architraves, while those between the aisles were surmounted by arches. The nave terminated in an apse; at the ends of the outer

aisles were low chambers, projecting slightly to either side, which perhaps served as sacristies. The floor was paved with marble of various colors, and there was probably a coffered ceiling. The church was sumptuously decorated with revetments of precious marble, gold foil in the apse, and gold and silver furnishings. Sixtus III (432–40) had the nave painted with a mural cycle representing biblical events.

The Lateran was sacked by invading Vandals in 455, and restored by Leo I (440–61); Sergius I (687–701) and Hadrian I (772–95) again had occasion to restore it. After an earthquake in 896, Sergius III (904–911) rebuilt it, preserving the original plan. In the twelfth century a narthex, or porch, was added. Its mosaic decoration celebrated a fictitious event in which the medieval church believed wholeheartedly: the Donation of Constantine, by which that emperor had sup-

posedly conferred upon Pope Sylvester I (314–35) and his successors temporal sovereignty over the Western world.

Between 1215 and 1252, a spacious cloister was constructed just to the south of the basilica. With its delicately carved paired colonnettes, some of them twisted and inlaid with mosaic, the cloister is a precious example of the art of the medieval Roman marble workers who are known generically as the Cosmati, after one of the families among them; an inscription tells us, however, that the creators of the cloister were a father and son called Vassalletto.

Under Nicholas IV (1288–92), the low chambers at the ends of the aisles were replaced by a continuous transept equal in height to the nave. At approximately the same time two Franciscan artists, Jacopo Torriti and his assistant Jacopo da Camerino, executed the

The cloister of San Giovanni in Laterano, constructed between 1215 and 1252, is a precious example of the art of the medieval Roman marble workers.

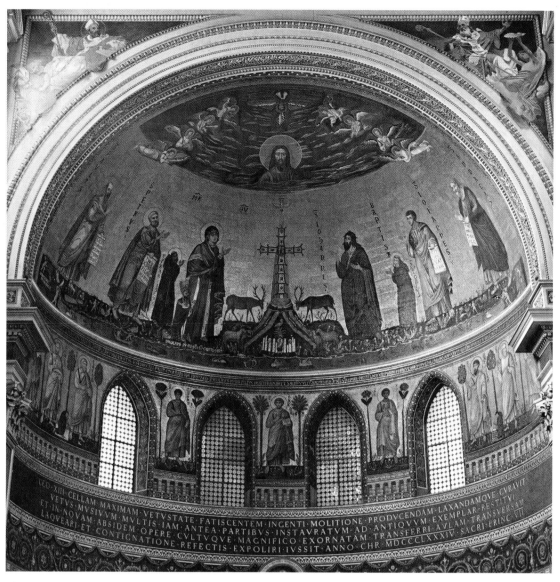

The apse mosaic of San Giovanni was executed by Jacopo Torriti
and Jacopo da Camerino at the end of the thirteenth century.
It was drastically restored in 1884.

mosaic in the vault of the apse (when the presbytery was enlarged and the apse moved further west under Leo XIII in 1884, the mosaic was so heavily restored that what we see today may best be considered a more or less faithful copy of the original). In the upper zone is the bust of Christ, surrounded by angels. Below, a jeweled cross, symbol of the Redemption, is flanked by the Virgin and saints, with the kneeling figure of the donor, Nicholas IV, on a smaller scale; beneath the cross is a representation of the Heavenly Jerusalem; in the foreground is the River Jordan. In the window zone are standing figures of apostles and tiny kneeling figures of the two mosaicists.

After a disastrous fire in May 1308, Clement V (1305–1314) restored the Lateran basilica, but it was again badly damaged by fire in 1360, during the period of the Avignon papacy. Urban V (1362–70) entrusted its reconstruction to the Sienese architect Giovanni di Stefano. Giovanni was responsible for the elaborate

baldacchino, in Italian Gothic style, that stands in the middle of the transept, over the high altar; the twelve frescoes that adorn it are attributed to Barna da Siena.

The basilica was given a new pavement of inlaid marble, in a style derived from the work of the medieval Cosmati, by Martin V (1417–31). The ornate coffered ceiling of carved and gilded wood, designed by Daniele da Volterra, was executed under Pius IV (1560–65) and Pius V (1566–72). Sixtus V (1585–90) had his architect, Domenico Fontana, add a two-story benediction loggia to the façade of the north transept.

The Lateran Baptistry is a separate structure, to the northwest of the basilica. Like the basilica, it was built by Constantine, in about 315, perhaps on the foundations of an earlier nymphaeum, or fountain house. At the center of the octagonal structure was a large basin for baptism by immersion. The Lateran Baptistry was an extremely important building in the life of the early church. For centuries, converts to

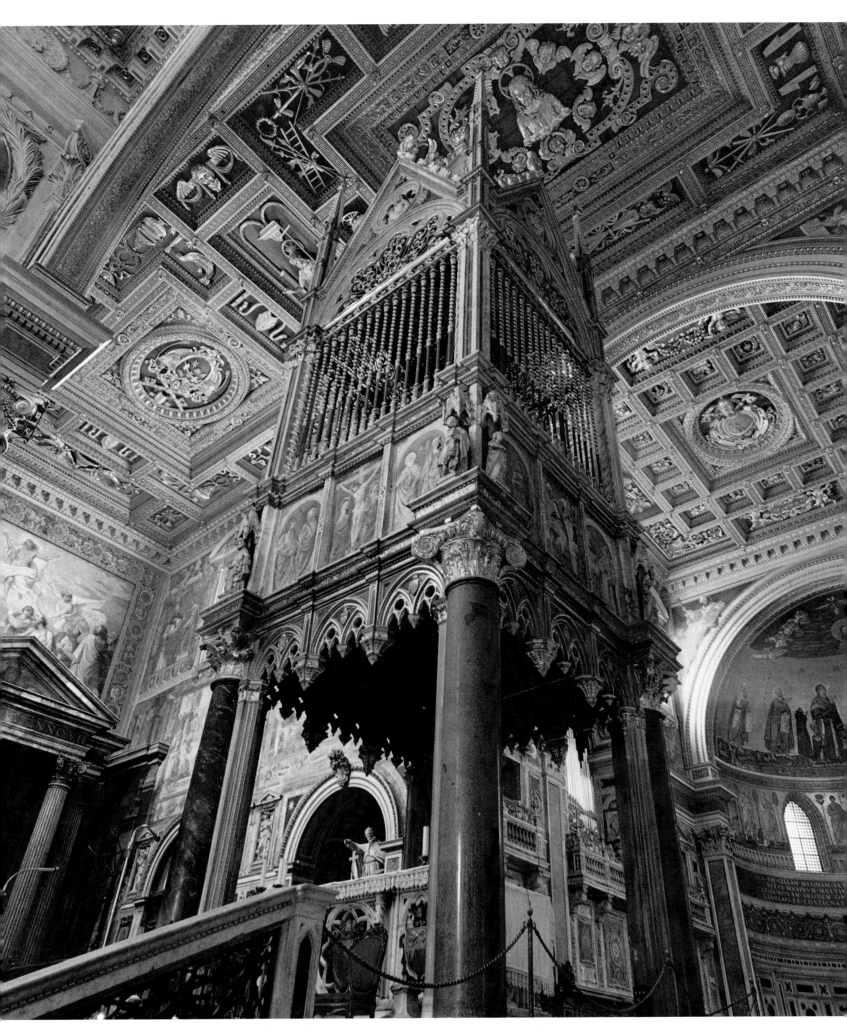

The Gothic baldacchino constructed by the fourteenth-century
Sienese architect Giovanni di Stefano.

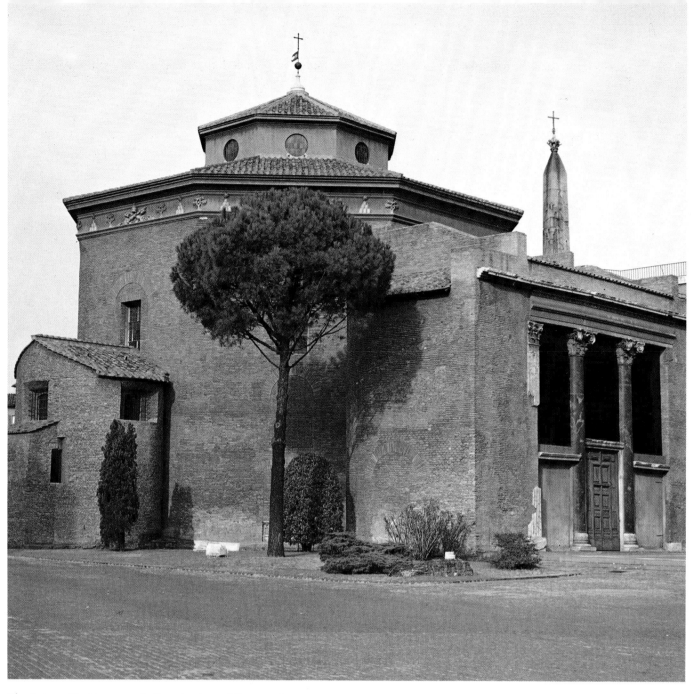

The Lateran Baptistry was built at the time of Constantine
and remodeled several times over the centuries.

Christianity assembled there on Easter Sunday and
Pentecost to be baptized by the bishop; only later did
other churches come to have baptistries of their own.
Sixtus III (432–40) remodeled and enlarged the build-
ing, retaining the Constantinian outer walls but con-
verting the interior into a high, domed central space
surrounded by a low ambulatory. He added a narthex
with an apse at either end; the apses were decorated
with mosaics, one of which has been preserved. Three
chapels, opening off the central octagon, were con-
structed during the early Middle Ages, and in the
twelfth century the narthex was transformed into a
fourth chapel; the seventh-century chapel of Saint
Venantius has an important mosaic cycle. The baptistry
was much altered during the sixteenth and seventeenth

centuries; the dome of Sixtus III was replaced by a
higher one, and the interior was redecorated with
canvases and frescoes by Andrea Sacchi, Carlo Maratta,
and others.

Adjoining the basilica to the north and east was
the Patriarchium, which served both as the papal res-
idence and as the administrative center of the Roman
church. It was gradually extended over the course of
the centuries. Pope Zaccarias (741–52) erected an en-
trance tower, and Leo III (795–816) added a magnificent
banqueting hall called the Triclinium, with porphyry
columns, marble-encrusted walls, and mosaics celebrat-
ing the spiritual and temporal authority of the papacy.
The chapel known as the Sancta Sanctorum, or Holy
of Holies, because of the vast number of relics that

were formerly kept there, probably goes back to the sixth century. It was rebuilt for Nicholas III (1277–80) by Cosma di Pietro Mellini. The mosaic in the vault of the presbytery apparently dates from this period; the bust of Christ, who imparts his blessing, is represented in a roundel supported by four flying angels. On the altar is an image of the Redeemer that probably dates from the fifth or sixth century; the medieval Romans believed that angels had painted it, and at times of imminent catastrophe it was carried through the streets in procession.

For the occasion of the first Holy Year, which he inaugurated in 1300, Boniface VIII (1295–1303) constructed a benediction loggia facing the square to the north of the palace. Writing at the beginning of the fourteenth century, Dante, in the *Paradiso*, describes

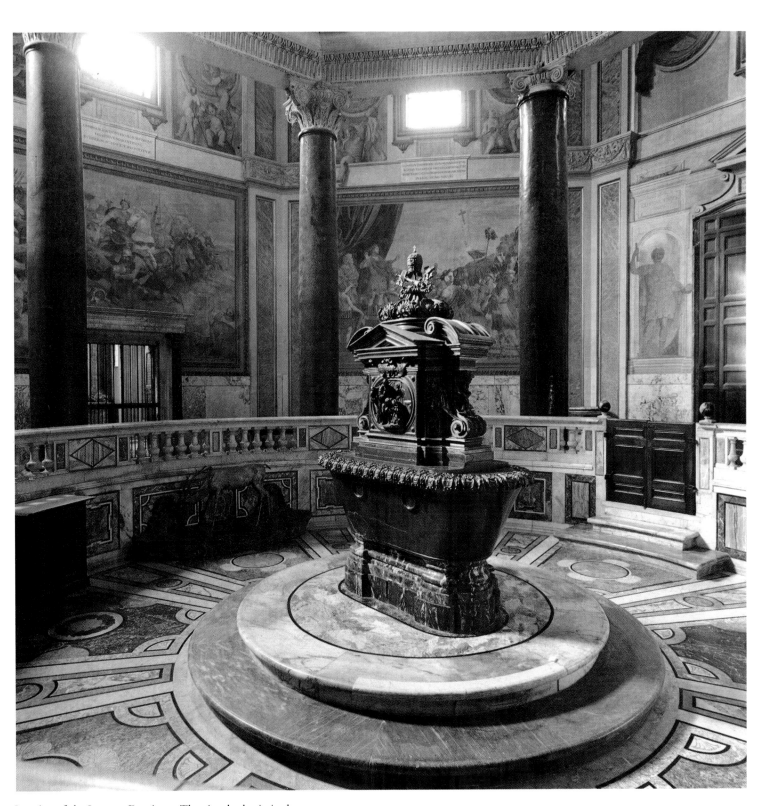

Interior of the Lateran Baptistry. The circular basin in the the center of the floor was used for baptism by immersion.

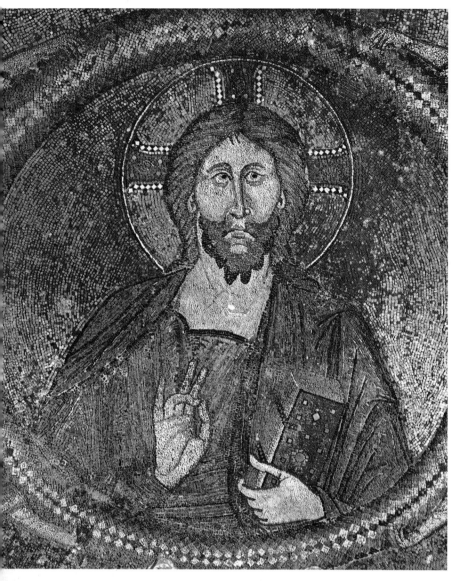

Mosaic with the bust of Christ in the chapel called the Sancta Sanctorum. The chapel was part of the Patriarchium, the old papal residence at the Lateran.

the Lateran as surpassing all earthly things in its magnificence. But the palace was virtually destroyed in the fire of 1360. It was never restored, because the popes made the Vatican their residence after their return from Avignon. Under Sixtus V the ruined Patriarchium was demolished to make room for the present-day Lateran Palace (which will be described in another chapter). Only the Sancta Sanctorum survives; Sixtus incorporated it into a separate edifice that he erected opposite the new palace. Medieval legend identified the stairway that gives access to the chapel with one in the Praetorium at Jerusalem that Christ had climbed during his Passion; Saint Helena had allegedly brought it to Rome. It is therefore known as the Scala Santa, and the pious practice of ascending it on one's knees persists to this day.

During the Early Christian and medieval periods, throughout Rome, innumerable works of art of pagan antiquity were destroyed. Paradoxically, however, several extremely important monuments owe their survival to the fact that they were preserved and displayed at the Lateran, the center of Roman Christendom. The equestrian statue of Marcus Aurelius, which was moved in 1538 to the piazza designed by Michelangelo on the Capitoline Hill, was supposed during the Middle Ages to represent Constantine. The famous archaic bronze statue of the she-wolf that nurtured Romulus and Remus was interpreted as a symbol of papal rule over Rome. More surprisingly, the Spinario, a Hellenistic statue of a nude youth extracting a thorn from his foot, was also preserved. The she-wolf and the Spinario were donated by Sixtus IV (1471–84) to the museum that he founded on the Capitoline.

The Present-Day Basilica

By the early seventeenth century San Giovanni was in an advanced state of disrepair. In April 1646, Innocent X (1644–55) decided to restore his cathedral for the coming Holy Year of 1650; he assigned the task to Francesco Borromini, who, together with Bernini, was one of the two great architectural geniuses of the Roman Baroque. We know from contemporary sources that Borromini would have liked to demolish the Constantinian basilica and construct a completely new church, as Bramante and his successors had done at Saint Peter's. But Innocent revered the Early Christian past; he specifically instructed Borromini to preserve as much as possible of the basilica's original form.

Borromini's solution was ingenious. He strengthened the walls of the outer aisles and the upper walls of the nave. The columns of the nave were replaced by massive piers, articulated by giant pilasters that rise to the ceiling. Ten arched openings, between the piers, connect the nave with the aisles. Set into the piers are

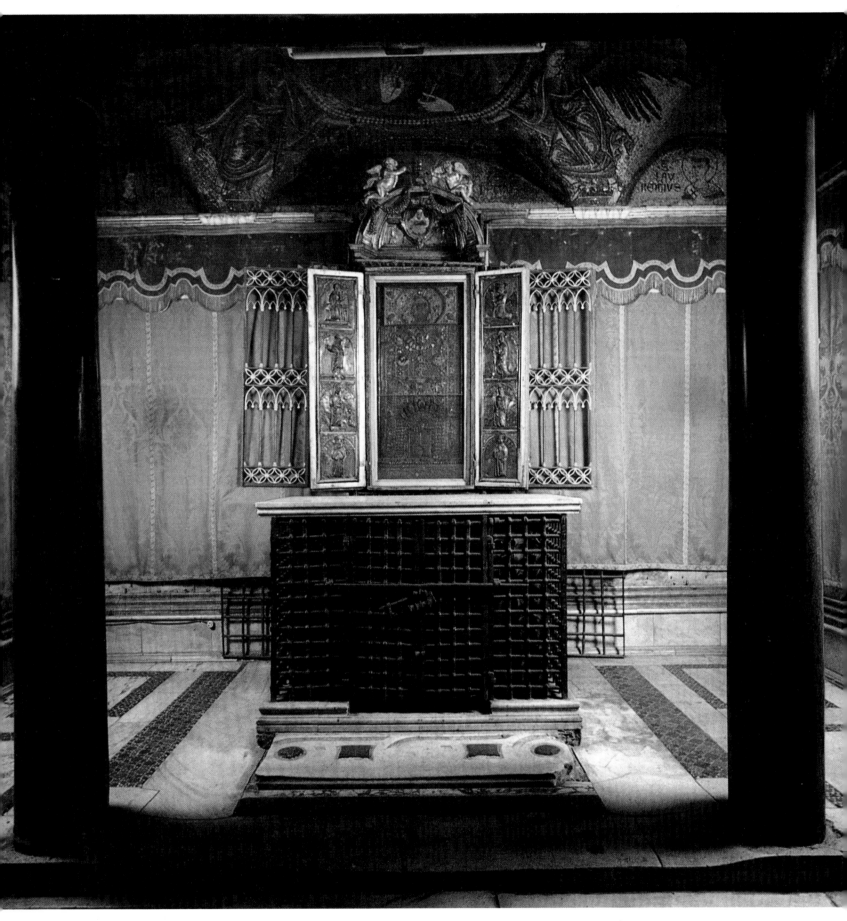

The image of the Redeemer on the altar of the Sancta
Sanctorum probably dates from the fifth or sixth century.
The medieval Romans believed that angels had painted it.

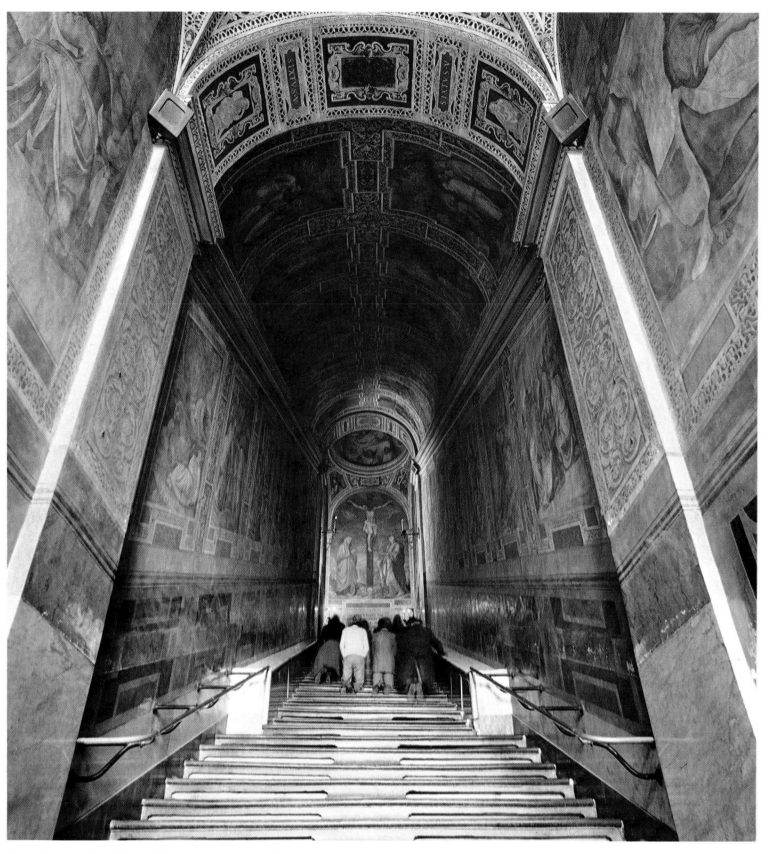

According to medieval legend, the stairway known as the Scala Santa had been climbed by Christ during his Passion and brought to Rome by Saint Helena. The pious practice of ascending it on one's knees persists to this day.

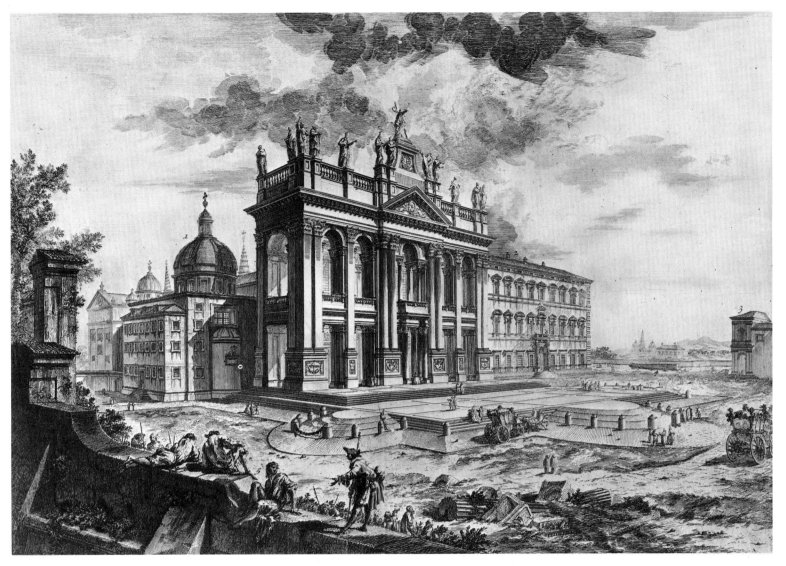

View of San Giovanni in Laterano, engraving by Giovanni
Battista Piranesi (1720–78), 1749, from *Vedute di Roma*.
The Metropolitan Museum of Art, Rogers Fund, 1941 (41.71).

huge niches; their dark marble is in sharp contrast to
the shimmering whiteness of the pilasters and upper
walls, and they project forcefully into the space of the
nave, in rhythmic alternation with the arched open-
ings. Every detail of the décor is worked out with the
elegant precision that was Borromini's hallmark. Un-
fortunately, perhaps, the pope insisted on preserving
the sixteenth-century coffered ceiling; beautiful as it
is, its relation to Borromini's architecture is inharmo-
nious. In the aisles, where Borromini had a freer hand,
space and light are manipulated with extreme subtlety.
The tombs of numerous popes and cardinals who had
been buried in San Giovanni during the Middle Ages
were dismantled when the basilica was remodeled,
but Borromini erected new tombs in the aisles, using
fragments of the old ones in a fanciful and some-
times bizarre blend of medieval and Baroque style.

Borromini also designed a new façade for San
Giovanni, but it was never executed. The present
façade, solemn and majestic, was constructed by the
Florentine architect Alessandro Galilei in 1745. In plan-
ning it, Galilei drew freely upon Renaissance models,
and especially upon the work of the great sixteenth-
century architect Andrea Palladio; in his youth, Galilei
had spent seven years in England, and it is possible that
the eighteenth-century English predilection for Pal-
ladian architecture influenced his project for San Gio-
vanni. A giant order of pilasters and engaged columns,
with a classical temple front at the center, is superim-
posed upon a two-story portico. The whole is crowned
by a balustrade with statues of Christ, Saints John the
Baptist and John the Evangelist, and twelve doctors
of the church silhouetted against the Roman sky.

ENNIO FRANCIA

San Paolo fuori le Mura

Saint Paul, the Apostle of the Gentiles, was beheaded in Rome during the Neronian persecution. He and Saint Peter have always been considered the patron saints of Rome; their joint feast is celebrated on July 29. According to an old tradition, Paul was buried in a tomb belonging to the matron Lucina in a cemetery on the Ostian Way, the road that led from Rome to the port of Ostia. Like Saint Peter's, the basilica of San Paolo fuori le Mura (Saint Paul's Outside the Walls) stands on the site of a pagan cemetery, and we know that this cemetery was held to contain the apostle's tomb at least from the end of the second century. Paul's relics, together with those of Peter, were apparently transferred at some point—perhaps during a persecution—to a locality near the church of San Sebastiano on the Appian Way, and later returned to their original resting places.

Constantine erected a shrine of modest dimensions at the site where Paul's remains were venerated. It was a longitudinal structure with a nave, two aisles, and a forecourt; the remains of an apse unearthed in 1850 during the course of construction work seem to have belonged to the Constantinian building. Perhaps the emperor lacked the time or the means to construct a sumptuous basilica like Saint Peter's. But political considerations were no doubt dominant; it was to Peter, not to Paul, that the bishops of Rome traced their authority.

The Constantinian shrine was replaced by a monumental basilica begun in 384 under the triarchy of the emperors Theodosius I, Valentinian II, and Arcadius. The new church was nearly as large as Saint Peter's; like Saint Peter's it had a high broad nave, two aisles on each side, a porticoed forecourt, a transept, and an apse. The columns of the nave, unlike those at Saint Peter's, supported arcades rather than straight entablatures. A dedicatory inscription of Pope Siricius (384–99) on one of the original columns, now preserved in the north porch, implies that the apse and transept were complete and the nave under way in the year 390. Construction and at least part of the decoration were completed under Theodosius's son Honorius, emperor of the West, before 402–403.

The basilica was damaged by a fire or an earthquake in about 442, and subsequently repaired and redecorated by Pope Leo the Great (440–61). The triumphal arch that separated the nave from the transept was given a mosaic with a rare iconographical theme: the twenty-four elders of the Apocalypse are shown offering their crowns to Christ. The walls of the nave were decorated with painted scenes from the Old and New Testaments. In 739 San Paolo was sacked by the Lombards, and again by the Saracens in 846 during one of their not infrequent raids on the Roman coast. To defend it against further attacks, John VIII (872–82) enclosed it within fortified walls. The enclosure was called Johannipolis, just as Leo IV's fortified Vatican was known as the Leonine City.

A Benedictine monastery was attached to the basilica, and between 1193 and 1208 the abbot Pietro da Capua began the construction of a cloister; it was finished, after two interruptions, in 1235. The artists were a certain Pietro, generally identified as Pietro Vassalletto, and his son—the same Roman marble workers who later built the cloister at San Giovanni in Laterano. The paired colonnettes are of various types: plain, octagonal, twisted, fluted, or decorated with mosaics. The intradoses of the arches are elegantly decorated with rosettes, and the spandrels are filled with figures and scenes of symbolic significance. A metrical inscription, running along three sides, extols the beauty of the spot and of the Benedictine rule. Three of the verses give an explanation, complete with etymology, of the meaning of the cloister:

Hic studet atque legit monachorum cetus et orat
claustrales claudens claustrum de claudo vocatur
cum Christo gaudens fratrum pia turma seratur

[Here the community of monks studies, reads, and prays; the place is called a cloister, from the verb "to close," because it closes in those who have chosen the enclosed life; here the pious flock of monks is shut in, rejoicing, with Christ].

During the Middle Ages, the basilica was enriched by many precious works of art. The famous Bible of San Paolo fuori le Mura, still preserved in the monastery library, is one of the masterpieces of Carolingian manuscript illumination. It was made, probably at Reims, in about 870 and was in all likelihood one of the lavish gifts presented to the pope by Charles the Bald when he was crowned emperor in Rome in 875; we do not know when it entered the possession of the monks of San Paolo. Charles is represented in one of the miniatures, enthroned and surrounded by the members of his court. The manuscript has a dedicatory prologue composed by the scribe, Ingobert, who boasts that he is the equal of the Italian illuminators of ancient times.

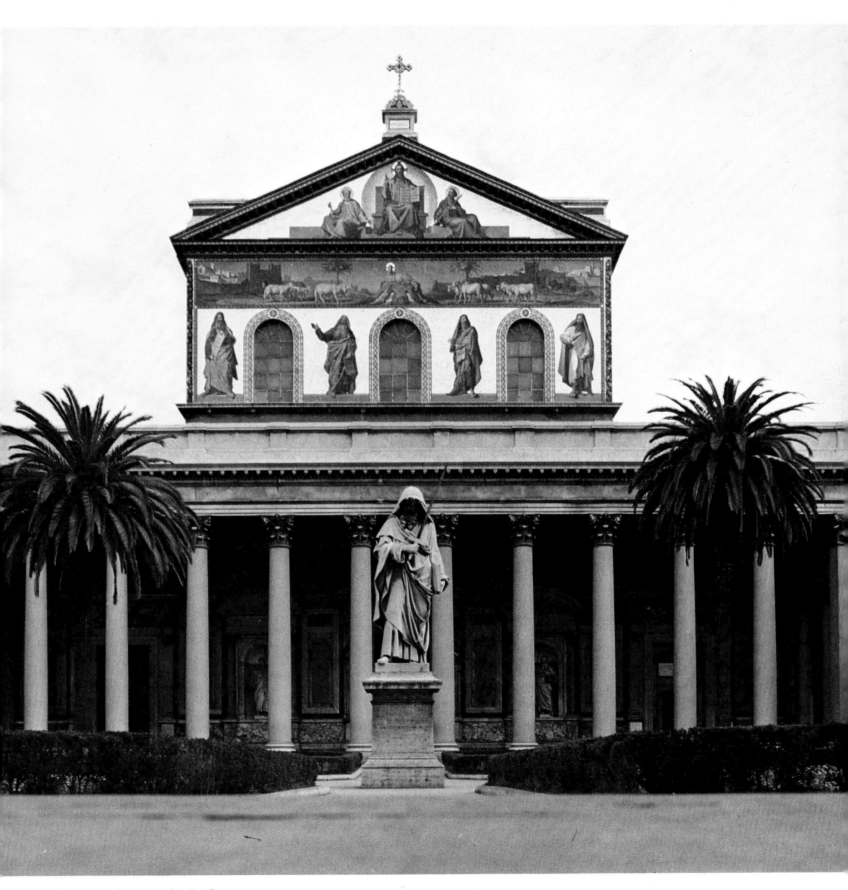

The nineteenth-century façade of
San Paolo fuori le Mura.

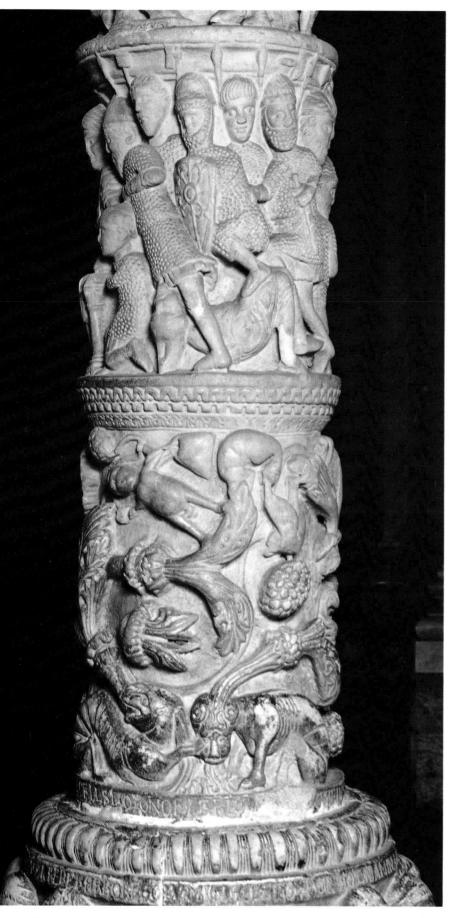

Detail of the twelfth-century paschal candlestick of San Paolo fuori le Mura, by Niccolò d'Angelo and Pietro Vassalletto.

In 1070 a pair of bronze doors, damascened with silver, was executed for San Paolo in Constantinople by a certain Staurakios; they were ordered by the abbot Hildebrand, the future Pope Gregory VII (1073–85), and paid for by Pantaleone, the consul of the republic of Amalfi at the Byzantine court. The fifty-four incised panels, representing personages and scenes from the Old and New Testaments, are in the pure Byzantine style.

The colossal paschal candlestick of marble, signed by Niccolò d'Angelo and Pietro Vassalletto, was carved late in the twelfth century. The base, of Oriental inspiration, is decorated with monstrous animals embraced by female human figures. The shaft is divided into seven sections: four of them are covered with animal or vegetable ornament, and three illustrate the Passion, Resurrection, and Ascension of Christ. The forms are crude but expressive, and they are combined to great decorative effect.

The mosaic in the apse is the work of Venetian artists who were sent to Rome by the doge Pietro Ziani at the request of Honorius III (1216–27); since the twelfth century Venice had been a leading center of mosaic production, famous above all for the vast cycle in the basilica of San Marco. In the San Paolo mosaic, which has been heavily restored, Christ is enthroned at the center, imparting his blessing; the tiny figure of Pope Honorius kneels at his feet. Saints Peter and Andrew stand to the right, and Saints Paul and Luke to the left. A jeweled cross, standing upon an altar with the instruments of the Passion, marks the center of the lower zone; it is flanked by angels and saints bearing scrolls with verses of the ancient hymn *Gloria in excelsis*. There are also kneeling figures of the abbot Giovanni Gaetani (1212–16) and of the sacristan Adinolfo.

The Florentine architect and sculptor Arnolfo di Cambio, who designed the cathedral of his native city, was active in Rome from about 1275 on. The baldacchino over the high altar of San Paolo was erected, as the inscription tells us, in 1285 by Arnolfo and an assistant called Pietro, who is perhaps to be identified with the painter and mosaicist Pietro Cavallini. Four porphyry columns, with capitals of gilded marble, support an elaborate canopy with trefoil arches, triangular gables, and pinnacles. Though the decorative details are derived from Gothic architecture, the baldacchino is essentially Romanesque in conception; at the same time, its sculptural decoration looks forward to the Renaissance. Statues of Saints Peter, Paul, Luke, and Benedict stand in the corner niches. The eight spandrel reliefs represent the abbot Bartolommeo, who commissioned the baldacchino, presenting it to Saint Paul; Constantine and Theodosius, the founders of the basilica; Adam and Eve after the Fall;

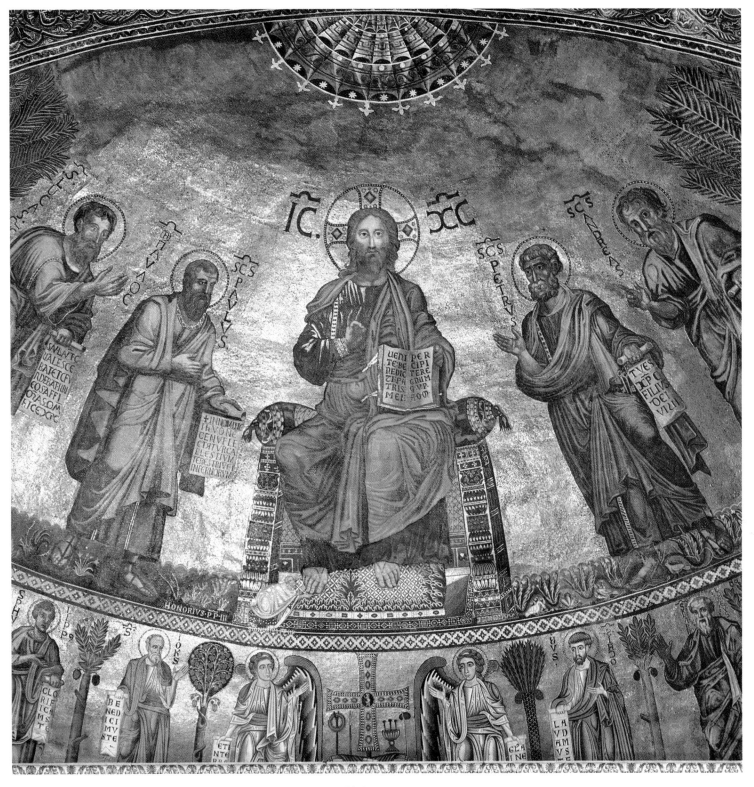

The apse mosaic is the work of thirteenth-century Venetian artists. Christ is enthroned with Saints Peter and Andrew to the right and Saints Paul and Luke to the left; the tiny figure of Pope Honorius III, who commissioned the mosaic, kneels at his feet.

and Cain and Abel offering their sacrifices to God the Father. In the gables, flying angels support the decorative rose windows.

Although we cannot be certain that Pietro Cavallini assisted Arnolfo with the baldacchino, we do know that between 1277 and 1290 he repainted the faded fifth-century murals in the nave and added new com-

positions of his own; these paintings are known today only through seventeenth-century copies. A monumental wooden crucifix, now housed in a seventeenth-century chapel off the left transept, was attributed to Cavallini by Vasari, but it is more probably the work of a Sienese master of the late thirteenth or early fourteenth century, perhaps Lorenzo Maitani or Tino di

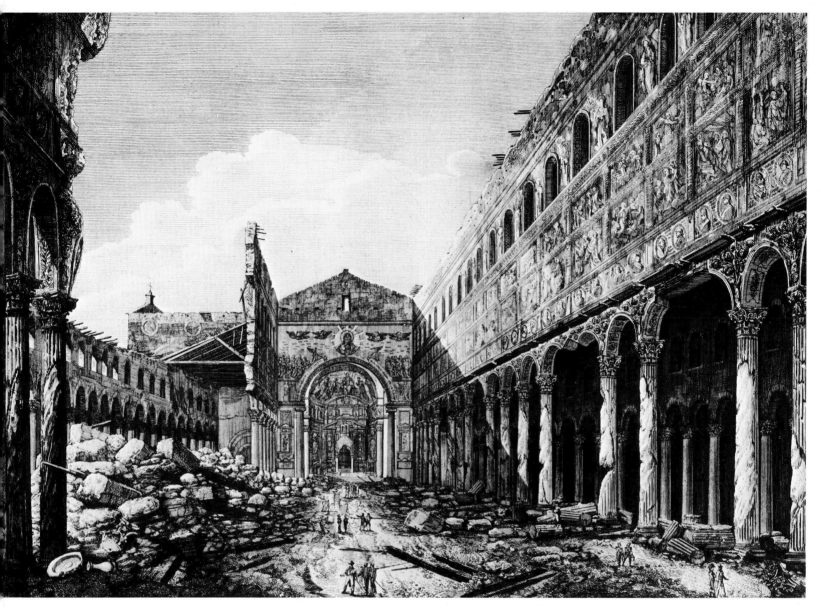

San Paolo fuori le Mura after the fire of 1823, engraving by Luigi
Rossini (1790–1857), published in *Le Antichità Romane* (1829).
The print itself is dated 1823. Avery Library, Columbia University.

Camaino. The vigorous, realistic figure of Christ is
said to have spoken to Saint Bridget of Sweden.

The few transformations that San Paolo under-
went during the Renaissance and Baroque periods—
Sixtus V (1585–90) gave it a new ceiling, chapels were
constructed adjacent to the transept in the seventeenth
century, and Benedict XIII (1724–30) added a portico
to the façade—did not seriously alter its Early Christian
architecture or Early Christian and medieval decora-
tion. But on the night of July 15, 1823, a fire destroyed
most of the nave; the transept and the apse fortunate-
ly escaped damage. Leo XII (1823–29) ordered the ba-
silica to be rebuilt with as few changes as possible,
and assigned the task to the architect Pasquale Belli.
Parts of the nave, including large areas of the upper
wall with Cavallini's frescoes, were still more or less
intact, and it would have been possible to reconstruct

the rest. But Belli, who was assisted by Pietro Bosio
and Pietro Camporesi, was in favor of rebuilding the
basilica completely, and in the end his view prevailed.

The cornerstone was laid in 1831; after Belli's death
in 1833 work was continued under Luigi Poletti, to
whom we owe the present appearance of the church.
Its style has been described as "Neo-Early Christian":
Poletti re-created the plan and elevation of a five-aisled
basilica, but his interpretation was academic and un-
imaginative. Even in the transept, which had not been
damaged in the fire, he covered the wall surfaces with
marble, so that it was impossible to replace the original
frescoes, which had been removed for restoration ten
years previously. The side altars of the transept are
adorned with lapis lazuli and malachite donated by
the czar Nicholas I, and with cold and correct statues
and paintings of the mid-nineteenth century.

The baldacchino was erected in 1285 by Arnolfo di Cambio
and an assistant called Pietro, perhaps the painter and
mosaicist Pietro Cavallini.

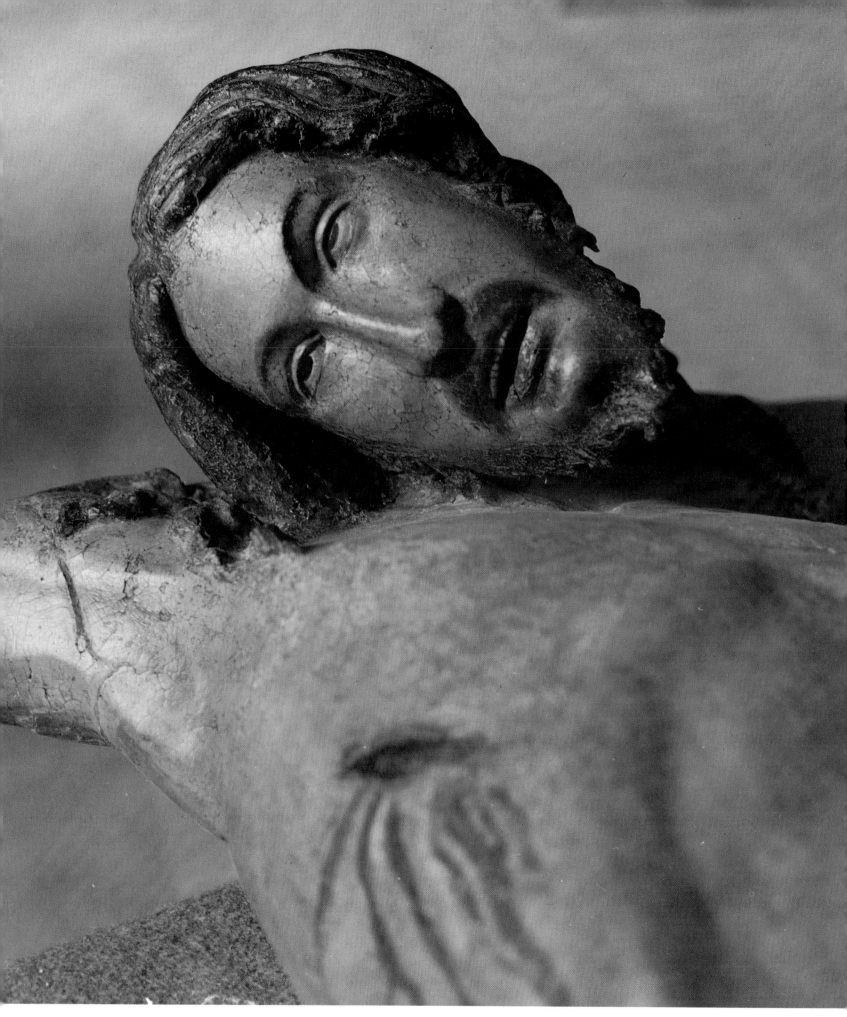

This realistically carved wooden crucifix is probably
the work of a Sienese sculptor of the late thirteenth
or early fourteenth century.

Virginio Vespignani, who worked under Poletti and later succeeded him as architect of San Paolo, designed the new façade and projected a large square forecourt, surrounded by a portico, in front of the church. Work was suspended when Rome fell to the kingdom of Italy in 1870, and the forecourt was constructed by Guglielmo Calderini between 1892 and 1928. Despite the grandiose scale and the magnificent materials—there are no fewer than 146 columns of white and pink granite—the forecourt is frigid and funereal. In the center is a statue of Saint Paul by Pietro Canonica. The mosaics on the upper part of the façade, by Filippo Agricola and Nicola Consoni, are nineteenth-century treatments of Early Christian themes. In the gable, against a gleaming gold background, Christ is enthroned in glory between Saints Peter and Paul. In the middle section, between the cities of Bethlehem and Jerusalem, the Lamb reclines upon a rock from which issue the four rivers of Paradise; a flock of sheep, symbolizing the Christian faithful, drink the restorative waters. Below, four prophets flank the windows.

ENNIO FRANCIA

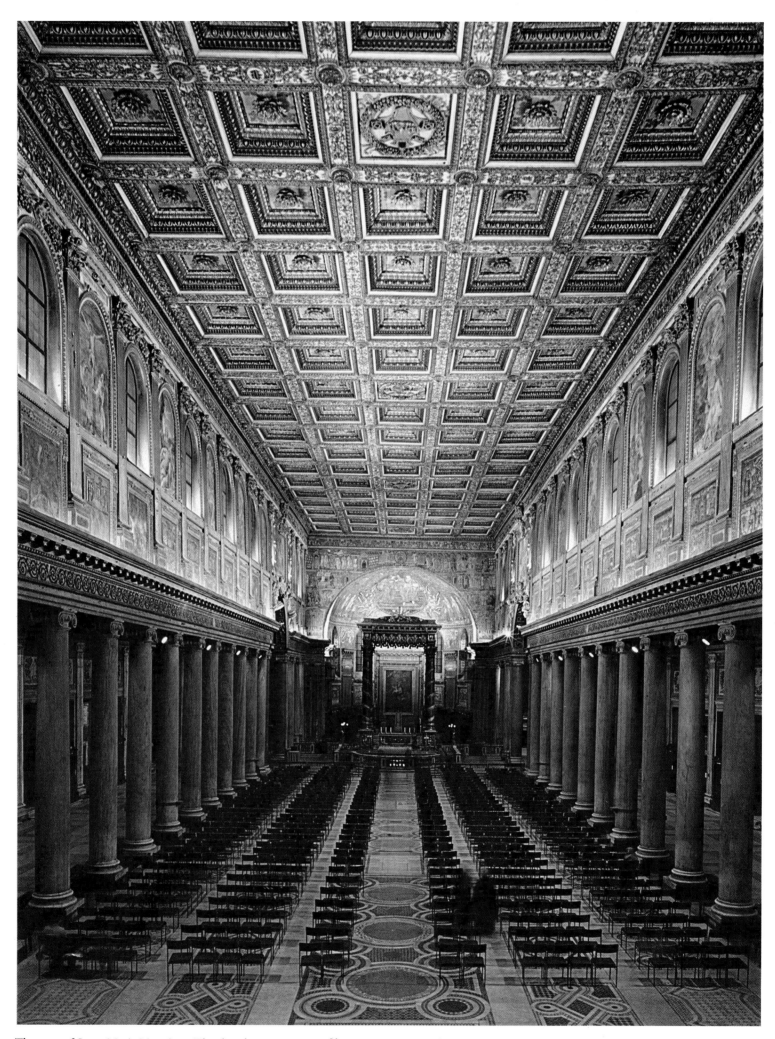

The nave of Santa Maria Maggiore. The church was constructed by
Sixtus III (432–40) and is the only major basilica to have remained
substantially intact. The magnificent ceiling was completed at the
end of the fifteenth century. It is said that the first gold brought
from America to Europe was used in its decoration.

Santa Maria Maggiore

Of the eighty churches in Rome dedicated to the Virgin Mary, the largest and most important is Santa Maria Maggiore (Saint Mary Major). According to a medieval legend, commemorated by the feast of Our Lady of the Snows on August 5, the Virgin herself made known her desire to have the basilica constructed by appearing in dreams to Pope Liberius (352–66) and to a rich patrician called Johannes; she even indicated the site, on the crest of the Esquiline Hill, by causing snow to fall miraculously amid the heat of August.

A Liberian Basilica on the Esquiline is mentioned in the *Liber Pontificalis*, an important source for the history of the early papacy, and archaeologists have attempted to find its traces. Excavations carried out between 1966 and 1971 brought to light, about six meters below the level of the present church, the remains of a building of Augustan date with a large porticoed courtyard and a number of rooms opening onto it; the walls of the portico are covered with fourth-century paintings illustrating the calendar and the Labors of the Months. This building, according to a hypothesis that has not been universally accepted, was the Macellum Liviae, the market inaugurated by Tiberius in A.D. 7 in honor of his mother Livia, next to which, according to the *Liber Pontificalis*, was the Liberian Basilica.

The present basilica was constructed by Sixtus III (432–40), shortly after the Council of Ephesus defined the dogma that Mary is the Mother of God. It has a high, wide nave with a low aisle to either side. Thirty-six monolithic columns of Hymettian marble are from the time of Sixtus III; four granite ones were added in the eighteenth century. The capitals are Ionic—the Greeks had used the Ionic order principally in temples dedicated to female divinities, and it is rare in the Early Christian architecture of Rome. The columns support a classical entablature with a mosaic frieze of vine scrolls against a gold background. The upper walls are articulated by pilasters; the windows that occupy every second bay flood the nave with a diffused light. Originally there was no transept; a semicircular apse, framed by a triumphal arch, communicated directly with the nave.

The mosaics on the triumphal arch and in the twenty-seven rectangular panels—there were originally forty-two—on the nave walls, directly above the entablature, are most likely contemporary with the basilica itself; in any event they are datable within the fifth century. They are among the great masterpieces of Early Christian art, and they remained a source of inspiration for many generations of medieval artists. A number of different hands may be distinguished: at least five artists appear to have worked on the triumphal arch, and eight in the nave.

The nave mosaics are perhaps slightly earlier than those of the arch. In their technique, which imitates the painter's art in the gradation of colors and in the use of shading, they seem to derive from Hellenistic prototypes. The narrative style grows directly out of the pictorial traditions of late antique Roman art: the scenes are lively and dramatic, yet imbued with classical gravity. Four series of events from the Old Testament—the stories of Abraham, Jacob, Moses, and Joshua—are illustrated as prefiguring the advent of the Messiah.

The history of salvation is continued on the triumphal arch, where the dedicatory inscription reads XYSTUS EPISCOPUS PLEBI DEI, "Bishop Sixtus to the people of God." At the center is the throne of God, studded with gems, with a royal mantle, a cross, and the book with the seven seals; flanking the throne are Saints Peter and Paul and the symbols of the four evangelists. To the right and left are representations of Jerusalem and Bethlehem and six scenes of the infancy of Christ, from the Annunciation to the Massacre of the Innocents. (Oddly enough, there is no representation of the story's central event, the Nativity. A possible explanation is that from the beginning, somewhere in the basilica, there was a chapel or oratory that reproduced the Grotto of the Nativity at Bethlehem. Since the early Middle Ages, the pope has come to Santa Maria Maggiore to celebrate the first mass of Christmas, and we know that, at least from the seventh century on, a supposed relic of the manger of Christ was venerated in the basilica.) The Annunciation mosaic is particularly splendid: the figure of the Virgin, wearing a diadem and covered with gold and precious stones, resembles an imperial portrait, and the artist demonstrates great skill in the handling of the drapery and in the realism of the features. The mosaics of the triumphal arch are stylistically more up-to-date than those of the nave: the technique is bolder and more rapid, and the effect more realistic and immediate. The gold tesserae used in the nave panels are so regular that they form smooth, compact surfaces. On the triumphal arch, the gold of the back-

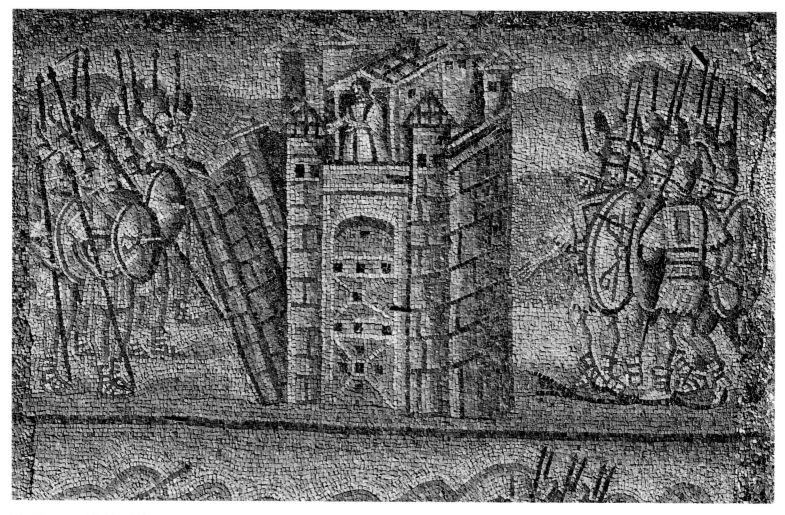

The Conquest of Jericho, fifth-century mosaic
in the nave of Santa Maria Maggiore.

ground is handled like the other colors; the tesserae are less smooth and regular, and the surface is consequently rougher and more animated.

The fifth-century apse has not survived; in all probability its vault was dominated by a mosaic representation of the Blessed Virgin.

Under Eugenius III (1145–53), the nave was given a beautiful pavement in the characteristic style of the Cosmati marble workers: inlaid marble of various colors is arranged in an elaborate geometric pattern. The donors were two Roman nobles, Scoto and Giovanni Paparone. Also during Eugenius's pontificate, an entrance portico was added to the façade.

Nicholas IV (1288–92) decided to modify the plan of the basilica; the old apse was demolished and a transept and a new apse were constructed. The work was financed by two cardinals of the powerful Colonna family, the brothers Giacomo and Pietro. In the vault of Nicholas's apse, Jacopo Torriti (who five years previously had produced the apse mosaic in San Giovanni) executed a mosaic—signed and dated 1295—whose theme is the Coronation of the Virgin. Its boldness of

invention and grandeur of design make it one of the most powerful mosaics of the thirteenth century. Beneath a canopy representing the Empyrean, and amidst vine scrolls inhabited by peacocks, pelicans, and other symbolic birds drawn from the medieval bestiary tradition, is a starry roundel in which Christ and Mary sit side by side on a golden, jewel-studded throne; Christ is in the act of placing a crown upon his mother's head. Two groups of nine richly clad angels give praise at the foot of the throne; there are standing saints to either side, as well as the kneeling figures of Nicholas IV and Cardinal Giacomo Colonna. Below is the River Jordan, with men, animals, and birds in its waters and along its banks, and an inscription affirming the doctrine of the Assumption. On the walls of the apse, between the pointed windows, are other splendid mosaics by Torriti with scenes from the life of the Virgin. Torriti's style is very much influenced by the Byzantine tradition, and susceptible to the preciosity inherent in the art of manuscript illumination. He was also open, however, to the innovations of Pietro Cavallini, who was working at about the same time

on the mosaics of the Roman church of Santa Maria in Trastevere. From Cavallini, Torriti learned greater freedom of composition, greater psychological depth, and a feeling for three-dimensional modeling derived ultimately from Roman sculpture.

The old façade of the basilica was also covered with mosaics at the end of the thirteenth century; they are signed by Torriti's contemporary Filippo Russuti and are still visible in the upper loggia of the present façade. Above, Christ is enthroned within an oval representing the firmament, flanked by angels and the evangelist symbols; in the lower zone—which according to Vasari was completed by the Florentine artist Gaddo Gaddi—are scenes commemorating the legendary foundation of the basilica by Pope Liberius.

The campanile of Santa Maria Maggiore, the tallest in Rome, was erected by Gregory XI (1371–78) after his return from Avignon. Built of red brick dec-orated with polychrome majolica disks, it continues the old Romanesque tradition of Roman bell towers.

The early Renaissance left few traces in the basilica. Sixtus IV (1471–84) constructed a baldacchino over the high altar, at the expense of the archpriest of Santa Maria Maggiore, Cardinal d'Estouteville; the baldacchino was later replaced, but four reliefs that adorned it, attributed to Mino del Reame, have been incorporated into the lower wall of the apse. Cardinal d'Estouteville also added the doors in the west walls of the transept, which face the center of Rome. The magnificent coffered ceiling, attributed to the Florentine architect Giuliano da Sangallo, was completed under the Borgia pope, Alexander VI (1492–1503), whose heraldic animal, the bull, appears in five of the coffers and innumerable times in the frieze over the windows. It is said that the first gold brought from America to Europe was donated to the pope by Fer-

The Annunciation, fifth-century mosaic on the triumphal arch of Santa Maria Maggiore.

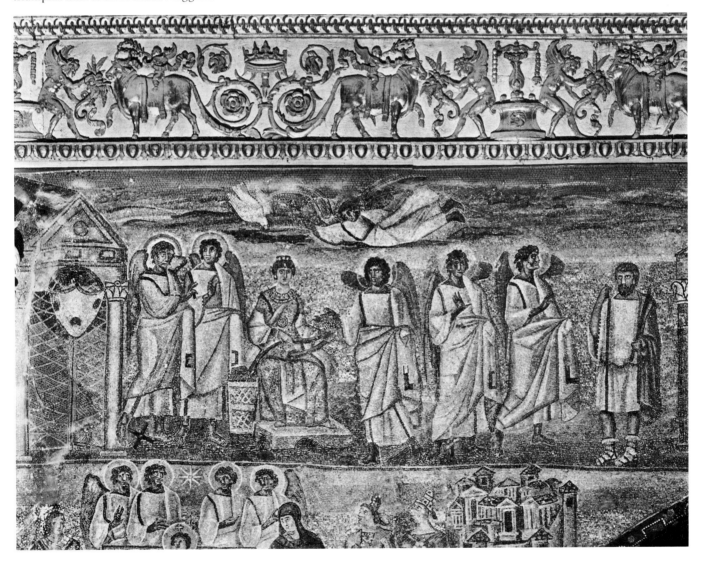

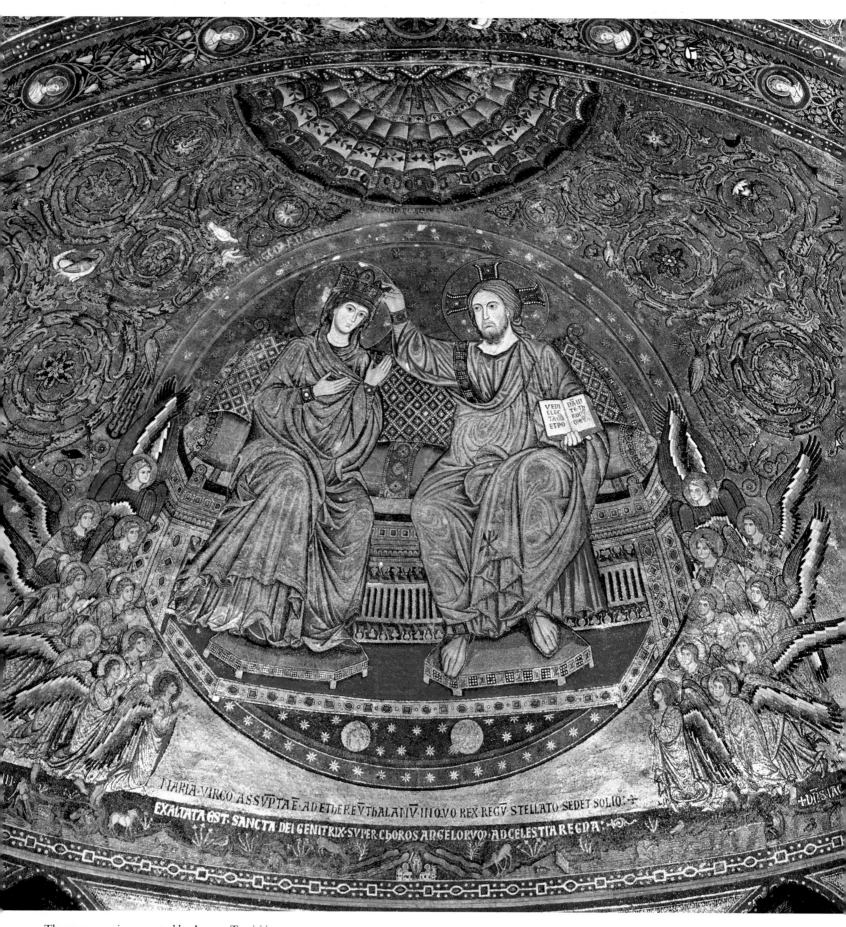

The apse mosaic, executed by Jacopo Torriti in
1295, represents the Coronation of the Virgin.

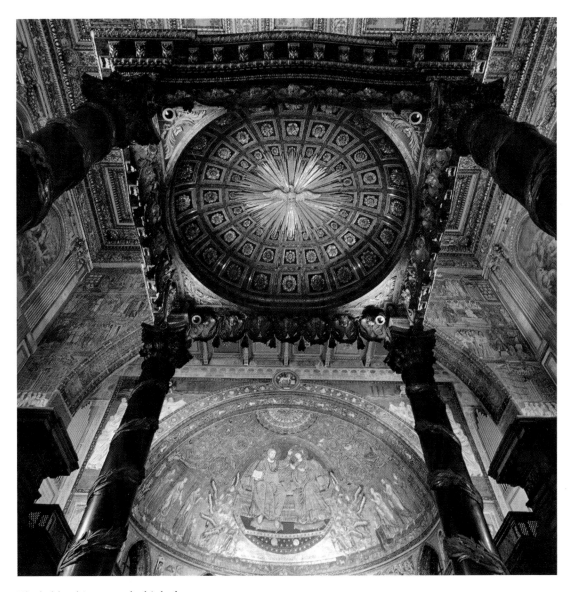

The baldacchino over the high altar,
by Ferdinando Fuga.

dinand and Isabella of Spain and used to decorate this ceiling.

During the sixteenth century two funerary chapels, opening off the left aisle, were constructed. The Cesi Chapel was planned by the architect Guidetto Guidetti in about 1550 and decorated by a number of Mannerist painters; the tombs of Cardinals Paolo and Federico Cesi are the work of Guglielmo Della Porta. The Sforza Chapel was commissioned by a grandson of Paul III (1534–49), Guido Ascanio Sforza; it was completed by Giacomo Della Porta, perhaps from a design by Michelangelo, one of whose pupils, Tiberio Calcagni, began the work. The plan is unusual: it is rectangular, with large elliptical apses, framed by columns, opening off the side walls. Gregory XIII (1572–85) rebuilt the portico of the basilica in 1575.

Under Sixtus V (1585–90) and Paul V (1605–21) the transepts of the basilica were transformed into monumental chapels. They are both centrally planned, domed structures, pendants to each other; the Roman people used to refer to them facetiously as "the Madonna's earrings." The Sixtine Chapel, also called the Chapel of the Blessed Sacrament, was designed by Domenico Fontana in 1585. It is richly decorated with frescoes and gilded stucco. Sixtus intended it as a setting for the relic of the manger of Bethlehem, which had been housed in a chapel off the north aisle. The ancient shrine, which perhaps goes back to Sixtus III, had been reconstructed under Innocent III (1198–1216) and decorated with sculpture by Arnolfo di Cambio at the end of the thirteenth century. Fontana transferred it to a small oratory beneath the altar at the center of the Sixtine Chapel. On the altar is a magnificent tabernacle of gilded bronze, in the form of an octagonal temple held aloft by four angels. It was designed by Giovanni Battista Ricci in 1590, and

the angels are by Sebastiano Torrigiani. The chapel also contains the monumental tombs of Saint Pius V (1566–72) and of Sixtus V, both Fontana's work. Pius, whose confessor Sixtus had been, was a leading figure of the Counter Reformation and the creator of the "Christian League" whose forces obtained a decisive victory over the Turks at Lepanto in 1571. The tomb has a statue of the pope, by Leonardo Sormani, and five reliefs commemorating the events of Pius's pontificate. Sixtus's tomb is similar in design, with a statue by Giovanni Antonio Valsoldo.

The Pauline Chapel was constructed in 1611 by Flaminio Ponzio, who, for the sake of symmetry, repeated the plan of Fontana's Sixtine Chapel. The excessively opulent décor exemplifies the mediocrity to which the Mannerist tradition had sunk by the beginning of the seventeenth century. The pendentives and the lunette over the altar are frescoed by the Cavalier d'Arpino and the dome by Ludovico Cigoli. On the altar, which is encrusted with jasper, agate, amethysts, and lapis lazuli, is a much-venerated Madonna that popular tradition attributes to Saint Luke. The painting is Byzantine in type, but scholarship has not ascertained whether it was painted in Rome or imported from the East; suggested dates have ranged from the ninth to the thirteenth century. The tombs of Clement VIII (1592–1605) and Paul V, designed by Ponzio, are of the same type as Fontana's tombs in the chapel opposite, with statues of the popes and reliefs commemorating their pontificates.

Flaminio Ponzio was also responsible for the beautiful baptistry, with its relief of the Assumption by Pietro Bernini (the father of Gianlorenzo), and for the sacristy, which is considered his masterpiece.

The statue of Philip IV of Spain, who was a benefactor of the basilica (which is still officially under the protection of Spain), was designed by Gianlorenzo Bernini, perhaps at the time of the king's death in 1665. It was cast in bronze after Bernini's death by Girolamo Lucenti, and set up in the portico in 1692.

The rear façade of the basilica, with the projecting apse in the center, was constructed by Carlo

Detail of the shrine of the manger of Bethlehem, with sculpture by Arnolfo di Cambio.

The tabernacle in the Chapel of the Blessed Sacrament
was designed by Giovanni Battista Ricci in 1590. The
angels are by Sebastiano Torrigiani.

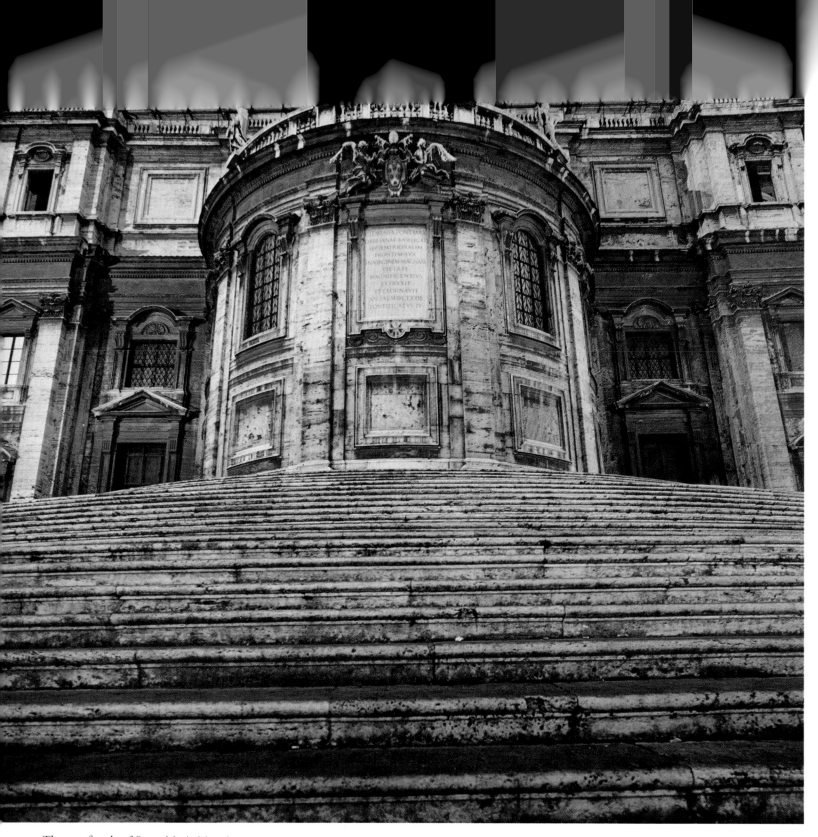

The rear façade of Santa Maria Maggiore,
constructed by Carlo Rainaldi in 1673.

Rainaldi in 1673. It is reached by a magnificent flight
of steps. This façade, visible from a distance along
the streets that converge upon the Piazza dell'Esquilino
(where Domenico Fontana had erected an obelisk for
Sixtus V in 1587), is one of the great scenographic
creations of the Roman Baroque.

The main façade was constructed for Benedict
XIV (1740–58) by the Florentine architect Ferdinando
Fuga between 1743 and 1750. Like Alessandro Gali-
lei's slightly earlier façade of San Giovanni in Latera-
no, it consists of an open portico surmounted by a loggia,
on the rear wall of which Russuti's mosaics are visi-

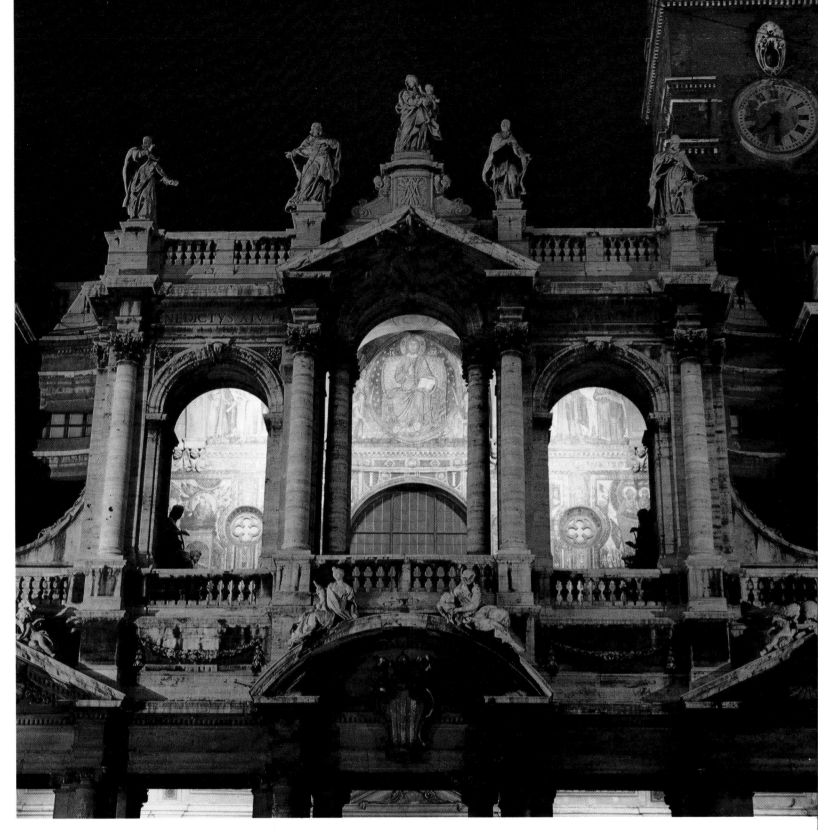

Detail of the main façade, built by Ferdinando Fuga between 1743 and 1750.
Thirteenth-century mosaics by Filippo Russuti are visible in the upper loggia.

ble. Fuga's architecture, however, is less solemn and monumental than Galilei's. Contrasts are everywhere emphasized: between mass and void; between light and shadow; between the five bays of the portico and the three bays of the loggia; between rectilinear and curvilinear forms. Decorative sculpture enhances the scenographic effect. Fuga draws heavily upon the vocabularies of Renaissance and Baroque architecture, but the overall effect is one of typically eighteenth-century delicacy.

ENNIO FRANCIA

San Lorenzo fuori le Mura

Saint Lawrence was a Roman deacon who was martyred—roasted alive, according to popular legend—during the persecution of the emperor Valerian in 258. He was buried in a catacomb on the Via Tiburtina, the road that leads from Rome to the nearby town of Tivoli. The *Liber Pontificalis* tells us that Constantine erected a basilica near Lawrence's tomb during the pontificate of Sylvester I (314–35). It was assumed until quite recently that the present-day church of San Lorenzo fuori le Mura was on the site of the Constantinian basilica and that it probably incorporated parts of its predecessor. But excavations in 1950 and 1957 uncovered the remains of a huge fourth-century building just to the south of San Lorenzo, beneath the approach to the cemetery of Rome, the Campo Verano. It now seems certain that this U-shaped structure—the nave terminated in an apse, and the aisles were continued by a semicircular ambulatory around the apse—was in fact the Constantinian basilica.

San Lorenzo consists of two parts: an eastern section dating from the time of Pope Pelagius II (579–90) and a western extension built by Honorius III (1216–27). The Pelagian church, described in a seventh-century guide for pilgrims as "a new basilica of admirable beauty," was originally a self-contained building.

Stone lions guard the central portal of San Lorenzo.

It was cut into the hillside, riddled with catacombs, where Saint Lawrence was buried, and so constructed that the martyr's tomb was isolated in the middle of the nave floor. (Saint Peter's had similarly been laid out, in Constantine's time, so as to incorporate the earlier monument, in the midst of a pagan necropolis, that was believed to mark the tomb of the Apostle.) The tall sixth-century nave (now the chancel) is flanked by splendid fluted columns, with Corinthian capitals, supporting an ornate architrave; the aisles are surmounted by arcaded galleries (a Byzantine feature absent in earlier Roman basilicas); the upper walls are pierced by arched windows. There was also an apse, later demolished, at the west end. The apse vault and the triumphal arch were decorated with mosaics; the scene on the triumphal arch, which has survived, shows Christ with Saints Peter and Lawrence and Pope Pelagius to his right, and Saints Paul, Stephen, and Hippolytus to his left (Saint Stephen, also a deacon and a martyr, is often associated with Saint Lawrence in the writings of the church fathers; Saint Hippolytus was supposedly converted by Saint Lawrence, martyred together with him, and buried in the same catacomb). The original narthex, at the east end, was converted in the nineteenth century into a funerary chapel for Pius IX.

The baldacchino now over the high altar was completed in 1148. It is signed by four of the Cosmati: Giovanni, Pietro, Angelo, and Sasso, the sons of Paolo. A cloister was added late in the twelfth century; it is the only cloister in Rome with an upper story.

At the end of the twelfth century and the beginning of the thirteenth, under the papal chancellor Cencio Savelli who then became Pope Honorius III, San Lorenzo was remodeled and turned back to front. The apse of the Pelagian basilica was pulled down and the old nave became the chancel. A new, longer nave, preceded by a narthex, was added at the west end; architraves and columns from the adjacent Constantinian basilica, which by now had fallen into disuse, were used in its construction. As in many medieval Italian churches, stone lions guard the central portal. The floor level of the nave was higher than that of the Pelagian church; the floor of the new chancel was raised and the space below it filled in, so that the martyr's tomb, at the original level, now stood in a crypt beneath the high altar.

Nave and chancel were given a Cosmatesque pavement, one of the oldest in Rome. The magnificent

The twelfth-century cloister at San Lorenzo fuori le Mura
is the only cloister in Rome with an upper story.

episcopal throne, with its twisted colonnettes and intricate intarsia decoration, was set up, according to the description, in 1254. It is also a work of the Cosmati. In the narthex is a fresco cycle, poorly preserved, that probably dates from the last quarter of the thirteenth century; the frescoes narrate the legends of Saints Lawrence and Stephen.

During the Renaissance and Baroque periods, San Lorenzo was not significantly altered, though a few chapels were added and parts of the church were variously embellished. Under Pius IX (1846–78) the Pelagian and Honorian structures were thoroughly restored by Virginio Vespignani. On July 19, 1943, the basilica was badly damaged in the only serious air raid that Rome suffered during the Second World War. It was restored again between 1946 and 1950.

JOHN DALEY

Santa Croce in Gerusalemme

Not far from the Lateran basilica, adjoining the city walls, was a large imperial palace known as the Sessorium; it was built in the early third century. Under Constantine it was the residence of his mother, the empress Helena. Helena made a pilgrimage to the Holy Land in 326. In Jerusalem, according to a legend that goes back to the end of the fourth century, she discovered the True Cross of Christ and brought part of it back to Rome. Between her return to Rome and her death, which probably took place in 329, she converted a large rectangular hall in the Sessorium into a palace chapel: an apse was added to one end and the

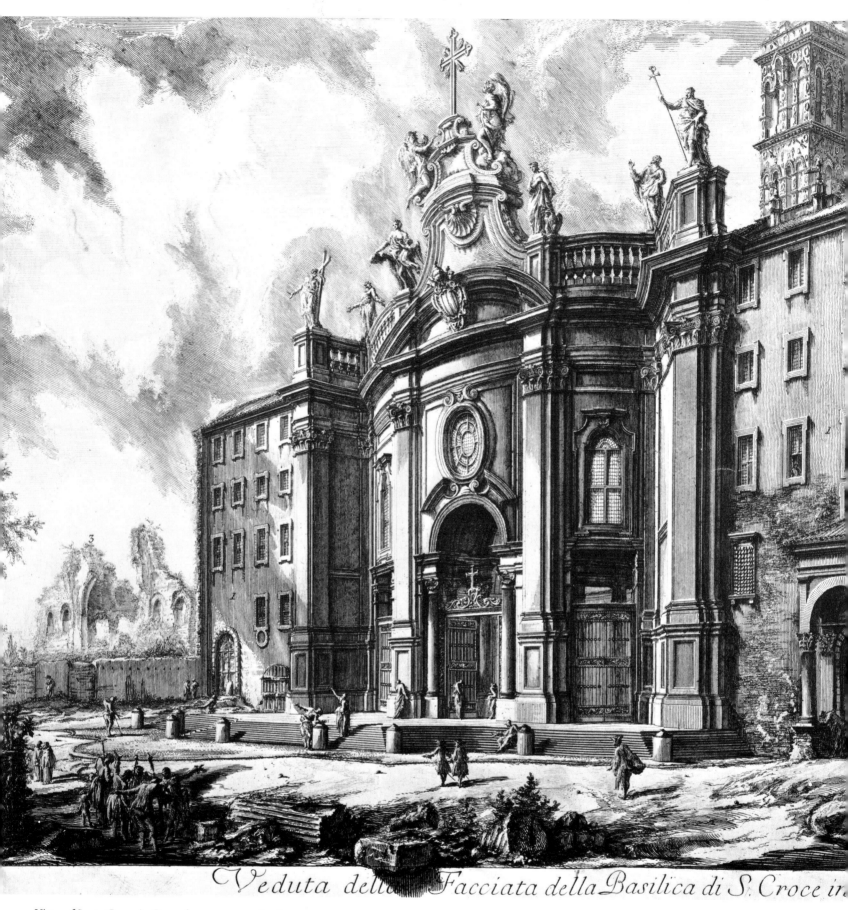

Veduta della Facciata della Basilica di S. Croce in

View of Santa Croce in Gerusalemme, engraving by
Giovanni Battista Piranesi, 1750, from *Vedute di Roma*.
The Metropolitan Museum of Art, Rogers Fund, 1941 (41.71).

usalemme

hall was subdivided into three parts by arcades supporting transverse walls. This arrangement, more intimate than that of the great public basilicas with their continuous naves and aisles, was suitable for a chapel where only the imperial family and its retinue were intended to worship.

In Early Christian and early medieval times the building was usually called *basilica Hierusalem* or *ecclesia Hierusalem*—the "Jerusalem Church"; the name Santa Croce is not recorded until the twelfth century, though the Holy Cross was apparently venerated there from the fourth century on. The relic may have been housed in the small rectangular room behind and to the right of the apse, known today as the Chapel of Saint Helena (beneath the pavement, according to tradition, is earth from Mount Calvary which Helena brought back from Jerusalem together with the fragment of the Cross). The emperor Valentinian III (425–55) had this room richly decorated with mosaics, of which no traces remain.

The church was restored during the eighth century under Gregory II (715–31) and Hadrian I (772–95). In the twelfth century, under Lucius II (1144–45), it was completely remodeled: the transverse arcades were removed, and Santa Croce was given a regular basilican plan with a nave, two aisles, a transept, and a narthex. Lucius also constructed the tall Romanesque campanile. The nave was decorated with frescoes, probably from Lucius's pontificate; the few fragments that have survived—they were discovered in 1913, and have since been detached—include roundels with heads of the Old Testament patriarchs, in the Byzantine style.

The late fifteenth and early sixteenth centuries saw another burst of artistic activity in Santa Croce under two titular cardinals of the basilica, Pedro Gonzalez de Mendoza, archbishop of Toledo, and Bernardino Lopez de Carvajal, a churchman who held a number of curial and diplomatic positions. Mendoza provided the apse and transept with a new coffered ceiling, decorated with his arms and those of the king of Spain. While work on the ceiling was in progress, in 1492, the relic of the Cross (whose whereabouts, strange as it may seem, had been forgotten) was discovered in a receptacle over the triumphal arch, where it had apparently been installed when the basilica was remodeled by Lucius II. The lively fresco in the vault of the apse, usually attributed to the local painter Antoniazzo Romano, shows the discovery of the Cross by Saint Helena; its immediate inspiration, however, was no doubt the second discovery. The fresco was probably commissioned by Carvajal, who succeeded Mendoza as titular cardinal of Santa Croce in 1495. Carvajal was also responsible for the vault mosaic in the Chapel of Saint Helena, executed before 1509 and attributed

to the Sienese artist Baldassare Peruzzi. Christ appears in glory in the center; he is surrounded by four large ovals with the figures of the evangelists, and between the ovals are small scenes with episodes from the legend of the Holy Cross.

Cardinal Carvajal died in 1523 and was buried in the apse, in a modest tomb designed by an unknown artist. His successor as titular cardinal, Francisco Quiñones (who was confessor to Charles V, the German emperor), commissioned his own tomb in 1536 from the Florentine architect and sculptor Jacopo Sansovino. It is a monumental structure in the center of the apse, incorporating a tabernacle for the sacrament; in the niches to either side of the tabernacle are statues of David and Solomon.

Santa Croce was again completely remodeled in 1743–44 by the architects Domenico Gregorini and Pietro Passalacqua, at the behest of Benedict XIV (1740–58). The narthex of Lucius II was replaced by an oval, domed vestibule of elegant proportions. The façade incorporates the outer curve of the oval; it is divided into three convex bays by a giant order of pilasters. As in Fuga's façade of Santa Maria Maggiore, which was begun in the same year, much is made of the contrast between mass and void: the cen-

tral bay is pierced by a huge arched portal surmounted by an oval window; the portals of the lateral bays have straight entablatures with arched vertical windows above them. There is a segmental pediment over the central bay; the attic zone consists of a balustrade with statues and a strange curvilinear gable terminating in a crownlike ornament upon which angels adore the Holy Cross.

Gregorini and Passalacqua's transformation of the interior was less radical: the basilican plan was preserved; the columns were left standing, though four of them were encapsulated within rectangular piers; the apse, with its fresco and its tombs, remained more or less as it had been in the sixteenth century. The nave walls and the new piers were covered with white and gilded stucco, and Cardinal Mendoza's flat ceiling was replaced by a false vault of wood. The great late Baroque painter Corrado Giaquinto produced for this vault a huge canvas representing Saint Helena in glory. He also painted a smaller *Apparition of the Cross on the Day of the Last Judgment* for the vault of the presbytery. Gregorini and Passalacqua designed an elaborate baldacchino of marble and gilded bronze for the high altar, to replace a Cosmatesque one from the time of Lucius II.

JOHN DALEY

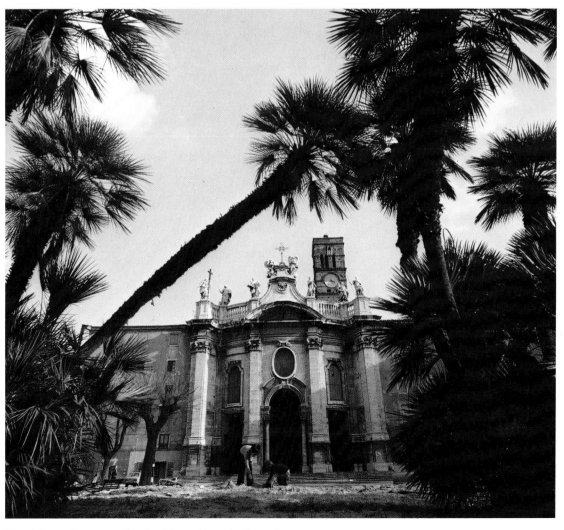

The eighteenth-century façade of Santa Croce in Gerusalemme.

San Sebastiano fuori le Mura

Roman law forbade the burial of the dead within the city walls; cemeteries and individual mausoleums lined the roads leading from the city for a distance of several miles. A cemetery on the Appian Way, about a mile south of the city gate known today as Porta San Sebastiano, became, in the middle of the third century, a flourishing center of the cult of the apostles Peter and Paul. Excavations begun in 1915 beneath the basilica of San Sebastiano fuori le Mura brought to light a small courtyard and a covered loggia, on the rear wall of which are numerous graffiti—one of them gives the year in which it was written, A.D. 260—recording *refrigeria*, or commemorative meals, held there in honor of the two apostles. The origin of this cult is a problem that scholars have been debating for many years. We know that from an even earlier date the remains of Peter were venerated in the Vatican and those of Paul in a cemetery on the Via Ostiense; we also know that martyrs in Rome were invariably honored at their tombs or, less frequently, at the sites of their martyrdom. The most plausible explanation—based on later accounts of doubtful reliability—is that during the persecution of Valerian in 258, when Christians were forbidden to assemble, the relics of Peter and Paul were brought for safekeeping to the cemetery on the Appian Way, and that they remained there until the time of Constantine, when they were returned to their original resting places. This hypothesis does not, however, account for the fact that the cult of the Apostles continued to be celebrated on the Appian Way long after the time of Constantine.

Once the cult was established there, the Appian Way cemetery became a favorite burial ground for Christians: interment in the vicinity of a martyr's remains was considered a high honor. One of the Christians buried at the site was Saint Sebastian. We have very little authentic information about this saint, though the presence of his tomb is documented from the middle of the fourth century; his enormous popularity was evidently the result of a highly romanticized fifth-century account of his life, the *Passio Sancti Sebastiani*. According to this legend, Sebastian was a young military officer who became a favorite of Diocletian's; taking advantage of his position, Sebastian converted so many members of the nobility to Christianity that he eventually aroused the ire of the emperor, who had him tied to a stake and shot full of arrows (the scene is represented in countless works of art from the fourteenth century on). He miraculously survived, however, and was nursed back to health by a pious widow, Saint Irene. Upon his recovery he insisted on presenting himself to Diocletian, who this time succeeded in putting him to death, by flagellation. The story concludes with Sebastian's burial *juxta vestigia apostolorum*, next to the remains of the Apostles, on the Appian Way. If the legend contains a kernel of historical fact, as it almost certainly does, Sebastian's martyrdom took place before Diocletian's abdication in 305. The great persecution of Christians under that emperor began in 303, but conspicuous individuals may have been put to death earlier.

During the first half of the fourth century, a huge basilica was constructed over the third-century shrine and the Christian tombs around it. It may have been begun as early as 310 (the Christians enjoyed considerable freedom under Constantine's predecessor, Maxentius), and it was perhaps completed under Constantine's son, Constans (337–50). Like the Constantinian basilica at San Lorenzo, it was U-shaped: the aisles and a semicircular ambulatory formed an unbroken unit surrounding the higher nave and apse. The arcades separating the nave from the aisles, unlike those of most Early Christian churches, rested on rectangular piers rather than columns. Despite remodelings that have completely altered its appearance, the fourth-century structure has remained largely intact.

Like Saint Peter's and a number of other basilicas on the sites of martyrs' tombs, the basilica on the Appian Way served as a covered cemetery. The graves in the nave were so densely packed together that the slabs which covered them constituted the only pavement, and the outer walls were lined with sepulchers stacked one above the other. Beneath the southwest corner of the nave and accessible from it by means of two flights of stairs is a rectangular chamber known as the Crypt of Saint Sebastian, and there is no reason to doubt that this was the original tomb of the martyr. During the course of the fourth century, a number of mausoleums for affluent Christians were constructed adjacent to the basilica.

Votive inscriptions of the early fifth century attest to a cult of Saint Sebastian, and a seventh-century itinerary for pilgrims lists the saint's tomb as the principal glory of the basilica. For a long time, however, the building was known as *basilica apostolorum*, or Basilica of the Apostles. But the cult of the Apostles on the Appian Way was gradually eclipsed by their far more important cults at Saint Peter's and at San Paolo,

and from the middle of the seventh century we find the basilica referred to as *ecclesia Sancti Sebastiani*.

Eugenius II (824–27) had the relics of Saint Sebastian removed: some were sent to Soissons in France others were installed in an oratory at Saint Peter's, and the head was enclosed within the high altar of the Roman church of Santi Quattro Coronati. In 1218 Honorius III (1216–27) restored the Vatican's share of the relics to San Sebastiano and consecrated an altar in the crypt.

Under Nicholas I (858–67) a monastery was established at San Sebastiano, and during the later Middle Ages the monastic buildings began to encroach upon the basilica. The arcades of the nave and apse were walled up, probably in the late twelfth or early thirteenth century, and the aisles and ambulatory thus ceased to be part of the church. The south aisle and the mausoleums adjoining it were incorporated into the monastery. The ambulatory and part of the north aisle have survived, and are used today as exhibition halls for the inscriptions and sculptural fragments brought to light in the excavations in and around the basilica.

The church was completely remodeled by Flaminio Ponzio and Giovanni Vasanzio, between 1609 and 1612, for Cardinal Scipione Borghese, the nephew of Paul V (1605–21). On the ground floor of the modest façade is a portico with three arches resting on paired columns. Above the arches are windows; the upper story is articulated by pilasters and surmounted by a triangular gable. The interior consists of a single nave, with altars in arched recesses along the walls. Cardinal Borghese transferred the altar of Honorius III, containing the relics of the saint, from the crypt to the nave. In 1672 Cardinal Francesco Barberini constructed a separate chapel to house it; the architect was Ciro Ferri, and the statue of the dead Saint Sebastian is by Antonio Giorgetti, a sculptor who belonged to Bernini's circle. The large, richly decorated Albani Chapel, designed by Carlo Maratta, was added by Clement XI (1700–1721) to house the tombs of his family.

JOHN DALEY

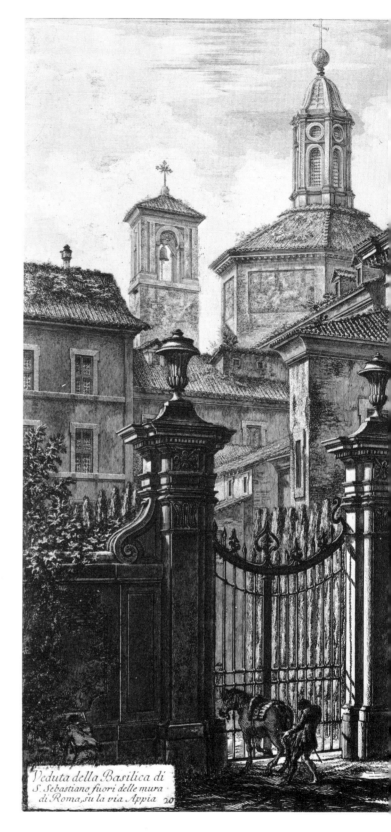

Veduta della Basilica di S. Sebastiano fuori delle mura di Roma, su la via Appia 20

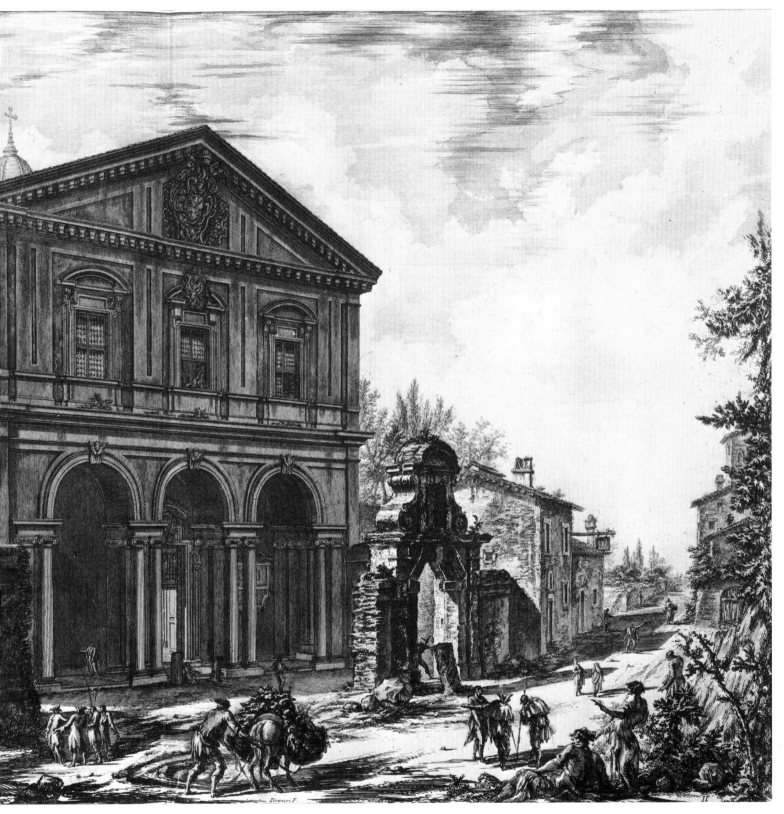

View of San Sebastiano fuori le Mura, engraving by
Giovanni Battista Piranesi, 1750, from *Vedute di Roma*.
The Metropolitan Museum of Art, Rogers Fund, 1941 (41.71).

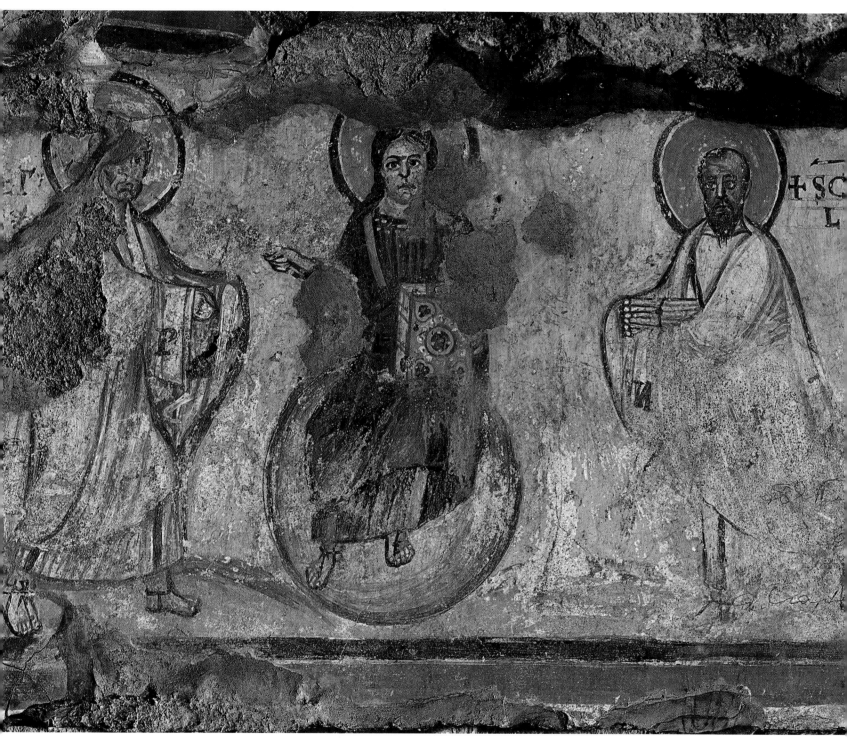

Christ Enthroned between Saints Peter and Paul: detail
of a fresco in the catacomb of Commodilla.

THE CATACOMBS

The catacombs are one of the most unusual features of Rome. Other cities, such as Naples and Syracuse, also possess catacombs, even quite extensive ones, but none of these cities is surrounded by such a large number of catacombs with such an impressive wealth of artistic monuments. In the past it was usual to identify the catacombs with the Christian Rome of very early times, and to consider them the seats of worship, of organization, and of the very life of the primitive Christian community. Today the progress of archaeological science has modified this view and shown that they were the cemeteries of the community during the first centuries, the shrines of the martyrs in later times, and popular centers of pilgrimage until the eighth century. In ancient times the site of the catacomb of Saint Sebastian was called *ad catacumbas*: the latter word, of Greek origin, apparently referred to a deep ravine beside the Appian Way, but during the Middle Ages "catacomb" came to signify any underground cemetery.

The catacombs are generally to be found along the consular roads that radiate from the city. More than forty, some of them of notable size, can be counted today within approximately three kilometers of the city wall. We know that the Christian community was organized by districts corresponding to modern parishes, called *tituli*, which in turn were grouped into seven ecclesiastical regions. To each of the regions there was assigned a burial area, outside the walls, containing a certain number of cemeteries. This system of organization dates from the relatively long, persecution-free pontificate of Pope Fabian (236–50). But collectively owned Christian cemeteries go back at least to the end of the second century; the earliest burials in the catacombs of Praetextatus, Saint Sebastian, Domitilla, and Priscilla are from that time. Previously, Christians had used public cemeteries, such as the ones on the Vatican Hill and on the Via Ostiense where the apostles Peter and Paul were buried. We have no certain knowledge of the origins, ownership, and evolution of the exclusively Christian cemeteries. It seems

likely that wealthy Christians turned over to the brethren the property surrounding their family tombs; this would account for the fact that so many of the catacombs bear the names of private citizens. Later, as the Christian community grew, individual *tituli* had more money at their disposal and were able to purchase high-priced communal land along the consular roads in the immediate vicinity of Rome.

One characteristic common to all the Roman catacombs is the existence of a cemetery area above ground, linked to the underground part and functioning in conjunction with it. Most of these surface cemeteries have been destroyed. After the time of Constantine rich mausoleums were built and areas were set aside for funeral meals. The excavations of recent years have revealed a great complex of mausoleums above the catacomb of Domitilla, an enclosed area over the catacomb of Saint Thecla, and a vestibule to the catacomb of Praetextatus, as well as its caretaker's house.

In contrast to the scarcity of these discoveries above ground is the great wealth of underground monuments. Some of the catacombs were plundered during the course of the centuries, but in general they were well protected by the tufa in which they were carved out. Most of them have been made accessible thanks only to modern excavating machinery.

The fact that the Christians, unlike their pagan contemporaries, practiced underground excavation to such an extent might lead one to suppose that they had special reasons for seeking security, or other unusual motives. But it should not be forgotten that the present appearance of the catacombs is the result of a long development. Originally they consisted only of entrance stairways and a few galleries and chambers. The need for further burial space led to the lengthening and deepening of the galleries, but it was only in the fourth century that the various branches and layers began to crisscross and vast underground necropolises were created.

The excavation of underground spaces of various

A view of the Appian Way. Several of the Roman
catacombs are situated along this road.

types, especially conduits and cisterns, was very common in central Italy. It was helped by the nature of the terrain; the compact tufa was easy to work and at the same time resistant and solid enough to permit tunneling on a large scale. The Etruscans had already excavated in this manner for burial purposes. In addition to their characteristic chamber tombs, they also dug short galleries with layers of tombs in the walls, not unlike the Christian catacombs. Pre-Christian examples have also been found in Roman territory; a small but complete cemetery was discovered near Anzio with funerary furnishings that date it to the third century B.C. The Jewish communities of Rome had underground cemeteries that were very similar to the Christian catacombs; six of them have been discovered.

The Christian gravediggers soon acquired a quite astonishing expertise in underground excavation. The galleries were about a meter wide, so that people could pass each other, and two or three meters high. Secondary galleries branched out from the principal passages, usually at right angles; networks with thousands of tombs were thus created. Excavation was restricted by law to the ground beneath the proprietor's plot of land; when the network of galleries reached the boundaries of the plot, a new level was begun, either above or below the original one, depending on the quality of the tufa. As many as four or five levels may sometimes be found, one on top of the other. For ventilation and lighting vertical wells were sunk; they cut through several levels and could light several areas at once.

In the walls of the galleries rectangular cavities called *loculi* were cut out, one above the other, each made to the measure of the body it was to hold. The dead were placed inside, wrapped in shrouds, which were sometimes coated with lime—this was a cheap form of embalming. The *loculus* was closed with tiles or with a slab of marble, and carefully sealed with lime. The name of the deceased was then painted on the surface with red lead or carbon, or simply scratched in the lime. In the early period the formulas used in the inscriptions were very simple and almost indistinguishable from contemporary pagan formulas: to the name of the deceased was added, at most, the name of the person dedicating the tomb, the day and month of death, and the deceased's age. As time went by, brief statements of Christian faith in salvation were included in the inscriptions, or symbols expressing faith in salvation were used. Among the latter are the anchor, standing for safe arrival at the port of eternity; a dove with an olive branch (a reference to the story of Noah), alluding to peace after tribulation; a vessel with flowing water, suggesting refreshment in the afterlife; and the palm or crown of victory, the reward for a Christian life. With the fourth century the epi-

This wall painting in the catacomb of Saints Peter and Marcellinus shows a gravedigger working in a gallery by the light of an oil lamp.

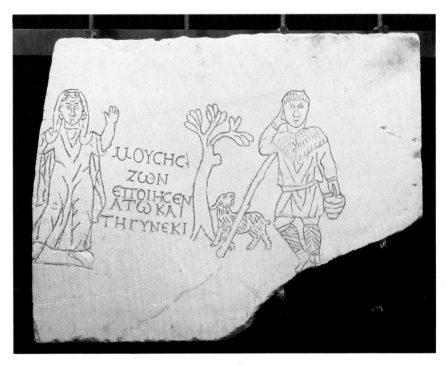

Gravestone for Mouses and his wife, from the catacomb of Saint Callistus.

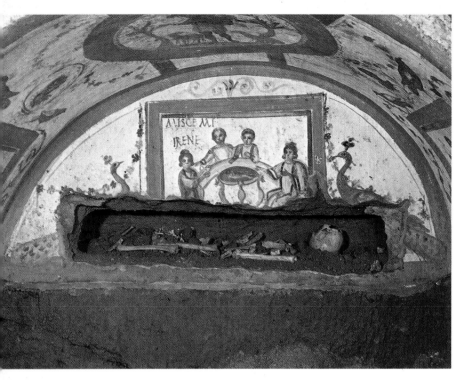

An *arcosolium* on the catacomb of Saints Peter and Marcellinus. The fresco shows a funeral banquet with praying figures.

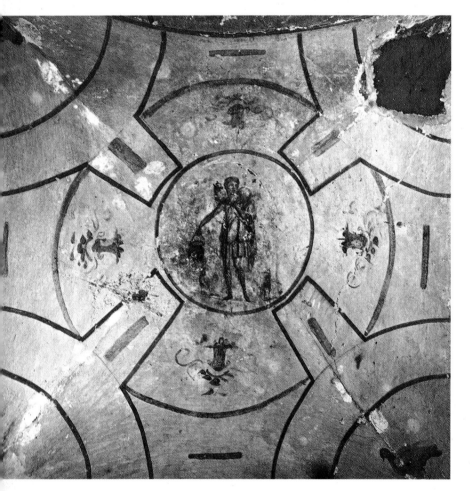

The Good Shepherd, fresco in the vault of a *cubiculum* in the catacomb of Saint Callistus.

taphs became longer; they began to include eulogies of the deceased with details of their lives.

A richer form of burial was the *arcosolium*. Here the slab closing the cavity was placed horizontally rather than vertically, and an arch was constructed above it. The arch was often plastered and decorated with frescoes. *Arcosolia* are usually found in *cubicula*, small family tombs that open out from the galleries here and there. Larger *cubicula* consist of two, three, or even four interconnecting chambers; the chambers may be square, rectangular, polygonal, circular, or semicircular in plan, and they may have flat ceilings, barrel vaults, groin vaults, or domes. Occasionally there are architectural elements carved in the tufa, such as corner columns with Ionic or Corinthian capitals, decorative cornices, and niches or projecting brackets for lamps.

The frescoes that are the great attraction of the Roman catacombs are mostly found in the *cubicula*. The paintings express in another form the ideas and sentiments of the epitaphs. One finds a limited number of biblical subjects, always represented in the same way. This repetitiveness does not indicate a lack of imagination on the part of Early Christian artists; the scenes were carefully selected for their symbolic value. The fundamental idea is salvation: the Good Shepherd is shown rescuing his sheep, Daniel is saved from the lions, the three young men in Babylon from the fiery furnace, Noah from the flood, Jonah from the whale, and Susanna from unjust accusation. Faith in the Resurrection is expressed in the miracle of Lazarus coming forth from the tomb. Jesus' healing of the blind man, the paralytic, and the leper, as well as the scene of the Adoration of the Magi, express faith in the divinity of Christ. Pictures of the Virgin Mary, the apostles, and the martyrs recall the intercession of the saints. Other scenes illustrate the teaching of Christian doctrine and the sacraments of baptism and the Eucharist. The dead are always represented in an attitude of prayer, with their arms raised, often in the garden of Paradise or surrounded by bucolic scenes that symbolize the joyfulness of the next life. These frescoes give the catacombs a feeling of serenity and peace.

The Catacombs in the Middle Ages

The custom of burying the dead in catacombs came to an end toward the beginning of the fifth century, but those catacombs that contained tombs of martyrs retained for several centuries an important place in the religious life of the Roman people and of the pilgrims who came from afar. During the pontificate of Damasus I (366–84), the catacombs became true sanctuaries. The martyrs' tombs were systematically sought out, restored, and embellished. On each of them the pope placed short poems, composed by himself and in-

A gallery with *loculi* in the catacomb of Saint Callistus.

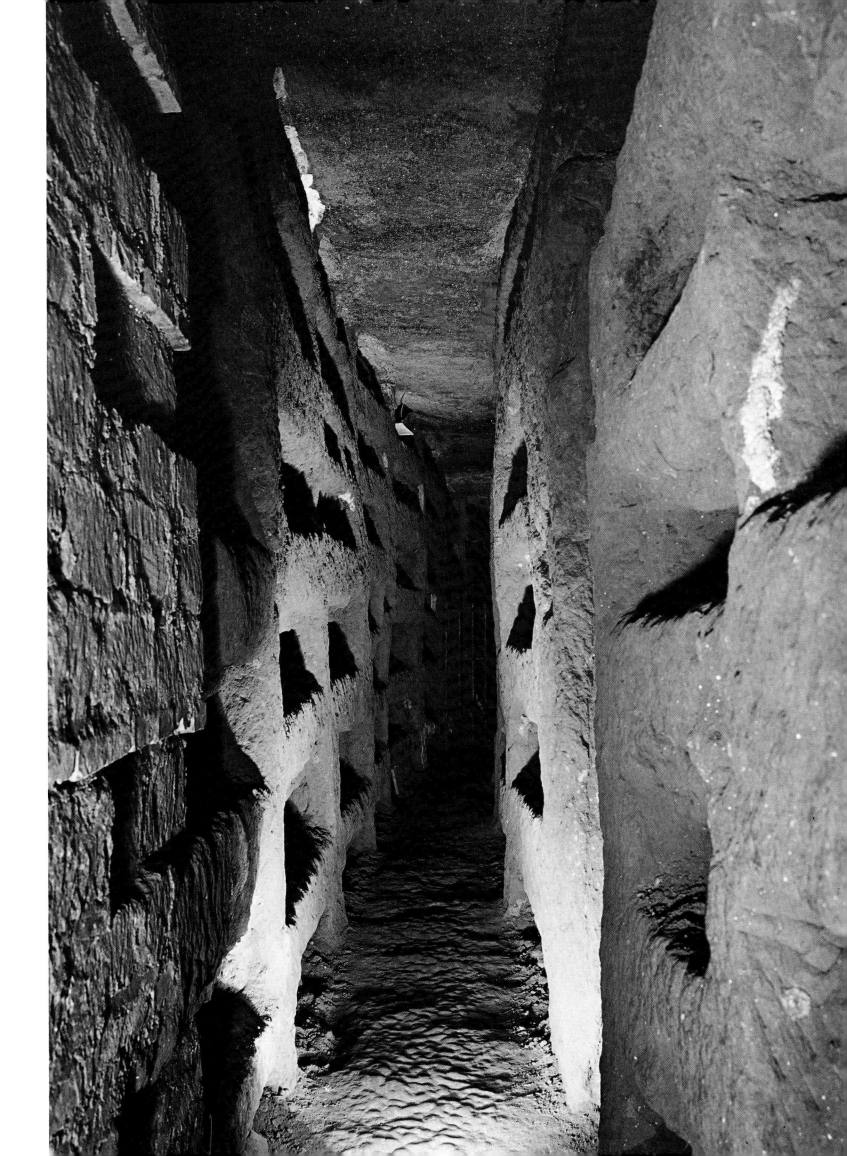

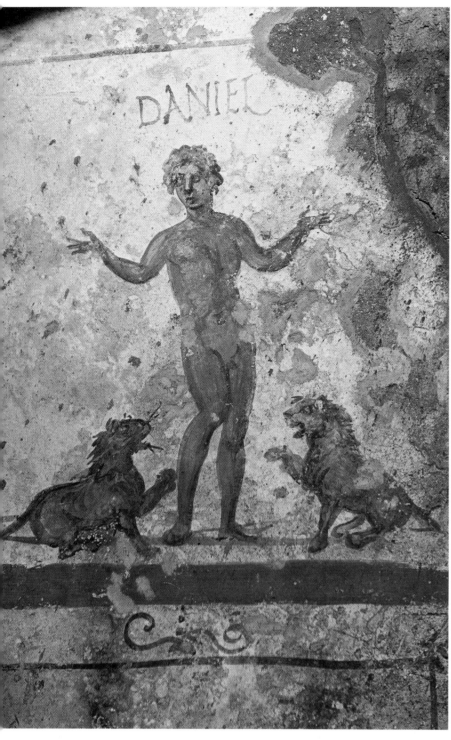

Daniel in the Lions' Den, fresco in the catacomb
of Saints Peter and Marcellinus.

scribed in elegant characters by the calligrapher Furius Dionysius Philocalus. In order to facilitate gatherings of the faithful at the tombs, galleries were widened into rooms; in some cases veritable underground basilicas, complete with apses, were created. Above ground, a number of great basilicas were constructed over the catacombs.

The Gothic invasions devastated the outskirts of Rome, but pilgrims continued to visit the shrines that had grown up there. Pope Vigilius (537–55) restored three of the sanctuaries outside the walls as soon as the Goths of King Witigis had struck camp, and Pelagius II (579–90) constructed the splendid new basilica of San Lorenzo fuori le Mura at the tomb of Saint Lawrence. The itineraries composed during the seventh and eighth centuries to guide pilgrims on their devotional visits are topographical documents of the greatest value; on the basis of the information they contain, archaeologists have been able to identify nearly all the Roman catacombs by their original names.

Toward the end of the eighth century pilgrimages to the catacombs began to fall off, and before long they ceased altogether. The suburbs of Rome, after repeated sackings by the Lombards, were abandoned. The city was greatly impoverished, and it became impossible for the popes to restore and maintain the churches of the martyrs. The last great systematic restorations were carried out under Hadrian I (772–95); his building activities fill page after page of the biography written by one of his contemporaries and included in the *Liber Pontificalis*.

The ever growing insecurity of the countryside and the danger of theft of the sacred relics by the barbarians led the popes, beginning in the eighth century, to translate martyrs' remains to churches inside the city. Paschal I (817–24) moved a great many relics from the "ruined" cemeteries, as a contemporary described them in the *Liber Pontificalis*, to the basilica of Santa Prassede, where a long catalogue of the relics, inscribed on marble, is still preserved.

The translation of its relics signified the end for each catacomb; many of the churches above ground, no longer cared for, gradually collapsed, and the entrances to the galleries disappeared under the rubble. A few decades after the final translations, most of the catacombs had been forgotten. Some of the galleries of the catacombs of Saint Pancratius on the Via Aurelia, of Saint Lawrence on the Via Tiburtina, and especially of Saint Sebastian on the Appian Way continued to be visited throughout the later Middle Ages. Until the fifteenth century, despite occasional excavations among the rubble by people searching for the treasures that they presumed to be hidden there, nearly all of the catacombs remained unknown. A twelfth-century scholar, Benedetto Canonico, drew

up a list of the ancient cemeteries and inserted it in his guide to the city. Although the author was an acute observer of ancient monuments, the list appears to have been copied from older sources, and it contains such serious topographical errors that we can only conclude that Benedetto had no direct knowledge of the cemeteries in question.

The Rediscovery of the Catacombs

Graffiti with the signatures of visitors, beginning in the fifteenth century, show that a few catacombs, such as those of Saint Callistus and of Saints Peter and Marcellinus and the so-called Coemeterium Maius, were once again being explored. Among the visitors were the members of the famous Roman Academy, headed by the humanist Pomponius Laetus.

The systematic search for the catacombs was begun by the chance discovery in 1578 on the Via Salaria of a group of galleries with beautiful paintings. This event aroused great enthusiasm among scholars, because it had unexpectedly brought to light a rich and ornate burial area, with the tombs still sealed and with their original furnishings intact. The paintings were copied and published, and scholars were encouraged to look for others. Antonio Bosio (1575–1629), the most active of these scholars, has been called "the Columbus of underground Rome." He discovered singlehanded some thirty catacombs, and laid the basis for scientific research by his topographical analysis of the monuments in the light of documents.

The archaeologists of the seventeenth and eighteenth centuries, unfortunately, did not follow Bosio's topographical method. They began to despoil the catacombs, carrying off the epitaphs and sarcophagi to museums and churches and opening a large number of the tombs in search of the bodies of the martyrs. The vinedressers of the surrounding areas completed the work of destruction by going down into the galleries to find materials for their farm buildings. It was at this time that vast areas of the catacombs took on the devastated appearance that characterizes them today, with the tombs open and empty and the marble slabs shattered. Only the frescoes were left, after unsuccessful and destructive attempts to remove them.

During the last century, thanks above all to the foundation by Pius IX of the Pontifical Commission for Sacred Archaeology, the work of destruction came to an end. Giambattista De Rossi (1822–94) restored the scientific study of the catacombs and established the principles of Christian archaeology. With his excavations he brought to light many martyrs' shrines that had escaped the depredations of the previous centuries.

Article 33 of the concordat between the Holy

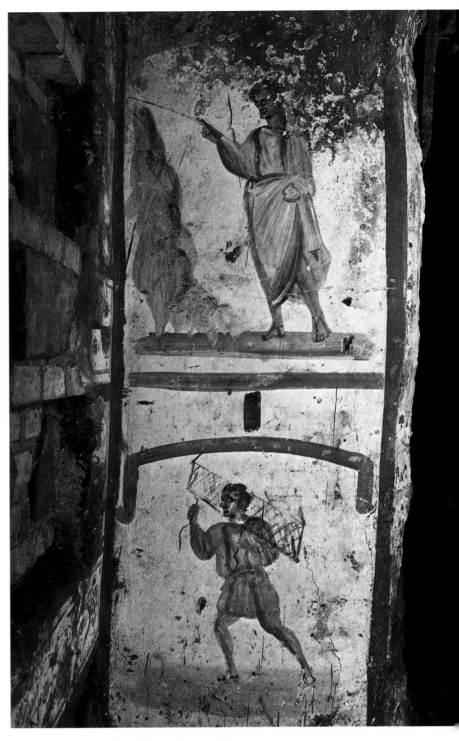

Moses Striking the Rock and the *Healing of the Paralytic*, frescoes in the catacomb of Saints Peter and Marcellinus.

See and the Italian state specifies that the catacombs of Rome, like those of the rest of Italy, are entrusted to the Holy See, which provides for their protection, preservation, and scientific exploration by the Pontifical Commission for Sacred Archaeology.

The Catacomb of Saint Callistus

This catacomb on the Appian Way was administered by Callistus I when he was still a deacon; during his pontificate (217–22) he enlarged it and established it as the official cemetery of the bishops of Rome. Here all the popes of the third century were buried, with the exception of Callistus himself, who was interred in the catacomb of Calepodius on the Via Aurelia, perhaps because of the disturbances that accompanied his martyrdom, and Urban I (222–30), who was buried in the catacomb of Praetextatus.

A large staircase leads down to the crypt of the popes, the most venerable part of the catacomb and one of the most sacred places in Rome. On the wall near the entrance are numerous graffiti, written one on top of the other by pilgrims in ancient times. Nine popes were buried here, most of them martyrs: Pontianus (230–35), Anterus (235–36), Fabian (236–50), Lucius I (253–54), Stephen I (254–57), Sixtus II (257–58), Dionysius (259–68), Felix I (269–74), and Eutychian (275–83). Five of the original Greek epitaphs have been preserved. Three bishops of other sees were also buried here, probably as a sign of deference to heads of local churches who died while visiting Rome. An inscription with a long poem by Pope Damasus, in honor of all the saints buried in the cemetery, may be seen below the central tomb. In it Damasus declares that he has longed to be buried in the crypt of the popes, but considers himself unworthy of the honor.

Through a passage beside the altar one comes to the nearby crypt of Saint Cecilia. On the walls are paintings of Saint Cecilia herself and, in a lower zone, Saints Polycamus, Sebastian, and Quirinus. Better preserved are the later pictures on the walls of the *cubiculum*, beside the niche where the saint's tomb stood. The youthful martyr, richly clothed and with a halo, is represented together with a bust of the Redeemer and a figure of Saint Urban. In the niche is a copy of the famous statue by Stefano Maderno, executed in 1600,

The crypt of the popes is the most venerable part of the catacomb of Saint Callistus.

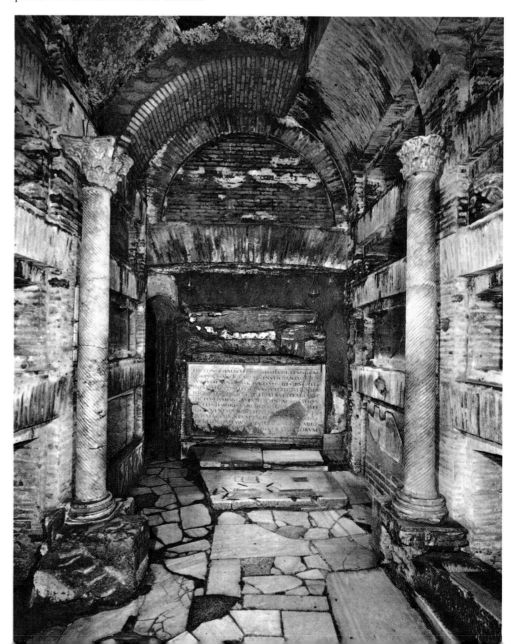

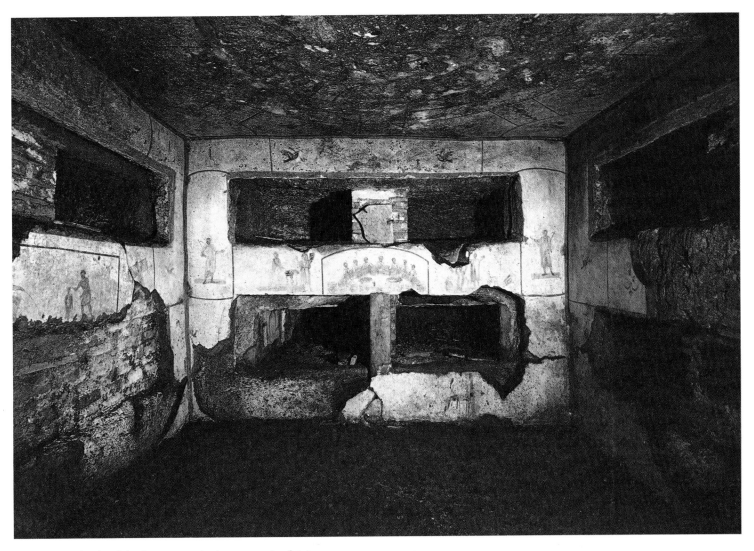

One of the *cubicula* of the Sacraments in the catacomb of Saint Callistus: the frescoes allude to baptism and to the Eucharist.

showing Cecilia at the moment of her death. The original is in the basilica of Santa Cecilia in Trastevere, to which Paschal I transferred the saint's remains in 821.

Behind the crypts of the popes and of Saint Cecilia is the earliest part of the cemetery, consisting of a vast rectangle of parallel galleries. Six small *cubicula* are decorated with frescoes that are among the most ancient catacomb paintings in Rome. These rooms are known as the *cubicula* of the Sacraments, because the frescoes allude to baptism and the Eucharist. The subjects include Jonah saved from the whale, Moses striking water from the rock, the Sacrifice of Abraham, the Baptism of Christ, and the Multiplication of the Loaves and Fishes.

Like all the other large catacombs, the catacomb of Callistus originally consisted of several independent nuclei, which were later joined as the cemetery expanded. One of the oldest areas, known as the crypt of Lucina, has painted Eucharistic symbols of the second century. In it is the tomb of Pope Cornelius (251–53), who died in exile at Civitavecchia but whose body was translated here. A fresco beside the tomb, probably from the sixth century, shows Cornelius and his friend Saint Cyprian, bishop of Carthage, who defended him against the Novatianist schismatics. The two saints are represented with haloes, in pontifical vestments, and bearing jeweled manuscripts in their hands. On the other side of the tomb is a fresco representing Sixtus II (257–58), who, as we know from a letter of Cyprian's, was martyred together with his deacons in this very catacomb during the persecution of Valerian (Sixtus is buried in the crypt of the popes). Another nucleus includes the *cubiculum* of Pope Eusebius (309–310), which is lined with marble and has niches decorated with mosaics; mosaics are rare in the catacombs. The inscription by Pope Damasus— only fragments of the original remain, but there is also a crude copy made shortly after the barbarian devastations of the sixth century—describes the pontificate of Eusebius, which was troubled by the controversy over pardon for Christians who, out of fear, had sacrificed to the pagan gods during the persecutions.

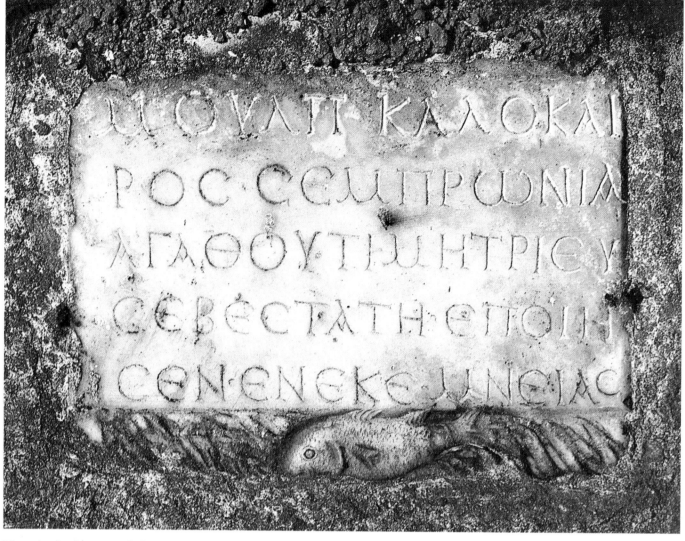

The epitaph of Marcus Clodius Hermes, in the oldest
part of the catacomb of Saint Sebastian. The fish
is an ancient symbol of Christ.

Eusebius, who was sympathetic to those who repented,
was exiled together with the leader of the rigorist party
to Sicily, where he died. Yet another nucleus is named
for Pope Melchiades (310–14), during whose pontifi-
cate Constantine granted peace to the church. The
pope was probably buried here, but his tomb has not
been identified with certainty.

The Catacomb of Saint Sebastian

The cult of the apostles Peter and Paul, recorded since
the middle of the third century at a site beside a ravine
on the Appian Way, has been discussed in the section
on the basilica of San Sebastiano. There was a quarry
at the bottom of the ravine, with galleries cut into the
tufa. After the quarry was abandoned, toward the end
of the first century A.D., the galleries were used for
burials. At about the same time a double row of
columbaria (tombs in the form of dovecotes, with niches
for funerary urns) was constructed at the edge of the
ravine. Around the middle of the second century, three
large mausoleums and a number of tombs with *loculi*
were cut into the slope about three meters from the

bottom. Here we find the first indications of Chris-
tian burials.

The mausoleum in the center contains tombs that
belonged to members of a burial association called
the Innocentiores; the inscription that identifies them
also gives the name of three emperors who reigned
briefly in A.D. 238, Gordian, Pupienus, and Balbinus.
The entire mausoleum was probably for the use of
this organization. A graffito was scratched in the lime
while it was still fresh: ΙΧΘΥΣ (*ichthus*, the Greek word
for "fish"), which was a famous acrostic for the brief
confession of faith "Jesus Christ, Son of God, Savior."
Between the first two letters a cross, the symbol of
Christian salvation, is inserted. On the façade of the
right-hand mausoleum is a marble inscription with
the name of the proprietor, Marcus Clodius Hermes.
A small terrace was constructed above the pediment,
with seats for funeral repasts. Paintings, now badly
faded, adorn the terrace walls. One can still make
out shepherds with their flocks, banqueters seated at
four tables, and servants carrying baskets of bread.
Another scene seems to represent the Gospel story of
the Gerasene swine. The frescoes inside the mausoleum

are better preserved; the five scenes in the niche at the far end apparently depict pagan funerary rites. Inscriptions on the *loculus* tombs have Christian symbols, the fish and the anchor.

Toward the middle of the third century the burial area with the three mausoleums was filled in and the ground level was raised by six meters. It was on the new level that the courtyard and loggia with graffiti in honor of Saints Peter and Paul were constructed. During the persecution of Diocletian, the body of Saint Sebastian was buried in a nearby crypt. Another martyr buried in the cemetery is Saint Eutychius; the splendid epitaph in his honor by Pope Damasus is still intact.

The galleries of the catacomb of Saint Sebastian are quite extensive, but only a few inscriptions and symbols remain in situ. A fine sarcophagus from the middle of the fourth century was found in 1950. Flanking a roundel with portraits of the deceased are reliefs of biblical scenes, arranged in two registers. The subject of one of the reliefs is rare in Early Christian art: Lot fleeing Sodom with his family. The excavation of 1950 also brought to light a *cubiculum* with frescoes of the story of Jonah.

The Catacomb of Domitilla

Flavia Domitilla was a grandaughter of the emperor Vespasian and the wife of Vespasian's cousin Titus Flavius Clemens, who was consul in A.D. 95. Clemens was put to death for practicing Christianity, and Domitilla was sent into exile on the island of Ventotene. This rich and influential couple had encouraged the creation of a Christian cemetery on a vast estate belonging to them on the Via Ardeatina. Several of the early nuclei in the large catacomb on this site date from the second century and were certainly part of the original foundation. One of these nuclei, known since De Rossi's time as the crypt of the Flavians (the name of the imperial dynasty to which Domitilla belonged), was apparently begun by pagans who then converted to Christianity; frescoes representing Daniel in the Lions' Den and Noah were added to the original decoration.

The original nuclei were later linked by a network of galleries, which reached imposing proportions in the fourth century. The galleries were cut through on two main levels; only in a few places are there galleries and *cubicula* on a third and a fourth level. The fourth-century cemetery was for the use of the Christians of the First Ecclesiastical Region, which had its center in the *titulus* of Fasciola (the present-day church of Santi Nereo and Achilleo) near the Baths of Caracalla. A number of inscriptions commemorate clergy and laymen of that parish, including Pollecla, a barley vendor in the Via Nova, and Cucumius, a wardrobe attendant at the baths.

One *cubiculum* was the resting place of a grave-digger called Diogenes; his name (made famous in the nineteenth century by Cardinal Wiseman's novel *Fabiola*) was painted on the *arcosolium* at the rear of the chamber. The fresco decoration has been badly damaged. Saint Paul is represented with a long, black, pointed beard, holding a scroll of the Scriptures, in the vault of the niche; the figure originally formed part of a group with Saint Peter and a bust of Christ.

Another *arcosolium* nearby, dating from the middle of the fourth century, shows the twelve apostles seated

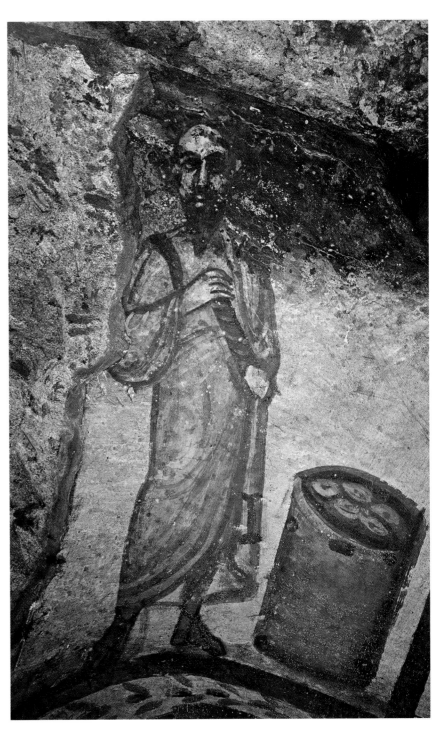

Saint Paul holding a scroll of the Scriptures: fresco in the *cubiculum* of the gravedigger Diogenes in the catacomb of Domitilla.

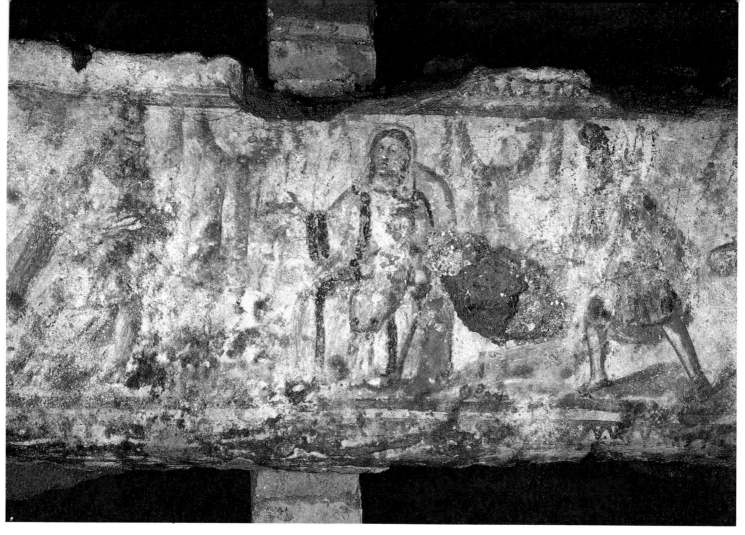

Detail of the fresco of the *Adoration of the
Magi* in the catacomb of Domitilla.

The underground basilica of Saints Nereus and
Achilleus in the catacomb of Domitilla.

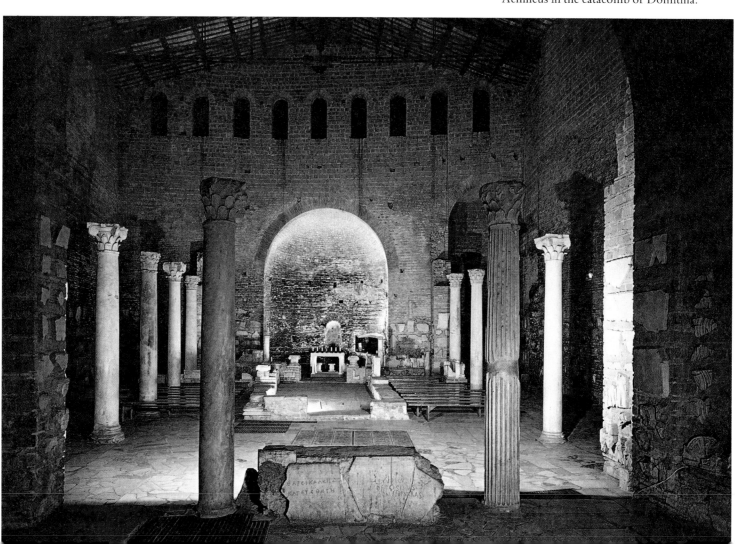

beside Christ. Saints Peter and Paul appear in the lunette with the praying figure of a deceased woman, for whom they are interceding. Christ is enthroned between Peter and Paul in an *arcosolium* decorated with mosaics; in the vault are mosaic representations of the Raising of Lazarus, the Three Young Men in the Fiery Furnace, and perhaps the Sacrifice of Abraham—most of the tesserae that made up the third scene have fallen away.

A large section of the catacomb is called the "area of the Madonna" after a fresco representing the Epiphany: four Magi, two to each side, offer their gifts to the Child seated in the Virgin's lap. A remote section is known as the "area of the bakers": frescoes there show workmen unloading sacks of grain from ships on the Tiber; the grain is about to be transported on wheelbarrows to the flour mills and bakeries.

Two martyrs, Saints Nereus and Achilleus, were buried in the catacomb of Domitilla. According to the legend, they were jailers at the tribunal of one of the persecutors of the Christians. Suddenly, transformed by grace, they threw down their arms and joyfully faced torture. The area surrounding their tomb was transformed into an underground basilica, perhaps by Pope Damasus, who dedicated one of his verse inscriptions to the two martyrs. Pope Siricius (384–99) demolished two levels of catacomb galleries in order to build a larger basilica on the site (it later fell into ruin, perhaps in the earthquake of 897, and was rediscovered only in 1874). There were numerous tombs beneath the pavement of the basilica and a new group of *cubicula* was carved into the tufa behind the apse. In one of these *cubicula* a fresco from the middle of the fourth century gives beautiful expression to the religious sentiment that inspired Christians to have themselves buried near the tombs of martyrs: a matron called Veneranda, who had succeeded in obtaining a tomb near that of the martyr Petronilla, is being led by the saint into the garden of Paradise. We do not know exactly where this martyr's grave was situated, but it cannot have been far away, because in some seventh-century descriptions the basilica bears the name of Santa Petronilla. Petronilla's sarcophagus, decorated with dolphins, and her relics were transported to the Vatican by Pope Paul I (757–67).

The Catacomb of Priscilla

Like the catacomb of Saint Sebastian, the catacomb of Priscilla on the Via Salaria was originally a quarry. The galleries of the first level are wide, with curving irregular walls and no preestablished plan, whereas most catacomb galleries are narrow and regular, with perpendicular walls suitable for the insertion of *loculi*. A massive landslide, perhaps caused by excessive ex-

Susanna and the Elders, fresco in the Greek Chapel in the catacomb of Priscilla.

Joseph Interpreting Dreams, fresco in the catacomb on the Via Dino Compagni.

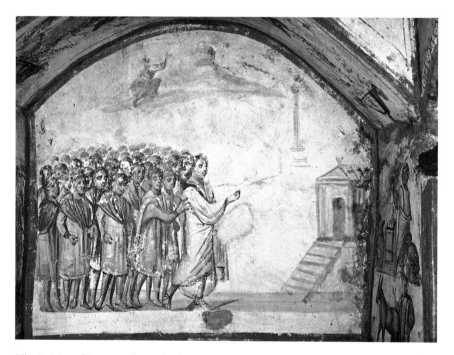

The Raising of Lazarus, fresco in the catacomb on the Via Dino Compagni.

cavations, blocked the entrance from the Via Salaria, and the quarry was abandoned.

The Christians began to use the site for burials toward the beginning of the third century. They dug a stairway to give access from above, and constructed about twenty tombs of masonry in the wide galleries; hundreds of other tombs were hollowed out in the walls. At some point the galleries must have threatened to collapse, and supporting walls of masonry were built. These walls sealed off the earlier tombs, thus saving them from being plundered during later periods; when archaeologists explored the catacomb in the late nineteenth century, many of the *loculi* were still intact. The inscriptions on these tombs are among the oldest of Christian epitaphs, and are moving in their extreme simplicity: we find the name of the dead person, an invocation for peace, a palm, an anchor, or a dove with an olive branch. One of the Christians buried here was a certain Vericundus, to whose name has been added the letter *M* with an abbreviation sign. It is possible that Vericundus was a martyr, though there are no indications of a cult; the tomb was isolated by a supporting wall.

A niche in the catacomb contains one of the earliest known images of the Blessed Virgin. She is sitting in a chair with the Child in her arms; in front of her is the prophet Balaam, who carries a scroll in his left hand and points with his right hand to a star. Other frescoes are found in the *cubicula* of the adjoining areas, which were added to the quarry in the second half of the third century. They include the Good Shepherd in the garden of Paradise; a beautiful figure of a veiled woman praying, with two scenes from her married life, the ceremony in which she received the wedding veil from the priest, and the birth of her first child; a group of vinedressers carrying barrels; and a scene that perhaps represents the Annunciation. In each of the *cubicula* there are also the usual biblical scenes referring to salvation.

A very old nucleus on the first level of the catacomb is known as the crypt of the Acilii; numerous inscriptions naming members of that noble family were found in the vicinity. One inscription mentions a certain Priscilla and gives her the title *clarissima*, which was reserved for persons of senatorial rank. This lady was perhaps the Priscilla who founded the cemetery and for whom the catacomb was named.

A room with three apses, intended for funeral meals, dates from the second century. It is called the Greek Chapel because there are inscriptions in Greek on the walls. The fresco decoration is of considerable interest. Many episodes from the Old and New Testaments are represented on the walls. On the frontal arch there is a banqueting scene in which the guest in the place of honor is breaking bread over a chalice.

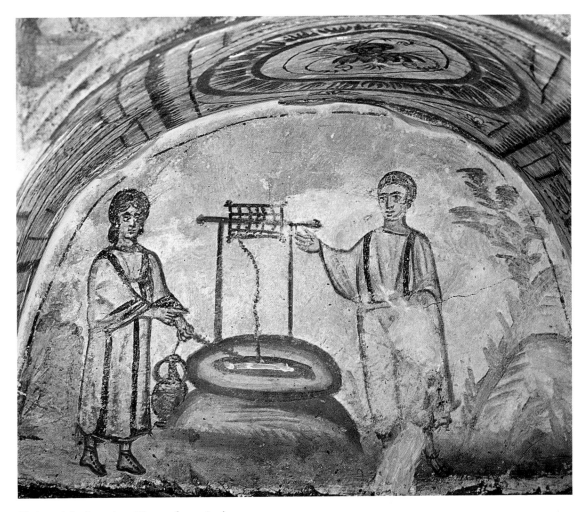

Christ and the Samaritan Woman, fresco in the catacomb on the Via Dino Compagni.

This fresco is known as the *Fractio Panis,* or "breaking of bread," the name given by the ancients to the Eucharistic celebration. A recently discovered painting in the corner shows a phoenix rising from the flames: the mythical bird was a symbol of the immortality of the soul.

The second level of the catacomb of Priscilla is very different from the first. It developed according to a unified plan, and consists of two long parallel galleries with branches arranged in a herringbone pattern. The galleries were extended continually to accommodate thousands of deceased Christians.

Other Catacombs

Space does not permit us to describe all of the catacombs of Rome. We may mention, however, a few of the more important ones.

The largest number are concentrated in the southern outskirts of the city. In the catacomb of Commodilla, not far from the Via Ostiense, the martyrs Felix, Adauctus, Merita, and Nemesius were buried. There is a small underground basilica with beautiful paintings dating from various periods; there is a recently discovered *cubiculum* that belonged to an employee of the food supply office, a man called Leo; and there are many galleries with the tombs still intact, furnished with small clay lamps and other objects.

The vast catacomb of Praetextatus, off the Appian Way, contains the tombs of a number of martyrs: Januarius, Quirinus, Felicissimus, Agapitus, Tiburtius, Maximus, Zeno, and Pope Urban I (222–30). It is richly decorated with frescoes and has fine architectural details.

A small catacomb discovered in 1956 on the Via Dino Compagni was constructed during the first decades after the peace between Constantine and the church. It was not a communally owned cemetery, but a private burial place that served a small number of wealthy families, not all of which were Christian. It is of exceptional interest for its plan, with chambers of various geometrical shapes laid out along a central axis, and for its beautiful, well-preserved frescoes. Many of the biblical subjects, especially those from the Old Testament, are unknown in the other catacombs. Pagan subjects, furthermore, are found to-

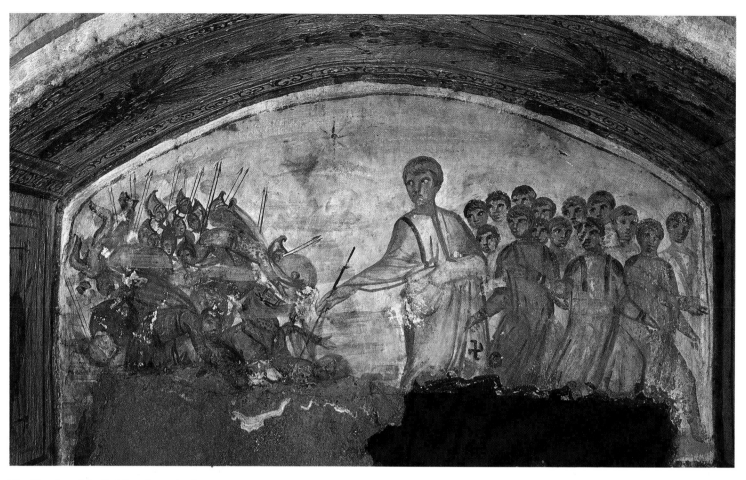

The Crossing of the Red Sea, fresco in the
catacomb on the Via Dino Compagni.

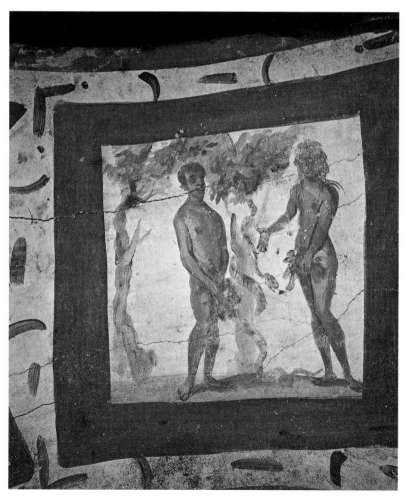

The Fall of Adam and Eve, fresco in the
catacomb of Saints Peter and Marcellinus.

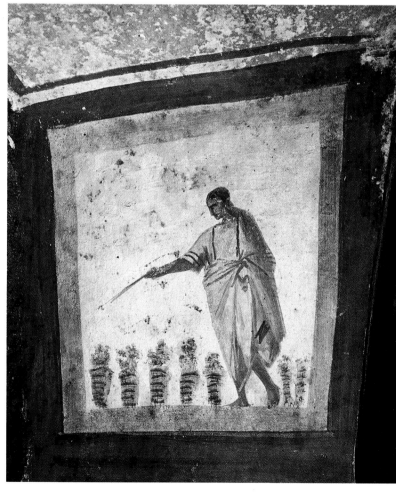

The Multiplication of the Loaves, fresco
in the catacomb on the Via Anapo.

gether with the Christian ones—this would not have been allowed in a cemetery dependent upon the ecclesiastical authorities.

Among the catacombs on the eastern edge of Rome is that of Saints Peter and Marcellinus, near the mausoleum of Saint Helena on the Via Casilina. It has a large number of frescoes, most of which are well preserved. A small underground basilica was discovered in 1896; it had been formed by demolishing a number of galleries so as to leave the crypt of the two martyrs isolated in its center.

Very little remains of the catacomb of Saint Agnes, north of Rome on the Via Nomentana. Constantine's daughter Constantia built a basilica over the much-venerated remains of the Roman virgin and martyr; Honorius I (625–38) rebuilt it, cutting deep into the hillside where the catacomb was and destroying most of the galleries. Only one part of the original, pre-Constantinian cemetery remains. It contains marble inscriptions with beautiful characters, simple formulas, and many symbols; no frescoes have been preserved.

The catacomb known as the Coemeterium Maius ("great cemetery"; it is thus called to distinguish it from a smaller catacomb nearby, the Coemeterium Minus) occupies two levels. It contains *cubicula* notable for their architectural detail, numerous frescoes, and thirteen seats, cut into the tufa, in crypts that were used for funeral meals. The names of the martyrs buried in the Coemeterium Maius are known from literary sources and from two inscriptions: Victor, Alexander, Felix, Papias, Maurus, and Emerentiana.

A catacomb on the Via Anapo, the original appellation of which has not been discovered, contains many frescoes. The catacomb of the Greek martyr Saint Hermes is notable chiefly for its underground basilica, the largest in all the Roman catacombs. It also contains the tombs of Saints Protus and Hyacinth, and *arcosolia* with interesting frescoes.

The area west of Rome is also rich in Early Christian cemeteries, though there are relatively few remains of artistic interest. In 1960 the tomb of Pope Callistus was discovered in the catacomb of Calepodius; his shrine is decorated with votive pictures representing his martyrdom. The catacomb of Pontianus, on the Via Portuense, is interesting for the sixth- and seventh-century frescoes in its crypts. The martyrs Abdon, Senno, Pollio, Pumenius, Milax, and Candida, as well as Popes Anastasius I (399–401) and Innocent I (401–417), were buried there.

UMBERTO FASOLA

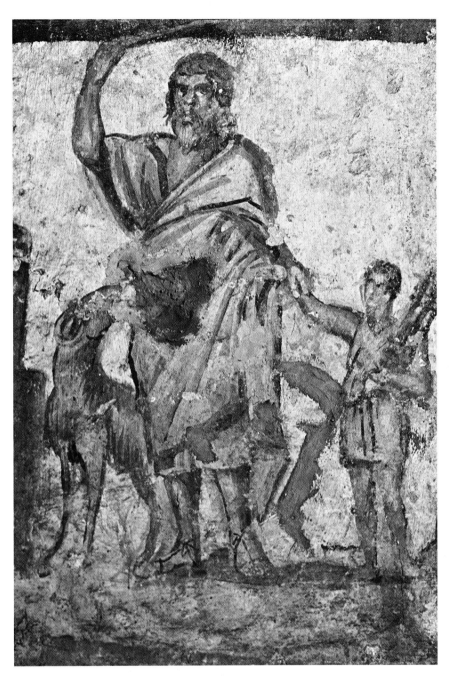

The Sacrifice of Abraham, fresco in the catacomb on the Via Anapo.

West façade of the Lateran Palace, seen from the
Benediction Loggia of San Giovanni in Laterano.

PALACES OF
THE HOLY SEE IN ROME

Note

According to Article 13 of the Lateran Treaty, the basilica of San Giovanni in Laterano and the adjacent Lateran Palace are recognized by Italy as property of the Holy See. The Palazzo della Cancelleria and the Palazzo di Propaganda Fide are part of the territory of the Italian state, but under Article 15 of the treaty, they have immunity accorded by international law to the seats of the diplomatic representatives of foreign states. The extraterritorial privileges enjoyed by the three palaces include exemption from expropriation and taxation, and structural work carried out inside the buildings is not subject to the approval of the Italian authorities.

The Lateran Palace

The Patriarchium, the vast palace adjoining the Lateran basilica where the popes resided for a thousand years, has been described in the section on San Giovanni in Laterano. It was severely damaged by fire in 1360 and never restored. Portions of the ruined building were still used: Eugenius IV (1431–47), Sixtus IV (1471–84), and Leo X (1513–21) stayed there for brief periods, and prelates were lodged there during the Fifth Lateran Council, which met in the basilica from 1512 to 1517. Under Paul III (1534–49) and Julius III (1550–55) the remains of the Patriarchium were partly demolished.

The energetic reformer Sixtus V (1585–90), who radically transformed both the administrative structure of the church and the urban fabric of Rome, felt that San Giovanni, the cathedral of Rome, should have a suitable patriarchal residence. He ordered his architect, Domenico Fontana, to construct a new palace. The last vestiges of the Patriarchium were pulled down, together with the houses of the canons of San Giovanni and several private buildings. The huge new palace was begun in 1586 and completed in three years.

Fontana was a competent builder but a conservative and unimaginative artist. The architecture of his Lateran Palace is derived from Roman buildings of the earlier sixteenth century, notably the Palazzo Farnese, begun about 1515 by Antonio da Sangallo the younger and completed by Michelangelo after Sangallo's death in 1546. The three identical façades—the fourth side of the palace is contiguous to the basilica—are monotonous, articulated only by rectangular windows; the windows of the *piano nobile* and the upper story have alternating triangular and segmental pediments. The visual emphasis is on the central bays, with rusticated portals supporting balconies; the windows communicating with the balconies are flanked by scrolls and surmounted by the arms of Sixtus V. Sixtus's heraldic lion and star also appear in the relief decoration of the cornice. The cortile, with Doric and Ionic arcades and an upper story articulated by telamones, is somewhat less forbidding than the façades.

Sixtus had the interior of the palace sumptuously decorated: about 10,000 square meters of wall surface were covered with stucco and frescoes by a team of late Mannerist painters headed by Giovanni Guerra and Cesare Nebbia. In the room formerly called the Sala dei Pontefici, espisodes from the legends of the first nineteen popes are represented together with the architectural achievements of Sixtus's reign. The room is now known as the Sala della Conciliazione: here the Lateran Treaty, which reconciled the Holy See and

The cortile of the Lateran Palace. Domenico Fontana's architecture is inspired by earlier sixteenth-century models.

the Italian state, was signed on February 11, 1929.

With all its vastness and richness, the Lateran Palace was something of a white elephant. Sixtus himself apparently had no intention of residing there permanently; he divided his time between the Vatican and his summer palace on the Quirinal Hill. Quarters were assigned to the Sacred Roman Rota and to the Apostolic Camera in 1589, and a concistory was held in the palace on May 31 of that year, but there could be no question of transferring the entire administrative apparatus of the church from the Vatican to the Lateran. Paul V (1605–21) made the palace the residence of the cardinal archpriest and the canons of the basilica, and Urban VIII (1623–44) turned it into a hospital. Gregory XVI (1831–46), Pius IX (1846–78), and Pius XI (1922–39) installed, respectively, the Museo Profano Lateranense, the Museo Cristiano Lateranense, and the Museo Missionario Etnologico in the halls of the palace. John XXIII (1958–63) wanted the Lateran, with its historic associations, to have a more central place in the life of the church; he ordered that the museums be transferred to new premises in the Vatican and that the offices of the Vicariate, or diocesan government, of Rome be established in the Lateran. The palace was thoroughly restored, and in 1967, under Paul VI (1963–78), it became the seat of the Vicariate.

JOHN DALEY

The Cancelleria

The basilica of San Lorenzo in Damaso, in the Campus Martius (the district of ancient Rome within the bend of the Tiber), was built by Pope Damasus (366–84), possibly on the site of an earlier church. No architectural traces of the fourth-century basilica have been identified with certainty, and its exact location is unknown. During the Middle Ages San Lorenzo in Damaso became one of the most important churches in Rome, and a cardinal's palace was constructed beside it. In 1350 Cardinal Hugo de Beaufort, the brother of Clement VI, put the palace at the disposal of Saint Bridget of Sweden, who resided there for four years.

The Renaissance pope Sixtus IV (1471–84), who built the Sistine Chapel in the Vatican, also promoted the urban development of the Campus Martius. The main thoroughfares were straightened and widened, and the widening of one street, later named the Via

del Pellegrino because it served as an artery for pilgrims traveling between Saint Peter's and San Giovanni, entailed the partial demolition of San Lorenzo in Damaso and the palace adjoining it. In 1483 Sixtus appointed his grandnephew Cardinal Raffaele Riario, the Chamberlain of the Apostolic Camera, titular cardinal of the basilica. Riario set out to restore the Early Christian church and the medieval palace, but he soon abandoned this project in favor of a more ambitious one: he decided to erect a completely new building, incorporating both a church and a residence.

Work began in 1484. By 1489 construction must have been well underway: in September of that year Riario won 14,000 ducats at dice from Franceschetto Cibo, the son of Sixtus's successor, Innocent VIII (1484–92); the pope ordered him to return the money, but Riario replied that he had already spent it all on his new palace. The main façade, or at least its two

Detail of the north façade of the Lateran Palace. The central window is surmounted by the arms of Sixtus V.

lower stories, was completed in 1495, according to the inscription on the frieze of the *piano nobile*. In 1495 the chapter of San Lorenzo in Damaso took possession of the new church, and in the following year Riario moved into the palace. Parts of it remained unfinished, however. The cardinal was absent from Rome from 1499 to 1503 because of a dispute with the Borgia pope, Alexander VI (1492–1503); work was resumed under Julius II (1503–1513), who was Riario's cousin. A few inscriptions on lintels and windows refer

to the cardinal as bishop of Ostia, which he became only in 1511. In May 1517 Riario and four other cardinals were implicated in a plot to assassinate Leo X (1513–21). One cardinal was killed in prison; Riario escaped with his life, but his palace was confiscated. It was made the residence of the papal vice-chancellor, and has been known ever since as the Palazzo della Cancelleria.

The Cancelleria is the crowning achievement of quattrocento architecture in Rome, but its authorship

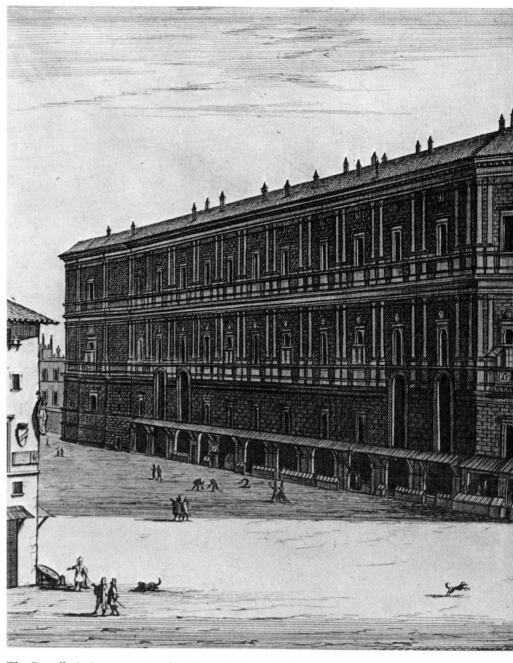

The Cancelleria, in an engraving by Alessandro Specchi. The two portals of the main façade lead to the cortile of the palace and to the basilica of San Lorenzo in Damaso.

remains a mystery. Vasari tells us that Donato Bramante, together with "other excellent architects," contributed to the "resolution" of the palace, and that the "executor" was a certain Antonio da Montecavallo. Scholars have long debated the implications of Vasari's statement. "Resolution" can be taken as referring either to the planning stage or to the final stage of construction. In the 1480s, when the palace was begun, Bramante was working for the duke of Milan, Lodovico il Moro, but it is not inconceivable that Riario, through Lodovico, obtained sketches or even a wooden model from the architect at that time. A letter from Lodovico to an ambassador implies that Bramante was in Rome for a brief visit at the end of 1492; he moved there definitively in 1499. Attempts to identify Bramante's style in various parts of the building that presumably belong to a late stage in its construction are not convincing; the Cancelleria is a highly unified structure, and there is no indication that significant changes were introduced after 1499. Antonio da Montecavallo, to whom Vasari attributes the execution of the project, is an otherwise unknown figure; it has been suggested that he was the brother of the Lombard architect and sculptor Andrea Bregno,

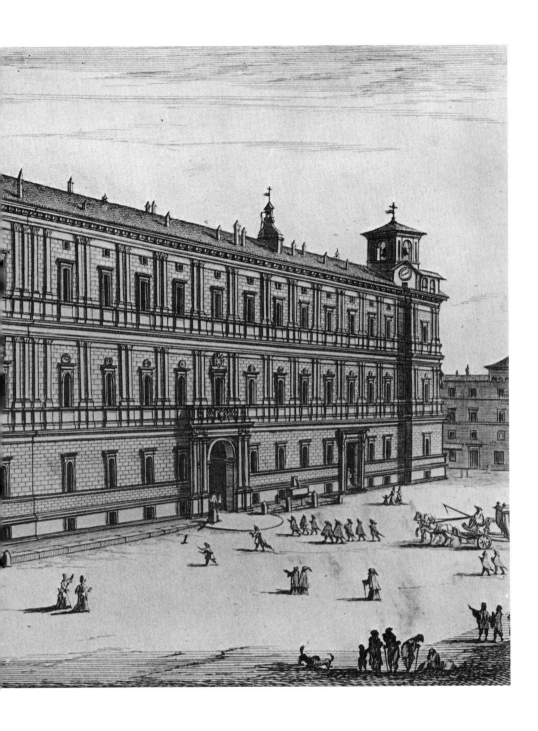

who was active in Rome in the late fifteenth century.

In its plan and elevation the Cancelleria belongs to the tradition of palace architecture that had developed, mainly in Florence, during the fifteenth century; it also has a number of features that are extraneous to that tradition. In Florentine palaces the rooms are arranged symmetrically around a cortile. The plan of the Cancelleria is asymmetrical, since it includes the relatively large church of San Lorenzo in Damaso as well as the residential wings. The façade gives no indication that part of the building is a church, except for the fact that there are two portals: one of them leads to the cortile and the other directly into the basilica. (The more elaborate portal, the one leading to the cortile, with its engaged columns and balcony, was given its present form by Domenico Fontana in 1589.) The corner bays project slightly; this feature is apparently derived from the fortified residences of the Middle Ages, which had corner towers for defense. The ground floor is plain; its rusticated masonry is interrupted only by the two portals and by twelve small arched windows surmounted by straight cornices. In deliberate contrast to the ground floor, the *piano nobile* is articulated by paired pilasters; the windows,

of the same size and type as those of the ground floor, are surmounted by roundels with the heraldic rose of the Riario family. The upper story repeats the scheme of the *piano nobile,* except for the windows, which are rectangular. The Cancelleria has a trapezoidal plan, and the wing facing the Via del Pellegrino forms an angle of about forty-five degrees with the main façade. It includes, on the ground floor, eleven shops with arched openings. (The medieval palace had also contained shops, whose keepers paid rent to the chapter of San Lorenzo in Damaso; when Riario decided to build a new palace, he had to promise the chapter to incorporate shops into its design.) In other respects the design of the Via del Pellegrino façade is similar to that of the main façade. The windows of the north façade, which overlooks a private garden, are irregularly spaced. The east façade, according to the inscriptions on five of its windows, was constructed after 1511. It repeats the scheme of the main façade in simplified form: the window bays are separated by single, rather than paired, pilasters, and there are no roundels over the windows.

The rectangular cortile is perpendicular to the main façade. Its elegant and perfectly symmetrical forms give no indication of the irregularity of the structure around it. There are two orders of arcades, with massive piers in the corners and Doric columns along the sides; the columns of the second order rest on pedestals, which are connected by a balustrade. At the third-story level the cortile is surrounded, not by a colonnade, but by a walled gallery with windows and Corinthian pilasters that echo those of the façades.

The new church of San Lorenzo in Damaso is adjacent and parallel to the cortile; its forms are ingeniously interlocked with those of the palace. One enters a deep, groin-vaulted vestibule that occupies only the ground-floor level; directly above it, on an axis parallel to the main façade, is the largest of the ceremonial rooms of the *piano nobile,* the Sala Riaria, which communicates with the open gallery surrounding the cortile. Beyond the vestibule is the nave, which corresponds in height to the three stories of the palace, though its area is relatively small. The low aisles are in fact extensions of the vestibule; like the vestibule, they are divided from the nave by arcades resting on heavy, square piers.

A number of rooms in the Cancelleria are richly decorated with frescoes. Only one, a small room in the west wing, appears to have been decorated during Cardinal Riario's time. It is known as the Saletta del Peruzzi, after the Sienese painter of that name, though the style of the frescoes is closer to that of Giovanni da Udine, who was Raphael's principal assistant in the Vatican Logge. The walls are articulated by trompel'oeil columns, which support an ornate frieze with putti and animals. A room in the northwest corner seems originally to have been a chapel. The frescoes are attributed to Perin del Vaga, who also worked in the Logge; as in the Logge, small biblical scenes are inserted into a framework of grotesques derived from the frescoes of Nero's Domus Aurea. The Florentine Mannerist Francesco Salviati was responsible for the architectural design as well as for the decoration in stucco and fresco of the present-day chapel. The best-known room in the Cancelleria is the Salone dei Cento Giorni, so called because Cardinal Alessandro Farnese, the vice-chancellor who commissioned the frescoes from Giorgio Vasari in 1546, stipulated that the vast cycle was to be completed in a hundred days. Vasari supplied the cartoons, but entrusted the execution to a team of assistants; he was so disappointed with the results that he vowed never again to rely on others. The historical and allegorical frescoes are a glorification of the reign of the Farnese pope, Paul III (1534–49).

JOHN DALEY

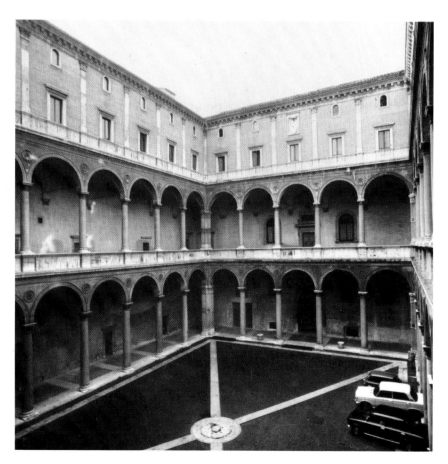

The cortile of the Cancelleria. Donato Bramante is said to have participated in the design of this palace.

The Palazzo di Propaganda Fide

The Congregation de Propaganda Fide, a curial department for the supervision of missionary activity, was instituted in 1622 by Gregory XV (1621–23). In 1626 a sixteenth-century building on the Piazza di Spagna, called Palazzo Ferratini, was donated to the congregation, and in the following year Gregory's successor, Urban VIII (1623–44), founded a seminary for the training of missionaries, known as the Collegium Urbanum. The seminary was installed in the Palazzo Ferratini, and in 1634 Gianlorenzo Bernini built a chapel with an oval plan, dedicated to the Magi, adjoining the palace to the southwest along the Via di Propaganda. Between 1639 and 1645 the architect Gasparo De Vecchi constructed another extension of the palace, with lodgings for the seminarians, along the Via Due Macelli.

The Piazza di Spagna façade of the Palazzo Ferratini was remodeled between 1642 and 1644. The design was apparently the work, later modified by Bernini, of a Theatine architect called Father Valerio. The façade is simple, harmonious, and dignified, more in the spirit of the sixteenth century than of the Baroque. The brick wall is articulated by pilasters and stringcourses; there is an imposing rusticated portal, and the Barberini arms are prominently displayed above the central window.

In 1646 it was decided to incorporate into the palace the entire trapezoidal block bounded by the Piazza di Spagna, the Via di Propaganda, the Via Due Macelli, and the Via Capo le Case. Urban VIII had died in 1644, and Bernini was out of favor with the new pope, Innocent X (1644–55). Through the influence of Virgilio Spada, an erudite clergyman who advised Innocent in artistic matters, the task of completing the palace was assigned to Francesco Borromini.

Borromini finished the wing that De Vecchi had begun, and then undertook the construction of a new wing along the Via di Propaganda. Work proceeded slowly. Borromini intended at first to incorporate Bernini's chapel into his plan, but then decided that it was too small: the chapel was demolished, probably in 1654. The design of the façade is ingenious. It is articulated by a giant order of pilasters, which are most unorthodox in form: the capitals are fluted, while the pilasters themselves are plain. The façade consists of seven bays. The central bay, containing the portal, is concave and the pilasters flanking it are set at an angle. The three bays to the left and to the right are rectilinear, but on the *piano nobile* level the windows of the outer bays are framed by aediculae that are concave in form, while the aedicula within the concave central bay is convex. All of the aediculae are surmounted by pediments of bizarre but very beautiful design. Since the Via di Propaganda is a narrow street, no vantage point offers a satisfactory single view of the façade: only by traveling its length does the spectator gradually take in the assonances and rhythms of the architecture.

Borromini's chapel, which was not finished until 1664, is parallel to the façade: it is entered from the passage that leads from the portal to the cortile. It is rectangular in plan, with rounded corners. The main altar is in a deep niche opposite the entrance, and there are shallow niches in the side walls and in the corner bays. There are rectangular windows above the niches, and round windows at the vault level. The décor is simple but extremely elegant. Ionic pilasters are continued by ribs projected diagonally across the vault. The intersecting ribs form a hexagon, in the center of the vault, containing a sunburst with the dove of the Holy Spirit. The arms of Alexander VII (1655–67), during whose pontificate the chapel was completed, appear over the main altar.

JOHN DALEY

PLAN OF OLD SAINT PETER'S AND THE VATICAN CIRCUS

MAP OF THE CATACOMBS IN THE CITY OF ROME

The Vatican Circus

Old Saint Peter's

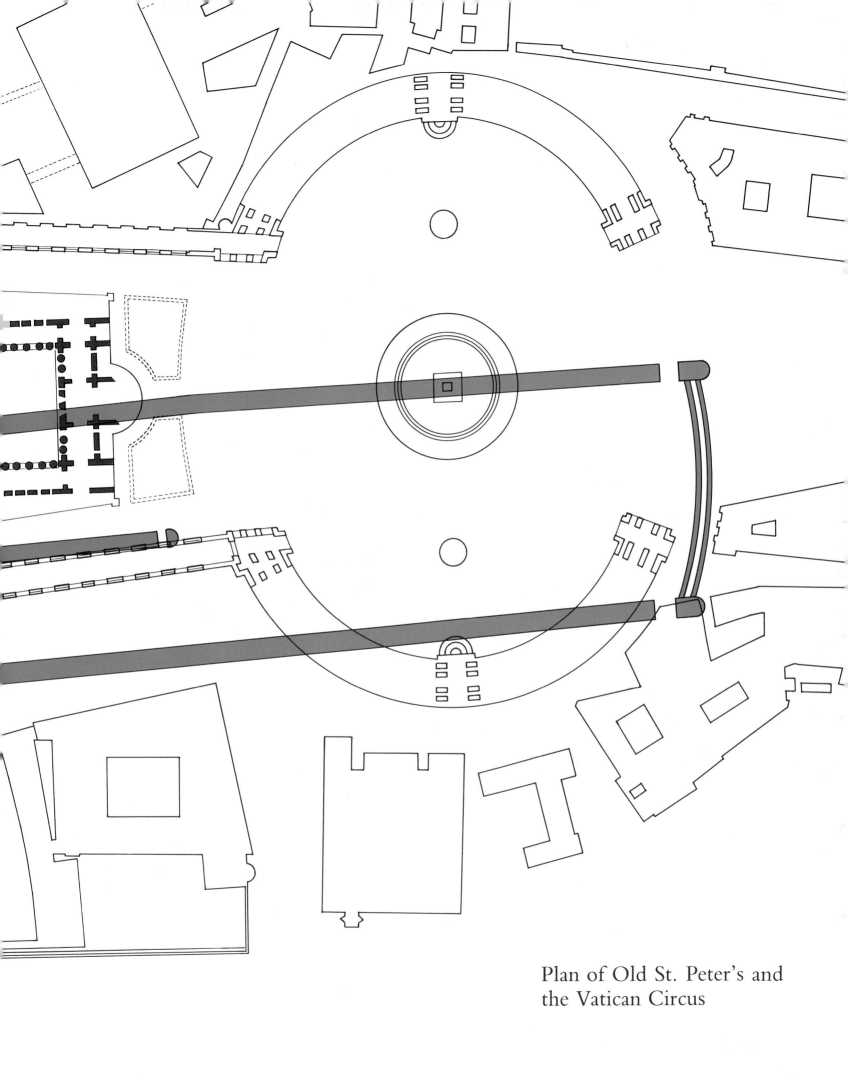

Plan of Old St. Peter's and
the Vatican Circus

m. 0 10 20 30 40 50 100
 c s.

Map of the Catacombs in the City of Rome

7th mile

CEMETERY OF ST ALEXANDER

COEMETERIUM MAJUS

CATACOMB OF ST AGNES

V. Lanciani

CEMETERY OF ST HIPPOLYTUS

CEMETERY OF NOVATIAN

CATACOMB OF SAN LORENZO FUORI LE MURA

Tiburtina

Viale Libia

Via Tripoli

UNNAMED CEMETERY OF VIA ANAPO

Corso Trieste

Via Nomentana

Viale XXI Aprile

CEMETERY OF ST NICOMEDES

Margherita

Via Salaria

CEMETERY OF PRISCILLA

CEMETERY OF THE JORDANI

Via Salaria

Viale Regina

CEMETERY OF MAXIMUS OR ST FELICITY

Stazione Termini

Porta Pia

CEMETERY OF BASSILLA OR OF ST HERMES

CEMETERY OF THRASO

CEMETERY OF PAMPHILUS

Via Pinciana

Via XX Settembre

Viale Parioli

TIBER

CEMETERY OF ST VALENTINE

Viale Pilsudski

Piazza del Popolo

Via del Corso

V. Cassia

Corso Francia

Via Flaminia

TIBER

Via Flaminia

V. Conciliazione

Vatican City

St Peter's

N

382

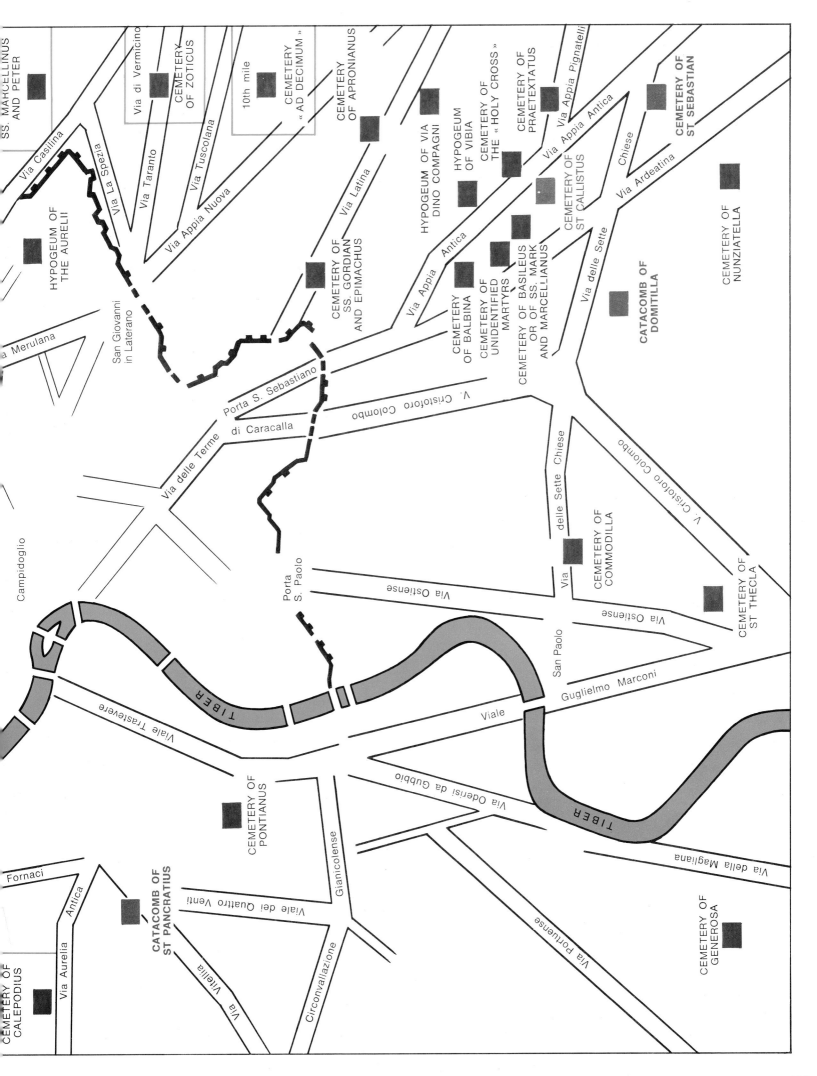

SS. MARCELLINUS AND PETER

CEMETERY OF ZOTICUS

Via di Vermicino

Via Casilina

Via La Spezia

Via Taranto

Via Tuscolana

10th mile

CEMETERY "AD DECIMUM"

Via Appia Nuova

CEMETERY OF APRONIANUS

HYPOGEUM OF THE AURELII

Via Merulana

San Giovanni in Laterano

Via Latina

CEMETERY OF SS. GORDIAN AND EPIMACHUS

Via Appia Antica

HYPOGEUM OF VIA DINO COMPAGNI

HYPOGEUM OF VIBIA

CEMETERY OF THE «HOLY CROSS»

CEMETERY OF PRAETEXTATUS

Via Appia Pignatelli

Via Appia Antica

Chiese

CEMETERY OF ST SEBASTIAN

CEMETERY OF ST CALLISTUS

Via Ardeatina

Via delle Sette

CEMETERY OF NUNZIATELLA

CEMETERY OF BALBINA

CEMETERY OF UNIDENTIFIED MARTYRS

CEMETERY OF BASILEUS OR OF SS. MARK AND MARCELLIANUS

CATACOMB OF DOMITILLA

Via Appia Antica

Porta S. Sebastiano

Via delle Terme di Caracalla

V. Cristoforo Colombo

delle Sette Chiese

V. Cristoforo Colombo

Campidoglio

Via delle Sette Chiese

CEMETERY OF COMMODILLA

CEMETERY OF ST THECLA

Porta S. Paolo

Via Ostiense

Via Ostiense

San Paolo

Guglielmo Marconi

TIBER

Viale Trastevere

Viale

Via Oderisi da Gubbio

TIBER

CEMETERY OF PONTIANUS

Gianicolense

Via della Magliana

Fornaci

CATACOMB OF ST PANCRATIUS

Via Aurelia Antica

Viale dei Quattro Venti

Via Vitellia

Circonvallazione

Via portuense

CEMETERY OF GENEROSA

CEMETERY OF CALEPODIUS

Via Aurelia

383

SAINT PETER AND HIS SUCCESSORS

This list of popes and antipopes is derived from one compiled by A. Mercati in 1947 under the auspices of the Vatican, though some changes have been made on the basis of recent scholarship and the list has been brought up to date. The dates of each pope's reign follow his name; for popes after the end of the Great Schism (1378–1417), family names are given as well. The names of antipopes are enclosed in brackets, while alternate numberings of papal names appear in parentheses.

Saint Peter (67)

Saint Linus (67–76)

Saint Anacletus (Cletus) (76–88)

Saint Clement I (88–97)

Saint Evaristus (97–105)

Saint Alexander I (105–15)

Saint Sixtus I (115–25)

Saint Telesphorus (125–36)

Saint Hyginus (136–40)

Saint Pius I (140–55)

Saint Anicetus (155–66)

Saint Soter (166–75)

Saint Eleutherius (175–89)

Saint Victor I (189–99)

Saint Zephyrinus (199–217)

Saint Callistus I (217–22)

 [Saint Hippolytus (217–35)]

Saint Urban I (222–30)

Saint Pontianus (230–35)

Saint Anterus (235–36)

Saint Fabian (236–50)

Saint Cornelius (251–53)

 [Novatian (251)]

Saint Lucius I (253–54)

Saint Stephen I (254–57)

Saint Sixtus II (257–58)

Saint Dionysius (259–68)

Saint Felix I (269–74)

Saint Eutychian (275–83)

Saint Gaius (Caius) (283–96)

Saint Marcellinus (296–304)

Saint Marcellus I (308–09)

Saint Eusebius (309)

Saint Melchiades (311–14)

Saint Sylvester I (314–35)

Saint Mark (336)

Saint Julius I (337–52)

Liberius (352–66)

 [Felix II (355–65)]

Saint Damasus I (366–84)

 [Ursinus (366–67)]

Saint Siricius (384–99)

Saint Anastasius I (399–401)

Saint Innocent I (401–17)

Saint Zosimus (417–18)

Saint Boniface I (418–22)

 [Eulalius (418–19)]

Saint Celestine I (422–32)

Saint Sixtus III (432–40)

Saint Leo I (440–61)

Saint Hilary (461–68)

Saint Simplicius (468–83)

Saint Felix III (II) (483–92)

Saint Gelasius I (492–96)

Anastasius II (496–98)

Saint Symmachus (498–514)

 [Lawrence (498; 501–05)]

Saint Hormisdas (514–23)

Saint John I (523–26)

Saint Felix IV (III) (526–30)

Boniface II (530–32)

 [Dioscorus (530)]

John II (533–35)

Saint Agapitus I (535–36)

Saint Silverius (536–37)

Vigilius (537–55)

Pelagius I (556–61)

John III (561–74)

Benedict I (575–79)

Pelagius II (579–90)

Saint Gregory I (590–604)

Sabinian (604–06)

Boniface III (607)

Saint Boniface IV (608–15)

Saint Deusdedit I (615–18)

Boniface V (619–25)

Honorius I (625–38)

Severinus (640)

John IV (640–42)

Theodore I (642–49)

Saint Martin I (649–55)

Saint Eugenius I (654–57)

Saint Vitalian (657–72)

Deusdedit II (672–76)

Donus (676–78)

Saint Agatho (678–81)

Saint Leo II (682–83)

Saint Benedict II (684–85)

John V (685–86)

Conon (686–87)

 [Theodore (687)]

 [Paschal (687)]

Saint Sergius I (687–701)

John VI (701–05)

John VII (705–07)

Sisinnius (708)

Constantine (708–15)

Saint Gregory II (715–31)

Saint Gregory III (731–41)

Saint Zachary (741–52)

Stephen (752)

Stephen II (III) (752–57)

Saint Paul I (757–67)

 [Constantine (767–69)]

 [Philip (768)]

Stephen III (IV) (768–72)

Hadrian I (772–95)

Saint Leo III (795–816)

Stephen IV (V) (816–17)

Saint Paschal I (817–24)

Eugenius II (824–27)

Valentine (827)

Gregory IV (827–44)

 [John (844)]

Sergius II (844–47)

Saint Leo IV (847–55)

Benedict III (855–58)

 [Anastasius (855)]

Saint Nicholas I (858–67)

Hadrian II (867–72)

John VIII (872–82)

Marinus I (882–84)

Saint Hadrian III (884–85)

Stephen V (VI) (885–91)

Formosus (891–96)

Boniface VI (896)

Stephen VI (VII) (896–97)

Romanus (897)

Theodore II (897)

John IX (898–900)

Benedict IV (900–903)

Leo V (903)

 [Christopher (903–04)]

Sergius III (904–11)

Anastasius III (911–13)

Lando (913–14)

John X (914–28)

Leo VI (928)

Stephen VII (VIII) (928–31)

John XI (931–35)

Leo VII (936–39)

Stephen VIII (IX) (939–42)

Marinus II (942–46)

Agapetus II (946–55)

John XII (955–64)

Leo VIII (963–65)

Benedict V (964–66)

John XIII (965–72)

Benedict VI (973–74)

 [Boniface VII (974; 984–85)]

Benedict VII (974–83)

John XIV (983–84)

John XV (985–96)

Gregory V (996–99)

 [John XVI (997–98)]

Sylvester II (999–1003)

John XVII (1003)

John XVIII (1004–09)

Sergius IV (1009–12)

Benedict VIII (1012–24)

 [Gregory (1012)]

John XIX (1024–32)

Benedict IX (1032–44)

Sylvester III (1045)

Benedict IX (1045)

Gregory VI (1045–46)

Clement II (1046–47)

Benedict IX (1047–48)

Damasus II (1048)

Saint Leo IX (1049–54)

Victor II (1055–57)

Stephen IX (X) (1057–58)

 [Benedict X (1058–59)]

Nicholas II (1059–61)

Alexander II (1061–73)

 [Honorius II (1061–72)]

Saint Gregory VII (1073–85)

 [Clement III (1084–1100)]

Blessed Victor III (1086–87)

Blessed Urban II (1088–99)

Paschal II (1099–1118)

 [Theodoric (1100)]

 [Albert (1102)]

 [Sylvester IV (1105–11)]

Gelasius II (1118–19)

 [Gregory VIII (1118–21)]

Callistus II (1119–24)

Honorius II (1124–30)

 [Celestine II (1124)]

Innocent II (1130–43)

 [Anacletus II (1130–38)]

 [Victor IV (1138)]

Celestine II (1143–44)

Lucius II (1144–45)

Blessed Eugenius III (1145–53)

Anastasius IV (1153–54)

Hadrian IV (1154–59)

Alexander III (1159–81)

 [Victor IV (1159–64)]

 [Paschal III (1164–68)]

 [Callistus III (1168–78)]

 [Innocent III (1179–80)]

Lucius III (1181–85)

Urban III (1185–87)

Gregory VIII (1187)

Clement III (1187–91)

Celestine III (1191–98)

Innocent III (1198–1216)

Honorius III (1216–27)

Gregory IX (1227–41)

Celestine IV (1241)

Innocent IV (1243–54)

Alexander IV (1254–61)

Urban IV (1261–64)

Clement IV (1265–68)

Blessed Gregory X (1272–76)

Blessed Innocent V (1276)

Hadrian V (1276)

John XXI (1276–77)

Nicholas III (1277–80)

Martin IV (1281–85)

Honorius IV (1285–87)

Nicholas IV (1288–92)

Saint Celestine V (1294)

Boniface VIII (1295–1303)

Blessed Benedict XI (1303–04)

Clement V (1305–14)

John XXII (1316–34)

 [Nicholas V (1328–30)]

Benedict XII (1335–42)

Clement VI (1342–52)

Innocent VI (1352–62)

Blessed Urban V (1362–70)

Gregory XI (1371–78)

Urban VI (1378–89)

Boniface IX (1389–1404)

Innocent VII (1404–06)

Gregory XII (1406–15)

 [Clement VII (1378–94)]

 [Benedict XIII (1394–1423)]

[Alexander V (1409–10)]

[John XXIII (1410–15)]

Martin V (Colonna, 1417–31)

Eugenius IV (Condulmero, 1431–47)

[Felix V (1440–49)]

Nicholas V (Parentucelli, 1447–55)

Callistus III (Borgia, 1455–58)

Pius II (Piccolomini, 1458–64)

Paul II (Barbo, 1464–71)

Sixtus IV (Della Rovere, 1471–84)

Innocent VIII (Cibo, 1484–92)

Alexander VI (Borgia, 1492–1503)

Pius III (Todeschini-Piccolomini, 1503)

Julius II (Della Rovere, 1503–13)

Leo X (Medici, 1513–21)

Hadrian VI (Florenz, 1522–23)

Clement VII (Medici, 1523–34)

Paul III (Farnese, 1534–49)

Julius III (Ciocchi del Monte, 1550–55)

Marcellus II (Cervini, 1555)

Paul IV (Carafa, 1555–59)

Pius IV (Medici, 1560–65)

Saint Pius V (Ghislieri, 1566–72)

Gregory XIII (Boncompagni, 1572–85)

Sixtus V (Peretti, 1585–90)

Urban VII (Castagna, 1590)

Gregory XIV, (Sfondrati, 1590–91)

Innocent IX (Facchinetti, 1591)

Clement VIII (Aldobrandini, 1592–1605)

Leo XI (Medici, 1605)

Paul V (Borghese, 1605–21)

Gregory XV (Ludovisi, 1621–23)

Urban VIII (Barberini, 1623–44)

Innocent X (Pamphili, 1644–55)

Alexander VII (Chigi, 1655–67)

Clement IX (Rospigliosi, 1667–69)

Clement X (Altieri, 1670–76)

Blessed Innocent XI (Odescalchi, 1676–89)

Alexander VIII (Ottoboni, 1689–91)

Innocent XII (Pignatelli, 1691–1700)

Clement XI (Albani, 1700–1721)

Innocent XIII (Conti, 1721–24)

Benedict XIII (Orsini, 1724–30)

Clement XII (Corsini, 1730–40)

Benedict XIV (Lambertini, 1740–58)

Clement XIII (Rezzonico, 1758–69)

Clement XIV (Ganganelli, 1769–74)

Pius VI (Braschi, 1775–99)

Pius VII (Chiaramonti, 1800–1823)

Leo XII (Della Genga, 1823–29)

Pius VIII (Castiglioni, 1829–30)

Gregory XVI (Cappellari, 1831–46)

Pius IX (Mastai-Ferretti, 1846–78)

Leo XIII (Pecci, 1878–1903)

Saint Pius X (Sarto, 1903–14)

Benedict XV (Della Chiesa, 1914–22)

Pius XI (Ratti, 1922–39)

Pius XII (Pacelli, 1939–58)

John XXIII (Roncalli, 1958–63)

Paul VI (Montini, 1963–78)

John Paul I (Luciani, 1978)

John Paul II (Wojtyla, 1978–)

ILLUSTRATIONS

THE APOSTOLIC PALACE

THE APOSTOLIC VATICAN LIBRARY

THE VATICAN SECRET ARCHIVE

THE PILGRIMAGE BASILICAS

THE CATACOMBS

PALACES OF THE HOLY SEE IN ROME

SELECTED BIBLIOGRAPHY

History

Brentano, R. *Rome Before Avignon: A Social History of Thirteenth-Century Rome.* London, 1974

Del Re, N. *La curia romana: Lineamenti storico-giuridici.* 3rd ed. Rome, 1970.

Gregorovius, F. *History of the City of Rome in the Middle Ages.* 8 vols. London, 1903–1912.

Krautheimer, R. *Rome: Profile of a City, 312–1308.* Princeton, 1980.

Llewellyn, P. *Rome in the Dark Ages.* London, 1970.

Lugli, G. "Il Vaticano nell'eta classica." In G. Fallani and M. Escobar, eds., *Vaticano*, pp. 3–22. Florence, 1946.

Mann, H. K. *The Lives of the Popes in the Middle Ages.* 2nd ed. 18 vols. London, 1925.

O'Connor, D. W. *Peter in Rome: The Literary, Liturgical, and Archaeological Evidence.* New York, 1969.

Partner, P. *The Lands of Saint Peter: The Papal State in the Middle Ages and the Early Renaissance.* London, 1972.

––––––– *Renaissance Rome, 1500–1559: A Portrait of a Society.* Berkeley, 1976.

Pastor, L. von. *The History of the Popes.* 40 vols. London, 1891–1953.

Pietri, C. *Recherches sur l'église de Rome, son organisation, sa politique, son idéologie de Miltiade à Sixte III (311–340).* Bibliothèque des Ecoles françaises d'Athènes et de Rome, vol. 224. Rome, 1976.

Richards, J. *The Popes and the Papacy in the Early Middle Ages: 476–752.* London, Boston, and Henley, 1979.

Ullmann, W. *The Growth of Papal Government in the Middle Ages.* 3rd ed. London, 1970.

Old Saint Peter's

Apollonj Ghetti, B. M., et al. *Esplorazioni sotto la confessione de San Pietro in Vaticano eseguite negli anni 1940–1949.* Vatican City, 1951.

Kirschbaum, E. *The Tombs of St Peter & St Paul.* New York, 1959.

Krautheimer, R. *Early Christian and Byzantine Architecture.* 2nd rev. ed. Harmondsworth and Baltimore, 1975.

Krautheimer, R., and Frazer, A. "San Pietro." In R. Krautheimer, ed., *Corpus Basilicarum Christianarum Romae*, vol. 5, pp. 165–279. Vatican City, 1977.

Toynbee, J., and Ward Perkins, J. *The Shrine of St. Peter and the Vatican Excavations.* London, 1956.

New Saint Peter's

Bruschi, A. *Bramante.* London, 1977.

De Tolnay, C. *Michelangelo: Sculptor, Painter, Architect.* Princeton, 1975.

Francia, E. *1506–1606: Storia della construzione del nuovo San Pietro.* Rome, 1977.

Galassi Paluzzi, C. *La basilica di San Pietro.* Roma cristiana, vol. 17. Bologna, 1975.

Hibbard, H. *Carlo Maderno and Roman Architecture, 1580–1630.* London, 1971.

––––––– *Michelangelo.* New York, Hagerstown, San Francisco, and London, 1974.

Lavin, I. *Bernini and the Crossing of Saint Peter's.* New York, 1968.

Wittkower, R. "Michelangelo's Dome of St. Peter's." In *Idea and Image: Studies in the Italian Renaissance*, pp. 73–89. [London], 1978.

The Apostolic Palace

Ackerman, J. *The Cortile del Belvedere.* Vatican City, 1954.

Battisti, E. "Il significato simbolico della Cappella Sistina." *Commentari*, 8, 1957, pp. 96–104.

Davidson, B. "The Decoration of the Sala Regia under Pope Paul III." *Art Bulletin*, 58, 1976, pp. 395–423.

Coffin, D. "Pope Innocent VIII and the Villa Belvedere." In I. Lavin and J. Plummer, eds., *Studies in Late Medieval and Renaissance Painting in Honor of Millard Meiss*, pp. 89–97. New York, 1977.

Dacos, N. *Le Logge di Raffaello: Maestro e bottega di fronte all'antico.* Rome, 1977.

Gilbert, C. "Fra Angelico's Fresco Cycles in Rome: Their Number and Date." *Zeitschrift für Kunstgeschichte*, 38, 1975, pp. 245–65.

Greco, A. *La Cappella di Niccolò V del Beato Angelico.* Rome, 1980.

Magnuson, T. *Studies in Roman Quattrocento Architecture.* Stockholm, 1958.

Parks, N. R. "On the Meaning of Pinturicchio's *Sala dei Santi*." *Art History*, 2, 1979, pp. 291–317.

Redig de Campos, D. *I palazzi vaticani*. Bologna, 1967.

Saxl, F. "The Appartamento Borgia." In *Lectures*, vol. 1, pp. 174–88. London, 1957.

Shearman, J. "The Vatican Stanze: Functions and Decoration." *Proceedings of the British Academy*, 57, 1971, pp. 1–58.

Other Buildings and the Vatican Gardens

Belli Barsali, I. *Ville di Roma*. Milan, 1970.

Castelli, L. *". . . Quel tanto di territorio . . .": Ricordi di lavori ed opere eseguiti nel Vaticano durante il pontificato di Pio XI (1922–1939)*. Rome, 1940.

D'Onofrio, C. *Acque e fontane di Roma*. Rome, 1977.

Frutaz, A. *Il torrione di Niccolò V in Vaticano*. Vatican City, 1956.

Gasbarri, C. "Mura e torri della zona vaticana e dei borghi." *L'Urbe*, 34, 1971, fasc. 6, pp. 6–13.

Giovannoni, G. "La chiesa vaticana di San Stefano Maggiore (trovamenti e restauri)." *Memorie della Pontificia Accademia Romana di Archeologia*, 4, 1934, pp. 1–28.

Krieg, P. *San Pellegrino: Die schweizerische Nationalkirche in Rom*. Zurich, 1974.

Lewine, M. "Nanni, Vignola, and S. Martino degli Svizzeri in Rome." *Journal of the Society of Architectural Historians*, 28, 1969, pp. 26–40.

———. "Vignola's Church of Sant' Anna de' Palafrenieri in Rome." *Art Bulletin*, 47, 1965, pp. 199–229.

Negro, S. *Vaticano minore*. Milan, 1937.

Smith, G. *The Casino of Pius IV*. Princeton, 1977.

Zaccagnini, C. *Le ville di Roma*. Rome, 1976.

Zanetti, G. "La fontana della Galera nei giardini vaticani." *Illustrazione vaticana*, 5, 1934, pp. 509–510.

The Vatican Museums

Brummer, H. *The Statue Court in the Vatican Belvedere*. Stockholm, 1970.

Helbig, W. *Führer durch die öffentlichen Sammlungen klassischer Altertümer in Rom*. Vol. 1, *Die Päpstlichen Sammlungen im Vatikan und Lateran*. 4th rev. ed. Tübingen, 1963.

Redig de Campos, R. *Wanderings among Vatican Paintings*. Rome, 1961.

The Vatican Collections: The Papacy and Art. Exh. cat., New York, The Metropolitan Museum of Art, February 2–June 12, 1983. New York, 1983.

The Apostolic Vatican Library

Bignami-Odier, J. *La Bibliothèque Vaticane de Sixte IV à Pie XI*. Vatican City, 1973.

Ruysschaert, J. "Sixte IV, fondateur de la Bibliothèque Vaticane." *Archivum historiae pontificiae*, 7, 1969, pp. 513–24.

Vian, N. *La Biblioteca Apostolica Vaticana*. Vatican City, 1970.

The Vatican Secret Archive

Ambrosini, M. L. *The Secret Archives of the Vatican*. Boston and Toronto, 1969.

Boyle, L. *A Survey of the Vatican Archives and of its Medieval Holdings*. Toronto, 1972.

Giusti, M. *Studi sui registri di bolle papali*. Collectanea Archivi Vaticani, vol. 1. Vatican City, 1968.

The Pilgrimage Basilicas

Blunt, A. *Borromini*. London, 1979.

Cecchelli, C. *I mosaici della basilica di S. Maria Maggiore*. Turin, 1956.

Ferrua, A. *S. Sebastiano f.l.m. e la sua catacomba*. 3rd ed. Rome, 1968.

Gardner, J. "Pope Nicholas IV and the Decoration of S. Maria Maggiore." *Zeitschrift für Kunstgeschichte*, 36, 1973, pp. 1–50.

———. "S. Paolo fuori le Mura, Nicholas III, and Pietro Cavallini." *Zeitschrift für Kunstgeschichte*, 34, 1971, pp. 240–48.

Golzio, V. *Le chiese di Roma dall'XI al XVI secolo*. Bologna, 1963.

Kendall, A. *Medieval Pilgrims*. New York, 1970.

Krautheimer, R. "S. Croce in Gerusalemme." In *Corpus Basilicarum Christianarum Romae*, vol. 1, pp. 165–95. Vatican City, 1937.

———. "S. Sebastiano." In R. Krautheimer, ed., *Corpus Basilicarum Christianarum Romae*, vol. 4, pp. 99–147. Vatican City, 1970.

Krautheimer, R., and Corbett, S. "S. Giovanni in Laterano." In R. Krautheimer, ed., *Corpus Basilicarum Christianarum Romae*, vol. 5, pp. 1–92. Vatican City, 1977.

Krautheimer, R., Corbett, S., and Frankel, W. "S. Maria Maggiore." In R. Krautheimer, ed., *Corpus Basilicarum Christianarum Romae*, vol. 3, pp. 1–60. Vatican City, 1967.

Krautheimer, R., and Frankel, W. "S. Lorenzo fuori le Mura." In R. Krautheimer, ed., *Corpus Basilicarum Christianarum Romae*, vol. 2, pp. 1–144. Vatican City, 1959.

Krautheimer, R., and Frazer, A. "S. Paolo fuori le Mura." In R. Krautheimer, ed., *Corpus Basilicarum Christianarum Romae*, vol. 5, pp. 93–164. Vatican City, 1977.

Mariani, V. *Le chiese di Roma dal XVII al XVIII secolo*. Bologna, 1963.

Martin, G. *Roma Sancta* (1581). Edited by G. B. Parks from the manuscript. Rome, 1969.

Matthiae, G. *Mosaici medioevali delle chiese di Rome*. Rome, 1967.

———. *Pittura romana del medioevo*. 2 vols. Rome, 1965 and 1968.

Ortolani, S. *S. Croce in Gerusalemme.* Rome, 1969.

Pelliccioni, G. *Le nuove scoperte sulle origini del Battistero lateranense.* Memorie della Pontificia Accademia Romana di Archeologia, vol. 12, part 1. Rome, 1973.

The Catacombs

Ferrua, A. *Le pitture della nuova catacomba di Via Latina.* Vatican City, 1960.

Josi, E. *Il cimitero di Callisto.* Rome, 1933.

Kirsch, G. P. *The Catacombs of Rome.* Rome, 1946.

Nestori, A. *Repertorio topografico delle pitture delle catacombe romane.* Vatican City, 1975.

Stevenson, J. *The Catacombs: Rediscovered Monuments of Early Christianity.* London, 1978.

Testini, P. *Le catacombe e gli altri cimiteri cristiani in Roma.* Bologna, 1966.

Wilpert, G. *Le pitture delle catacombe romane.* Rome, 1903.

Palaces of the Holy See in Rome

Antonazzi, G. *Il Palazzo di Propaganda.* Rome, 1979.

Schiavo, A. *Il Laterano: Palazzo e Battistero.* Rome, 1969.

———. *Il Palazzo della Cancelleria.* Rome, 1964.

PHOTO CREDITS

Photographs by Mario Carrieri

Photographs also contributed by:

Bruno Del Priore
Editorial Photocolor Archives, Inc.—New York
Foto Giordani
The Metropolitan Museum of Art Photograph Studio
Pasquale De Antonis
Photo Researchers—New York
The photographic archives of the Apostolic Vatican Library
The photographic archives of the Pontifical Commission for Sacred Archaeology
The photographic archives of the Reverenda Fabbrica di San Pietro
The photographic archives of the Vatican Museums
SCALA—Istituto Editoriale—Florence